Mary Cassatt

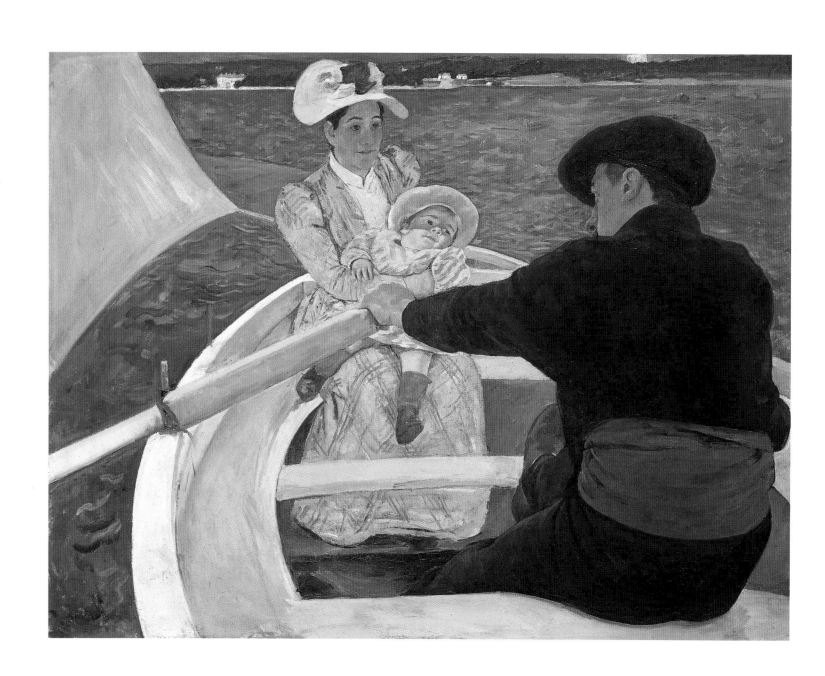

Mary Cassatt: *Modern Woman*

Organized by Judith A. Barter

With contributions by Erica E. Hirshler, George T. M. Shackelford, Kevin Sharp,

Harriet K. Stratis, & Andrew J. Walker

The Art Institute of Chicago

in association with

Harry N. Abrams, Inc., Publishers

This book was published in conjunction with the exhibition "Mary Cassatt: Modern Woman," organized by The Art Institute of Chicago in collaboration with the Museum of Fine Arts, Boston, and the National Gallery of Art, Washington, D.C. The dates of the exhibition are: The Art Institute of Chicago (Oct. 10, 1998–Jan. 10, 1999), Museum of Fine Arts (Feb. 14–May 9, 1999), and National Gallery of Art (June 6–Sept. 6, 1999).

In Chicago the Sara Lee Corporation is the primary sponsor of "Mary Cassatt: Modern Woman." Support is also provided by the Henry Luce Foundation.

Aetna is proud to sponsor this exhibition in Washington, D.C.

FRONT COVER: Mary Cassatt. *On a Balcony*, 1878/79 (cat. 13)
BACK COVER: Mary Cassatt. *Tea*, 1879/80 (cat. 27)
FRONTISPIECE: Mary Cassatt, *The Boating Party*, 1894 (cat. 77)

Edited by Susan F. Rossen, Executive Director of Publications, assisted by Laura Kozitka and Britt Salvesen
Photo edited by Jonathan Stuhlman
Production by Amanda W. Freymann, Associate Director of Publications, Production
Designed and typeset by Steven Schoenfelder Design, New York
Printed and bound by Amilcare Pizzi, Milan, Italy

All photographs of works of art in The Art Institute of Chicago are by the Department of Imaging, Alan B. Newman, Executive Director.

Clothbound edition published in 1998 in association with Harry N. Abrams, Inc., 100 Fifth Avenue, New York, N.Y. 10011. www.abramsbooks.com

First edition

Library of Congress Cataloging-in-Publication Data

Cassatt, Mary, 1844–1926
Mary Cassatt, modern woman/organized by Judith A. Barter; with contributions by Erica E. Hirshler . . . [et al.]. p. cm.
Published to accompany a traveling exhibition opening at The Art Institute of Chicago.
Includes bibiographical references and index.
ISBN 0–8109–4089–2 (ABRAMS HC) —
ISBN 0–8109–2766–7 (BOMC PB) —
ISBN 0–86559–167–9 (AIC PB)
1. Cassatt, Mary, 1844–1926—Exhibitions.
2. Impressionism (Art)—Exhibitions.
3. Cassatt, Mary 1844–1926—Criticism and interpretation.
I. Cassatt, Mary, 1844–1926.
II. Barter, Judith A., 1951–
III. Hirshler, Erica E.
IV. Art Institute of Chicago.
V. Title
N6537.C35A4 1998
760'.092—DC21 98–7306

AUTHORS:
Judith A. Barter, Field-McCormick Curator of American Arts at The Art Institute of Chicago, organized the exhibition that accompanies this volume. George T. M. Shackelford is the Mrs. Russell W. Baker Curator of European Paintings, and Erica E. Hirshler is Associate Curator of American Paintings, both at the Museum of Fine Arts, Boston. Kevin Sharp is Curator of American Art, Norton Museum of Art, West Palm Beach, Florida. Andrew J. Walker is Research Assistant in the Department of American Arts, and Harriet K. Stratis is Paper Conservator in the Department of Prints and Drawings, both at The Art Institute of Chicago.

Contents

Sponsors' Statements

For nearly twenty years, Sara Lee Corporation has had the pleasure of owning a fine group of Impressionist paintings. So we observe with particular interest how Mary Cassatt created a unique and beautiful place within one of the great artistic movements in Western history.

That Cassatt happened to be one of only three women to join the French Impressionists also endears her to us. And of course, in the patriotic sense, Mary Cassatt was a superb American artist, and the only one invited to exhibit with the French Impressionists.

While a young woman, she developed her own response to the Impressionists' ideas about art and modern life. As a patron and collector herself, she had a hand in starting some of the first great American collections of French Impressionist art.

Sara Lee is pleased to recognize Mary Cassatt's remarkable achievements through sponsorship of "Mary Cassatt: Modern Woman."

John H. Bryan
Chairman and Chief Executive Officer
Sara Lee Corporation

The Henry Luce Foundation is delighted to support "Mary Cassatt: Modern Woman" and applauds The Art Institute of Chicago for mounting the first retrospective in several decades of this important North American artist's work.

Including a number of the artist's best paintings, pastels, drawings, and prints, the exhibition and book that accompanies it chronicle her long and distinguished career. We look forward to a beautiful and compelling exhibition.

The Henry Luce Foundation's art program has been dedicated to scholarship in American art since its inception in 1982. We welcome "Mary Cassatt: Modern Woman" to our roster of significant exhibitions and books about American art and are pleased to assist in bringing her much-loved work before the public.

Henry Luce III
Chairman and Chief Executive Officer
The Henry Luce Foundation, Inc.

Lenders

Public Institutions

INTERNATIONAL

Collection Rau, Zurich: 85

Museo de Bellas Artes
de Bilbao: 54

Musée du Petit Palais, Paris: 29

National Gallery of Canada,
Ottawa: 56–65

UNITED STATES

The Art Institute of Chicago: 6, 13,
23, 25, 36, 40, 50, 56–65, 72, 78, 86

Carnegie Museum of Art, Pittsburgh: 68

Chrysler Museum, Norfolk: 71

Cincinnati Art Museum: 21

Cleveland Museum of Art: 43

Corcoran Gallery of Art,
Washington, D.C.: 45

Detroit Institute of Arts: 32

Fine Arts Museums of
San Francisco: 55

Flint Institute of Arts: 38

Huntington Library and Art Gallery,
San Marino: 83

Joslyn Art Museum, Omaha: 14

Los Angeles County Museum
of Art: 28

Maryland Commission on Artistic
Property of the Maryland State
Archives: 16

The Metropolitan Museum of Art,
New York: 33, 35, 87, 88

Museum of American Art of the
Pennsylvania Academy of the Fine
Arts, Philadelphia: 1

Museum of Fine Arts, Boston: 7, 17,
27, 73, 81

National Gallery of Art, Washington,
D.C.: 9, 11, 20, 42, 44, 47–49, 56–65,
67, 69, 77, 89

National Museum of American Art,
Smithsonian Institution, Washington,
D.C.: 4

National Portrait Gallery, Smithsonian
Institution, Washington, D.C.: 26, 91

The New York Public Library: 22,
24, 37

Philadelphia Museum of Art: 3, 18,
34, 46, 82

Sterling and Francine Clark Art
Institute, Williamstown: 5

Terra Foundation for the Arts, Daniel J. Terra Collection, Chicago: 76

UCLA at the Armand Hammer
Museum of Art and Cultural
Center, Los Angeles: 79

Virginia Museum of Fine Arts,
Richmond: 70, 75

Wichita Art Museum: 52

William Benton Museum of
Art, University of Connecticut,
Storrs: 53

Private Collectors/
Galleries

Philip and Charlotte Hanes: 8

Collection of Mr. and Mrs.
Charles Hermanowski: 31

Ursula and R. Stanley Johnson
Family Collection, Chicago: 41, 51

Mr. and Mrs. Meredith J. Long: 12

Collection of Fayez Sarofim: 80, 90

Dr. and Mrs. Jeb Stewart: 39

Estate of Daniel J. Terra,
Chicago: 84

Anonymous lenders: 2, 10, 15,
19, 30, 66, 74

Foreword

Mary Cassatt developed special relationships with many art museums in the United States, including two of the three institutions hosting this exhibition. Keenly feeling, as an art student in Philadelphia, the lack of fine art to study in her homeland, she worked diligently to encourage Americans to collect. She knew that this activity on the part of her nation's wealthy leaders would eventually enrich the country's nascent public art museums. While Cassatt may not have envisioned the impressive number of North American institutions that now boast works by her—as our exhibition demonstrates—she was absolutely correct in her belief that the country's young museums, and future generations of Americans, would benefit directly from the investment in art by her family, friends, and acquaintances.

After her return from studying in Europe, Cassatt chose to promote her art in Chicago, traveling to the city with her work. Her timing was inauspicious: she barely escaped the 1871 Great Chicago Fire with her life and lost two paintings in the process. Although she never again visited the city, she became acquainted with its leading collectors, Potter and Bertha Honoré Palmer, and their art agent, Sara Tyson Hallowell. Mrs. Palmer gave Cassatt an opportunity that heretofore had never been offered a woman, the execution of a monumental mural for the 1893 World's Columbian Exposition in Chicago. Her *Modern Woman* graced the Woman's Building at that event; it disappeared sometime after 1910. Thanks to Cassatt's advice and perseverance, she managed to persuade museum trustees Martin A. Ryerson and Charles L. Hutchinson, as well as director William M. R. French, to purchase El Greco's *Assumption of the Virgin*, one of the Art Institute's most celebrated and important possessions. The Palmers, the Ryersons, and other Chicagoans collected Cassatt's works, much of which is housed today in the museum.

The city of Boston showed an interest very early on in the art of Mary Cassatt, with a number of its citizens becoming her supporters and friends. In 1878 the Massachusetts Charitable Mechanic Association exhibited her paintings. Two decades later, the St. Botolph Club presented one of the first solo exhibitions of Cassatt's art to be held in the United States. In that year, which saw Cassatt visit the United States after more than twenty years in France, the artist journeyed to Boston to see friends and complete a number of portrait commissions. Over many years, the artist assisted trustees and supporters of the Museum of Fine Arts, Boston, most notably Sarah Choate Sears and Frank Gair Macomber, with their collections; their gifts enhanced the museum's holdings, which include important paintings, pastels, and prints by Cassatt, as well as decorative arts once owned by her family.

The National Gallery of Art, Washington, D.C., is perhaps the richest repository of Cassatt's oeuvre. Four of the nine original founding benefactors of the Gallery were serious collectors of the artist's work. The first was Lessing J. Rosenwald, a former Chicagoan whose extraordinary collection of over twenty thousand works on paper entered the National Gallery in 1943, not long after the museum was founded. Included in this remarkable collection, alongside examples by such

masters as Schongauer, Dürer, Lucas van Leyden, Nanteuil, and Blake, are magnificent prints and drawings by Cassatt. So too Chester Dale considered Cassatt's work essential to his extraordinary presentation of Impressionist and Post-Impressionist art, which he bequeathed to the National Gallery in 1962. Finally Paul Mellon and Ailsa Mellon Bruce assured, through their gifts, that all periods of Cassatt's career would be represented in this national collection.

For their generous support, as well as for the important works of art contributed to this exhibition, I would like to thank my colleagues at the participating institutions: Malcolm Rogers, Ann and Graham Gund Director, Museum of Fine Arts, Boston; and Earl A. Powell III, Director, National Gallery of Art, Washington, D.C. The organization of "Mary Cassatt: Modern Woman," the first retrospective of this artist in over thirty years, was the responsibility of Judith A. Barter, Field-McCormick Curator of American Arts at The Art Institute of Chicago. She and members of her staff, Kevin Sharp and Andrew J. Walker, along with Harriet K. Stratis, are to be commended for culling through thousands of paintings, pastels, prints, and drawings to select ninety objects that represent Cassatt's achievements during a career that extended over fifty years. In this endeavor, they worked closely with Erica E. Hirshler, Associate Curator of American Paintings, and George T. M. Shackelford, the Mrs. Russell W. Baker Curator of European Paintings, both at the Museum of Fine Arts, Boston. This group also envisioned the shape and content of the book that accompanies the exhibition, and provides new scholarship upon which others can build. I am grateful to Susan F. Rossen, Executive Director of Publications, and Amanda W. Freymann, Associate Director, Production, who oversaw the editing and production, respectively, of this volume.

Finally I would like to thank our institutional and private lenders, listed on page 7, most of whom generously agreed to part with works of art for more than one year. This project would never been achieved in Chicago without the generous support of our primary sponsor, the Sara Lee Corporation, and the Henry Luce Foundation. The National Gallery wishes to thank Aetna for generously supporting the exhibition in Washington, D.C. All of these individuals, institutions, and organizations, along with those listed in the Acknowledgments and still others too numerous to mention, have worked tirelessly to reaffirm Mary Cassatt's place in history as one of the most important and modern American artists of her time.

James N. Wood
Director and President
The Art Institute of Chicago

Acknowledgments

The exhibition "Mary Cassatt: Modern Woman," as well as the publication that accompanies it, is the result of an international collaboration among many institutions, collectors, and colleagues. We are first and foremost grateful to the three sponsoring institutions that have made this project possible and to their directors: The Art Institute of Chicago, James N. Wood, Director and President; Museum of Fine Arts, Boston, Malcolm Rogers, Ann and Graham Gund Director; and National Gallery of Art, Washington, D.C., Earl A. Powell III, Director. For their generous financial support of the catalogue and the exhibition in Chicago, we thank our primary sponsor, the Sara Lee Corporation, and the Henry Luce Foundation. At Sara Lee, we would particularly like to acknowledge John H. Bryan, Chairman and Chief Executive Officer, as well as Janet L. Kelly, C. Steven McMillan, and Michael E. Murphy. At the Luce Foundation, we thank Henry Luce III and Ellen D. Holtzman. For Aetna's support of the exhibition in Washington, D.C., we wish to thank its Chairman, Richard L. Huber.

At The Art Institute of Chicago, many staff members—past and present— contributed to the success of this project. Teri J. Edelstein, Deputy Director; Dorothy M. Schroeder, Assistant Director of Exhibitions and Budget; Edward W. Horner, Jr., Executive Vice-President for Development and Public Affairs; and Robert E. Mars, Executive Vice President for Adminstrative Affairs all provided support on a number of levels. We are particularly grateful to the talented and dedicated staff of the Publications Department, including Amanda W. Freymann, Laura Kozitka, Cris Ligenza, Susan F. Rossen, and Britt Salvesen, who worked tirelessly to make sure that the catalogue will be a significant addition to Cassatt scholarship as well as appealing and useful to broad audiences. Their approach to the material and support of all the authors was very much appreciated. We are also grateful to Steven Schoenfelder for his elegant design.

In the Burnham and Ryerson Libraries, Jack Perry Brown, Maureen Lasko, Natalia Lonchyna, Susan Perry, and Bart Ryckbosch dedicated much of their time to finding obscure resources. Gloria Groom in the Department of European Paintings provided helpful advice. Steven Starling, Kirk Vuillemot, Faye Wrubel, and Frank Zuccari of the Department of Conservation graciously treated, reframed, and examined works of art. In the Department of Prints and Drawings, Caesar Citraro, Christine Conniff-O'Shea, and Harriet K. Stratis expertly prepared fragile prints and pastels for exhibition. Bernd Jesse and Steven Little, in the Department of Asian Art, facilitated the loan of Japanese prints to the exhibition in Chicago. Mary Solt and her staff in the Registrar's Office handled transportation requirements. The exhibition installation was designed by John Vinci and Ward Miller of Vinci/Hamp Architects and carried out by the Art Institute's Physical Plant Department, under William J. Heye, Calvert Audrain, William D. Caddick, and Ron Pushka.

Others to be thanked include Frances Baas, Reynold Bailey, Christine Bouillette, Kirsten Buick, Jane Clark, Jay Clarke, Joseph Cochand, Lyn DelliQuadri, Douglas Druick, Sanna Evans, Shirley

Fitzpatrick, Donna Forrest, Chris Gallagher, Jennifer Geiger, Eileen Harakal, Ronne Hartfield, John Hindman, Michael Kaysen, Kimberly Kruskop, Clare Kunny, Robert Lifson, Celia Marriott, Meredith Hayes Miller, Barbara Mirecki, John Molini, Anne Morse, Alan Newman, Anders Nyberg, Mark Pascale, Greg Perry, Cheryl Povalla, Marija Raudys, Mollie Riess, Stephanie Skestos, Martha Thorne, Maria Titterington, Felicia Weatherspoon, Greg Williams, Iris Wong, Julie Zeftel, and Peter Zegers. In the Department of American Arts, Christopher Fitzgerald, Linda Pryka, Kimberly Rhodes, and Seth Thayer provided invaluable support. We are also indebted to our enthusiastic interns: Josephine Albanese, Greg Foster-Rice, Juliet Hardesty, Miriam Lowenstamm, Suzanne A. Miller, Susannah Papish-Horner, and Ana Vargas, each of whom contributed to our research. Wendy Bellion patiently combed myriad sources to create the Chronology found in this volume. Last, but not least, Jonathan Stuhlman worked with energy, efficiency, and grace as the book's photography editor and as a compiler of the backmatter.

At the Museum of Fine Arts, Boston, many deserve thanks for their dedication to making the exhibition a success. We are particularly indebted to the John Moors Cabot Curator of American Paintings, Theodore E. Stebbins, Jr., who enriched the project with his wide-ranging scholarship and judicious eye. Curator for Development Projects Barbara Stern Shapiro, who has worked for many years on Cassatt's printed oeuvre, was most generous with her expertise and advice. Katie Getchell cheerfully and expertly guided all aspects of the exhibition organization and design; in her office, we also thank Andi Cocita, Val McGregor, and Susan Tomasian. Paul Bessire and Pat Jacoby of the Development Office worked to assure funding; Registrar Pat Loiko skillfully coordinated transportation of the exhibition; and Barbara Martin employed her educational skills to inform the Boston audience about the exhibition. Anne Poulet and Jeff Munger of the European Decorative Arts Department, Ann Coleman of Textiles and Costumes, Jonathan Fairbanks of American Decorative Arts and Sculpture, and Anne Morse and Emiko Mikisch of the Asiatic Department were generous with the loans of objects from their collections. Conservation staff members Andy Haines, Lydia Vagts, and Jim Wright insured that the museum's paintings by Cassatt looked their best; and Annette Manick and Roy Perkinson offered assistance with works of art on paper. We acknowledge with gratitude the help of Brent Benjamin, Joanne Donovan, Deanna Griffin, Shelley Langdale, Julia McCarthy, Kathleen McDonald, Maureen Melton, Karen Otis, Kim Pashko, Karen Pfefferle, Amanda Prugh, Ellen Roberts, Mary Sluskonis, and Erika Swanson.

At the National Gallery of Art, Washington, D.C. we owe a debt of gratitude to D. Dodge Thompson, Chief of Exhibitions; to Kathleen McCleery Wagner and Jennifer Bumba-Kongo of his staff; and to Susan Arensberg, Head of Exhibition Programs. In the Department of American and British Paintings, we thank Senior Curator Nicolai Cikovsky, Jr. and Heidi Applegate. Also to be mentioned are Carlotta Owens, Assistant Curator, Modern Prints and Drawings; Michelle Fonda,

Registrar of Exhibitions; Nancy Hoffmann, Assistant to the Treasurer for Risk Management and Special Projects; and Sandra Masur, Chief Corporate Relations Officer. Finally we thank Mark Leithauser, Chief of Design and Installation, and his staff: Gordon Anson, Barbara Keyes, Debbie Kirkpatrick, Donna Kwederis, John Olson, Jane Rodgers, and Stephan Wilcox.

"Mary Cassatt: Modern Woman" would not have been possible without the support of over forty lenders to the exhibition, both private and institutional. In two cases, the contributions have been especially generous, representing a significant part of each museum's Cassatt holdings. The staff of The Metropolitan Museum of Art, New York, was supportive from the outset. We are grateful to its director, Philippe de Montebello; H. Barbara Weinberg and N. Mishoe Brennecke in the Department of American Painting; and Rebecca Rabinow, Susan Alyson Stein, and Gary Tinterow in the Department of European Painting. The Philadelphia Museum of Art has been equally considerate. We extend our thanks to its director, Anne d'Harnoncourt, as well as to Joseph J. Rishel, Darrel L. Sewell, and Christopher J. Riopelle (now of the National Gallery, London).

Every loan to this exhibition was crucial to creating a representation of the finest works Cassatt produced. We extend our sincere thanks to all those who helped us realize this goal: Shirley L. Thomson, former director, and Anne Maheux and Colin B. Bailey at the National Gallery of Canada, Ottawa; Thérèse Burollet, Director, Musée du Petit Palais, Paris; Miguel Zugaza, Director, Museo de Bellas Artes de Bilbao, Spain; Robert Clémentz, Chief Curator, Collection Rau, Zurich; Graham W. J. Beal, Director, and Ilene Fort, Los Angeles County Museum of Art; David Rodes, Director, and Cynthia Burlingham of UCLA at the Armand Hammer Museum of Art and Cultural Center, Los Angeles; Harry S. Parker III, Director, and Steven A. Nash, Fine Arts Museums of San Francisco; Edward Nygren, Director, and Amy Meyers of the Virginia Steele Scott Collection, Huntington Library and Art Gallery, San Marino, California; former acting director Thomas P. Bruhn and George Mazeika, William Benton Museum of Art, University of Connecticut, Storrs; David C. Levy, Director and President, and Jack Cowart, Corcoran Gallery of Art, Washington, D.C.; Elizabeth Broun, Director, National Museum of American Art, Smithsonian Institution, Washington, D.C.; Alan Fern, Director, Carolyn Carr, and Wendy Wick Reaves, National Portrait Gallery, Smithsonian Institution, Washington, D.C.; James D. Terra, Judith F. Terra, James W. Collins, Tracy Colquhoun, Shelly Roman, and Catherine A. Stevens, Terra Foundation for the Arts, Daniel J. Terra Collection; Inez S. Wolins, Director, Novelene Ross, Garner Shriver, and Roger Turner, Wichita Art Museum; Carol E. Borchert of the Maryland State Archives, along with Doreen Bolger, Director, Sona Johnston, Jay Fisher, and Susan Dackerman of the Baltimore Museum of Art; Michael Conforti, Director, Martha Asher, Sterling and Francine Clark Art Institute, Williamstown, Massachusetts; Leslie Paisley, Williamstown Regional Art Conservation Laboratory; Nancy Rivard Shaw, The Detroit Institute of Arts; John Henry, Director, and Christopher Young, Flint Institute of Arts; John E. Schloder, Director, and Claudia Einecke, Joslyn Art Museum, Omaha, Nebraska; Roberta Waddell, New York Public Library; Barbara K. Gibbs, Director, and Kristin Spangenberg, Cincinnati Art Museum; Robert P. Bergman, Director, Diane Degrazia, and Carter Foster, Cleveland Museum of Art; Daniel Rosenfeld, Director, Cheryl Leibold, Gail Rawson, and Sylvia Yount, Pennsylvania Academy of the Fine Arts, Philadelphia; Richard Armstrong, Henry J. Heinz II Direc-

tor, and Allison Revello, Carnegie Museum of Art, Pittsburgh; William J. Hennessey, Director, and Catherine Jordan Wass, Chrysler Museum, Norfolk; and Katharine C. Lee, Director, and David Park Curry, Virginia Museum of Fine Arts, Richmond. We are particularly grateful to the private lenders who agreed to part with works from their collections: Philip and Charlotte Hanes, Mr. and Mrs. Charles Hermanowski, Mr. and Mrs. George A. Skestos, Dr. and Mrs. Jeb Stewart, Fayez Sarofim, and those individuals who wished to remain anonymous. Several fine-art dealers also contributed to this exhibition; we gratefully acknowledge Michael Altman of Michael Altman, Inc., New York; James Berry Hill of the Berry-Hill Galleries, New York; Margo Schab of Margo Pollins Schab, Inc., New York; Martha Parrish and James Reinish of Martha Parrish and James Reinish, Inc., New York; and Joseph de Baillio of Wildenstein and Co., New York. We are especially grateful for the generous support of the Ursula and R. Stanley Johnson family and R. Stanley Johnson Fine Art in Chicago, as well as that of Mr. and Mrs. Meredith J. Long in Houston, Texas, for their gratifying interest and involvement in our project. For loans *hors catalogue* to the exhibition, we wish to thank Edith Smith; Katherine Dibble, Boston Public Library; and Richard Wendorf, Boston Athenaeum.

Many colleagues at other institutions, scholars, dealers, collectors, and arts professionals of all kinds provided invaluable support and advice throughout the planning of this exhibition. In particular we wish to thank Marina Ferretti and Michèle Melchionda for their efforts relating to the catalogue. We are also grateful to Warren Adelson, Sigurd Anderson, Scott Atkinson, Rutgers Barclay, Elizabeth Anne Bilyeau, Laura Bradley, Montgomery S. Bradley, Steven Bradley, Jean Coyner, Marianne Delafond, Steve Doell, John Dorsey, Berris Esplen, William Gerdts, Franck Giraud, Caroline Durand-Ruel Godfroy, Nicholas Graver, Shepherd Holcombe, Steven Kern, Sarah Kianovsky, Judy Larson, Jacques and Monique Lay, Suzanne G. Lindsay, Mary Lublin, Mr. and Mrs. J. Robert Maguire, Laure Beaumont-Maillet, Andrea Maltese, Debra Mancoff, Marena Grant Morrisey, Claire Goldberg Moses, Polly Pasternak, Joachim Pissarro, Ian Reeves, Susan Rolfe, Anne Rosenthal, Corinne Burin des Roziers, Chase Rynd, Andrew Schoelkopf, Randy Seelye, Mrs. Eric de Spoelborch, Miriam Stewart, Charles F. Stuckey, Carol Tonieri, Reagan Upshaw, Susan Wegner, Sandy Wheeler, Robert N. Whittemore, the Whittemore Family Collection, and Helena Wright.

Our project would not have been possible without the efforts of a number of scholars whose work on Mary Cassatt and other women artists of her time has been invaluable: We acknowledge our debt to the late Adelyn Breeskin, Frederick Sweet, and Frances Weitzenhoffer. We are most grateful to Anne Higonnet, Colta Ives, Griselda Pollock, Barbara Stern Shapiro, and last, but certainly foremost, Nancy Mowll Mathews. Finally we would like to express our deepest gratitude to a group of very special modern women and men who have endured the long and demanding process of organizing this exhibition and book: Ann Brizzolara, Harold D. Clark, Jr., Matt Glucksberg, Paula Lupkin, and Michèle Melchionda.

Judith A. Barter, Erica E. Hirshler, George T. M. Shackelford,
Kevin Sharp, Harriet K. Stratis, and Andrew J. Walker

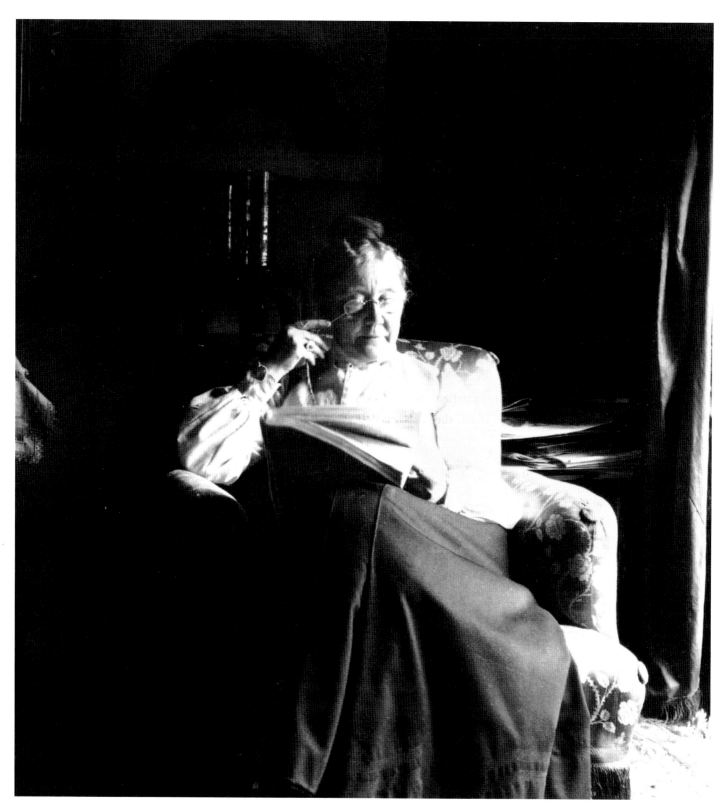

Fig. 1. Theodate Pope (American; 1868–1946). Photograph of Mary Cassatt
seated beneath her Degas fan (Barter, fig. 22), 1903. Photo: courtesy Hill-Stead
Museum, Farmington, Conn.

Introduction

Judith A. Barter

When Charles Durand-Ruel, son of Mary Cassatt's primary dealer, Paul Durand-Ruel, died prematurely in September 1892, the artist traveled to Paris from her summer home to attend the funeral. She was accompanied by her sister-in-law Lois Cassatt, who wrote of the event to her son, "I saw all the great artists there and Aunt Mary pointed them out to me."[1]

Mary Cassatt not only knew "all the great artists" gathered together that day, but she was very much one of them. In the late 1870s and early 1880s, she had been at the center of the Impressionist group; moreover she had achieved a significant position in the Parisian art world despite her status as a foreigner and as an unmarried woman. Either of these facts could have marginalized her professionally and socially in late-nineteenth-century France, where modern art was the province of men. But Cassatt, serious about her chosen career, turned these perceived deficits into advantages. As an American living in France, she was able to build a career and a following on both sides of the Atlantic. Her unmarried status gave her freedom of movement, and she traveled and studied extensively. In her travels, she braved discomfort, cold, bed-bugs, disease, and danger with a tough and tenacious spirit. In fact Cassatt faced all of life's challenges with what her young friend the artist George Biddle described as "an electric vitality."[2]

Beneath Cassatt's determination lay a prodigious talent and an acuity of mind that impressed men and women alike and earned her the respect of other artists. Her lifelong friend Louisine Havemeyer called her "the most intelligent woman I had ever met,"[3] and the noted Symbolist poet Stéphane Mallarmé greatly admired her work. Edgar Degas, Cassatt's closest ally among the Impressionists, paid tribute to her both in his art and in many documented remarks. Although often expressed in a backhanded fashion, his estimation of her work—"No woman has the right to draw like that"[4]—was the ultimate affirmation of their close professional relationship. Cassatt's passport described her as five and one-half feet tall, with gray eyes, a bit of a snub nose, a large mouth and chin, a ruddy complexion, and brown hair. In his several, unsentimental representations of her, Degas saw this and more, suggesting her strong personality and keen intelligence.

The purpose of this book and the exhibition it accompanies is to convey the innovative and multifaceted achievements of this outstanding, late-nineteeth-century artist. Any meaningful presentation of her art requires appreciation not only of the works she produced but of the larger cultural milieu in which she produced them. The six essays that follow consider Cassatt's career and oeuvre from several points of view. While they are sequenced more or less chronologically, they do not constitute a biography, since that project has been skillfully accomplished by other scholars. An illustrated chronology is included, however, to provide the reader with an overview of the artist's life.

Our current effort would have been Herculean without the accomplishments of past and current Cassatt scholars, who, with two exceptions, have all been women. These scholars had to be as

persistent and focused in their pursuit of their subject as the artist was in forging her career. Intensely private, Cassatt did not leave biographers and scholars an easy path to follow. She was not a diarist. Late in life, she apparently destroyed most of the letters she received. Scholars therefore have had to rely on what she wrote to relatives and friends, as well as on correspondence between family members and between friends. For example, while Cassatt's surviving letters to Camille Pissarro are few, we catch a glimpse of their relationship in Pissarro's letters to his son, Lucien. The richest repository of Cassatt's letters are those she wrote to Louisine Havemeyer over the many decades of their friendship. It was clearly upon this material that Havemeyer relied when she described her friendship with Cassatt and their collaboration in assembling one of America's greatest private art collections in a text that was added to the 1993 revised edition of her memoirs, *Sixteen to Sixty: Memoirs of a Collector*, initially published posthumously in 1930.

The first book-length assessment of Cassatt's career appeared in the artist's seventieth year, with her cooperation. Achille Segard's *Mary Cassatt: Un Peintre des enfants et des mères* (Paris, 1913) nonetheless reduces her to a one-subject artist and attributes her success to the fact that she chose to leave the culturally bleak United States for the rich civilization of France. In 1936, ten years after Cassatt's death, the Baltimore Museum of Art organized the first major retrospective of the artist's work (memorial exhibitions had been mounted immediately after her death by The Art Institute of Chicago; The Metropolitan Museum of Art, New York; the Philadelphia Museum of Art [then the Pennsylvania Museum], and the New York Public Library). The force behind the Baltimore show was the museum's curator of prints, Adelyn Breeskin. Her efforts established a new interpretive paradigm for the artist, moving beyond the sentimentalized and limited view propagated by Segard. Breeskin focused on Cassatt the professional artist, as well as on the variety of her themes and materials. Over the next thirty-five years, she prepared and published two catalogues raisonné on Cassatt: one on her prints (1948); and one on her paintings, pastels, watercolors, and drawings (1970). Along the way, Breeskin found time to organize no fewer than seven additional exhibitions of Cassatt's art.

The work of Frederick Sweet complemented Breeskin's efforts to enumerate Cassatt's achievements. A curator at The Art Institute of Chicago, Sweet helped contextualize the artist's work by considering it alongside that of her male contemporaries John Singer Sargent and James McNeill Whistler. His 1954 exhibition "Sargent, Whistler, and Mary Cassatt" (he evidently felt he needed to include her first name to clarify her gender) inscribed Cassatt on the roster of important nineteenth-century American expatriate painters. Although some critics who saw this exhibition deemed her contributions to be lesser than Sargent's and Whistler's, it was Cassatt's life and career that Sweet chose to pursue further. In 1966 he published a full-length biography, *Miss Mary Cassatt: Impressionist from Pennsylvania*. Citing data gleaned from interviews with members of Cassatt's family and from previously unpublished letters, he captured the artist's genteel character and a sense of the life someone of her elite social standing could enjoy. Not only did his efforts result in establishing a solidly researched chronology of the artist's life, but he also made his archival work available to future scholars when he deposited his papers with the Archives of American Art (Smithsonian Institution), Washington, D.C.

The rebirth of feminism in the late 1960s resulted in the rediscovery of forgotten women artists,

as well as in the celebration of the few, like Cassatt, who had always been known. In Cassatt's case, the publication of a number of books, as well as a plethora of reproductions of her work in calendars, greeting cards, and so forth, have served to reinforce public perception of her as an artist whose imagery all women can relate to. As interest in feminist theory and in women artists grew in the 1970s, Cassatt posed a particular problem for historians and cultural theorists, for her signature theme of mothers and children, as well as women in domestic settings, struck a conservative note that did not accord with radical feminism. Cassatt's views on women in fact are often strikingly contradictory; for example in 1913 she denounced a plan to initiate a national holiday for mothers as absurd.[5] Nonetheless a number of serious scholars began to focus on Cassatt's importance to the history of nineteenth-century art, as well as the role she played as a woman artist. Nancy Hale's 1975 *Mary Cassatt: A Biography of the Great American Painter* is a speculative attempt to construct a psychological portrait of the painter. Griselda Pollock's short monograph *Mary Cassatt* (1980) emphasizes Cassatt's position as a woman artist and addresses gender-related issues in the her choice of subject matter. Pollock's essay "Modernity and the Spaces of Femininity" (1988) explores female vision in works by Cassatt and other women artists. Harriet Chessman's "Mary Cassatt and the Maternal Body" (1993) discusses the sexual and sensual dimensions of the artist's maternal images.

In 1978 Barbara Stern Shapiro organized a thematic show entitled "Mary Cassatt at Home" at the Museum of Fine Arts, Boston, in which she displayed decorative-art objects owned by Cassatt and her family alongside the artist's paintings. In 1986 Suzanne Lindsay organized an exhibition at the Philadelphia Museum of Art that focused on Cassatt's connections to the city in which she received her initial training and in which her family lived. The catalogue for the exhibition, *Mary Cassatt and Philadelphia*, is an especially helpful resource on the artist's early training at the Pennsylvania Academy of the Fine Arts and on the Cassatt family's holdings of works by her and her contemporaries. Along these lines, Frances Weitzenhoffer approached Cassatt through the artist's friendship with H. O. and Louisine Havemeyer. Her remarkable book *The Havemeyers: Impressionism Comes to America* (1986) establishes Cassatt's crucial role as an art advisor to the famous benefactors of the Metropolitan Museum. Three years later, Shapiro published groundbreaking research on Cassatt's color prints in an essay, "Mary Cassatt's Color Prints and Contemporary French Printmaking," included in the exhibition catalogue *Mary Cassatt: The Color Prints* (1989).

Without question the most extensive contributions to Cassatt studies have been made by Nancy Mowll Mathews. Her 1980 dissertation for New York University considers Cassatt's "Madonna" subjects alongside other nineteenth-century maternal images. In 1984 Mathews published the invaluable *Mary Cassatt and Her Circle: Selected Letters*, including translated and annotated transcriptions of just over 200 letters. Her first biography of the artist appeared in 1987 as part of the National Museum of American Art's monographic series on American artists. She and Shapiro coauthored *Mary Cassatt: The Color Prints* (1989), which accompanied an exhibition presented at the National Gallery of Art, Washington, D.C. ; Museum of Fine Arts, Boston; and Williams College Museum of Art, Williamstown, Massachusetts. Most recently Mathews consolidated her extensive knowledge of the artist in *Mary Cassatt: A Life*, published in 1994 and *Mary Cassatt: A Retrospective*, published in 1996.

Relying on all of the groundwork summarized here, we have been able to ask new questions and

then to situate ourselves in the ongoing discussion of Cassatt's life and work and their place within the art and culture of her time. In "Mary Cassatt's Modern Education: The United States, France, Italy, and Spain, 1870–73," Andrew J. Walker examines Cassatt's training, particularly the confidence she gained in Italy—when she was engaged in a commission to copy works by Correggio for Pittsburgh's recently constructed cathedral— to paint and exhibit original compositions based on her assimilation of Old Master models. In "Mary Cassatt: Themes, Sources, and the Modern Woman," I pay particular attention to the ways in which Cassatt's study of contemporary life draws upon past and present models and to the very contemporary ideas reflected in her work concerning the lives of modern women: their domestic responsibilities and entertainments, as well as motherhood, childhood, and feminism. George T. M. Shackelford, in "*Pas de deux*: Mary Cassatt and Edgar Degas," discusses the long, complex, and rich dialogue between Cassatt and her mentor from the years in which she worked closely with him to the end of his life, when she helped take care of him. In "How Mary Cassatt Became an American Artist," Kevin Sharp analyzes the way Cassatt managed her career on both sides of the Atlantic, with particular emphasis on her relationship to Durand-Ruel, whose plans for this artist extended beyond her art to the role she could play in helping establish his enterprise in the United States. Cassatt's critical role as an art consultant to many important American collectors is explored by Erica E. Hirshler in "Helping 'Fine Things Across the Atlantic': Mary Cassatt and Art Collecting in the United States"; not only does Hirshler examine the artist's relationship to such well-known collectors as Louisine Havemeyer and James A. Stillman, but she also provides new information about the relationship between Cassatt and the Whittemore and Sears families. Finally Harriet K. Stratis studies the artist's methods as a pastellist ("Innovation and Tradition in Mary Cassatt's Pastels: A Study of Her Methods and Materials"); at first following the highly experimental technique of her mentor, Degas, Cassatt eventually turned back to more traditional methods, under the influence of such Rococo pastellists as J. B. Chardin and Maurice Quentin de La Tour. Stratis also offers advice on the conservation and maintenance of Cassatt's pastels, which are the most fragile of her works.

The nearly thirty years that have transpired since the last major retrospective of Cassatt's career, held in 1970 at the National Gallery of Art, Washington, D.C., have witnessed not only new research on the artist and new ways to consider her oeuvre, but also the emergence of heretofore uncatalogued works of art by her. Some of these discoveries are included among the ninety objects gathered for this exhibition.[6] Cassatt was a multifaceted artist who became accomplished in a variety of media. We have included a number of her prints, since her contributions to this area are original and significant; but we are presenting her primarily as a maker of oil paintings and pastels. While the condition of many of Cassatt's pastels limited our selection of works in this medium, we nonetheless were able to find several superb examples that indicate her mastery of the technique.

By examining nearly 1,500 letters, well over half of which have never been published in any form, as well as by studying recently located exhibition catalogues, we have been able to reassign the artist's original titles to many of the paintings, pastels, and prints we are exhibiting. The removal of sentimental epithets that became attached to works in intervening years permits an understanding of the artist's purely descriptive and modern intent. We have also assembled the first complete record of

the exhibitions in which Cassatt participated during her lifetime. This allowed us to provide missing provenance information and to firmly redate works that were included in specific exhibitions, gaining a clearer sense of the artist's development. We have also prepared an extensive list of published references to Cassatt's art and career during her lifetime. It is our hope that all of these documents serve scholars as important building blocks for further study.

Our title, *Mary Cassatt: Modern Woman*, speaks to Cassatt's personality, to her subject matter—the lives of women in a contemporary world—and to the eponymous, long-lost mural that the artist executed for the Women's Building at the 1893 World's Columbian Exposition in Chicago. While we cannot re-create this monumental and pioneering effort, placed on view one hundred five years ago, we offer ninety paintings, pastels, and prints to represent the remarkable achievement of a thoroughly modern woman.

NOTES

1. Lois Cassatt to Edward Cassatt, Sept. 23, 1892, in Mathews 1984, p. 348.

2. Biddle 1926, p. 107.

3. Havemeyer 1993, p. 269.

4. Cassatt to Homer Saint-Gaudens, Dec. 28, 1922, in Mathews 1984, p. 335.

5. Cassatt to Louisine Havemeyer [May 1913], in Mathews 1994, p. 308.

6. See cats. 2, 15, 43, 74, 76.

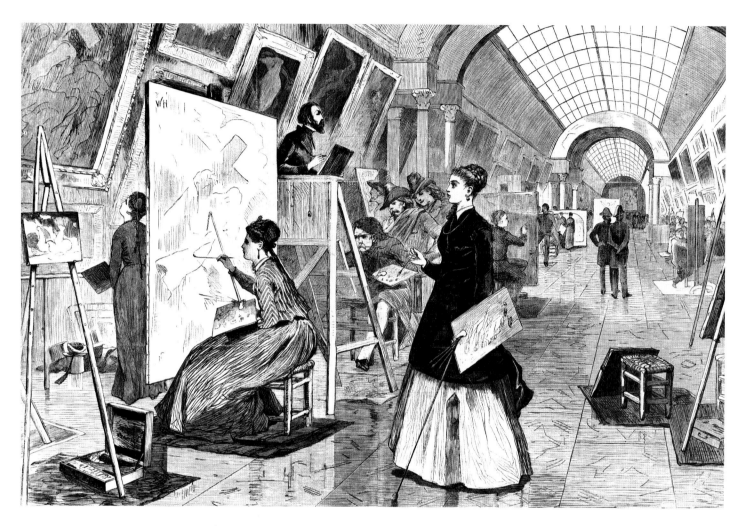

Fig. 1. Winslow Homer (American; 1836–1910). *Art Students and Copyists in the Louvre Gallery*, 1868.
Wood engraving; 22.9 x 34.9 cm. Photo: courtesy Bowdoin College Museum of Art,
Brunswick, Maine.

Mary Cassatt's Modern Education:
The United States, France, Italy, and Spain, 1860–73

Andrew J. Walker

Introduction

The noted mural painter Edwin Austen Abbey described the atmosphere of the Pennsylvania Academy of the Fine Arts in the 1860s as a "fusty, fudgy place," where "the worthy young men who caught colds in that dank basement with me, and who slumbered peacefully by my side during long anatomical lectures all thought the only thing worth doing was the grand business, . . . 'High Art.'" It was into this "fusty" environment, peppered with pretension, that Mary Cassatt launched her formal art studies in 1860. Over the next thirteen years, the young student would mature into a gifted professional able to face the challenges for women artists of the period with creativity, dignity, and resolve.

Established in 1805, the Academy's original charter pledged "to promote the cultivation of the Fine Arts in the United States of America, by introducing correct and elegant copies from works of the first masters in Sculpture and Painting." In choosing this school, Cassatt became part of its distinguished and pathbreaking history of training women artists in the United States:

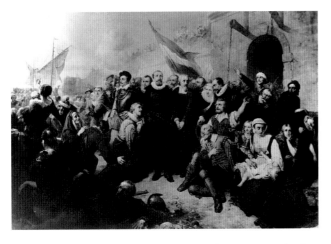

Fig. 2. Johann Bernard Wittkamp (Belgian; 1820–1885). *The Deliverance of Leyden*, 1848. Oil on canvas; 426.7 x 744.2 cm. Location unknown.

The Academy was among the first institutions in the world to train females, particularly as copyists. In 1844 its directors gave women the opportunity of copying from antique casts; by 1859 they had extended this privilege to include copying Old Master and contemporary works in the institution's collection.[1]

Although the more limited educational opportunities offered to women made their bid for professional standing a challenge, Cassatt quickly took advantage of this essential experience of copying. The practice would have an enormous impact on Cassatt's maturation as an artist. In March 1862, along with her colleague and close friend Eliza Haldeman, she petitioned to copy heads from Johann Bernard Wittkamp's huge painting *The Deliverance of Leyden* (fig. 2). Wittkamp's crowd of figures provided young artists with a variety of expressions and gestures representing "different classes of society" from which to practice their technique. Cassatt and Haldeman, who were almost inseparable, also visited Philadelphia's most important private collections and sketched in classes taught by Peter Rothermel and Christian Schussele, alongside male Academy students, such as Thomas Eakins, Howard Roberts, William Sartain, and Earl Shinn.[2]

For a woman artist interested only in achieving amateur status, the Academy's pedagogical program was sufficient. Cassatt's ambitions, however, were much greater; she wanted to be a professional, respected for her artistic skill, and not confined by the perceived limitations of her gender. Like her male counterparts, she understood that, in order to become a professional, even those trained at what was then a leading art academy had to travel to Europe, and particularly to Paris, where a treasure-trove of art masterpieces waited to be studied and copied. Determined to overcome the obstacles she would inevitably face in Europe, Cassatt, accompanied by her mother, and Haldeman packed their bags and departed for the Continent.

First Successes in France

By December 1865, Cassatt had settled in Paris with its community of American artists. Unlike her male colleagues from the Pennsylvania Academy, Eakins and Roberts, who had also moved to Paris, Cassatt faced a restrictive admissions policy concerning women at the Ecole des beaux-arts, the city's official art academy. Again creating her own opportunities, Cassatt sought out alternative instruction, a strategy many women artists pursued. She attended an art class for women conducted by the genre painter Charles Chaplin and remarkably even managed private lessons with Jean Léon Gérôme, a professor at the Ecole and the French artist most admired by Americans at the time. Her success stunned friends in Philadelphia, such as Charles Fussell, who eagerly wrote to Eakins, another of Gérôme's American students, asking for details. Between April and May 1867, Cassatt and Haldeman left Paris for Ecouen, a village thirty miles north of Paris, to study with Pierre Edouard Frère and Paul Constant Soyer. Frère was particularly popular among female art students for his ability to record the activities of children. One year later, Cassatt visited Villiers-le-Bel, another small town frequented by adventurous American artists, and remained to study with the renowned painter Thomas Couture.[3]

To supplement her private instruction, Cassatt continued the practice of copying she had begun in Philadelphia by working in the galleries of the Musée du Louvre, Paris. This was standard practice, but Gérôme was particularly passionate about it; he counseled his students, "Surround yourself with everything you can—casts, photographs, terra-cottas, vase paintings—and look at them constantly with all your might." An engraving by Winslow Homer for an 1868 issue of *Harper's Weekly* (fig. 1) evokes the setting in which Cassatt and Haldeman worked. As the engraving suggests and documents confirm, women artists were a common sight in the Louvre's long hallways. The art historian Paul Duro, who studied the culture of copying in nineteenth-century Paris, noted that this activity became an end in itself, with an enthusiastic market for reproductions. The execution of such copies, along with still life and portraiture, was considered an "appropriate" activity for females; this of course reflects attitudes that marginalized the talent and work of many women, keeping them secondary to their male counterparts.[4]

Yet Cassatt was not interested in copying as an end in itself; for her the activity was purely educational. As she made clear on numerous occasions, her artistic ambition extended beyond being classified as an amateur or copyist. She intended to be a professional and, throughout her time in Paris, consistently submitted original compositions for exhibition at the annual Salon. She was not always successful. Her 1867 submission was rejected. The following year, however, the jury accepted her *Mandolin Player* (fig. 3), which she submitted under the name "Mary Stevenson." According to Haldeman, Cassatt did not want to exhibit under her own name. "It is much pleasanter when one is a girl," Haldeman wrote, "as it avoids publicity." The painting was hung in a preferred location, "on the line," meaning at eye level and not "skied," or placed near the ceiling. Excited by her success and intent upon self-promotion, Cassatt persuaded a Mr. Ryan, an American critic living in Paris, to highlight her painting in his next review. In the June 7 *New York Times*, he wrote: "A portrait of an Italian girl, by MARY STEVENSON, of Pennsylvania, has obtained a place on the line, and well deserves it, for its vigor of treatment and fine qualities of color. MISS STEVENSON has been a pupil of GEROME, and proposes shortly to visit Italy to improve herself." In the 1870 Salon, she again successfully entered an Italian subject, *Una contadina di Fobello: val Sesia (Piémont)* (now lost).[5]

Fueled by this success, Cassatt wished to expand her horizons with further travel, particularly in Italy, undoubtedly to study the works by Renaissance masters that filled the churches and galleries of Florence and Rome. Unfortunately the outbreak of the Franco-Prussian War made remaining in Europe difficult. Following a brief summer stay in Rome, Cassatt set sail for the United States in the spring of 1870.

Back in Pennsylvania

After four years of intensive study in France with such celebrated artists as Couture and Gérôme, Cassatt must have been struck by the quiet and provincial character of Philadelphia. She set up a studio at 23

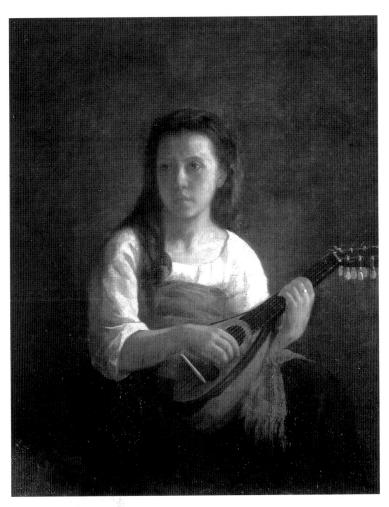

Fig. 3. Mary Cassatt. *Mandolin Player*, 1868. Oil on canvas; 92 x 73.5 cm. Private collection. Photo: Nancy Mowll Mathews, ed., *Cassatt: A Retrospective* (New York, 1996), p. 33.

South Street to continue her artistic training and rejoined a number of her compatriots, including those who had studied in Paris and Ecouen. Eakins, Haldeman, Roberts, William Sartain, and Shinn, along with Cassatt, were all engaged in building their reputations as professional artists.

Undoubtedly Cassatt took advantage of what Philadelphia had to offer and interacted with the community of artists she had become part of abroad. However, her primary artistic relationship in 1870 was with Emily Sartain, sister of William Sartain and daughter of the celebrated engraver John Sartain. Cassatt's alliance with Emily Sartain, whom she probably met at the Academy in 1864, when Sartain first enrolled, proved particularly advantageous. As a mem-

ber of one of Philadelphia's most respected artistic families, Sartain exposed Cassatt to a creative milieu not available to every young, aspiring artist. Together the two women enjoyed numerous opportunities for critical comment on their works, as well as access to the library and print collection of John Sartain, who advised them on materials and techniques. They also arranged to share models for life study at Cassatt's South Street studio.[6]

Despite these efforts to advance their artistic training, Cassatt and Sartain ran up against an impediment in 1871. The construction of a new building forced the Pennsylvania Academy to suspend classes; without institutional support, the two women found that arranging for models and copying masterworks became more difficult. Cassatt experienced further aggravation when her family decided in May to move to Hollidaysburg, a small suburb outside Altoona and seventy miles east of Pittsburgh. With limited art supplies and few models, she became discouraged, and her passion for art wavered. Cassatt wrote to Sartain: "I have given up my studio & torn up my father's portrait, & have not touched a brush for six weeks nor ever will again until I see some prospect of getting back to Europe."[7]

Cassatt's frustration may have made her prone to exaggeration: she did not actually tear up her father's portrait but rather worked over it. Dissatisfied with her efforts, she inverted the canvas and began a composition of a bare-shouldered black woman wearing a white kerchief (fig. 4). The lack of professional models in Hollidaysburg prompted her to make use of the family's maid. In addition to upending and partially obliterating her father, who had compelled her to trade Philadelphia for artistic exile, this image seems to reveal her longing to return to Europe. The turbanlike head-covering gives the sitter an exotic appearance not unlike subjects favored by Cassatt's Parisian teacher Gérôme (see fig. 5). Thus a simple sketch made in suburban Pennsylvania took on the contours of something more grand: a fanciful study perhaps for a large-scale, exotic genre scene worthy of submission to the Paris Salon. But shortly after Cassatt began her sketch, the model gave notice that she was leaving the family's employ to be married.[8] Isolated in Hollidaysburg, Cassatt hit bottom. She confided to her friend: "I am in such low spirits over my prospects that

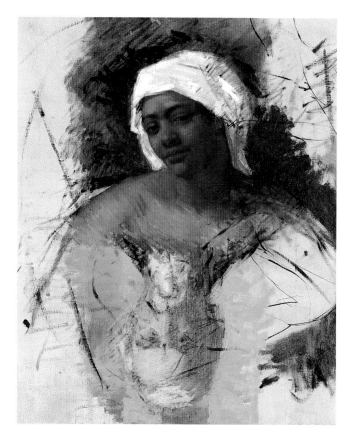

Fig. 4. Mary Cassatt. *Sketch of Mrs. Currey; Sketch of Mr. Cassatt*, c. 1871. Oil on canvas; 81.9 x 68.6 cm. The Hendershott Collection.

the Great Chicago Fire of 1871. But just when life seemed darkest, an event occurred that gave Cassatt work, money, respect, and most importantly the opportunity to return to Europe.

That opportunity came in the form of the Catholic bishop of Pittsburgh, Father Michael Domenec. Born in 1816, in the Spanish city of Ruez, Father Domenec arrived in the United States in 1837; he served as a parish priest in Barrens, Missouri, and in Philadelphia before being named bishop of Pittsburgh. It is likely that Cassatt may first have met Domenec in Hollidaysburg. The town was part of his diocese, and he traveled there frequently in 1870–71, when he was considering the establishment of a temporary seminary for the region. Sometime in September 1871, the bishop approached Cassatt with a proposal: He would pay her $300 for two full-sized religious paintings intended for the interior of the newly erected St. Paul's Cathedral in Pittsburgh. After more than a decade of construction, the last bricks had recently been laid on the monumental front towers of the

although I would prefer Spain I should jump at anything in preference to America."⁹

Cassatt's disappointments continued to multiply in the ensuing months. Her success at the Paris Salons of 1868 and 1870 had motivated her to consign two paintings (now destroyed) to the New York branch of the Paris gallery Goupil and Co., in hopes of sparking some attention. Gérôme, who was Goupil's son-in-law, may have helped Cassatt with this significant achievement. However, no critical notices appeared, and no collectors emerged to buy her work. Discouraged but not deterred, Cassatt took these two canvases to Chicago to test a midwestern audience. The paintings were exhibited in a Chicago jewelry store; according to a letter the artist wrote to Sartain, they were "met with more enthusiasm than anywhere else since I have been home."¹⁰ Cassatt hoped that the public's interest would lead to actual sales. In a cruel twist of fate, one week after going on view, the paintings were destroyed in

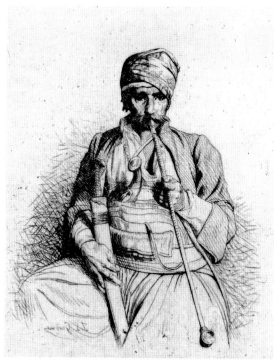

Fig. 5. Jean Léon Gérôme (French; 1824–1904). *Egyptian Smoker*, 1868. Etching on ivory-simulated Japanese paper; 12.6 x 10 cm. The Art Institute of Chicago, Clarence Buckingham Collection, 1938.1499.

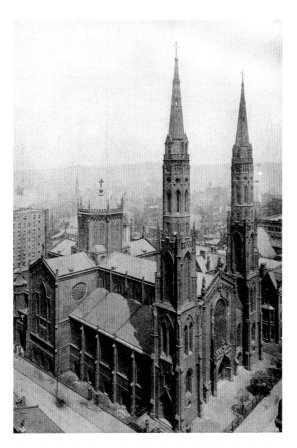

Fig. 6. St. Paul's Roman Catholic Cathedral, Pittsburgh, Pa. Photo: *American Architect and Building News* 62, 1194 (Nov. 12, 1898), fig. 1.

Fig. 7. Samuel Kneeland (American[?]; 1821–1888). Interior of a part of St. Paul's Cathedral. Pittsburgh, Pa. Photograph; 18.4 x 19.7 cm. Photo: courtesy collection of Nicholas M. and Marilyn A. Graver, Rochester, New York.

Latin cruciform church (figs. 6, 7). When Cassatt and the bishop met, all that remained to complete Pittsburgh's grand cathedral were appropriate decorations for the interior.[11]

Cassatt was hired to replicate two works by the sixteenth-century northern Italian painter Antonio Allegri da Correggio: *Madonna of Saint Jerome* (fig. 8) and *Coronation of the Virgin* (fig. 9).[12] Both were located within the church complex of S. Giovanni Evangelista in Parma, Italy. How the bishop and Cassatt decided that these subjects were appropriate for Pittsburgh's new cathedral is impossible to reconstruct precisely. In the nineteenth century, it was common church practice to hire artists to make copies of Renaissance and Baroque paintings. Along with Raphael's *Madonna of the Chair* (Florence, Palazzo Pitti), Correggio's *Madonna of Saint Jerome* was one of the most popular Madonna

images and therefore frequently copied. Sir Robert Strange, who in 1787 made both painted and engraved copies (fig. 10) of the masterwork, described it as follows: "It must certainly be considered the best picture in Italy, if not in the world". Similarly Correggio's *Coronation of the Virgin* ranked high in nineteenth-century guidebook lists of what travelers should see in northern Italy.[13] The bishop's official duties often took him to Italy, and it is likely that he had seen works by Correggio in Parma on more than one occasion.

To prepare herself for this project, Cassatt relied on her knowledge of Correggio's work through copies and reproductive prints. Correggio, considered at this time the equal of Michelangelo and Titian, enjoyed widespread popularity among Cassatt's peers in the art world; students frequently copied his works for annual exhibitions. The Pittsburgh commission allowed Cas-

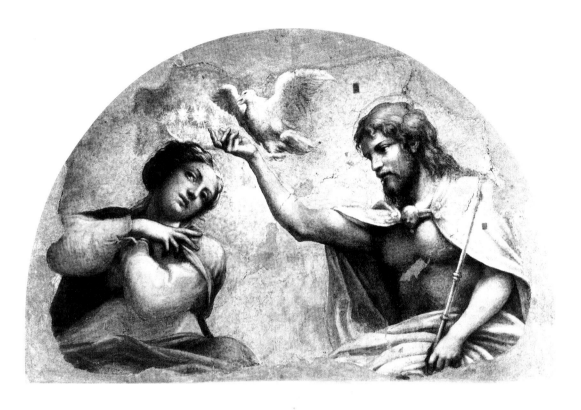

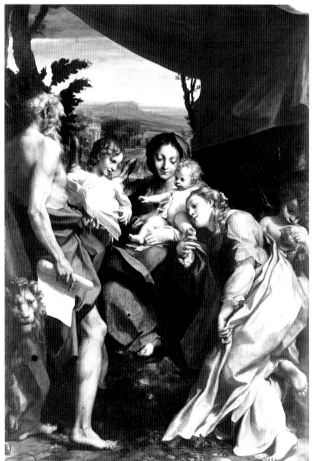

Fig. 8. Antonio Allegri da Correggio (Italian; 1489–1534). *Madonna of Saint Jerome*, 1527–28. Oil on panel; 205 x 141 cm. Parma, Galleria nazionale, 351. Courtesy: Ministero per i Beni Culturali.

Fig. 9. Antonio Allegri da Correggio. Central fragment of the *Coronation of the Virgin*, 1522. Detached fresco; 212 x 342 cm. Parma, Galleria nazionale. Photo: Alinari/Art Resource, NY.

satt to join the legions of students who copied Correggio's work. Much of her understanding of the Old Masters, particularly during her years in the United States, came through visiting private collections in order to study prints and engraved replicas.[14] Her appetite for art was insatiable; and the practice of visiting private holdings of both Old Master and modern works would become a staple of her life.

In the early 1870s, there was keen interest in the efforts of individual collectors in the United States. Cassatt's friend and colleague Earl Shinn authored a series of articles in 1872 for *Lippincott's Magazine* on Philadelphia's collectors, singling out James L. Claghorn, a well-respected businessman and banker who was actively involved with the Pennsylvania Academy. Cassatt certainly knew of Claghorn's collection and

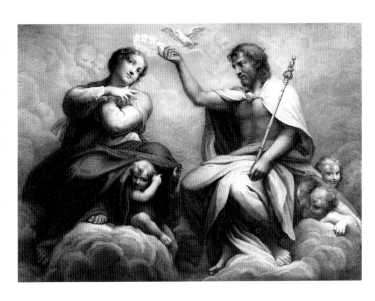

Fig. 11. Paolo Toschi (Italian; 1788–1854). *Coronation of the Virgin*, n.d. Engraving; 42.2 x 57.8 cm. Baltimore Museum of Art, Garrett Collection, 1984.81.2439.

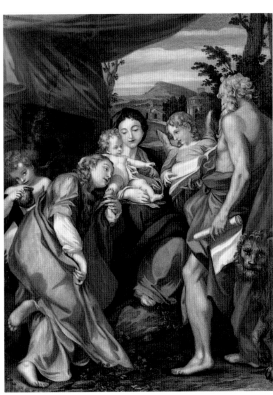

Fig. 10. Sir Robert Strange (British; 1721–1792). After Correggio's *Madonna of Saint Jerome*. Color lithograph. Photo: Sir Robert Strange, *A Collection of Historical Prints Engraved from Pictures of the Most Celebrated Painters of the Roman, Florentine, Lombard, Venetian, and Other Schools* (London, 1787), n.p.

probably visited his home in 1871, perhaps with Emily Sartain. Claghorn's collection may have played a part in Cassatt's Correggio commission. In addition to his strong selection of mostly contemporary paintings, the businessman owned a spectacular array of engravings, etchings, and mezzotints that spanned the history of printmaking from Martin Schöngauer to James McNeill Whistler. Shinn called it "the best representative collection . . . now in this country." In addition to original prints, Claghorn owned engraved reproductions of famous Renaissance and Baroque paintings, including numerous copies after Correggio by Nicholas Bazin, Agostino Carracci, Guillaume Chasteau, and others.[15] Most importantly, however, Claghorn owned the series by the Italian engraver Paolo Toschi after Correggio's fresco cycle at S. Giovanni Evangelista. Toschi's copy of *Coronation of the Virgin* (fig. 11) is one of the most accomplished engravings of the group. Its square format and simplified composition accentuate the focus on Christ and Mary, an emphasis appropriate for Cassatt's replica, which seems to have been intended for the cathedral's Chapel of the Holy Virgin.

Toschi's engravings after Correggio's Parma cycle were well known to a broad range of artists, critics, and tourists. In his 1855 guide to northern Italy, George Street explicitly compared his experience of

the actual frescoes to Toschi's engraved series. In the writer's opinion, Correggio's "confused mass of distorted figures and limbs" compared poorly with Toschi's "careful engravings . . . full of beautiful drawing and skillful chiaroscuro." Sartain, who accompanied Cassatt on her trip to Parma, had another reaction entirely. After their arrival in Parma, Sartain wrote to her father, "I think very much less of Toschi's work, since I have seen the originals, he has left all the squareness out. His copy of the *Virgin Crowned Queen of Heaven* that Miss C. is doing, is absolutely miserable— it gives you no idea of the picture." The opinion of Sartain, an accomplished printmaker who had long worked in her father's engraving firm, no doubt carried authority with Cassatt. Indeed Sartain complained to her father about Cassatt's lack of expertise regarding various print processes.[16] Nonetheless the possibility that Cassatt had ready access to Toschi's prints, "miserable" or not, before her departure for Europe is significant for understanding not only the genesis of the Pittsburgh commission, but also how essential the process of studying copies was to a maturing artist, especially in the United States, where a wide range of great originals did not yet exist.

Undoubtedly Bishop Domenec considered a replica of the Madonna as befitting and auspicious for Pittsburgh's grand, new cathedral. The project also bode well for Cassatt's career. Although Domenec requested a copy, not an original composition, his project sparked new life in Cassatt. It represented after all her first paying job as a professional artist. Even though her family had considerable financial means, Cassatt greatly valued such economic independence as a sign of her professional artistic status. The commission also meant that Cassatt could return to Europe, the site of earlier inspiration, to copy Correggio's compositions in Parma. Moreover the payment promised by the bishop would make it possible for her to achieve her dream of going to Spain to study its Old Masters and to experience its people and exotic customs firsthand. Armed with important letters of introduction to "all the bishops" in Italy and Spain, Cassatt even began to hope that more projects of this type would be forthcoming. "I wonder," she wrote to Sartain, "if I could get any orders for churches in New York? The Madonna's [sic] of Murillio [sic] are great favorites with Catholics."[17]

Lack of specific information relating to Cassatt's Pittsburgh commission has led scholars not to consider it in discussions of her early development. However, the project becomes notable when viewed as a major step in her education. Both in Philadelphia and in Paris, Cassatt had learned the value of copying Renaissance, Baroque, and even contemporary works. With the Correggio project, copying became more than academic training. In effect the project functioned as a bridge that Cassatt traversed from student to professional status. Shortly after agreeing to undertake the copies, she advised Sartain, "If one only gets one hundred dollars for a small copy it pays better than twice the sum for an original because you have no rent no models & no fire to pay while at work, & a *little copying* is good for one; not too much however."[18] Although she valued the $300 she was to be paid for her work, Cassatt's ambition extended far beyond such activity. Her excitement over the commission came from her belief that thorough knowledge of the Old Masters would enable her to discover her own identity as a professional artist.

Off to Italy

Cassatt and Emily Sartain departed for Europe in early December of 1871. After a brief stop in London, they continued on to Paris, where they witnessed the devastation wrought upon the city by the Franco-Prussian War. In a letter to her father, Sartain described the city's dark streets: "We expected to see the destroyed quarter near the Bastille in driving to the station to leave,—but the fog was so thick everything was lost at fifty feet off. I could scarcely see the pictures in the Louvre it was so dark."[19] Anxious to leave, they endured a twenty-eight-hour train ride to Turin. Arriving in Parma, they rented quarters at 21 Borgio Riolo, an address convenient to S. Giovanni Evangelista. After settling in, they sought out an instructor who could offer general access to local art resources and provide helpful criticism. They met with a number of the faculty of Parma's Accademia, selecting Carlo Raimondi, who directed the school's engraving program. Raimondi's standing in Parma proved especially beneficial to this pair of young and determined women. He helped arrange studio space and models

Fig. 12. Carlo Raimondi (Italian; 1809–1883). *Paolo Toschi Working in the Cupola of the Cathedral, Parma,* n.d. Engraving; 27.9 x 22.7 cm. Baltimore Museum of Art, Garrett Collection, 1984.81.518.

tain profited considerably from Raimondi's instruction. He had after all been a student and friend of Toschi and, at least on one occasion, invited the women to his studio to view both his and his teacher's engravings. No doubt many of these were familiar to the Americans from their study of prints in Claghorn's collection, including a particularly poignant engraving by Raimondi that depicts Toschi copying in the cupola of Parma's cathedral (fig. 12). Seated behind a wooden balustrade, a nattily dressed Toschi looks up at the entwined figures painted on the ceiling, while his hands are engaged in the meticulous task of transferring Correggio's composition to the engraving plate. The raised, perpendicular table at which the artist labors is similar to an apparatus Sartain observed in Raimondi's studio, a device she found particularly intriguing.[21] Cassatt, less schooled in printmaking, may have been drawn to Raimondi's engraving because it celebrates the tenacity of an accomplished artist copying an Old Master.

for them and proved an able guide to the art treasures of the city, including masterpieces by Correggio, Parmigianino, Annibale Carracci, and others. Over the course of Cassatt's and Sartain's stay, Raimondi became a reliable mentor who offered critiques of their work, sometimes as often as twice a day. Much to Sartain's chagrin, however, he became particularly attentive to Cassatt's eager ambition and considerable skill. "I notice," Sartain wrote to her father, "that if Miss Cassatt and I differ in our estimate of an artist, he [Raimondi] adopts her opinion immediately, without the least deference to mine."[20]

Despite this competitiveness, both Cassatt and Sar-

Cassatt traveled to Parma to study the same works by Correggio that Toschi, and Raimondi, for that matter, had copied previously, their copies making the original accessible to artists such as herself. In a city where replicating Correggio's art was considered a noble pursuit, she was joining a distinguished tradition. In contrast Sartain did not share her friend's enthusiasm for copying. As she wrote to her father, "Miss C. is very desirous I should make studies from the Correggio but I think I had better stick to life,—especially where models cost so little. . . . All the artists here have been constantly copying Correggio, and yet it has not done them any good. They all paint

miserably." Cassatt, however, launched into her commission with a determination that seemed to impress Italian artists working in Parma. She employed a local painter, Giacomo Cornish, to do the tedious, mechanical labor of drawing in the composition by squares. Cassatt's version of *Madonna of Saint Jerome* demonstrated such startling skill that Sartain urged her father to purchase her friend's copy for the Pennsylvania Academy's collection (ever since an 1848 fire that destroyed a large portion of the institution's collection, the Academy had been on the lookout for suitable copies of Old Masters for student use).[22]

For unknown reasons, Cassatt never finished her replica of *Madonna of Saint Jerome*. She did, however, complete a *Coronation of the Virgin*. Part of Correggio's cycle for S. Giovanni Evangelista, he had painted the fresco around 1524 in the apse of the tribune, which was demolished in 1587 in an enlargement of the church. The central group, showing Christ and the Virgin enthroned, was saved and reinstalled in the church's library, where Cassatt copied it. (The work is now located in Parma's Galleria nazionale.) Working from both the original and a copy by Annibale Carracci, Cassatt set upon completing her replica. About the time the bishop planned to install the replica, Pittsburgh's Catholic newspaper published a full account of the legend of the Assumption of the Virgin, attesting to the story's popularity and timed perhaps to coincide with the placement of the painting. The Virgin Mary's Assumption begins with her body being borne aloft into heaven by a multitude of angels and concludes with her coronation at the hands of Christ, the subject of Cassatt's copy.[23]

Sartain related somewhat enviously to her father, "All Parma is talking of Miss Cassatt and her picture, and everyone is anxious to know her—The compliments she receives are overwhelming." Exactly which work attracted such praise is not clear. Cassatt completed her copy of the *Coronation* and sent it to the United States in June. Although she pronounced it "beastly," the positive response the work elicited from Bishop Domenec when he installed it in the cathedral would suggest a stirring achievement. Unfortunately the painting does not survive. Most probably, it burned in a small but devastating fire in 1877 that consumed the Chapel of the Holy Virgin, next to the main altar

and directly in front of the sacristy. As one reporter noted, "Entering the church by the main doorway this writer saw the altar of the Blessed Virgin in flames, and watched it until it was entirely consumed."[24]

More than likely, however, the people of Parma were praising an original composition by Cassatt, *During Carnival* (cat. 2), which she prepared for the 1872 Paris Salon while she worked on the Pittsburgh commission. *During Carnival* depicts two Italian women throwing flowers, presumably from a balcony, during Mardi Gras. The pre-Lenten festival was particularly popular among travelers to Italy and a lively subject for foreign writers and artists. The climax of Nathaniel Hawthorne's novel *The Marble Faun* (1860) for example takes place during the height of Carnival on Rome's Via Corso. Hawthorne, who witnessed such revelry firsthand, believed that its bacchanalian character in effect masked profound social malaise. A decade later, Henry James described the week-long celebration as an ignoble event:

> Masked and muffled ladies there were in abundance; but their masks were of ugly wire, perfectly resembling the little covers placed upon strong cheese in German hotels. . . . They were armed with great tin scoops or funnels, with which they solemnly shoveled lime and flour . . . down on the heads of the people in the street. . . . The scene was striking, in a word; but somehow not as I had dreamed of its being. I stood regardful . . . for in a moment I received half a bushel of flour on my too-philosophic head.[25]

Vulgar and decidedly messy, as James depicted it, the event contrasts significantly with Cassatt's genteel portrayal of women throwing flowers, not flour, on the crowd below.

The negative response of foreigners such as Hawthorne and James to Carnival can be related to their dislike of the ritualistic practices of the Roman Catholic Church. James Jackson Jarves, North America's best-known art critic of the time and a great art collector in his own right, did not disguise his criticism of Catholicism; he likened Carnival to the elaborate ceremonies fashioned by the Papacy to pay tribute to the Virgin Mary. He viewed both as fictitious anachronisms that revealed the essentially polytheistic and therefore barbaric nature of the Church.[26] However, it is doubtful that Cassatt intended to convey, even indirectly, any anti-Catholic sentiment in her

work. She was after all simultaneously working on her commission for the diocese of Pittsburgh. *During Carnival* may simply represent an attempt to demonstrate her versatility with an exotic subject.

Around the same time, Cassatt began painting *Bacchante* (cat. 1) for the 1872 Esposizione di belle arti in Milan. Bacchanalian subjects were popular among nineteenth-century artists, particularly those associated with the French academic tradition.[27] Cassatt's painting depicts a female follower of the Roman god of wine. The half-length figure is crowned with grape leaves, wears an Italian peasant costume, and plays the cymbals. As figure studies rather than true narratives, *During Carnival* and *Bacchante* reveal much about Cassatt's professional ambitions. The canvases demonstrate art-historical erudition and skill at handling paint, qualities she believed would secure favor with critics and potential collectors. The brief but positive notices that both paintings received in Paris and Milan seemed to confirm Cassatt's hopes, and she even confided to Sartain that a few lines from Ryan in the *American Register* would further bolster her nascent reputation. "I find it has done me good," she wrote, "and I am getting anxious to see myself in print; one gets used to anything in this world." A further, commercial victory came later that fall; Cassatt sent *During Carnival* to Philadelphia for exhibition, and an American collector purchased it for $200.[28]

Cassatt's desire to gain favor in the market did not dominate her aspirations. To fully understand her aim, it is helpful to look at the writings of Jarves on art and art education, which influenced many artists of Cassatt's generation. While preparing for her trip to Italy, Cassatt very likely read his important, 1869 publication *Art Thoughts: The Experiences and Observations of an American Amateur in Europe*. Here the author drew together his many experiences of the work of the Old Masters and contemporary European artists. For a person with ambitions such as Cassatt's, the most compelling aspect of Jarves's account would have been the advice he gave to aspiring artists preparing to travel through Europe. He counseled them to learn all they could by thoroughly absorbing the work of their hallowed predecessors. He further urged them to study not just the subject matter of great art but also its form. In his view, borrowing from a work specific details—a particular figure, gesture, or action—and incorporating them into one's own efforts were noble, if such appropriation was disguised, reinterpreted, or improved upon.[29]

More than simple celebrations of carnivalesque theater, both *During Carnival* and *Bacchante* exhibit such quotations from works by Correggio. Evidently the straightforward copies Cassatt was involved in for Pittsburgh did not satisfy her aims; she set out to produce for competitive exhibitions these two, smaller canvases, both of which embody subtle translations of Correggio's style into her own manner. The seated Virgin in the Italian artist's *Coronation* inspired the tilt of the head of the female reveler in *Bacchante*, as well as her foreshortened, lower left arm, which bends back at the elbow to clang the cymbals. If *Bacchante* can be read as a kind of disguised homage to this prototype, then *During Carnival* can be understood as a tribute to the work Cassatt never finished copying, *Madonna of Saint Jerome*. Although more fragmented, the visual quotations are no less dramatic. The woman behind throwing the bouquet exhibits the same profile and rose-tinted cheeks as Correggio's Saint Elizabeth, whose gentle hands grasp the foot of the infant Jesus. Cassatt, who admired the Renaissance artist's ability to paint expressive hands, appropriated the saint's finely articulated fingers to emphasize the connection between her two comely figures.[30] Over the course of her career, Cassatt would also become a painter of expressive hands (see Barter, pp. 65–66).

Cassatt's use of Correggio's example in independent work marked a significant moment in her professional development. Like Edouard Manet, who appropriated compositional groupings or figure types from Renaissance and Baroque paintings he admired, Cassatt processed and recast Correggio's creations. Some scholars have tended to interpret such methods as signifying a "lack of imagination."[31] Ultimately, however, the end result for gifted artists, such as Manet or Cassatt, seeking inspiration in the work of others, is that they reinvent the borrowed elements and imbue them with renewed relevance. Cassatt's experience of Correggio prepared her for the next step in her education, her long-awaited visit to Spain to study more Old Masters in Madrid and Seville.

The Allure of Spain

Cassatt arrived alone in Madrid in early October 1872 (Sartain had left Italy the previous May to begin a course of study in the Paris studio of the painter Evariste Luminais). Finally Cassatt fulfilled a cherished dream that not long before had seemed impossible. "I have been abandoning myself to despair & homesickness," she had written movingly to Sartain while still in Pennsylvania, "for I really feel as if it was intended I should be a Spaniard & quite a mistake that I was born in America, as the German poet says, 'Spanien ist mein heimats land.'"[32] Cassatt's hunger for this "heimats land," or homeland, mirrored in part the rage for things Spanish that had captivated educated Europeans and North Americans throughout the nineteenth century. The French occupation of Spain from 1808 to 1813 focused new attention on the peninsula; by the 1820s, it had become an important stop on the Grand Tour, attracting such notable writers as Théophile Gautier, Victor Hugo, and Washington Irving. The country's exotic blend of cultures, and its reputation for banditry, bad roads, and general backwardness all contributed to its romantic appeal.[33]

The source of Cassatt's attraction, however, extended beyond fascination with a picturesque nation in decline. Young artists increasingly felt compelled to pay homage to Spanish art. The French in particular found Madrid's Museo del Prado to be a treasure house of forgotten masterpieces by Goya, El Greco, Murillo, Ribera, Velázquez, and Zurbarán. Manet spent most of the 1860s studying the Spanish Old Masters in the Louvre, traveling in Spain, and painting Spanish subjects. While Cassatt's teacher Gérôme encouraged his students to visit Madrid, he also recommended travel through the Pyrenees, as well as to Andalusia and further south, to the even more exotic lands of Morocco and Algeria. Indeed it was probably the account by his students Eakins and William Sartain of their 1869–70 trip to Madrid that captivated Cassatt's imagination.[34]

Cassatt registered at the Hôtel de Paris on Madrid's Puerta del Sol. The hotel was a short distance from the Prado, where she intended to spend many hours. Exhilarated by what she saw, she wrote to Sartain, urging her to join in this adventure. "Indeed Emily you

must come," Cassatt wrote. "I see the immense capital that can be drawn from Spain, it has not been 'exploited' yet as it might be." She even tried, with a bit of humor, to tempt her friend with promises of Spain's abundant cultural resources: "I intended sending you a photograph of one of the finest pictures, but perhaps I had better not or you will go really crazy."[35] Sartain, however, could not be lured away from her academic program in Paris, where she no longer had to compete with Cassatt for the attention of her instructors.

Eager to absorb the lessons of the Spanish Old Masters, Cassatt turned the Prado into her classroom. There she copied Velázquez's *Spinners* and *Don Baltasar Carlos*, reporting excitedly to Sartain, "I think one learns *how to paint* here, Velázquez [*sic*] manner is so fine and simple." Cassatt's letters also make clear that she was comparing her experiences in Madrid with those she had in Parma. In her view, Velázquez could not paint hands with the subtlety of Correggio (who, she continued to insist, was "the greatest painter that [*sic*] ever lived"), but "these Spaniards make a much greater impression *at first*." Indeed Cassatt's keen eye recognized in both Velázquez and Estébán Bartolomé Murillo a painterly bravura that she soon would attempt to emulate. She wrote, "I feel like a miserable little 'critter' before these pictures, and yet I feel as if I could paint in this style easier, you see the manner is so simple."[36]

After three weeks in Madrid, Cassatt left for Seville, possibly hoping to meet there the artist Mariano Fortuny, whose work she admired and who had been in Paris in 1869 and 1870, when she was still in the city. During her Parisian sojourn, she had visited on occasion the private gallery of American expatriate William Stewart, who once had lived in Philadelphia. Although he collected paintings and watercolors from many nations, Stewart was best known for his selection of Spanish art. His Paris residence, at 6, avenue d'Iéna, served as a haven for Spanish-speaking artists, including Fortuny, Raymundo de Madrazo, José Villegas, Edouardo Zamacois, and many others whose works Stewart owned. The art patron often invited guests to his home, including regular Sunday afternoons for artists and connoisseurs.[37] At Stewart's Cassatt would have seen images such as Villegas's *Ring at*

she began to explore modern life. With the assistance of a local administrator, she took a studio at the Casa de Pilatos, a spectacular sixteenth-century palace (see fig. 14). There she began to apply what she had learned from the Old Masters to scenes of contemporary Andalusian society. The French writer Théophile Gautier's popular 1845 travel guide to Spain served Cassatt as a kind of blueprint of life on the Iberian peninsula. His observations and anecdotes describe in detail the various types of people that would naturally have attracted a young artist in search of "exotic" subjects to depict.[38] In one instance, he compared the old women of Castile to Francisco Goya's series *Los Caprichos*, stressing that the artist's etchings were not nightmares, but rather actual portraits of a fierce and unapologetic veracity. Gautier's pejorative characterization was echoed by other artists and tourists who had traveled to Spain and commented on their fascination with the vagrants, guitar-twangers, water-carriers, dancers, and toreadors of Spain's "picturesque" or lower classes. One author, writing for *Lippincott's Magazine*, was disgusted by the moral decadence he found on Madrid's every corner. "Every man we meet of every degree," he wrote, "is smoking a piece of tissue paper wrapped about tobacco. Beggar and beggar's brat alike are fumigating lustily, and Heaven knows they need it bad enough!"[39] In letters to Sartain, Cassatt also expressed similar prejudice. Writing again to tempt Sartain to join her, she declared, "Don't mind about clothes or anything,

Fig. 13. José Villegas (Spanish; 1844–1921). *Ring at the Bullfight*, 1870. Oil on canvas; 52 x 38 cm. Private collection. Photo: courtesy *GOYA, Revista de Arte.*

Fig. 14. Rafael Garzón (Spanish; act. 1870s–90). General view of the Patio of the Casa de Pilatos, Seville, c. 1880/1900. Albumen silver print from glass negative; 15.1 x 20.4 cm. New York, The Metropolitan Museum of Art, gift of Mrs. John L. Swayze, 1983, 1983.1191.20.

the Bullfight (fig. 13), which depicts not only a section of the picturesque audience in the arena but also a number of bullfighters on the sidelines awaiting their turn to fight; some appear alert and attentive to the fray, while others seem listless or even bored. Cassatt's exposure to such images in both Paris and now in Seville not only colored her vision of the art of Spain's older artists but also whetted her appetite for the direct experience of such dramatic events and colorful characters.

If in Madrid Cassatt studied Renaissance and Baroque art, then in Seville

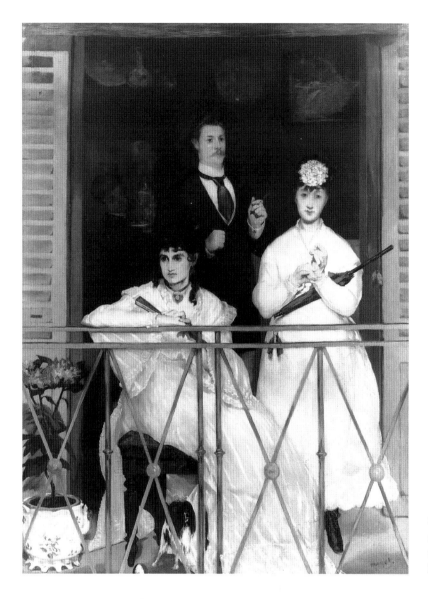

Fig. 15. Edouard Manet (French; 1832–1883). *The Balcony*, 1868–69. Oil on canvas; 169 x 125 cm. Paris, Musée d'Orsay. R.F. 2772.

for the people here are little more than barbarians." Two months later, her negative view became more explicit: "I think the Spaniards infinitely inferior in education and breeding to the Italians."[40]

These "barbarians" provided rich material for Cassatt's imagination. Writing to Sartain on New Year's Eve 1872, she described her first depiction of life in Seville:

My present effort is on a canvass [*sic*] of thirty and is three figures life size half way to the knee—All three heads are foreshortened and difficult to pose, so much so that my model asked me if the people who pose for me live long. I have one mans [*sic*] figure the first time I have introduced a man's head into any of my pictures.[41]

This painting (cat. 3) became the first of four pictures with Spanish subjects that Cassatt would produce over the next five months. Within a shallow space, a male figure emerges from a darkened opening and leans over two standing females. The composition contains many of the elements that artists depicting Spanish genre scenes preferred: picturesque types such as courtesans and cavaliers, native costumes, and a balcony. It is likely that Cassatt, the consummate art observer, had seen either Murillo's *Two Women at a Window* (Washington, D.C., National Gallery of Art) or Goya's *Majas on a Balcony* (New York, The Metropolitan Museum of Art). She may even have been familiar with Manet's 1868 composition *The Balcony* (fig. 15), first exhibited at the

Fig. 16. Unknown artist. Balcony scene. Photo: *Godey's Lady's Book and Magazine* 4 (July 1868), frontis.

1869 Paris Salon, when she was studying in the city.[42]

But unlike Manet's composition, in which three fashionably dressed figures (Berthe Morisot, Antoine Guillemet, and Fahny Claus) seem assembled for a group portrait, Cassatt—inspired by Correggiesque gestures and poses—introduced a narrative tension. Indeed hers represents a recurrent image of flirtation, and not just among Iberian types. For example an engraving published in the December 1868 issue of *Godey's Lady's Book and Magazine* (fig. 16) similarly positions a man standing behind two women. The man's eager interest in the primary female, handsome and beautifully dressed, over whom he dangles a branch of mistletoe, suggests that some sort of physical contact is immanent. When Cassatt first exhibited her painting at the 1873 Cincinnati Industrial Exposition, it carried a title that reinforced her meaning: *The Flirtation: A Balcony in Seville*. Furthering this coquettish narrative, she introduced Spanishness into her scene through her use of traditional costumes. The women wear embroidered shawls; one holds an open fan and the other, a closed one. The shadowy male figure sports the broad-brimmed hat of a cavalier (see fig. 20). Cassatt employed dress to signify national types in all of her Spanish paintings, but nowhere more strongly than in *A Seville Belle* (cat. 4). Such costumes were so popular that they inspired fashions in Europe and the United States in the 1860s and 1870s (see fig. 17).

As Cassatt herself noted, *The Flirtation: A Balcony in Seville* marked her first depiction of an adult male in a fully realized composition. This work is significant as well for the change it marks in Cassatt's handling of paint. The sketchy brush strokes and somber palette relate technically to her intensive study of the Spanish Old Masters. For the first time, Cassatt was able to link the painterly bravura she admired in the art of Velázquez and Murillo to the figural complexity in works by Correggio. The loose and direct portrayal of the male figure may also indicate a new adventurousness in Cassatt, a willingness to break away from the polite subjects expected of women painters of her day. M. Elizabeth Boone persuasively connected *The Flirtation: A Balcony in Seville* to the above-mentioned balcony compositions of Murillo and Goya, whose subjects a nineteenth-century audience could identify as prostitutes. "Provocative behavior, to say nothing of pros-

Fig. 17. Unknown artist. A Spanish-inspired head covering. Photo: *Godey's Lady's Book and Magazine* 30 (June 1870), p. 584, fig. 4.

titution," stated Boone, "is not something we are accustomed to finding in the work of this genteel woman artist."[43]

Whether or not Cassatt's flirting courtesans are prostitutes being propositioned from the shadows may never be known. Shrouded here in semidarkness, however, this vague but provocative figure would take center-stage in two later canvases depicting the romantic exploits of a Spanish toreador. Gautier's descriptions of the Spanish bullfighter's costume seem to have guided Cassatt's interpretation in both *Offering the Panal to the Bullfighter* and *After the Bullfight* (cats. 5, 6). Traditionally, according to Gautier, a bullfighter wore a short jacket (open in the front) of orange, red, blue, or green velvet embellished with sequins and gold and/or silver filigree. Beneath the jacket, he sported a jabot, or shirt with a ruffled front; a loose, colorful, narrow tie; a silk belt; and pants made of leather. The bullfighter, who was usually tall and always athletic, carried a vivid, red-silk cape hung over a horizontally held baton, which he used to attract and agitate the bull.[44]

Tourists flocked to the bullfights, where they could observe a vibrant cross-section of Spanish customs and types (see fig. 13). While fascinated, some found the spectacle disturbing. The American painter George Healy wrote to his wife in 1871 about his first experience of such a contest: "What I saw of the bull fight this afternoon quite upset me. At least twelve horses were killed. . . . The immense amphitheater was crowded, and that was to my mind the finest part of the show." Gustave Doré's lithograph *The Triumph of the Matador* (fig. 18) captures both the gore and the excitement of the bullfight that Healy described. Disemboweled horses lie scattered at the feet of a triumphant, swarthy matador. The crowd erupts in adulation, as the hero catches the eyes of two young maidens, one of whom tosses flowers his way. Although many French artists—including Doré, Gérôme, and Manet—chose to depict the toreador in the midst of the bloody drama, Cassatt avoided representing the fight itself, focusing instead on one or two figures against an undifferentiated background, as in Manet's *A Matador* (fig. 19). Filtered perhaps through the example of Velázquez, Cassatt's subject, like Manet's, is as

Fig. 18. Gustave Doré (French; 1832–1883). *The Triumph of the Matador*, 1862. Lithograph; 23.6 x 16 cm. Paris, Bibliothèque nationale.

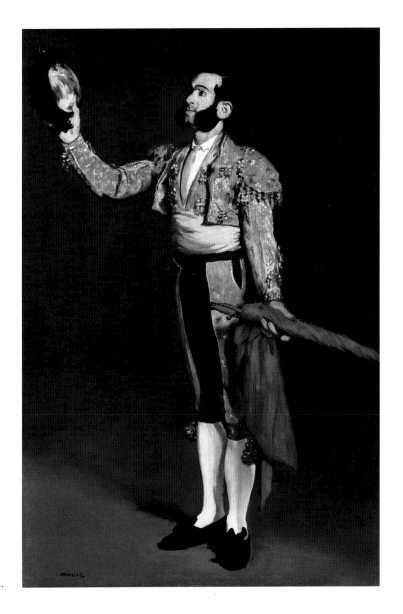

Fig. 19. Edouard Manet. *A Matador*,
1866/67. Oil on canvas; 171.1 x 113 cm.
New York, The Metropolitan Museum
of Art, Havemeyer Collection, 29.100.52.

much about the thick and vigorous application of paint, particularly in the details of the costumes, as it is about flirtation. Manet exhibited his image of a matador, along with at least fourteen other works exploring Spanish subjects, in Paris in 1867. Cassatt very likely saw these images; in 1898 she would urge her friends Louisine and Henry O. Havemeyer to purchase *A Matador* for their collection.[45]

In *Offering the Panal to the Bullfighter*, as in *The Flirtation: A Balcony in Seville*, Cassatt represented a scene of seduction. The woman offers a bullfighter water into which he can plunge his panal, or honeycomb, for sweet refreshment. Cassatt may well have conceived *After the Bullfight* as a logical counterpart to this work, since together they suggest a romantic encounter, followed by a moment of solitude and relaxation. In *After the Bullfight*, the male figure, his red-silk scarf draped loosely over a wooden support, casually lights a cigarette (the association of smoking with male bravura was common in toreador imagery[46]; see fig. 20). Clearly, in her Spanish pictures, Cassatt demonstrated a sensuality and wit not usually associated with her work.

Although she never explicitly stated so in her correspondence, Cassatt seems to have intended her Spanish paintings for the American art market. By the end of June, she had packed up *After the Bullfight* and sent it to the United States. There it joined two other paintings, *The Flirtation: A Balcony in Seville* and *A Seville*

Fig. 20. Unknown artist. "Picador." Photo: Manuel de Cuenndias and V. de Féréal, *L'Espagne pittoresque, artistique et monumentale* (Paris, 1848), n.p.

Belle, in the 1873 Cincinnati Industrial Exposition. Cassatt probably hoped that the exoticism of the imagery would appeal to a midwestern audience. But the three works went unnoticed in local reviews. Not discouraged, one year later, Cassatt decided to exhibit in New York; she sent *The Flirtation: A Balcony in Seville* and *Offering the Panal to the Bullfighter* to the annual exhibition at the National Academy of Design.[47] With all four of her Spanish compositions now in the United States, notices began to appear in the New York press. The most enthusiastic of these came from *The Nation*:

The Spanish subjects by Mary Cassatt are remarkable and have a most cruel blighting effect on whole that we remember from Mr. Hall, our own familiar guide among the scenes of Spain. In one of these balcony groups there is a leaning girl's head, full of somber power, and painted with the best traditions of Murillo.[48]

This reviewer's comments provide a fitting summary of Cassatt's achievement in her Spanish series. The "familiar guide" the writer referred to was George Henry Hall, a painter popular in the early 1870s for his Spanish genre scenes. With its sentimentalized figures, Hall's *Young Lady of Seville and Her Duenna* (fig. 21), exhibited at the National Academy in 1870, contrasts strongly with Cassatt's more visually complex canvases. Most likely, it was her comparatively aggressive painterly method, used as a means of realism, that, in the reviewer's opinion, had a "blighting effect" on Hall's syrupy, smooth-skinned portrayal of a Spanish courtesan. The writer's mention of "somber power" reflects the sense of narrative Cassatt learned from Correggio, while the reference to Murillo recognizes the powerful effect that Cassatt's study of seventeenth-century Spanish technique and realism had on her work.

The abundant references in these genre images to sexual rituals and to the Spanish national character, as Cassatt and others perceived them, embody social meanings that must be examined. Boone speculated astutely on Cassatt's examination of gender and class relations in Seville in relation to the artist's genuine attempt to capture the romantic allure of a foreign culture. Boone concluded: "In Spain, Cassatt remained a tourist, and this 'outsider' position allowed her to consider themes deemed inappropriate for nineteenth-century women." Equally important, Cassatt's Andalusian adventure seems to have liberated her to a new

Fig. 21. George Henry Hall (American; 1825–1913). *Young Lady of Seville and Her Duenna*, 1767–69. Oil on canvas; 125.7 x 92.1 cm. Photo: *Antiques* 108 (Sept. 1975), p. 314.

level of experimentation. Having now found a way to reflect her admiration for the Old Masters through a more daring technical style, Cassatt approached the modernity of Manet's finest canvases, but without any overt suggestion of sexuality.[49]

Nonetheless Cassatt's desire to be a painter of modern life began to blossom only after she left Spain for Paris. She arrived in March 1873. The devastated city Cassatt had witnessed in 1871 had largely been repaired, and it was again the art capital of the world. She exhibited *Offering the Panal to the Bullfighter* at the 1873 Salon. However she found this exhibition disappointing. In comparison to works by the Old Masters of Italy and Spain, the pictures of Léon Bonnat, Alexandre Cabanel, and other academics struck Cassatt as particularly weak. As Emily Sartain explained, "Her [Cassatt's] own style of painting and the Spanish

school which she has been studying all winter is [*sic*] so realistic, so solid,—that the French school in comparison seems washy, unfleshlike and grey."[50]

Once again Cassatt decided to leave the French capital. She commenced a year-long journey that took her back to many of the European cities so important to her artistic training. Her brief return visit to Raimondi in Parma in November 1873 proved an utter failure: "The only satisfactory thing in my visit," she wrote, "was to see the improvement I had made."[51] Eventually she settled in Rome. But, after several months there, she seems to have understood that there was only one place for her to finally discard the mantle of "student with great potential" and join a professional community with which she shared a common aesthetic vision: that place was Paris.

Notes

I am particularly grateful to the following people for their help and advice: Judith A. Barter, Kevin Sharp, Paula Lupkin, Helena Wright, and Susan Dackerman.

1. "Fusty, fudgy . . .": Edwin Austin Abbey, in Marc Alfred Simpson, "Reconstructing the Golden Age: American Artists in Broadway, Worcestershire, 1885 to 1889," Ph.D. diss. (New Haven, Conn.: Yale University, 1993), pp. 38–39.

"To promote the cultivation . . .": Earl Shinn 1872b, p. 144.

For a general discussion of the pedagogical importance of copying Old Master examples in North American art education, see Susan E. Wegner, "Copies and Education: James Bowdoin's Painting Collection in the Life of Bowdoin College," in Brunswick, Maine, Bowdoin College Museum of Art, *The Legacy of James Bowdoin III*, exh. cat. (1994), pp. 143–46. The first woman to petition to copy in the galleries wished to replicate a small canvas, *Ganymede*, attributed to the Italian Baroque artist Guido Reni and now lost; see Philadelphia, Pennsylvania Academy of the Fine Arts, *The Pennsylvania Academy and Its Women*, exh. cat by Christine Jones Huber (1973), p. 13.

2. Cassatt's and Haldeman's petition to copy Wittkamp's composition was submitted to the Committee on Instruction on Mar. 4, 1862; see PAFA. According to Cheryl Leibold, the Academy's archivist, Wittkamp's painting was popular with the public and copyists alike. The painting's file, also at the Academy, contains a list of names of many artists who copied the work. In 1951 the Academy presented it to the government of the Netherlands; its current location is unknown.

"Different classes . . .": Philadelphia, Pennsylvania Academy of the Fine Arts, *Catalogue of the Thirty-Second Annual Exhibition . . .* (1855), p. 27.

3. For reaction to Cassatt's studying with Gérôme, see Howard Sellin, *The First Pose, 1876: Turning Points in American Art; Howard Roberts, Thomas Eakins, and a Century of Philadelphia Nudes* (New York, 1976), pp. 34–35.

For American students studying with Thomas Couture, see College Park, University of Maryland Art Gallery, *American Pupils of Thomas Couture*, exh. cat. by Marchal E. Landgren (1970), p. 18.

4. On the practice of copying in nineteenth-century Paris, see Theodore Reff, "Copyists in the Louvre, 1850–1870," *Art Bulletin* 46, 4 (Dec. 1964), pp. 552–59; and Paul Duro, "Copyists in the Louvre in the Middle Decades of the Nineteenth Century," *Gazette des beaux-arts* 111, 6 (Apr. 1988), pp. 249–54.

"Surround yourself . . .": Jean Léon Gérôme, in Edwin Blashfield, "Open Letters, American Artists on Gérôme," *The Century Magazine* 37, 4 (Feb. 1889), p. 635. For Cassatt's and Haldeman's work in the Musée du Louvre, see Mathews 1994, pp. 32–33; and Sellin (note 3), p. 12.

Paul Duro, "The 'Demoiselles à Copier' in the Second Empire," *Women's Art Journal* 7, 1 (spring/summer 1986), pp. 1–7.

5. On Cassatt's professional ambition, see Eliza Haldeman to her mother, May 15, [1867], in Mathews 1984, p. 45. Haldeman declared that Cassatt aspired to "paint *better* than the old masters," even though her mother, Katherine Kelso Cassatt, "wants her to become a portrait painter as she has a talent for likenesses."

"It was much pleasanter . . .": Eliza Haldeman to Mr. and Mrs. Samuel Haldeman, May 8, [1868], in Mathews 1984, p. 54.

Cassatt continued to use her professional name "Mary Stevenson" until at least 1872. In that year, her brother Alexander commented, "Mary's art name is 'Mary Stevenson' under which name she expects to become famous, poor child"; see Pollock 1980, p. 65.

"A portrait of an Italian girl . . .": Ryan 1868.

For Cassatt's 1870 Salon painting, see Lifetime Exhibition History (Paris 1870).

6. The Sartain family was one of the most accomplished artistic lineages in nineteenth-century Philadelphia. John Sartain was a highly respected engraver, specializing in reproductions of fine art. He worked for several magazines and in 1849 began his own short-lived publication, *Sartain's Union Magazine of Literature and Art*. In 1870 he joined the board of directors of the Pennsylvania Academy. In addition to his daughter, Emily, Sartain's two oldest sons, Samuel and Henry, became well-known engravers; a younger son, William, became an artist and traveled through Spain with Eakins in 1869. On Emily Sartain, see Phyllis Peet, "The Art Education of Emily Sartain," *Woman's Art Journal* 11, 1 (spring/summer 1990), p. 11. On John Sartain's "mentoring" of his daughter, see Philadelphia (note 1), p. 19. Emily Sartain told her father about Cassatt's gratitude for his advice; see Emily Sartain to John Sartain, Oct. 9, 1872, in Mathews 1984, pp. 104–107. On Cassatt's and Emily Sartain's sharing of models, see letter from Cassatt to Emily Sartain, May 22, [1871], in Mathews 1984, p. 70.

7. On the suspension of classes at the Academy, see Doreen Bolger, "The Education of the American Artist," in Philadelphia, Pennsylvania Academy of the Fine Arts, *In This Academy: The Pennsylvania Academy of the Fine Arts, 1805–1976*, exh. cat. org. by Frank H. Goodyear, Jr. (1976), p. 62.

"I have given up . . .": Cassatt to Emily Sartain, July 10, [1871], in Mathews 1984, p. 75.

8. See Cassatt to Emily Sartain, June 7, [1871], in Mathews 1984, p. 74. Cassatt stated, "I am working by fits & starts at fathers [*sic*] portrait but it advances slowly he drops asleep while sitting. I commenced a study of our mulatto servant girl but just as I had the mask painted in she gave warning. My luck in this country."

9. Cassatt to Sartain, June 7, 1871, in Mathews 1984, pp. 73–74.

10. Cassatt to Sartain, Oct. 21, [1871], in Mathews 1984, pp. 76–77.

11. For the most detailed material on Bishop Domenec, see A. A. Lambing, *A History of the Catholic Church in the Diocese of Pittsburg and Allegheny from its Establishment to the Present Time* (New York, 1880), pp. 85–105. On his visits to Hollidaysburg, see Bishop Domenec to Thomas Haydon, Mar. 1, 1870, in "Miscellaneous Manuscript," in box 765, Archives, Diocese of Pittsburgh; see also "Circular of Bishop Domenec," *The Catholic*, Sept. 30, 1871, p. 260. When Domenec began his tenure in 1860 as bishop of the diocese of Pittsburgh, plans for constructing the cathedral were virtually complete. The design comprised five aisles, the outer two terminating at the front in monumental towers. In 1866 the cathedral's small organ was replaced by a powerful instrument that, in its day, ranked among the largest in the nation. For a complete history of Old St. Paul's Cathedral in Pittsburgh, see *St. Paul's Cathedral Record: Containing an Historical Sketch of St. Paul's Cathedral from the Beginning of the First Parish in the City of Pittsburgh to May 10, 1903* (Pittsburgh, 1903).

Cassatt documented the commission in

a letter to Sartain, Oct. 21, [1871], in Mathews 1984, p. 76: "I went to Pittsburgh with my mother & went to call on the Catholic Bishop who is a Spaniard, & he has given me two orders for copies for the church."

The only notable painting in the cathedral at the time of Cassatt's commission was a large *Crucifixion* by the nineteenth-century Italian painter Piero Gagliardi. On this painting, see J. T. C., "Description of St. Paul's Cathedral," *St. Paul's Cathedral Record* 6 (Apr.–July 1901), p. 4. Bishop Michael O'Connor, Domenec's predecessor, purchased this work in Rome in 1857.

12. Commissioned in 1523 by "Donna Briseide" of Parma for an altarpiece in the city's church of S. Antonio, the *Madonna of Saint Jerome* was seized by Napoleon's forces and carried off to Paris. It was returned, much against its captors' wishes, to Parma in 1815. By 1872 it was hanging in its own silk-lined room in the city's Galleria. *Coronation of the Virgin* constituted the central subject of the fresco cycle Correggio painted between 1520 and 1524 in the great Benedictine church of S. Giovanni Evangelista in Parma. See David Ekserdjian, *Correggio* (New Haven/London, 1997), pp. 193–94; and Selwyn Brinton, *Correggio* (London, 1907), pp. 78–79.

13. In the eighteenth century, North American artists such as Matthew Pratt, John Trumbull, and Benjamin West had all copied *Madonna of Saint Jerome* as part of their artistic training.

"It must certainly . . .": Sir Robert Strange, *A Collection of Historical Prints Engraved from Pictures of the Most Celebrated Painters of the Roman, Florentine, Lombard, Venetian, and Other Schools* (London, 1787), p. 15.

Among the guidebooks that list the fresco cycle as an essential experience for tourists to Parma, see George E. Street, *Notes of a Tour in Northern Italy* (New York, 1986; 1st ed., 1855), p. 356.

14. On Americans who copied Correggio, see Theodore E. Stebbins, Jr., "American Painters and the Lure of Italy," in Boston, Museum of Fine Arts, *The Lure of Italy: American Artists and the Italian Experience*, exh. cat. (1992), pp. 31–35; and Dorinda Evans on the artist Matthew Pratt, in Washington, D.C., National Portrait Gallery, *Benjamin West and His American Students*, exh. cat. (1980), pp. 24–25.

In 1860 Cassatt visited the Philadelphia print collections of Joseph Harrison and Henry Carey, which were accessible to artists and art students; see Eliza Haldeman to Samuel Haldeman, Jan. 26, 1860, in Mathews 1984, pp. 22–23.

15. On Claghorn see Catherine Stover, "James L. Claghorn: Philadelphia Collector," *Archives of American Art Journal* 27, 4 (1987), pp. 4–8. I am grateful to Susan Dackerman, Assistant Curator of Prints, Drawings, and Photographs at the Baltimore Museum of Art, where the Claghorn print collection is now housed, for her tireless assistance, as well as for bringing this article to my attention.

"The best representative . . .": E. S. (Earl Shinn), "Private Art-Collections of Philadelphia: I.—Mr. James L. Claghorn Gallery," *Lippincott's Magazine* 9 (Apr. 1872), p. 443. Shinn's series, a total of ten articles, appeared in *Lippincott's Magazine* 9–10 (Apr. to Dec. 1872). I am grateful to Helena Wright, Curator of Graphic Arts, National Museum of American History, Smithsonian Institution, Washington, D.C., for informing me about Shinn's articles and for general discussions about the role of prints in the education of American artists.

16. "Confused mass . . .": Street (note 13), p. 356. In a similar vein, Corrado Ricci, director of Parma's Galleria nazionale, extolled Toschi's ability to accurately reproduce Correggio's soft tones and subtle color variations "which students have accepted as characteristic of the master"; see Corrado Ricci, *Antonio Allegri da Correggio, His Life, His Friends, His Time*, trans. by Florence Simmonds (New York, 1896), p. 203.

"I think very much less . . .": Emily Sartain to John Sartain, Jan. 12, 1872, in Mathews 1984, p. 87.

For Sartain's complaint, see Emily Sartain to John Sartain, Feb. 18, [1872], in Mathews 1984, p. 93.

17. Cassatt to Sartain, Oct. 21, [1871], in Mathews 1984, p. 76.

18. Cassatt to Emily Sartain, Oct. 27, [1871], in Mathews 1984, p. 77.

19. Emily Sartain to John Sartain, Dec. 15, [1871], in Mathews 1984, p 80.

20. Much of the information regarding Cassatt's and Emily Sartain's experiences in Parma, Italy, is conveyed in letters Emily, a consummate correspondent, wrote to her father, John Sartain. On the convenience of Cassatt's and Sartain's location, see Emily Sartain to John Sartain, Jan. 22, 1872, in Mathews 1984, p. 92.

"I notice . . .": Emily Sartain to John Sartain, Feb. 18, 1872, in Mathews 1984, p. 93.

21. For reference to Raimondi's studio visits and Sartain's interest in the perpendicular engraving table, see Emily Sartain to John Sartain, Jan. 12, [1872], in Mathews 1984, p. 87.

22. "Miss C. is . . .": Emily Sartain to John Sartain, Feb. 18, [1872], in Mathews 1984, p. 93.

For Cassatt's reputation among local painters, see William Sartain to John Sartain, Mar. 25, [1872], in Mathews 1984, p. 67, in which he wrote, "Prof. Raimondi and other Italian painters of reputation are quite enthusiastic in regard to our fair young countrywoman's talent which they pronounce to be nearly akin to genius."

For Giacomo Cornish, see Emily Sartain to John Sartain, Jan. 1, 1872, in Mathews 1984, p. 85.

For Emily Sartain's suggestion that the Pennsylvania Academy purchase Cassatt's copy of *Madonna of Saint Jerome*, see Emily Sartain to John Sartain, Mar. 7, 1872, in Mathews 1984, p. 96. It is an odd suggestion, since the copy was to have been the property of the Pittsburgh cathedral; in any case, there is no evidence that the Academy ever planned to purchase the copy. A large number of copies the school owned of paintings by such Old Masters as Raphael, Titian, Peter Paul Rubens, and Salvador Rosa were destroyed by a fire in 1845. This loss prompted academy leaders to rethink the institution's mission to collect, and to cut back on purchasing painted copies for student use. Around the time Sartain suggested it acquire Cassatt's replica, the Academy purchased a group of carbon photographic reproductions of Old Master compositions by the French photographer Adolphe Braun. See Ronald Onorato, "The Pennsylvania Academy of the Fine Arts and the Development of American Curriculum in the Nineteenth Century," Ph.D. diss. (Providence, Rhode Island: Brown University, 1977), pp. 46–47.

23. For Cassatt's process of copying *Coronation*, see Emily Sartain to John Sartain, Jan. 1, [1872], in Mathews 1984, p. 85. Cassatt worked from both Correggio's original and Carracci's copy of the *Coronation of the Virgin* because the church's library, where

the work was kept, was not heated and therefore impossible to work in during the winter months. For more on Carracci's copy, see Anna Ottani Cavina, "Coronation of the Virgin" in New York, The Metropolitan Museum of Art, *The Age of Correggio and the Carracci: Emilian Painting of the Sixteenth and Seventeenth Centuries*, exh. cat. (1986), p. 287.

"A Legend of the Assumption of the Blessed Virgin," *The Pittsburgh Catholic*, Aug. 10, 1872, p. 2. For many centuries, the Assumption of the Virgin was celebrated as a Church festival. In 1850 the event was declared an article of faith by Pope Pius XII. For a contemporary discussion of the subject, see John P. Lundy, *Monumental Christianity or the Art and Symbolism of the Primitive Church as Witnesses and Teachers of the One Catholic Faith and Practice* (New York, 1876), pp. 227–29.

24. "All Parma . . .": Emily Sartain to John Sartain, Mar. 7, 1872, in Mathews 1984, p. 95.

"Beastly": Cassatt to Emily Sartain, May 25, [1872], in Mathews 1984, p. 99.

Cassatt sent the completed copy to Pittsburgh in early June 1872. She routed it through Genoa, where it left for New York on June 25. The painting reached Philadelphia by Oct. 5. There seems to have been some concern over its condition upon arrival, most likely in relation to the way Raimondi had packed it. By Nov. 17, the canvas was in Pittsburgh. The important letters charting the painting's shipment include: Cassatt to Emily Sartain, May 25 (see above) and June 2, in Mathews 1984, p. 100; and Emily Sartain to John Sartain, Nov. 17, 1872, in ibid., p. 111. It is in this letter that Emily told of the bishop's enthusiastic response.

A thorough search for Cassatt's copy of *Coronation* in Pittsburgh turned up nothing. All archival evidence (detailed written descriptions of the cathedral and photographs of its interior) suggests that, by the time the cathedral was readied for demolition in 1903, Cassatt's painting was no longer in situ. The cathedral was torn down in order to make way for the Union Trust Building. Reportedly Henry Clay Frick was behind the deal and paid a sum in excess of one million dollars for the property. The Diocese of Pittsburgh was eager to accept the offer because the demographic patterns of parishioners had shifted over the ensuing forty years to the Oakland neighborhood, where the new St. Paul's Cathedral was to be built.

"Entering the church . . .": "A Night of Alarms," *Pittsburgh Chronicle*, June 2, 1877, p. 1. For additional coverage of the conflagration, see "The Cathedral Ablaze," *Pittsburgh Post*, June 2, 1877, p. 2; "The Destructive Element," *Pittsburgh Evening Chronicle*, June 2, 1877, p. 1; and "Fire at St. Paul's Cathedral,"

The Pittsburgh Catholic, June 9, 1877, p. 3.

25. According to Sartain, Cassatt had all but finished *During Carnival* by mid-Feb.; see Emily Sartain to John Sartain, Feb. 18, 1872, in Mathews 1984, p. 92.

For writers and artists who were inspired by Carnival, see William L. Vance, *America's Rome* (New Haven/London, 1989), vol. 2, p. 197.

"Masked and muffled . . .": Henry James, "Roman Holiday," in *Traveling in Italy with Henry James*, ed. Fred Kaplan (New York, 1994), pp. 129–30.

26. James Jackson Jarves, *Italian Sight and Papal Principles, Seen Through American Spectacles* (New York, 1856), pp. 253–54.

27. For the artist's work on *Bacchante*, see Cassatt to Emily Sartain, June 2, [1872], in Mathews 1984, p. 101. For its showing, see Lifetime Exhibition History (Milan 1872).

On French academic artists' interest in bacchanalian themes, see Pierre Larousse, *Grand Dictionnaire universel du XIXe siècle*, vol. 2 (Geneva/Paris, 1982; 1st ed., Paris, 1867), pp. 20–21.

28. For a contemporary review, see H. B. 1872.

"I find it has . . .": Cassatt to Emily Sartain, June 2, [1872], in Mathews 1984, p. 100. In this letter, Cassatt also wrote to Sartain of reviews of her work appearing in the *Gazetta di Parma*.

Cassatt further emphasized the importance of garnering critical reviews in an earlier letter to Sartain, who was by then in Paris. "I know you don't like the Ryan set but still it is just as well to be in with the 'press'?" See Cassatt to Sartain, May 25, [1872], in Mathews 1984, p. 99.

For the sale of *During Carnival*, see Emily Sartain to John Sartain, Nov. 17, [1872], in Mathews 1984, p. 110.

29. James Jackson Jarves, *Art Thoughts: The Experiences and Observations of an American Amateur in Europe* (New York, 1869), p. 68. For more discussion by Jarves on the Old Masters, see his *Art Studies: The "Old Masters" of Italy; Painting* (New York, 1861). For a biography of Jarves, see Francis Steegmuller, *The Two Lives of James Jackson Jarves* (New Haven, Conn., 1951).

30. Cassatt wrote: "Now that I have begun to paint from life again, constantly the thought of Correggio's pictures returns to my mind and I am thankful for my six months [sic] study in Parma. In all of Velazquez [sic] pictures I can think of no beautiful hand, no! not one"; see Cassatt to Sartain, Dec. 31, [1873], in Mathews 1984, p. 114.

31. "Lack of imagination": John Rewald, *The History of Impressionism* (rev. ed.: New York, 1961), p. 86. The first criticism of Manet's penchant for appropriation to appear in print seems to have been Ernest Chesneau, *L'Art et les artistes modernes* (Paris, 1864), p. 190.

32. Cassatt to Emily Sartain, May 22, [1871], in Mathews 1984, p. 70.

33. For an overview of the romantic appeal of Spain, see London, The British Museum, *The Painted Voyage: Art, Travel and Exploration 1564–1875*, exh. cat. by Michael Jacobs (1995), pp. 29–32.

34. For a study of Manet's interest in Spain, see Joel Isaacson, "Manet and Spain," in Ann Arbor, Mich., The Museum of Art at the University of Michigan, *Manet and Spain*, exh. cat. by Joel Isaacson (1969), pp. 9–16.

For Gérôme's advice to his students to travel to Spain, see H. Barbara Weinberg, *The American Pupils of Jean-Léon Gérôme* (Fort Worth, Tex., 1984), pp. 38, 49.

For Eakins's and Sartain's 1869–70 trip to Spain, see "Autobiography of William Sartain, c. 1910," PMA.

35. "Indeed Emily . . .": Cassatt to Emily Sartain, Oct. 27, [1872], in Mathews 1984, p. 109.

"I intended sending . . .": Cassatt to Emily Sartain, Oct. 13, [1872], in Mathews 1984, p. 108.

36. "I think one learns . . ." and "I feel like . . .": Cassatt to Emily Sartain, Oct. 13, [1872], in Mathews 1984, p. 108.

"The greatest painter . . .": Cassatt to Emily Sartain, Oct. 5, [1872], in Mathews 1984, p. 103.

37. In October 1872, while Cassatt was in Madrid, she wrote to Sartain that Fortuny planned to stop in the city and implied that she hoped to see him; see Cassatt to Emily Sartain, Oct. 13, [1872], in Mathews 1984, p. 108.

One contemporary art critic declared Stewart's collection to be "particularly rich in specimens of the modern Spanish school"; see Lucy Hooper, "Private American Art Galleries in Paris: II—The Collection of William Stewart, Esq," *The Art Journal* 1 (1875), p. 283. On the accessibility of Stewart's collection for artists and amateurs, see W. R. Johnston, "W. H. Stewart, the American Patron of Mariano Fortuny," *Gazette des beaux-arts* 77 (Mar. 1971), p. 186.

38. Théophile Gautier, *Un Voyage en Espagne* (Paris, 1908; 1st ed., 1845). For Cassatt's reliance on Gautier's book, see Cassatt to Emily Sartain, Oct. 13, [1872], in Mathews 1984, p. 107.

39. Gautier (note 38), p. 33.

"Every man we meet . . .": David Adee, "Types of Castilian Vagrancy," *Lippincott's Magazine* 9 (June 1872), p. 67.

40. "Don't mind about clothes . . .": Cassatt to Emily Sartain, Oct. 13, [1872], in Mathews 1984, p. 107.

"I think the Spaniards . . .": Cassatt to Emily Sartain, Dec. 31, [1872], in Mathews 1984, p. 114. For further disapproving comments on the Spanish, in comparison with Italians, see Cassatt to Emily Sartain, Oct. 27, [1872], in Mathews 1984, p. 109.

41. Cassatt to Emily Sartain, Dec. 31, 1872, in Mathews 1984, p. 114.

42. Murillo's painting had been engraved several times in the eighteenth and nineteenth centuries, most notably by W. G. Mason in William Stirling-Maxwell's *Annals of the Artists of Spain* (London, 1848), vol. 3, p. 1092. Although Cassatt never mentioned Goya in her letters, she knew his *Majas* well enough that in 1902 she advised the Havemeyers to purchase the version now in The Metropolitan Museum of Art, New York. Recently Gary Tinterow showed that this canvas was probably an early copy after Goya's composition; see New York 1993, pp. 15–16. On Manet's *The Balcony*, see Joel Isaacson, "Manet and Spain: A Chronology," in Ann Arbor (note 34), p. 19.

43. M. Elizabeth Boone, "Bullfights and Balconies: Flirtation and Majismo in Mary Cassatt's Spanish Paintings of 1872–73," *American Art* 9, 1 (Spring 1995), p. 61.

44. For a contemporary description of the toreador costume, see Gautier (note 38), pp. 73–77.

45. "What I saw . . .": George Healy, in Mary Healy Bigot, *Life of George P. A. Healy* (n.p., n.d.), p. 61.

For more on *A Matador* and the Havemeyers' purchase of it, see New York 1993, pp. 27, 30, 352–53.

46. See for example "Smoking," *Lippincott's Magazine* 2 (Aug. 1868), p. 152.

47. See Lifetime Exhibition History (Cincinnati 1873; New York 1874).

48. *The Nation* 1874, p. 321.

49. "In Spain . . .": Boone (note 43), p. 70.

Interestingly Cassatt continued to make copies in this period, even as her work evolved into a more contemporary idiom. The copy she made (Mrs. Perry C. Maderna, Jr., Berwyn, Penn.) of Frans Hals's *Officers and Sergeants of the St. Hadrian Civic Guard* (Haarlem, Frans Halsmuseum) in 1873 became something of a personal declaration about the value of copying. Her ability to capture the quality of Hals's light so pleased her that, fifty years later, she showed this canvas to students visiting her Paris studio, assuring them that the study of the Old Masters was essential to their artistic development; see D. Dodge Thompson, "Frans Hals and American Art," *The Magazine Antiques* 136, 5 (Nov. 1989), p. 1175.

50. "Her own style . . .": Emily Sartain to John Sartain, May 15, [1873], in Mathews 1984, p. 118.

51. "The only satisfactory thing . . .": Cassatt to Emily Sartain, Nov. 26, [1873], in Mathews 1984, p. 123.

Fig. 1. Mary Cassatt. *A Corner of the Loge*, 1879. Oil on canvas; 43.8 x 62.2 cm. Private collection.

Mary Cassatt: Themes, Sources, and the Modern Woman

Judith A. Barter

The Fashionable Spectacle

Mary Cassatt settled permanently in Paris in 1874. Her friend Emily Sartain explained this decision: "She says she sees it is necessary to be here, to look after her own interests."[1] Indeed Cassatt would have preferred to return to Italy, but she recognized that Paris was the center of the modern art world and the best place to earn her living as a professional artist. Cassatt's elder sister, Lydia, journeyed from Philadelphia to join her in this adventure.

When the sisters settled in Paris, the city was in a period of radical and rapid transformation. In the 1860s and 1870s, advances in technology literally made the city glow; gas and later electric lighting illuminated interiors and streets, extending the possibilities of nighttime entertainment. Large department stores opened, their windows glittering with lights, tinsel, and goods. A plethora of new magazines promoted fashion, products, and entertainments. The well-to-do middle class provided a ready and eager audience for a parade of ever-changing fashions. In this materialistic culture, women, rather than men, emerged as the most significant consumers. Displaying fashionable goods in their homes and on their bodies, these *Parisiennes* became objects of visual consumption themselves—*objets de luxe* (see fig. 2). Born into a wealthy family, Cassatt belonged to the leisured class, and, as her paintings would later reveal, she participated in the recreations of Paris: she and Lydia were always fashionably attired and clearly conversant with the city's fashion magazines and glamorous stores. They entertained and frequently attended the theater and opera.[2] If Cassatt wished to establish herself as a successful professional artist, she had to lead an active social life herself.

Early on Cassatt seems to have received commissions and to have painted some conventional portraits (see cats. 7, 8). She also exhibited works in the Paris Salons of 1874 (see Shackelford, fig. 2), 1875,

Fig. 2. Bertall (Albert d'Arnoux) (French; 1820–1882). "Quand je vous dis que c'est une robe de chez Worth, je reconnais la touche" ("When I tell you that it's a dress by Worth, I recognize the touch"). Photo: Bertall, *La Comédie de nôtre temps* (Paris, 1874), vol. 2, p. 307.

and 1876. But after her encounter with Degas's pastels in a shop window on the boulevard Haussmann, perhaps as early as 1875, her work changed forever. Cassatt arrived in Paris only weeks after a number of artists, led by Edgar Degas and others, had declared their independence from the official exhibition system by staging a show of their own in the former studio of the photographer Nadar on the boulevard des Capucines. While she did not see this first exhibition of works by the painters who eventually would be known as the Impressionists, a few years later she would be in the thick of their activities. These individuals had begun to embrace the spectacle of modern, urban existence as the subject of their art. They found nothing more compelling than

Fig. 3. Artist unknown. Interior of the Opéra, Paris, designed by Charles Garnier (French; 1825–1898), 1862–75. Engraving. Photo: courtesy Bibliothèque nationale, Paris.

painting the world around them. They too became avid consumers, immersing themselves in the pleasures of Paris, savoring the experience of sensations, and exploring the act of seeing itself. It is not surprising therefore that opera glasses and lorgnettes, mirrors, lighting devices, reflective surfaces, and other ocular signifiers proliferated in their images as they focused not just on the things of life but on the process by which they visually perceived them.

By the late 1870s, Cassatt's work conveys the life she and Lydia led in Paris—at the city's many public entertainments and in the private, domestic realm. Of all the arts in nineteenth-century France, theater was the most popular. To many it seemed that all of Paris lived at the theater. Nowhere else could one experience such a lavish display of light, color, ornament, extravagance, and society. By far the most opulent theater in Paris was the Opéra (fig. 3), built between 1862 and 1875 at the conjunction of several of the sweeping, new boulevards that had been created under the direction of Baron Haussmann. Among the building's many sumptuous and grand-

scale decorations, the murals of Paul Baudry (see fig. 61) would prove a valuable model to Cassatt later, when she embarked upon her mural for the 1893 Columbian Exposition in Chicago (see fig. 51). But Paris was filled with many other elegant, if smaller, theaters. The horseshoe-shaped house of a typical theater was illuminated by gaslight (gradually replaced by electricity during the 1880s), which provided dramatic, flickering patterns. The stage itself was lit by "limelight" (calcium oxide heated to incandescence), which threw out a strong, white, spreading light. As historian Eugen Weber pointed out, the spectacle on stage went hand-in-hand with that of the audience. Auditorium lights were sometimes dimmed, but, unlike theaters today, never totally extinguished, allowing the audience to read a libretto, or more importantly, to watch one's neighbors. One observer wrote that the gas "chandelier, superb, shone like a sun . . . [upon] resplendent bodices [and] people busily chatting."[3]

Theater subjects had attracted a number of realist and Impressionist artists, including Honoré Dau-

Fig. 4. J. A. D. Ingres (French; 1780–1867), *Portrait of Comtesse d'Haussonville*, 1845. Oil on canvas; 131.8 x 92 cm. New York, The Frick Collection, 27.1.81.

mier, Degas, and Pierre Auguste Renoir (see fig. 9). Cassatt's theater pictures distinguish themselves by their exclusive focus on the female members of the audience. Cassatt portrayed women sitting in loges, or boxes, at the theater, opera, or ballet. With yearly loge rentals costing thousands of francs, only the well-to-do could afford such seating. While the stall seats on the ground floor cost less, the price of a single ticket was equivalent to several-days' wages for working men and women, which forced the enthusiastic poor to take seats high up, in the gallery. Even higher, at the roof-line, sat the "claque," a group of men rounded up from the street or from cafés who were drilled to applaud on cue. Their payment was free admission to the performance. Women could attend matinées alone during the day and could even sit in the stalls; at these performances, they wore high-collared afternoon dresses (see cats. 8, 17). In the evening, however, they wore more formal, low-necked gowns ("décolletées") (see cat. 18). They were

not permitted to sit in the orchestra but could occupy a stall if accompanied by a man; when occupying a loge with a male escort, women always sat at the front of the box with the men behind (see figs. 8, 9). Without male companions, they sat with other women in a loge (see fig. 1 and cat. 20), the architecture of which partially hid them from view, as did the gaslight, which illuminated discrete areas, leaving pockets of darkness. Friends could enter a loge to visit and take refreshment, making it almost an extension of the domestic salon. A space midway between private and public, the loge harbored activities rivaling the performance on the stage. The poet Charles Baudelaire, inspired by the theater scenes of one of his favorite artists, Constantin Guys, declared,

Sometimes in the diffused radiance of opera or theater, young girls of the best society, their shoulders, eyes, and jewels catching the light, resemble gorgeous portraits as they sit in their boxes, which serve as picture-frames. Some prim and proper, others frivolous and fair. Some, with aristocratic unconcern, display a precocious bosom, others candidly reveal their boyish chests. Fans on teeth, with fixed or wandering eye, they are theatrical or solemn like the play or opera they pretend to be looking at.[4]

The architecture of the loge was often embellished with an expensive, mirrored back wall; this feature allowed the occupants discreetly to observe themselves and others, as well as to be surrounded by the flickering lights of stage and house reflected in the mirrors. The mirror became an important compositional element in both Cassatt's theater and domestic images in the late 1870s and early 1880s. She may have learned to employ the device from her teacher Charles Chaplin, who in 1863 had depicted his wife standing before a large overmantel mirror (Paris, Musée du Petit Palais). The motif was of course a signature mark of Chaplin's teacher, J. A. D. Ingres. The great portraitist, whose work Degas admired and collected, for example placed the elegant Comtesse d'Haussonville in front of a mirrored mantelpiece, upon which rests a pair of opera glasses (fig. 4).

To devise compositional strategies for her depictions of women in public and private places, Cassatt looked not only to the traditions of society portraiture but also to illustrations in contemporary fashion

Fig. 5. Adèle Anaïs Colin Toudouze (French; 1822–1899). Women in loges. Photo: *La Mode illustrée* (Feb. 9, 1879), before p. 42. Photo: courtesy Boston Public Library.

magazines (see fig. 5). She was not alone in this: her new colleagues, including Paul Cézanne, Claude Monet, and Berthe Morisot, had earlier turned to these sources for thematic and compositional models.[5] For the consumer engaged in the pursuit of modern goods, fashion magazines were essential. More than one hundred different periodicals devoted to fashion appeared between 1830 and 1848, but the greatest growth of this type of periodical occurred after mid-century. By 1890 the most important of these—*Le Moniteur de la mode, La Mode illustrée, Le Petit Echo de la mode*—enjoyed combined circulations of 500,000. These magazines promoted the activities of leisured women: shopping, browsing, traveling, attending exhibitions, and enjoying the theater.[6] Cassatt's work also focuses on stylish women, who look much like their counterparts in fashion plates (see figs. 5, 6, 17, 18).

Cassatt used mirrors in such images as *At the Theater* (cat. 19) and *Women in a Loge* (cat. 20) to play upon the double-figure compositional device often used by fashion-magazine illustrators to present the front and back view of a dress, hat, or coiffure (see fig. 6). But Cassatt's motives in incorporating mirrored images

Fig. 6. Artist unknown. "Sortie de bal en Sicilienne" ("Leaving the Ball in a Sicilian Jacket"). *La Mode illustrée* (Dec. 24, 1882), p. 1. Photo: courtesy Boston Public Library.

Fig. 7. Artist unknown. Theater accoutrements. Photo: *L'Art de la mode* 3 (1881–82), p. 19. Photo: courtesy Boston Athenaeum.

Fig. 8. Bertall. Loge scene. Photo: Bertall, *La Comédie de nôtre temps* (Paris, 1874), vol. 1.

were more complex and sophisticated: her mirrors function to expand the pictorial space, emphasize her female subjects, create a sense of movement, and even to investigate coexistant systems of perception. Typically mirrors serve to remove a painted scene one step further from reality and to remind us that the image and space within it are two-dimensional. Thus it seems, at first glance, that *Woman in a Loge* (cat. 18) depicts two women seated in a box, one behind the other. On closer inspection, however, we realize that there is only one; her back is reflected in the mirror, in which we can also see the audience and the sweeping lines of the theater.

No doubt the Impressionists' exploration of the boundary between reality and illusion—between the physiological and psychological components of vision—was in part responsible for the emphasis on ocular instruments in their images. Opera glasses in particular symbolized and underscored the act of looking. Illustrations of opera glasses sitting on the ledge of the loge are scattered throughout fashion magazines of the 1870s and 1880s (see fig. 7). Similarly the subject of people looking through opera glasses appears in popular illustrated literature, such as Bertall's *Comédie de nôtre temps* (see fig. 8). In Cassatt's *Corner of the Loge* (fig. 1) and *At the Français, a Sketch* (cat. 17), opera glasses occupy a central place. In both examples, the protagonists who look at the stage are being looked at as well. The watcher becomes the watched; the spectacle of the theater, seen through a

version of spectacles (opera glasses), is not just the action on the stage but in the audience as well. In turn we as viewers are drawn into this exchange of gazes, which extends the illusion and reminds us of the artificial nature of the canvas.

In Cassatt's loge pictures, women do not make eye contact with the viewer. Rather they look off to the side, or look away, presumably at the stage or at others. The woman in *At the Français, a Sketch* appears oblivious to those gazing at her, including us, in contrast to the young woman in Renoir's *Theater Box* (fig. 9), who confronts us directly. Indeed the differences between these paintings, which were both shown in the 1879 Impressionist exhibition, are more telling than their similarities. Like Renoir, Cassatt included opera glasses, lights, and shimmering fabrics; but unlike Renoir, whose focus was the radiant beauty of his model, Cassatt emphasized the relationship of the figure to the architecture and lighting of the space around her. The gaze of Renoir's female theater-goer is direct, even brazen. Cassatt's women are not just objects to be looked at; rather they are absorbed in looking at the spectacle before them.

In recent years, both Marxist and feminist historians have interpreted such forthright eye contact between a female subject and the viewer as embodying sexual meaning. According to them, the viewer, who is considered to be male, exerts control over the female subject, who is positioned as an object to be regarded. This control implies sexual content and has

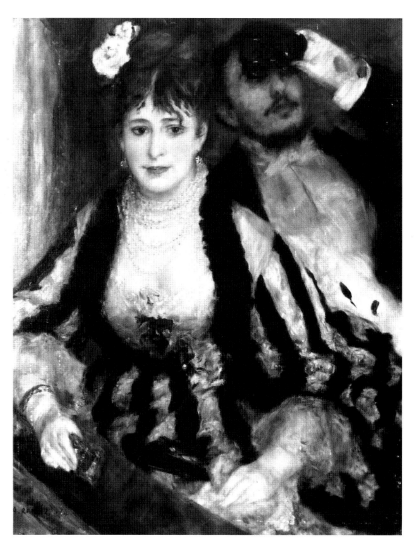

Fig. 9. Pierre Auguste Renoir (French; 1841–1919). *The Theater Box*, 1874. Oil on canvas; 80 x 63.5 cm. London, Courtauld Institute Galleries.

lorgnettes, veils, large hats, and fans. In three images of women at the theater (cats. 19, 20, and Shackelford, fig. 3), the figures raise their fans, erecting a barrier between themselves and us. Yet, in all three examples, they do not cover their eyes, which allows the fan to become a tool of seduction, a subtle indicator of demarcation and desire. Moreover the fashionable women Cassatt painted expected to be watched, or were so comfortable being watched that they could detach themselves from the viewer. In *Woman in a Loge* (cat. 18), the youthful subject—healthy, open, and unrestrained—leans informally on her arm, her parted lips revealing her teeth and seemingly the beginning of a hearty laugh.[8] Confident in her golden, good looks, she is not merely on display. She does not invite our attention by looking at us directly; rather she draws us to her because she is clearly enjoying herself.

Thus circumventing the masculine conventions of looking, Cassatt rendered us as marginal as the man with the opera glasses in *At the Français, a Sketch*. We see him leaning out of his seat for a better view of the painting's heroine; but he is tiny in comparison, and she does not notice or care.[9] By including and, at the same time, minimizing the man, Cassatt raised the level of her female subject's independence. Freed from the need or desire to respond either to male interest or to us, and totally engaged in looking herself, Cassatt's theater-goer is self-sufficient and modern. Furthermore, as she watches the performers and the audience through her opera glasses, she literally mirrors the action of the man who observes her.

Cassatt employed some of the same objects featured in her loge subjects—mirrors, fans, bouquets—in her domestic compositions of the same period. Unlike the mirrored walls of loges, which

prompted these writers to describe eye contact between the presumed male artist/viewer and the female subject/model as the "male gaze": men look; women are looked at.[7] In the late-nineteenth century, viewers of both sexes understood such unabashed visual confrontation to be the language of the demimonde. By depicting her female protagonists in such a way that, more often than not, they look away, Cassatt may have intended to indicate their social respectability.

In a culture obsessed with looking, however, it does not seem probable that fashionable and upstanding middle-class women constantly averted their eyes. Rather they looked differently than men did at the world around them. They could employ certain accoutrements to protect their privacy (and their reputations), while they gazed where they pleased: foremost among these were opera glasses or

permitted the artist to give fuller definition to her figures and to reflect the expansive space, sweeping lines, and brilliant lights of the theater interior, her domestic mirrors are often darkened, almost opaque, creating a sense of intimacy, privacy, and quiet thoughtfulness. This can be seen in *Portrait of a Lady* (cat. 9), which depicts the artist's friend Mary Ellison. The composition—so similar to a number of the loge pictures—also includes a fan and a mirror. Used to emphasize the subject's head, the mirror reflects little else save the darkness of the room's interior. The sketchy vase of flowers, at the upper right, serves to lead the viewer's eye back to the sitter's face, while the fan, shoulder, and curve of the sofa provide the solid, formal structure that is so central to Cassatt's vision.

Cassatt's domestic mirrors in fact suggest the degree of quiet reflection and lack of self-consciousness that bourgeois women enjoyed in their homes. This can be seen by comparing *Portrait of a Lady* to a work by the fashionable Belgian-born painter Alfred Stevens, utilizing the theme of woman and mirror (fig. 10). In Stevens's image, reproduced in the *Gazette des beaux-arts* in 1878, a female Narcissus leans on the edge of a sofa, completely absorbed by her own reflection. Cassatt's sitter, with her back to the mirror, seems absorbed by her thoughts rather than by the appearance of her face. Cassatt used the

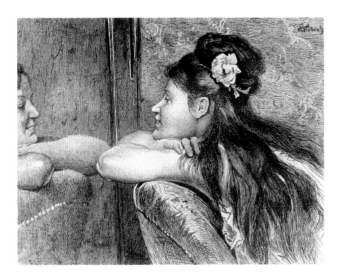

Fig. 10. I. Flamang, after Alfred Stevens (Belgian; 1823–1906). *The Coquette*, c. 1878. Engraving. Photo: *Gazette des beaux-arts* 17 (1878), p. 339.

mirror as a device to signal privacy and thoughtfulness again in a depiction, also entitled *Portrait of a Lady*, of her mother reading a newspaper (cat. 10). Here the mirror reflects a portion of the paper and Mrs. Cassatt's hand, a nod to Edouard Manet's and Degas's device of showing partial figures at the edges of their pictures. The mirror's gilt frame provides a strong, vertical anchor, further emphasized by the crease of the newspaper, all of which serve to contain (and protect) the subject. The mirror device continued to intrigue the artist, figuring in her series of color prints of 1890–91 (cats. 60, 61, 65) and in oil paintings at the turn of the century (see cats. 87, 89, 90).

Cassatt made her debut with the Impressionists in their fourth exhibition, in 1879, with a mix of domestic scenes and portraits (see cats. 9, 11, 14) and loge pictures (see cats. 18, 19). At the exhibition, held on the newly constructed avenue de l'Opéra, Degas and his two closest colleagues, Cassatt and Jean Louis Forain, displayed their works in adjoining rooms. Degas and Forain between them showed at least nineteen compositions of dancers and musicians. Like Cassatt, who portrayed what she knew, the two men also painted what they knew: the view from the orchestra and from places in the wings where men could watch and wait. That their submissions were exhibited in such close proximity suggests that these three colleagues intended their work to be seen as an ensemble, thus extending the theme of theatrical vision to include the exhibition as part of the fashionable spectacle itself. Since the Impressionist exhibitions were open to visitors at night, the event was in fact established as a form of evening entertainment.[10]

Cassatt's fascination with perception may have influenced her technical experimentation with mixed media, such as metallic paint, distemper, and pastel applied to paper over canvas, innovations that enhance surface reflection (see Stratis). Critical response to Cassatt's use of color was mixed. Discussing a pastel entitled *At the Theater* (Shackelford, fig. 6), which Cassatt showed in the 1880 Impressionist exhibition, one writer admired her use of "shocking" yellows, greens, and reds, as well as the way in which reflected, artificial light models the sitter's bare shoulders and flesh. Another reviewer castigated the

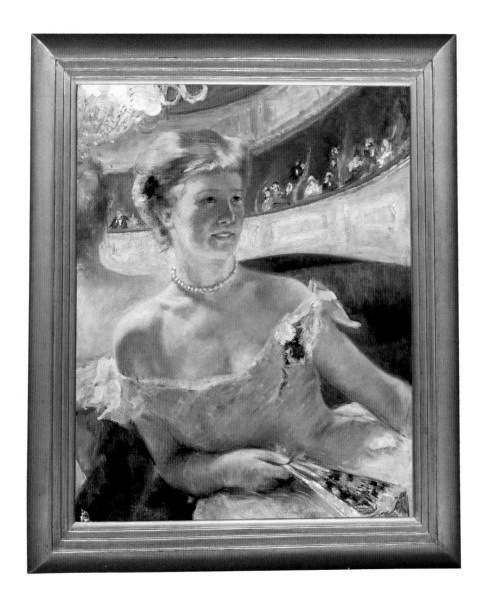

"fishlike face and orange hair" of the model in the same pastel. He went on to describe her as "dressed in yellow muslin and seated on a tomato-colored sofa; the reflection of the furniture, costume, and hair in the mirror vaguely suggest the image of a basket of fruit." Charles Ephrussi, editor of the *Gazette des beaux-arts*, a writer sympathetic to Impressionism, and a patron of Degas and Cassatt (he owned cat. 28 and Shackelford, fig. 6), called Cassatt's color harmonies "bold," but criticized her drawing.[11] Even Degas may have been wary of Cassatt's color experiments. Writing to a friend who bred dogs, in the hope of securing a griffon for Cassatt, he commented: "[Miss Cassatt,] whom you know for a good painter, [is] at this moment particularly engrossed in the study of the reflection and shadow of flesh or dresses, for which she has the greatest affection and

understanding, not that she resigns herself to use only *green and red* for this effect, which I consider the only salvation." While it is not always possible to distill exact meaning from Degas's often-elliptical remarks, he seems to have been suggesting that his young American colleague was perhaps inviting trouble by not employing exclusively, as did he, the red and green undertones that Old Master painters had used to build areas of shadow.[12]

Yet Cassatt's palette may have closely resembled the actual quality of light and color of the theater environment. In *Nana*, serialized in 1879, the novelist Emile Zola described the colored lighting of the Théâtre des Variétés, on the boulevard Montmartre:

The great crystal chandelier was ablaze with pink and yellow reflections from the high gas flames that sent down a rain of light from the ceiling to the floor. The garnet-colored velvet

of the seats was mottled with patches of deeper red, while the glitter of the gilding was softened by the pale green decorations beneath the garish paintings on the ceiling. . . . In one of the boxes a bare shoulder shone like white silk. Other women were calmly and languidly fanning themselves as the they watched the surging crowd. . . .[13]

Beyond her challenge of traditional approaches to subject matter and technique, Cassatt also experimented with the presentation of her paintings. We know, from reviews of the 1879 Impressionist exhibition, that she played further with the visual field by employing unusual frames for her pictures. She colored the surrounds of her loge subjects with red or green pigment, harmonizing the frames to the palette of her paintings, and in effect spreading and continuing the colored surface beyond the picture space. An annotated copy of the 1879 exhibition catalogue notes that *Portrait of a Lady* (cat. 9) was surrounded by a vermillion frame, and that *Woman in a Loge* (cat. 18) was framed in green (see fig. 11).[14] Some reviewers found such gambits interesting, while others were appalled.[15] Perhaps based on the contemporary color theories of Michel Eugène Chevreul—who advocated tinting a frame in order to complement the predominating colors of a painting and thus enhance the overall effect—Cassatt's frame experiments appear to have been bolder even than those of Degas, who also colored his frames. For Cassatt, Degas, and other innovators in the late 1870s, the gilt frame no doubt symbolized official painting; its traditional profile and finish established a boundary, which they rejected. Colored frames also served as harmonizing segues between picture surface and wall.[16]

Cassatt's early use of the frame as a compositional device reflects the importance of design and structure in all her oeuvre. The solidity of her drawing and the emphasis upon structure are even more apparent in her prints of this period, when she was particulary influenced by the graphic work of Degas and Manet. *Woman at the Theater* (cat. 23), one of several experimental, soft-ground etchings produced while Cassatt was collaborating with Degas and Pissarro on the journal *Le Jour et la nuit* in 1879 and 1880, is composed of intersecting curvilinear forms: the fan; the back of the armchair; the sitter's shoulders, stalls, and lights. The rich contrasts of black and white in this, and other versions of the loge theme, such as *At the Theater* (cat. 24), accentuate the surface and heighten the geometry. In this, Cassatt's only known lithograph, the drawing is unusually buttery and flowing.

While working in the black-and-white print mode, Cassatt may have looked again to fashion prints to expand her subject matter. Most fashion magazines contained at least some hand-tinted plates, but a new publication, *L'Art de la mode*, featured primarily black-and-white illustrations. The most stylish of the fashion periodicals of the time, it began publication in 1879-80 and devoted itself to the life of contemporary *Parisiennes*. It depicted women at the theater or at art exhibitions, at home taking tea, in the garden or park, driving in the Bois de Boulogne, or relaxing at the seashore. The magazine, under the editorship of Ernest Hoschedé, a

Fig. 12. Joseph Isnard Louis Desjardin (French; 1814–1894), after Alfred Stevens. *Her Majesty, La Parisienne*, 1880. Photo: *L'Art de la mode* 1 (1880), n.p.

Fig. 13. Artist unknown. Woman driving a carriage. *L'Art de la mode* 2 (1881), p. 112. Photo: courtesy Boston Athenaeum.

Fig. 14. Artist unknown. Couple playing cards by lamplight. *L'Art de la mode* 3 (1881–82), p. 119. Photo: courtesy Boston Athenaeum.

textile merchant and collector of modern art, featured articles that were more intellectually oriented than those of other fashion magazines, with reviews of theater, poetry, books, and exhibitions. Hoschedé wrote about Cassatt, Morisot, and other women artists, giving them a professional status not usually accorded to their sex.[17] Writers sympathetic to Impressionism such as Astruc, Burty, Claretie, Halévy, and Houssaye also contributed reviews.

In its commitment to the modern phenomena of fashion and contemporary art, *L'Art de la mode* drew upon the best in criticism and illustration by artists involved with the Impressionist circle. Among its illustrators were Norbert Goeneutte, Giuseppe de Nittis, and Stevens, all friends of Degas and of Manet's sister-in-law, the Impressionist Berthe Morisot. Their black-and-white illustrations were decidedly less static and more informal than those in more traditional fashion journals. An image by Stevens, *Her Majesty, La Parisienne* (fig. 12), shows an elegant women leaning on her parasol in much the same pose that Degas used to represent Cassatt at the Musée du Louvre, Paris (Shackelford, fig. 1). The pages of *L'Art de la mode* were filled with illustrations and topics analogous to Cassatt's own themes. For example a depiction of a woman driving a carriage (fig. 13) can be compared with *Driving* (cat. 34). While the magazine illustration is condescendingly humorous toward women drivers, Cassatt's composition is focused and less frivolous. The heads of the three models—Cassatt's sister, Lydia; Degas's niece Odile Fèvre; and the groom—are close together, but they do not regard one another nor do they look at the same thing. The woman and girl gaze straight ahead with intent. The male servant looks away from

the action. Cassatt further marginalized the backward-facing groom by pushing him out of the picture almost entirely. Not without humor, she truncated the composition to allow a glimpse of the horse's hindquarter. Finally the artist cropped the composition so that we cannot see what the protagonists see. In this way, she emphasized the entirely different viewpoints of each figure, as well as our own observation of the scene, and again made the act of looking itself, rather than driving, the true subject of the picture.

Driving reflects the Cassatts' enjoyment of horses and carriages. The Cassatt sisters were well-bred ladies, but also independent and fun-loving. It should be noted that unmarried women, sisters, or female friends living together had a certain freedom of movement that married women did not.[18] May Alcott, a painter and sister of the writer Louisa May Alcott, spent an amusing evening in September 1877 with Cassatt and mutual friends. After 10 p.m., the four women drove to the "Bois" (de Boulogne) for ices. Alcott wrote that the city never slept,

all the world being abroad apparently till morning. The avenues lined . . . with brilliant street lights. . . . We turned into a great court-yard filled with little tables surrounded by a set of nice looking people sipping their coffee, wine or absinthe. The dense darkness of the wood surrounding it being illuminated by colored lamps giving the whole thing a most theatrical appearance. . . . We felt as if in a play, all was so fantastic.[19]

The "theatrical appearance" of artificial lights enthralled all of Paris. After the invention in 1877 of the electric lamp, electric lighting replaced gas in some of the city's main arteries and in certain department stores.[20] In homes, however, gas lighting

remained prevalent until the 1890s. Its irregular arc formed uneven patterns of illumination, leaving pools of darkness within a room. Artificial lighting sometimes heightened or altered color, but, at other times, drained it so that all was reduced to black and white. Cassatt captured this effect in her soft-ground etching *Evening* (cat. 40), where the contrast of rich blacks and reserved areas of white paper accentuate the brilliant, almost abstract handling of light and shade. *Evening* resembles an illustration in an 1882 issue of *L'Art de la mode* of a couple playing cards under lamplight (fig. 14). But unlike the magazine illustration, in which the precious, available light is used to clarify a narrative of shared activity, Cassatt's subjects do not face each other and remain separate in their focus: one sews, the other reads. The isolated, close-up view, which Cassatt preferred throughout her career, helps impart a feeling of immediacy and silent intimacy to the image.

By 1882 Cassatt had painted her last loge picture and had become increasingly interested in domestic themes. Her theater images nonetheless had been noticed, and by some of the best eyes in Paris. Edouard Manet's famous *Bar at the Folies-Bergère* (fig. 15), painted in 1881–82, features the most famous mirror depicted in late nineteenth-century art. The mirror—a brilliant expanse of glittering reflections that underscores the magical and transitory nature of nocturnal entertainment—exhibits a shorthand description of the theater's ambience and audience, including, just to the left of the barmaid who faces us, a woman in black looking through opera glasses. While, as discussed above, this was a common sight in such environments, Manet may have included the detail in homage to Cassatt's achievements in the outstanding and original loge pictures she had exhibited in previous years.[21] If so, this constitutes a significant tribute from an artist Cassatt clearly admired as she evolved her own, very contemporary views of modern life.

Fig. 15. Edouard Manet (French; 1832–1883). *Bar at the Folies-Bergère*, 1881–82. Oil on canvas; 96 x 130 cm. London, Courtauld Institute Galleries, Home House Trustees.

At Home

In 1877 Mary Cassatt's parents, Robert S. and Katherine Kelso Cassatt, left Philadelphia to settle with the artist and her sister, Lydia, in Paris. The senior Cassatts were aging, and by 1879 Lydia was diagnosed with Bright's disease, a slowly progressing, painful, and deadly affliction of the kidneys for which there was no cure. Until her death in 1882, Lydia was increasingly confined to home. No longer able to depend on her older sister for help with the household, Cassatt had to take on greater responsibilities. The change in her personal life is reflected in her art: she focused more on domestic life, and the tone of her work became more meditative and internalized.

The Cassatt family moved, in the spring of 1878, to a top-floor apartment at 13, avenue Trudaine, a few blocks from Cassatt's studio on the place Pigalle. They lived in this neighborhood, which had until recently marked the northern boundary of Paris, until 1884. Between her home and studio, Cassatt passed by the Café de la Nouvelle Athènes (fig. 16), frequented by the group of independent artists who had created Impressionism. These artists all had studios and/or residences in the area. The writer George Moore, a close observer of the Impressionist circle, remembered many years later: "Among the Impressionist painters, there was an English, I should say American, Mary Casat [sic]. She did not come to the Nouvelle Athènes it is true, but she lived on the Boulevard Extérieur; her studio was within a minute's walk of the Place Pigalle, and we used to see her every day."[22]

As many art historians have correctly pointed out, Mary Cassatt and women of her class were limited, in their subject matter, to depicting a world that was much more narrow and proscribed than that open to their male counterparts.[23] Respectable women did not frequent the cafés painted by Edouard Manet, nor did they have access to the wings of the stage and certainly not the brothels depicted by Edgar Degas. But Cassatt's themes were not simply forced upon her. She chose to represent the world with which she was most familiar and the activites that were central to the life of upper middle-class women: women as consumers of pleasurable and ostentatious entertainments, such as the theater; women receiving friends according to the social rituals of the home; women as the primary teachers and protectors of children; and women creating and managing the environment that was so crucial to family, the private household.

In Cassatt's case, as a single woman, the protection of home was critical. French census figures between 1851 and 1896 show that twelve percent of women over the age of fifty had never married and that thirty-four percent over fifty were single. These women usually lived with their parents, siblings, or with other female companions. As parents aged, unmarried daughters assumed responsibility, often taking the place of their mothers as the head of domestic matters.[24] It is therefore not surprising that the bourgeois household—its rituals, relationships, organization, and personnel—became the central focus of Cassatt's exploration of modern life. The middle-class home was in fact a private universe, providing Cassatt and the other Impressionists with abundant scenes of everyday activities—bathing, dressing, sewing, caring for children, receiving guests—

G. C. A., Paris 794 Montmartre. — La rue Pigalle — Nouvelle Athènes

Fig. 16. View of the Café de la Nouvelle Athènes, on the place Pigalle, Paris, c. 1890/1900. The café, which was the gathering place of the Impressionist circle in the 1870s and early 1880s, was across the street from Cassatt's studio. Photo: courtesy Bibliothèque nationale, Paris.

LA MODE ILLUSTRÉE

Bureaux du Journal 56 Rue Jacob Paris

Fig. 17. Artist unknown. Two women in an interior. *La Mode illustrée* (Mar. 13, 1881), after p. 82. Photo: courtesy Boston Public Library.

Fig. 18. Unknown artist. *The De Bonnechose Chapeau.* Photo: *Le Moniteur de la mode* 3, 1 (Jan. 1, 1884), p. 3.

and related industries, such as laundries and millinery shops.

While the upper-middle-class home was insulated and protected, it was by no means unworldly. Cassatt's depictions of this environment are in fact thoroughly cosmopolitan, informed by all that Paris had to offer, especially in view of its leadership in fashion and art. The modernity of Cassatt's domestic scenes is demonstrated in their striking parallels with plates in contemporary fashion magazines. The sitter in her arresting *Portrait of Madame J.* (cat. 16) sports a hat (most likely felt) that, with its turned-up brim, high crown, stuffed bird, and black-lace veil, is just like one illustrated in *Le Moniteur de la mode* (fig. 18). The predominantly blue, brown, and rose palette of

Cassatt's *Tea* (cat. 27) resembles tints used to enliven fashion illustrations, such as one showing two women in an interior (fig. 17). Both include similar domestic details. In Cassatt's picture, reflective surfaces—silver, porcelain, the mirror—figure prominently. The viewer's eye is also drawn to the strong designs of the vertically-striped wallpaper, floral upholstery, and dress fabrics. In both the fashion plate and *Tea*, the depth of the pictorial space is flattened by intersecting patterns, and the room is cropped to emphasize the figures.[25]

For all of Cassatt's awareness of fashionability, *Tea* is clearly not about fashion. In order to showcase the dresses, the fashion illustrator had to depict them on full-length figures. Cassatt's women are shown half-length; they wear rather plain afternoon dresses and pose casually. The visitor is distinguished from the hostess by her hat and gloves. Cut off by the diagonal of the table and tea set, the costumes become part of the overall design, shape, and color. Nor is *Tea* a portrait: one woman is seen in profile, while the other holds a teacup that obsures her face. Through such means, as well as through the titles she gave her compositions—*Tea, Portrait of a Lady, Woman Reading,* and so forth—Cassatt located her domestic scenes between portraiture and genre, making these experiences universal rather than specific and emphasizing activities rather than personalities.

The increasing emphasis on surface pattern and the narrowing of the spatial field in *Tea* and other contemporary works by the artist (see cats. 13, 28) reveal the influence of another kind of graphic image that currently was having an enormous impact on Paris's art world: the Japanese woodblock print. With the opening of Japan to the West, in the 1860s, a flood of objects—ivories, cloisonné enamels, porcelains, bronzes, laquerware, satin brocades, standing screens, and prints—reached an eager market in Paris, which responded enthusiastically to the Japanese pavilion at the 1867 Exposition universelle. In 1878, when this exhibition was staged again, the

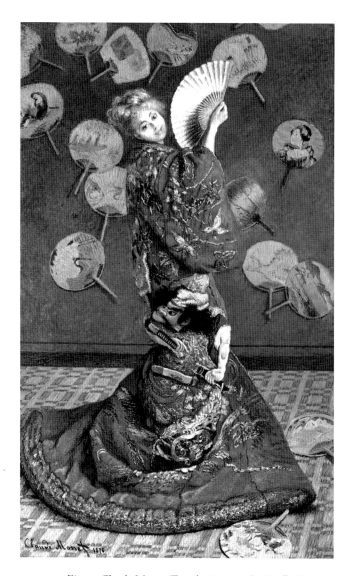

Fig. 19. Claude Monet (French; 1840–1926). *Camille Monet in Japanese Costume*, 1876. Oil on canvas; 231.6 x 142.3 cm. Boston, Museum of Fine Arts, 1951 Purchase Fund.

Gazette des beaux-arts was able to report on the activities of such collectors of Asian art as Théodore Duret and Emile Guimet, and to list an impressive number of people acquiring this material: artists such as Braquemond, Carolus-Duran, Degas, Fantin-Latour, Manet, Monet, Stevens, and Tissot; and writers such as Burty, Champfleury, the Goncourt brothers, and Zola. In 1883 Louis Gonse, head of the *Gazette des beaux-arts*, published his beautifully illustrated, two-volume study *L'Art japonais*. Manet's good friend Duret, whom Cassatt also knew well, traveled to Japan in the early 1880s and returned to France with more than 1,300 print albums (today these are housed in the Bibliothèque nationale, Paris). He began publishing articles in which he made connections between Japanese prints and Impressionism,

pointing to the artists' shared interest in daily life and preference for primary colors.[26]

For more than a century, Japanese artists had used color woodcuts to disseminate glimpses of a picturesque and somewhat hidden side of existence in Edo (present-day Tokyo), that of the theater and the brothel. Called *ukiyo-e* (pictures of the floating world) by the Japanese, they allow the viewer to witness the off-stage life of actors and the daily routines of courtesans. Such prints were particularly admired and collected by artists of Cassatt's generation, perhaps because they were more affordable than other imported Japanese objects and works of art. By the mid-1870s, these prints could be purchased at several small galleries, especially those of Siegfried Bing and Tadamasa Hayashi; a decade later, they were available at Paris's most luxurious department stores, such as Bon Marché, Louvre, and Printemps.[27]

By the turn of the twentieth century, Cassatt herself owned about two dozen woodblock prints, by Eisen, Hiroshige, Hokkei, Kiyonaga, Utamaro, and others (see Hirshler, figs. 11, 12). She treasured what she thought to be a Japanese tea service (actually it was Chinese export porcelain), as well as a set of porcelain dishes, inspired by Japanese prototypes, that the artist Félix Braquemond designed in 1879. She also owned several Chinese screens. Cassatt's knowledge of Japanese prints contributed to the visual language she was developing to create direct, fresh, and appealing images of domestic life. Like other artists of the Impressionist circle, she quickly assimilated and reinterpreted a number of aspects of Japanese art: decorative pattern, asymmetrical composition, lack of traditional Western perspective, strong contours, flattened shapes, and bold coloration. She must have been very pleased when the critic Armand Silvestre, writing in 1880 about her submissions to the fifth Impressionist exhibition, praised the way in which peonies frame the model's head in *On a Balcony* (cat. 13), and lauded the picture as "a true model of Japanese art in its absence of distant space and the happy mixture of color in an entirely pleasant range."[28]

The vogue for all things Japanese can be seen in the proliferation of fans in Impressionist paintings, perhaps the most outrageous being Monet's 1876

Fig. 20. Paul Avril (Edouard Henri Avril) (French; 1849–1928). *Cupids and Fan*, 1882. Photo: Octave Uzanne, *L'Eventail* (Paris, 1882), p. 16.

depiction of his wife, Camille, in Japanese costume (fig. 19). In 1882, shortly after Cassatt painted her loge pictures, which, as we have seen, are replete with opened and closed fans, the writer Octave Uzanne published a book entitled *L'Eventail* ("The Fan") (see fig. 20), which was part of a series of studies he

wrote on feminine attire and attributes.[29] A number of artists, following Far Eastern prototypes, painted fan-shaped compositions, including Degas, Fantin-Latour, Forain, and Pissarro (see Hirshler, fig. 6). Such works were often appropriated into the decor of interiors and hung like pictures on the wall, as in Berthe Morisot's double portrait of her sister Edma and herself (fig. 21), which prominently features a fan painted by Degas displayed above them.[30] Degas also painted the fan (fig. 22) seen in *Portrait of Madame J.*, which Cassatt showed in the 1880 Impressionist exhibition (she had received the fan from Degas in 1879; see Introduction, fig. 1). Cassatt's friend the critic Burty lauded this portrait as "vigorous," but he had one reservation: while he praised the face as "vivacious," he found "the background too prominent."[31] Burty preferred portraits such as *Woman Reading* (cat. 14), in which the artist subordinated objects to the figure. Cassatt, however, understood full well the critical role background plays in

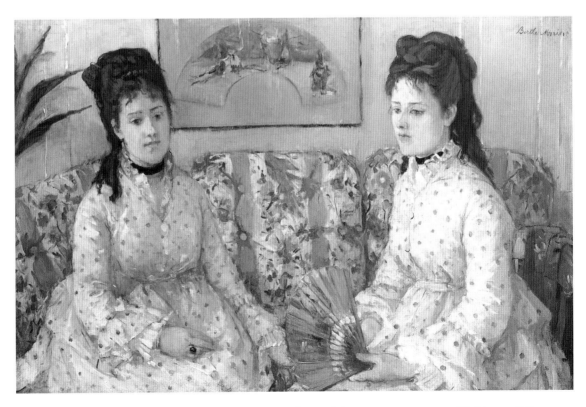

Fig. 21. Berthe Morisot (French; 1841–1895). *Two Sisters on a Couch*, 1869. Oil on canvas; 52.1 x 81.3 cm. Washington, D.C., National Gallery of Art, gift of Mrs. Charles S. Carstairs.

Fig. 22. Edgar Degas (French; 1834–1917). *Fan Mount: Ballet Girls*, 1879. Watercolor, silver, and gold on silk; 19.1 x 57.8 cm. New York, The Metropolitan Museum of Art, H. O. Havemeyer Collection, bequest of Mrs. H. O. Havemeyer, 1929, 29.100.555.

establishing compositional structure and mood, and would, throughout her career, devise compositions that balance a centrally important figure against an equally forceful surround (see for example cat. 88).

Cassatt's, Monet's, and Morisot's great interest in new ideas certainly prompted them to insert fans and fan-shaped paintings into the backgrounds of their works. But Cassatt and Morisot did so for reasons that extend beyond the decorative. Unlike Monet's portrait of his wife, which emphasizes the material trappings of chic, neither Cassatt nor Morisot allowed such details to define femininity. If anything their inclusion of Degas's fans in their portraits places contemporary art and their own professionalism as contemporary artists at the heart of these images.[32]

In *Portrait of Madame J.*, Cassatt referenced another, related trend of the period: the Rococo revival. Madame J. sits in a *fauteuil* "Marie Antoinette," a low armchair richly upholstered in a floral fabric meant to evoke the naturalism and lightness of eighteenth-century prototypes. The Rococo revival was encouraged, to a great degree, by the activities of the Union centrale des arts décoratifs, founded in Paris in 1864. Between 1878 and 1883, the Union organized exhibitions of drawings, tapestries, ceramics, and furniture to elevate the decorative arts and to unify them with the fine arts.[33] These goals were shared by the con-temporaneous English Aesthetic movement and the associated renewal of interest in crafts and the applied arts in England and North America; but, unlike English Arts and Crafts practitioners, who often looked to preindustrial, especially medieval, sources for inspiration, their French counterparts sought to resuscitate the ancien régime. To many the pre-revolutionary eighteenth century represented the apogee of French decorative production, when craft guilds, supported by royal patronage, made exquisite objects for harmoniously designed environments.

In Paris a seminal group of *amateurs*, or collectors—including Philippe de Chennevières, Gustave Dreyfus, Ephrussi, and Edmond de Goncourt, as well as others who figured in the craze for Japanese art—promoted exhibitions and collecting and eventually established the Musée des arts décoratifs in 1877. Between 1879 and 1882, they planned exhibitions of Rococo designs and ornament and initiated the monthly journal *Revue des arts décoratifs*. By the mid-1880s, two of Cassatt's supporters, the minister of fine arts Antonin Proust and the critic Roger Marx, were promoting the Rococo and the craft revivals based on Rococo models.[34] All of these efforts helped the decorative arts attain new importance, and demonstrate that the emphasis on objects associated with femininity in Cassatt's work of the

late 1870s and 1880s was part of a larger social and cultural phenomenon.

Women of Cassatt's class of course were concerned with the decoration of their domestic environments, but Cassatt seems to have been interested in creating an artistic home. She owned a Louis XVI secretary and another writing desk of the same period. In her bedroom, she had a green-painted, nineteenth-century Rococo-revival commode.[35] Cassatt embodied Uzanne's belief that a woman of distinction and elegance is defined by the way she chooses to adorn herself and by extension her living environment. May Alcott described Cassatt's apartment/studio, at 19, rue Laval, in 1876 when she attended a tea party there, along with other North American friends:

. . . [we ate] fluffy cream cakes and chocolate, with French cakes, while sitting on carved chairs, on Turkish rugs, with superb tapestries as a background, and fine pictures on the walls looking down from their splendid frames. Statues and articles of vertu filled the corners, the whole being lighted by a great antique hanging lamp. We sipped *chocolat* from superior china, served on an India waiter, upon an embroidered cloth of heavy material. Miss Cassatt was charming as usual in two shades of brown satin and rep, being very lively[36]

Cassatt's work also owed a debt to the Rococo. She admired the pastels of such eighteenth-century masters as Jean Baptiste Siméon Chardin and Maurice Quentin de La Tour and modified her technique to imitate the effects they achieved (see Stratis). Her paintings of women reading not only emulate eighteenth-century dress, but also attempt to achieve the spontaneity and delicate sensibility of artists such as Jean Honoré Fragonard (see fig. 23) and Jean Baptiste Greuze.[37] In *Woman Reading* (cat. 14), shown in the 1879 exhibition, a young model wears a dress and cap of eighteenth-century inspiration. Moreover the painting exhibits the influence of Rococo palettes: immaculate whites accented by touches of pink and blue, small areas of rose-scarlet and green-gray. Nonetheless Cassatt maintained the firm structure

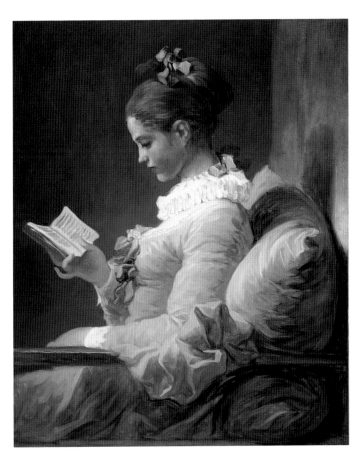

Fig. 23. Jean Honoré Fragonard (French; 1732–1806). *The Reader*, c. 1776. Oil on canvas; 82 x 65 cm. Washington, D.C., National Gallery of Art, gift of Mrs. Mellon Bruce in memory of her father, Andrew W. Mellon, 1961.161.1.

and flattened visual field that were hallmarks of her modernity.

French writers did not seem to apprehend Cassatt's interest in or interpretation of eighteenth-century art; they reacted negatively to the innate "strength" of her drawing and the solidity of her forms, which they considered neither feminine nor French. They often invoked her prowess to set her apart from Berthe Morisot, whose "gaiety, elegance, and nonchalance" they deemed to be particularly French. They likened Morisot's airy and delicate brushwork to that of Fragonard. They praised her palette of subtle whites, pinks, and grays as feminine, light, and "charming."[38] In contrast to Morisot's art, Cassatt's *Tea* (cat. 27) prompted Ephrussi, when he saw it at the 1880 Impressionist exhibition, to note the influence of "English soil" on a compo-

Fig. 24. John Everett Millais (English; 1829–1896). *Hearts Are Trumps*, 1872. Oil on canvas; 165.7 x 219.7 cm. London, The Tate Gallery.

sition he found a bit dull.[39] Yet some critics expressly admired the "Englishness," by which they meant solidity, of Cassatt's style. Duranty declared: "A most remarkable sense of elegance and distinction— and very English (she is American)—marks these portraits. Cassatt *merits our very particular attention.*"[40]

Whether or not they liked her work, all these critics labeled Cassatt a foreigner. They may have associated her with Britain for a number of reasons: She was English-speaking. She dealt with themes associated with English artists, such as family scenes and domestic activities, including tea-drinking (although the consumption of tea had become quite stylish in France[41]). Others linked Cassatt to English artists because her work reminded them of examples they had seen in the British section of the 1878 Exposition universelle. Joris Karl Huysmans's review of Cassatt's submissions to the 1881 Impressionist exhibition specifically mentions the affinity of her style to that of John Everett Millais in *Hearts Are Trumps* (fig. 24), in that both exhibited firm modeling and attention to detail. The rigorous draftsmanship, structured compositions, and sober palette of her genre scenes (in contrast to the yellows, greens, and reds of her contemporaneous loge pictures) seemed closer to the harder-edged style of English artists than to the brushy surfaces, shimmering hues, and loosely defined forms of French artists such as Morisot. In Huysmans's opinion, her domestic interiors captured "a very effective comprehension of the quiet life [and] . . . a deep sensation of intimacy."[42]

Cassatt's exploration of this sort of intimacy is part of a long tradition with which she was certainly familiar. It was not entirely English in inspiration. The artist greatly admired the domestic interiors of seventeenth-century Dutch and eighteenth-century French artists.[43] She was drawn to the quiet verisimilitude of Jan Vermeer's and Chardin's depiction of women absorbed in everyday tasks (see fig. 28), as well as the delight they each took in depicting household objects. Both of these painters composed such scenes according to a clear vertical and horizontal grid. In Dutch pictures, in particular, windows and doors provide clear physical (and psychological) paths between exterior and interior. These carefully constructed, reassuring enclosures allow their inhabitants to gaze out the window, work, or daydream without apparent interruption. So too Cassatt incorporated references to wallpaper, mirrors, fireplaces, and objects in order to fashion appealing, contained, and feminized environments.

Cassatt suggested intimate, private moments by depicting her subjects in informal clothing. In *Portrait of a Lady* and *Woman Reading* (cats. 10, 14), the women appear in morning dress ("déshabillé"). The *haute-bourgeoise* wore such a loose, white garment at home in the morning, when she attended to the servants, the children, and other household concerns. She used this time to plan entertainments and menus, deal with tradespeople, organize shopping trips, take care of correspondence, or catch up on reading. Late in the morning, she would dress to eat lunch; to receive guests at home; or to go out for shopping, a promenade, driving, visiting, or attending a matinee theater performance. Impressionists such as Cassatt, Morisot, and Renoir liked to depict models in morning dress to infuse their compositions with a feeling of familiarity and casualness; the white of the dress also allowed them to employ the lightened palette they favored.[44]

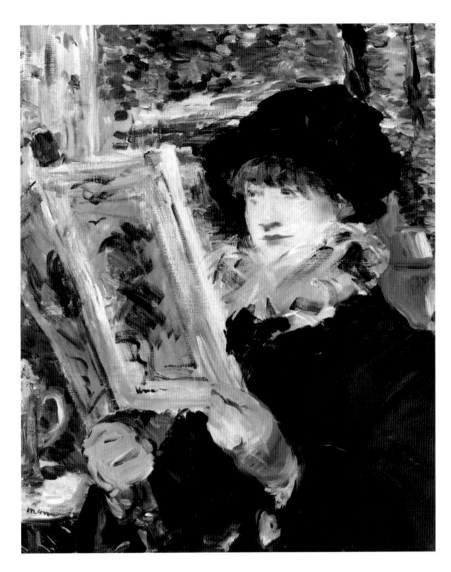

Fig. 25. Edouard Manet (French; 1832–1883). *Reading*, 1879. Oil on canvas; 61.2 x 50.7 cm. The Art Institute of Chicago, Mr. and Mrs. Lewis Larned Coburn Memorial Collection, 1933.435.

In three of Cassatt's pictures, *Portrait of a Lady*, *Woman Reading*, and *On a Balcony*, the models study a newspaper. (One reviewer of the 1879 Impressionist exhibition interpreted the paper in *Woman Reading* as a novel.[45] No doubt he considered fiction more proper than current events for a lady of leisure.) Manet portrayed a smartly dressed female seated in an outdoor café reading a periodical (fig. 25); cafés typically provided reading material for clients in bamboo holders, like the one depicted here. But this beautiful young woman is also on display; she sits in a public space and makes herself visible to the viewer through her partially frontal pose. By contrast Cassatt, through various means—the obvious relaxation of her sitters, the positions of their heads, the choice of a profile or three-quarter view, a private indoor setting—emphasized that the focus of her models

was on reading. Thus, even while at home, Cassatt's women are connected to the contemporary world. The Cassatt family was well read and informed about current events. Cassatt's mother, the model in *Portrait of a Lady*, regularly read such newspapers as the *Figaro*, which she is seen holding here. In the *Figaro*, she and her family could have learned about preparations for the International Congress of Women's Rights held concurrently with the 1878 Exposition universelle, upon which the newspaper reported at length.[46]

By 1877 prohibitions against women holding public meetings had been lifted, in anticipation of the upcoming Congress. When it convened, eleven foreign countries and sixteen organizations participated. The Congress's main focus was education, "as it is in America." Education, feminists argued, should be the same for both sexes, free, compulsory, and not regu-

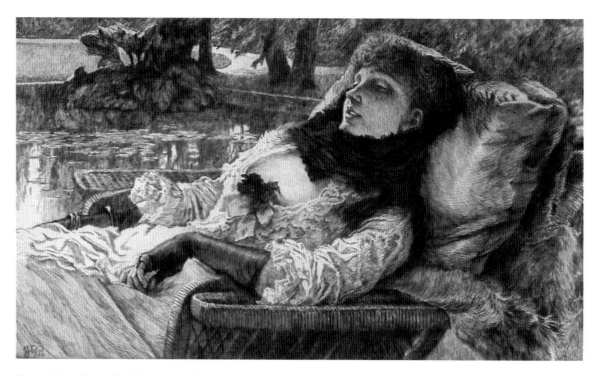

Fig. 26. James Tissot (English; 1836–1902). *Soirée d'été (Summer Evening)*, 1882. Etching and drypoint on wove paper (second state); 23.2 x 39.7 cm. Chicago, private collection.

lated by the Church. On other topics, feminists opposed the employment of wet nurses and encouraged women to become more involved in the care of their children. They wished to see a change in the status of women in the home: for women to have a truly meaningful impact on family life, they needed better educational and professional opportunities.[47] The Camille See Law, which guaranteed secondary education for girls, was passed in 1880 as part of the legislative alliance between feminists and the liberal republican government. Between 1879 and 1886, legislation created secondary schools and reformed primary education, making it both free and secular. In another critical arena, in 1884 women secured the right to initiate divorce.

Cassatt quietly but firmly participated in these societal shifts by keeping her predominantly female figures free from objectification and cliché. When they are not reading, they converse, sew, and drink tea; when they are inactive, they seem lost in thought. Compare for example *Autumn* (cat. 29), which features the ailing Lydia wrapped tightly in a shawl and sitting in a park bench, with James Tissot's *Soirée d'été (Summer Evening)* (fig. 26), which was shown in an 1883

exhibition sponsored by the Union centrale des arts décoratifs.[48] His subject was his mistress, Kathleen Newton, who suffered from tuberculosis and was to die, like Lydia Cassatt, in 1882. Tissot's elegant model is recumbent in a garden setting, her hands lying inertly in her lap. While the shadows around her eyes indicate illness, she nonetheless smiles and displays her fashionable dress and gloves. In Cassatt's canvas, Lydia sits quietly, wrapped in an "India" or paisley shawl. Her sharp profile expresses the concentration of a woman whose body is failing but whose mind remains active and acute.

In Cassatt's studies of women, such inactivity is relatively rare. More often than not, her models are absorbed in solitary, productive activity, as in *Lydia Seated at an Embroidery Frame* (cat. 38). The popularity of needlework in the late nineteenth century derived from the association of this activity with the handicraft and Rococo revivals. Henri Fantin-Latour exhibited a composition on a similar theme (fig. 27) at the Salon of 1881, the same year in which Cassatt executed her version of it. Both images could have been inspired by Vermeer's *The Lacemaker* (fig. 28), which had entered the Louvre to great acclaim

Fig. 27. Henri Fantin-Latour (French; 1836–1904). *The Embroiderer*, 1881. Oil on canvas; 103 x 82 cm. Private collection. Photo: courtesy Galerie Schmidt, Paris.

in 1870.[49] Fantin's *The Embroiderer* demonstrates his characteristic, highly finished manner. To underscore the connection between the sitter's eye and hand, he used light sparingly, accentuating the sitter's left hand and placing her face in deep shadow. The focal point of Cassatt's work is also the relationship between Lydia's face and hands. But in contrast to Fantin's canvas, her image exhibits a higher-keyed palette and a surface animated throughout by strong brushwork that in fact conveys the sitter's mental and physical energies. Lydia's face expresses concentration, and the rapid strokes that define her hand suggest its deft and constant motion. As Anne Higonnet pointed out, both Cassatt and Morisot were conscious of the balance of power between women and objects in their paintings.[50] The bourgeois women Cassatt depicted are not defined by decorative objects, but rather tend to interact with and to dominate the things with which they live.

Cassatt's treatment of women's hands in her many interior pictures differs markedly from their appear-ance in fashion plates and contemporary portraits by others. In fashion illustrations, hands typically sit inactive on the lap or hold an object such as a fan; even in Morisot's female portraits of the 1870s and 1880s, the hands are decorative, idle appendages (see fig. 21). Cassatt's own, active hands may explain her interpretation of them in her work. As May Alcott observed in 1876, "A woman of real genius, [Cassatt] will be a first-class light as soon as her pictures get a little circulated and known, for they are handled in a masterly way, with a touch of strength one seldom finds coming from a woman's fingers."[51] Many years later, the artist George Biddle described his last visit to an old and infirm Cassatt:

There she lay, quite blind, on the green painted bed which I knew so well from the painting in the Metropolitan. . . . She was terribly emaciated. Her hands, which used to be such big, knuckled, capable artist's hands, were shrunken and folded on the quilt. When she began to talk they waved and flickered about her head; and the room became charged with the electric vitality of the old lady.[52]

Unlike proper French women of the day, Cassatt used her hands not only for expression but also for

Fig. 28. Jan Vermeer (Dutch; 1632–1675). *The Lacemaker*, 1669–70. Oil on canvas transferred to panel; 23.9 x 20 cm. Paris, Musée du Louvre. Photo: Alinari/Art Resource, New York.

Fig. 29. Gustave Caillebotte (French; 1848–1894). *Man on a Balcony*, 1880. Oil on canvas; 117 x 90 cm. Switzerland, private collection. Photo: The Art Institute of Chicago et al., *Gustave Caillebotte: Urban Impressionist*, exh. cat. (Chicago, 1994), p. 169.

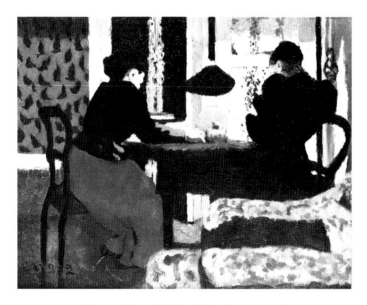

Fig. 30. Edouard Vuillard (French; 1868–1940). *Two Women in Lamplight*, 1892. Oil on canvas mounted on board, 32.5 x 41.5 cm. St.-Tropez, Musée.

work. It is no coincidence that, in Degas's portrait of her (cat. 91) and in one of his milliner pastels for which she served as model (Shackelford, fig. 23), her hands figure prominently. In the portrait, Degas chose to paint Cassatt leaning forward aggressively and unselfconsciously on her chair, her hands and *cartes de visite* thrust forward, spread out like one of the fans in her loge pictures.[53] Later the critic Félix Fénéon wrote of the hands of the figures in her color prints (cats. 56–65): "And always, these large, beautiful, masculine hands that Cassatt likes to give her women, have decorative functions, especially when set against the bodies of naked infants, they disturb the lines, then blend with them to create unexpected arabesques."[54] As Fénéon clearly understood, hands play a vital role in Cassatt's maternal themes. For example, in *The Child's Bath* (cat. 72), the strong, mature hands of the mother or nurse are juxtaposed with the child's less confident, clinging pair. In this patterned, tight, interior space, as in most of Cassatt's pictures of adults and children, touching hands and encircling arms reinforce a feeling of protection and intimacy.

While Cassatt's interiors are microcosms of urbane Paris, as well as the locii of familial bonding, social exchange, quiet reflection, and solitary activity, they can also feel suffocating. In Cassatt's early prints, the emphasis on pattern is particularly confining. The artist constructed her remarkable *Interior Scene* (cat. 44) so that the chair and floor tilt upward disconcertingly and figures, furniture, and patterns push into one another. As if to further constrict the space, the standing figure, clearly the guest because she wears a hat and gloves, pulls her chair forward. The only relief here is provided by a window that silhouettes the guest; but she turns away from it, back toward the interior space. Unlike other Impressionists who painted men looking out of windows (see fig. 29), Cassatt's women are drawn to the light, but reject the view. This can be seen as well in *Woman Standing, Holding a Fan* (cat. 15) and in *Young Girl at a Window* (cat. 45), in which female subjects look down rather than out.[55] (The claustrophobic feeling produced by intense patterning, as well as the use of light and dark to establish mood in such prints as *Evening* [cat. 40], may have influenced the airless, but

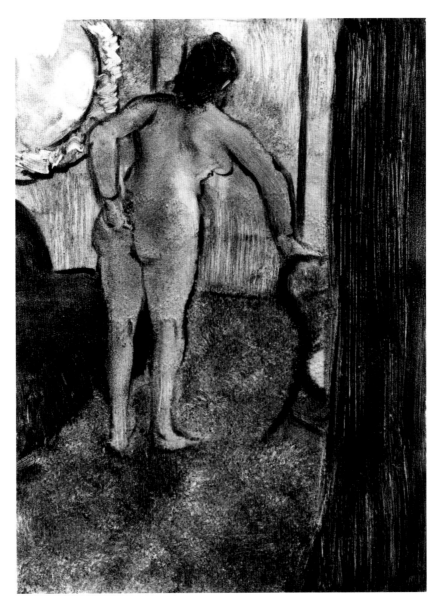

Fig. 31. Edgar Degas. *Room in a Brothel*, c. 1879. Monotype in black ink on laid paper; plate: 21 x 15.9 cm. Stanford University Museum of Art, The Mortimer C. Leventritt Fund and The Committee for Art at Stanford, 73.23.

intensely seductive, domestic scenes of Edouard Vuillard [see fig. 30] and other younger artists in the Nabis fellowship.)

The pose of Cassatt's visitor in *Interior Scene* is startlingly close to that of a female nude, her back turned to us, in a montoype by Degas from the same period (fig. 31). This bleak interior, with a naked figure leaning on a chair, depicts the raw anonymity of a brothel. The room in Cassatt's image, with its curtained window and furniture, is clearly domestic; and her visitor, shown frontally, is clad in appropriate afternoon attire. Thus, while Cassatt and Degas addressed related themes—theater, bathing, interi-

ors—they each approached these subjects differently. Degas's monotype almost certainly depicts an environment for the sexual trafficking between men and women. Cassatt's print shows a homey space where women exchange confidences. Cassatt and Degas each pictured a world the other could not know. Both images were produced around 1879–80, when Cassatt, Degas, and Pissarro were working closely together to produce a new journal, *Le Jour et la nuit* ("Day and Night") (see Shackelford, pp. 118–25). The title of the ill-fated publication suggests several meanings. The concept of day and night refers to the black-and-white etchings it was to contain, but

also to the daytime and nighttime activities that Degas and Cassatt in particular chose to represent, each from their own, gendered point of view. Thus Cassatt's diurnal etching represents the world of women; Degas's nocturnal subject, the world accessed by men.[56]

Sometimes pilloried as a misogynist, Degas, as Norma Broude observed, may have been sympathetic not only to his independent friend Cassatt, but, to a certain degree, to feminism as well.[57] As early as 1868, he painted the psychologically probing image entitled *Interior* (Hirshler, fig. 23), which depicts a fully dressed, young, middle-class man and a partially clothed female servant. The man leans against the doorway, as if to prevent escape; the woman sits near a bed and an opened box. Perhaps a sewing box, it is lined in pink and may represent her lost virginity. The man is perhaps both her master and her violator. While the exact narrative is unclear, the sexual tension is unmistakable, so much so that the painting was also called *The Rape*. When Durand-Ruel offered the work for sale in 1906, Cassatt wrote to her friend Louisine Havemeyer of her amusement that Durand-Ruel was selling the work under this "offensive" title. She added that indeed Degas had told her he intended it to represent "moral rape."[58] If Degas was sensitive, as his selection of such a daring subject indicates, to a woman's right to her own body, privacy, and possessions—all crucial issues for early French feminists—then the national debate about the status of the woman within the family and her role in society (stirred up by the 1878 International Congress of Women's Rights) might surely have been a topic of lively discussion between these two colleagues in 1879 and 1880.

In these years, feminism was considered a respectable political position among French republicans, who supported legislative reforms and family welfare without necessarily calling for woman's suffrage. Degas's monotype of the prostitute may in fact reflect the then-current debate about state-regulated prostitution. Prostitutes were expected to register with the police, a practice feminists found an abhorrent violation of personal freedom.[59] In fact both Cassatt's print of two women in a middle-class domestic interior and Degas's monotype of the brothel room and its occupant can be read as images of spaces where women were confined—regardless of class differences. Cassatt's female figures, in afternoon dress, retain their privacy; Degas's nude has none.

Even in Cassatt's *plein-air* experiments of 1880-82, painted while she summered in Marly-le-roi or Louveciennes, her subjects occupy enclosed spaces (see cats. 30, 35). The gardens in which they sit—flower beds and plantings—function to restrict their environment. The sense of boundary is accentuated when the sitter's back is turned, as in a painting of a woman with a dog in her lap (cat. 30). This serves to accentuate the inaccessibility of the sitter. If indeed this figure is Lydia, as the painting's traditional title indicates, she was already ill in 1880, when this work was executed. Thus the composition is particularly compelling, as if, before our eyes, the artist's sister is being shrouded in flowers and transported to another world. A decade later, Cassatt would release her female protagonists, now clearly healthy and robust, by literally opening windows and moving them out-of-doors. In her garden pictures of the late 1890s, she bonded her women subjects actually and symbolically with nature. For Cassatt the bridge leading to the expansion of the woman's universe and potential was the theme of motherhood.

Childhood and Maternity

Critics commenting on Mary Cassatt's submissions to the sixth Impressionist exhibition, in 1881, singled out for special acclaim her images of children and of women and children together. Joris Karl Huysmans found her scenes of figures in interiors and in gardens and her portraits of children to be fresh and personal. He praised such compositions as *Reading* (fig. 32), which shows the artist's mother, Katherine Cassatt, with her grandchildren, and a pastel of a mother and baby embracing (fig. 33), calling them "impeccable pearls." In his opinion, the artist successfully avoided the sentimentality of most English and French "doodlers," who, in his view, painted infants in fatuous, pretentious poses. "But of course," he continued, "a woman is equipped to paint childhood. There is a special feeling men would be unable to render unless they are particularly sensitive and nervous. Their fingers are too big not to leave some rough and awkward mark."[60]

Huysmans's assumption that children are best represented by females reflects his acceptance of stereotypes concerning both the domestic role of women and the inferiority of women painters. But it also attests to a new sense of the importance of depicting childhood and motherhood. Cassatt's focus on these themes was as timely as her exploration of the modern entertainments and domestic activities of comfortable, middle-class life. A contemporary Swedish feminist, Ellen Key, labeled the 1800s as the century of the woman and predicted that the 1900s would belong to the child.[61] But the epoch of the child had in fact already begun by the last quarter of the nineteenth century. In the 1870s, socialist thinkers helped draw attention to children of poverty. In 1874 France banned employment of persons under the age of twelve; in 1881 laws were established to provide all children with free, secular, elementary education. By 1885 funding for teachers' salaries and schools had substantially increased; the following year, the French government instituted an inspection system to assess and enforce national educational standards. During the 1880s, both France and Great Britain enacted legislation that allowed children to be removed from abusive parents. In addition to such governmental intervention, private philanthropies were established to focus on these issues, which re-

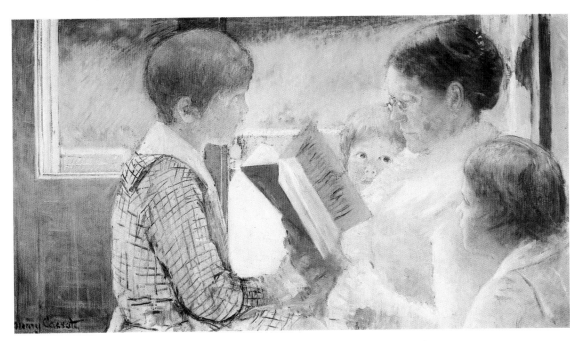

Fig. 32. Mary Cassatt. *Reading*, 1880. Oil on canvas; 55.9 x 100.3 cm. New York, private collection. Photo: New York, Coe Kerr Gallery, *Mary Cassatt: An American Observer. A Loan Exhibition for the Benefit of the American Wing of The Metropolitan Museum of Art*, exh. cat. by Warren Adelson and Donna Seed (1984), fig. 9.

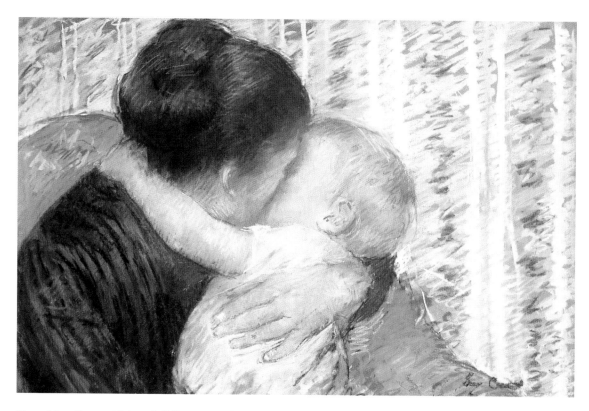

Fig. 33. Mary Cassatt. *Mother and Child*, 1880. Pastel on paper; 42 x 61 cm. Private collection. Photo: San Francisco 1986, p. 348.

sulted in greater professionalism in the areas of social justice, education, and health care. Doctors, scientists, and welfare workers began advising mothers on the care of children.[62]

Healthy children, it was felt, insured not only the well-being of the family unit but also that of the republic—both of which, many believed, were at risk. Infant mortality remained high in Europe throughout the nineteenth century: one of every five newborns did not survive, and one-third to one-half of children died before age five.[63] In France the continuing, high infant-mortality rate, together with the casualties and widespread disease suffered during and after the Franco-Prussian War (1870–71), increased concern about national regeneration. A healthier, stronger society, it was believed, required reform from the very outset of life.

For nearly three quarters of the century, half of the infant population of Paris was breast-fed by wet-nurses rather than by mothers. Upper- and middle-class families typically employed wet-nurses, as reflected in works by Berthe Morisot, and nannies, as seen in Cassatt's 1878 composition *Children in a Garden* (cat. 12), where well-to-do children are watched

by a capped and aproned domestic.[64] After 1870 French scientists and physicians, such as Louis Pasteur, led campaigns to provide a safe milk supply for infants, to develop a science of child-rearing, and to involve mothers in the primary care of their offspring. One of the leading French proponents of such reform was Alfred Donné, who published a manual on the subject in 1842. He directed this publication to physicians and their upper-class clientele, but many of the reformers of the 1880s and 1890s relied on Donné's articulation not only of the medical soundness of mothers breast-feeding their own offspring whenever possible, but the importance of the act in creating an elemental bond between mother and child. In addition to providing natural nourishment to infants, Donné argued that mothers must manage their children's health with a regular regimen of hygiene, bathing, exercise, and sleep. By the 1890s, doctors, reformers, and municipal governments in France had opened special clinics for the medical treatment and welfare of infants and young children.[65]

New definitions emerged of the psychological, as well as physical, nature of childhood. Before the mid-eighteenth century, children had generally been

viewed as small adults, to be developed as quickly as possible into fully functioning members of society. However, after the Enlightenment, childhood began to be regarded (and revered) as a special, distinct period of life. Until the onset of sexuality, it was believed, children are innocent, vulnerable, and therefore deserving of protection. Over the second half of the nineteenth century, a plethora of books appeared in England both related to childhood and specifically geared to children. This included a new genre of beautifully illustrated publications called "toybooks."[66] With their handsome, colored woodblock illustrations by such leading figures as Randolph Caldecott, Walter Crane, and Kate Greenaway, these high-quality productions greatly impressed Huysmans when they were exhibited at the Paris Salon of 1881. In his review of that event, he devoted over twenty pages to this new art form and in particular to the work of Crane and Greenaway. He noted the connections of these books to Japanese print albums, such as those by Hokusai, as well as to the most modern of French styles, Impressionism. "These English albums," Huysmans wrote, "like their Japanese counterparts, will be all that's left in France to contemplate when the Independents' [the Impressionists'] exhibition closes—which, it seems, is the only exhibition with a reason to exist." He praised Greenaway's brilliantly colored images, straightforward presentation, and strong draftsmanship (see fig. 34). He was drawn to her depictions of mothers and children, as well as to the fashionability of her settings: the upper-middle-class English home and garden. In his discussion of Greenaway, he repeated the view he had already expressed concerning Cassatt: that women have a particular sensibility for depicting children.[67]

This development in the history of modern illustration reflects a concern to capture in images the brief period of innocence that is childhood. This explains as well the proliferation in art and literature of images and descriptions of children—whether at play, at rest, bathing, listening to stories, or embracing family members or caretakers. Such images provided adult viewers with an escape from responsibility, a way to contemplate and re-experience a lost, carefree, and spiritually pure moment.[68] As Anne

Higonnet recently pointed out, Greenaway's linear simplicity and delicate palette, the eighteenth-century-style costumes worn by her children, and the flattened picture space result in images that appear naive, childlike, and thoroughly engaging. Capitalizing on traditional biases such as those of Huysmans, aspiring women artists found that this new interest in the depiction of childhood provided them with expressive avenues for their talents. Combined with new technologies for the printing and marketing of children's books, the subject of childhood also proved lucrative.[69]

It is therefore no accident that Cassatt produced her first important images of children and maternity between 1878 and 1880 (see cats. 12, 28). More than following a trend, however, Cassatt especially liked children, doting on her nieces and nephews and the offspring of friends. Naturalism and sensuality of a pure, elemental, and nonsexual sort are the hallmarks of Cassatt's portrayals of childhood during the 1880s

Fig. 34. Kate Greenaway (British; 1846–1901). Scene from *A Day in a Child's Life* (London, 1881), p. 29.

and 1890s. An example is *Children on the Shore* (cat. 47), which she showed at the last Impressionist exhibition, in 1886. While this seaside subject is unique in her oeuvre, the close-up focus on the pair of toddlers and the firm draftsmanship are typical of the artist's style in the 1880s. In his review of the exhibition, Gustave Geffroy commented on this painting: "[It] has the sharp outline that things and people have on the sand with the background of water and sky. The short arms and the dollish faces let you guess the flesh under a thick layer of suntan." In the same review, Geffroy also responded to the sensuousness of Cassatt's rendering of youngsters in *Children in a Garden* (cat. 12), likening them to "flowers in the heat."[70]

The physicality in Cassatt's work seems to have made some uncomfortable. Eloquently capturing a moment between rest and play, *Portrait of a Little Girl* (cat. 11) portrays the daughter of friends of Degas in an interior with Cassatt's dog. Cassatt submitted the painting to the American section of the 1878 Paris Exposition universelle; its rejection enraged her.[71] The jury could have been affronted by the girl's insouciant sprawl: she has flopped into the chair, looking hot, disheveled, exhausted, even bored. With her clothing pushed up to reveal her legs and petticoat and her left arm lifted and bent around her head, the young model can be perceived as totally unconscious and innocent or as coquettish and sexually precocious. Harriet Chessman argued that the girl's pose derives from the traditional, erotic odalisque and thus was intended to foreshadow her adult sexuality.[72] But in fact it seems that the meaning of this image lies in its naturalism. Children are less self-conscious than adults; they continually rearrange their clothes and limbs and are often unaware of social conventions. Thus the work can be seen to reflect the then-current view of children as pure and unfettered beings. The jury may have objected to the artist's radical handling of the background. As in her domestic interiors of the time, she reduced spatial depth by choosing a sharp, high angle for the floor, crowding the chairs together, and abruptly cropping the windows. Again, as in *Children on Shore*, the viewpoint from which the

Fig. 35. Alfred Cluysenaar (Belgian; 1837–1902). *Portrait of the Artist's Son André*, 1878. Oil on canvas. Brussels, Koninklijk Musea voor Schone Kunsten.

subject is observed is low and empathetic—the same level from which a child would see.

While *Portrait of a Little Girl* was rejected, a not totally dissimilar work by the Belgian painter Alfred Cluysenaar, depicting his son André (fig. 35), was accepted by his country's jury and shown in its section.[73] Like Cassatt's little girl, the artist's son is totally relaxed, wearing a skirt, from which his short legs emerge akimbo. (In the nineteenth century, girls and boys younger than seven or eight dressed alike; since children of both sexes wore dresses, gender distinctions were blurred, further idealizing childhood as a presexual time.[74]) Cluysenaar's portrait offers the conventional viewpoint and neutral background of portraits by such society painters as Jean Jacques Henner and Cassatt's former teacher Charles Chaplin. Cassatt had completely absorbed from her Impressionist colleagues Caillebotte, Degas, Forain, and Renoir, as well as her study of Japanese prints,

the modern idea that the background of a painting might be as significant as the foreground. She understood that establishing a tension between the two would capture the immediacy of vision, as well as mimic or falsify by turns, the focal shifts of human sight and perception. Thus the space and the objects in *Portrait of a Little Girl* that surround the figure seem to be in motion; the floor lifts up, and the chairs appear to have slid into various, almost accidental positions, not unlike that of the young girl. These changing elements affect our perception of the painting's psychological subtext: in contrast to Cluysenaar's son, whose connection to the viewer is made clear by his direct, outward gaze, that of Cassatt's "subject" to us is more complicated and elusive; the little girl's sideways glance, which avoids ours, makes her independent of us. She is in a world of her own, one that adults could fully understand only by recapturing their childhood personae.

Even more compelling for Cassatt than children per se was their care and the emotional and physical involvements with adults this entailed. Cassatt's compositions of 1880 and after—depicting children being bathed, dressed, being read to or held, nursing, and napping—reflect the most advanced ideas about the importance of maternity and the raising of children. As she concentrated increasingly on maternal images, she retained the highly formal structure of her earlier loge and domestic compositions but narrowed her focus, enlarging her figures of women and children in order to emphasize caretaking and physical contact. The pastel *Mother and Child* (fig. 33) for example exhibits her continuing interest in pattern, but addresses primarily the powerful emotional bond between the two subjects. These conjoined, faceless figures, like many of Cassatt's models, were not literally mothers and their offspring but rather children posed with various other family members, servants, or professional models.[75] Thus Cassatt's depictions of maternity are not literal; rather they are at once symbolic and physically evocative representations of the intimacies and sensual nature of childcare.

In Cassatt's upper-middle-class world, maternity was the only acceptable, public expression of female sexuality. Scholars have intuited this socialized definition of sexuality in a number of the artist's works,

including *Breakfast in Bed* (cat. 83), in which an adult female lies in bed with a child whose gender is ambiguous. While we have the sense that we are interrupting an intimate moment, we are not being improper. The sexuality of this bedroom scene relates strictly to a woman's role in giving birth; in effect this composition has been described as an allegory of the maternal body.[76] Social historians have confirmed that, in nineteenth-century upper-middle-class households, intimacy between adults and children, such as that in *Breakfast in Bed*, was commonplace. One wife wrote to her absent husband in 1883 that upon waking their children would rush into her bed: "If only you could see the litter in my bed every morning. They make me lazy, the little darlings. It's anyone's guess who looks the happiest. . . . Jane throws her pretty little arms around my neck . . . and then hugs me as hard as she can. If you were there, . . . how happy I would be. . . ."[77]

The directness and empathy with which Cassatt expressed the sensual nature of the mother-child relationship is clear in a comparison between this composition and Alfred Stevens's *Young Mother* (fig. 36). In Stevens's work, the mother and child touch, but there is nothing of the sense of relaxed intimacy evident in Cassatt's painting, where the sensuality of encircled bodies at the edge of a bed evokes a sense of warmth and comfort provided as well by the cup of morning coffee. The cloying, trite character of Stevens's interpretation is capped by the use of a prop—a crucifix—to signal protection. While Stevens emphasized the sanctity of birth, Cassatt focused on the exclusionary relationship between mother and child.

The most famous male practitioner of the mother-and-child theme was Eugène Carrière. In the late 1880s, he painted numerous images of mothers and children, seen through a brownish haze (see fig. 37). Working within this severely reduced, thinly applied palette, the artist made his forms nebulous and mystical. This soft-focus style, which reduces material facts to vaporous, indistinct forms, stood in strong contrast to Impressionism, with its claim to naturalism. By the end of the decade, Carrière's paintings were hailed as visual equivalents of Symbolist writing. Indeed he seemed to follow Paul Verlaine's defi-

nition of poetry, published in 1882: "No color, nothing but nuance! . . . Nuance alone betrothes the dream to the dream."[78]

In contrast to Stevens's sentimental and Carrière's poetical renderings of childhood and maternity, Cassatt's approach to the theme was informed by contemporary attitudes about motherhood, the debate in France over women's political and social role, and new concepts of childhood. With the illness of Lydia Cassatt, the birth of the artist's nieces and nephews, and the aging of the senior Cassatts, the family kept abreast of the latest developments in medicine and health.[79]

Among the changes in approaches to health and personal hygiene, bathing was one of the most significant. For most of the nineteenth century, few French families bathed frequently. It was not unusual, in the French provinces, for some families

never to bathe in the winter and only occasionally in the summer. Upper-class families residing in cities, however, sometimes bathed as often as once a week. Generally people washed themselves in low, round basins containing a few inches of water, like those both Cassatt and Degas depicted in their work. Large bathtubs, in which the bather submerged his or her entire body, were a most unusual feature in a home, but they could be rented. Girls from very proper or religious families tended to bathe in nightshirts rather than in the nude, not only because they were expected to be modest but also because seeing themselves naked in the water's reflections was considered threatening to their purity. By the mid-1880s, in the face of several cholera epidemics, progressives began to encourage regular bathing not only as a remedy for body odors but as cosmetically essential and medically sound. Cassatt herself first installed

indoor plumbing at her country home, Beaufresne, in 1894. In 1900 she wrote to an American friend, "I have done more plumbing, another bath room, . . . I hope I am now nearly up to the American standard. I need not say that I am so far beyond my French neighbours, that they think I am demented."[80]

Cassatt's many bathing scenes reveal her upperclass background. But she was also drawn to the theme because it allowed her to explore private actions, the sensuousness of water and touch, and the nude. *The Child's Bath* (cat. 28) suggests a number of levels of intimacy between an adult and a child, who regard and touch each other. In a work executed over a decade later—also entitled *The Child's Bath* (cat. 72)—the figures do not look at each other but rather at their reflections in the water. Here, however, strong modeling, firm drawing, and the child's compact and oddly proportioned body impart an unequivocal,

unidealized physicality to the scene; this tactility, in combination with the way the two bodies intertwine, produces a feeling of great tenderness.

The subject of bathing of course ties Cassatt's work to that of her friend Degas. While the bathers of both artists display a singular lack of self-consciousness, the two artists nonetheless gravitated to opposite aspects of the theme. Degas painted intimate scenes of nude women, most often in isolation but surrounded by the warmth of water and towel; he concentrated on the function and form of their movements. So unaware are they of being observed that there is the sense that, as has often been noted, Degas looked at them with the complicity of a

voyeur.[81] In contrast to the glimpses of private moments of individuals that Degas offered, Cassatt never depicted nude or seminude children bathing alone; rather they are always in the presence of an attentive adult. In fact the close physical contact between the figures became the artist's central focus. One critic observed Cassatt's indebtedness to Degas's draftsmanship in *Mother and Child* (fig. 33), but took pains to note that the compassion, freedom, and freshness of her work distinguished the American artist from her French colleague.[82]

Cassatt owned a pastel by Degas of a bather (see Hirshler, fig. 7), which she had received from him in exchange for her *Study* (cat. 48) in 1886. This work by Cassatt hung in Degas's drawing room until his death in 1917 (see Shackelford, fig. 26). Shown in the eighth and last Impressionist exhibition, it was described by a critic as "a young girl in a chemise twisting her plait in front of her dressing table, still flushed with sleep and the humidity of her first washing."[83] The model's arms strike a pose similar to that of the child in *Portrait of a Little Girl*. The sensuality of warm bath water is implied, rather than depicted, since the girl has moved on to arranging her coiffure. Cassatt succeeded once again in conveying physical sensation, that of pulling on and braiding long tresses of hair. Since the model here is somewhat older, it is possible to read into this work a suggestion of nascent sexuality. But compared to any dressing-room picture by Degas, this image is chaste indeed.

Cassatt's bath subjects are further distinguished from those of Degas in that they rarely depict adult nudes. Tamar Garb among others pointed out that women artists in France had limited opportunities to paint the nude, since they were excluded from the Ecole des beaux-arts, Paris, until 1897. However, Cassatt had access to paid models. As early as 1871, the artist wrote that she had engaged a male model and was looking for a female one as well. We do not know that these models posed for Cassatt in the nude, but she depicted female nudes in two prints from 1879–80 (Shackelford, figs. 17, 18); she owned, as noted above, one of Degas's bather pastels, as well as one of his monotypes; and she encouraged other women of her social class to buy them (see Hirshler, pp. 184–85). In 1881 Cassatt admired Gustave Courbet's

nudes in an exhibition at the Théâtre de la Gaîté and persuaded Louisine Havemeyer to purchase *Torso of a Woman* in 1889.[84] Thus the absence from her oeuvre of adult nudes may have been a conscious choice. The subject was considered the province of men, an opportunity for them to portray women as erotic objects. Cassatt rejected this view of women, choosing instead to favor the moral sensibility and totality of their lives as her theme and to allude to female sexuality through representations of maternal relationships. In her work, the act of touching between adult females and children seems to suggest enormous emotional and physical satisfaction. Even when a woman bares her breast to nurse an infant (see cat. 85), Cassatt never suggested the erotic role of the breast but rather the emotional and physical connection between woman and child and the intimacy and nourishment it produces.

For Cassatt it seems to have been sufficient to limit her exploration of the nude body to that of the very young. In fact she was the only one of the French Impressionists to depict unclothed children. In showing fully dressed women with partially covered or nude children, she negated any possible suggestion of reciprocal, pleasurable sexual feelings. The artist relegated the sensual aspect of the adult/child relationship to a proper sphere—that of the sanctity of motherhood, in which tender, physical intimacy is permitted. In Cassatt's work, child nudity is not sexual but natural and sensual, symbolizing goodness, purity, and lack of artifice. As Sigmund Freud was later to write, "Small children are essentially without shame . . . and show an unmistakable satisfaction in exposing their bodies."[85] Moreover the children being bathed in Cassatt's works are learning, at an elemental level, about cleanliness as a moral force.

Cassatt explored the adult/child relationship in a different way in a portrait of her brother Alexander and his second son, Robert (cat. 46). Residing in Philadelphia, Alexander and his family traveled to Paris to be with the Cassatts after Lydia's death, in November 1882. In December Alexander's wife, Lois, described her grieving sister-in-law as "very lonesome." She continued, "She feels now that perhaps she would have been better off to have married when she thinks of being left alone in the world. . . . She

has not had the heart to touch her paintings for six months, and she will scarely now be persuaded to begin." Lydia Cassatt's death was clearly traumatic for the artist, whose period of mourning was protracted. Both Cassatt and her mother continued to use black-bordered writing paper until November 1884, one year longer than convention required.[86] Only weeks after she ceased using this stationery, Cassatt began the portrait of Alexander and his son. The solid forms and finish of this composition perhaps reflect Cassatt's attempt to replace her lost sibling with the concrete presence of another. While she rarely painted men and boys together, this image clearly portrays Alexander as a good father, and also expresses the artist's affection for her nephew. Perhaps it indicates as well Cassatt's belief in the essential role of parenting, whether by a father or a mother, although in fact very few men at this time actively participated in child-rearing.

In Cassatt's portrait, father and son sit together in an armchair. The large, continuous expanse of black clothing joins them as a single unit; an air of authority and sobriety pervades the scene. The strong similarities of their facial features—underscored by the striking alignment of their eyes—their physical closeness, and their obvious psychological rapport accentuate the father's maturity and the boy's youth, but also suggest that the adult, in the form of the father, is clearly present in the son. The stiffness of the poses of these two male figures precludes the sense of tender protection that permeates Cassatt's maternal images. However, the portrait's serious and deliberate character apparently belies the process by which the portrait was actually achieved. As the artist's mother, Katherine Cassatt, reported:

Mary had a little thing only two & a half years old to pose for her & it was funny to see her pretending to sew . . . she posed so beautifully! I wish Robbie would do half as well— I tell him that when he begins to paint from life himself, he will have great remorse when he remembers how he teased his poor Aunt wriggling about like a flea.[87]

Thus, in this work, the artist accorded a formality to male models that she eschewed in the more naturalistic approach she would take in her images of mothers and children. Perhaps this is because, as discussed above, feminists in the nineteenth century, unlike

their twentieth-century counterparts, emphasized the differences between the sexes rather than their equality, and championed maternity as the locus of female power.[88]

The authority that women derived through motherhood was at once glorified, as well as contained, by religious associations.[89] This can be seen in the sanctimonious image of Stevens and in the lyrical interpretation of Carrière. While Cassatt's maternal subjects are distinct from those of such contemporaries, she, as they, looked back to traditional depictions of the Madonna and Christ Child in evolving her approach to the theme. Anna Jameson, England's first professional art historian, published line drawings of sixteenth-century Madonna-and-Child images in her 1852 book *Legends of the Madonna*. In his short story "Madonna of the Future" (1873), the American writer Henry James related the experience of seeing the most-revered painting in the nineteenth century—Raphael's *Madonna of the Chair* (1514; Florence, Palazzo Pitti)—which he described as showing a young mother seated in a rustic chair and embracing the pudgy, half-naked baby on her lap, while a second child clings to her knee. No doubt James, and other urbane, late-nineteenth-century viewers, were drawn to this image not because it embodied religious doctrine but rather because it reinforced current attitudes about maternity. Motherhood itself had become holy, and women and children had become inseparably linked.

Many of Cassatt's depictions of mothers and children from the 1890s put a naturalistic and secular gloss on traditional religious subjects, drawn especially from the Renaissance period. One critic observed that the artist was always attracted to styles that tried to approach nature. For this reason, Cassatt and many of her contemporaries admired early Renaissance sculpture and painting.[90] As Nancy Mowll Mathews demonstrated, these prototypes exerted a strong influence on Cassatt's portraits, depictions of children, and maternal images.[91] Her love of the art of this period was nourished not only by her travels in Italy but also by a number of exhibitions that began with an installation of early Tuscan sculpture at the Palais du Trocadéro during the 1878 Exposition universelle, which Cassatt likely vis-

ited. Renaissance portrait sculpture had been little seen in Paris during the first half of the nineteenth century. Reflecting post-Revolutionary sympathies, many associated sculpted portraits of Italian nobility with the French aristocrats who had collected them. Consequently such sculpture had languished for decades in cellars and museum storerooms. Thus, when the Trocadéro show opened, the Tuscan portraits it featured constituted a revelation.[92]

One of the most enthusiastic visitors was Eugène Piot, a leading apologist for Italian Renaissance sculpture. In a review of the exhibition, he castigated French collectors for having, in the past, eschewed this material in favor of jewelry and Palissy faience, Limoges enamels, Flemish ivories, and eighteenth-century terracottas. Piot—who became himself an important collector of Tuscan sculpture—lauded the achievements of Italian artists working in marble, bronze, and enameled terracotta. Unlike preceding generations, the writer did not regard this work as elitist but rather quite the opposite: he associated the taste in the Renaissance era for public works—large-scale fountains, tomb sculptures, and civic monuments—with the growth of the Italian city-states and thus with republicanism. He proposed that Renaissance sculpture was a particularly apt model for France. Gustave Dreyfus, who owned an outstanding collection of Renaissance art, lent to the exhibition a marble portrait bust of a legendary beauty, Beatrice of Aragon (fig. 38), daughter of Ferdinand I of Naples and later queen of Hungary. *Beatrice of Aragon*, and other fifteenth-century female portrait busts, also figured in a major exhibition of Renaissance sculpture at the Louvre, which opened to the public in the spring of 1881 and which Cassatt must have seen. What mattered to Piot about portraits such as this was, in his view, their essential humanity, naturalism, and lack of artifice. "They express modern sentiments," he declared. "They are sketches that allow the imagination to complete the thought."[93]

The English critic Frederick Wedmore was thinking along similar lines. Reviewing an 1882 exhibition of French Impressionist works at the White Gallery, London, he noted affinities between Impressionism and the art of the fifteenth-century Florentine sculp-

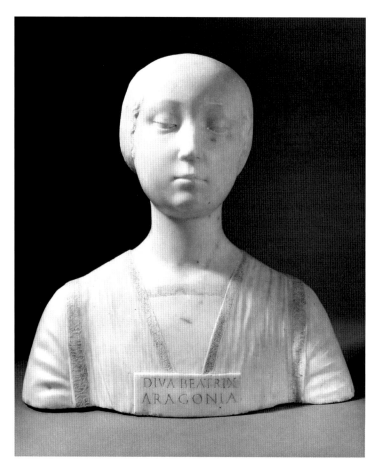

Fig. 38. Francesco Laurana. (Italian; c. 1430–c. 1502). *Beatrice of Aragon*, 1470/80. Marble; h. 40.6 cm. New York, The Frick Collection.

severe but elegant representation of Mary Dickinson Riddle, *Lady at the Tea Table* (Shackelford, fig. 24).

In addition to the installations at the Trocadéro and the Louvre, Cassatt had ample opportunity to see early Italian sculptures in a number of private collections in Paris. Piot, in his review of the 1878 Exposition universelle, had praised Gustave Dreyfus and Emil Gavet, critic Charles Ephrussi, and Cassatt's teacher Jean Léon Gérôme for their commitment to collecting in this area. Cassatt must have visited Dreyfus's apartment on the boulevard Malesherbes, with its extraordinary, wall-to-wall display of paintings and sculptures. He opened his "little museum" to all; anyone interested in art and collecting could visit, and he especially welcomed foreigners. Cassatt could have seen work by Luca della Robbia in the collections of Dreyfus or Gavet.[95]

tor Luca della Robbia. Describing a painted terracotta bas-relief of a Madonna and Child intended as an over-door decoration, he was struck by the ways in which past and present can intersect:

What has Luca Della Robbia to do with the Impressionists? Well, he has this to do with them; he knew at all events— what they believe—that the art that has the chance of living is generally the art that is inspired by the life of its own day. Exceptions there may be, but they are rare. Luca represented what he saw and what he enjoyed. And that is the first plea one must put forward in justification of the work of the best among a group of latter-day Frenchmen, whose efforts have thus far been a good deal disregarded by the English *amateur. . . .*[94]

One of the pictures Wedmore would have seen in London was Cassatt's *Women in a Loge* (cat. 20). While Cassatt's treatment of this theme was partly inspired by period fashion plates, in its geometric organization, this very contemporary scene also shows the influence of Tuscan portrait sculpture. The frontality of the shoulders and the oval shape of the heads recall the forms of *Beatrice of Aragon*, as does Cassatt's

There are striking similarities between Luca's *Madonna and Child in a Niche* (fig. 39), which Gavet owned, and Cassatt's *Child Picking a Fruit* (cat. 70), especially in the infants' facial features and extended arms. So too the contrapposto stance of the baby boy in the Gavet piece is not unlike that of the child in *Mother and Child* (cat. 87), a painting owned by H. O. and Louisine Havemeyer. In 1895, a time when Cassatt was most actively involved, along with the dealer Paul Durand-Ruel, in helping the New York couple build its collection, the Havemeyers acquired a work that Gavet had owned by Luca's contemporary the sculptor Mino da Fiesole. The connections between Cassatt's mother-and-child images and such Renaissance examples were not lost upon these collectors: Mrs. Havemeyer called one of her pastels by Cassatt "my Florentine madonna."[96] Even more closely related to *Mother and Child* is a terracotta (fig. 40) by Andrea della Robbia that had been in Piot's collection and was auctioned in 1890. Cassatt seems to have borrowed and then reinterpreted the

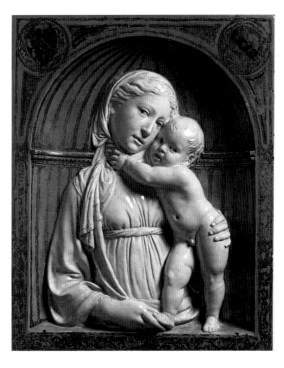

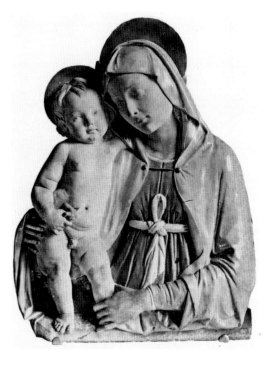

Fig. 39. Luca della Robbia (Italian; 1399/1400–1482).
Madonna and Child in a Niche, c. 1440/60. Enameled terracotta;
h. without frame: 48.3 cm. New York, The Metropolitan
Museum of Art, bequest of Susan Dwight Bliss, 1966,
67.55.98.

Fig. 40. Workshop of Andrea della Robbia (Italian; 1435–
1525). *Madonna and Child*, c. 1500. Enameled terracotta; 68 x
54 cm. London, Victoria and Albert Museum. Photo: Paris,
Hôtel Drouot, *Catalogue des objets d'art de la Renaissance: La Col-
lection feu M. Eugène Piot*, sale cat. (May 20, 1890), pl. 7.

Madonna and Christ Child's conjoined heads, clasped hands, and double halo. In her secularized version of a sacred theme, she used a mirror to refer playfully to a halo. Among the Renaissance works Dreyfus assembled were numerous depictions of children, including the celebrated *Bust of a Little Boy* (fig. 41) by Desidario da Settignano. The shape of the head, hair style, and full cheeks of the model relate closely to those of the infant in Cassatt's *The Family* (cat. 71).[97]

In addition to Italian sculpture, Florentine painting exerted a strong influence on Cassatt's technique and compositions. She had traveled to northern Italy in 1879 particularly to study mural painting. Like her experiments with painted frames discussed above, her interest in the matte qualities of fresco, which she emulated in her chalky, unvarnished surfaces, reveals her continuing willingness to explore unconventional methods and effects. She indicated her association of *Reading* (fig. 32) with Italian models when she wrote

Fig. 41. Desidario da Settignano (Italian; c.1430–1464).
Bust of a Little Boy, 1455/60. Marble; h. 26.4 cm. Washington,
D.C., National Gallery of Art, Kress Collection. Photo: "La
Collection de M. Gustave Dreyfus," *Les Arts* (Dec. 1907), p. 3.

to her brother Alexander about this work: "I think the group will look well in a light room; that is light paper & perhaps over a door . . . as the Italian painters used to do, they are called 'dessus de porte' here." In 1881 Cassatt's friend Ernest Hoschedé noted the indebtedness of Cassatt's light palette and dry handling to the Italian "primitives." In an article, he commented that she had indeed incorporated the "style of the *primitifs* in composition, and [possesses] an exquisite modernity."[98]

Cassatt particularly admired the art of Sandro Botticelli, whose art enjoyed a resurgence of interest in the latter part of the nineteenth century, thanks to the writings of such critics as the English aesthetician Walter Pater and the American Theodore Childs. Botticelli's *Virgin and Child with the Young Saint John the Baptist (Madonna of the Rose Garden)* (fig. 42), in the Louvre, may have inspired Cassatt's *The Family.* She transformed the figure of Saint John into a young girl and the Christ Child's adoration of his mother into filial love. Cassatt's protagonists, who hold flowers and wear floral-patterned dresses reminiscent of Renaissance-era styles, recall figures in works by the Italian artist. Botticelli always remained important to Cassatt; she referred to the *Madonna of the Rose Garden* in 1911, some seventeen years after she had painted *The Family,* in response to criticism of her work by her friend Theodate Pope:

So you think my models unworthy of their clothes? You find their types coarse. I know that is an American newspaper criticism, everyone has their criterion of beauty. I confess I love health and strength. What would you say to the Botticelli Madonna in the Louvre. The peasant girl & her child clothed in beautiful shifts & wrapped in soft veils. Yet as Degas pointed out to me, Botticelli stretched his love of truth to the point of painting her hands with the fingernails worn down with field work! Come over and I will go to the Louvre with you & teach you to see the Old Masters [*sic*] methods. You don't look enough at pictures. . . . these are elemental things which no culture changes. . . . No you must learn before snubbing me.[99]

The predominance in Italian Renaissance art of the Madonna and Child theme provided Cassatt with a rich and timeless set of referents upon which she could draw to inform her own visual language: a language she had evolved to express her increasing belief that women are the primary procreative ele-

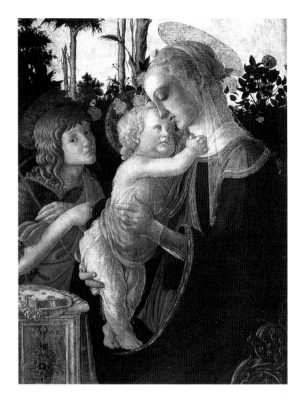

Fig. 42. Sandro Botticelli (Italian; 1445–1510). *Virgin and Child with the Young Saint John the Baptist (Madonna of the Rose Garden),* c. 1468. Tempera on panel; 93 x 69 cm. Paris, Musée du Louvre. Photo: Ronald Lightbown, *Sandro Botticelli: Life and Work* (New York, 1989), pl. 5.

ment in society, as well as her growing dedication to depicting and celebrating them. This she did to the exclusion of men; even in the rare instance where she portrayed a male figure, as in her large composition *The Boating Party* (cat. 77), the importance of women remains clear. In this work, however, the roles of both male and female adults are ambiguous. Is the massive, dark figure the father/husband or a hired boatman? Is the simply dressed woman the mother or a nanny? Whichever is the case, the man is physically and psychologically separated from the woman and the child she holds in her lap, and he is turned away from us. On the other hand, the brightly lit maternal group is enclosed protectively at the center, in the bow of the boat, which the man pilots through the water. The hands of all three meet in the middle of the composition, but only those of the woman and child touch. We can read this as a metaphor for the nineteenth-century family: The husband focuses on his work, which provides for his

wife and offspring. From her protected space, the woman watches over and cares for her children and her mate.

The Boating Party is similar to a composition that won a gold medal at the 1889 Exposition universelle in Paris, Emile Renouf's *Helping Hand* (fig. 43).[100] Whereas Renouf used an oar to create a bond between adult male and child, Cassatt employed the device to clearly separate male and female realms. By boldly moving the horizon to the top of the composition in order to flatten the space, she not only created a startling, abstract design but enshrined and empowered her female figure. This is further reinforced by comparing *The Boating Party* with Edouard Manet's 1874 *Boating* (fig. 44), to which Cassatt was clearly paying homage. Calling *Boating* "the last word in painting," she urged the Havemeyers to purchase it through Durand-Ruel in 1895.[101] In the two canvases, a high horizon line, dramatic cropping, bold palette, and strongly realized forms owe much to the Japanese prints that both artists admired. However, in Manet's composition, the man occupies center stage. The casualness of the female passenger's pose and the total lack of eye contact between the two suggest a familiarity that could be sexual. In fact the man's direct gaze seems challenging, as if to protect his "property" from us. By contrast Cassatt's later version of a boating scene reverses the positions—thus the balance of power—between male and female.[102]

Cassatt executed *The Boating Party* in 1894 at Cap d'Antibes, where she had taken her ailing mother. From there she wrote to her friend the painter Rose Lamb that "the woman you knew as my Mother is no more, . . . only a poor creature is left." Katherine Cassatt would die the following year. In January 1894, the family had celebrated the birth of the artist's niece Ellen Mary Cassatt (see cat. 81) to her

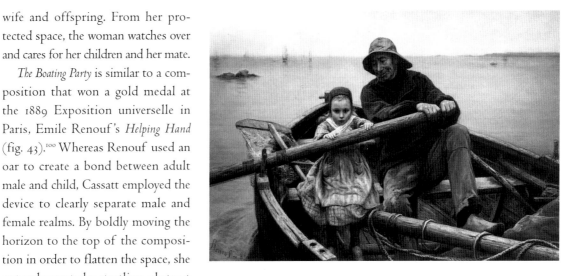

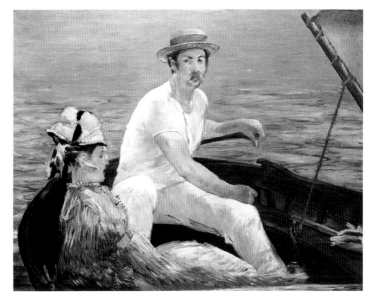

Fig. 43. Emile Renouf (French; 1845–1894). *Helping Hand*, 1881. Oil on canvas; 152.4 x 226.1 cm. Washington, D.C., private collection.

Fig. 44. Edouard Manet (French; 1832–1883). *Boating*, 1874. Oil on canvas; 97 x 130 cm. New York, The Metropolitan Museum of Art, H. O. Havemeyer Collection, bequest of Mrs. H. O. Havemeyer, 1929, 29.100.115.

brother Gardner and his wife, Jennie. Perhaps the artist intended *The Boating Party* to reflect these events in her family. By elevating a maternal figure and a child to the top and center of her composition, and by enthroning them in a bow, she may have wished to allude to the cyclical character of life and the crucial role women play in it.[103] Cassatt's works, in the 1890s, would become increasingly Symbolist in content and form, with women, in association with nature, representing powerful forces of creativity and renewal.

Symbolism and the Allegory of Modern Woman

In April and May 1890, Paris was dazzled by a large exhibition of Japanese graphic arts at the Ecole des beaux-arts. Organized by the dealer Siegfried Bing, the display featured more than seven hundred *ukiyo-e* prints and four hundred illustrated books. Cassatt wrote with excitement to her friend Berthe Morisot that she must see "the Japanese prints at the Beaux-arts." She continued:

Seriously, you must not miss that. You who want to make color prints you couldn't dream of anything more beautiful. I dream of it and don't think of anything else but color on copper. [Henri] Fantin [-Latour] was there the first day I went and was in ecstasy. I saw [James] Tissot there who is also occupied with the problem of making color prints. . . . P.S. You must see the Japanese—come as soon as you can.[104]

Cassatt visited the exhibition repeatedly. That summer at Septeuil, in a country house not far from that of Morisot, Cassatt began her own series of color prints "à la japonaise" (cats. 56–65). She was inspired not only by the bold linearity of the compositions and the evocative color harmonies of the prints in Bing's show, but also by a predominant theme, that of the daily lives and ordinary activities of women. She was drawn particularly to the work of the eighteenth-century master Kitagawa Utamaro, who depicted courtesans washing and dressing themselves, combing their hair, bathing children, and drinking tea.[105] Utamaro explored the moods of women through pose and gesture, costume, pattern, and color. He produced seventeen sets of prints, including "The Twelve Hours in the Pleasure Quarter of the Yoshiwara," twelve images that, as Barbara Shapiro suggested, constituted a model not only for the concept of Cassatt's suite but also for particular subjects, compositional devices, and color schemes.[106]

Unlike the Japanese works she so admired, Cassatt's ten prints are not woodcuts. Rather they are drypoints and aquatints, made from copper plates covered with printer's inks, approximating the color effects achieved by the Japanese. The palette of Cassatt's suite contrasts soft, diffuse tones—pale roses, greens, and yellows—with deeper-toned, yet translu-

cent blues, as well as browns, grays, and blacks (on the technique Cassatt and her printer employed, see Shackelford, p. 132).[107] Emulating her Japanese models, Cassatt used background patterns to enrich her essentially linear compositions; she set the designs of wallpaper, upholstery, drapery, and costume against areas of solid or pale color. She also minimized facial features in order to emphasize the universality of her theme.

Cassatt introduced her suite of color prints in an exhibition held at the Galerie Durand-Ruel in Paris in April 1891 (see Sharp, p. 146). In that same month, the critic Roger Marx wrote a piece for Bing's periodical *Le Japon artistique*, in which he commented upon the modern sensibility that he and others (he credited Théodore Duret, Edmond Duranty, and Joris Karl Huysmans as sharing his opinion) saw in Japanese prints. Among the links Marx found between the woodblock prints and Impressionism was not only a shared sense of the primacy of nature, but also the graceful gestures of women, flattened space (which reminded the critic of photography), dense pattern, and powerful expression achieved through line, silhouette, and simplicity.[108]

Both Shapiro and Colta Ives have closely examined the connection between Cassatt's suite and specific works by Utamaro, including a number of prints that she actually owned.[109] For example *Study* (cat. 65) relates thematically to Utamaro's *Takashima Ohisa Using Two Mirrors to Observe Her Coiffure* (fig. 45). The Japanese artist aligned femininity with the mirror, using this device to explore reflection, reality, and illusion. As we have seen, these are issues Cassatt had investigated in her loge pictures (see cats. 18–20) and interior scenes (see cats 9, 10) in the late 1870s and early 1880s and would return to in ensuing years (see cats. 87, 89, 90).

A number of the subjects treated in the color-print suite reveal Cassatt revisiting earlier interests. In addition to the three scenes of mothers or caretakers with nude infants (cats. 56, 62, 63), the set includes an interior with two women drinking tea (cat. 64). Unlike *Tea* (cat. 27) of 1879–80, in which the protagonists sit closely together but do not seem to interact, the pair of women in the print connect through gesture, the gentle proffering of a plate,

Fig. 45. Kitagawa Utamaro (Japanese; 1754–1806). *Takashima Ohisa Using Two Mirrors to Observe Her Coiffure*, 1797. Color woodblock print; 38.1 x 25.5 cm. The Art Institute of Chicago, Clarence Buckingham Collection, 1925.3030.

much as in a similar scene by Utamaro (fig. 46). In the print, Cassatt replaced the painting's insistent wallpaper background with a window, flowing curtain, and open screen, which results in a much airier, lighter effect. Likewise *The Lamp* (cat. 57) returns to a subject that the artist had treated in her black-and-white print experiments with Degas and Pissarro (see cat. 40). But instead of exploring the optical effects of gas lamps casting light through dark interiors, the illumination in the color aquatint is even and diffuse, as in *ukiyo-e* prints. There are no shadows, as if time has been suspended. The familiar elements of Cassatt's interiors—fan, lamp, mirror, and table with object—blend into a lyrical, flowing composition of large, flat, colored shapes, patterns, and intersecting lines.

As Nancy Mowll Mathews pointed out, while half of the series recasts signature themes in a spare,

elegant formal language, the other half treats subjects that are new to the artist. These include *Young Woman Trying on a Dress* (cat. 60), in which the seamstress and her client are not distinguished from each other so much as conjoined, through their shared focus and patterned garments, a device that recalls Japanese prints in which women help one another to dress. In another image, Cassatt applied Japanese aesthetic ideas to a totally contemporary Parisian scene. *Interior of a Tramway Passing a Bridge* (cat. 58) shows a mistress, maid, and child crossing a bridge over the Seine on public transport. Behind them a view through three windows of another bridge, the river, and tree-lined banks spreads out like the paneled screens Cassatt would have seen in Bing's exhibition. The artist's original drawing (fig. 47) for *Interior of a Tramway* includes a man in a top hat sitting at the right. She deleted him from her composition before the plate

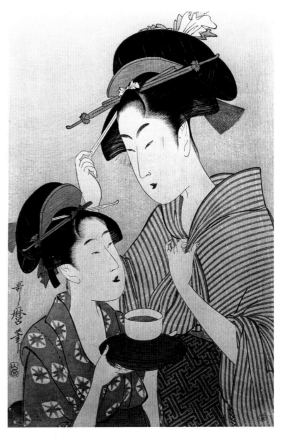

Fig. 46. Kitagawa Utamaro. *Two Beauties, One Holding a Teacup, the Other Fingering Her Hairpin*, c. 1797. Color woodblock print; 37.6 x 25.4 cm. The Art Institute of Chicago, Clarence Buckingham Collection, 1925.3039.

Fig. 47. Mary Cassatt. *Drawing for "Interior of a Tramway Passing a Bridge"* (cat. 58). Recto: pencil and black chalk on dark cream wove paper; 45.4 x 27.3 cm. Washington, D.C., National Gallery of Art, Rosenwald Collection, 1948.11.51a.

was etched. This deletion, as well as the total absence of men in the final series, indicates that the artist wished it to represent the hours of a woman's day. While Cassatt did not arrange her cycle in a clear, narrative order, as did the *ukiyo-e* masters, she clearly intended that it be considered and sold as a whole. As Mathews observed, "With its occasional repetition of models and its suggestion of times of day— morning rituals, daily errands, afternoon socializing, evening entertaining, and bedtime rituals . . . these ten prints provide us with a more complete glimpse of 'daily life' [than] . . . anywhere else in her art."[110]

Another print, *The Letter* (cat. 59) borrows formally from Utamaro's *Hinzaru of the Keizetsuro* (fig. 48). While Cassatt's subject seals a letter and the Japanese courtesan blots her make-up, both images celebrate a humble, everyday act and present private moments as the basis of universal experience. In two prints, Cassatt ventured a subject she had never before treated in a major work: the partially nude female figure. In *The Bath* (cat. 61), she demonstrated

discretion in allowing us only to observe the half-nude bather from behind. She protected her model's privacy in *Study* (cat. 65) by restricting her frontal nudity to the reflection in a mirror, at a greater remove from the spectator. By thus framing the female figure, as Anne Higonnet correctly observed, the mirror also serves to remind us that "we are looking at a picture, not a person." Perhaps, at this point in her career, the artist felt free to explore female nudity in works that exhibit obvious debt to an exotic cultural tradition. "Once Cassatt and Morisot had seen the female body through foreign eyes," Higonnet stated, "they could begin to see it differently themselves."[111] In any case, both images display a distillation of form and lack of artifice that mediate against specificity; and yet the very ordinariness of the activities depicted, combined with the delicacy of handling, economy of means, and sensitivity of expression, lends each image an exquisite intimacy.

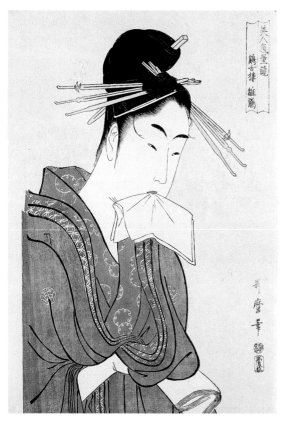

Fig. 48. Kitagawa Utamaro. *Faces of Beauty: Hinzaru of the Keizetsuro.* Color woodblock print; 39.1 x 26.2 cm. The Art Institute of Chicago, Clarence Buckingham Collection, 1925.3047.

Cassatt's great color-print suite marks a watershed in her career, for, in the process of its creation, her fidelity to the description of physical reality became secondary to the evocation of mood and the suggestion of larger meanings. The direction her art now took had a name—Symbolism—and a growing number of adherents. The seeds of change were evident five years before she produced the suite, notably in the Impressionists' eighth and last group exhibition. In addition to showcasing the work of regulars such as Cassatt, Degas, Morisot, and Pissarro, the 1886 exhibition had also included the highly stylized Neo-Impressionism of Georges Seurat, as well as works by Paul Gauguin and Odilon Redon, whose investigations of subjective and spiritual realms were far removed from the empirical referents of Impressionism. That same year, the poet Jean Moréas published an essay in the literary supplement to *Le Figaro*, which he entitled the "Manifesto of Symbolism." Here he advocated that writers reject material reality except as a means to suggest the spiritual and mysterious, and urged them to "clothe the Idea in sensual form." Moréas declared:

As to subject matter, we are tired of the quotidian, the near-at-hand, and the contemporaneous. . . . We want to substitute the struggle of sensations and ideas for [that] of individual personalities, and for the center of action, instead of the well-exploited backdrop of squares and streets, we want the totality of the mind.[112]

Moréas thus explicitly rejected the naturalist aesthetics of a critic such as Edmond Duranty (see Shackelford, pp. 113–14). Writers had been the first to display this antirealist impulse. Cassatt's admirer Huysmans had published in 1884 his novel *A Rebours* (*Against the Grain* or *Against Nature*) tracing the odyssey of a bored, decadent aesthete, followed in 1891 by *Là-bas* (*Down There*), with its focus on nineteenth-century occultism. In 1887 Stéphane Mallarmé published *Poésies*—a collection of thirty-five poems in which he explored essences and spheres beyond reality in elegant, distilled language. And a major journal, serving as the voice of the new movement, the *Mercure de France*, began publication in 1890.

Cassatt came to Symbolism through several avenues. We have seen the powerful effect Japonism exerted upon her art. Her literary connections to the movement were not insignificant: she was thoroughly familiar with the works of Huysmans; she probably met Mallarmé around 1888, through their mutual friend Berthe Morisot. She was drawn to Mallarmé's poetry, while he admired her painting.[113] Her belief in women as the primary procreative force tied her to a related development in the visual arts, Art Nouveau, with its emphasis on flowing lines and biomorphic shapes and its pervasive conflation of natural and female forms. Given her appreciation and understanding of Renaissance art and other historical styles, which she believed any significant contemporary artist had to study and absorb, she would have embraced the painter Maurice Denis's suggestion that artists use the term "Neo-Traditionalism" instead of "Symbolism." Inspired by the ideas of his mentor, Gauguin, Denis believed that "the most important aspect of the new art of 1890 was not its experimentation with abstract signs and symbols, but its revival of qualities in art that existed from ancient times. . . . His emphasis was on unlocking the secrets of the past and applying them in an art relevant to modern times."[114] Cassatt must have been familiar with Denis's work, in particular the mural (now destroyed) he produced for Bing's gallery in 1891. And surely she would have read Albert Aurier's 1891 essay about Gauguin, in which he argued that Impressionism, a variation on realism, relied on sensory, material appearances, but that the goal of true art was to go beyond these—to express the realm of ideas.[115]

While Cassatt's work of the 1880s celebrates sensual impressions, in the 1890s she seems to have turned toward a recognition of higher levels of meaning. Intensifying her preoccupation with modern women—their routines, their domestic surroundings and responsibilities, and their entertainments—she began to explore her gender in a larger, spiritual sense, as the essential link between nature and humanity, the source of regeneration and morality. That she was asked to participate in the 1886 exhibition of the Brussels-based, avant-garde group Les Vingt signals that a younger generation detected the Symbolist possibilities of Cassatt's increasingly visionary and lyrical appreciations of her female subjects.[116]

The meditative quality of many of Cassatt's works

from the 1890s may reflect the losses the artist experienced during these years, as well as her growing belief in Spiritualism. Her father passed away in 1891; her mother and her friend Berthe Morisot died in 1895. The origins of Cassatt's interest in Spiritualism cannot be firmly dated, but her involvement in the movement can be documented to 1903 and probably occurred earlier. She attended séances, admired the Spiritualist writings of William James, read the papers of the Society for Psychical Research and F. W. H. Myers's *Human Personality and Its Survival of Bodily Death*, and advised her friends, including Louisine Havemeyer, Theodate Pope, and Sarah Choate Sears, on the subject.[117]

Spiritualism was a good fit with Cassatt's beliefs and interests. Spiritualists highly valued children, believing that they come into the world as pure beings and thus reflect the image of God. They also held that God could be approached through nature, whose beauty and harmony they thought confirmed the essential goodness of human beings. Death was understood not as an immutable ending but rather as a transmutation of physical form into an eternal psychical state. Finally Spiritualists believed in the equality of the sexes; the American feminist leaders Elizabeth Cady Stanton and Susan B. Anthony praised the sect for being unique in the world in this regard. Not only did séances take place in the home, but the mediums were always female, for women were seen to bridge the material and spiritual worlds.[118]

When Cassatt returned to easel painting after the debut of her prints at Durand-Ruel's, her work grew in scale and monumentality. The meditative mood of her model in *Revery* (cat. 67) reflects the Symbolist belief that contemplation, quiet, and daydream help to access a spiritual state. In this work, the red-haired model, familiar to us from the color prints in which she appears (see cats. 60, 64), has moved out-of-doors, where she sits on a bench and contemplates a flower. While achieved in a volumetric, even robust style that is the antithesis of the ethereal, dreamy arabesques of Art Nouveau, *Revery* shares with this

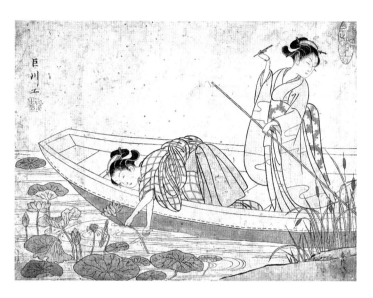

Fig. 49. Suzuki Harunobu (Japanese; c. 1724–1770). *Gathering Lotus Flowers*, 1765. Color woodblock print; 20.6 x 27.6 cm. The Art Institute of Chicago, Clarence Buckingham Collection, 1925.2028.

and other manifestations of Symbolism a concern with the connections between the feminine, emotional, and subjective (as opposed to the masculine, intellectual, and empirical). While we know this association to be age-old and, in the wake of late twentieth-century feminism, can take passionate issue with it, the late nineteenth century avant-garde framed the bond it saw between women and the earth so as to make it appear totally modern.[119] The ability of nature to induce profound relaxation, and the spiritual peace this affords, is also seen in Cassatt's several images of women, with and without children, in boats on rivers and ponds (see cats. 78–80). Feeding ducks or trailing their hands in water, these figures recall images in Japanese prints (see fig. 49) and bring to mind an Asian concept of life as a voyage down an unending, ever-changing river. But even here the artist's vigorous brushwork and strong palette infuse these images with physicality and vitality.

Cassatt's deepening interest in nature, and women's relationship to it, coincided with a shift in her lifestyle, as she began after 1889 to spend more time in the French countryside, renting the Château de Bachivillers (Chronology, fig. 17), near Gisors. In 1894 she purchased Beaufresne (Chronology, fig. 20), a property in Mesnil-Théribus, to indulge her pas-

sion for gardening. Increasingly she presented women and children in outdoor settings rather than in domestic or public interiors. In *Young Women Picking Fruit* (cat. 68), two women carry on a conversation in an orchard as the younger woman hands fruit she has just plucked off the tree to her older, seated companion. But this is no image of sylphs populating a sacred grove. Cassatt's women are large and solid—actual individuals (we recognize again the red-haired model in the standing figure) engaged simultaneously in mental discourse and physical activity.

This composition relates to a project on which Cassatt embarked at Bachivillers in 1892, a monumental mural for the Woman's Building at the 1893 World's Columbian Exposition in Chicago. The commission provided her with the opportunity to present this new phase of her career to North American audiences on an unprecedented scale. Bertha Honoré Palmer (see Hirshler, fig. 26), President of the Fair's Board of Lady Managers, offered Cassatt the challenge of creating a decorative allegory of "Modern Woman" as a pendant to a second mural, with the subject of "Primitive Woman," which she commissioned from another American artist living in France, Mary MacMonnies.[120]

Although Cassatt may have met the Chicagoans Potter Palmer and his wife earlier, through their art agent, Sara Tyson Hallowell (Chronology, fig. 18), the artist clearly knew them by April or May of 1891. The Palmers probably saw her print show at Durand-Ruel's; they acquired a set of the color prints and a pastel (cat. 50) one year later (see Hirshler, p. 200). Bertha Palmer's charm, energy, and leadership skills impressed Cassatt: "I suppose it is Mrs. Palmer's French blood which gives her organizing powers and her determination that women should be *someone* and not *something*."[121]

Since both Cassatt's and Macmonnies's murals disappeared some years after the fair closed, they are known only through contemporary photographs (see figs. 50–53, 55), drawings and studies (see fig. 57), and related works (see cats. 68, 70).[122] Unlike MacMonnies, who had trained in the Paris studio of Pierre Puvis de Chavannes, Cassatt had always been an easel painter associated with Impressionism and therefore with realism. At the time France's most renowned

muralist, Puvis practiced a peculiarly static form of Symbolism. A large, complicated allegory was not her stock in trade. She was understandably reluctant when presented with the opportunity, turning to her old friends Edgar Degas and Camille Pissarro for advice. They responded negatively, not just because the project would constitute such a departure from her work to that point, but also because they had strong reservations about decoration in general. Degas exploded in a rage over the commission. As Pissarro wrote to his son Lucien:

Speaking of Miss Cassatt's decoration, I wish you could have heard the conversation with Degas on what is known as "decoration" I am wholly of his opinion; for him [a mural] is an ornament that should be made with a view to its place in the ensemble, it requires the collaboration of architect and painter. The decorative picture is an absurdity, a picture complete in itself is not a decoration.[123]

Despite her friends' feelings, Cassatt agreed to paint a fourteen by fifty-eight-foot mural for the fair. Perhaps she felt encouraged by the new climate for decorative painting among the Parisian avant-garde, especially among the Nabis group, whose members seem to have heeded Aurier's call "to decorate the common walls of human edifices with thoughts, dreams, and ideas." Cassatt was also drawn to the feminist character of the entire undertaking. The prospect of contributing a major mural on the subject of women to a building designed and decorated by women and devoted to work by women at a venue sure to be seen by hundreds of thousands proved irresistible. Cassatt explained her decision: "Gradually I began to think it would be great fun to do something I had never done before."[124]

Palmer and her associate in this venture, Sara Hallowell, planned to place the murals in the two tympana high above, and at each end, of the central court of the Woman's Building (see fig. 58). Sophia Hayden, one of the first women to be professionally trained as an architect in the United States, designed the Italian Renaissance-style building (Chronology, fig. 19), intended to showcase the accomplishments of women as artisans, artists, poets, educators, reformers, and more. It was Palmer who determined that the message of the murals would be the advancement of women. In a letter to Hallowell, she

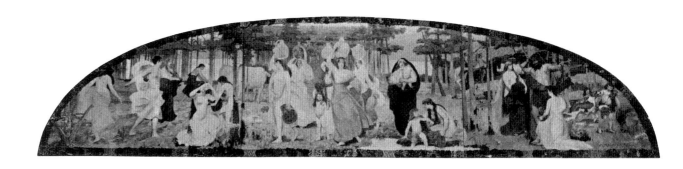

outlined the expectations of the Board of Lady Managers: One panel, she declared, should "show woman in her primitive condition as a bearer of burdens and doing drudgery, either an Indian scene or a classic one in the manner of Puvis." The panel about contemporary women, on the other hand, should show "[in] contrast women [*sic*] in the position she occupies today."[125]

The murals that Cassatt and MacMonnies submitted conformed to Palmer's general framework. Each artist divided her composition into three sections: a large, central group flanked by two supporting scenes. In *Primitive Woman* (fig. 50), MacMonnies created a frieze of figures that moved across the foreground of each of the three parts, which she further linked with a continuous landscape, in the manner of her teacher Puvis.[126] In the center, the draped women hauling water and caring for children drew the viewer's eye to the left, where another group sowed the land. To the right, a husky, bearded man, having returned from the hunt, was tended to by two women, while a young girl and boy playfully mimicked the adults.

The subject of "Modern Woman" was a more challenging assignment, since Cassatt had to find a meaningful way to allegorize the present. She described her goals for the work in a letter to Palmer:

I took for the subject of the central and largest composition young women plucking the fruits of knowledge or science & — that enabled me to place my figures out of doors & allowed for brilliancy of color. I have tried to make the general effect as bright, as gay, as amusing as possible. The occasion [*sic*] is one of rejoicing, a great national fête. . . . I will still have place on the side panels for two compositions, one, which I shall begin immediately, is young girls pursuing fame. This seems to me very modern & besides will give me an opportunity for some figures in clinging draperies. The other panel will represent the Arts, Music . . . , Dancing & all treated in the most modern way.[127]

The foreground of the centerpiece, *Young Women Plucking the Fruits of Knowledge* (figs. 51, 52) depicted ten women of various ages, each garbed in contemporary dress, working together to harvest fruit from an orchard. In the left-hand panel, *Young Girls Pursuing Fame* (see fig. 51), three girls, chased by geese, try to overtake a flying, naked child. At the right, *The Arts,*

Fig. 52. Mary Cassatt. *Young Women Plucking the Fruits of Knowledge* (central section of fig. 51). Photo: Pauline King, *American Mural Painting* (Boston, 1902), p. 89.

Music, and Dancing (see fig. 51), a young female, symbolizing the visual arts, sits demurely watching a figure strumming a banjo and another performing a skirt dance. A common horizon line unites the three parts, as does the wide, decorative border framing the top and bottom. Cassatt also used two vertical bands to separate the central panel from the flanking scenes.[128]

In producing this colossal, public work, Cassatt had to overcome a number of problems. Difficult contract negotiations almost forced her to withdraw. The artist Frank Millet, who was in charge of the financial arrangements for the art to be exhibited at the fair, insisted that Cassatt and MacMonnies follow rigid guidelines. Both objected to four conditions of the contract: the due date of October 1892, the required submission of a sketch, the terms of payment, and the expense of delivery. During the negotiations, MacMonnies made it clear to Palmer that both she and Cassatt were well-informed about the procedures involved in contracting artists for large, civic projects:

[Millet] does not seem to know that it is the invariable custom in all contracts where any outlay is required, to make adequate payments as the work progresses nor is he, evidently, aware that in Paris all the large decorative paintings in the Panthéon, Sorbonne, Hôtel de Ville, and the various Mairies have always been placed at the expense of the State, City, or Arrondissement as the case may be, but never at the expense of the artist. . . . Until now, there has been done comparatively little of this kind of work in America, and he may be pardoned for not knowing what is customary.

Hallowell expressed surprise that Millet, "himself a painter," would wish to enforce such terms. Completing an undertaking such as this required an enormous outlay of cash. Cassatt for example had to remodel a greenhouse into a studio, complete with a ditch and an elaborate pulley system to raise and lower the mural. With Hallowell's intercession, however, the issues were resolved. The two artists agreed to complete their work by mid-February 1893. MacMonnies submitted a sketch. Cassatt did not; instead she sent Palmer a photograph of the work in progress.[129]

It is not surprising that, in developing her compositional ideas, Cassatt looked for guidance primarily to early Italian Renaissance frescoes, with their pure color effects; large, simple, and decorative forms; and the matte quality and unity of image and wall surface permitted by fresco. When her dealer Paul Durand-Ruel traveled to Bachivillers to see the as yet unfinished work, Cassatt was amazed that he did not recognize the influence of the Italian primitives: "I found he had never seen the frescoes of the early Italian masters, in fact he has never been to Italy except to Florence for a day or two on business."[130]

The rather straight and stiff postures of the figures in all three panels recall those in Giotto's great cycle of frescoes in the Arena Chapel, Padua. But an even more direct inspiration for Cassatt may have been Benozzo Gozzoli's frescoes at the Campo Santo, Pisa, which had become something of a pilgrimage shrine for nineteenth-century artists interested in early Renaissance art.[131] In the center section

Fig. 53. Mary Cassatt. Detail of fig. 52. Photo: William Walton, *The Art and Architecture of the World's Columbian Exhibition*, vol. 1 (Philadelphia, 1893), pl. opp. p. xxxvi.

Fig. 54. Benozzo Gozzoli (Italian, 1420–1497). *Drunkenness of Noah* (detail), 1468/69. Fresco. Pisa, Campo Santo. Photo: Alinari/Art Resource, NY.

of *Modern Woman* (fig. 53), the young female in a striped dress standing on a ladder and handing a piece of fruit down to a little girl recalls a male figure in Gozzoli's *Drunkenness of Noah* (fig. 54). Also standing on a ladder in an arbor, he lowers a bucket of grapes to a woman. With her arms extended over her head, she parallels the white-gowned figure who stands to the left of the ladder in Cassatt's mural. So too, in the fresco, the blue-smocked worker holding a basket of grapes and standing next to the wine press cuts the same sharp profile as Cassatt's woman in the reddish brown, floral-print dress, who cradles an oval panier of apples.

The decorative borders that surround and divide Cassatt's mural also derive from early Italian examples. These wide bands, decorated with floral motifs

Fig. 56. Taddeo Gaddi (Italian; c. 1300–1366). *Tree of the Cross and Other Biblical Scenes*, c. 1360. Florence, Museo Opera di Santa Croce. Photo: Alinari/Art Resource, NY.

and accented with medallions enclosing portrait busts and the figures of playful infants (see fig. 55), resemble the border motifs commonly found in Luca della Robbia's reliefs and in Tuscan murals. In a monumental fresco (fig. 56) in Santa Croce, Florence, Taddeo Gaddi used such a device to unify his multipart composition, as well as to emphasize the central scene and to distinguish it from the side and lower sections. Cassatt intended her borders to serve an identical purpose, describing them as the only purely decorative elements of her design.[132]

Fig. 55. Mary Cassatt. *Medallion with Baby Holding Apples* (detail of fig. 51). Photo: Pauline King, *American Mural Painting* (Boston, 1902), p. 91.

Another Florentine who inspired both Cassatt and MacMonnies was Sandro Botticelli, whose murals and panel paintings, as we have seen, enjoyed a resurgence of popularity in the latter part of the nineteenth century. In addition to individuals, such as Gustave Dreyfus, who collected Botticelli's work, artists began to copy his paintings with new-found enthusiasm. In the 1880s, MacMonnies spent one year copying two frescoes by Botticelli that had entered the Musée du Louvre, Paris, in 1882: *Lorenzo Tornabuoni and the Liberal Arts* and *Venus and the Three Graces* (fig. 59). Although MacMonnies made her copies a decade before she became involved in the fair project, this experience no doubt proved seminal as she developed her mural.[133]

While Cassatt never seems to have copied anything by Botticelli, she used, as noted above, his *Virgin and Child with the Young Saint John* (fig. 42), also in the Louvre, as an inspiration for her 1891 painting *The Family* (cat. 71). In her visits to the Galleria degli Uffizi, Florence, she certainly would have seen one of its masterpieces, Botticelli's *Primavera* (fig. 60), which most contemporary scholars considered to be the artist's greatest work.[134] The impact of *Primavera* on the central section of Cassatt's *Modern Woman* can be seen in the friezelike arrangement of the figures and their placement in an orchard of trees with straight trunks and thick branches laden with fruit

Fig. 57. Mary Cassatt. *Study for "Young Woman Plucking the Fruits of Knowledge"* (fig. 52), 1892. Oil on canvas; 59.7 x 73 cm. Private collection.

and blossoms. Cassatt's interest in Botticelli's painting may have been intellectual as well. Although most twentieth-century art historians have connected *Primavera*'s highly complex iconographic program to Neoplatonism, in the late nineteenth century, the painting tended to be regarded as a puzzle or allegory whose mystery was enhanced by the artist's subjective approach to naturalism. As the American critic Theodore Childs proclaimed,

No words can give an idea of the fascination of Botticelli's work; for although a naturalist in the same sense as all the primitive painters were naturalists . . . , keenly impressed by outward things, by flowers, trees, rivers, and hills, by man . . . , he was essentially a visionary and lyrical painter; of his compositions we may truly say that they are exponents of states of soul. Far from remaining impassive before the spectacle of nature and life, he clothes everything that he sees with the color of his own moods and ideas.[135]

Following Botticelli's lead in her mural, Cassatt avoided specifics to preserve a sense of the lyrical and universal.

Cassatt and MacMonnies did not limit themselves to studying Renaissance paradigms in shaping their ideas. Public murals executed during the Third Republic also played an important part in the development of both artists' conceptions. Cassatt expressed her sympathy with French muralists upon learning, to her surprise, that *Modern Woman* was to be hung high above the central court (see fig. 58). Rather

Fig. 58. Sophia Hayden (American; 1868–1953). Interior of the Woman's Building, World's Columbian Exposition, Chicago, 1893, showing placement of Cassatt's mural, *Modern Woman* (fig. 51) in the south tympanum of the main exhibition hall. Photo: courtesy Chicago Historical Society.

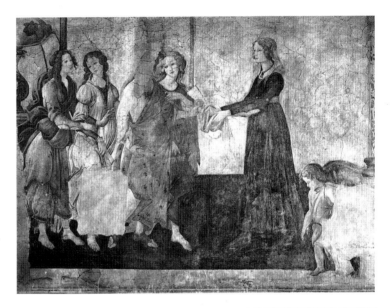

than object, she replied, "Better painters than I am have been put out of sight, Baudry spent years on his decorations. The only time we saw them was when they were exhibited in the Beaux-Arts, then they were buried in the ceiling of the Grand Opera." Her allusion to Paul Baudry's designs for the foyer of the Paris Opéra is revealing, since they had gone on view at the Ecole des beaux-arts almost twenty years previously.[136] Cassatt's admiration of this decorative cycle can also be deduced from the more-than-passing similarity between the right-hand panel of her mural, with the banjo player and dancer, and Baudry's *Salomé* (fig. 61), in which a young male plays a stringed instrument for the semi-clothed seductress, who swirls her veils provocatively.

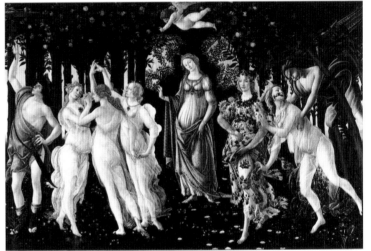

Cassatt's project also reflected more recent developments in French mural painting. Increasingly, in the 1880s and 1890s, French muralists saw as their central mission the delactation of the

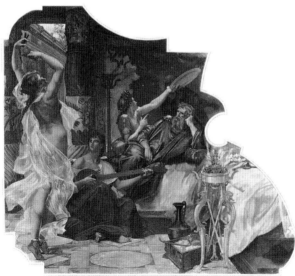

Fig. 61. Paul Baudry (French; 1828–1886). *Salomé,* c. 1874. Oil on canvas. Photo: E. About, *Peintures décoratives du grand foyer de l'Opéra par Paul Baudry* (Paris, 1876), pl. 15.

viewer, a shift away from expectations of public commissions during the Second Empire, which were intended to instruct, through clearly legible forms and heroic narrative. As Marie Jeannine Aquilino recently demonstrated, during the Third Republic, under the leadership of arts minister Philippe de Chennevières and such critics as Eugène Veron, muralists were encouraged toward an aesthetic of *jouissance* (pleasure), an approach that infused even the most basic aspects of daily life with pleasurable associations and visually engaging treatment. The two artists who, many French critics agreed, most successfully achieved these objectives were Albert Besnard and Pierre Puvis de Chavannes. Although their individual styles are widely divergent, each used allegory and symbol to suggest ideas and states of soul.[137]

Both Cassatt and MacMonnies looked to the example of Puvis. MacMonnies consulted her former teacher while developing her mural. Palmer noticed this influence: "It [*Primitive Woman*] carries

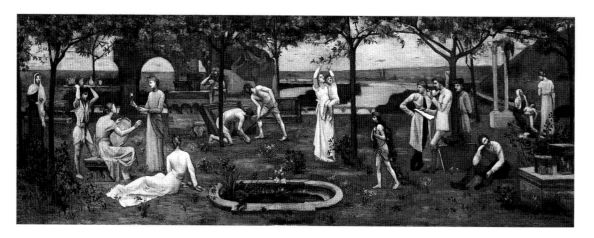

Fig. 62. Pierre Puvis de Chavannes (French; 1824–1898). *Replica of "Inter Arts et Naturam,"* 1890. Oil on canvas; 40.3 x 113.7 cm. New York, The Metropolitan Museum of Art, gift of Mrs. Harry Payne Bingham, 1938.

quite a suggestion of Puvis, and I can fancy an approach to his delightful grays and blues in the coloring."[138] Cassatt's interest in the artist seems to have been more in line with that of the new avant-garde, for whom Puvis's great value had less to do with his classical-revivalist style than with his professed rejection of illusionism.

In the 1890s, a number of artists depicted women harvesting fruit in orchards or groves. In 1889–90 Puvis completed *Inter Arts et Naturam* (see fig. 62), in which he explored the relationship between art and nature. Installed at the Musée des beaux-arts, Rouen, just ten miles from Cassatt's residence at Bachivillers, the mural features a group of women clothed in modern dress (as opposed to his customary Greco-Roman imagery) and communing in a garden. Among the figures is one, in the center, who picks fruit from a tree. Critics praised Puvis for his ability to incorporate contemporary elements and still create a sense of universality.[139]

In addition to Puvis, Berthe Morisot made studies of women harvesting cherries (see fig. 63); Pissarro (who lived in Eragny, just a few miles from Cassatt's country residence) depicted peasant women among flowering apple trees; Denis executed the decorative fantasy *Ladder Among Leaves* (fig. 64); and the American Theodore Robinson (working in Giverny) painted women gathering plums. Perhaps they were all drawn to the subject as a modern interpretation of the Garden of Eden. The meaning of this motif

is more complex in Cassatt's and Puvis's murals, where picking fruit constitutes only one part of the action. In Cassatt's *Modern Woman*, the women picking fruit are as symbolic as the girls chasing fame and the personifications of the arts. All the figures are depicted out of doors; they are all symbolic of creative forces, deeply connected to the ultimate force, that of nature. Moreover, in the examples by Puvis and Cassatt, fruit is passed from a woman to a child, symbolizing the transmission of inherited knowledge from one generation to another. By involving an infant in communal work, both these artists presented maternity as a civilizing force.[140]

Cassatt produced similar images in both paintings and color prints during the years of her involvement with the Chicago commission. Like Puvis's mural, her 1893 painting *Child Picking a Fruit* (cat. 70) depicts a young woman pulling the branches of an apple tree within reach of her child's grasp. She reworked the theme slightly in *The Kitchen Garden* (cat. 69), in which a woman standing on a ladder passes a piece of fruit to a child held by a second woman. By similarly focusing on the direct transfer of fruit from one member of the community to another, Cassatt presented the mother/child relationship as a crucial social model that gives women, as the primary providers of childcare and education, an important moral role, different from that of men.

Unlike MacMonnies, who draped her figures in antique garb, Cassatt depicted her protagonists in

Fig. 63. Berthe Morisot. *Cherry Tree*, 1891. Oil on canvas; 135.9 x 88.9 cm. Philadelphia, private collection.

Fig. 64. Maurice Denis (French; 1870–1943). *Ladder Among Leaves*, 1892. Oil on canvas, glued to cardboard; 235 x 172 cm. St.-Germain-en-Laye, Musée départemental Maurice Denis.

modern dress. As she explained to Palmer, "I have tried to express the *Modern Woman* in the fashions of our day and have tried to represent those fashions as accurately & as much in detail as possible." Cassatt seemed unaware of the feminist promotion in the 1890s, especially in England and the United States, of dress reform, which called for emancipation from the unreasonable confines of corsets and girdles that helped a woman achieve an ideal, hourglass figure, as well as from the excessive heat of many-layered clothing. In contrast Cassatt's modern women display their upper-class fashionability: their garden dresses are made of taffeta, satin, and lace. One newspaper writer criticized Cassatt on this point,

declaring "This is modern woman as dressed by [the designer] Worth."[141]

Another sign of the contemporaneity of Cassatt's mural is the inclusion of a banjo in the panel devoted to the arts. While the banjo is a uniquely American instrument, the motif relates to the images of women of leisure playing *samisen* in Japanese woodblock prints (see fig. 65). Although women of some means had been encouraged for centuries to

Fig. 65. Suzuki Harunobu. *The "Samisen" Players.* Color wood-block print. Photo: *Le Japon artistique* I (1890), pl. BHE.

develop their musical skills, the banjo would not have been an instrument of choice until the 1880s, when it began to be professionally manufactured and its popularity extended across class and racial lines.[142] Cassatt also depicted models playing banjos in pastels and color prints in the year after finishing the Chicago mural (see cats. 73–75).

When the two murals arrived in Chicago, Bertha Palmer was exultant. In her opinion, MacMonnies's and Cassatt's combined achievement proved not only what female artists could do but also provided a spectacular overview of women's progress from the dawn of civilization to the present day. Writing to Cassatt, Palmer declared:

I consider your panel by far the most beautiful thing that has been done for the Exposition, and predict for it the most delightful success. It is simple, strong, and sincere, so modern and yet so primitive, so purely decorative in quality, and with still the possibility of having an allegory extracted.[143]

Unfortunately Palmer's enthusiasm was not universal. Fairgoers were shocked by Cassatt's bold palette, which included vivid pink, apple green, purple, and gold. Writing for the *Art Journal*, Florence Miller described the mural as a "singular failure" and accused the artist of mocking the "enthusiastic ladies who have employed her." In Miller's opinion, MacMonnies's contribution, conceived "in the true spirit of mural design" was the "superior" work.[144] In fact Miller and other critics had a point. Cassatt had not received information about the height at which her mural would be installed until much too late in the process. It was thus situated higher than she had anticipated and was hard to see, which compromised the impact of its artistry and message. While this consequence was not entirely the artist's fault, her inexperience with such a project is revealed in its weaknesses. Macmonnies's training under Puvis and her more traditional approach enabled her to provide a more readable work. But the negative criticism that dogged Cassatt's painting during the fair, and long afterward, does not negate its significance in her own development.

As one historian put it, Cassatt's mural reflected the artist's "commitment to see in women's everyday activities humanity's highest aspirations."[145] Focusing on the contemporary female's role as creator, nurturer, teacher, and muse, *Modern Woman* was in line with the generally apolitical yet progressive view of womanhood prevalent in Cassatt's class and time. This view would certainly have pleased Bertha Palmer, who firmly believed that females should achieve their goals in a "womanly" fashion, according to particularly feminine virtues: tenderness, sympathy, and intuition. Palmer did not agree with woman suffrage, nor did she question the current division of labor. In her view, women need not seek equality with men in their sphere of activity, but rather should be encouraged to move freely in the feminine realm and be respected for their skills and achievements.

In the United States, the term "new woman" initially described those who operated with this phi-

losophy. This phrase applied to a woman who had "improved herself so as to be in every way the best companion for man, and without him the best fitted for a place of usefulness in the world." Such women believed that their place in society transcended politics. Wealthy American progressives like Palmer conceived their role in terms of charity work: helping to improve infant care, education, the status of poor women and orphans; to secure regulations to control child labor; to institute legal reforms for married women.[146] Finally their genteel progressivism sought to accommodate new professional opportunities for women with the traditional roles of wife and mother, both of which were exalted as occupations concerned with family and with molding children into good citizens.

This emphasis on the specifically feminine role of women led Cassatt to write to Palmer: "An American friend asked me in a rather huffy tone the other day 'Then this is woman apart from her relations to man?' I told him it was. Men . . . are painted in all their vigour on the walls of the other buildings [of the fair]; to us the sweetness of childhood, the charm of womanhood; if I've not conveyed some sense of that charm . . . , if I have not been absolutely feminine, then I have failed."[147] Thus, in her desire to be "absolutely feminine," even while engaged in such a traditionally unfeminine venture as painting a monumental mural, Cassatt aligned herself with a less-than-radical point of view.

These tenets are revealed in a number of Cassatt's compositions featuring women and flowers. In *Revery* (cat. 67), a woman meditates upon a single blossom—either a zinnia or a carnation, the latter long associated with betrothal. Whether she is contemplating imminent marriage and motherhood, or simply the ephemeral beauty of nature, cannot be determined. Cassatt began using flowers symbolically in her compositions in the early 1890s. *The Family* (cat. 71), which includes a mother and children but lacks a father, shows the older, female child offering a carnation to a baby, whose gender the artist did not specify. The composition

evokes traditional depictions of the mystical marriage of Saint Catherine and the Christ Child. While this association is not to be taken literally, Cassatt's image does address the beauty of maternal and filial love, with the female child holding a symbol of her biological destiny, according to which she will become a selfless, nurturing mother.

In *The Mirror* (cat. 89), Cassatt united floral symbolism—a prominent sunflower—with one of her favorite compositional motifs. The sunflower enjoys a long history in the visual arts. In the seventeenth

Fig. 66. Pierre Puvis de Chavannes. *Ave Picardia Nutrix* (detail), 1865. Encaustic on canvas support affixed to the wall; 45 x 175 cm. Amiens, Musée de Picardie. Photo: Photographie Bulloz.

century, this flower, which turns to follow the path of the sun, had been used as a metaphor of loyalty to God and ruler, and of the protection and salvation such trust can bring. Long before then, it was associated with fecundity, appearing in medieval images of the Madonna.[148] It is to this early tradition that Puvis was referring in his mural *Ave Picardia Nutrix* (fig. 66), installed at the Musée de Picardie, Amiens, one of Cassatt's favorite day trips from her home at Beaufresne. The older artist's composition is unequivocal in its association of the flower and woman's creative powers. Thus the prominent placement of the sunflower in Cassatt's image, pinned to the young mother's bodice, lends authority to the institution of motherhood. The flower's monumental size and aureolelike appearance also appealed to Cassatt's contemporaries, such as Gauguin, Vincent van Gogh, and Monet.[149] It also figures prominently as a symbol of regeneration in designs of the English Arts and Crafts movement and in French Art Nouveau decorations (see fig. 67).

It is interesting that, at the same time she was working on *The Mirror*, Cassatt purchased Simon Vouet's *Toilet of Venus* (fig. 68), a seventeenth-century painting that offers a number of parallels to her own canvas. Even though this mythological subject usually provided an artist with the opportunity to paint beautiful women and luxurious items, it evokes the moralizing concept of *vanitas* compositions that remind the viewer that life's pleasures are momentary and that death is inevitable. A number of symbols that *vanitas* pictures often encompass—mirrors, a flower, and an attractive woman (sometimes with a young child on her lap)—appear in *The Mirror*. While this composition depicts a moment shared between mother and child that may be quickly lost, it may, at the same time, represent an image imprinted forever in a child's memory. One of Cassatt's favorite authors, the scientist J. H. Fabre, who drew lessons about human behavior from his studies of insect life, observed that "the child is the best guardian of tradition, the great conservative. Custom and tradition become indestructible when confided to the archives of his memory."[150] Thus *The Mirror* can also be read in the opposite way from a *vanitas* image, as affirming life, in that the mother-and-child relationship guarantees immortality. Cassatt found her beliefs reflected in *Elizabeth and Her German Garden*, a feminist novel she particularly loved. Written by Elizabeth von Arnim and published in London in 1898, it tells the story of an upper-class woman with three young daughters—April, May, and June. In her children, as well as in her garden, Elizabeth finds solace for a "stale soul." She bathes her baby herself, "for she is far too precious to be touched by any nurse She is knelt

Fig. 67. Exterior of Siegfried Bing's shop "L'Art nouveau," rue de Provence, and rue Chauchat, Paris, 1895. Photo: courtesy Archives nationales, Institut français d'architecture, fonds Louis Bonnier.

Fig. 68. Simon Vouet (French; 1590–1649). *Toilet of Venus*, c. 1640. Oil on canvas; 165 x 115.9 cm. Pittsburgh, Carnegie Museum of Art, gift of Mrs. Horace Binney Hare, 52.7.

down on her mother's lap, a little bundle of fragrant flesh, and her face reflects the quiet of her mother's face as she goes through her evening prayer for pity and peace."[151]

For Cassatt motherhood constituted the basis of a feminism that extended maternal nurture and protection to the preservation of all life. However, by 1908 she supported woman suffrage; her views were further politicized by World War I. Blaming wars on male-dominated governments, she lamented, "Is this wholesale slaughter of men necessary to make women rise to an equality such as they have never before had?" With the help of her friend Louisine Havemeyer, an ardent suffragist, Cassatt came to believe that the ballot box was the only sure way to prevent further folly. "Women," she declared, "must

be up and doing—let them league themselves to put down war."[152] The artist lived to see women vote in the United States but not in France, which did not institute universal suffrage until after World War II.

By 1926, the year of her death at eighty-three, Cassatt had experienced the age of feminism, the century of the child, the collapse of the artistic academy, and the making of the modern world. Looking back upon her career, she wrote to Theodate Pope in 1911 that her works had addressed universal meanings beyond the descriptive or sentimental: "Almost all my pictures with children have the mother holding them, would you could hear them talk, their philosophy would astonish you."[153] Indeed Mary Cassatt gave them a voice.

Notes

THE FASHIONABLE SPECTACLE

1. Emily Sartain to John Sartain, June 17, 1874, in Mathews 1984, pp. 124–25.

2. Shopping was a passion for at least one Cassatt family member: in her travel diary of 1882, Lois Buchanan Cassatt, wife of the artist's brother Alexander, described almost daily visits to the Parisian department store Le Louvre; see Travel Diary (1882–83).

Cassatt's interest in opera was apparent by 1868, when she met Emanuele Muzio, director of the Théâtre italien of Paris, who was married to Lucy Simmons, from Harrisburg, Pennsylvania. Muzio provided Cassatt with an introduction to the director of the Parma opera when she went there to work in 1873; see Mathews 1984, p. 81, n. 5.

3. Eugen Weber, *France: Fin de Siècle* (Cambridge, Mass./London, 1986), pp. 159–66.

"The chandelier, superb. . .": in ibid., p. 166.

4. On the social role of the theater for the French middle class, see Anne Martin-Fugier, "Bourgeois Rituals," in Michelle Perrot, Philippe Ariès, and Georges Duby, eds., *A History of Private Life: From the Fires of the Revolution to the Great War* (Cambridge, Mass., 1990), p. 278. See also Alice M. Irving, *Woman's Guide to Paris* (New York, 1910), pp. 74–77; and *Guide to Paris and Environs* (New York, 1912), pp. 58–60.

Charles Baudelaire, in *Constantin Guys: Femmes Parisiennes*, trans. Louise Varèse (New York, 1945), n.p.

5. For other artists' use of fashion illustrations, see Mark Roskill, "Early Impressionism and the Fashion Print," *The Burlington Magazine* 112, 807 (June 1970), pp. 391–95; and Marie Simon, *Fashion in Art: The Second Empire and Impressionism* (Paris, 1995), p. 177.

6. On this phenomenon, see Raymond Gaudriault, *La Gravure de mode féminine en France* (Paris, 1983); Simon (note 5); Cynthia Leslie Whaite, *Women's Magazines: 1693–1968* (London, 1970); and Higonnet 1992, pp. 90–91.

7. For various interpretations of the meaning of looking in Impressionist art and French culture, see: T. J. Clark, "Olympia's Choice," in *The Painting of Modern Life: Paris in the Art of Manet and His Followers* (Princeton, N.J., 1984), pp. 74–146; Tamar Garb, "Gender and Representation," in *Modernity and Modernism: French Painting in the Nineteenth Century* (New Haven/London, 1993), pp. 219–87; Griselda Pollock, "Modernity and the Spaces of Feminity," in *Vision and Difference: Feminity, Feminism, and the Histories of Art* (London/New York, 1988), pp. 50–90; and Steven Kern, "Prostitution," in *Eyes of Love: The Gaze in English and French Paintings and Novels, 1840–1900* (London, 1996), pp. 128–52.

8. Although no documentation exists to identify the model in this work, Adelyn Breeskin (Breeskin 1970, 64) thought her to be Cassatt's sister, Lydia, probably because of the model's reddish-blond hair. But the resemblance is tenuous at best. Suzanne Lindsay challenged Breeskin's identification; see Philadelphia 1985, p. 41. When Cassatt executed this work, Lydia was forty-one years old and chronically ill. The Philadelphia canvas depicts a young, healthy woman who personifies a type of beauty much admired in Paris in the 1860s and 1870s, when blondes and redheads created a stir in the city.

9. For an insightful discussion of this painting, see Kern (note 7), p. 78.

10. On the display of works by Degas's circle in the 1879 Impressionist exhibition, see San Francisco 1986, pp. 243, 251–53, 256, 260. For a contemporary appreciation, see Havard 1879. See also Jann Matlock, "Censoring the Realist Gaze," in Christopher Prendergast and Margaret Cohen, eds., *Spectacles of Realism* (Minneapolis/London, 1995), pp. 28–65.

Degas's love of the theater extended to playwriting: He helped to write a play entitled *La Cigale* ("The Cicada"), a comedy that satirized the Impressionist group, which was performed at the Théâtre des Variétés, Paris, in 1877; see Ellen Williams, *The Impressionists' Paris* (New York, 1997), p. 70.

11. "Shocking": Hervilly 1879.

"Fishlike face . . .": Burty 1880.

"Bold": Ephrussi 1880. On the works by Cassatt that Ephrussi owned, see note 39.

Like Cassatt, Forain rendered several of his opera pictures predominantly in reds and greens; on his palette, see Memphis, Tenn., Dixon Gallery and Gardens Collection, *Jean-Louis Forain: The Impressionist Years*, exh. cat. by Theodore Reff and Florence Valdès-Forain (1995), p. 124.

12. "Whom you know . . .": Edgar Degas to Viscount Ludovic Lepic, [1879], in Mathews 1984, p. 148. For the original French text, see Guérin 1945, pp. 150–51. I am grateful to Douglas W. Druick for his help with interpreting this comment.

13. Emile Zola, *Nana* (Paris, 1880), trans. Lowell Blair (New York, 1995), p. 9. One critic (*Le Soir* 1879) wrote that the bare shoulders of Cassatt's women in loges looked dirty, which he associated with characters in Zola's novel *L'Assommoir* (Paris, 1877). In fact the Cassatts admired Zola's writing. In 1878 Cassatt's father, Robert S. Cassatt, enclosed a photograph of the writer in a letter to his grandson in Philadelphia: "I enclose for Papa [Alexander Cassatt] a likeness of Emile Zola the now celebrated author of the Assommoir"; see Robert S. Cassatt to Edward Cassatt, Apr. 3, 1878, in Sweet 1966, p. 34.

14. For the annotated catalogue, see San Francisco 1986, p. 264, n. 81; see also *Le Soir* 1879.

15. For negative critical responses to Cassatt's work, see Renoir 1879 and Hervilly 1879.

16. See Isabelle Cahn, "Degas's Frames," *The Burlington Magazine*, 131, 1033 (Apr. 1989), p. 289.

Unfortunately Cassatt seems never to have used this device again after the 1879 exhibition. A little more than a decade later, she framed her spectacular series of ten color prints (cats. 56–65) in narrow, neutral, gray painted frames, not unlike those favored by Degas for his own pastels and prints.

17. For Hoschedé's essay on Cassatt, see Hoschedé 1881.

18. See Deborah Cherry, *Painting Women: Victorian Women Artists* (New York, 1993), pp. 47–48.

19. Quoted in Ticknor 1927–28, pp. 237–38.

20. For a discussion of the replacement of gas with electric lighting, see Boston 1984, pp. xlix–l.

21. Two scholars have noted the figure with opera glasses in the background of Manet's composition that may acknowledge

admiration for Cassatt's loge pictures: see Novelene Ross, *Manet's Bar at the Folies-Bergère* (Ann Arbor, 1982), pp. 6–7, 67–68, 85; and Kern (note 7), p. 84.

Either in the summer of 1880 or 1881, while summering at Marly-le-Roi, Cassatt and a guest, her friend Louisine Havemeyer, walked to the Manet family summer residence to visit the artist. They were met by Berthe Morisot, who explained that her brother-in-law was too sick to receive visitors (he died in 1883). Morisot, whom Havemeyer later described as very "friendly," then walked the two Americans back to Cassatt's house; see Havemeyer 1993, pp. 217–18.

AT HOME

22. On Cassatt's various residences and studios in Paris, see Chronology.
George Moore, *Reminiscences of the Impressionist Painters* (Dublin, 1906), p. 36.

23. See Pollock 1980; and Garb (note 7).

24. See Michelle Perrot, "Roles and Characters," in Perrot, Ariès, Duby (note 4), p. 255; and Bonnie Smith, *Ladies of the Leisure Class: The Bourgeoises of Northern France in the 19th Century* (Princeton, N.J., 1991).

25. For a discussion of this picture and fashion illustration, see Valerie Steele, *Paris Fashion: A Cultural History* (New York/Oxford, 1988), pp. 184–85.

26. For the *Gazette's* survey, see Ernest Chesneau, "Le Japon à Paris," *Gazette des beaux-arts* 18 (1878), p. 385.
Théodore Duret, "L'Art japonais," *Gazette des beaux-arts* 26 (1882), pp. 113–31; and idem, *Critique d'avant-garde* (Paris, 1885), p. 64. For Duret's comments on the colors of Japanese prints, see Klaus Berger, *Japonisme in Western Painting from Whistler to Matisse*, trans. by David Britt (Cambridge/New York, 1992), pp. 88–89.

27. On the outlets for Japanese prints in Paris in these years, see Berger (note 26), pp. 97–98.

28. On Cassatt's set of china designed by Braquemond, see Boston 1989, p. 64.
"A true model . . .": Silvestre 1880a.

29. The other books in the series, *Le Gant*, *L'Ombrelle*, and *Le Manchon* ("The Glove," "The Parasol," and "The Muff"), were published in Paris in 1883.

30. On Morisot's double portrait, see Higonnet 1992, pp. 142–47. The fan in Morisot's composition is Degas's *Spanish Dancer and Musicians* (1868–69; private collection [Lemoisne 173]).

31. Burty 1880.

32. Higonnet 1992, pp. 144–45.

33. For an examination of these activities, see Debora Silverman, *Art Nouveau in Fin-de-Siècle France* (Berkeley, 1989), pp. 112–26.

34. Proust purchased Cassatt's *Woman Reading* (cat. 14) from the 1879 Impressionist exhibition; see Lostalot 1879. Marx owned many of Cassatt's prints, as well as the painting *The Mirror* (cat. 89), the pastel *Girl with a Banjo* (cat. 74), and others.

35. Featured in her color print *The Letter* (cat. 59), Cassatt's Louis XVI secretary (*secrétaire à abattant*) is now in the Museum of Fine Arts, Boston. For a description of her painted Rococo-revival bed, see Biddle 1926, p. 107. The matching commode appears in the background of *The Child's Bath* (cat. 72). She may also have owned the white Louis XVI style chair in *Young Mother Nursing Her Child* (cat. 85).

36. Quoted in Ticknor 1927–28, pp. 151–52. See also Paris *Cadastre*, 1875.

37. Degas owned several works by Quentin de La Tour; see New York 1997, pp. 9–11, 129. Cassatt often visited the Musée Lecuyer (now called the Musée La Tour) in St. Quentin, which boasts over fifty pastels by this artist.
Greuze was particularly popular in the 1870s, even in the United States. *Godey's Lady's Book and Magazine* reported on the foreign sales and "the modern rage" for his work and described his 1756 painting *The Broken Eggs* (New York, The Metropolitan Museum of Art); see *Godey's Lady's Book and Magazine* 81, 483 (Sept. 1870), p. 287.

38. For various critical comparisons of Cassatt's and Morisot's art, see Ephrussi 1880, Echerac 1880, and Burty 1880.

39. Ephrussi 1880. Despite his criticism of Cassatt's work, Ephrussi apparently owned *The Child's Bath* (cat. 28) and may have owned an opera pastel (Shackelford, fig. 6); see Philippe Kolb and Jean Adhémar, "Charles Ephrussi (1849–1905) Ses Secrétaires: Laforgue, A. Renan, Proust, 'sa' Gazette des beaux-arts" in *Gazette des beaux-arts* 103 (Jan. 1984), pp. 30, 39, n. 9.

40. "A most remarkable . . .": Duranty 1879.

41. Earlier in the century, the bourgeois French had a large midday dinner and lighter supper. As the century progressed, it became fashionable to take a later evening meal, at eight or nine in the evening. Inspired by the English example, the French adopted the five o'clock tea to stave off hunger. High tea did not just involve the consumption of a beverage but rather of a meal, including sandwiches, cakes, or cookies. Only wealthy households, with several servants, could afford the luxury of preparing numerous meals for family and guests. See Martin-Fugier (note 4), pp. 272–74. Cassatt's family, as well as the people she knew socially, participated in this new ritual.

42. On Cassatt's Englishness, see for example Ephrussi 1880.
On her affinity with Millais, see, Huysmans 1881.
"A very effective . . .": ibid.

43. Cassatt had seen Dutch pictures during her visit to Holland with her mother in 1873, and many of her teachers and colleagues also visited Dutch museums between 1870 and 1875. They included Carolus-Duran, Fantin-Latour, Gérôme, Manet, and Monet. See Petra ten Doesschate-Chu, "French Realism and the Dutch Masters: The Influence of Dutch Seventeenth-Century Painting on the Development of French Painting Between 1830 and 1870," Ph.D. diss. (New York, Columbia University, 1972), pp. 6–7, 15.

44. Simon (note 5), p. 205.

45. Silvestre 1879b.

46. *Le Figaro* was a right-of-center newspaper that reflected the conservative views of the republican bourgeoisie. It was often critical of the popular press and governmental attempts to control freedom of the press in the 1877–79 period. A more sophisticated publication than many, it attracted literary-minded writers and published some notices in English. See Claude

Bellanger et al., *Histoire général de la presse française*, vol. 3 (1871–1940) (Paris, 1982), pp. 158–63, 193–95. For the essentially conservative nature of French republicanism during the 1870s and 1880s, see Roger Macgraw, *France 1815–1914: The Bourgeois Century* (Oxford, 1983), pp. 209–24.

The International Congress of Women's Rights received sympathetic coverage from republican newspapers even before the event took place; see Patrick Kay Bidelman, *Pariahs Stand Up! The Founding of a Liberal Feminist Movement in France, 1858–1889* (Westport, Conn., 1982), p. 104. I am grateful to Claire Goldberg Moses for pointing out this reference to me.

47. For the Congress and a discussion of the issues it dealt with, see Claire Goldberg Moses, *French Feminism in the Nineteenth Century* (New York, 1984), pp. 207–209.

48. See *Exposition des oeuvres de M. J.-J. Tissot organisée par L'Union centrale des arts décoratifs*, exh. cat. (Paris, 1883), repr. in Theodore Reff, ed., *Modern Art in Paris 1855–1900* (New York, 1981), p. 13; see also Susan P. Casteras, *Images of Victorian Womenhood in English Art* (New Haven/London, 1987), pp. 46–47. Tissot was a friend of Degas and Manet in the 1860s and 1870s.

49. In his discussion of the activities of chic Parisian women, *La Femme à Paris: Nos Contemporaines* (Paris, 1890), Octave Uzanne illustrated a woman at an embroidery frame (p. 322). Vermeer's *The Lacemaker* entered the Louvre not long after the French scholar Théophile Thoré-Bürger had rediscovered the artist—who had fallen into relative oblivion—and began to attribute paintings to his hand.

50. On objects in the work of Morisot and Cassatt, see Higonnet 1992, pp. 154–55.

51. Quoted in Ticknor 1927–28, p. 152.

52. Biddle 1926, p. 107.

53. On this portrait, see Higonnet 1992, pp. 135, 155–56. Although difficult to decipher, these *cartes de visite* resemble Cassatt's watercolor self-portrait (cat. 26). Hands were important to the artist early on: In 1873 she wrote, "In all of Velasquez [*sic*] pictures I can think of no beautiful hands, no! not one. Murillo's hands of the St. Elizabeth are exquisite but even in that picture there is a boy scratching his head in the most grotesque manner; indeed throughout I think the Spanish school lack taste"; Cassatt to Emily Sartain, Jan. 1, 1873, in Mathews 1984, p. 114.

54. Fénéon 1891; also quoted in Boston 1989, p. 72.

55. The view in *Young Girl at a Window* is most likely from the Cassatt's apartment at 13, avenue Trudaine. Katherine Cassatt wrote to her granddaughter: "You know we live up very high . . . but we have a balcony all along the front of the house from which we can see over the houses opposite, so that we have a magnificent view"; Katherine Kelso Cassatt to Katharine Cassatt, July 2, [1878], PMA.

56. Degas owned the drawing (cat. 43) for *Interior Scene*, as well as thirteen states of the etching; see New York 1997, pp. 240–41.

57. Norma Broude, "Edgar Degas and French Feminism, c. 1880: 'The Young Spartans,' the Brothel Monotypes, and the Bathers Revisited," *The Art Bulletin* 70, 4 (Dec. 1988), p. 647.

58. Cassatt to Louisine Havemeyer, Oct. 12, 1906, NGA. Cassatt wrote, ". . . the picture represented a moral rape or words to that effect, now that is just what Degas told me he meant to represent. . . ." For a discussion of this work and its various titles, see Theodore Reff, *Degas: The Artist's Mind* (New York, 1976), pp. 200–38; Ottawa 1988, no. 84, pp. 143–46; and Henri Loyrette, "Modern Life," in New York, The Metropolitan Museum of Art et al., *Origins of Impressionism*, exh. cat. (1994), pp. 278–80.

59. See Hollis Clayson, *Painted Love: Prostitution in French Art of the Impressionist Era* (New Haven/London, 1991).

CHILDHOOD AND MATERNITY

60. Huysmans 1881. In particular the critic deplored the work of English painter Henrietta Ward, whose historical subjects featured domestic settings. See Ellen C. Clayton, *English Female Artists* (London, 1876), vol. 2, pp. 164–65. Robert Cassatt sent his son Alexander a copy of Huysman's collected writings, *L'Art moderne* (Paris, 1883), upon its publication; see Robert S. Cassatt to Alexander Cassatt, May 16, 1883, PMA.

61. Ellen Key, *The Century of the Child* (1900; repr. New York/London, 1909), p. 45.

62. On French educational reforms, see Eugen Weber, *Peasants into Frenchmen: The Modernization of Rural France 1870–1914* (Stanford, 1976), pp. 308–309. The Society for the Prevention of Cruelty to Children was founded in the United States and in Great Britain in the 1880s, based on the Society for the Prevention of Cruelty to Animals, which began in Britain in 1824. In France similar philanthropic organizations for the

protection of children appeared in the 1860s; see Hugh Cunningham, *Children and Childhood in Western Society Since 1500* (London, 1995), p. 151.

63. For discussions of infant- and child-mortality statistics, see Cunningham (note 62), p. 90; and James R. Kincaid, *Child-Loving: The Erotic Child and Victorian Culture* (New York, 1992), p. 75.

64. On Morisot's images of wet-nurses, see Linda Nochlin, "Morisot's Wet Nurse: The Construction of Work and Leisure in Impressionist Painting," in idem, *Women, Art and Power and Other Essays* (New York, 1988), pp. 37–56.

65. Alfred Donné, *Conseils aux mères sur la manière d'élever les enfans nouveaux-nés, ou de l'éducation physique des enfans du premier âge* (Paris, 1842). See Ann F. La Berge, "Mothers and Infants, Nurses and Nursing: Alfred Donné and the Medicalization of Child Care in Nineteenth-Century France," *Journal of the History of Medicine* 46 (Jan. 1991), pp. 20–43. Donné's book was first published in the United States as *Mothers and Infants, Treatise on Nursing, Weaning, and the General Treatment of Young Children* (Boston, 1857), and was still widely used during the early years of the twentieth century.

For an overview of the increasing emphasis on the protection of children in the late nineteenth century, see Cunningham (note 62), pp. 134–46. On the development of clinics and welfare stations for infants, see ibid., pp. 153–54; and La Berge, pp. 37–41.

66. Illustrations for toybooks began as pen and ink sketches, to which shading and hue were added by using watercolor. The images were then transferred to colored woodblocks, which permitted the simultaneous printing of text and color illustrations. On the development of toybooks, see Tanya S. Yatzeck, "Toybooks," in Debra Mancoff, ed., *Life Imitates Art: The Aesthetic Movement: 1860–1900* (Beloit, Wis., 1987), p. 23. For more on the development of the toybook and the illustration of children's literature in the last half of the nineteenth century, see Walter Crane, *The Decorative Illustration of Books* (London, 1901); Brian Anderson, *Sing a Song of Sixpence* (Cambridge/London, 1986); and Ina Taylor, *The Art of Kate Greenaway* (London, 1991).

67. Huysmans 1883, pp. 211–12. Walter Crane's books were published in France by Hachette; see ibid., p. 213.

68. Kincaid (note 63), pp. 66–67.

69. Anne Higonnet, *Pictures of Innocence: The History and Crisis of Ideal Childhood* (Lon-

don/New York, 1998), pp. 53, 60, 61.

70. Geffroy 1886.

71. Many years later, Cassatt, still vexed, complained: "The jury consisted of three people, of which one was a pharmacist!"; see Cassatt to Ambroise Vollard, [1903], in Mathews 1984, pp. 281–83. In this letter, she also claimed that Degas had liked the painting and had "even worked on the background." For more on this painting, see Adelyn Dohme Breeskin, "Little Girl in a Blue Armchair—1878," in John Wilmerding, ed., Essays in Honor of Paul Mellon, Collector and Benefactor (Washington, D.C., 1986), pp. 39–45.

72. Harriet Chessman, "Mary Cassatt and the Maternal Body," in David C. Miller, ed., American Iconology (New Haven/London, 1993), pp. 248–50.

73. See Exposition universelle internationale de 1878, à Paris (Paris, 1878), ill. p. 135. See also Theodore Reff, Modern Art in Paris: World's Fair of 1878 (New York/London, 1981), p. 263, where the portrait is listed under "Cluysenaar (A.)" as "54. Une Vocation."

74. See Cunningham (note 62), p. 75; and Kincaid (note 63), pp. 64–65.

75. On Cassatt's use of a variety of models to suggest the universality of the mother-and-child theme, see Segard 1913, pp. 38–40, 160.

76. See Chessman (note 72), pp. 252–53.

77. "If only . . .": in Martin-Fugier (note 4), p. 322.

78. "No color . . .": Verlaine, in Robert James Bantens, Eugène Carrière: The Symbol of Creation (New York, 1990), p. 70.
On Degas's response to Carrière's works was not nearly so enthusiastic. They prompted him to exclaim, "They've been smoking again in the children's room"; Degas, in Allentown, Pennsylvania, Allentown Art Museum, Eugène Carrière 1849–1906: Seer of the Real, exh. cat. with intro. by Richard Teller Hirsch (1968), p. 7.

79. Throughout the 1860s, when the Cassatt family still resided in Pennsylvania, its members would have had access to the Philadelphia-based, serial publication Godey's Lady's Book and Magazine, which included regular articles on modern motherhood. See for example Jno. Stainback Wilson, M.D., "Position of Children in Sleep," vol. 66 (June 1863), pp. 579–80; "Right Food for Infants and Children," vol. 72 (Jan. 1866), p. 87; Mrs. Hopkinson, "Hygiene," vol. 74 (Mar. 1867), pp. 258–60; and Dr. Chas. P. Uhle, "The Dress of Chil-

dren," vol. 77 (Sept. 1868), pp. 269–79. The Cassatt family correspondence is filled with descriptions of ailments and potential cures, as its members dealt first with Lydia's Bright's disease and then with Katherine's recurring episodes of congestive heart failure.

80. On bathing and hygiene in nineteenth-century France, see Weber (note 3), pp. 59–61.
On the plumbing at Beaufresne, see Cassatt to Paul Durand-Ruel, [summer 1894], in Mathews 1984, p. 260; and Cassatt to Ada Pope, Apr. 7, [1900], in Mathews 1984, p. 274.

81. Some recent scholars have posited that Degas's nude bathers may actually have been prostitutes, who bathed often, between clients. See for example Eunice Lipton, Looking into Degas: Uneasy Images of Women and Modern Life (Berkeley, 1986); and Clayson (note 59).

82. Silvestre 1881a.

83. Geffroy 1886. During the cataloguing of the contents of Degas's studio after the artist's death, both Study (cat. 48) and At the Theater (Shackelford, fig. 3) were misidentified as being by Degas; see Cassatt to Louisine Havemeyer, Dec. 12, [1917], in Mathews 1984, p. 330.

84. Tamar Garb, "The Forbidden Gaze: Women Artists and the Male Nude in Late Nineteenth-Century France," in Kathleen Adler and Marcia Pointon, eds., The Body Imaged: The Human Form and Visual Culture Since the Renaissance (Cambridge, 1993), pp. 33–42.
On the upper-class American women who purchased Degas's bathers, see Hirshler, pp. 184–85. On the Havemeyers' purchase of Courbet's Torso of a Woman, see Weitzenhoffer 1986, pp. 22, 79–80; and New York 1993, cat. 137, p. 315, and pp. 22–23, 214.

85. Sigmund Freud, quoted in Kincaid (note 63), p. 223.

86. Lois Cassatt to Eliza Cassatt, [Dec. 1882], in Mathews 1994, pp. 162–63.
On traditional mourning practices at this time, see Martin-Fugier (note 4), pp. 331–36.

87. Katherine Kelso Cassatt to Katharine Cassatt, Jan. 21. 1885, in Mathews 1984, p. 187.

88. Michelle Perrot, "Roles and Characters," in Perrot, Ariès, Duby (note 4), p. 191.

89. For a late-nineteenth-century image of a child—the Victorian painter T. C. Gotch's Child Enthroned—which was under-

stood by contemporaries to portray the Christ Child, see Cunningham (note 62), p. 75 and cover ill.

90. See Geffroy 1904. In Renaissance Fancies and Studies ([2d ed.]; London/New York, 1909), pp. 154–61), Vernon Lee (the nom de plume of Violet Paget) offered an explanation of the late nineteenth century's taste for early Italian "primitives." She noted the naturalism with which Desiderio, Donatello, Jacopo della Quercia, and Mino da Fiesole depicted children, in contrast to the idealization of adolescent nudity by ancient Greek sculptors. Cassatt and Paget knew each other by September 1891, when the artist arranged for the writer to see works by Degas in the Faure collection; see Cassatt to Paul Durand-Ruel, [Sept. 1891], in Mathews 1984, p. 225, and Venturi 1939, vol. 2, p. 114. By 1906 the two seem to have had a falling out, since Cassatt wrote to Louisine Havemeyer on Dec. 27 of that year that Paget had once stayed with her and "never will again"; see Mathews 1994, p. 273.
For Paul Vitry, describing Gustave Dreyfus's collection of Renaissance art (see note 95), the appeal of Italian Renaissance representations of the Christ Child and Saint John derived from the directness and naturalism with which they were achieved; see Paul Vitry, "La Collection de M. Gustave Dreyfus (sculpture)," Les Arts 72 (Dec. 1907), p. 10.

91. See Nancy Mowll Mathews, "Mary Cassatt and the 'Modern Madonna' of the Nineteenth Century," Ph.D. diss. (New York University, 1980).

92. Eugène Piot, "Exposition universelle: Sculpture à l'exposition rétrospective du Trocadéro," Gazette des beaux-arts 18 (1878), pp. 576–600.

93. "They express . . .": ibid., p. 594.
For a contemporary discussion of Beatrice of Aragon and other Renaissance sculptures in the Louvre, see Louis Courajad, "Observations sur deux bustes du Musée de Sculpture de la Renaissance au Louvre," Gazette des beaux-arts 28 (1883), pp. 28–36. I am grateful to Bruce Weber for pointing this article out to me. The bust of Beatrice of Aragon was copied in plaster, and casts were disseminated to many art schools. By the late 1880s, it had appeared in paintings by a number of Americans, including Emil Carlsen's Unknown Woman (1888; New York, Berry-Hill Galleries); and Charles Courtney Curran's Alcove in the Art Students' League (1888; The Art Institute of Chicago).

94. Wedmore 1883a. He employed the word amateur to connote its meaning in French: collector.

95. Gustave Dreyfus had purchased art both from Piot and the painter Charles Timbal and by 1872 was well known in Paris as a collector. Both Gustave and his son Carle were friendly with the critic Charles Ephrussi, who wrote sympathetically on Impressionism. Carle became curator of objects at the Musée du Louvre and the Union centrale des arts décoratifs. He left a significant collection of pastels by Degas to the Louvre. On Gustave Dreyfus, see Gaston Migeon, *Gustave Dreyfus: Vice-Président de la Société des Amis du Louvre* (Paris, 1929).

96. On the Havemeyers' purchase of the work by Mino da Fiesole, see Weitzenhoffer 1986, pp. 104, 105; and New York 1993, p. 218.
"My Florentine madonna": Louisine Havemeyer, in Weitzenhoffer 1986, p. 104. The *Mother and Child* (1888) to which she referred was destroyed in a fire; see ibid., pl. 54.

97. Desiderio's *Bust of a Child* was owned by painter-collector Charles Timbal and was in Dreyfus's collection after 1870; see Louis Courajad, "Eugène Piot et les objets d'art légués au Musée du Louvre," *Gazette des beaux-arts* 3 (1890), p. 404.
Cassatt owned a gesso relief attributed to Donatello, which she displayed on an easel in the parlor of her Paris apartment; see Havemeyer 1993, p. 282, and Weitzenhoffer 1986, p. 142. Cassatt's friend James Stillman owned a stucco relief also attributed to Donatello; perhaps Cassatt sold hers to him. For Stillman's piece, see *Metropolitan Museum of Art Bulletin* 1922, p. 51.

98. On the connection between Italian frescoes and Impressionist surfaces, see Anthea Callen, "The Unvarnished Truth: Matteness, 'Primitivism,' and Modernity in French Painting. c. 1870–1907," *The Burlington Magazine* 136, 1100 (Nov. 1994), p. 738. See also Jean Paul Bouillon, "Degas, Bracquemond, Cassatt: Actualité de l'Ingrisme autour de 1880," *Gazette des beaux-arts* 111 (Jan.–Feb. 1988), pp. 125–27.
"I think that . . .": Cassatt to Alexander Cassatt, June 22, 1883, in Mathews 1984, pp. 169–70.
"Style of the *primitifs* . . .": Hoschedé 1881.

99. Cassatt to Theodate Pope, Feb. 19, [1911], in Mathews 1984, pp. 305–306. For Pater's writings on Botticelli, see for example Walter Pater, *The Renaissance,* intro. by Arthur Symons (1873; New York, n. d.), pp. 41–51. For Theodore Childs on the painter, see note 135 below. Another conduit to this particular panel by Botticelli may have been the writing of the American William J. Stillman, which Cassatt admired; see Cas-

satt to Bertha Palmer, Oct. 11, [1892], and Cassatt to Rose Lamb, Nov. 30, [1892], in Mathews 1984, pp. 238–39, respectively. Stillman published, beginning in 1892, a series of articles in *Century Magazine* under the heading "Old Italian Masters Engraved by Timothy Cole with Historical Notes by W. J. Stillman." The collected essays appeared as a book with the same title (New York, 1892). The chapter on Botticelli (pp. 155–65) contains a plate of the artist's *Madonna of the Rose Garden* (opp. p. 161).

100. Renouf's composition was lent by the Corcoran Art Gallery, Washington, D.C.

101. Cassatt, in Havemeyer 1993, p. 225.

102. Other boating scenes that may have influenced Cassatt's are two that Gustave Caillebotte showed in the 1879 Impressionist exhibition, *Boating Party* and *Oarsmen* (both private collections; see The Art Institute of Chicago et al., *Gustave Caillebotte: Urban Impressionist,* exh. cat. [Chicago, 1996], nos. 23, 24, pp. 75–77). In each of these works, the angle of the boat creates an emphatic, arrowlike shape; and the figures sit close to the picture plane. Caillebotte's interest was the physical effort required to propel the vessel through the water, which he suggested by emphasizing the postures of his rowers' powerful bodies and the strength with which they pull on the oars. Striking images of sport and athleticism, these scenes by Caillebotte are far removed from Cassatt's more serene and abstract composition.

103. "The woman you knew": Cassatt to Rose Lamb, Apr. 26, 1895, in Weitzenhoffer 1986, p. 105.
Cassatt kept *The Boating Party* for many years, noting on several occasions that it was painted the year Ellen Mary was born. She apparently intended to give the work to her niece; when she showed no interest in it, the artist sold it to the Durand-Ruels; see Cassatt to Louisine Havemeyer, Mar. 22, 1920, in Mathews 1984, p. 332.

Symbolism and the Allegory of *Modern Woman*

104. Cassatt to Berthe Morisot, [1890], in Mathews 1984, p. 215. For Morisot's response to the exhibition, see Berthe Morisot, *Correspondence with Her Family and Friends,* ed. Denis Rouart, trans. Betty W. Hubbard, (London, 1987), p. 174.

105. These subjects are not unlike those explored by Edgar Degas in the great series of women bathing, washing and drying themselves, and combing their hair, which

he showed in the 1886 Impressionist exhibition (see Hirshler, figs. 7, 9).

106. See Boston 1989, p. 65.

107. See ibid. Cassatt seems to have been oblivious to the fading of prints; she hung her collection of Japanese prints in a sunbathed corridor at Beaufresne.

108. Roger Marx, "Le Rôle et l'influence des arts de l'extrême orient et du Japon," *Le Japon artistique* 2, 36 (Apr. 1891), pp. 141–48. Bing inaugurated this publication in 1888 and dedicated it to all aspects of Japanese culture. The journal, which continued until 1891, included full-page reproductions of prints by leading Japanese printmakers, and featured articles by such critics as Burty, Duret, and the Goncourt brothers, in addition to Marx.

109. Shapiro (Boston 1989, pp. 65–67, 71–72); and Colta Ives (New York, The Metropolitan Museum of Art, *The Great Wave: The Influence of Japanese Woodcuts on French Prints,* exh. cat. by Colta Ives [1974]).

110. Boston 1989, pp. 43–43.

111. Higonnet 1992, p. 192.

112. Jean Moréas, "Le Manifeste du symbolisme," *Le Figaro,* Sept. 18, 1886. For an English translation, see John Rewald, *Post Impressionism: From Van Gogh to Gauguin* (New York, 1956), p. 148.

113. Cassatt's letters mention dinners with Mallarmé from 1888 on. On his invitation to Cassatt to contribute an illustration to his publication *Pages,* see Stéphane Mallarmé to Edmond Deman, Apr. 14, 1889, in Mondor 1984, vol. 11, p. 46, n. 2. The book appeared without anything of Cassatt's reproduced.

114. Mathews (note 91), p. 82.

115. Albert Aurier, "Le Symbolisme en peinture—Paul Gauguin," *Mercure de France* 2, 15 (Mar. 1891), p. 157; repr. in idem, *Oeuvres posthumes* (Paris, 1893), p. 215. For an English translation of this piece, see Herschel B. Chipp, *Theories of Modern Art* (Berkeley/Los Angeles, 1968), pp. 89–91. Gauguin admired Cassatt's art. He wrote to his wife in 1885 that, if she needed money, she could sell their drawing by Degas, but not their Manet or their Cassatt, a pastel loge scene (cat. 19); see Paul Gauguin to Mette Gauguin, Nov. 1885, in Malingue 1946, p. 75.

116. She turned down the invitation because of a prior commitment to participate in that year's Impressionist exhibition; see Cassatt to Octave Maus, Dec. 13, 1885,

in Brussels 1993, pp. 29, 175.2, n. 42. She did, however, participate in the group's 1892 exhibition; see Lifetime Exhibition History (Brussels 1892).

117. Cassatt informed Louisine Havemeyer that she did not believe in a *personal God . . .* [or in a] Master of the Universe." Rather, she continued, "I think we are surrounded by spiritual forces but I agree with [J. H.] Fabre [the nineteenth-century scientist] in thinking the human brain unfit to grasp the universe." See Cassatt to Louisine Havemeyer, Dec. 11, [1913], in Mathews 1984, pp. 313–14. On the Cassatt family's lack of religious affiliation, see Mrs. Haldeman to Eliza Haldeman, Dec. 18, 1866, in Mathews 1994, p. 36.

According to the philosopher William James, the Society for Psychial Research was founded in 1882 to bring together science and the occult, by exploring "hypnotic subjects, mediums, clairvoyants, and to collect evidence concerning apparitions, haunted houses, and similar phenomena"; see Gardner Murphy and Robert O. Ballou, eds., *William James on Psychical Research* (New York, 1960), p. 29. Myers's book was published in New York, London, and Toronto in 1903.

On Cassatt's interest in Spiritualism, see two letters from her to Theodate Pope, Apr. 21, 1903, in Sweet 1966, p. 179; and Nov. 30, [1903], in Mathews 1984, pp. 289–90. See also Cassatt to Minnie Cassatt, Feb. 2, 1906, in Sweet 1966, p. 180; Cassatt to Louisine Havemeyer, Dec. 11, [1913], in Mathews 1984, pp. 313–14; Cassatt to Theodate Pope, Oct. 12, [1910], in Mathews 1984, pp. 300–301; and Cassatt to Electra Havemeyer [Webb], May 27, 1909, in Sweet 1966, p. 181.

118. See Ann Braude, *Radical Spirits: Spiritualism and Women's Rights in Nineteenth-Century America* (Boston, 1989), pp. 2–3.

119. Between 1889 and 1895, a number of leading critics promoted art exhibitions that related women and nature; see Silverman (note 33), pp. 202–206.

120. The wife of the Chicago hotelier and financier Potter Palmer, society matron Bertha Honoré Palmer was active in the arts locally, nationally, and internationally. A feminist and activist, she supported the charitable and social-reform programs of Chicago's Woman's Club and Jane Addams's Hull House. Her pathbreaking activities as the President of the Board of Lady Managers of the World's Columbian Exposition are chronicled in Ishbel Ross, *Silhouette in Diamonds: The Life of Mrs. Potter Palmer* (New York, 1960); Jeanne Madeline Weimann, *The Fair Women: The Story of The Woman's Building, World's Columbian Exposition, Chicago 1893*

(Chicago, 1981); and Virginia Grant Darney, "Women and World's Fair: America International Expositions, 1876–1904," Ph.D. diss. (Atlanta, Emory University, 1982), pp. 65–124.

Palmer first approached the artist Elizabeth Gardner, an American also living in Paris. When Gardner turned down the commission because she felt it would be too demanding and taxing (see Mathews 1994, pp. 202–203), Palmer, at the suggestion of art agent Sara Tyson Hallowell, turned to Cassatt and MacMonnies. For more on MacMonnies, see Mary Smart, *A Flight with Fame: The Life and Art of Frederick MacMonnies* (Madison, Conn., 1996).

121. On the Palmers' purchase of Cassatt's prints, see sales records for Mr. and Mrs. Potter Palmer, AIC. These archives also establish that, at the same time the Palmers acquired works by Cassatt, they also bought examples by Symbolists Maurice Denis and Paul Sérusier.

For Cassatt on Mrs. Palmer, see Sweet 1966, p. 136.

122. When the fair was dismantled, at the end of October 1893, Bertha Palmer paid to have the murals stored in Chicago. They seem to have disappeared around 1911. For more on their history, see Sally Webster and Carolyn Kinder Carr, "Mary Cassatt and Mary Fairchild MacMonnies: The Search for Their 1893 Murals," *American Art* 8, 1 (winter 1994), pp. 53–69.

123. MacMonnies, on the other hand, had no qualms about accepting the commission. Her decision to go forward was facilitated not only by her first-hand experience as a student of Puvis's, but also by her access to a large studio her sculptor husband, Frederick MacMonnies, had set up in Paris to execute his own commission for the fair, a massive fountain for the Grand Basin. See Smart (note 120), p. 112.

"Speaking of . . .": Camille Pissarro to Lucien Pissarro, Oct. 2, 1892, in Sweet 1966, p. 133.

124. "To decorate . . .": Aurier (note 115). For an English translation, see Chipp (note 115), p. 92.

"Gradually I began . . .": Cassatt to Louisine Havemeyer, [spring 1892], in Mathews 1984, p. 229, n. 2.

125. Bertha Palmer to Sara Hallowell, Feb. 24, 1892, in Webster/Carr (note 122), p. 58. See also Robert Rydell, "A Cultural Frankenstein? The Chicago World's Columbian Exposition of 1893," in *Grand Illusions: Chicago's World's Fair of 1893* (Chicago, 1993), p. 156. Rydell aptly observed: "In the Woman's Building, as in the exposition as a whole, pursuit of the civilized

ideal required the representation of its counterpart–savagery."

In addition to the tympanum murals by Cassatt and MacMonnies, the Lady Managers commissioned four smaller panels— from Lydia Field Emmet, Lucia Fairchild Fuller, Amanda Brewster Sewall, and Rosina Emmet Sherwood—to hang on the east and west walls of the main exhibition hall. See Pauline King, *American Mural Painting: A Study of the Important Decorations by Distinguished Artists in the United States* (Boston, 1901), pp. 87–88; and Weimann (note 120), pp. 310–12.

Palmer's plans also called for exhibits on women's arts-and-crafts production over four hundred years, a library of books by and about women, a model kitchen, and meeting rooms for women's congresses; see Weimann (note 120).

Palmer, it turned out, asked a great deal of the women she had involved in the project, forcing them to meet challenges never before before faced by women anywhere. Hayden, who was young and inexperienced, seems to have had a breakdown during the process of designing and overseeing construction of the Woman's Building and appears never to have designed anything else of significance. For more on Hayden, see Weimann (note 120), pp. 145–57; and Madeleine B. Stern, *We the Women: Career Firsts of Nineteenth-Century America* (New York, 1963).

126. On MacMonnies's admiration of Puvis, see Eleanor Greatorex, "Mary Fairchild MacMonnies," *Godey's Magazine* 126, 755 (May 1893), p. 624.

127. Cassatt to Bertha Palmer, Oct. 11, [1892], in Mathews 1984, p. 238.

128. The division of the mural into three sections may also reflect yet again the influence of tripartite Japanese screens.

129. On Cassatt's concerns about the contract, see Cassatt to Sara Hallowell, [July 23?, 1892], in Mathews 1984, p. 231.

"[Millet] does not . . .": Mary MacMonnies to Bertha Palmer, Aug. 22, 1892, AIC.

"Himself a painter": Sara Hallowell to Bertha Palmer, July 22, 1892, in Mathews 1984, p. 230. Palmer does not seem to have been totally receptive to Cassatt's demand for greater remuneration. She wrote Hallowell: "Of course it is unfortunate that Miss Cassatt had to build a studio which has increased her expenses, but she is well enough off to make this tremendous step on the road to fame"; Bertha Palmer to Sara Hallowell, Aug. 3, 1892, in Mathews 1984, p. 233.

Despite Cassatt's agreement to deliver the mural by mid-February 1893, it did not

arrive in Chicago until April. On the delivery schedule, see Bertha Palmer to Sara Hallowell, Aug. 3, 1892, in Mathews 1984, p. 232. On Cassatt's substitution of a photograph for a sketch, see Mathews 1994, p. 211; and Cassatt to Bertha Palmer, Oct. 11, [1892], in Mathews 1984, p. 237.

130. Cassatt to Bertha Palmer, Dec. 1, [1892], in Mathews 1984, p. 241; this letter is also in Sweet 1966, pp. 132–33.

131. On the great interest of nineteenth-century artists in Gozzoli's cycle in Pisa, see George Manning Tapley, Jr., "The Mural Paintings of Puvis de Chavannes," Ph.D. diss. (Minneapolis, University of Minnesota, 1979), pp. 79, 181–82.

132. On the decorative nature of her borders, see Cassatt to Mary MacMonnies, [Dec. 1892], in Mathews 1984, pp. 243–44.

The borders, which Cassatt considered to be essential to the overall structure of her composition, created something of a furor in relationship to MacMonnies's *Primitive Woman*, with its much thinner and less significant floral border. Cassatt was shocked when Palmer wrote to say that the width of her borders would require MacMonnies to revise her design, in order to make the proportions of the elements in her composition the same as those of Cassatt's; see Weimann (note 120), pp. 207–208. MacMonnies, who minimized her borders to preserve the sense of spatial unity between her mural's three parts, was devastated; she refused to make substantial changes, citing the murals in the Panthéon in Paris, "where each artist painted his design according to his taste, without regard to the others and with no sort of uniformity of treatment"; Mary MacMonnies to Bertha Palmer, Oct. 7, 1892, PMA. Cassatt sided with MacMonnies: "Considering the immense height at which the pictures will be placed & the distance apart they will be, we agreed that unity of any kind was not necessary"; Cassatt to Mary MacMonnies, [Dec. 1892], in Mathews 1984, p. 244. This problem resulted from the lack of organization of the Exposition's managers; MacMonnies and Cassatt had not been provided with final dimensions for their murals until late in the fall of 1892.

133. The discovery of Botticelli's frescoes in the Villa Lemmi, in Fiesole, caused quite a sensation in the European art world. In an attempt to preserve them, the Louvre purchased both frescoes in 1882 for 76,000 francs. Charles Ephrussi, a friend of Cassatt, wrote ecstatically about them in the *Gazette des beaux-arts*, adding to their celebrity; see Charles Ephrussi, "Deux Fresques du Musée du Louvre," *Gazette*

des beaux-arts 25 (1882), pp. 475–83.

MacMonnies's dedication to copying the frescoes so impressed the director of the Louvre that he reportedly offered to buy her paintings, saying, "such copies were invaluable"; see Greatorex (note 126), p. 630. In a letter Hallowell wrote to Palmer, she mentioned she had plans for MacMonnies's copies; see Sara Hallowell to Bertha Palmer, Nov. 28, 1892, AIC. While she did not describe her idea, it may have been to display the copies in the Woman's Building. The copies were exhibited at The Art Institute of Chicago in 1911; see clipping from *Chicago Post*, July 29, 1911, AIC.

134. See for example W. J. Stillman, *Old Italian Masters* (New York, 1892), pp. 159–65.

135. For various twentieth-century approaches to the iconography of *Primavera* and other works by Botticelli, see E. H. Gombrich, "Botticelli's Mythologies: A Study in the Neoplatonic Symbolism of His Circle," *Journal of the Warburg and Courtauld Institutes* 8 (1945), pp. 7–60; Mirella Levi d'Ancona, *Botticelli's "Primavera": A Botanical Interpretation Including Astrology, Alchemy, and the Medici* (Florence, 1983); Charles Dempsey, *The Portrayal of Love: Botticelli's "Primavera" and Humanist Culture at the Time of Lorenzo the Magnificent* (Princeton, N.J., 1992); and Joanne Snow-Smith, *The "Primavera" of Sandro Botticelli: A Neoplatonic Interpretation* (New York, 1993), p. 228.

"No words . . .": Theodore Childs, "Sandro Botticelli," *Harpers New Monthly Magazine* 77 (Aug. 1888), p. 466. See also Walter Pater's comments on Botticelli's poetic, abstract qualities, quoted in Donald Hill, ed., *The Renaissance: Studies in Art and Poetry* (Berkeley, 1980), p. 40.

136. Cassatt's memory of Baudry's decorations for the Opéra may have been kept alive by a fully illustrated book of the cycle; see E. About, *Peintures décoratives du grand foyer de l'Opéra par Paul Baudry* (Paris, 1876).

Particularly relevant to their project were Besnard's *Homme primitif* and *Homme moderne*, which he contributed, along with six other panels, to decorate the Ecole de pharmacie in Paris; see Gabriel Mourey, *Albert Besnard* (Paris, 1906), pp. 73–77. While Besnard's compositions are totally different in style from Cassatt's and MacMonnies's murals, they represent a contemporary pairing of the ages of man. These panels were exhibited in 1887 at the sixteenth annual Exposition internationale de peinture, held at the Galerie Georges Petit, Paris. Cassatt, who visited this establishment often, probably saw this exhibition. On the sixteenth annual Exposition internationale de peinture, see Rewald (note 112), p. 63. On the role Georges Petit played in encouraging a *juste milieu*, see Robert Jensen, *Marketing Mod-*

ernism in Fin-de-Siècle Europe (Princeton, N.J., 1994), pp. 65, 138–50. In her correspondence, Cassatt mentioned numerous visits to the gallery, which showed the work of both fashionable and avant-garde artists, such as Claude Monet.

137. See Marie Jeannine Aquilino, "Painted Promises: The Politics of Public Art in Late Nineteenth-Century France," *The Art Bulletin* 75, 4 (Dec. 1993), pp. 697–712. On Puvis's murals, see Tapley (note 131), p. 26.

138. Bertha Palmer to Mary MacMonnies, Jan. 4, 1893, Archives, Chicago Historical Society. Palmer was quite knowledgable about Puvis's style and technique. In 1891 she and her husband purchased from the Galerie Durand-Ruel a reduced replica (*The Sacred Grove, Beloved of the Arts and Muses*, 1884/89; The Art Institute of Chicago) by the artist of his mural for the Musée des beaux-arts, Lyon; see John Hallmark Neff, "Puvis de Chavannes: Three Easel Paintings," *The Art Institute of Chicago Museum Studies* 4 (1969), p. 68. Cassatt may have met Puvis through her connection to the Manet and Morisot families in the 1870s.

139. Amiens, Musée de Picardie, *Les Peintures murales de Puvis de Chavannes à Amiens*, exh. cat. by Dominique Vieville (1989), p. 212.

140. Robinson reported meeting Cassatt in Giverny on Oct. 3, 1892, when she spoke to him of her Chicago mural; see Theodore Robinson diary, Oct. 3, 1982, Frick Art Reference Library, New York.

Denis's painting decorated the residence of Henri Lerolle, the father-in-law of collector Alexis Rouart and a founder of the Union centrale des arts décoratifs. It is thus possible that Cassatt may have seen it. See Anne Distel, *Impressionism: The First Collectors, 1874–1886* (New York, 1990), p. 190; and Lyons, Musée des beaux-arts et al., *Maurice Denis*, exh. cat. (1994), p. 156.

On Puvis's iconography, see Claudine Mitchell, "Time and the Idea of Patriarchy in the Pastorals of Puvis de Chavannes," *Art History* 10, 2 (June 1987), p. 192.

141. "I have tried . . .": Cassatt to Bertha Palmer, Oct. 11, [1892], in Mathews 1984, p. 237; this letter is also in Sweet 1966, p. 130.

"This is . . .": Cassatt, quoting a critic, to Bertha Palmer, Oct. 11. [1892], in Mathews 1984, p. 237.

Not surprisingly the topic of dress reform was current at the World's Columbian Exposition. The National Council of Women even recommended several dress styles for fair-going purposes. Reformers encouraged women to wear simple, loose-waisted, cotton dresses with divided skirts

and with pockets, all of which allowed them greater freedom of movement and activity. Young mothers were urged to dress reasonably, not only for their own health and comfort, but also to set an example for their children to lead a natural life. See "Dress Reform at the World's Fair," *Review of Reviews* 7 (Apr. 1893), pp. 312–16; and Weimann (note 120), pp. 531–37. For an excellent summary of the Dress Reform Movement in the United States, see Sally Buchanan Kinsey, "A More Reasonable Way to Dress," in Boston, Museum of Fine Arts, *"The Art That Is Life": The Arts and Crafts Movement in America, 1875–1920*, exh. cat. by Wendy Kaplan et al. (1987), pp. 358–67.

142. In American art, the banjo was associated with slavery and with minstrel shows. It appears in paintings by Thomas Eakins, William Sidney Mount, Henry Ossawa Tanner, and others. See Lawrence Libin, *American Musical Instruments in The Metropolitan Museum of Art* (New York, 1985), p. 14; and Celia Betsky, "American Musical Paintings, 1865–1910," in Clinton, New York, Hamilton College, Fred L. Emerson Gallery, *The Art of Music: American Paintings and Musical Instruments, 1770–1910*, exh. cat. (1984), pp. 51–57.

143. "I consider your panel . . .": Bertha Palmer to Mary Cassatt, Dec. 15, 1892, in Mathews 1984, p. 242.

144. Florence F. Miller, "Art in the Woman's Section of the Chicago Exhibition," *Art Journal* 55 (1893), supp. p. xiv.

145. "Commitment to see . . .": Sally Webster, "Mary Cassatt's Allegory of Modern Woman," *Helicon Nine* 1 (fall/winter 1979), p. 42.

146. The term "new woman" was used by novelist Sarah Grand (the *nom de plume* of Frances E. Clark) in her important essay "The New Aspect of the Woman Question," *North American Review* 158 (Mar. 1894), pp. 270–76; see also idem, "The Modern Girl," *North American Review* 158 (June 1894), pp. 706–14. In France many journals in the 1890s portrayed women who left home and family to pursue careers as masculine and menacing; see Silverman (note 33), pp. 63–65.

Palmer's political skills were revealed in the way she jockeyed between the Queen Isabella Society (a group of ardent suffragists led by Susan B. Anthony), and the various men's organizations that ran the fair. Although supportive of a separate Board of Lady Managers, which the Queen Isabella Society opposed (demanding, in the fair's presentation of women, true equality and integration with men), Palmer did fight for combining exhibits related to men and to women in appropriate exhibition buildings. Because the male leadership opposed such arrangements, ultimately Palmer reconciled herself to a separate-but-equal building for women. For more in-depth discussions of these events, see Rydell (note 125), pp. 151–57; and Judy Sund, "Columbus and Columbia in Chicago, 1893; Man of Genius Meets Generic Woman," *The Art Bulletin* 75, 3 (Sept. 1993), pp. 443–70.

147. Cassatt to Bertha Palmer, Oct. 11, [1892], in Sweet 1966, p. 131.

148. For a seventeenth-century example, see Anthony van Dyck, *Self-Portrait with a Sunflower*, c. 1635/36, London, Collection of the Duke of Westminster. For a medieval image of a Madonna with a sunflower springing from her halo, see Elizabeth Haig, *The Floral Symbolism of the Great Masters* (New York/London, 1913), p. 199.

149. Sometime between November 1895 and June 1897, Degas acquired from the dealer Ambroise Vollard van Gogh's *The Sunflowers* (Berlin, Kunstmuseum); see New York 1997, pp. 12–13.

150. See J. H. Fabre, *Social Life in the Insect World* (New York, 1912), p. 2.

151. Elizabeth von Arnim, *Elizabeth and Her German Garden* (1st ed., 1898; London, 1899), p. 141.

152. "Is this wholesale . . .": Cassatt to Louisine Havemeyer, Aug. 30, 1916, NGA.
"Women must . . .": Cassatt to Louisine Havemeyer, Aug. 13, 1914, NGA.

153. "Almost all . . .": Cassatt to Theodate Pope, Feb. 19, [1911], in Mathews 1984, p. 306.

Fig. 1. Edgar Degas
(French; 1834–1917).
*Mary Cassatt at the Louvre:
The Paintings Gallery*, 1879–
80. Etching, aquatint, dry-
point, and *crayon électrique*,
heightened with pastel,
on tan wove paper; plate:
30.5 x 12.6 cm. The Art
Institute of Chicago, be-
quest of Kate L. Brewster,
1949.515.

Pas de deux: Mary Cassatt and Edgar Degas

George T. M. Shackelford

"She has infinite talent," mused Edgar Degas to Ambroise Vollard, gazing at Mary Cassatt's *Portrait of a Little Girl* (cat. 11). "The first sight of Degas['s] pictures was the turning point in my artistic life," Cassatt wrote in 1915.[1] No artist was more important to Cassatt than her mentor Degas, and, with the possible exception of Edouard Manet, no contemporary was more important to the difficult and discerning Degas than this young woman from Pennsylvania. United by their upper-middle-class backgrounds, they also shared a restless, vivid intelligence and a predilection for self-criticism that led them both to reject the conservative artistic directions that had seemed so promising to them at the beginning of their careers. From their meeting in the late 1870s, they remained lifelong friends, despite their fiercely independent natures. Their friendship was not without its moments of frustration, however, in large part due to Degas's irritable character and Cassatt's uncompromising sense of dignity and pride. When asked how she maintained a long-term relationship with the temperamental artist, Cassatt told a friend:

Oh, I am independent! I can live alone and I love to work. Sometimes it made him furious that he could not find a chink in my armor, and there would be months when we just could not see each other, and then something I painted would bring us together again and he would go to Durand-Ruel's and say something nice about me, or come to see me himself.[2]

It is not easy to construct a picture of their relationship, nor can this picture ever be complete. This is because there are no extant written communications between them: In the body of more than one thousand known letters by Degas, there is none to Cassatt; she is said to have destroyed all her letters from Degas. And Degas seems not to have saved letters addressed to him, including those from his Impressionist comrades, so Cassatt's letters to Degas are lost as well.[3] Thus our understanding of the nature of their friendship and interaction must be built on what they said to others, commentary of

family and friends, statements of critics, and comparison of their works. In the absence of firsthand evidence about their relationship, some historians have proposed that they were romantically involved, although nothing we know about these two individuals would lead to such a conclusion.

How did they come to know of each other? We are told that, when in Antwerp early in the summer of 1873, Cassatt made the acquaintance of the French artist Joseph Gabriel Tourny, who was there on an official commission to copy paintings by Peter Paul Rubens. Tourny, a watercolorist and printmaker, had been an occasional colleague of the young Degas at the Académie française in Rome, where Tourny had gone as a winner of the Prix de Rome in engraving. Their friendship is commemorated in Degas's etched portrait *The Engraver Joseph Tourny*, executed in Rome in 1857.[4]

Tourny seems to have introduced Cassatt's work to Degas in 1874, at that year's Salon. According to Achille Segard, Cassatt's first biographer, Tourny led Degas to her painting of a red-haired woman in a lace veil (fig. 2). "It's true," Degas is supposed to have said, examining the work closely, "*Here* is someone who feels as I do."[5] Degas's reported response seems uncharacteristically sentimental: Perhaps Cassatt told Segard the story while in a mood of wistfully imaginative recollection. It is unlikely that the usually incisive Degas would have seen his own feelings mirrored in the technically accomplished but picturesque paintings that Cassatt submitted to the Salons in the early 1870s, such as *During Carnival* (cat. 2) and *Offering the Panal to the Bullfighter* (cat. 5), works still imbued with the spirit of her teachers Charles Chaplin and Thomas Couture. By 1874 Degas was at the vanguard of the movement to reject such narratives, with their flirtatious overtones, preferring the offbeat and off-center. A more realistic scenario is that Tourny told Degas about the art of a young woman who had become an admirer of the painter's

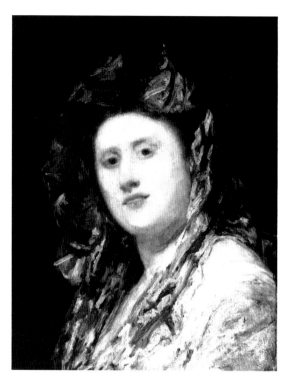

Fig. 2. Mary Cassatt. *Ida*, c. 1874. Oil on canvas; 58.4 x 45.7 cm. Private collection. Photo: New York, Sotheby's, *Important American Paintings, Drawings, & Sculptures*, sale cat. (Dec. 3, 1987), lot 189.

work. After her return to Paris from Antwerp, she had seen by chance, or had sought out by design, the art of Degas, pressing her face to the window of a gallery or shop on the boulevard Haussmann to see a picture or two by him on display.[6]

The exact date and circumstances of the first meeting between Cassatt and Degas cannot be determined. In 1877 Cassatt persuaded her young friend Louisine Elder (later Havemeyer) to purchase the first of the sixty-five works by Degas that eventually figured in her collection, the recently completed *Rehearsal of the Ballet* (Hirshler, fig. 1).[7] The two artists knew each other by some time in 1877, when Degas suggested to Cassatt, whose painting—perhaps a portrait of her sister (now lost)—had been rejected by the Salon jury, that she join the so-called "intransigents," who were becoming known as the Impressionists. In addition to Degas, the core group comprised Caillebotte, Cézanne, Guillaumin, Monet, Morisot, Pissarro, Renoir, and Sisley; they were joined, from time to time, by other painters and printmakers. Cassatt participated in the planning sessions for the

never-realized exhibition of 1878. By the spring of 1879, she was eager for her debut among this band of artists, who that year exhibited as "independents," in order to signal, as critic Edmond Duranty explained, "that they are independent of the official organization. To be one of them, one must engage not to exhibit at the Salon."[8]

Cassatt's affiliation with the Impressionists sealed her lifelong antipathy toward and rejection of the jury system. She advocated more open exhibition opportunities, although it must be said that, inasmuch as participation in the Impressionist exhibitions was by invitation only, they could hardly be called egalitarian. Nonetheless she was one of the invited artists, "not only the *impressionists* but also artists of diverse leanings,"[9] who agreed to submit works to the exhibition, held between April 10 and May 11, 1879, in rooms rented at 28, avenue de l'Opéra. Cassatt contributed a harmonious group strongly redolent of Degas in subject matter, style, and facture. One, the aforementioned *Portrait of a Little Girl*, had been rejected by the American section of the 1878 Exposition universelle, despite the fact that, as Cassatt related to Vollard in 1903, Degas had assisted with the background.[10] Whether or not he actually painted on the canvas, Cassatt's recollection indicates that, by 1877 or 1878, he took an active interest in his protégé, advising her on works of art in progress. He thus may have been able to guide her away from the picturesque subjects of her early European career toward the naturalist aesthetic championed by Duranty and other critics.

In addition to *Portrait of a Little Girl*, Cassatt exhibited three paintings, *Portrait of a Lady* (cat. 9), *Woman in a Loge* (cat. 18), and *A Corner of the Loge* (Barter, fig. 1), shown *hors catalogue*, as well as two pastels, both entitled *At the Theater* (cat. 19 and fig. 3).[11] Displayed in a room of their own, they were closely linked to Degas's submissions, which were on view in an adjacent gallery. Coloristically the works of Cassatt and Degas shared a certain strident quality. In a letter written about this time to his friend the Viscount Ludovic Lepic, Degas described Cassatt as "a good painter, at this moment particularly engrossed in the study of the reflection and shadow of flesh or dresses, for which she has the greatest affection and

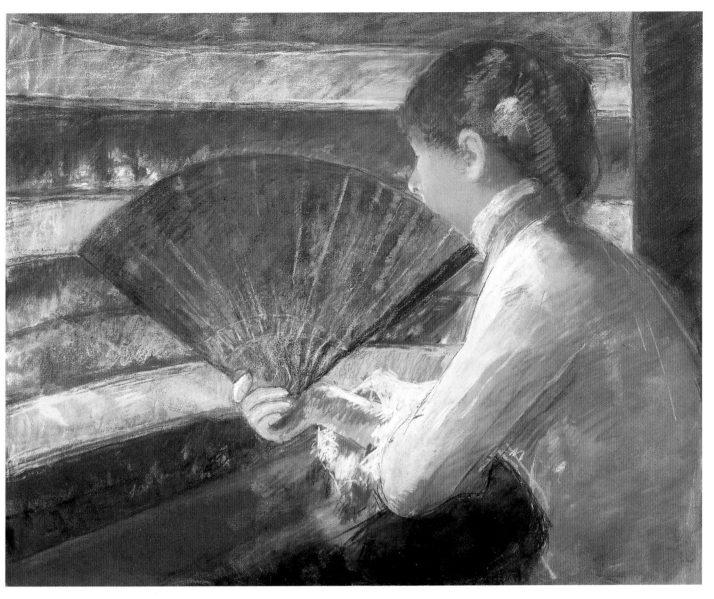

Fig. 3. Mary Cassatt. *At the Theater*, 1879. Pastel and metallic paint on canvas; 65.1 x 81.3 cm. Philadelphia Museum of Art, gift of Margarett Sargent McKean, 50–52–1.

understanding, not that she resigns herself to use only *green and red* for this effect, which I consider the only salvation."[12] In *Woman in a Loge*, the subject sits, in evening dress, in front of a mirror reflecting the brilliantly illuminated hall of a theater or opera house. Here Cassatt juxtaposed intense, warm hues—the red of the upholstery, the pink of the gown, and the tawny copper color of flesh and hair—accented by the gold and green of the background, with its dynamically distorted perspective. A work that Degas exhibited, *Miss LaLa at the Cirque Fernando* (fig. 4), presents a more radically foreshortened space; like Cassatt he isolated a pink-clad figure against the brilliantly lit architecture of a place of public spectacle. Degas chose as his subject a most bizarre type of performer and adopted an emphatically oblique

point of view, whereas Cassatt merely hinted at the degree to which her subject was on display, through the distant spectators reflected in the mirror behind the young woman and above all through the magnificent vulgarity of her palette. The critic Henry Havard compared the sensation of looking at Cassatt's works to "the acidity of a green [unripe] fruit"[13]; there is something of this bite in the harsh oranges, reds, yellows, and greens that pervade both paintings.

Apart from their color schemes, Cassatt's loge pictures likewise reflect her increasing appreciation for Degas's unusual subjects, particularly his fascination with artificial illumination, which he had explored in depth in pastels and monotypes depicting nocturnal entertainments. Degas had exhibited several of

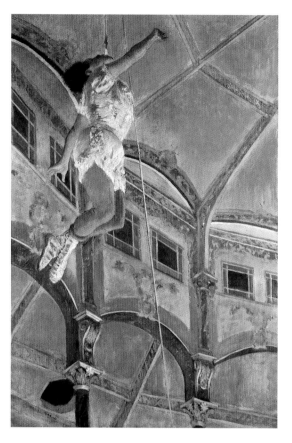

Fig. 4. Edgar Degas. *Miss LaLa at the Cirque Fernando*, c. 1879. Oil on canvas; 117 x 77.5 cm. London, National Gallery, bought by the Trustees of the Courtauld Fund, NG4121.

these—including images of dancers and café-concert performers—in 1877.[14] In the 1879 Impressionist exhibition, the artist showed *Café Singer* (fig. 5), one of the most dramatic of all of his café-concert images. Cassatt did not choose to represent the entertainments of Paris's boulevards: this was not her natural element, although we know that, ten years before, she had been taken to the rowdy Jardin Mabille, an outdoor dance-hall.[15] Nonetheless, while Cassatt's status as a gentlewoman restricted her depiction of nighttime activities to those of the drawing room and theater box, her works, like those of Degas, seem the product of a sophisticated social commentator, an observer of wit and discretion who, through subtle indicators of gesture, glance, and detail, conveyed social and emotional complexity.

The way in which Cassatt most closely resembled Degas in 1879 was her adoption of pastel for exhibition pictures. Degas had distinguished himself in the

medium: his twenty submissions to the previous Impressionist exhibition, of 1877, had included as many as ten works in pastel, *peinture à l'essence*, or a combination of the two, many over monotype bases. Cassatt must have looked to her friend for guidance to capture, in the chalky medium of pastel, the painterly effects she preferred. If we assume that she began to experiment with pastel after becoming involved with the Impressionists, and specifically with Degas, it is remarkable how sure and resolved her technique became within just a few years (see Stratis). In examples such as three works entitled *At the Theater* (cat. 19 and figs. 3, 6), the application of the medium is deft and expressive, combining exquisite effects of superimposed hatchings with broad, seemingly careless passages. Degas was able, after twenty years of practice, only just to surpass his colleague's skill; compared to Cassatt's, his pastels display a broader range of stylistic devices and unorthodox techniques. This is evidenced, in his *Café Singer*, by

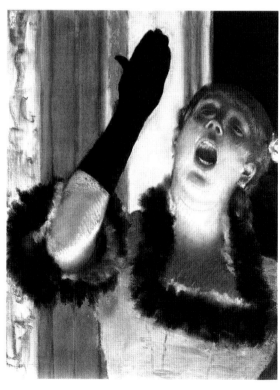

Fig. 5. Edgar Degas. *Café Singer (Singer with a Glove)*, c. 1878. Pastel and distemper on canvas; 51.4 x 40 cm. Cambridge, Mass., Fogg Art Museum, Harvard University Art Museums, bequest from the collection of Maurice Wertheim, 1951.68.

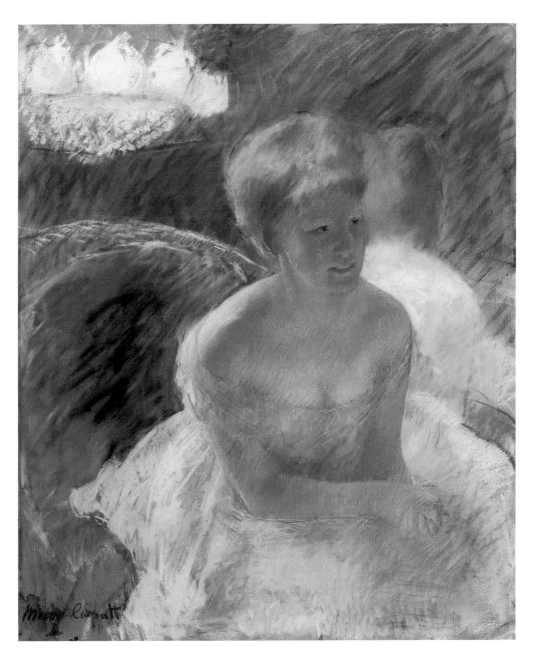

Fig. 6. Mary Cassatt. *At the Theater*, 1880. Pastel on paper, 55.4 x 46 cm. Kansas City, Missouri, Nelson-Atkins Museum, purchase: acquired through the generosity of an anonymous donor, F77-33.

the broad, flat passages of unified tone, worked with brush as well as with crayon, which he juxtaposed with areas of shimmering striations that evoke the effects of reflected light on the powdered skin of his model.

The critic Duranty, himself the subject of one of Degas's 1879 submissions (fig. 25), praised Cassatt's entries, announcing that it was "impossible to visit the exhibition without being interested in the extreme in the portraits of Mlle Cassatt. A sense of the most remarkable elegance and distinction—very English (she is American)—mark these portraits. Mlle Cassatt *is worthy of the most particular attention.*"[16] The critic might have recognized in such casual

"portraits" a response to the call he had made for a revitalization of the figure in his "Nouvelle Peinture," the essay he wrote in 1876. In one of the essay's most famous passages, the critic had argued for a new attitude toward the representation of character and psychology in painting through gesture, expression, and environment:

. . . what drawing wants in terms of its current goals is just to know nature intensely and to embrace nature with such strength that it can render faultlessly the relations between forms, and reflect the inexhaustible diversity of character. Farewell to the uniform monotony of bone structure, to the anatomical model beneath the nude. What we need are the special characteristics of the modern individual—in his

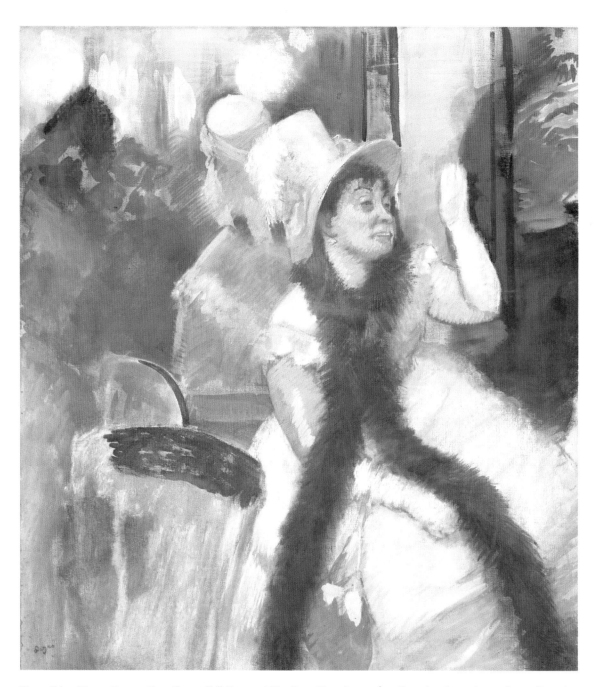

Fig. 7. Edgar Degas. *Portrait After a Costume Ball (Portrait of Mme Dietz-Monnin)*, 1877/79. Gouache, charcoal, pastel, metallic paint, and oil on canvas; 85.5 x 75 cm. The Art Institute of Chicago, Joseph Winterbotham Collection, 1954.325.

clothing, in social situations, at home, or on the street. . . . This is the joining of torch to pencil, the study of states of mind reflected by physiognomy and clothing. It is the study of the relationship of a man to his home, or the particular influence of his profession on him, as reflected in the gestures he makes[17]

Degas followed these dictates in his curious portrait of Madame Dietz-Monnin (fig. 7), who leans forward awkwardly to salute a guest, as if she were about to become the last, slightly absurd, reveler at her own costume ball.[18] Cassatt's model in *Portrait of a Little Girl*, slouched in an overstuffed armchair, unconsciously adopts the pose of a *maja* by Francisco Goya or an odalisque by J. A. D. Ingres, but her slumped posture, splayed legs, and pouting mouth express lassitude, boredom, and indolence. Cassatt's and Degas's use of abrupt, awkward perspectives also answered Duranty's call for an expressive environment. The bold, geometric backgrounds of Cassatt's loge pictures parallel the flattened spatial effects that

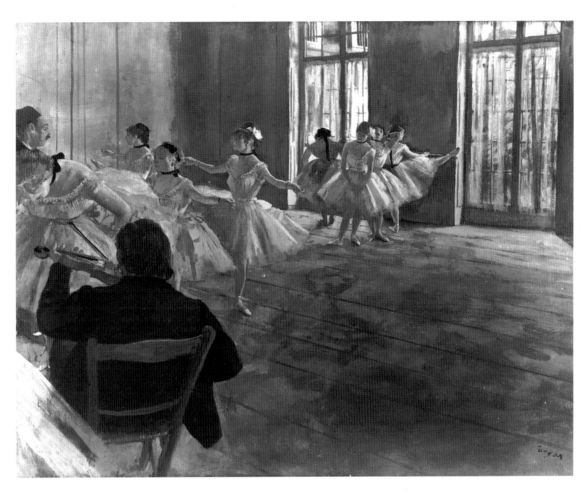

Fig. 8. Edgar Degas. *Dance School*, c. 1876. Oil on canvas; 43.8 x 58.4 cm. Shelburne, Vt., Shelburne Museum, 27.3.1-35a.

Degas employed in his café-concert and circus pictures. *Portrait of a Little Girl* moreover shares the strange, forced diagonal perspective of Degas's *Dance School* (fig. 8), exhibited in 1879, as well as the arbitrary cropping of elements that resulted from a narrowly focused field of vision. Another common feature is the play of light through curtained windows on a distant wall, the area in Cassatt's work about which Degas offered her advice. Not only were the two artists linked by their subjects and the employment of similar motifs, but also by their use of distinctive frames. Degas is known to have chosen severe modern moldings painted in dull greens. Cassatt apparently colored hers, now lost, in brilliant tints. According to Auguste Renoir's brother Edmond, they were "smeared with red or green, . . . truly ugly and in the worst taste."[19]

In addition to their common pursuit of novel,

and frankly ungainly, treatments of expression and pose, the 1879 exhibition's participants found other ways of reacting to one another. Degas promoted the notion among his closest allies within the independents that they could unite the exhibition imaginatively if each artist would submit a number of fan-shaped paintings to the show. Degas himself contributed five such works, influenced by Japanese prototypes, on the subject of dancers in imaginary theatrical scenes, viewed from a box high above the stage (see Barter, fig. 22). Camille Pissarro sent eleven fan-shaped compositions, depicting laborers in the fields against a setting or rising sun, surrounded by sheaves of wheat or stacks of hay (see Hirshler, fig. 6). The fans expected from Morisot never materialized; after the birth of her daughter, Julie, in November 1878, she had not been able to prepare the fan-shaped watercolors she had planned. In her loge

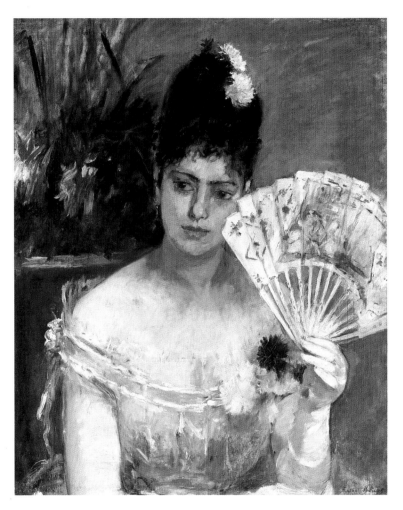

Fig. 9. Berthe Morisot (French; 1841–1895). *At the Ball*, 1875. Oil on canvas; 62 x 52 cm. Paris, Musée Marmottan, Donop de Monchy bequest, 4020.

dispensed to younger artists. From the time of the 1879 exhibition, Cassatt was linked with Degas in the public imagination and was considered a follower of the older artist. Some years later, the Irish writer George Moore —who sat for both Cassatt and Manet around 1880—stated that "her art was derived from Degas as Madame Morisot's art was derived from Manet." About Morisot, who was married to his brother Eugène, Manet had flippantly commented to Moore: "My sister-in-law would not have existed without me. She did nothing but carry my art across her fan."[22] This pairing of female to male artists—which arises not only from the connections between these painters' styles but also from awareness of the actual social affiliations and affinities they shared—has so marked subsequent thinking about Cassatt and Morisot that a modern viewer is hard pressed to see beyond such a condescending cliché.

In 1879, however, despite her strong adherence to Degas's example and advice, not everyone treated Cassatt as a female follower of the French artist. Accompanying his review of the exhibition with reproductions of drawings by both Degas and Cassatt, Alfred de Lostalot singled out her work:

M. Degas presents one of his students: it is a young American lady whose debut is most promising. Miss Cassatt does not in the least resemble her master, which is intended to surprise, perhaps, since we are not used to such. It is the general rule that a student of M. Cabanel [the academic painter and teacher] should resemble M. Cabanel, and likewise the other students of other ateliers. Here then is the superiority of impressionist—or rather independent—teaching. The master teaches his students the art of seeing, but he leaves them free to choose their means, when it comes to rendering.[23]

The uniqueness of Cassatt's work was perhaps

suite, Cassatt, perhaps in emulation of two paintings that Morisot had exhibited in 1876 and 1877, *At the Ball* (fig. 9) and *Head of a Young Woman* (New York, private collection), showed her fans at one remove, as objects depicted in the hands of women.[20]

The close links between the art of Degas and Cassatt evoked a range of responses from the informed public and critics. One reviewer, unaware that the artist listed in the catalogue as "CASSATT (Mary)" was a woman, declared, "He exhibits a portrait of a woman in a loge that is quite simply horrible."[21] A number of reviewers were aware that Cassatt participated with the group as a sort of unofficial "pupil" of Degas, who, like all the Impressionists, never had an official atelier, in spite of the advice he readily

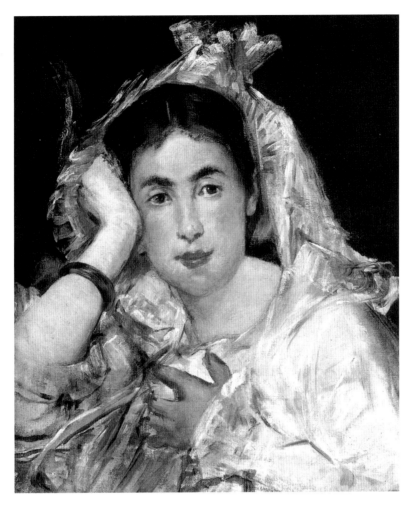

Fig. 10. Edouard Manet (French; 1832–1883). *Portrait of Marguerite de Conflans with Headdress.* 1873. Oil on canvas; 55,5 x 46,5 cm. "Am Römerholz," Winterthur, Switzerland, Oskar Reinhart Collection. Photo: T. A. Gronberg, ed., *Manet: A Retrospective* (New York, 1988), pl. 60.

were told he was too ill to receive visitors.[25] His name appears in the artist's correspondence and in that of her family only as someone whose works might be collected by the Americans whom Cassatt advised (see Hirshler, p. 180). Notorious in the Parisian art press since his rise to prominence in the 1860s, Manet had declined to link himself directly with the Impressionists, although critics recognized him as their aesthetic leader in absentia. In addition to reading about Manet, Cassatt must have seen the painter's *Repose: Portrait of Berthe Morisot* (Providence, Museum of Art, Rhode Island School of Design) at the Salon of 1873, where she showed *Offering the Panal to the Bullfighter.* Moreover Manet's *Bon Bock* (Philadelphia Museum of Art) was a critical success at the same exhibition.

due to the variety of her sources of inspiration. Her earlier submissions to the Salon, such as the 1872–73 *Offering the Panal to the Bullfighter* (cat. 5), display the fluency of her technique, which had evolved not only through the influence of Chaplin and Couture but also through her study of Spanish painting, "the most wonderful painting that ever was seen," as she exclaimed in 1872 (see Walker, pp. 32–33).[24] *Portrait of a Lady* (cat. 9), on the other hand, suggests that, by the last half of the decade, Cassatt may have begun to admire another artist trained in the methods of Spanish painting. The bold hatchings and daubs of oily pigment that describe the dress, fan, and upholstered chair, as well as the abbreviated treatment of the background of this painting, are strongly reminiscent of the style of Manet.

There is little information about Cassatt's interaction with Manet: when she and Louisine Havemeyer attempted to see him in the early 1880s, they

Circumstances would have led naturally to a familiarity, if not intimacy, between the two artists, as Manet was close to Degas, and was a brother-in-law of Morisot, with whom Cassatt had formed a friendship.

In her paintings of the later 1870s and early 1880s, Cassatt continued to employ the apparently spontaneous brushwork that was associated, in the public imagination, with Manet and his disciples. Her brilliant depiction of white clothing in such images as *Portrait of a Lady* and *Woman Reading* (cats. 10, 14) owes a debt to the art of Diego Velásquez, but even a greater one to the more immediate example of such works as Manet's *Portrait of Marguerite de Conflans* (fig. 10), which Cassatt was to acquire in 1884 for the collection of her brother Alexander. The subjects Cassatt chose to depict also present a parallel with those of Manet: witness her scenes of women drinking tea, reading, or sewing, surrounded by flowers or in

Fig. 11. Edgar Degas. *Mary Cassatt at the Louvre: The Etruscan Gallery* (seventh state of nine), 1879–80. Softground etching, drypoint, and aquatint, printed in black on laid paper; plate: 26.7 x 23.2 cm. The Art Institute of Chicago, bequest of Mrs. Gordon Palmer, 1985.480.

gardens (see for example cats. 13, 30, 35), which are roughly contemporary with compositions by Manet of the later 1870s in which he cultivated a hothouse *pleinairisme*, as in *In the Conservatory* (Berlin, National-galerie) or *Reading* (Barter, fig. 25).

Degas, on the other hand, in an effort to distance himself from the school of bravura painting, was to declare that "no art was ever less spontaneous than mine." He began to paint *Dance School* for example only after studying each of his figures in detail, through an elaborate series of drawings in pencil and in black-and-white chalks. In contrast Cassatt hardly ever made preparatory drawings for her paintings: the few drawings of hers that have survived from the later 1870s and early 1880s were almost all made directly for the preparation of her etchings. Half-fin-

ished paintings by Cassatt suggest that she painted *alla prima*, applying colors directly to the prepared ground, over only the most cursory indications of contour.[26]

At the close of the 1879 Impressionist show, in which both Cassatt and Degas were singled out for praise, the artists determined to continue working together in order to maintain the momentum of their critical success. The celebrated writer Ludovic Halévy—librettist for opera composers Jacques Offenbach and Georges Bizet, and a friend of Degas since their youth—went to see the artist one day in May, shortly after the close of the exhibition. "I encountered him in the company of the 'indepen-dent' Miss Cassatt, one of the exhibitors. . . . They are most excited. Each one has, from the exhibition,

440 francs profit. They are thinking of starting a journal; I ask to write for it."[27] Degas was in fact involved in intense negotiations with artists and publishers to produce a periodical entitled *Le Jour et la nuit* ("day and night"), in reference to its concentration on black-and-white images. The intent was probably to publish it, as Douglas W. Druick and Peter Zegers surmised, in two separate "editions." Degas believed the sale of the first edition—original prints, mostly etchings—would cover all expenses. The second edition would comprise mechanically reproduced images of the original prints, produced in larger quantities for a public interested in modern painting and printmaking.[28]

For months, at the end of 1879 and the beginning of 1880, Degas and Cassatt worked together intensively, preparing etchings for the initial number of *Le Jour et la nuit*, which they planned to issue at the moment the 1880 Impressionist exhibition opened. In Degas's company, Cassatt began to concentrate on prints; as she had when she took up pastels, she became extremely adept almost immediately.[29] Those of Cassatt's prints that are thought to date from 1879 to 1881 show the impact of Degas's counsel, not only in their compositional strategies but also in their sure manipulation of tonal media. Thus, as Barbara Stern Shapiro noted, Cassatt's *Interior Scene* (cat. 44) relates closely to Degas's print *Mary Cassatt at the Louvre: The Etruscan Gallery* (fig. 11), which was almost certainly planned as Degas's first entry for the inaugural edition of *Le Jour et la nuit*.[30] Both prints show an interior containing two female figures, one standing and one seated. In Degas's print, the standing figure of Cassatt is seen from the back; she leans on her umbrella and gazes at a sarcophagus, while the seated woman, usually identified as Lydia Cassatt, looks up from a guidebook. Likewise, in *Interior Scene*, a bonneted young woman apparently is about to sit in a balloon-back chair, while a second woman looks on at lower

Fig. 12. Camille Pissarro (French; 1830–1903). *Wooded Landscape at the Hermitage* (fifth state of five), 1879. Softground etching, aquatint, and drypoint on ivory laid paper; plate: 22 x 27 cm. The Art Institute of Chicago, Clarence Buckingham Collection, 1977.490.

right. Degas and Cassatt proceeded in much the same way to place the design on the plate, employing preparatory drawings (see cat. 43) to fix the outlines of the figures in the soft ground. Successive states record the printmakers' experimentation with the application of incisive lines of drypoint or of rich veils of tone in areas of either irregular or fine-grained aquatint. The artists' evident delight in technical exploration meant that the process was elaborate: *Interior Scene* is known in at least six states, thirteen proofs of which Degas retained for his personal collection; *Mary Cassatt at the Louvre: The Etruscan Gallery* went through nine stages of development.[31]

The third collaborator in *Le Jour et la nuit* was Camille Pissarro. He lived in the country at Pontoise, more than twenty miles from Paris, and thus was not always party to Cassatt's and Degas's experimentation. However, he actively solicited Degas's advice on the preparation of his plates and their printing and enlisted his aid, in at least one instance, in the actual inking and printing of an etching in color.[32] To judge from letters from Degas to Pissarro and from Pis-

sarro to his son Lucien, as well as from the observations of Cassatt's family, it seems that all three artists were in close communication, working actively together on inventing new techniques and new combinations of effects.[33] More than one author has compared the process to a kitchen, the artists to cooks, and their art to a new cuisine: if Degas was the principal chef, then Cassatt and Pissarro were often literally at his side, suggesting new additions to the *batterie de cuisine* or new recipes for the complex, inky sauces that flavor the plates they intended for the journal's first number. This collaboration, the results of which Shapiro rightly characterized as "a black and white Impressionism," was accorded great significance by the artists, as suggested by the fact that each of them chose to show multiple states of recent prints at the 1880 Impressionist exhibition. Degas announced in the catalogue (but may not have

exhibited) "Etchings. Trials and proof states," probably referring to states of *Mary Cassatt at the Louvre*; Cassatt presented the first and last states of *At the Performance* (cat. 25), along with seven other printed compositions. Pissarro exhibited, among many other etchings, four of the six states of his *Wooded Landscape at the Hermitage*, mounted together in one frame (see fig. 12).[34]

Each of these compositions is the result of close interaction between two or more artists. The collaborations have been documented in individual studies of the painters' printed oeuvres, but many details of their activity are as yet unknown. It is clear that Degas's studio was the locus of their experimentation, not only from 1879 to 1880, but also for some time thereafter. Thus it is not surprising that the artists should have shared ideas, techniques, and actual equipment and tools, including printing

Fig. 13. Mary Cassatt. *Warming His Hands* (only known state), c. 1879/80. Softground etching or aquatint on paper; 16 x 11.7 cm. Chicago, Ursula and Stanley Johnson Collection.

Fig. 14. Edgar Degas. *The Laundresses* (first state of four), c. 1880. Etching and aquatint on cream laid paper; 11.7 x 15.8 cm. Minneapolis Institute of Arts, gift of Mrs. E. Bates McKee, 1975, P.75.44. In this illustration, the image has been turned on its side to demonstrate that Degas etched his design on a plate that already bore an original composition by Cassatt (see fig. 13).

plates. In 1891 Pissarro was delighted when Degas, in cleaning his studio, found a group of Pissarro's plates, left there years before for printing and considered lost.[35]

The artists in Degas's orbit seem, in the late 1870s, to have used a stock of silvered copper plates, each measuring approximately 16 x 12 centimeters, with slightly crimped corners. These dimensions accord with those of one of the standard sizes for daguerreotype photographic plates, the format known as a half-plate. By the 1870s, these would have been considered obsolete for their original purpose and may therefore have been cheaply obtained. Degas made three etchings on such plates, all of which bore, in one corner, the punched stamp "F. Schneider/ Linkstr. 9 Berlin." This is the name and address of a known maker of daguerreotype plates; when inked his mark transferred in reverse in the process of printing the image. Interestingly Pissarro used plates bearing the same mark for three compositions; an etching by Cassatt, *Warming His Hands* (fig. 13), known in a single proof (which Degas owned), also shows this mark, in reverse at the upper right.[36] Degas used other plates of this size extensively for etchings, as well as for monotypes, some of which, in the transfer process he favored, became the basis for lithographs.[37] In addition to the three prints by Degas that display the words "F. Schneider/Linkstr. 9 Berlin" in reverse at their margins, there is another, *Seated Woman in Bonnet and Shawl* (fig. 15), which was printed from what seems to be an identically shaped plate, perhaps by another manufacturer, since no inscription is visible on the image. This unfinished composition, which has always been called a work by Degas, seems never to have been printed by the artist, as it is known only from impressions taken after the cancellation of the plate (now lost). In spite of its long association with the corpus of Degas's graphic art, the composition actually seems closer to those of a group of prints by Cassatt than to any work by Degas: the figure, barely indicated by areas of coarse aquatint, is similar to forms in a suite of three etchings she did called *The Corner of the Sofa*, particularly to the first of these three (fig. 16).[38] Thus it is possible that the print is not the work of Degas at all, but rather an abandoned essay by his American colleague.

Fig. 15. Mary Cassatt or Edgar Degas. *Seated Woman in Bonnet and Shawl* (only known state), c. 1879. Aquatint, drypoint, and etching on paper; plate: 16 x 11.8 cm. Baltimore Museum of Art, Blanche Adler Memorial Fund, BMA55.17.

Fig. 16. Mary Cassatt. *The Corner of the Sofa* (only known state), c. 1880. Softground etching and aquatint on paper; plate: 25.7 x 21.5 cm. Photo: Breeskin 1948, no. 14.

Such questions of attribution are not unprecedented: Shapiro proposed that Cassatt's *Warming His Hands* (fig. 13) might actually be by Pissarro, because of its resemblance to a monotype composition by the latter artist.[39] The etching, like *Seated Woman in Bonnet and Shawl*, represents only the beginning of a composition, with the silhouette of a man, in two strengths of softground or aquatint, defined by white lines burnished through the tone. *Warming His Hands* thus resembles not so much the finished states of indisputable Cassatt etchings, but their earliest states, where tone was established; if it had been completed, the print would doubtless have been further articulated and elaborated. In view of its unfinished state, it is difficult to assign it conclusively to any one printmaker, although its origins in the circle of Degas are certain, given its provenance and the coincidence of the "Schneider" mark on the plate.[40]

These questions aside, we can now establish, for the first time, that Degas subsequently used the plate on which *Warming His Hands* was articulated in softground and aquatint. It provided the basis for his etching *The Laundresses* (fig. 14): the seemingly inexplicable atmospheric scratches on the left of this print, which have previously been recognized as belonging to "another composition,"[41] are actually part of the original composition of *Warming His Hands*. Over the cross-hatched silhouette of the man, turned so that his face points to the bottom of the plate, Degas used wire brushes and an unusual, double-pronged pen to create a peculiar scene of the interior of a laundry, with women ironing. In his playful reworking of the existing image, the shape of the man's hat is subsumed into the skirt of the laundress at right, and his hands become the laundress seated at lower left.[42] Is *Warming His Hands*, although traditionally ascribed to Cassatt, actually by Pissarro or even by Degas? Whatever the print's authorship, it is more important to realize that around 1880 these three artists were so intimate that works of such indeterminate finish do not indisputably reveal one artist's hand over that of another.

This period of technical exploration saw Cassatt adapt the half-length portrait-format compositions she favored in painting to this new medium (see cat. 36). Her print explorations also led her to a new sub-

Fig. 17. Mary Cassatt. *Standing Nude (Dark)* (only known state), c. 1879. Softground etching or aquatint on paper; plate: 27.3 x 17.7 cm. Chicago, Ursula and Stanley Johnson Collection.

Fig. 18. Mary Cassatt. *Standing Nude with a Towel* (fourth [?] state of four), c. 1879. Softground etching and aquatint with scratching on paper; plate: 27.8 x 21.8 cm. Private collection.

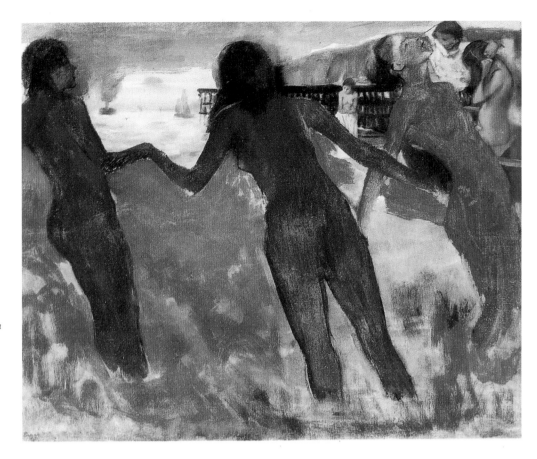

ject, that of the nude. Although she may have studied anatomy and the nude at the Pennsylvania Academy of the Fine Arts, in Philadelphia, drawing from prints, plaster casts, and the live model, the first instances of nudes in Cassatt's extant oeuvre occur in three etchings done at the time she was working under Degas's supervision. He owned one impression of her *Standing Nude (Dark)* (see fig. 17), apparently abandoned after one state; and three impressions of another print, *Standing Nude with a Towel* (see fig. 18). Cassatt took the latter through at least four states, to achieve greater detail and above all to exploit the expressive potential of areas of striated tone. The third image, *Back View of Draped Model Arranging Her Hair* (fig. 20), has been traditionally assigned to 1889,[43] but instead seems to relate stylistically to works of the years around 1880.

All three etchings show some awareness, on the part of Cassatt, of the prints of nudes Degas had executed in the years after 1876. In *Standing Nude (Dark)*, she isolated the shadowy figure against a painterly ground of textured tone; in later states of *Standing Nude with a Towel*, she achieved rich tonal areas by biting the plate with acid and scraping it with wire brushes or other tools, creating pits that caught

the black ink.[44] These complex manipulations in an intaglio process parallel the effects that Degas was creating at the same time through the planar method of monotype. His *Combing the Hair* (fig. 21) for example reveals similar juxtapositions of rich black, inky zones with bright white highlights, which the artist achieved without reliance on a matrix of etched lines or scrapings. Beginning with a plate completely covered with black ink, he arrived at an image by wiping the metal clean to create areas of white, then by stippling or brushing it to render half tones and leaving the ink untouched, or restoring it, to capture the deepest shadows.[45] When passed through a press, the ink-smeared plate yielded what Degas called a "printed drawing" (now commonly called a monotype), a unique image that, because of the mutability of the ink-on-metal stage, can be more freely worked than any print or drawing.

Years would pass before Cassatt (in her color prints) experimented so boldly in the inking of her plates; but her observation of Degas's execution of monotypes seems to have affected her manipulation of tone. Like *Interior Scene*, her prints of nudes play upon *contre-jour* effects, either dark on light or light on dark. The same interest in silhouette can be

Fig. 20. Mary Cassatt. *Back View of Draped Model Arranging Her Hair* (second state of two), c. 1880 (?). Softground etching and aquatint on paper; plate: 14.5 x 11 cm. New York, The Metropolitan Museum of Art, Rogers Fund, 1920, 20.1.1.

Fig. 21. Edgar Degas. *Combing the Hair*, c. 1880. Monotype on paper; plate: 31.3 x 27.9 cm. Paris, Musée du Louvre, Département des arts graphiques, fonds du Musée d'Orsay, gift of the Société des amis du Louvre, RF.16.724. Photo: Jean Adhémar and Françoise Cachin, *Degas: The Complete Etchings, Lithographs, and Monotypes* (London, 1974), no. 168.

observed in many of Degas's bather images of the 1870s, not only his so-called "dark-field monotypes" of around 1877–80, but also in such paintings as the astonishingly summary *Peasant Girls Bathing in the Sea Toward Evening* (fig. 19), which probably dates from around 1875/76 and which Cassatt may well have seen in Degas's studio.[46] Like Cassatt's *Standing Nude (Dark)*, the painting exhibits a curiously abbreviated, almost primitivizing treatment of female anatomy, and shares with her *Standing Nude with a Towel* a disquieting relationship of

figure to ground, with the model appearing to wade or stumble in patches of ink. Cassatt's deployment of silhouette, coupled with the fact that none of her nudes looks back at the viewer, makes these women seem disconcertingly anonymous, not unlike some of Degas's bathers. This may result in part from the possibility that she did not draw any of them from a live model but rather based them on memory or on her study of Degas's monotype nude studies.

As Cassatt worked on her images of bathers, it is possible that Degas could have shown her some of his more daring monotypes. Such a work as his *Room in a Brothel* (Barter, fig. 31), probably dating from this time, resembles not only Cassatt's *Standing Nude with a Towel* but also *Interior Scene* (cat. 44). (There is nothing to preclude the intriguing possibility that this brothel scene is Degas's ironic riposte to Cassatt's images.) Nonetheless it has generally, and probably correctly, been assumed that Degas intended his brothel-scene monotypes for an exclusively male audience. But Cassatt must have had access to those images: she owned a tender nude by Degas, *Girl Putting on Her Stocking*, a work of around 1880 that she gave to Louisine Havemeyer in 1889.[47]

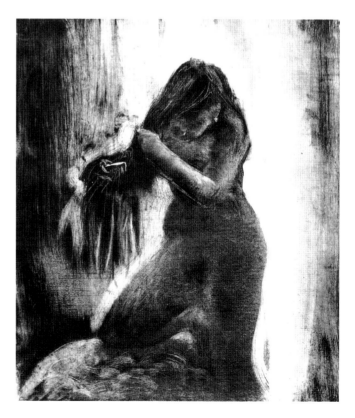

Degas exhibited some of the less explicit bathing scenes as early as 1877, in the form of pastels. As was his habit, he often covered second, probably weaker, impressions from his monotype plates with pastel to create images in color, thus making "paintings" from the black-and-white matrices of the printed "drawings." Beginning in 1877, with the third Impressionist exhibition, he showed a large number of these pastel-covered monotypes, including *Woman Leaving Her Bath*, *Woman Taking Her Bath, Evening*, and *Dressing Room*. Cassatt saw these of course and presumably many others in Degas's studio.[48] While Degas liked to make "paintings" out of prints, Cassatt, throughout her career, often worked in the opposite direction, using her oil paintings and pastels as points of departure for her prints (see cats. 69, 70 and 78, 79). However, the artist seems to have executed at least one of her pastels, *Women in a Loge* (cat. 21), over a unique intaglio print (for a related work, see cat. 23; see also Stratis, pp. 215–16).

Le Jour et la nuit, the inspiration for all these experiments, in the end did not materialize, most likely because Degas was unable or unwilling to complete the prints required of him for its publication. Despite Cassatt's mother's complaint in 1880 that the publication had failed because, "as usual when the time arrived to appear, he [Degas] wasn't ready," and that "he has thrown away an excellent chance for all of them,"[49] her daughter maintained with the French artist the intense collaboration that had preceded the 1880 exhibition. This led to a continuing alliance, both artistic and strategic, between the two. Cassatt began to promote her friend's art, recommending important pictures to her brother Alexander, who was forming a collection of paintings, mostly by his sister's artist friends (see Hirshler, pp. 187–88).

Demonstrating great respect for Degas, Cassatt continued to act in accordance with his principles and point of view. Like him she declined to submit works to the Impressionist exhibition of 1882. "Did your mother tell you that Mame has some artistic trouble?" Robert Cassatt wrote to his son Alexander. "The Impressionists have quarreled among themselves, and it is believed now that their annual exhibition will be dropped." The quarrel was only the latest manifestation of a breach between two "camps"

within the vanguard movement. One group, which the critic and novelist Joris Karl Huysmans characterized as "the painters called Impressionists," included Renoir and Alfred Sisley, who had not exhibited with the group since 1877, and of course Claude Monet, who had not participated since 1879. Their work was seen as distinct from the urbane naturalism of Degas, who, with Cassatt and his protégé Jean Louis Forain, rejected the term "Impressionist" and preferred the term "independent." They defined themselves not by style, facture, or optical method but by their continuing opposition to the official Salon system. In response to the renewed commitment of the "Impressionists," the "independents" defected in turn, although each remained a dues-paying subscriber to the enterprise.[50] As Eugène Manet wrote to his wife, Berthe Morisot, "I have not yet been able to uncover the secret of the withdrawal of Degas and Miss Cassatt. A stupid Gambettist newspaper (Paris) says tonight that the Impressionist exhibition has been 'decapitated' as a result of this withdrawal."[51] The exhibition undoubtedly lost a certain number of "heads" without Cassatt and without Degas, perhaps the group's most cerebral painter. While the 1882 exhibition was not without important figurative compositions—with entries by Caillebotte, Gauguin, Morisot, Pissarro, and Renoir—in light of the dozens of landscape paintings submitted by Monet and Sisley, the event was characterized as the victory of the landscape over the figure.[52]

While the exhibition was on view, Cassatt spent time with Degas, posing for one of his best-known pastels, *At the Milliner's* (fig. 22), a signed and dated work that he sold to Durand-Ruel in July of that year.[53] As we have seen, Cassatt had posed for Degas before (see figs. 1, 11). She also served as a model for a series of drawings, thought to date from about 1879, of women in street apparel (see fig. 33), in which Degas investigated the suggestive potential of pose, or in today's parlance, "body language." *At the Milliner's* and two other pastels from the same time, one with the identical title (fig. 23) and a related study, *Woman Tying the Ribbons of Her Hat* (Paris, Musée d'Orsay), give equal attention to facial expression and gesture. Why Degas chose Cassatt as his model, or why she agreed to spend so much time posing for

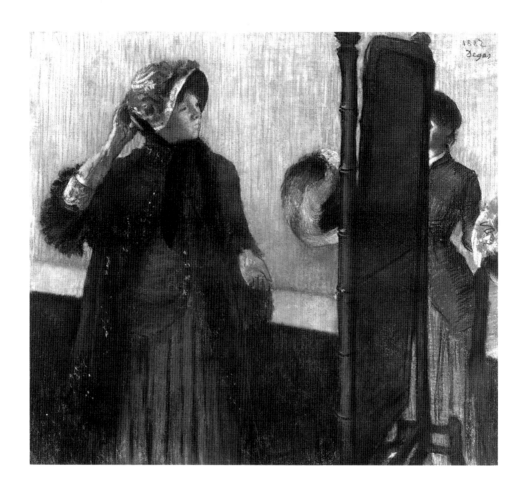

Fig. 22. Edgar Degas. *At the Milliner's*, 1882. Pastel on pale gray wove paper; 76.2 x 86.4 cm. New York, The Metropolitan Museum of Art, H. O. Havemeyer Collection, bequest of Mrs. H. O. Havemeyer, 1929, 29.100.38.

Fig. 23. Edgar Degas. *At the Milliner's*, 1882. Pastel on paper; 70.2 x 70.5 cm. New York, The Museum of Modern Art, gift of Mrs. David M. Levy, 141.57.

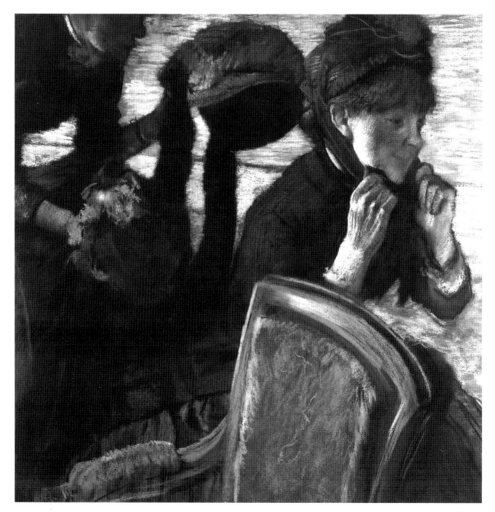

him, is unclear. Perhaps she felt indebted to him for his counsel and flattered that he asked her to pose when no other model would do: As Louisine Havemeyer reported, she "once asked Miss Cassatt if she often posed for Degas. 'Oh, no,' she answered carelessly, 'only once in a while when he finds the movement difficult, and the model cannot seem to get his idea.'"[54] In fact the works of art themselves demonstrate that Cassatt modeled for Degas more than "once in a while"; in addition to the above-mentioned studies, there is the superb portrait (cat. 91), executed sometime in the early 1880s, which Cassatt grew to loathe and eventually sold (see p. 137 and Hirshler, p. 183). The milliner pastels seem not to have aroused the same distaste in her, perhaps because as likenesses they were less distinct and because they so amply justify her claim to skill as a model. For Cassatt brilliantly assumed two entirely different personae in the two finished pictures, one aloof and disengaged, the other eager and fascinated with the process of trying on the hat. She brought a painter's intelligence to the undertaking that Degas must have valued greatly; in this way, she became in effect a collaborator in the execution of his "idea."

Before and after the death of her sister, Lydia, in 1882, Cassatt did not work for many months. When she at last returned to painting, at the end of 1883, her greatest project was the distinctive *Lady at the Tea Table* (fig. 24), a portrait of Mary Dickinson Riddle, a cousin of the artist's mother. Katherine Cassatt reported that "both Degas & [Jean François] Raffaelli said it was 'la distinction même.'"[55] In fact the painting demonstrates the degree to which, by the early 1880s, Cassatt had mastered the kind of insightful characterization that Degas had revealed in his *Portrait of Edmond Duranty* (fig. 25). Based on earlier historical portrait types (see Barter, p. 78), the painting calls to mind the scenes of bourgeois ritual in which Gustave Caillebotte specialized. In the portrait of Mrs. Riddle, however, Cassatt paid particular attention to facial features—the shape of eyes, nose, and mouth—and the play of light over the skin of her aging relative. While the artist's attention to details of costume and environment serve to define the figure in a social and historical framework—that of a wealthy woman in the 1880s—her attention to

physiognomy, pose, and gesture specify the individual—Mary Dickinson Riddle. Here Cassatt showed Mrs. Riddle at work in her sphere, as Degas had shown Duranty, the apologist for the naturalist portrait, at work in his. The novelist sits in a pensive mood in his study, behind a table littered with papers, his arm and hand resting on a book. Cassatt depicted the gentlewoman, who, with magnificent propriety, sits erect in her drawing room, behind a table laden with the implements of hospitality, her hand reaching to offer tea to her unseen guests.

Degas's opinion that the portrait was "the essence of distinction" mattered little it seems: it was not a success with Mrs. Riddle or her daughter, neither of whom appreciated its complete lack of sentimentality and conscious avoidance of flattery (see Sharp, p. 157). It is precisely these qualities that might have made Degas exclaim, with profound sincerity, "*Here is someone who thinks as I do.*" In deference to the wishes of the sitter or perhaps because Cassatt had been wounded by her disapproval of the portrait, the artist hid it away until 1914. It was not among her submissions to the eighth and last Impressionist exhibition, in 1886, at the close of which Degas and Cassatt exchanged works, as they had in 1879. Degas chose to add to his nascent personal collection a work of incisive characterization, Cassatt's *Study* (cat. 48). In return Cassatt picked the pastel *Woman Bathing in a Shallow Tub* (Hirshler, fig. 7), perhaps the most uncompromising of the suite Degas had listed in the exhibition catalogue as "nude women bathing, washing, drying or wiping themselves, combing their hair or having it combed."[56] This ensemble was the critical sensation and *succès de scandale* of the 1886 Impressionist exhibition. For the vanguard critic Félix Fénéon, the figure in *Woman Bathing in a Shallow Tub* was wholly unconventional: "A bony spine becomes taut; forearms, leaving the fruity, pearlike breast, plunge straight down between the legs to wet a washcloth in the tub water in which the feet are soaking." In contrast to Degas's nudes, the awkward figure in Cassatt's *Study*, which also appeared in the 1886 exhibition, seems almost elegant. The Belgian writer Octave Maus, citing Gustave Geffroy's now-famous observation that Degas "wanted to paint a woman as one would see her, hidden by a curtain, or through a

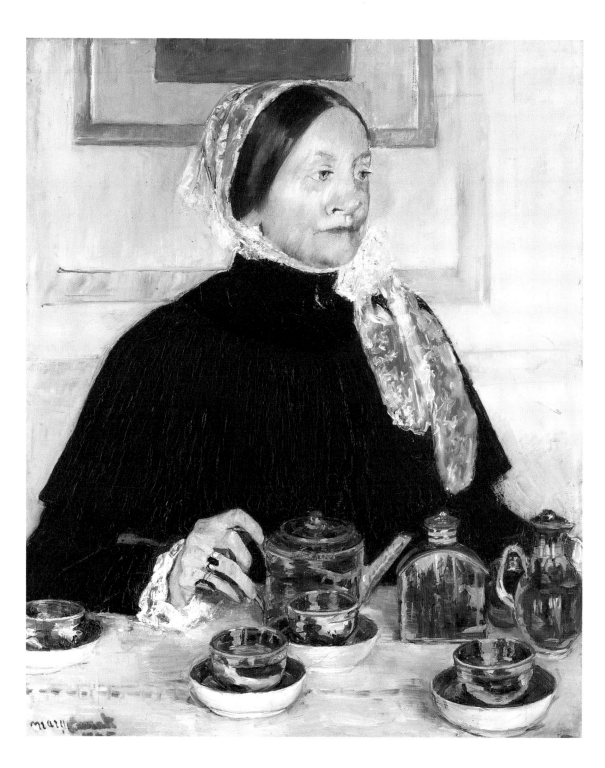

Fig. 24. Mary Cassatt.
Lady at the Tea Table, 1883.
Oil on canvas; 73.4 x 61
cm. New York, The Met-
ropolitan Museum of Art,
gift of the artist, 23.101.

keyhole," described Cassatt's work as a "very seductive study that shows a young girl in her underdress, in the disorder of her dressing room, twisting the braid of her blond tresses with a simple and truthful gesture."[57]

Cassatt's *Study* hung prominently in Degas's apartment, at 37, rue de Victor-Massé, not in the "museum" he created on the first floor of the building, but in the salon of his living quarters one floor up. A photograph Degas took in the mid-1890s (fig. 26) shows

the painting hanging alongside a pastel portrait by Manet of his wife, for which Degas had traded two thousand francs' worth of his work to the dealer Alphonse Portier.[58] In addition to the oil, Degas owned three of Cassatt's pastels, *At the Theater* (fig. 3) and two sketchily finished female head studies. Not surprisingly he had a great number of Cassatt's prints: almost one hundred impressions from approximately sixty plates.[59] The majority of these date from the

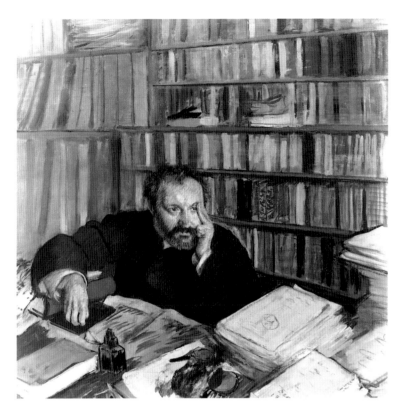

Fig. 25. Edgar Degas. *Portrait of Edmond Duranty*, c. 1879. Pastel, tempera, watercolor, and charcoal on canvas; 100 x 102 cm. Glasgow Art Gallery and Museum, The Burrell Collection, 35/232.

period of the artists' collaboration, but the number of works in his possession from the later 1880s and early 1890s attest to Degas's continuing interest in Cassatt's graphic output.

It became clear, after the 1886 Impressionist exhibition, that the cohesion of the group had eroded and that other opportunities for exhibition would have to be sought. Cassatt and Degas continued to see each other often, but their art began to diverge. In her paintings and pastels, Cassatt now devoted herself almost exclusively to the theme of mothers and children, a subject she had begun to investigate as early as 1880 (see Barter, pp. 71–72) and that her friend almost never treated. This is not to say that Degas never depicted the parent-child relationship, but his por-

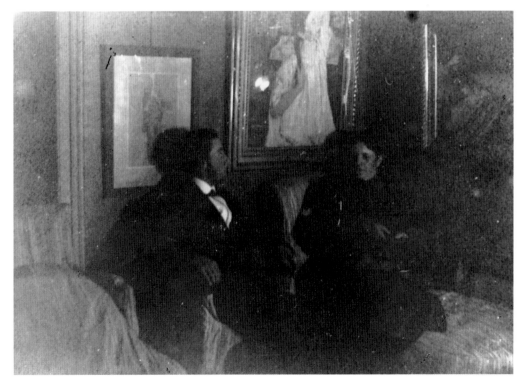

Fig. 26. Edgar Degas. *Elie Halévy and Mme Ludovic Halévy*, c. 1895. Photo: courtesy Archives, The Metropolitan Museum of Art, New York. The photograph shows the salon on the second floor of Degas's residence, at 37, rue Victor Massé. Hanging above Madame Halévy and her son are Edouard Manet's *Portrait of Madame Manet* (Paris, Musée d'Orsay) and Cassatt's *Study* (cat. 48).

trayals of mothers and children, such as the haunting pastel of his friend Madame Alexis Rouart, whom the artist described as a "poor little woman," and her children (fig. 27), all tend to emphasize not tender affection but rather psychological distance.[60] Cassatt's decision to focus on a subject that one would not associate with Degas might be understood as a move to distinguish her art from his. As the general public identified Degas with the ballet, in the same way it could link Cassatt with maternity.

At about the same time, Cassatt also showed a new independence in her choice of media. Around 1885 she began to make prints in drypoint, which previously she had used only for the enhancement of designs primarily etched by acid baths. After a few, tentative efforts at this difficult and painstaking direct-etching technique, she entered into the process with her usual concentration, producing, between 1888 and 1890, a remarkable group of compositions in pure, rich drypoint. The twelve prints she presented as a set at the 1890 exhibition of painter-engravers reveal a totally new economy of means and elegant linearity. Up to this time, she had relied heavily on the contrast of lights and darks to create "Impressionist" effects. This new emphasis on contour paralleled the recent, more classical approach of Renoir, who, in the mid-1880s, rejected the ephemeral effects of Impressionism, and whose first exhibited work in his "new style" was a canvas entitled *Child at the Breast* (fig. 28), which he exhibited at the Galerie Georges Petit in June 1886. On June 17, two days after this exhibition opened, Cassatt wrote to her brother Alexander, "This morning I went to see Degas and he insisted on my going to see the exhibition at Petits Gallery *at once* as he wanted me to judge of the Monets," of which there were nine on view, along with five Renoirs. Although Cassatt did not mention Renoir's works in this letter, she is sure to have seen them. She must have taken particular note of *Child at the Breast*, which may have inspired her drypoint *Nursing* (fig. 29) several years later. She shared with Renoir a renewed interest in the carefully defined, solid forms of Italian Renaissance art (see Barter, pp. 89–

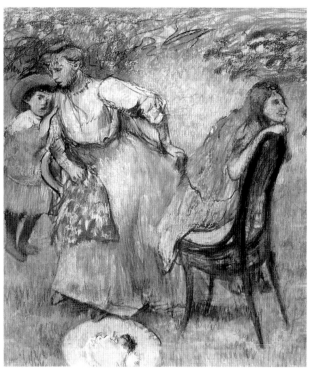

Fig. 27. Edgar Degas. *Madame Alexis Rouart and Her Children*, c. 1905. Pastel over charcoal on tracing paper; 160 x 141 cm. Paris, Musée du Petit Palais, PPD3021. Photo: Jean Sutherland Boggs and Anne Maheux, *Degas Pastels* (New York, 1992), pl. 63.

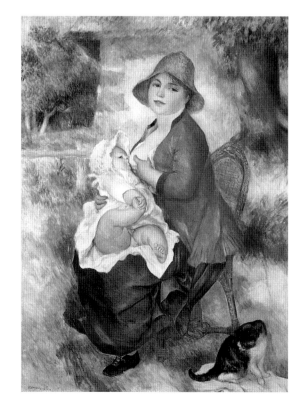

92) and the elegant, classicizing draftsmanship of Ingres and his followers.[61] Ironically, as she explored the expressive qualities of needle-thin line, her friend Degas—a longtime champion of Ingres—now extended his investigation of broader media, abandoning the pencil altogether in favor of denser charcoal and black chalk, which he would smudge with a cloth or with his fingers to suggest smoky shadows.

Six of Cassatt's twelve 1890 drypoints show women—mothers or nurses—with children; the display of so many maternity images constitutes her first explicit statement of the primacy of this theme in her oeuvre. Another is an image of two girls looking at a piece of paper, traditionally identified as a map (see Sharp, fig. 1). The remaining five show single figures. Four of these, which may feature the same model, depict a young woman, seated in street dress, plucking at a mandolin, languorously holding a fan, or gazing absently into a hand mirror. Indeed this group of meditative subjects calls to mind the many print compositions of women in interiors that Cassatt had etched a decade earlier, at the height of her

close collaboration with Degas. The remaining image (fig. 30) features Cassatt's maid Mathilde Valet; perched on her hand is the artist's parrot, Coco, about whom Degas had written a sonnet:

Parrots

To Mademoiselle Cassatt
On her dearest Coco

When, far away, that manlike voice cried out,
At the slow start of a long tropic day
Spent reading from his faded Testament
What must the listless Robinson have felt?

The voice he heard—no longer strange to him—
Did he then laugh? That is, he doesn't say
It made him, poor man, cry, when it arrived,
Shrieking his name, upon his desert isle.

But as for yours, 'tis you who pity him,
Not he you. Yet beware: this tiny saint—
Coco—takes in and gives away, in flight,

That which your heart said to the confidant.
His wing once clipped, snip off a bit of tongue
As well. Leaving him silent . . . and green.[62]

Degas probably penned this sonnet in 1889, at about the same time that Cassatt was preparing her drypoint; neither can be shown to precede the other. Cassatt was well aware of Degas's new interest in verse, however. At the end of January 1889, she planned a dinner party; along with Degas, she invited the poet Stéphane Mallarmé, who, the summer before, had asked her, Degas, and Morisot, among others, to contribute illustrations to *Pages*, a volume of his verse. "[Degas] dreams only of poetry at the moment," Cassatt wrote to Mallarmé; one month later, Mallarmé informed Morisot that Degas's writing was "taking up his attention, for—and this will be the notable event of the winter—he is on his fourth sonnet. In reality, he is no longer of this world; one is perturbed before his obsession with a new art in which he is really quite proficient."[63] Degas can hardly have written a sonnet about a woman and her parrot without being aware of the long visual and emblematic tradition that associated parrots with the keeping of a woman's deepest secrets. The sonnet is one of the rare instances in

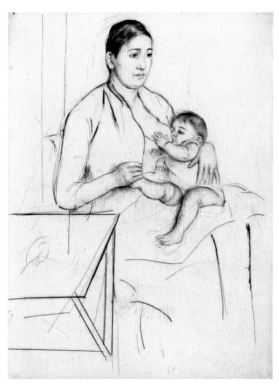

Fig. 29. Mary Cassatt. *Nursing* (second state of two), c. 1890. Drypoint on ivory laid paper; plate: 23.5 x 17.8 cm. The Art Institute of Chicago, gift of C. L. Hutchinson, 1911.609.

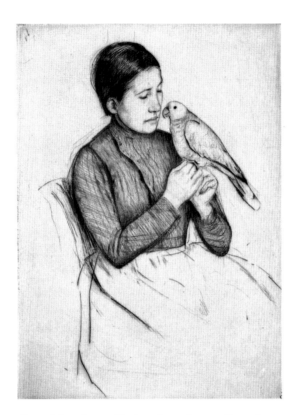

Fig. 30. Mary Cassatt. *The Parrot* (seventh state of seven), c. 1890. Drypoint on cream laid paper; plate: 15.9 x 11.8 cm. The Art Institute of Chicago, gift of C. L. Hutchinson, 1911.611.

which Degas personalized Cassatt's femininity; more typically he sidestepped the issue by deflecting or subverting any admission of her gender: "No woman has a right to draw like that," he told her when he saw her painting *Young Women Picking Fruit* (cat. 68) in the early 1890s.[64]

Critics generally admired Cassatt's drypoints when they were first shown, in the early spring of 1890, although Edmond de Goncourt as usual was dismissive: "The admiration expressed in all the papers for Mlle Cassatt's etchings is enough to make you die of laughter," he wrote. He found "the drawing . . . stupidly heavy and the acid bite clumsy. Oh! truly, this is an age that makes a religion of failures; its high priest is Degas, and Mlle Cassatt is the choirboy."[65] Contrary to Goncourt's assertion, Cassatt must have seen her drypoints as an opportunity to create a body of work that was distinctly unlike Degas's. She was soon to push her independence even further, in the now-famous suite of color prints she began in

the summer of 1890 and completed in early 1891.

In April 1890, little more than one month after the opening of the second painter-engravers show at Durand-Ruel, a massive exhibition of Japanese art opened at the Ecole des beaux-arts, Paris. Cassatt was one of many artists who were overwhelmed by the display, which featured more than seven hundred items, including prints and paintings. Degas wrote jokingly to a friend, "Dinner Saturday at the Fleury's with Mlle Cassatt. The Japanese exhibition at the Beaux-Arts. A fireman's helmet on a frog. Alas! Alas! taste everywhere." For the remainder of 1890 and the first months of 1891, Cassatt thought of nothing else "but color on copper."[66] She absorbed and adapted the color woodblock prints she so admired at the Beaux-arts exhibition, works by artists of the *ukiyo-e* tradition (see Barter, pp. 82–84). A dozen years after her first exploration of printmaking with Degas, Cassatt this time worked on her own, bringing in a talented printer, M. Leroy, to give her technical assistance in preparing the plates. Her new procedures combined aspects of her former working methods: To a matrix of lines traced from a pencil drawing into a soft ground and then etched, Cassatt added strengthening lines of drypoint. This produced a linear design that resembles her 1889 suite of prints. To fill in the outlines, Cassatt prepared at least one, and more often two, additional plates, which would hold the finely grained aquatint that provided blocks of color and pattern. To achieve the complex combinations of color, pattern, and line, Cassatt and Leroy carefully and selectively inked the plates by hand. For example, on the contour plate, the lines that described a woman's hair might be tinted black, while those of a face or hand might be colored a soft, warm brown. At this point, they printed the two or three plates, using pinholes as registration marks; they generally printed the contour plate last.

Approximately twenty-five suites of prints were made at this time, each slightly different from the others, because of the selective inking of the plate and the irregularity of their printing. The result of this painstaking labor was a magnificent group of ten compositions (cats. 56–65) unlike anything that had been achieved by Western printmakers up to that time. Presented, along with a pair of paintings and a

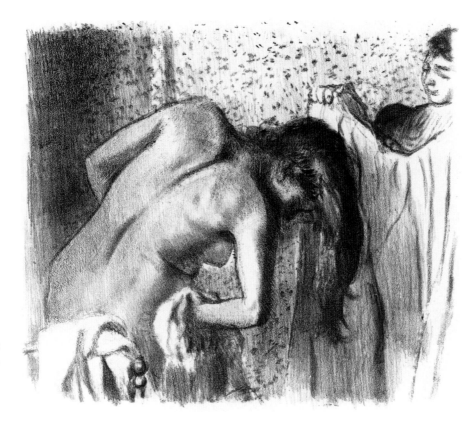

Fig. 31. Edgar Degas. *After the Bath* (large plate), 1891–92. Transfer lithograph, crayon, and scraping on paper; image: 30.2 x 32.7 cm. The Art Institute of Chicago, Clarence Buckingham Collection, 1962.80.

pastel, at a special exhibition at Durand-Ruel, the prints generally were much admired. Pissarro exhibited a selection of recent works as well, and reported to his son that Degas "was charmed by the noble element in [Cassatt's] work, although he made minor qualifications which did not touch their substance." Pissarro also extolled her prints as "rare and exquisite works," describing the tone as "even, subtle, delicate, without stains or seams: admirable blues, fresh rose, etc. . . . The result is admirable, as beautiful as Japanese work, and it's done with printer's ink."[67]

Visiting Cassatt's exhibition, Degas seems to have been struck by her latest treatments of the nude, particularly her figure of a bather, nude to the waist, who bends gracefully toward a bowl on a washstand (cat. 61). He would have recognized its references not only to *ukiyo-e* images of Japanese bathhouses, but also to his own incorporation of similar poses in monotypes of the late 1870s and early 1880s. Scholars have proposed that Cassatt's arresting image may have been the impetus for Degas's return to the nude in 1891, the "set of lithographs, a first series of nude women at their toilette, and a second one on nude

dancers" that he described in July of that year and that resulted in his greatest exploration of the lithographic process (see fig. 31).[68]

As Degas walked through Cassatt's color-print exhibition with Pissarro, he kept secret from his colleague the fact that he had already begun his own set of color prints: During a trip to Burgundy in the fall of 1890, he had produced a group of monotypes on landscape themes, which he printed in oil colors in the studio of his friend Georges Jeanniot, and in the company of his traveling companion, the sculptor Albert Bartholomé. But Degas's procedure was as impromptu and haphazard as Cassatt's was methodical and controlled. Jeanniot, who witnessed Degas's first, impetuous experiments with color monotype, described him as gleefully covering a large copper plate with oil color, daubing at the metal with a paint-soaked rag, and wiping or brushing away the pigment to create highlights. The colors sometimes ran in the process of printing, producing unpredictable and serendipitous landscape images. While Cassatt's suite of color prints realized its potent simplicity of form through the most complicated prepa-

Fig. 32. Edgar Degas. *Squall in the Mountains*, 1890. Monotype printed in oil colors on paper; plate: 30 x 40 cm. Pasadena, Norton Simon Museum, museum purchase, B. Gerald Cantor Fund, 1965.

ration of multiple plates and exacting printing, Degas's somewhat simple, direct working methods produced images that he intended to be deliberately diffuse and vague in order to achieve poetic and unusually emotional effects (see fig. 32). Each artist had evolved an entirely personal response to the art of Japan, with Cassatt's being more literal and emulative and Degas's more intuitive and interpretive.

Later, back in Paris, Degas produced another series of landscape monotypes on a smaller scale. In a return to his practice of the late 1870s and early 1880s, he enhanced these impressions with layers of pastel. Although in 1891 he had quarreled with Durand-Ruel and seems to have embraced the idea that he, Cassatt, and Pissarro join together to exhibit elsewhere, Degas nonetheless returned to the dealer when he decided to show some twenty-four of his landscape monotypes—most covered by layers of pastel—in the autumn of 1892. Having visited the exhibition, Cassatt wrote to her friend the artist Rose Lamb that "at Durand Ruels [*sic*] there has been an exhibition of a series of landscapes in pastel by Degas, not from nature. I prefer his landscape when used as a background for his figures."[69] But Cassatt's criticism of the exhibition might have been provoked by pique. She complained to Lamb that "Degas takes a pleasure in throwing me off the track"; she confided to Louisine Havemeyer the reasons for her exasperation with her old friend:

I am going to do a decoration for the Chicago Exhibition [World's Columbian Exposition of 1893; see Barter, pp. 87–96]. . . . As the bare idea of such a thing put Degas in a rage and he did not spare every criticism he could think of, I got my spirit up and said I would not give up the idea for anything. Now, one has only to mention Chicago to set him off.

As Cassatt's work on her monumental mural, *Modern Woman* (Barter, fig. 51), progressed, she felt herself "no longer capable of judging what I have done. I have been half a dozen times on the point of asking Degas to come and see the work, but if he happens to be in the mood he would demolish me so completely that I could never pick myself up in time to finish for the exposition. Still he is the only man I know whose judgment would be a help to me."[70]

From the beginning, Cassatt must have understood that her concept for the mural would not accord with Degas's ideas about modern decoration. His interest in the theory of decoration went back nearly a quarter century. In the 1860s, Degas had planned a pair of family portraits to be installed as

decoration in a dining room; in a passage from a notebook he used in about 1870—the notebook in which he expressed his often-quoted desire to "make portraits of people in familiar and typical attitudes"—Degas ruminated on issues that apply to the notion of decoration:

Ornament is the interval between one thing and another. One fills in this interval with a relationship between the two things, and *there* is the source of ornament. Think of a treatise of ornament for women or by women, after their way of observing, of combining, of feeling their costume [*toilette*] and everything else. Every day, more than men, they compare, one with another, a thousand visible things.[71]

Degas here closely juxtaposed theories of the origins of ornament and the creation of expressive portraiture, theories that must have been at the back of his mind when around 1879 he executed the beautiful pastel and chalk drawing *Portraits in a Frieze* (fig. 33), which he exhibited in the sixth Impressionist exhibition, in 1881, *hors catalogue*. Inscribed at the lower right, "portraits in a frieze for decoration in an apartment," the image depicts three women in street clothing, evenly dispersed across a sheet of gray paper. This and other related works are connected to

Degas's pastel *At the Louvre* (private collection) and to the two prints of roughly the same date, *Mary Cassatt at the Louvre: The Etruscan Gallery* (fig. 11) and *Mary Cassatt at the Louvre: The Paintings Gallery* (fig. 1).[72]

It seems that Degas's projected decoration of a frieze of women in modern dress never materialized. In the 1879 Impressionist exhibition, however, he did present a work in distemper under the title *Essai de décoration* (this work, as yet unidentified, has sometimes been confused with the pastel *Portraits in a Frieze*). His tentative exploration of decorative ideas at this period parallels developments in the work of Caillebotte, Manet, Monet, Renoir, and Whistler, each of whom apparently hoped not only to extend his work beyond the scale of the easel but also to expand his market and clientele at the same time.[73]

Cassatt, we now know, also participated in this trend: a recently discovered painting by her, *Woman Standing, Holding a Fan* (cat. 15), depicts a figure clad in an apple-green day dress, holding an open fan; she stands against a glowing, backlit white curtain in a simply decorated interior, with a deep blue wall, warm pink rug, and upholstered chair. The painting, unusually vertical in format and large in scale, was

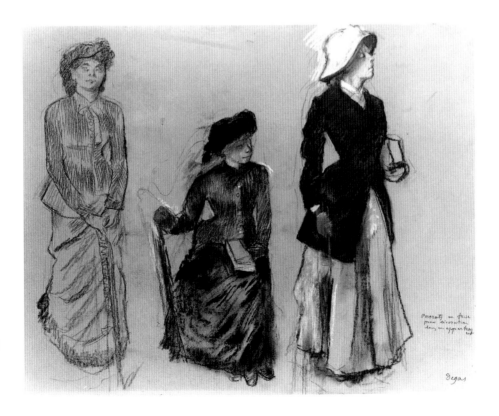

Fig. 33. Edgar Degas. *Portraits in a Frieze*, 1879. Pastel and black chalk on gray paper; 50 x 65 cm. Private collection.

almost certainly conceived as a decoration. It is the only surviving work by Cassatt wholly in distemper, which she had employed around 1879 for a lost work entitled *In a Garden*.[74] Despite her lack of familiarity with this medium, Cassatt seems to have reveled in the dry effects that distemper yields, handling the pigment roughly and simplifying the modeling of the figure and her surroundings, as Degas had done in such distemper paintings as *Portrait After a Costume Ball (Portrait of Mme Dietz-Monnin)* (fig. 7). Cassatt was to employ similarly sketchy effects in the frescolike "overdoor" she painted in the summer of 1880 (*Reading*; Barter, fig. 33), the only decorative work she heretofore is known to have undertaken before the mural project of 1892.

What are the circumstances surrounding the creation of *Woman Standing, Holding a Fan*? Its composition relates to a number of drawings and prints by both Degas and Cassatt: the gently undulating silhouette of the woman recalls the curving figure in his *Mary Cassatt at the Louvre: The Paintings Gallery*, while the simplicity of the composition and its schematic background relate to the effects observed in Cassatt's prints, notably *Interior Scene* (cat. 44) and *The Corner of the Sofa* (fig. 16). Its surface texture recalls the effects of Cassatt's pastels of the late 1870s, such as *At the Theater* (fig. 3), where the fan is similarly embellished with metallic pigments. In light of these similarities, it seems likely that *Woman Standing* dates from the months around the Impressionist exhibition of 1879, perhaps from the time when Degas and Cassatt were working at a fever pitch on the etchings for *Le Jour et la nuit* and when, we must assume, she was modeling for *Portraits in a Frieze* and related pastels. It is all the more remarkable then that, in its matte surface, delicate hues, and gently Japonizing arabesques, this painting anticipates by more than a decade the decorative schemes of the Nabis, young artists who, in the 1890s, began to dedicate themselves to a marriage of modernity and decoration, and who responded—in their designs for domestic wall decorations, standing screens, and theater sets—to the aesthetics of Cassatt's color prints of 1890–91.[75]

While *Woman Standing, Holding a Fan* is among the largest of Cassatt's surviving paintings, its modest scale—when compared to other decorations of the period—and intimate subject make it nearly the idealized realization of Degas's vision of a modern ornamentation for a Parisian apartment. Since he believed that mural decoration should be compatible with the architectural surround and that a muralist should work in close collaboration with an architect, it is easy to understand his concern, even alarm, that Cassatt, the author of *Woman Standing* and an "independent" such as himself, should in 1892 have undertaken a monumental decoration on the theme of modern woman for a public building in the grandest North American Beaux-Arts style—a building she would never see and whose designer she would never meet. In fact, perhaps because Cassatt sensed the incompatibility of modern ideas and classical architectural schemes, it was not to the "independents" but to avatars of the establishment that she looked for inspiration, citing the decorations that Paul Baudry had executed for the Paris Opéra as touchstones for her coloration, degree of finish, and speed of execution (see Barter, pp. 92–93).[76]

A decorative series was not something to undertake without patronage; in the absence of a commission, it is not surprising that, after the World's Columbian Exposition, Cassatt never returned to mural painting. She also chose not to embrace the development of modern decorative painting in the early years of the twentieth century. To Louisine Havemeyer, she confided her opinion of Monet's large water-lily compositions: "I must say his . . . [water-lily] pictures look to me like glorified wallpaper. . . . I wont [*sic*] go so far as D[egas] who thinks he has done nothing worth doing for 20 years, but it is certain that these decorations without composition are not to my taste." All the same, her involvement with the mural for the Chicago fair had a profound effect on her easel paintings of the early 1890s, furthering a tendency toward monumentality, abstraction, and symbolism, expressed through simple contours and static compositions (see Barter, pp. 82–99). Relating to her long-lost mural thematically and presumably coloristically, they mark a pronounced change in her facture and compositional strategies and prompted Degas's cautious approval, perhaps because he saw the shift as a return to the values of early Renaissance art.[77] Nonetheless these

works declare, more than ever, Cassatt's independence from Degas's direct stylistic influence.

On another front, Cassatt stood against Degas by championing the cause of Captain Alfred Dreyfus, a Jewish army officer wrongly accused and convicted of treason, whose case was to become the most divisive issue in French political life in the 1890s. In keeping with the traditions of their upper-middle-class, conservative backgrounds, neither Cassatt nor Degas was free from anti-Semitism, despite the fact that, as members of the Parisian artistic vanguard, each had close ties to Jews—their friend Pissarro being only the most notable example. While Cassatt joined Claude Monet and Emile Zola in the camp of Dreyfus's supporters, Degas, a fierce nationalist, resented the vivid stain on the honor of the state that the affair revealed and resisted all arguments for the officer's innocence. His recalcitrance led him to sever ties to a number of close Jewish friends; his antipathy for Monet deepened; and it seems, from the reminiscences of Louisine Havemeyer, that he even quarreled with Cassatt over her support of Dreyfus's cause.[78]

From the 1890s until the end of Degas's life, his relationship with Cassatt assumed—in addition to their old ties of friendship—a decidedly commercial aspect. In the early 1890s, Cassatt's friends the Havemeyers were well on their way to assembling the greatest collection ever formed of Degas's works, and Cassatt took an active part in shaping it (see Hirshler, pp. 182–83). From 1894 to 1900, the couple acquired between twenty and thirty paintings, pastels, and drawings from the artist and his dealer, as well as on the secondary market. The Havemeyers often solicited Cassatt's advice, since they considered her the best-informed authority on Degas; by the same token, Durand-Ruel called on Degas to recommend works by Cassatt that he had for sale. Writing to H. O. Havemeyer in July 1899 about Cassatt's *Mother and Child* (cat. 87), the dealer said that he had "asked Degas his opinion about the picture; he considers it the finest work that Mary Cassatt ever did; he says it contains all her qualities and is particularly characteristic of her talent." Later Louisine Havemeyer learned from Cassatt that Degas had said something somewhat different to her about this painting: "It has all your qualities and all your faults—*c'est l'Enfant Jésus et sa bonne anglaise* [it's the baby Jesus and his English nurse]."[79]

The Havemeyers' pursuit of Degas's works slowed somewhat after the turn of the century, particularly in the years just before and after H. O. Havemeyer's death in 1907. But, on December 10, 1912, Louisine Havemeyer purchased Degas's *Dancers Practicing at the Bar* (Hirshler, fig. 17). Acquired anonymously through Durand-Ruel, for 478,500 francs (almost $100,000), this work set a world record for the selling price of work by a living artist.[80] Degas attended the sale, as Daniel Halévy reported, "sitting motionless like a blind man." At the end of the event, he was asked how he felt about the record sum. "Like a racehorse that has won the Grand Prix," he replied, "and receives only his ration of oats." Not having been consulted in advance, Cassatt was apparently amazed at Havemeyer's willingness to spend so much for the painting, although she attributed the purchase to her friend's sentiments for her husband, who had especially admired the painting.[81]

The high price nonetheless seems to have spurred Cassatt into action; at the beginning of 1913, she asked Durand-Ruel to sell the portrait Degas had painted of her in the 1880s (cat. 91), as well as the fan she had received from him as an exchange in 1879 (Barter, fig. 22). Some months later, she asked Durand-Ruel to return the portrait and then immediately sold it to Vollard, who eventually succeeded in finding a purchaser. In putting the painting up for sale, Cassatt took a considerable risk, for she must have known of Degas's fierce resentment when collectors or friends sold his works. But Cassatt also knew that Degas was in serious decline and would most likely not notice or learn of the portrait's appearance on the market. As early as May 1904, Daniel Halévy had remarked upon the artist's degeneration: "It gave me rather a shock," he wrote in his diary, "to see him dressed like a tramp, grown so thin, another man entirely."[82]

Cassatt—accustomed to caring for the aged and infirm—seems to have kept abreast of Degas's health. At the beginning of 1912, she had written to Louisine Havemeyer of her visit to the Fèvre family on the outskirts of Nice: "I have been this afternoon

to see Degas['s] nieces. There was only one at home, the Countess. I had not seen her since she was a child. . . . I told her about her uncle, his state of health, [and also] what a value his pictures had—they did not know!" Nine months later, she wrote again to Havemeyer on this subject: "I am expecting a visit from a niece of Degas, she is to come out for the day. I urged her to come to Paris to see for herself and for her sister and brothers her uncle's state. She is staying with him and writes that he is just as I said, immensely changed mentally but in excellent physical health—Of course he may live for years yet—he is 79—but his family will have to take care of him later."[83]

In 1914 Cassatt agreed to work with Louisine Havemeyer on an exhibition to be held in New York City in support of woman suffrage that would showcase Degas's work, knowing full well that the once-reactionary artist would never learn of the political nature of the endeavor. In the ensuing months, the concept of the exhibition expanded to include eighteen Old Master paintings and the work of a second modern artist: Cassatt. In a large room on the ground floor of M. Knoedler and Co., twenty-four paintings by Degas hung alongside nineteen by her (see fig. 34 and Sharp, fig. 15). "I am surprised," Cassatt wrote Havemeyer a month before the exhibition opened, "at the coolness I show in thinking of exhibiting with Degas alone, but one thing Louie I can show, that I don't copy him in this age of copying. I cannot open a catalogue without seeing stealings from me." In the end, the press supported Cassatt's vision of her independence. As one critic wrote:

Miss Cassatt has been a profound student and admirer of Degas, and although never in a strict sense his pupil, has profited from his advice. . . . She has also been, from her early days, an admirer of Manet, and these enthusiasms have had their influence on her art, strengthening her zest for realism and the science of form. In combining her pictures in the present exhibition with those of Degas, however, her freedom from . . . [imitative] execution is much more remarkable than any likeness between the two styles, each so rich in personal thought and feeling.

These bland contours, these candid innocent glances, this untroubled, wholesome sane interest in the common necessities of daily living have nothing to do with the artifice of the stage or the abnormal training of the race course. Here is only nature, married to civilization, certainly, for Miss Cassatt presents to our attention no barbaric types, but nature as one may observe it in a society of simple and intelligent people. No artist could more justly claim for women all the rewards due to good sense and good feeling. The earlier paintings, the one of an old lady in a bonnet taking tea, for example, show a certain reminiscence of the dry, firm notation of artistic facts that we get in the oils by Degas. But in the later work even this vanishes in favor of a fatter pigment, a less angular modeling.[84]

The reviewer did not point out, and may not have understood, the degree to which the exhibition, as an opportunity to compare Cassatt with Degas, was skewed. Cassatt's paintings were mostly recent, with the exception of one dating from 1883 (*Lady at the Tea Table* [fig. 24]). The selection of works by Degas, on the other hand, was more retrospective in character. Lent almost exclusively by private collectors from New York and New England, the examples extended back to the 1860s, with the majority dating from the Impressionist years. Degas's last works, which had rarely if ever been seen in public at this date, were not included, nor was there anything from the late 1890s and the turn of the century, even though the Havemeyers owned several examples.[85] It might be argued that Cassatt deliberately shaped the exhibition to present her late, less Degas-influenced work—significantly examples that the public could buy in 1915—in juxtaposition with Degas's earlier work, which had actually most influenced her. If so she also thus avoided comparison of Degas's revolutionary, recent art with her own, more conservative pictures of a similar date. It is not surprising then that the critic distinguished Cassatt's placid, classicizing, late images of a "society of simple and intelligent people" from Degas's caustic, early work, with its "artifice" and suggestion of the "abnormal." But Degas had no say in this exhibition, if indeed he was even aware of it. For Cassatt the exhibition must have presented an occasion—the last one—in which she could simultaneously affirm her allegiance with Degas and declare her independence from him.

From the summer of 1915 on, the events of World War I preoccupied Cassatt increasingly. Younger than Degas by ten years, she nonetheless recognized her own vulnerability, writing to Havemeyer, "I have lost

Fig. 34. Installation view
of the loan exhibition
"Masterpieces by Old and
Modern Painters for the
Benefit of Woman Suffrage,"
M. Knoedler and Co., New
York, April 1915. Photo:
courtesy M. Knoedler and
Co. This view shows a wall
of works by Mary Cassatt
(left) and by Edgar Degas
(right).

eight pounds and my sight is affected. I cannot read even large print. . . . In imagining old age I didn't think of that . . . old age with one's faculties unimpaired is the best part of life, otherwise weariness and despair." Cassatt underwent eye surgery in the autumn; it is not known how she kept informed about Degas's worsening condition, but in 1916, at her urging, Degas's niece Jeanne Fèvre, a trained nurse, came to live with him permanently.[86]

Cassatt wrote to a young American friend on September 29, 1917: "Degas died at midnight not knowing his state—His death is a great deliverance but I am sad . . . [as] he was my oldest friend here, and the last great artist of the 19th Century—I see no one to replace him." She wrote to Louisine Havemeyer in early October:

You have seen that Degas is no more. We buried him on Saturday, a beautiful sunshine, a little crowd of friends and admirers, all very quiet and peaceful in the midst of this dreadful upheaval of which he was barely conscious. You can well understand what a satisfaction it was to me to know that he had been well cared for and even tenderly nursed by his niece in his last days.

Tellingly Cassatt could not resist reminding her friend: "There [will] of course be a sale. The statue of the 'danseuse' [*Little Fourteen-Year-Old Dancer*] if in a good state you ought to have." The four sales of the contents of Degas's studio and of his collection took place over a period of many months, between May 1918 and July 1919.[87] His holdings of the works of other artists were to be sold first, beginning in March 1918. "I am glad that in the collection of pictures of other painters he owned I will figure honorably," Cassatt wrote to Havemeyer on December 12, 1917. "In fact they [the sales' organizers] thought the

two, a painting & a pastel were his at first."[88] Cassatt was referring to the pastel *At the Theater* (fig. 3), which she had given to Degas in 1879, and to the painting *Study* (cat. 48), which she had presented in an exchange in 1886; Havemeyer would acquire the latter at the sale. A little over two weeks later, Cassatt offered to sell her friend the three works by Degas still in her possession: the pastel *Woman Bathing in a Shallow Tub* (Hirshler, fig. 7), the fan decorated with dancers (Barter, fig. 22), and a small portrait of a woman. "If you don't take them, of course they will be sold as no one in the family can understand them . . . ," the artist declared, clearly morose in the wake of Degas's death.[89]

Frail in her old age, unnecessarily insecure about her finances, and frightened by the war, she was desperate that these works join the Havemeyer collection, the most prestigious selection of Degas's art in existence. Havemeyer acquired the three works early the following year, before the first Degas studio sale took place. They were shipped to Durand-Ruel for safekeeping until the war's end. Cassatt was left with her memories of a friendship that had lasted most of her adult life. Only Louisine Havemeyer had remained her constant friend for a longer period of time. The collector recorded one of Mary Cassatt's most poignant recollections of Edgar Degas:

"When criticism was at its worst, he said to me 'They are all jealous of us, and wish to steal our art. But,' continued Miss Cassatt after a quiet moment, and I saw her face light up with a beautiful expression, '[he was] magnificent! and however dreadful he was, he always lived up to his ideals.' Miss Cassatt folded her hands and I saw she had said all she cared to for the moment."[90]

Notes

1. "She has . . .": Edgar Degas, in Ambroise Vollard, *Degas: An Intimate Portrait*, trans. Randolph T. Weaver (New York, 1927), p. 48.
"The first sight . . .": Mary Cassatt to Colonel Oliver Payne, Feb. 28, [1915], in Mathews 1984, p. 321.

2. Havemeyer 1993, p. 244.

3. For this information, I am indebted to Theodore Reff, who is compiling a new edition of Degas's correspondence. It is possible that Cassatt burned her personal papers, as well as works of art, "to save [her] family the trouble." On the destruction by Cassatt of works of art, see Mathews 1994, p. 82.

4. On Cassatt's encounter with Tourny, see Cassatt to Emily Sartain, June 25, [1873], in Mathews 1984, p. 121. Mathews listed the French artist as Léon Auguste Tourny (b. 1835), but it seems more likely to have been Joseph Gabriel Tourny (b. 1818). It is tempting to think that Cassatt's first encounter with Degas's work may have been a glorious impression of this portrait etching, which the artist had executed in Rome, in the engraver's possession. With the exception of a single proof of the first, recently discovered state of the etching, which Degas seems to have given to the artist Gustave Moreau, who was also in Rome, he kept the earliest known printings of the etching. Only if he had given Tourny a proof pulled much later would the engraver have owned one; see Boston 1984, no. 5, pp. 8–19. Cassatt later owned another impression of this print, which she gave to Louisine Havemeyer in 1889; see ibid., p. 12, n. 4.

5. Segard 1913, p. 35. On this painting, see Mathews 1994, p. 91, fig. 36. It does not appear in Breeskin 1970.

6. Cassatt told this story to Louisine Havemeyer, who repeated it in her remarks at the opening of the exhibition in support of woman suffrage she organized in 1915; see Mathews 1994, p. 114.

7. The exact date of the purchase of *Rehearsal of the Ballet* has been much discussed. The work was probably executed in 1876, but all that is certain is that the collector owned the painting no later than February 1878, when she lent it to the "Eleventh Annual Exhibition of the American Water Color Society" in New York; see New York 1993, p. 203.

8. Duranty 1879.

9. Ibid.

10. Cassatt to Ambroise Vollard, [1903], in Mathews 1984, p. 281; and Sweet 1966, p. 39 (for a different translation).

11. See Berson 1996, vol. 2, pp. 108–109.

12. See Degas to Viscount Ludovic Lepic, [1879], in Mathews 1984, p. 148.

13. Havard 1879.

14. See Berson 1996, vol. 2, pp. 72–74, 89–91. Among the best known of the works he showed in 1877 are *L'Etoile*, now in the Musée d'Orsay, Paris; and two *Café-Concerts*, one in the Corcoran Gallery of Art, Washington, D.C., and the other in the Musée des beaux-arts, Lyons.

15. On Cassatt's visit to the Jardin Mabille, see Mathews 1994, p. 53.

16. Duranty 1879.

17. Edmond Duranty, *The New Painting: Concerning the Group of Artists Exhibiting at the Durand-Ruel Galleries* (Paris, 1876); repr. in San Francisco 1986, pp. 43–44.

18. For more on this portrait, see The Art Institute of Chicago, *Degas in The Art Institute of Chicago*, exh. cat. by Richard R. Brettell and Suzanne Folds McCullagh (1984), pp. 106–109.

19. Renoir 1879.

20. Degas wrote to Braquemond that there would be "a room of fans . . . Pissarro, Mlle Morisot and I, up to now, will place things there. You and your wife should also contribute"; see Guérin 1947, pp. 49–50.
On Morisot's planned fan submissions, see San Francisco 1986, p. 249.
For the Morisots, see Berson 1996, vol. 2, pp. 41, 78. For the Cassatts, see ibid., pp. 108–109.

21. *Le Soir* 1879. The writer for *La Petite République française* was similarly misinformed; see *La Petite République française* 1879.

22. For Manet's portraits of Moore, see Rouart/Wildenstein 296, 297. For Cassatt's portrait of him, see Breeskin 1970, 27.
George Moore, *Reminiscences of the Impres-*

sionist Painters (Dublin, 1906), p. 36.

23. Lostalot 1879.

24. Cassatt to Emily Sartain, Oct. 13, [1872], in Mathews 1984, p. 107.

25. Havemeyer 1993, p. 217.

26. "No art was . . .": George Moore, "Degas: The Painter of Modern Life," *Magazine of Art* 13 (1890), p. 423.
For an unfinished work that shows Cassatt's *alla prima* technique, see Breeskin 1970, 141. See also Barter, fig. 57, for a later example.

27. Diary entry for May 16, 1879, in Halévy 1937, p. 823.

28. Boston 1984, p. xiv.

29. See for instance the evolution of Cassatt's *At the Dressing Table* (Breeskin 1948, 10), as presented by Nancy Mowll Mathews, in Boston 1989, pp. 28, 30–31. Barbara Stern Shapiro is planning a catalogue of Cassatt's black-and-white prints, describing each state and identifying the techniques the artist employed in preparing her plates.

30. Boston 1989, p. 59. See also New York 1997, pp. 240–41.

31. For Cassatt's print, see Breeskin 1948, no. 34; Breeskin underestimated the number of states at six. For Degas's drawing and print, see Boston 1984, no. 51, pp. 168–83. For Degas's collection of proofs of this print, see New York 1997, p. 240.

32. New York 1997, p. 243. See also Shapiro, "Pissarro as Print-maker," in London, Arts Council of Great Britain, *Pissarro*, exh. cat. by Richard R. Brettell, Christopher Lloyd et al. (1980–81), pp. 191–93, and nos. 164–68, pp. 205–206.

33. Two letters from Degas to Pissarro make clear the degree to which they and Cassatt were in contact; see Guérin 1947, pp. 52–55.

34. "Black and white Impressionism": New York 1997, p. 244. On the artists' entries, see Berson 1996, vol. 2, pp. 146–48, 152–53; see also New York 1997, pp. 240–41. For Pissarro's entries, see also London (note 32), nos. 156–61, pp. 201–202.

35. See London (note 32), p. 192.

36. See ibid.; and Boston 1984, p. 98, where the authors cited Degas on how to etch a "plaque argentée (de daguerre)," as well as his notes on the different sizes of daguerreotype plates. As Reed and Shapiro (Boston 1984, p. 98) discovered, Schneider founded his business in Berlin in 1847. For the three prints, see ibid., nos. 32, 33, 48.

Pissarro's three etchings are *Saint Martin's Day Fair at Pontoise* (Delteil 21), *Setting Sun* (Delteil 22), and *Tree and Plowed Field* (Delteil 26); see London (note 32), p. 196, n. 5.

For the single proof of *Warming His Hands*, see Breeskin 1948, 28.

37. Etchings pulled from plates measuring approximately 16 x 12 cm include Boston 1984, nos. 22, 34, 46, in addition to nos. 32, 33, 48, cited above in note 36. More than fifty monotypes were pulled from one or more plates of the same dimensions.

38. This observation was also made by Reed and Shapiro during the preparation of Boston 1984, according to notes in the files, Department of Prints, Drawings, and Photographs, of the Museum of Fine Arts, Boston.

39. See Boston 1989, p. 59.

40. Colta Ives, of The Metropolitan Museum of Art, New York, pointed out to me that the only known impression of the print (Chicago, Ursula and Stanley Johnson Collection) was part of a group of working proofs from unfinished Cassatt plates that were sold as lot 58 in the sale of Degas's print collection; Paris, Hôtel Drouot, *Catalogue des estampes anciennes et modernes . . . composant la collection Edgar Degas . . .*, sale cat. (Nov. 6–7, 1918). See New York 1997, nos. 98–104 (*Warming His Hands* is catalogued as no. 102). At first glance, the attribution of the print to Cassatt in the Degas collection sale would seem to be conclusive, but we must remember that she had little or nothing to do with the cataloguing of Degas's print collection and was not present to correct an error in attribution, being in the south of France at the time of the sale. R. S. Johnson in fact recently suggested that the composition might be attributed to Degas; see Chicago 1997, p. 62.

41. Boston 1984, p. 149.

42. I am grateful to David Schorr for these observations.

43. Breeskin 1948, 91.

44. For *Standing Nude (Dark)*, see Breeskin 1948, 8; for *Standing Nude with a Towel*, see ibid., 9.

45. For *Combing the Hair*, see Cambridge, Mass., Fogg Art Museum, Harvard University, *Degas Monotypes: Essay, Catalogue, and Checklist*, exh. cat. by Eugenia Parry Janis (1968), no. 156.

46. *Peasant Girls Bathing in the Sea Toward Evening* (Lemoisne 377) is listed in the catalogues for the Impressionist exhibitions of 1876 and 1877 but was never mentioned by critics; see Berson 1996, vol. 2, pp. 36, 73.

47. The print is Cambridge (note 45), no. 40.

48. For a pastel-monotype pair, see ibid., checklist nos. 156, 157.

In the first Impressionist exhibition, Degas exhibited *After the Bath, Study* (probably Lemoisne 376, a study of three figures in chemises). Of the three pastels he showed in 1877, two, *Woman Leaving Her Bath* (Lemoisne 422) and *Dressing Room* (Lemoisne 547), belonged to Gustave Caillebotte and are now in the Musée d'Orsay, Paris. The third, *Woman Taking Her Bath, Evening*, is probably Lemoisne 890. See Berson 1996, vol. 2, pp. 7, 72–74.

49. Katherine Cassatt to Alexander Cassatt, Apr. 9, [1880], in Mathews 1984, pp. 150–51.

50. "Did your mother . . .": Robert S. Cassatt to Alexander Cassatt, Jan. 19, 1882, in Sweet 1966, p. 67.

See "Appendice," in Huysmans 1883, repr. in Berson 1996, vol. 1, p. 396.

Degas's group of defectors also included Jean François Raffaelli and Federico Zandomeneghi. Both had initially exhibited with the group at Degas's invitation; the question of whether these two should continue to participate in the exhibitions was the pretext for the disagreement among the group's founding members.

51. Eugène Manet, in Denis Rouart, *Correspondence de Berthe Morisot* (Paris, 1950), p. 111. Presumably he was referring to an article by Jacques de Biez (Biez 1882). The author stated, "MM. Raffaelli and Degas having fled, and after them M. Forain and Mlle Mary Cassats [*sic*], here is the association of the impressionists (seventh year) coming apart, and, let us say it, dealt a blow to the head."

52. On the characterization of the 1882 exhibition as the victory of landscape, see San Francisco 1986, pp. 373–89.

53. On *At the Milliner's*, see Ottawa 1988, no. 232, pp. 395–97. While Cassatt did not participate in the 1882 exhibition, she went to see it and did not mean to break with those Impressionist colleagues who did exhibit. As Eugène Manet wrote to his wife, "Yesterday I met Miss Cassatt at the exhibition. She seems to wish to be more intimate with us. She asks to do portraits of Bibi [their daughter, Julie] and you. I said, yes, gladly, on condition of reciprocity." None of these portraits ever materialized. See Adler/Garb 1987, p. 33.

54. Quoted in Havemeyer 1993, p. 258.

55. Katherine Cassatt to Alexander Cassatt, Nov. 30, [1883], in Mathews 1984, pp. 174.

56. See Berson 1996, vol. 1, p. 442, and vol. 2, pp. 240–41.

57. Fénéon 1886; trans. in Ottawa 1988, p. 443.

Maus 1886. See Geffroy 1886.

58. For the Manet portrait, see New York 1997, no. 806.

59. For the pastels by Cassatt that Degas owned, see ibid., nos. 47–49; for the prints, see nos. 50–104. The descriptions of several lot numbers in the sale of prints in Degas's collection make it difficult to discern how many different compositions were included in a given lot. In the case of lot 58, described as "a group of thirteen proofs from unfinished plates" ("Réunion de treize épreuves d'essai, de planches restées pour la plupart inachevées"), several compositions made up the lot. But whether any one composition was represented in multiple impressions is impossible to determine.

60. For Degas on Madame Rouart, see Guérin 1947, p. 211.

Family Portrait (The Belleli Family) (Paris, Musée d'Orsay) is the artist's most famous representation of familial dysfunction. He portrayed a few isolated images of mothers and children, including *The Duchess of Montejasi with Her Daughters Elena and Camilla* (private collection [Lemoisne 637]). Among Degas's many images of "stage mothers" with their adolescent or nearly grown children can be

cited the Denver Art Museum's *Dance Examination*, which Louisine Havemeyer once owned; and *Waiting* (Los Angeles, J. Paul Getty Museum, and Pasadena, Norton Simon Museum), which the Havemeyers purchased in 1895. To this should be added his monotype illustrations for Ludovic Halévy's novel *M. et Mme Cardinal* (Paris, 1872), which explores Madame Cardinal's difficulties with her daughters, who are dancers at the Opéra. Degas's depictions of men and children include *Ludovic Lepic and His Daughters* (Zurich, Foundation Collection Emil G. Bührle), *Place de la Concorde* (formerly in the Gerstenberg Collection, Berlin, now in the State Hermitage Museum, St. Petersburg), *Henri de Gas and His Niece Lucy* (The Art Institute of Chicago), *Henri Rouart and His Daughter Hélène* (Lemoisne 424), and *Henri Rouart and His Son Alexis* (Lemoisne 1176). Degas also depicted children with nurses, such as *Henri Valpinçon as a Child* (Lemoisne 270), *Children Sitting in the Doorway of a House* (Ordrupgaardsamlingen, Denmark), and *A Nurse in the Luxembourg Gardens* (Lemoisne 416), which may be compared with Cassatt's *Children in a Garden* (cat. 15).

61. For the shift in Renoir's style, see London, Hayward Gallery et al., *Renoir*, exh. cat. by Anne Distel and John House (1985), pp. 241–49.

"This morning . . .": Cassatt to Alexander Cassatt, May 17, 1886, in Sweet 1966, p. 104. Sweet incorrectly dated the letter to May 17; in fact Petit's "Fifth International Exhibition"—surely the exhibition to which Cassatt was referring—opened on June 15; see The Art Institute of Chicago, *Monet*, exh. cat. by Charles F. Stuckey (1995), p. 213.

Cassatt may have taken particular notice of Renoir's work, because she was about to leave Paris with her family to spend the summer in the village of Arques-la-Bataille, on the recommendation of M. and Mme Paul Berard, Renoir's great patrons during the 1880s; see Ottawa, National Gallery of Canada et al., *Renoir's Portraits: Impressions of an Age*, exh. cat. by Colin B. Bailey et al. (1997), p. 38. Cassatt wrote to her sister-in-law Lois that "the Berards live about six miles & a half from here, it was partly our reason for coming"; see Cassatt to Lois Cassatt, June 30, [1886], in Mathews 1984, p. 199.

62. The series is catalogued in Breeskin 1948, nos. 127–38. For Degas's sonnet, see Lemoisne, vol. 1, p. 206. The French text reads:

Perroquets

à Mademoiselle Cassatt
à propos de son Coco chéri

Quand cette voix criait, presqu'humaine, là-bas,
Au long commencement d'une même journée,
Ou qu'il lisait sur sa Bible fanée,
Que devait ressentir ce Robinson, si las?

Cette voix de la bête à lui accoutumée,
Le faisait-elle rire? Au moins il ne dit pas
S'il en pleurait, le pauvre. A cris perçants et gras,
Elle allait, le nommant, dans son île fermée.

C'est vous qui le plaignez, non pas lui qui vous plaint,
Le vôtre. Mais sachez, comme un tout petit saint
Qu'un Coco se recueille et débite, en sa fuite,

Ce qu'a dit vôtre coeur, au confident ouvert . . .
Après le bout de l'aile, enlevez-lui de suite
Un bout de langue. Alors il est muet . . . et vert.

I am grateful to Jean Coyner, with whom I collaborated to translate this text.

63. On Mallarmé's invitation to artists, see Stéphane Mallarmé to Edmond Deman, Apr. 14, 1889, in Mondor 1984, vol. 11, p. 46, n. 2.

Pages was published (Paris, 1889), but without a contribution from Cassatt.

"[Degas] dreams . . .": Cassatt to Stéphane Mallarmé, Jan. 22, 1889, in Mondor 1969, vol. 3, p. 291, n. 1.

"Taking up his attention . . .": Stéphane Mallarmé to Berthe Morisot, Feb. 17, 1889, in ibid., p. 290.

64. As recounted by Cassatt in a letter to Homer Saint-Gaudens, Dec. 28, 1922, in Mathews 1984, p. 335. Cassatt remembered that the painting was done in 1891, but it dates from 1891–92; see ibid., p. 335, n. 3. It was typical of Degas thus to combine praise and scorn. In response to Monet's brilliant depictions of light, he is said to have remarked, "Let me get out of here. Those reflections in the water hurt my eyes!" See Vollard (note 1), p. 46.

65. Edmond de Goncourt, in Boston 1989, p. 62.

66. Degas to Albert Bartholomé, late Apr. 1890, in Guérin 1947, pp. 145–46.

"But color . . .": Cassatt to Berthe Morisot, [Apr. 1890], in Mathews 1984, p. 214.

67. The paintings and pastel Cassatt included in the exhibition are Breeskin 1970, 151, 189, 185.

"Was charmed . . .": Camille Pissarro to Lucien Pissarro, Apr. 8, 1891, in Rewald 1972, p. 160.

"Rare and exquisite . . .": Camille Pissarro to Lucien Pissarro, Apr. 3, 1891, in ibid., p. 219.

68. For Cassatt's inspiring Degas, see Boston 1984, p. lxii.

"Set of lithographs . . .": Degas to Evariste de Valernes, July 6, 1891, in Guérin 1947, p. 175; the letter is misdated by Guérin, according to Ottawa 1988, p. 499.

69. For Degas's color prints, see Richard Kendall, *Degas Landscapes* (London/New Haven, 1993), pp. 145–81; see also Boston 1989, p. 80. On the 1892 exhibition of Degas's landscapes, see Kendall, ibid., pp. 183–229.

"At Durand Ruels [*sic*] . . .": Cassatt to Rose Lamb, Nov. 30, [1892], in Mathews 1984, p. 240.

70. "Degas takes a pleasure . . .": Cassatt to Rose Lamb, Nov. 30, [1892], in Mathews 1984, p. 240.

"I am going to do . . .": Cassatt to Louisine Havemeyer, as cited in a fragment of an unpublished chapter from Havemeyer's memoirs, in ibid., p. 229, n. 2.

"No longer capable . . .": Cassatt to Bertha Palmer, Dec. 1, [1892], in ibid., p. 241.

71. "Make portraits . . .": Degas notebook 23, p. 47, in Theodore Reff, *The Notebooks of Edgar Degas* (Oxford, 1976), vol. 1, p. 118.

"Ornament is . . .": Degas notebook 23, pp. 46–47, in ibid. See also Washington, D.C., The National Gallery of Art, *Degas: The Dancers*, exh. cat. by George T. M. Shackelford (1984), pp. 105–107.

72. For a discussion of *Portraits in a Frieze* and the following works, see Ottawa 1988, p. 318. *Portraits in a Frieze* was not exhibited in 1880 but in 1881, along with Degas's *Little Fourteen-Year-Old Dancer* and his *Criminal Physiognomies* (Lemoisne 638, 639). See Washington, D.C. (note 71), pp. 80–81; and Berson 1996, vol. 2, p. 180. A related work, *Two Studies of Mary Cassatt* (Brame/Reff 105) was later owned by Cassatt's friend and sometime advisee Harris Whittemore (see Hirshler, pp. 197–98). For *At the Louvre*, see Lemoisne 581; for *The Etruscan Gallery* and *The Paintings Gallery*, see Boston 1984, nos. 51, 52.

73. In 1879 Manet proposed, without success, to the Prefect of the Seine to execute a decoration on the theme of Parisian labor for the Municipal Council Chamber of the Hôtel de Ville; see New York, The Metropolitan Museum of Art et al., *Manet 1832–1883*, exh. cat. (1982), p. 515. Whistler, who, as early as 1867, had planned a decorative scheme for his patron Frederick Leyland in London, was engaged by 1876 in a dining room for this patron, his famous "Peacock Room." Whistler seems to have arranged for other clients, Alexander and Lois Cassatt, to see the completed room in 1883. On these projects, see Washington, D.C., The Freer Gallery of Art, *James McNeill Whistler at the Freer Gallery of Art*, exh. cat. by David Park Curry (1984), pp. 53–69, 107–11; Washington, D.C., National Gallery of Art et al., *James McNeill Whistler*, exh. cat. (1994), pp. 92–94, 164–67; and Mathews 1994, p. 169.

Monet and Caillebotte also attempted decorative paintings. For Monet's commission from Ernest Hoschédé, see Wildenstein

285, 416. For his decorations for the salon of Paul Durand-Ruel, see ibid. 918–58. For Caillebotte see Berhaut 1978, 89–91; The Art Institute of Chicago et al., *Gustave Caillebotte, 1848–1894*, exh. cat. (1995), nos. 26–28; and Berson 1996, vol. 2, pp. 106–107. Renoir's interest in decoration—which dated from his early years as a decorator of porcelain objects—is revealed in his having exhibited his famous 1887 *Bathers* (Philadelphia Museum of Art) with the title *Trial for Decorative Painting*; see Christopher Riopelle, "Renoir: *The Great Bathers*," *Philadelphia Museum of Art Bulletin* (fall 1990), p. 20.

74. The work is no. 56 in the catalogue of the Impressionist exhibition of 1879; see Berson 1996, vol. 2, p. 109.

75. The closest parallel with Cassatt's *Woman Standing, Holding a Fan* in the Nabis group can be found in the art of Edouard Vuillard, who, from the early 1890s, produced large-scale easel paintings as moveable decorations for his Parisian patrons. The matte effects that he achieved through the use of glue-bound pigments resemble Cassatt's execution in distemper, and like her he employed compositions strongly influenced by Japanese prints. The triptych-format panels of his *Public Gardens* series, commissioned by Alexandre Natanson in 1893, resemble the tripartite scheme of Cassatt's *Modern Woman* mural: both may derive from *ukiyo-e* triptych prints. For Vuillard's decorative projects, see Gloria Groom, *Edouard Vuillard, Painter-Decorator: Patrons and Projects, 1892–1912* (New Haven, 1993).

76. For Cassatt on her sources for the Chicago mural, see her letters to Bertha Honoré Palmer, in Mathews 1984, Oct. 11, [1892] and Dec. 1, [1892], pp. 237–38, 241, respectively.

77. "I must say. . .": Cassatt to Louisine Havemeyer, Sept. 8, [1918], in Mathews 1984, p. 331.
On Degas's cautious praise, see p. 132 and note 64.

78. On Cassatt's anti-Semitism, see her letter to her niece about the American expatriate collectors Gertrude, Leo, and Michael Stein, where she observed that "they are not Jews for nothing. They . . . started a studio, bought Matisse's pictures cheap and began to pose as amateurs of the only real art"; Cassatt to Ellen Mary Cassatt, Mar. 26, [1913?], in Mathews 1994, p. 283. The Dreyfus Affair brought out Degas's most virulent attacks on Jewish culture and its influence in France, as well as his most chilling silences; see Daniel Halévy, *My Friend Degas* (Middletown, Conn., 1964), pp. 100–101. In addition to Pissarro, Cassatt was close to her patron Moïse Dreyfus (who was not related to the indicted officer); Degas maintained his friendship with Louise and Ludovic Halévy and their son Daniel until long after the affair broke, but eventually interrupted relations with them. See ibid., pp. 97–105. Daniel Halévy nonetheless watched closely over Degas in his later years. For Cassatt's break with Degas, see Mathews 1994, p. 275.

79. See New York 1993, pp. 325–38. The exact dates of acquisition of some of the works are unknown.
"Asked Degas . . .": Paul Durand-Ruel to H. O. Havemeyer, July 7, 1899, in Weitzenhoffer 1986, p. 136.
"It has all . . .": Degas, in Havemeyer 1993, p. 244.

80. On Havemeyer's record-setting purchase, see New York 1993, pp. 260–61.

81. "Sitting motionless . . .": Halévy (note 78), pp. 108–109.
"Like a racehorse . . .": Etienne Charles, "Les Mots de Degas," *La Renaissance de l'art français et des industries de luxe* (Apr. 2, 1918), p. 4, in Henri Loyrette, *Degas* (Paris, 1991), p. 595.
For Cassatt's explanation of the spectacular purchase, see Cassatt to Paul Durand-Ruel, Dec. 26, [1912], in Venturi 1939, vol. 2, p. 127 (misdated to 1911), trans. and quoted in Weitzenhoffer 1986, p. 209.

82. The demand for Degas's art, like that for Monet's, had continued to grow through the years; the impetus to take advantage of the scarcity of available works, as well as the accompanying rise in prices, had tempted a number of Degas's friends to sell, with fatal consequences for their relationships with the artist. For example in 1894 Degas insulted Théodore Duret, an early champion of the Impressionists, when the writer sold his collection of their works. "You glorify yourself as having been one of our friends . . . ," Degas declared, "I won't shake hands with you." For this contretemps, see Halévy (note 78), p. 94.
"It gave me . . .": ibid., p. 103. For a thorough discussion of Degas's activities in the first decade of the twentieth century, see London, National Gallery et al., *Degas: Beyond Impressionism*, exh. cat. by Richard Kendall (1996).

83. "I have been . . .": Cassatt to Louisine Havemeyer, Dec. 3, 1912, NGA.
"I am expecting . . .": Cassatt to Louisine Havemeyer, Sept. 11, 1913, NGA.

84. "I am surprised . . .": Cassatt to Louisine Havemeyer, Mar. 12, [1915], in Mathews 1984, p. 322.
"Miss Cassatt . . .": *New York Times Magazine* 1915b, p. 15.

85. The late works by Degas Havemeyer owned by the time of the 1915 exhibition include, in New York 1993, no. 355 (1894, acquired 1894), no. 257 (1894, acquired 1901), no. 258 (1899, acquired 1906), no. 254 (c. 1900, acquired 1906).

86. "I have lost . . .": Cassatt to Louisine Havemeyer, July 13, 1915, NGA.
For Cassatt's role in Degas's care, see Ottawa 1988, pp. 496–97.

87. "Degas died . . .": Cassatt to George Biddle, Sept. 29, [1917], in Mathews 1984, pp. 327–28.
"You have seen. . .": Cassatt to Louisine Havemeyer, Oct. 2, [1917], in ibid., p. 328. Cassatt had not forgotten that, in Apr. 1903, she had taken Louisine Havemeyer to Degas's studio, where the collector encountered, for the first time, "the remains of his celebrated statue." Remembering this encounter many years later, Havemeyer mentioned "how faded the gauze was and how woolly the dark hair appeared, but nevertheless I had a great desire to possess the statue," which she regarded as "one of the greatest works of art since the dynasties of the Nile"; Havemeyer 1993, pp. 254–55. She decided to buy the piece, but, as Cassatt wrote in exasperation to Paul Durand-Ruel, Havemeyer "would have nothing but the original, and she tells me that Degas, on the pretext that the wax has blackened, wants to do it all over in bronze or in plaster with wax on the surface"; Cassatt to Paul Durand-Ruel, [1903], in Mathews 1984, p. 287. In the end, the negotiations were not successful. Nonetheless the sculpture remained a much-admired object for the collector and her advisor.

88. "I am glad. . .": Cassatt to Louisine Havemeyer, Dec. 12, [1917], in Mathews 1984, p. 329.

89. "If you don't . . .": Cassatt to Louisine Havemeyer, Oct. 28, [1917], in Mathews 1984, p. 330.

90. The portrait of a woman Havemeyer acquired from Cassatt is Lemoisne 861.
"'When criticism . . .'": Havemeyer 1993, pp. 244–45.

PARIS, 22 novembre 1890. N° 1. — Tirage justifié : 10,000 Ex. Un Numéro : 30 centimes.

PARIS
Rue Saint-Georges, 43
RÉDACTION

J. ROUAM & Cᵉ
Rue du Helder, 14
Dépositaires

NEW-YORK
318, Cinquième Avenue

Adresse Télégraphique :
YVELING-PARIS

TELÉPHONE

L'ART
DANS LES
DEUX MONDES

Journal Hebdomadaire Illustré paraissant le Samedi.

ABONNEMENT :
FRANCE & COLONIES

UN AN 20 Francs.
SIX MOIS 11 —
TROIS MOIS 6 —

Prix des annonces . 2.50 *la ligne.*

Directeurs : YVELING RAMBAUD & CAMILLE DE RODDAZ
Principaux Collaborateurs :

PAUL ARÈNE; ÉMILE BERGERAT; R. DE BONNIÈRES; ALPHONSE DAUDET;
MARCELIN DESBOUTIN; L. DE FOURCAUD; GUSTAVE GEFFROY; EDMOND DE
GONCOURT; MAETERLINCK; PAUL MANTZ; ROGER MARX; O. MIRBEAU;
GÉO NICOLET; A. SYLVESTRE; ZOLA.

ABONNEMENT :
ÉTRANGER (UNION POSTALE)

UN AN 24 Francs.
SIX MOIS 13 —
TROIS MOIS 7 —

Prix des annonces · 2.50 *la ligne.*

SOMMAIRE :

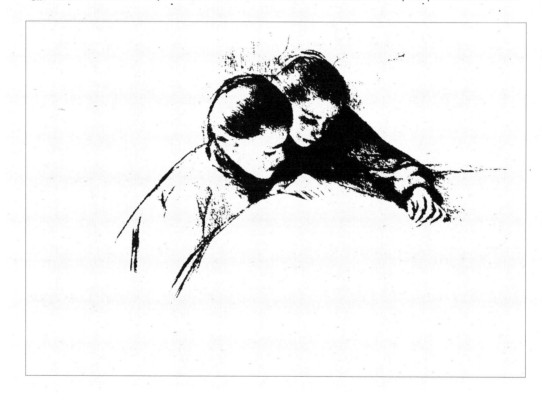

Fig. 1. Mary Cassatt. *The Lesson*, 1890. Drypoint; 15.8 x 22.9 cm. Reproduced
on the cover of the first issue of *L'Art dans les deux mondes* (Nov. 22, 1890).

How Mary Cassatt Became an American Artist

Kevin Sharp

Mary Cassatt was an American artist by birth, but not altogether by inclination. As a young woman, she had left the United States for Europe, seeking the solid, academic training and Old Master examples her country lacked. By 1874 she had settled in Paris, where she eventually built a reputation as a serious artist, exhibiting with the Impressionists between 1879 and 1886. During these years, Cassatt's audience was decidedly French. Such important Parisian critics as Philippe Burty, Edmond Duranty, and Joris Karl Huysmans recognized and at times lauded her contributions to the Impressionist shows. In the late 1870s and early 1880s, a small yet significant group of collectors—including the fabulously wealthy Rouart brothers, Henri and Alexis; the porcelain manufacturer Charles Haviland; the French Minister of Fine Arts, Antonin Proust; the artists Edgar Degas and Paul Gauguin; the businessman Léon Clapisson; and perhaps most notably the art dealer Paul Durand-Ruel (fig. 2)—all added works by Cassatt to their impressive private holdings. On the strength of this following, the artist, a permanent resident of Paris—along with her parents and sister, Lydia—probably rightfully expected her career to flourish or flounder in France. The United States must have seemed a very faraway place, not just geographically but also in terms of building a following comparable to what she already had in France.[1]

Cassatt's work, however, was not unknown in her native land. Her brothers, Alexander and Gardner, lived in Philadelphia; each owned a number of his sister's paintings and pastels. In turn the brothers, Alexander especially, lent generously to exhibitions in the United States, although it is unclear whether at their sister's urging or in response to requests from the organizing groups or institutions. In any case, such exposure was sporadic and hardly sufficient to establish Cassatt's reputation firmly in the country of her birth. Moreover it was familial bonds rather than reputation-building that prompted the artist early

Fig. 2. Pierre Auguste Renoir (French; 1841–1919). *Paul Durand-Ruel*, 1910. Oil on canvas; 65 x 54 cm. Private collection. Photo: courtesy Archives Durand-Ruel, Paris.

on to send so many of her finest works to the United States.[2]

The "end" of Impressionism, marked by the eighth and final group exhibition, in 1886, forced Cassatt to seek new venues for her art in Paris. But France, in the late 1880s and 1890s, was more nationalistic than when Cassatt first had settled there; now she often found herself an outsider in her adopted land. As Impressionist art began slowly to attract some attention in the United States, Cassatt actively pursued a North American audience for the first time in many years. Although initially disappointed by American ambivalence to her work, and later frustrated by the critics' failure to understand it, Cassatt eventually found herself championed by a half-dozen wealthy and influential collectors in the United States. This small group bought enough of Cassatt's

art after 1890—most of it through Paul Durand-Ruel—to insure that her stature in the United States, at the end of her career, would be even higher than in France.

Cassatt and French Nationalism, 1891

Cassatt spent much of 1890 and the first part of 1891 preparing for the third annual painter-engravers exhibition, to be held at the Galerie Durand-Ruel in Paris in April 1891. She seemed intent on making as significant a contribution to the emerging painter-engravers movement as she had to Impressionism, and rightfully expected her ambitious suite of ten color prints (cats. 56–65) to be as well received as her more modest submissions to the two prior shows. She had devoted considerable effort, time, and expense to realize the suite. But even as she carefully editioned the prints, in January 1891, the once loosely affiliated painter-engravers—led by her Impressionist colleague Félix Braquemond and the etcher Henri Guérard—shifted their focus from aesthetic to political and economic aims, which they hoped to achieve through a more openly nationalist program. Less than three months before the 1891 show, the formerly amorphous collective became the Société des peintres-graveurs français, with membership limited to native-born artists.[3]

Cassatt's reaction to this development is unrecorded. It infuriated her friend and fellow Impressionist Camille Pissarro, who had lived in France nearly all of his professional life, but had not been born there (he was actually born on St. Thomas in the Virgin Islands). He explained to his son Lucien that he had been excluded from membership in the organization "because I am an alien! They intend to invite foreign-born artists [to exhibit with them], but I will not accept any invitation from them. How officious they are." At least for Cassatt and Pissarro, Durand-Ruel resolved the immediate problem by offering them adjacent rooms in his gallery for their work. But Cassatt again was denied a regular venue to showcase her art.[4] More importantly, for the first time, she was omitted from a French project because she was not French.

Despite the exhibition of her work in a side room of Durand-Ruel's gallery, Cassatt was perhaps an-gered by his sanctioning of the Société; certainly she was dissatisfied when the dealer balked at buying most of the suites of color prints, so much so that she considered severing their relationship. She mentioned her profound dissatisfaction to Pissarro, who relayed their conversation to Lucien:

We had a long talk about the problem of selling pictures, I told her about my position *vis-à-vis* Durand; she is incensed at Durand on her own account and asked me if I would go along with her if she left Durand. We will probably exhibit with Degas. She will use all the influence she has to push our paintings and etchings in New York, she is very desirous of upsetting Durand. She has a lot of influence and Durand, who suspects that she is irritated with him, is trying to calm her down with promises and offers which he does not make good.[5]

In effect Durand-Ruel did make promises in order to appease Cassatt, including a fall 1891 "general exhibition" of her work in the gallery he had opened in New York in 1887. The offer apparently worked. By this point, Cassatt may have considered the United States, despite its far remove, an easier site for furthering her reputation than France was proving to be. It was not so much that she was giving up on the French; she probably shared Claude Monet's opinion that Paris was the last city in the world where some semblance of artistic taste survived.[6] But in New York, her nationality was not in question, and her plans would not be undermined by chauvinism.

Counting on Her "Country Men"

In June 1891, Cassatt wrote to the only important collector of her work in the United States, Samuel P. Avery, a New York print dealer. She described at length the technical aspects of her recent experiment in color printmaking, generously authorizing Avery to share the information with any interested New York etchers. But the main point of her letter was to announce plans for her exhibition in the United States and to ask Avery to support the show with loans from his collection, the only complete representation of her graphic oeuvre outside of the artist's own holdings. Playing to his vanity, Cassatt offered to donate a work to the still relatively new Metropolitan Museum of Art, New York, an institution he had been instrumental in founding:

I should like very much to give something to the Museum,

but I don't feel as if I were well enough known yet at home to make it worthwhile. After my exhibition if I have any success with the artists & amateurs I will certainly present something to the Museum if you think they would care to have it.[7]

The importance to Cassatt of this New York exhibition can be discerned from the enthusiasm with which she seems to have described it, not only to Avery, but to her family and friends, an enthusiasm she had once reserved solely for Impressionist projects. As Pissarro noted, again to his son: "She has surely every chance of being a great success there, for she knows the people and the situation so well." The artist's mother became caught up in the excitement, writing from France to her son Alexander in the United States, "Mary is at work again, intent on fame & money she says, & counts on her fellow country men now that she has made a reputation here."[8]

But just as Pissarro had anticipated, Durand-Ruel reneged on his promise, canceling the New York exhibition. In the ten years that Cassatt had known him, Durand-Ruel had been for her the source of almost as many troubling incidents as sales. In 1881, when she tried to buy a painting from Degas for her brother Alexander, the artist insisted that she purchase it from Durand-Ruel, who tacked on a 1,000-franc commission. Katherine Cassatt described her daughter's irritation:

She was . . . not a little provoked at Durand Ruel . . . because he took so large a commission she being an artist & having just sold him a picture which he himself said in my presence was "not a price for a picture of that size," but [for] which she refused to ask for more—

In 1883 Durand-Ruel had included at least two works by Cassatt in a group of Impressionist paintings he sent to an exhibition in London. Mistakenly listing both in the catalogue as not for sale, the dealer again frustrated the artist. Her father, Robert S. Cassatt, characterized the situation to Alexander: "Any little contretemps of this kind upsets Mame [Mary], & makes her think any thing [sic] but favorably of human nature generally."[9]

Durand-Ruel was always highly selective in his support of the Impressionists, particularly in the 1880s and early 1890s. The careers of Degas, Monet, and Renoir eventually flourished with the dealer's strong backing, while those of Cassatt, Morisot, Pis-

sarro, and Sisley languished, as he acquired and showed their work more infrequently. Certainly before 1890 he had invested in no more than a handful of Cassatt's paintings, perhaps as few as the two or three her mother mentioned in late 1886.[10] Whatever the number, Cassatt was far from satisfied with the volume and regularity of his purchases. By the time the dealer canceled her homecoming show in New York, she was determined to reduce her involvement with him and more intent than ever on expanding her audience beyond the borders of France.

Aware of Cassatt's dissatisfaction, Durand-Ruel attempted to redeem himself. He deposited sets of her color prints with three prominent New York galleries: M. Knoedler and Co., Frederick Keppel and Co., and H. Wunderlich and Co. Keppel presented his set in a large group show in the fall of 1891; while this was not the one-person exhibition Cassatt had hoped for, it gave her work exposure nonetheless. Her family and friends in the United States contributed to her increasing visibility as well. At the end of 1892, on the occasion of an exhibition of the Society of American Artists inaugurating new quarters on West 57th Street, New York, Alexander Cassatt contributed his sister's *Portrait of a Lady* (cat. 10) and another work, probably depicting one of his children. Cassatt's friends Henry O. and Louisine Havemeyer loaned the *Portrait of the Artist* (fig. 3) to the same exhibition. Cassatt had been supportive of this group since its inception in 1878 and hoped that an American school would grow out of its efforts, but she had not participated in a Society exhibition since 1879.[11]

Unfortunately neither project succeeded in strengthening Cassatt's reputation in the United States. Her name did not appear in a long *New York Times* review of the Society of American Artists exhibition. Perhaps more disappointing was the lack of interest New York collectors showed in her color prints, a fact that, to some extent, justified Durand-Ruel's cancellation of her 1891 exhibition in the city. She wrote to the dealer's son Joseph in February 1892, after two Parisian collectors expressed interest in her color prints: "Of course it is more flattering from an Art point of view than if they sold in America, but I am still very much disappointed that my compatriots have so little liking for any of my work."[12]

Fig. 3. Mary Cassatt. *Portrait of the Artist*, 1878. Gouache on paper; 59.7 x 44.5 cm. New York, The Metropolitan Museum of Art, bequest of Edith Proskauer, 1975. 319.1.

Cassatt may have felt somewhat humbled in admitting her failure to attract a North American audience; she also probably judged Durand-Ruel too harshly, holding him to a standard that was difficult to meet, considering his primarily commercial concerns. While he did not promote her art as vigorously as she would have liked and made promises he did not keep, he was remarkably attentive to her interests, given the relatively tiny revenues her art generated. Perhaps anticipating her anger over the Peintres-graveurs français, he reproduced her drypoint *The Lesson* on the cover of the first issue of his

firm's promotional publication, *L'Art dans les deux mondes* ("Art in the two worlds") (fig. 1). The choice was appropriate: the image shows two girls studying what has been identified as a map; its artist, more than any other in Durand-Ruel's stable, bridged the "two worlds"—Europe and North America—in which the dealer's enterprise was invested. And even as Cassatt sought out other outlets in 1891, Durand-Ruel made certain her work was featured in Georges Lecomte's volume on Impressionist pictures from the dealer's own private collection. The book includes an etched reproduction of a painting (fig. 4) and of a

recent pastel, both apparently drawn from Durand-Ruel's stock, since he subsequently sold them to the Havemeyers.[13]

Durand-Ruel had reasons to be generous and to keep Cassatt at least somewhat satisfied with his representation. Having had his eye on the United States as a potential market for modern French art since 1885, he may have known from the start that Cassatt would figure into his plans somehow. His shipment of a group of Impressionist paintings from Paris to New York in 1886, his first attempt to directly penetrate the North American market, included nothing by Cassatt. To represent her in the exhibition he organized at the National Academy of Design, New York, the dealer borrowed two works from Alexander Cassatt. Thus from the outset of Durand-Ruel's American venture, it was not the marketability of Cassatt's art that secured her inclusion so much as her social connections. The presence of her work and the participation of her wealthy and powerful brother in the dealer's project helped legitimize his venture and provided him with an entrée to potential clients among the Cassatt family's social peers.[14]

By the following year, when Durand-Ruel opened his own gallery in New York, he could already count on support from such wealthy Americans as Erwin Davis, the Havemeyers, and Cyrus J. Lawrence. Although eager to create an audience for Impressionism, the gallery, at least in the beginning, steered a course that was more conservative than avant-garde. As often as not, the New York branch, headed by Durand-Ruel's three sons, Charles, Joseph, and George, found itself selling the work of artists already popular in the United States and whose investment value was firmly established, notably that of the Barbizon painter Camille Corot and the sculptor Antoine Louis Barye. But when American collectors began to acquire Monet's works almost feverishly in 1891, in Paris as well as New York, Durand-Ruel saw his opportunity to promote Impressionism more aggressively in the United States. With such plans in mind, a disgruntled Cassatt would not have proved helpful; Durand-Ruel again courted the artist's favor, that same year promising her yet another New York exhibition for the fall of 1892.[15]

This was another promise Durand-Ruel would not keep, but this time, he did not have to. In the spring of 1892, Cassatt was offered a mural commission for the 1893 World's Columbian Exposition in Chicago. Bertha Honoré Palmer, the Chicago socialite, collector, and chairperson of the fair's Board of Lady Managers, asked the artist to produce a fifty-eight-foot painting addressing the theme of "Modern Woman" for the Woman's Building. Cassatt was reluctant at first, no doubt on a number of scores, one of which may have been that she was still stinging from the cool response to her color prints in the United States. Perhaps not altogether coincidentally, that same spring, Palmer acquired a suite of the artist's prints, along with a pastel, *Young Mother* (cat. 50) from Durand-Ruel's Paris gallery. The gesture may have warmed the artist to the project and to its principal organizer. By no later than June, she accepted the commission. The task was monumental, and Cassatt labored in relative isolation for months to complete the work. The only person from the artist's Parisian circle known to have seen the

Fig. 4. Artist unknown. Etching after Mary Cassatt. *Mother and Child*, 1888. Oil on canvas. Formerly in the collection of H. O. and Louisine Havemeyer, New York, and believed destroyed. Photo: Lecomte 1892, p. 129.

mural in progress was Durand-Ruel. He praised the
artist in the best way he knew, insisting that she had
given Chicago much more than it had paid for and
offering to buy it then and there. Cassatt declined,
but was grateful for his encouragement and pleased
that their differences had diminished so significantly.[16]

The exhausting effort, logistical and contractual
difficulties, and general disorganization of the fair
administration soured Cassatt on the event. She
declined invitations to visit Chicago, participate in
the opening celebration, and serve on the jury for the
fine-arts exhibition. Apparently she was intent on
putting *Modern Woman* behind her as soon as she dis-
patched it to the United States, in mid-February
1893. The mural, which might have secured Cassatt's
reputation in her homeland, was almost universally
ridiculed in the press (see Barter, p. 96). Cassatt was
convinced that the caustic criticism was directed not
at the work itself, but stemmed from its having been
produced by a woman. As she stated to her friend
the art agent Sara Hallowell: "After all give me
France—women do not have to fight for recognition
here, if they do serious work. I suppose it is Mrs.
Palmer's French blood which gives her organizing
powers and her determination that women should be
someone and not *something*." Cassatt may have consid-
ered it easier to overcome nationalism in France than
sexism in the United States, and, for the moment,
made no further effort to cultivate a North Ameri-
can audience.[17]

Cassatt's First Retrospective Exhibition, Paris 1893

In the fall of 1893, Durand-Ruel finally fulfilled his
promise to stage a survey of Cassatt's work, although
he did so in Paris, rather than in New York. For
Durand-Ruel the timing and locale of the exhibition
may have reflected a critical moment in his relation-
ship with the artist. He had already hosted retro-
spectives or major one-person shows for Monet
(1891), Renoir (1892), Degas (1892), and even Pis-
sarro (1892). After having put off Cassatt in 1891 and
1892, the dealer must have felt compelled now to
grant her some type of solo treatment in his gallery.
She may have forced the matter by appealing to
Durand-Ruel's competition, as did Morisot, who
defected to the dealer's rival Boussod, Valadon, & Co.
in 1892 for her first one-person exhibition. Sometime
in 1892, or possibly during the first months of 1893,
Cassatt sold an important early painting, *At the
Français, a Sketch* (cat. 17), to a small gallery, Martin,
Camentron, and Co. While Durand-Ruel may have
been willing to cede Morisot (at least for the time
being), Cassatt's influence on wealthy North Ameri-
can collectors was perhaps too valuable to risk by not
taking an active interest in her work. Thus not sur-
prisingly, he bought *At the Français, a Sketch* from his
small competitor late in 1893 or perhaps early 1894
(see fig. 5). By the fall of 1893, he was not only show-
casing Cassatt's art in a major retrospective in Paris,

but had again promised an exhibition in New York and agreed to buy all of the new works she produced. As she noted to her American friend Harris Whittemore (Hirshler, fig. 24), an aspiring young artist from Connecticut:

I painted three pictures of naked babies this summer, two of the three pictures are out of [doors? Of] these three I have reserved one which, when you see it in New York at my exhibition, if it pleases you, you are to have at the price the Durand-Ruels pay me. . . . Of the three pictures there is one of 3 figures [*The Family* (cat. 71)] which perhaps I would have chosen for you, but M. Joseph Durand-Ruel bought it for themselves [*sic*], & told me would not sell, as they take everything I do & as they have all the expense and trouble of the Exhibition & I have an agreement they buy all I do of course I had no choice.[18]

The fact that the site of the exhibition was in Paris, rather than in New York, probably pleased Cassatt, in view of the recent disappointments in her homeland, but this must have reflected Durand-Ruel's interests as well. An international economic depression had stymied the dealer's progress in the United States. After attracting an enviable list of North American collectors as clients, including the Havemeyers, Sir William van Horne, Cyrus J. Lawrence, and A. A. Pope (all of whom did or would own works by Cassatt), the gallery experienced a considerable decline in business.[19] Moreover Durand-Ruel's oldest son, Charles, died suddenly and prematurely in September 1892, leaving the organization of the American venture in a state of transition, if not in complete disarray. Finally by 1893 there was something of a backlash in France against the growing number of Parisian art dealers exporting the nation's cultural heritage to wealthy buyers across the Atlantic. Few lamented the loss of Impressionist pictures at this point, since they were not yet fully appreciated, but many were alarmed by the flow to the United States of Old Master works, eighteenth-century canvases, and earlier nineteenth-century paintings. As the novelist Edmond de Goncourt observed, "And we admit to each other that the Americans, who are in [the] process of acquiring taste, will, when they have acquired it, leave no art object for sale in Europe but will buy up everything."[20]

For all these reasons, Durand-Ruel closed ranks around the Parisian flagship gallery. However, the dealer's decision in 1893 to reduce the number of exports to the United States was only temporary. Less than one month after Cassatt's Paris exhibition closed, the Havemeyers returned to their earlier practice of buying art in volume. On January 16, 1894, alone, they purchased from Durand-Ruel a Manet, a Sisley, three Monets, three Degases, a Cassatt color print, a Delacroix, and a Corot. The dealer must have recognized the relationship (one that would continue for years) between Cassatt's good will and the number and frequency of Havemeyer purchases (see Hirshler, pp. 190–92). Throughout 1894 no issues divided or caused friction between Durand-Ruel and the artist; by the end of the year, his New York gallery had relocated to a building owned by H. O. Havemeyer (see fig. 6).[21]

Fig. 6. Durand-Ruel Gallery, Fifth Avenue at 36th Street, New York, c. 1894. Photo: courtesy Archives Durand-Ruel, Paris.

Recognition Frustrated: The Musée du Luxembourg Incident

As for Cassatt, she was delighted with the results of her Paris show. It earned largely positive reviews and her colleagues' admiration. Moreover Léonce Bénédite, director of the Musée du Luxembourg, expressed interest in acquiring for the nation one of the paintings exhibited, a *Mother and Child* (see fig. 4) from the late 1880s. The Luxembourg was the most prestigious public collection in Paris, or anywhere, in which a living artist could hope to be represented. A clearly pleased Cassatt could not resist sharing the news, particularly with fellow Americans. In one instance—a letter to Whittemore—she managed to couple her success in France with a comment on the state of the arts in her homeland:

I am almost sure that there will be an exhibition of my pictures & etchings in New York this winter or spring, if it is only half as well received as the one just closed in the rue Lafitte I will be satisfied—I can hardly imagine though, that the Metropolitan Museum will propose, to buy one of the pictures as the Musée du Luxembourg has just made me the compliment of doing—[22]

Cassatt was, and would always be, wary of official honors, but after her disappointments in the United States, she was grateful for the admiration of the French. The artist could hold up the success of her Paris exhibition and the Luxembourg's proposed acquisition to North Americans as proof that they had been mistaken in thinking so little of her art. But there was a problem with the work Bénédite selected: it was part of Durand-Ruel's personal collection. Not only was the dealer unwilling to part with it, but the Luxembourg's acquisition policy stipulated that purchases could only be made directly from artists. The provision was easily and frequently circumvented, however; the owner would quietly sell back to the artist the work the Luxembourg selected. Cassatt urged Durand-Ruel to consider just such a compromise. "I don't need to say," she wrote, "that I would be very glad if that could be arranged, first for myself and then for my family."[23] While the dealer no doubt recognized that the work's inclusion in the Luxembourg would benefit him as well as Cassatt, in the end, he refused to expedite the transaction.

A number of factors seem to have influenced Durand-Ruel's decision. The Luxembourg paid notoriously low prices; the honor of entering the collection was thought to be more than ample compensation. Moreover, as a dealer, he would not have supported the Luxembourg's circumvention of the market. In bringing Cassatt around to his point of view, Durand-Ruel probably counted on her longstanding and well-known distrust of the state-sponsored art oligarchy in France. Just as Monet and Renoir had refused to be made *chevaliers* of the Légion d'honneur earlier in the decade, the dealer could lodge his unwillingness to cooperate with the Luxembourg as a form of protest against a system Cassatt and her colleagues, for the most part, believed was corrupt and contemptible. He must have convinced her, in the end, that, if the Luxembourg admired one painting, they would have no difficulty choosing another. But the museum would make no other choice. The artist wrote to Durand-Ruel once the negotiations had stalled for good:

I agree with you, it is ridiculous of them only to buy from artists, the whole purpose is to have good pictures. . . . It really doesn't matter to me, but I couldn't say that. As for my family, that's another matter. I will write to M. Bénédite. But the matter is settled. It was the only painting that pleased them, they found it free of "sentimentality."

The artist accepted Durand-Ruel's decision, but not without some regret. She informed Harris Whittemore of the outcome, "which ends my hope of immortality in that direction!"[24]

New York Discovers Cassatt, 1895

The New York exhibition Cassatt mentioned to Whittemore did in fact take place, but one year later, in the spring of 1895. Unlike her solo exhibition in Paris, in which she was deeply involved, Cassatt probably left most of the preparations for the New York event to Durand-Ruel and his two remaining sons, Joseph (Chronology, fig. 21) and George, who now headed the American branch. She would have preferred to postpone the exhibition even further, noting to an American friend that she had "worked amid distraction this last winter." Her mother was in poor health, and the renovation of Beaufresne, the

French country house Cassatt purchased in 1894, was proving to be more difficult than expected. But it was just as well that the exhibition did go on as planned. Pope and Lawrence, collectors who were already clients of Durand-Ruel, acquired works from the exhibition, as did Cassatt's old friends the Havemeyers and perhaps Harris Whittemore. Surprisingly one of the works the Havemeyers purchased was the very painting Durand-Ruel had refused the Luxembourg in 1893.[25]

During the 1890s, there was considerable fluidity between Durand-Ruel's personal holdings and his firm's inventory. A substantial private collection was almost essential for the dealer to position himself—for the benefit of American and European collectors—as not only *the* commercial agent for Impressionism but as a connoisseur as well. When an opportunity emerged to enhance his relationship with potentially or particularly important collectors, such as the Havemeyers, he almost always graciously parted with a work he originally had claimed for himself. Certainly for Durand-Ruel to have allowed the Havemeyers to acquire something he had denied his own government made him appear magnanimous. In reality he was far more predisposed to satisfy these American collectors than the French state; the Havemeyers could and did buy directly from him and paid higher prices.[26]

Important though the commercial success at the New York show would prove to be, it was perhaps most notable for the substantial volume of critical attention it attracted. New York writers covered the exhibition thoroughly and, for the most part, favorably. Montague Marks, writing for *Art Amateur*, insisted that those "who have guaged [sic] the ability of this lady only by her ill-considered mural decoration in The Woman's Building at The World's Fair [will be] surprised at this display of her work. Miss Cassatt is the only American artist in whom Mr. Durand-Ruel has ever shown any interest." An anonymous critic for the *New York Times* predicted: "Without doubt the collection will attract much attention to a woman whose reputation in Paris is of a high order among latter-day painters, and who, though following in the train of the Impressionists . . . manages to preserve a powerful personality and a strong

originality." A writer for the *New York Tribune* suggested that her talent "awakens the liveliest regret that Miss Cassatt has so long preferred to remain an alien to her country and its picture exhibitions." And, in a second article in the *New York Times*, a commentator insisted on the "right to regard her as a true American representative."[27] While most of the reviews, including those cited above, finally settle into conventional criticism, admiring some works, pointing out the shortcomings of others, the most impassioned discussion always centers on Cassatt's nationality and a desire to reclaim her accomplishment for the United States. After years of accepting notions of European cultural superiority, Americans were at last in a position to celebrate their own successes in the arts unapologetically. The attraction on the part of American critics, collectors, artists, and dealers to painters such as Cassatt, John Singer Sargent, and James McNeill Whistler, as well as writers like Henry James, all of whom had gone to Europe and made their mark there, was difficult, if not impossible, to suppress. In the 1890s, nationalism and the competitive spirit that accompanies it were so strong in New York that these issues were mentioned far more frequently than gender in reviews of Cassatt's 1895 exhibition. When critics mentioned her sex, they expressed surprise at how "masculine, vigorous and full of a powerful personality" they found her work. Implicitly they suggested that, as a woman, she could not have survived, let alone succeeded, in Europe without these "American" qualities.[28] For New York critics, at least in 1895, Cassatt's gender was significant insofar as it contributed to her national identity.

Two major exhibitions, in as many years, apparently satisfied Cassatt's need for public exposure; she withdrew to the peace and quiet of the country house that had been such a distraction the previous year. The artist's mother died there in the fall of 1895. The loss was significant and the adjustment to living by herself difficult; she was alone in France for the first time since her family had joined her in Paris in 1877. While Cassatt remained highly productive in 1896 and 1897, executing a substantial number of paintings and pastels, she was also, to some degree, isolated professionally during these years, excluded

from significant artistic developments in Paris, to which she must have believed she rightfully belonged.[29]

Exclusion from the Print Revival and the Caillebotte Bequest

In an 1896 book, *Lazy Tours of Spain and Elsewhere*, Louise Chandler Moulton described meeting Stéphane Mallarmé. She asked the eminent French poet about Impressionism and the artists who comprised the movement. Mallarmé drafted a list of painters whose art he believed Moulton would find interesting, handed it to her, but then "took it back and added the name of an American woman, Miss Mary Cassatt, who was too important, he said, to be omitted in selecting these chosen few."[30] Given that Mallarmé was not only an informed observer of Impressionism but also a friend of Cassatt, it is telling that he forgot even momentarily to include her on his list. The absence of Cassatt from such

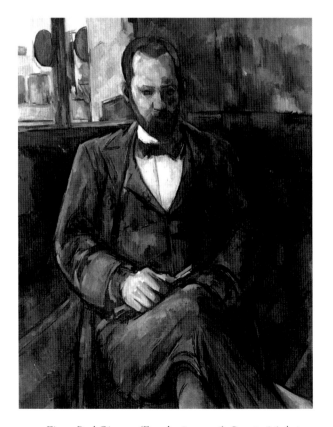

Fig. 7. Paul Cézanne (French; 1839–1906). *Portrait of Ambroise Vollard*, 1899. Oil on canvas; 100 x 81 cm. Paris, Musée du Petit Palais, Ambroise Vollard bequest. Photothèque des Musées de la Ville de Paris.

rosters was becoming all too common in France. While she rarely complained about being forgotten or neglected by the French, two omissions in Paris in the mid-1890s must have struck her as particularly unfair.

The print revival taking place in France fostered a renewed enthusiasm for all of the various printmaking processes, and especially for color techniques. Capitalizing on the painter-engravers movement, the centenary of lithography, and a number of other popular print exhibitions and publications in Paris, the editor and writer André Marty had founded the portfolio series *L'Estampe originale*, for which he commissioned and assembled into albums original etchings, lithographs, and wood engravings by some of the leading artists in France and throughout Europe. His portfolios were much admired by artists, critics, and collectors, and were credited with advancing printmaking in France. Despite the inclusion of such foreign artists as Cassatt's fellow expatriate Whistler, and her Impressionist colleagues Pissarro and Renoir, she was never asked to submit to any of the albums.[31]

The young and ambitious dealer Ambroise Vollard (fig. 7) similarly commissioned original prints for deluxe albums, again giving special emphasis to color. Cassatt may not have known Marty, but had met Vollard by at least 1896, when she purchased from his then-new gallery a still life by Paul Cézanne; but still he too did not invite her to participate in his publishing venture. For Cassatt it must have been especially frustrating to see Cézanne and Renoir featured in the dealer's 1897 album. Throughout their careers, neither demonstrated a commitment to printmaking equal to Cassatt's, and both their contributions owed almost as much to Vollard's talented printer, Auguste Clot, as to their own efforts. She may well have been excluded from the dealer's publishing ventures because of her nationality. With only a handful of exceptions, his albums were dominated by the work of French artists, many of whom, including Pierre Bonnard, Odilon Redon, Henri de Toulouse-Lautrec, and Edouard Vuillard among others, either enhanced or established their reputations in France through these albums and other events spawned by the print revival.[32]

Receiving no invitation to contribute to these

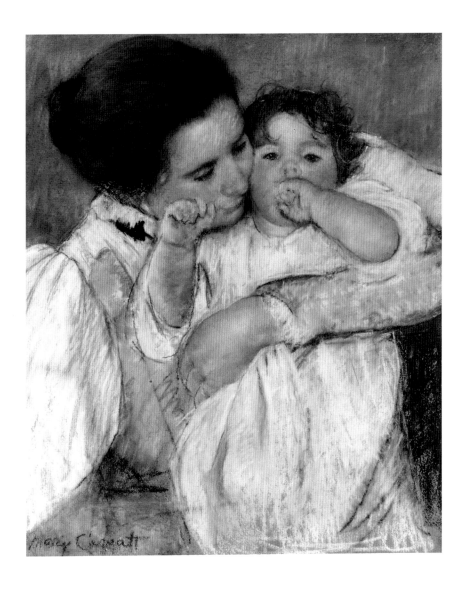

Fig. 8. Mary Cassatt. *Little Anne Sucking Her Finger, Embraced by Her Mother*, 1897. Pastel on paper; 71.1 x 58.4 cm. Paris, Musée d'Orsay. © Photo RMN-Jean Schormans.

popular albums, Cassatt considered a publication of her own. The writer Violet Paget, who published under the pseudonym Vernon Lee, described Cassatt's plans in 1895:

She wants to make art cheap, to bring it within reach of the comparatively poor, and projects a series of colored etchings, for which she wants me to write a little preface. She wants other artists to do something similar, [and] suggested Sargent. . . . She has most generously given me one of her new and most beautiful etchings, a mother and baby, green on green, quite lovely. . . .

Cassatt's reference to Sargent is both logical and curious. He was a mutual acquaintance; Paget and Sargent were close, childhood friends, and Cassatt had known him since at least the late 1870s. But Sargent was a celebrated painter of society portraits, a man who was becoming famous by flattering the fabulously wealthy. He hardly cared whether art was within reach of the masses; moreover, in his entire life, he only made one print, which, by July 1895, he may not have yet executed. Thus Cassatt's suggestion

of Sargent was probably prompted by his American citizenship. However, the project seems never to have developed beyond Cassatt's conversation with Paget.[33]

The artist experienced a lack of recognition even more troubling than her exclusion from the print revival: when the painter and collector Gustave Caillebotte died suddenly in early 1894, he left impressive works by Degas, Manet, Monet, Pissarro, Renoir, and Sisley to the Musée du Luxembourg. A source of considerable controversy, Caillebotte's collection finally entered the museum in 1896 (it today forms the core of the Musée d'Orsay's holdings of late nineteenth-century French art). Augmented by Manet's *Olympia* (1863), which was already in the Luxembourg; a Morisot painting (*Young Woman Dressed for the Ball*) acquired in 1894; and Caillebotte's *Floor Scrapers* (1875), which Renoir, as executor of the estate, added to represent the art of the donor, the gift was displayed in the Luxembourg galleries in early 1897. It was the first exhibition of an ensemble of Impressionist paintings in a public institution.

Cassatt, who had neither been particularly close to Caillebotte nor required his patronage, as had so many other Impressionists, was not represented with the artists she had long supported and with whom her reputation had been established. Later in 1897 she quietly donated a recent pastel (fig. 8) to the Luxembourg.[34]

Cassatt Returns Home, 1898

Just as in 1891, when she faced a kind of exclusion in France, Cassatt began thinking of an audience for her work in the United States. It is probably not coincidental that in 1897 she made plans to return home early the following year, her first trip back in more than two decades. Although hardly one to create a career-serving spectacle, Cassatt, in her own proper, Philadelphia way, was looking to enhance her position in her native land with a not-altogether-unpublicized tour of the Northeast.

Durand-Ruel made certain that Cassatt's arrival in the United States was met with some fanfare. Within one week of her January 4 landing, the annual exhibition of American painting and sculpture opened at Cassatt's alma mater, the Pennsylvania Academy of the Fine Arts, graced by two of her paintings, *Revery* (cat. 67) and *The Child's Bath* (cat. 72), both lent by the dealer. The review in the *Philadelphia Inquirer*, which included a reproduction of *The Child's Bath*, stated:

An exhibit of peculiar interest is composed of three [*sic*] of Mary Cassatt's unique productions. Miss Cassatt is the sister of A. J. Cassatt of this city. She is an artist of renown, whose work—suggesting somewhat the teachings of Manet—is well-known abroad, where Miss Cassatt has lived and painted for many years. She rarely exhibits on this side of the water, and the present opportunity to view her productions will be greatly appreciated here.

While the artist may not have been pleased that her accomplishments required the invocation of her brother, the notice is concise, respectful, and interested.[35] By late February, Durand-Ruel had opened a one-person show of her work in New York. At the end of March, yet another solo exhibition was underway at the St. Botolph Club in Boston, comprising paintings, pastels, and prints lent mostly by Durand-Ruel.[36] Only seven years earlier, she had lamented how little her compatriots admired her

work; but now, as she traveled from Philadelphia to New York and to Boston, it was seemingly everywhere she turned.

Adding to the enthusiasm surrounding Cassatt's American homecoming was the flurry of portrait commissions she executed during her stay. Fashionable European portraitists, such as Edmond Aman-Jean, Paul Helleu, and Anders Zorn (see Hirshler, fig. 26), were crossing the Atlantic with increasing frequency in the 1890s to fulfill the lucrative commissions that awaited them in the United States. As Cassatt herself commented just a few years later to Louisine Havemeyer:

I was amused to hear that it was to paint the Elkins family [that] Sargent is going to America, we were told in the "Herald" that it was to paint the President. . . . To think of Aman-Jean being over there, are they all bent on that Eldorado. Helleu I hear expects to net $50,000, if not more.[37]

Cassatt similarly hoped to profit from her journey, not so much to earn vast sums of money but rather to strengthen ties to her audience. The strategy proved successful. The artist arrived in the United States with only one commission, but, as she traveled, the number of requests apparently mounted. She wrote to Harris Whittemore, probably in late February or early March, from the Hotel Vendome in Boston:

I came home for a change of scene & before arriving had promised to come to Boston to do some pastel portraits of children, these are almost finished, but I have accepted two more orders here & these will keep me two or three weeks longer, & then I hope to go to New York for the remainder of my stay. I expect to return to France the last of April, as I have only promised one or at most two portraits in New York. I should have time to attempt your family, nothing would give me more pleasure. Will you be satisfied with pastel? It is the most satisfactory medium for children. . . .The Durand-Ruels arrange all the material affairs, you will find no difficulties on my side.[38]

This letter helps to clarify how Cassatt's American tour unfolded, as well as the order in which she executed her portrait commissions. More likely than not, upon arriving in the United States, she first visited Philadelphia, where she produced *Portrait of Mrs. Clement B. Newbold* (private collection), a work that relates closely, in its flattering likeness and bold

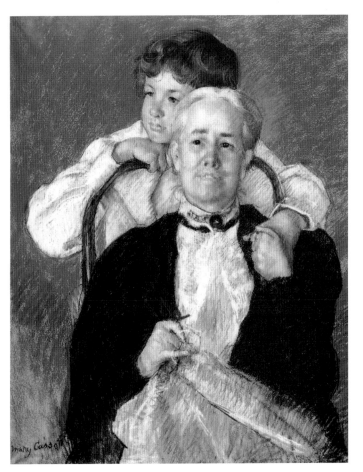

Fig. 9. Mary Cassatt. *Grandmother and Grandson*, 1898. Pastel on paper; 55.3 x 43.2 cm. Williamstown, Mass., Sterling and Francine Clark Art Institute.

composition, to the images of the society painters she would later suspect were working more for money than in the interest of great art. But the likeness—with its shimmering brushwork—is probably most indebted to the work of another society portraitist, the Philadelphian Cecilia Beaux, whose portrait of the same Mrs. Newbold (Philadelphia, Pennsylvania Academy of the Fine Arts) hung in the aforementioned 1898 Academy exhibition in which Cassatt also participated. Mrs. Newbold was the granddaughter of a distant relative of the artist, Mary Riddle, whom Cassatt had painted in Paris in 1883 (Shackelford, fig. 24). Riddle, and her daughter Anna Riddle Scott, had presented Cassatt with an elegant china tea service; in thanks the artist had portrayed the Philadelphia society matron with her gift. But the sitter and her daughter refused the painting,

finding it unflattering. Cassatt was vulnerable enough at that time to have believed she had truly failed; for nearly three decades, this painting—which Degas had particularly admired—remained hidden in a closet of her Paris apartment. Thus the atypical portrait of Mrs. Newbold she produced some fifteen years later could very well represent the artist's desire both to redeem herself for the failure of the Riddle portrait and to demonstrate to her compatriots that she could master the conventions of society portraiture they so admired.[39]

Cassatt's flirtation with this manner was short-lived, however. Even as she completed her oil portrait of the society belle, she returned to subjects, a compositional format, a medium, and handling more in keeping with her own aesthetics: In Philadelphia she executed two pastels depicting her niece Ellen Mary, daughter of her younger brother, Gardner. Traveling to Boston, she completed three pastel portraits of the Hammond children, the commission she mentioned in her letter to Whittemore cited above. While in Boston, the artist also agreed to execute a pastel of Mrs. Bayard Thayer (location unknown), which may have been one of the projects that kept her from leaving Massachusetts. Once in New York, she produced two portraits, also in pastel, for the Lawrence family, one of Mary Say Lawrence and another, a double portrait of Mrs. Cyrus J. Lawrence with her grandson, R. Lawrence Oakley (fig. 9). Finally the artist made her way to Naugatuck, Connecticut, where she was reunited with her friend Harris Whittemore and executed three portraits of his family. While the Hammonds never added any more Cassatts to their collection, preferring more fashionable artists such as Sargent, Cassatt did succeed in solidifying her relationship with the Lawrence and Whittemore families. Both remained devoted collectors of her work for the rest of their lives, with the Whittemores providing especially sensitive and generous support.[40]

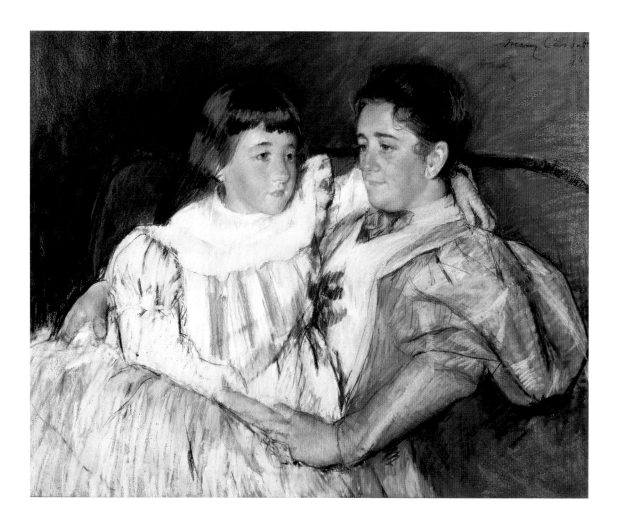

Fig. 10. Mary Cassatt.
*Portrait of Mrs. Havemeyer
and Her Daughter Electra,*
1895. Pastel on paper;
61 x 77.5 cm. Shelburne,
Vt., Shelburne Museum.

As Cassatt traveled—visiting her own family in Philadelphia; the Havemeyers and Lawrences in New York; the Popes and Whittemores in Connecticut; the Hammonds and Searses in Boston—she saw not only examples of her own work hanging in their residences, but also an impressive number of French Impressionist paintings that had found homes in the United States in large part because of her efforts (see Hirshler). She certainly took the opportunity to encourage the Havemeyers' continuing enthusiasm for Impressionist art, persuading them to buy major paintings by Manet and Degas during her visit. Given their close, personal attachment to Cassatt, her representation in their collection was far from stellar, in comparison to their holdings of works by Degas and Manet for example.[41] They owned the small self-portrait referred to above (fig. 3), which Mrs. Havemeyer had acquired in 1879, and pastel portraits of Louisine and the two Havemeyer daughters (see fig. 10) executed in 1895. But these had probably entered the collection either as gifts or perhaps at token prices. They had also purchased a set of the color prints and two *Mother and Child* compositions (see fig.

4 and another in the New Britain Museum of American Art) from the 1895 exhibition in New York. Perhaps in response to Cassatt's New York trip, they began more regularly to pepper their acquisitions of works by Degas and Manet with purchases of Cassatt's art as well. After buying several examples by Degas late in 1898 and early in 1899, H. O. Havemeyer wrote to Durand-Ruel: "I bought the Cassatt with three figures and landscape [fig. 11], as I consider it an admirable work. My wife is very pleased with it." Later in the year, the Havemeyers offered an unusually high price of $2,000 for another *Mother and Child* (cat. 87), a work Degas had admired while it was still in Paris. Durand-Ruel must have been delighted. Not only was he reaping the rewards of Cassatt's influence with American collectors, but he was also profiting from her art, which he had bought in part to insure that she would use her influence on his behalf. Upon the artist's return to France, the dealer commissioned her to execute a portrait of his daughter, Madame A. F. Aude, with her two children (private collection). It is one of the few works by Cassatt connected with Durand-Ruel that would

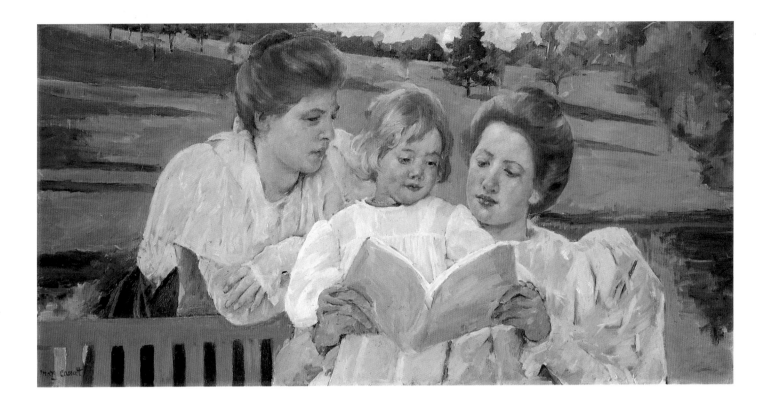

Fig. 11. Mary Cassatt.
The Garden Lecture, 1898.
Oil on canvas; 56.5 x
112.4 cm. The Philadelphia
Museum of Art, given by
Mr. and Mrs. J. Watson
Webb.

remain in France.[42] By 1899, with the Havemeyer example to invoke and a growing number of collectors to cajole, nearly everything Cassatt gave the dealer he sent to New York.

Once Durand-Ruel recognized the appeal of Cassatt's art, he explored another way to introduce her work to new and expanded North American audiences. He had noticed that a growing number of American museums and arts organizations sponsored annual exhibitions of contemporary art, following the model established by the Pennsylvania Academy, and of course by the Paris Salon. By the late 1890s, and proliferating after the turn of the century, annual shows occurred in a number of cities, including Buffalo, Chicago, Cincinnati, Pittsburgh, Providence, St. Louis, Washington, D.C., and Worcester. While the exhibition at Pittsburgh's Carnegie Institute was international, most focused exclusively on American art. Durand-Ruel only rarely exhibited the work of American artists in either his Parisian or New York galleries. In 1897 he rather cautiously had submitted Cassatt's *The Child's Bath* (cat. 72) to the Carnegie International in Pittsburgh, which allowed

him to skirt the issue of the artist's nationality. But only months later, he boldly "repatriated" Cassatt, as we have seen, by submitting *The Child's Bath* and *Revery* to the Pennsylvania Academy show, at the moment of her homecoming.

By the turn of the century, at least for museums and arts organizations in the United States, Cassatt was established as an American artist, thanks to Durand-Ruel's nearly constant circulation of her paintings and pastels. For example, in 1901 alone, her work could be seen in Pittsburgh, Philadelphia, Buffalo, Cincinnati, and Worcester. Or, from another perspective, one canvas—*The Child's Bath*—traveled to Pittsburgh in 1897; Philadelphia, New York, Boston, and Omaha in 1898; Cincinnati in 1900; Worcester in 1901 and 1905; New York in 1903; and Boston in 1909 (it entered the collection of The Art Institute of Chicago in 1910). Indeed nearly every important work Cassatt produced after 1900 made at least one circuit of major American cities. Not only did this create a public for her art beyond New York, bringing her new individual and institutional patrons, but Durand-Ruel's support of these events also gave him

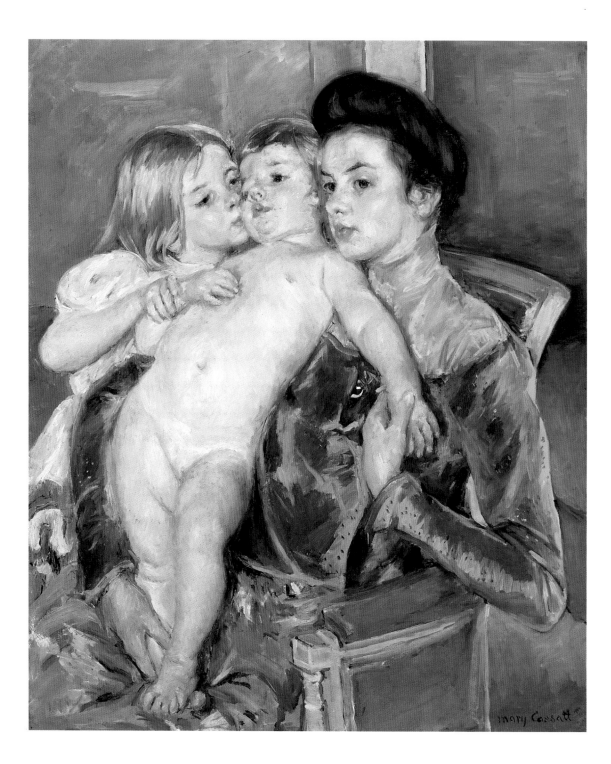

Fig. 12. Mary Cassatt. *The Caress*, 1902. Oil on canvas; 81.3 x 67.7 cm. Washington, D.C., National Museum of American Art, Smithsonian Institution.

entrée to fledgling American art museums and their enthusiastic trustees. Eager to build respectable collections of European and American art, these organizations were fertile ground for dealers, and particularly for Durand-Ruel.[43]

While Cassatt must have been pleased to be reaching a broad audience in the United States through such exhibitions, she was determined that she would earn American admiration for the right reasons and on her own terms. In 1904 Harrison S. Morris, then the Pennsylvania Academy's managing director, wrote to inform Cassatt: "We are most happy that [*The Caress* (fig. 12)] should have received [the Walter Lippincott Prize] as denoting an honor paid to a distinguished artist who is also our townswoman." Cassatt ignored the reference to her

origins and rejected the award, explaining to Morris:

I, however, who belong to the founders of the Independent Exhibition must stick to my principles, our principles, which were, no jury, no medals, no awards. Our first exhibition was held in 1879 and was a protest against official exhibitions and not a grouping of artists with the same art tendencies. We have been since dubbed "Impressionists[,]" a name which might apply to Monet but can have no meaning when attached to Degas' name. Liberty is the first good in this world and to escape the tyranny of a jury is worth fighting for, surely no profession is so enslaved as ours. . . . When I was at home a few years ago it was one of the things that disheartened me the most to see that we were slavishly copying all the evils of the French system. . . .[44]

The distinction Cassatt made here, between the concept of Impressionism as a matter of aesthetics and that of the "independent exhibition" as a movement forged out of principle, clearly defined how she wished to be perceived on both sides of the Atlantic. She would not have her work celebrated in the United States at the expense of the spirit it embodied; she would not betray her values to assure popularity for herself or for her colleagues. If her tone borders on the self-righteous, it was because she was not declining an award so much as setting an example, offering her ethics, goals, and conduct as a standard for American artists and museums to follow.

Cassatt's letter to Morris, and others like it, reveal her concern that, with the last Impressionist exhibition having taken place eighteen years before, North Americans still failed to grasp the movement in all its complexity. They knew about Claude Monet. His name had become familiar and celebrated, his work vigorously collected, and his technique so frequently emulated by young artists in the United States that, to many Americans, he embodied Impressionism. But Monet's innovations were only part of the Impressionist story. Monet for instance had not always adhered to the principles of independence that Cassatt and Degas had championed and followed: in periods of severe financial crisis, Monet had sought to exhibit his work at the Salon.[45] But Cassatt's consistent stance on this issue was not intended as an indictment of the great landscapist; rather she wished to expand American understanding of what her particular contribution to Impressionism signified.

The Impressionist Exhibition at Bernheim-Jeune, Paris, 1903

Cassatt's attentive maintenance of her artistic reputation in the United States may reflect concerns over how her career was perceived in Paris. In a flurry of essays and articles in French publications between 1902 and 1904, she is increasingly identified as a "painter of children"; while such categorization was hardly pejorative, it did at least partially obscure the role she played in Impressionism in the 1870s and 1880s. Cassatt's sensitivity to this issue may have been further heightened by her exclusion from the more general history that was being shaped for Impressionism in France. After the turn of the century, the movement rapidly became a French national treasure, requiring defense as other nations staked their claims to it as well. In England for example Wynford Dewhurst's 1904 book *Impressionist Painting* traced the style to the influence of Constable and Turner on Monet and Pissarro during their 1870–71 exile in London, an assertion that even the hardly patriotic Pissarro vehemently denied. While the national origin of the movement was open to debate, the results of Impressionism—the paintings themselves—were attracting increasingly fierce competition among collectors, as often as not from outside of France. Americans such as the Havemeyers and, more frequently after 1900, German and Russian collectors and dealers were buying Impressionist works with such enthusiasm that the French became distressed that few examples of the movement would remain in France. This anxiety stimulated a number of French versions of the Impressionist narrative, from which Cassatt, as often as not, was excluded.[46]

In this context, one can understand Cassatt's enthusiasm at being included in a 1903 "Impressionist" exhibition organized by one of Durand-Ruel's competitors in Paris, Galerie Bernheim-Jeune. She was clearly pleased to be exhibiting again among the artists with whom she had launched her career. Before the show opened, she wrote to her friend Ada Pope: "There is to be an exhibition opening April 2nd . . . of all our set, including Manet, Degas, Monet, Sisley, Berthe Morisot & myself. I think there will be some interest excited, it is so long since

anything of the kind has been done." In addition to *The Caress, Girl in a Large Hat* (Shreveport, Louisiana, Norton Museum of Art), and *After the Bath* (Cleveland Museum of Art), all retrieved from Durand-Ruel's inventory, she borrowed an earlier work from the collector Georges Viau, a vigorous 1889 *Mother and Child* (cat. 52). The project so delighted her that she also agreed to loan from her collection Manet's *Peonies and Pruning Shears* (Hirshler, fig. 4) and Morisot's *Woman in White*.[47]

By the time of the Bernheim-Jeune Impressionist show, Cassatt may have come to think of Durand-Ruel primarily as her representative in the United States. She was perhaps concerned that she was giving too much to the dealer, suspecting that, with so much of his inventory of her work in New York, he was having difficulty finding buyers for it in Paris. He had not staged a major exhibition of her work in Paris since the 1893 show, although, during the same ten-year period, he had hosted two in New York, with a third planned for the fall. While Cassatt did not discourage the dealer's efforts in the United States and certainly appreciated her fellow citizens' admiration and support, she clearly felt that they did not fully comprehend the originality and importance of such artists as Degas and Manet. Writing about the deficiencies of American art criticism, she lamented, "If those painter-journalists knew how entertaining they are. Unfortunately they are the ones who are going to shape art in America."[48] When they claimed her as an American painter, they deprived her of the French context in which she had flourished and that she valued so highly.

Durand-Ruel versus Vollard

As early as 1903, Cassatt had turned to another French dealer, Ambroise Vollard, hoping he would enlarge her audience and further resuscitate her standing in France. As stated above, she had known Vollard since at least 1896, when she purchased a Cézanne still life from him. By 1901 she had introduced him to the Havemeyers, who also acquired works by the Provençal artist from him and apparently lent him money to save his struggling gallery. Cassatt admired Vollard's aggressive promotion of

the artists he represented—he had for example almost single-handedly turned the aging Cézanne, isolated in the south of France and only modestly successful, into one of the most sought-after artists in Paris. In addition Vollard also offered Cassatt the advantage of having no particularly strong ties to collectors or museums in the United States. There was little risk, from her point of view, that the works she deposited with him would leave France the moment he received them. To circumvent her agreement with Durand-Ruel, in what may have been her first transaction with Vollard, Cassatt sold him an early, rather than a new, painting, an 1878 *Portrait of a Little Girl* (cat. 11).[49] Along with this canvas, she provided the dealer with a brief history of the work. She recalled that the model was the daughter of friends of Degas and that he had advised her as she worked, even providing assistance with the background. Upon its completion, she continued, she submitted the painting to the three-person American jury for the 1878 Exposition universelle in Paris, which rejected it (at least one jury member, according to Cassatt, was egregiously lacking in qualifications to discharge his duties). Cassatt's letter to Vollard seems to have been an implicit warning that, if he wished to handle her art, he must represent her as the independent artist she was and never compromise her principles by submitting her work to juried exhibitions, as Durand-Ruel had so often done in the United States. They apparently came to an agreement; by 1904 Vollard was buying her paintings and pastels in increasing numbers and at significantly lower prices than the artist demanded from Durand-Ruel. There is no evidence that Vollard ever submitted anything of Cassatt's to a juried exhibition, and, for the most part, the dealer sold her works to European collectors (see for example cats. 11, 15, 20).[50]

Perhaps not eager to cede Cassatt's career to another dealer or to allow his competition access to the American collectors in her sphere of influence, Durand-Ruel played an instrumental role in attaining for Cassatt the rank of *chevalier* in the Légion d'honneur. In so doing, he may have been hoping to persuade the artist that he was attending to her reputation on both sides of the Atlantic. The award was not easy to arrange, especially given Cassatt's gender

and nationality. Despite her aversion to such honors, she did not refuse this one, which was officially conferred on December 31, 1904. She hoped it would give her more influence with museums in the United States, but she must have known it would not harm her reputation in France either.[51]

It would be an overstatement to suggest that Durand-Ruel and Vollard were now equal competitors for Cassatt's favor, but she cleverly placed them in a kind of opposition, allowing herself a choice should she become dissatisfied with one or the other. And it was Durand-Ruel who displeased her almost immediately by excluding her from an important exhibition in London. The dealer had organized a large show of Impressionist paintings for the Grafton Galleries, but had failed to represent anything by Cassatt.[52] Instead he contributed an incomplete set of her color prints to the New Gallery in London, for an exhibition of the International Society of Painters, Sculptors, and Engravers, an organization to which Cassatt had never belonged.[53] She was justifiably hurt and angry that the dealer had wasted an opportunity for her to be seen again among artists she admired and with whom she believed she belonged. Despite a strong aversion to sea travel, Cassatt journeyed to London, ostensibly to have Tiffany's make spoons for her new grandnephew.[54] But she may have wished to see the Grafton show for herself.

Months later she was still angry at Durand-Ruel's insensitivity, but called an end to the feud: "I believe we must no longer discuss the affair of your exhibition. . . . I found myself, I believe justifiably, wounded to have been thus thrown aside."[55] The issue of Durand-Ruel's control over where Cassatt did and did not exhibit re-emerged weeks later, just as the relationship was finally beginning to mend. The artist received a letter from the Woman's Art Club of New York asking her to authorize the dealer's submission of at least one of her works to their annual exhibition. A livid Cassatt wrote instantly to Durand-Ruel:

I have just received a letter from a lady secretary of the Woman's Art Club, telling me that you promised her a choice of my pictures belonging to you to show in the exhibition that these ladies are going to have, subject to my consent. I refuse absolutely and I believe that you will not profit at all in showing my work in this exhibition. I know that my works have been sent even to the most amateur exhibitions of women artists in America. I doubt that this practice will do me any good, nor you. I would have thought that for selling there would have been more opportunity last year in London.[56]

She was absolutely right. Durand-Ruel had been sending her work to this group's exhibitions regularly since 1891, although Cassatt had repeatedly insisted that her participation was harmful to her standing as an artist. She was supportive of women's organizations, as well as other groups based on independent action, but she believed that such shows best served artists just establishing their reputations, which she had managed long ago.[57] Ignoring the artist's unequivocal instructions, Durand-Ruel lent to the exhibition at least one pastel, *The Cup of Tea* (cat. 84). The relationship between artist and dealer was to remain cool for many years.[58]

Other dealers were poised to benefit from Durand-Ruel's blunders. One of these was a specialist in antiquities, the American Dikran Kelekian, who owned galleries in New York, Paris, and eventually Cairo, and who counted J. Pierpont Morgan and the Havemeyers among his clientele.[59] It would be unfair to suggest that Cassatt's new-found fascination with ancient and medieval decorative arts was nothing more than a punitive response to the sins of Durand-Ruel, but her interests definitely diversified after 1906. Rather than pursuing Impressionist paintings for American patrons, she increasingly searched for older art—works by Chardin, Poussin, Watteau, and other Old Masters—often using galleries, agents, and dealers other than Durand-Ruel.[60]

During Cassatt's partial estrangement from Durand-Ruel, Kelekian earned the greater measure of Cassatt's devotion and friendship, and Vollard made the heftier financial gains. Only months after the Grafton Galleries incident, Cassatt bought a "Courbet head" from Vollard for the Havemeyers. Thus encouraged, he rather boldly branched into areas he had previously conceded to Durand-Ruel, including the art of Degas and especially Cassatt. By 1905 not only was Vollard acquiring much of her recent work but in 1906 she opened her studio to the dealer, selling him a significant body of drawings, preliminary sketches, and unfinished paintings and pastels.[61]

Cassatt did not turn over all of her incomplete efforts to the dealer; works continued to trickle out of her closets and boxes for years. But Vollard had watched Durand-Ruel manipulate Cassatt's allegiance into a vehicle for sales in the United States, and he probably welcomed the opportunity to explore that market. Indeed, as Vollard left Cassatt's country residence, Beaufresne, with this new stock, Cassatt encouraged him to send photographs to the Havemeyers of available paintings by Cézanne.[62]

At least some of the works that Vollard did not take Cassatt chose to burn, as she explained it, "to save my heirs the trouble." This fire not only consumed what she considered to be unsalable art, but it may also have claimed letters, journals, diaries, scrapbooks, and ledgers, none of which survive. Now in her sixties, and having outlived a number of her colleagues—including Manet, Morisot, Pissarro, and Sisley—Cassatt may have believed that she was nearing the end of her career and that there was nothing else for her to do but tie up loose ends.[63]

James Stillman: Friendship and Support

But another chapter awaited her, in the person of James Stillman (Hirshler, fig. 29), whom she had met in Paris in the spring of 1906.[64] Along with John D. Rockefeller and J. P. Morgan, Stillman was one of the most important financiers in the United States. After several extended stays in Paris, he retired there in 1909. Stillman had been immersed in international banking for so long that he had never traveled for leisure nor indulged his incipient cultural interests. He was not that familiar with Paris, and his understanding of the visual arts was limited. In Cassatt Stillman found a friend who knew the city and its art world intimately. Upon arriving in Europe, he had caused something of a sensation by buying important works by Chardin, Gainsborough, Rembrandt, and Watteau. However, he had also fallen under the dubious influence of a German portraitist, Friedrich August von Kaulbach, whose advice resulted in several less-inspired purchases.[65]

By the end of 1906, Cassatt had sparked in Stillman a passion for Old Master pictures and for modern art (although his taste never developed much beyond the style of his new mentor). By 1908 he had acquired two important works by Cassatt: the now much-touted The Caress, and an exquisite pastel, Girl Seated in a Chair (New York, The Metropolitan Museum of Art). Between 1908 and 1914, the banker bought twenty-four of Cassatt's paintings and pastels, all but one of which were recent. Most he acquired from the Durand-Ruel gallery in Paris, where he was a regular visitor; this in itself must have resulted in a significant reduction in the rate that Cassatt's works migrated to the United States. Stillman's interest may even have invigorated the artist. She was more productive between 1908 and 1910 than she had been for several years, filling a number of portrait commissions and even broadening her range of subjects to include at least one likeness of a man, her neighbor Octave de Sailley (France, private collection). Apparently Stillman tried to persuade her to execute a portrait of him, but unfortunately this never occurred.[66]

In 1910 Stillman presented Cassatt with a pair of scissors as a Christmas gift. Her touching words of thanks reveal the degree to which she valued their relationship: "I don't suppose the scissors will cut our friendship, I would not like that, though you did laugh when I told you you had brought something to my life I had not before." In fact Stillman introduced a number of new elements into Cassatt's life. He admired her work more than that of any other modern artist, including Degas and Manet; he was an American with whom she could enjoy Paris; and apparently he even offered an element of romance, which she quickly quashed, insisting, "I won't allow him to have me on his mind." Most importantly he was an American collector living and buying her work in Paris. This was the first time she did not have to consider her career as American or as French, or to distinguish between her homeland and the place she called home. After seeing her work hanging in Stillman's residence (see fig. 13), near the fashionable Parc de Monceau, in January 1910, Cassatt wrote to Louisine Havemeyer: "I thought my things looked very well at Mr. Stillman's, perhaps they are right when they say I will survive, who knows."[67]

Impressed by Cassatt's many accomplishments and by the position she occupied in Parisian art circles,

Fig. 13. Photograph of bedroom in James Stillman's apartment, Paris, c. 1910, showing one of the numerous works by Cassatt that the banker owned (*Daughter and Mother Admiring the Baby*, 1906; Cambridge, Mass., Harvard University, Fogg Art Museum). Photo: courtesy Archives, The Metropolitan Museum of Art, New York.

Stillman may have become convinced that her reputation in France was more secure than it was in the United States. In 1908, the first year the banker spent more time in France than at home, the artist was honored with two major exhibitions of her work in Paris: a spring show at Vollard's gallery, and another in the fall at Durand-Ruel's (this was the first the dealer had staged in Paris since 1893; he had arranged four for her in New York in that time). She also received a commission to execute portraits of Dikran Kelekian's two children. But this attention in Paris was anything but typical. It is probably not coincidental that Vollard, Durand-Ruel, and Kelekian—all of whom had profited enormously from the Havemeyers' passion for collecting—so aggressively courted Cassatt's favor within months of H. O. Havemeyer's sudden death, in December 1907. These dealers could easily have assumed that, concerning further acquisitions, as well as the future of the New York couple's collection, Louisine Havemeyer, in her husband's absence, would depend more than ever upon the advice of her friend of thirty years, Mary Cassatt.

Furthermore, beginning in 1911, Stillman saw Cassatt's work featured in posthumous dispersal sales of the most important collections of modern art in Paris, including those of the brothers Alexis and Henri Rouart, who died in 1911 and 1912 respectively. The series of auctions of the Rouarts' respective holdings was covered extensively in the Parisian press, attracted record-breaking prices, and reinforced the growing status of the artists whose works figured in the auctions. While Cassatt could derive satisfaction from the company she kept, at least one writer on the Rouart sales, the painter and critic Jacques Emile Blanche, revealed a prejudice, rooted in French nationalism, about her art when he declared, "Apart from some works by the American Mary Cassatt, who owes to the friendship of her master, Degas, the honor of having been included, [Henri Rouart's collection] was purely French"[68] Not everyone felt this way, as Stillman was pleased to note when he visited members of the Wildenstein family, owners of a distinguished gallery. Among the works of art hanging in their apartment was a pastel by Cassatt:

It was of a little girl, and Madame Wildenstein went up to it so tenderly and took it in her hands so caressingly, I thought she was going to kiss it. I had not up to that time said a word. Then in a most indifferent tone, I asked the price, they replied "Ah Monsieur this is ours, it's not for sale," and they seemed to feel hurt at any pecuniary reference to it—as if it were alive. . . . In fact no business was discussed afterwards, and they kept talking of Miss Cassatt's talent and repeated several times she is a grand maître and we are surprised not to have realized it sooner. I am quite sure they meant what they said.[69]

Early in 1913, Stillman, inspired by the high prices being paid for Degas's paintings, offered Cassatt some advice as to how to stimulate the market for her work. As he related to his sister:

Now I am telling Miss Cassatt never to offer another of her paintings for sale, that then they will begin running after her and when they have often enough, to consent to dispose of one for a hundred thousand francs. I have also made the prediction that Degas will decline and her's [*sic*] advance so much that, in ten years her paintings will sell for as much as his and I believe it. You should have heard her shrieks![70]

Stillman's inflated assessment of Cassatt's standing in France must have been reinforced when, that same year, Achille Segard published in Paris a biography of the artist, *Mary Cassatt: Un Peintre des enfants et des mères*. The banker bought what must have been a substantial number of copies; he may even have promoted the idea of an English translation to the book's French publisher, Ollendorf, hoping perhaps to strengthen Cassatt's reputation in the United States. Cassatt wrote to Joseph Durand-Ruel in 1914, describing a conversation with Stillman:

Mr. Stillman is in Cannes. He tells me that, according to Ollendorf, Segard's book was one of his good books, in terms of sales—I suppose—if that's so, Mr. Stillman must have contributed much to this. Now Miss Brown wants to translate. The publisher has consented and, I suppose, Segard. All this will make Segard known; he hasn't anything to complain about.

Within a few days, the project seems to have moved beyond mere discussion. Cassatt relayed the latest developments to Joseph Durand-Ruel:

I have just received a letter from Miss Brown, who asked Ollendorf for the right to translate Segard's book into English. He agreed, asking for 500 francs and a price for the right to use the reproductions. She wrote to Brentano's in New York. Do you think this will work?[71]

Joseph Durand-Ruel's response is not known; in any case, the proposal never advanced further. The book itself perhaps provides the best explanation for the project's quick demise. Segard's biography stresses not so much the contributions Cassatt made to modern art in France, but rather the influence of French modernism on Cassatt. In chapter after chapter, the author emphasized the intellectual and aesthetic superiority, as well as the historical record, of French culture, in contrast to the immaturity and provincialism of the United States. The book implies that Cassatt's greatest achievement was her decision to move to France, a thesis that would not have appealed to most American readers. Later Cassatt regretted having cooperated with this writer, not because of his nationalistic bias but rather because he had treated her as if her career were all behind her. As the artist put it, "I may astonish Segard yet, who rather finishes me in his book." There is no record of how Stillman disposed of the many copies

he acquired; a number of the surviving volumes in American museum and art libraries were presented anonymously. Since Stillman is known to have made anonymous gifts, he may well have been the donor.[72]

Despite Stillman's interest in promoting Cassatt's art in the United States, she did not particularly need his help. Owing largely to Durand-Ruel's almost continual circulation of her art—in 1911 for example paintings and pastels by Cassatt appeared in New York, then traveled on to Philadelphia, Pittsburgh, Buffalo, Cincinnati, St. Louis, Chicago, Worcester, New York again, and Washington, D.C.—private collectors were buying her art with increasing frequency. More importantly American museums had also begun to add her work to their collections, such as The Metropolitan Museum and The Detroit Institute of Arts in 1908; the Worcester Art Museum and the Corcoran Gallery of Art, Washington, D.C. (cat. 45) in 1909; and The Art Institute of Chicago (cat. 72) and the Museum of Fine Arts, Boston (cat. 17) in 1910. Each of these works came directly or indirectly from Durand-Ruel and had appeared in at least one annual exhibition in the United States.[73]

Similarly American writers and critics discovered Cassatt in these years. While this body of writing no more accurately characterizes her career than that of New York writers in the 1890s, discussion of Cassatt's oeuvre appeared more frequently and was significantly more reverential. A 1909 headline in *Current Literature* describes the artist as the "Most Eminent of Living American Women Painters." An article by Lulu Merrick, in the August 1909 edition of *The Delineator*, bears the long-winded but admiring title "The Art of Mary Cassatt: Talent, Intelligence, Industry and Poetic Feeling Have Placed an American Girl in the Front Rank of Contemporary Painters." Articles on the artist appeared not only in major daily newspapers in Boston, Chicago, New York, and Philadelphia, but also in such popular magazines as *The Craftsman, Good Housekeeping,* and *Harper's Monthly.*[74] And of course Americans could always find her work on public view somewhere in the nation.

Important though Stillman was to Cassatt in life, it was in death that he made the greatest contribution to her career, helping to insure that she would

be better known to posterity in the United States than in France. Stillman remained in Europe even after the outbreak of World War I. However, in 1917, when the United States joined the conflict, he lost his "neutrality" status; he packed up his art collection and returned to New York, heartbroken at the state of world affairs. His health, which had been fragile for years, worsened and, in March 1918, he died.[75] Stillman had not discussed with Cassatt any plans for his collection; upon learning of his death, she was saddened and had no sense of what was to become of her paintings and pastels. She learned secondhand, through Durand-Ruel's son George, that the Stillman family intended to auction his holdings. Cassatt wrote to Louisine Havemeyer in August 1918:

He [George Durand-Ruel] told me that Mr. S[tillman]'s secretary had given them to understand without positively stating that all his pictures were to be sold, amongst the moderns is that fine little Courbet's [sic] which you want—As for mine there will be 24, which when sold at auction may not bring much, my day is over for caring.[76]

While some of Stillman's collection was eventually auctioned, he bequeathed much of it, including half of his Cassatt holdings, to The Metropolitan Museum of Art, New York. It is not altogether clear that the museum was pleased to receive so many works by Cassatt, but it accepted the gift. A provision of the bequest permitted the Metropolitan to distribute a portion of the Cassatts to other museums in the United States. Whether this codicil was part of Stillman's plan to see the artist's work reach an even broader audience, or was the museum's way of thinning an ensemble it was less than eager to receive, is unknown. In either case, public museums in Cleveland, Detroit, Minneapolis, St. Louis, and Worcester benefited from Stillman's generosity and his devotion to Cassatt.[77]

A Friend Becomes a Patron: Louisine Havemeyer

Louisine Havemeyer finally picked up where Stillman left off. Although she was Cassatt's closest and most trusted friend, she had been at best something of a sporadic collector of the artist's work. Since the turn

of the century, she had purchased only *Young Mother* (cat. 50), in 1901. In 1912, five years after her husband's death, she bought *Girl Reading* (private collection). Cassatt was herself at least partly responsible for the diminishing number of purchases of her work by the Havemeyers in the first decade of the twentieth century. While annoyed at Durand-Ruel, she had effectively persuaded the couple to explore other areas of collecting, such as Old Master paintings, ancient glass, and Persian miniatures.[78]

Late in 1912, Louisine Havemeyer was secretly preparing to purchase Degas's *Dancers Practicing at the Bar* (Hirshler, fig. 17) at the Henri Rouart sale (she paid 478,500 francs, a record price for the work of a living artist). Her late husband had coveted the painting, and she intended to acquire it in his memory. Before the sale, Cassatt wrote to Havemeyer about her own works in the same collection, perhaps hoping her friend would buy one of them: "They [the Durand-Ruels] expect the Mother & child [fig. 14] in the Rouart sale to bring 10,000 frs., I sold it for 600, and the Thé [*Tea* (cat. 27)] for 1000; together they may bring 25 to 30,000 & I used to be afraid my pictures were not a good investment." Louisine Havemeyer disregarded her friend's thinly-veiled enticement; even *Tea* did not reach the relatively modest estimate Cassatt mentioned in her letter. Somewhat disappointed, the artist wrote to Havemeyer after the sale: "Kelekian bought my picture. I am glad he did for it was not dear, and a good picture." She went on to gently scold her friend by reminding her that, "Mr. Havemeyer [had] wanted to buy it from Rouart." Cassatt's reprimand was particularly well-timed, for she was not yet aware that it was Havemeyer herself who had bought the Degas. When the artist learned that it was her own friend who had made the purchase, she understood her reasons for doing so, conceding: "It was a matter of sentiment, since her husband had wanted it."[79] But she may have wondered why her own painting, *Tea*, would not have satisfied the same purpose.

Cassatt's interest in the market value of *Tea* reveals her increasing concerns about her personal finances. She had never worried about her income, but after the death in 1906 of her extremely wealthy brother, Alexander, and more recently the loss in 1911 of her

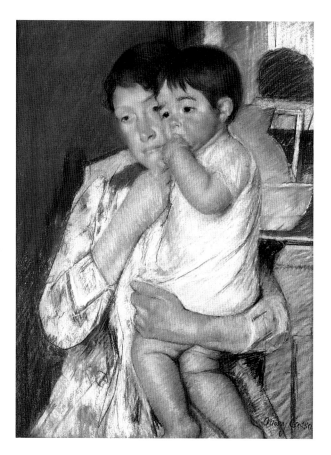

Fig. 14. Mary Cassatt. *Mother and Child*, 1889. Pastel on paper; 63.5 x 48.2 cm. Paris, Musée d'Orsay, © Photo RMN.

youngest and last surviving sibling, Gardner, she noted more regularly the state of economic affairs of her Parisian household and took more interest in the market for her work. In September 1913, Cassatt mentioned to Havemeyer the advice Stillman had given her months earlier, which apparently she was still pondering:

Mr. S[tillman] wants me not to sell anything so as to put things up [in value]. The J. Durand-Ruels were here on Sunday & wanted me to send them everything. I will have to sell with all that is before us, my apartment [rent] is going to be raised I don't know how much—& income tax in America and here.[80]

Cassatt's financial worries were more imagined than real. She was after all maintaining an apartment in Paris, her country house, and a small but comfortable villa in the Alpes-Maritime—all with staffs. Even so she must have felt increasingly isolated, since she found her closest living relatives—in-laws, nephews, nieces, and their children—mostly unsympathetic. Cassatt made a number of moves, in 1912 and 1913, designed to protect her standard of living

and to put her finances in order. She rewrote her will, transferring beneficiary status from Alexander's children and grandchildren—whom (with the exception of her nephew Robert) she considered ungrateful and spoiled—to the daughters and son of Gardner. She began to sell her archive of her own works to Durand-Ruel, and offered the dealer two examples by Degas as well, although the pair did not sell until much later, and not through Durand-Ruel (see Hirshler, p. 183). She also sold the portrait Degas had painted of her in the early 1880s (cat. 91) to Vollard, much to the consternation of the Durand-Ruels, to whom she had originally promised it. She later explained her decision: "I do not want to leave it with my family as being [a picture] of me. It has some qualities as art, but it is so painful and represents me as such a repugnant person, that I would not want it known that I posed for it." Although she believed Vollard would not let it go to the United States, as Durand-Ruel would surely have done, it eventually ended up there anyway, with Cassatt clearly identified as the sitter.[81]

Louisine Havemeyer, perhaps made sensitive to Cassatt's financial concerns through their correspondence, acquired several works by Cassatt in 1914: At the sale of Roger Marx's collection, she added two color prints from the critic's outstanding holdings of Cassatt's graphic art, as well as the painting *The Mirror* (cat. 89). Though Cassatt's work had never fetched anywhere near a price of 15,000 francs in the open market, Havemeyer left a bid for this amount with Joseph Durand-Ruel, perhaps remembering the high-end estimate Cassatt had suggested for *Tea*. Naturally hers was the winning offer. Havemeyer further reinforced the market value of Cassatt's work two weeks later, when she bought from Durand-Ruel a large *Mother and Child* (Rochester, New York, Memorial Art Gallery of the University of Rochester), also for 15,000 francs, and a smaller work (*Mother and Sleeping Child*; New York, The Metropolitan Museum of Art) for 8,000 francs. Both were part of a group of seven pastels Cassatt had summoned the strength to execute in 1913 and 1914: one last, heroic effort in a long and productive life.[82] The combination of poor health, failing eyesight, and the traumatic disruptions of war finally made it impossible for Cas-

satt to continue working after 1914. Havemeyer, who visited the artist in France that year, probably recognized that her friend was at the end of her career; this flurry of acquisitions may have been an atonement for years of relatively unspectacular patronage.

The Suffrage Exhibition at Knoedler's, April 1915

In the years after her husband's death, Louisine Havemeyer had become a vocal exponent of woman suffrage in the United States and was determined to put her collection to use in support of the movement. She eventually settled on a benefit exhibition at Durand-Ruel's New York gallery, the proceeds of which would go to the Woman Suffrage Campaign Fund. She initially planned an exhibition solely of Degas's paintings and pastels, nearly all of which were to come from her holdings. After seeing Cassatt in France, she enlarged the project to embrace her friend's work, including the acquisitions she had recently made. By November or December 1914, the show took another turn. In its final form, it featured not just works by Degas and Cassatt but a spectacular selection of Old Master paintings from some of the most important private collections in the United States. The event's organizers also relocated it from Durand-Ruel's establishment to the galleries of M. Knoedler and Co., New York.[83]

Like Havemeyer, Cassatt was a passionate supporter of the suffrage movement, which had been fueled by the onset of war in Europe and what was perceived as the poor handling of international affairs by the world's male leaders. "Go home and work for the suffrage," she instructed her friend in 1914, "If the world is to be saved, it will be the women who save it." At Havemeyer's urging, Cassatt rifled through her closets in Paris, searching for some long-hidden treasures to add to the show. She turned up *Lady at the Tea Table* (Shackelford, fig. 24). Although initially reluctant to exhibit the canvas, Cassatt eventually yielded to Havemeyer's insistence that it be included.[84]

Although the "Loan Exhibition of Masterpieces by Old and Modern Painters," which opened on April 6, 1915, hardly put a wrinkle in the entrenched American political fabric—it would be nearly four more years before women won the right to vote in the United States—Cassatt was utterly and completely delighted by the show. This was the American exhibition she had always wanted and the first in which she had actively participated. Americans now could appreciate the artist in the company she desired. At last she was able to present herself without the mediating, sometimes careless, and often self-serving influence of Durand-Ruel.

Remarkably, after so many years, the event at Knoedler's was also the first time the work of Cassatt and Degas had been seen together, in isolation from the rest of the Impressionist circle (see fig. 15). As the date of the exhibition approached, Cassatt began to consider the ramifications of her work hanging in the same room with so many by the artist she considered the nineteenth century's greatest master. Despite their closeness, she must have felt some concern at the inevitable prospect of comparison, but ultimately she only became more confident that her work would hold up (see Shackelford, p. 138). Knowing that this display was intended to promote a cause the misanthropic Degas abhorred—he knew nothing about it—gave Cassatt almost devilish delight: "It is 'piquant' considering Degas [sic] opinions," she declared.[85]

Taken as a whole, with examples by such Old Masters as Bronzino, Rembrandt, and Vermeer hanging alongside modern works, the exhibition represented the very formula Cassatt had always insisted was essential both to a good artist and to a good collector. Louisine Havemeyer aptly quoted Cassatt in her remarks at the private viewing: "To make a great collection it is necessary to have the modern note in it, and to be a great painter, you must be classic as well as modern."[86] The suffrage exhibition reflected the high standards Cassatt had always promulgated. At every turn, she defended the integrity of the exhibition as a showcase for her own art and that of artists she admired. When Havemeyer proposed raffling one of Cassatt's paintings, in the hope of bringing an extra $5,000 to the suffrage movement, the artist resisted:

I hope the exhibition will be a success. Of course you have seen Joseph [Durand-Ruel], he has all the pictures I own. I hope they got there safely. I really cannot give any of those to

Fig. 15. Installation photograph of the "Loan Exhibition of Masterpieces by Old and Modern Painters for the Benefit of Woman Suffrage," M. Knoedler and Co., New York, April 1915. Photo: courtesy M. Knoedler and Co. The ten works by Cassatt that appear here include cats. 88 (fifth from the left), 87 (fourth from the right), and 89 (far right).

be raffled for nor do I think it is a good thing, it is lowering Art. You ought to do well without that. I wish I had sent over [my] Degas. Fancy giving that to be raffled for and its falling into the hands of some one knowing nothing of Art. How many do you think would appreciate anything outside of a chromo. No, don't lower the exhibition by anything like that. Keep it very high. I would far rather give $5,000 than one of my pictures.[87]

For Cassatt there was no cause, not even suffrage, more worthy than that of art, to which she had devoted her entire life.

Critical and popular response to the exhibition, and to Cassatt's work, was enthusiastic.[88] The idea of a young woman from Pennsylvania having crossed the Atlantic and conquered the continent appealed to Americans hungering for something of which to be proud as war raged in Europe. Long deprecated as culturally undeveloped, unsophisticated, and even vulgar, the North American audience saw this presentation of Cassatt's art not only as a triumph for this artist but as a vindication of her native land as well. Although she did not leave France to see the exhibition, she drew enormous satisfaction from it. At Havemeyer's urging, she donated what proved to be one of the show's more popular works, *Lady at the Tea Table*, to the Metropolitan, although she had as much as promised it to the Petit Palais, Paris, and noted to Havemeyer, seemingly without too much regret, "its home ought to be in Paris where I painted it."[89]

The same could be said for all of Cassatt's work, but in truth precious little remained in France.

While North American museums and collectors assembled Cassatt's oeuvre into impressive ensembles, their French and European counterparts were far less inclined to do so. With one exception (Chronology, fig. 13), at the time of her death in 1926, the only paintings and pastels in French public collections were either those donated by the artist herself (see cat. 29) or the work given by Stillman. The small coterie of devoted collectors she had cultivated and trained to her taste—the Havemeyers, Lawrences, Popes, Searses, Whittemores, and Stillman—had already or would become significant philanthropists and donors to American cultural institutions. Their generosity insured that Cassatt would be best represented and most celebrated in her native land. She may not have always agreed with the way her work was presented in the United States or the company it had to keep, but her fellow citizens were pleased and proud to enshrine her among the growing fold of American painters with international reputations. Three years after Louisine Havemeyer persuaded the artist to donate *Lady at the Tea Table* to the Metropolitan Museum, an official sent Cassatt a letter, describing the galleries of mostly American art in which the work was displayed. She relayed this information to Havemeyer with some irritation: "Did I write to you that they told me my portrait of Mrs. R[iddle] was in the room with a Sargent! They thought I ought to be very proud."[90]

Notes

1. For the reviews of Cassatt's submissions to the Impressionist exhibitions, see Burty 1879; Burty 1880; Duranty 1879; Huysmans 1880. For the Rouart brothers's acquisitions, see cats. 18, 27. For Haviland's purchase, see cat. 12; and Edgar Degas to Félix Bracquemond, [c. May 11, 1879], in Guérin 1945, p. 47. For Proust's purchase, see cat. 14; and San Francisco 1986, p. 257. For the works owned by Degas and Paul Gauguin, see cat. 19 and Shackelford, fig. 3. For the work owned by Léon Clapisson and then Paul Durand-Ruel, see cat. 33; and Anne Distel, "Appendix II: The Notebooks of Léon Clapisson," in Ottawa, National Gallery of Canada et al., *Renoir's Portraits: Impressions of an Age*, exh. cat. by Colin B. Bailey et al. (1997), p. 347.

2. Alexander, Cassatt's older brother, was the first to marry and achieve professional success. Very much a benefactor to his family in Paris, he received a far greater share of works by his sister than Gardner did. See for example cats. 10, 32, 34, 35, 46 and Breeskin 1970, 77, 79, 86, 127.

3. Lindsay Leard, *The Société des peintres-graveurs: Printmaking 1889–1897*, Ph.D. diss. (New York, Columbia University, 1992), pp. 47–49.

4. "Because I am . . .": Camille Pissarro to Lucien Pissarro, Jan. 10, 1891, in Bailly-Herzberg 1988, vol. 3, pp. 13–14, in the original French; see Rewald 1972, pp. 145–46, for an English translation. On the exhibition of works by Cassatt and Pissarro, see Lifetime Exhibition History (Paris 1891).

5. On the dealer's hesitation, see Camille Pissarro to Lucien Pissarro, May 21, 1891, in Bailly-Herzberg 1988, vol. 3, pp. 88–89.
"We had . . .": Camille Pissarro to Lucien Pissarro, Apr. 25, 1891, in Mathews 1984, p. 220.
For a critical response to Cassatt's color-print suite, see Fénéon 1891.

6. For Monet's opinion on Paris as the last cultural bastion, see Claude Monet to Paul Durand-Ruel, July 28, 1885, in Venturi 1939, vol. 1, pp. 294–95. For a similar opinion from Cassatt, see Cassatt to Joseph Durand-Ruel, Feb. 18, [1892], in Mathews 1984, p. 228.

7. Cassatt to Samuel P. Avery, June 9, [1891], in Mathews 1984, p. 221.

8. Camille Pissarro to Lucien Pissarro, July 7, 1891, in Bailly-Herzberg 1988, vol. 3, p. 102, in the original French; see Rewald 1972, p. 179, for an English translation.
"Mary is at work . . .": Katherine Cassatt to Alexander Cassatt, July 23, 1891, in Mathews 1984, p. 222.

9. "She was . . .": Katherine Cassatt to Alexander Cassatt, Sept. 19, [1881], in Mathews 1984, p. 162.
"Any little contretemps . . .": Robert Cassatt to Alexander Cassatt, May 25, [1883], in Mathews 1984, p. 167.

10. For Durand-Ruel's ownership of Cassatt's works, see Katherine Cassatt to Alexander Cassatt, Dec. 10, 1886, in Mathews 1984, pp. 202–203.

11. For Cassatt's dissatisfaction with Durand-Ruel, see Camille Pissarro to Lucien Pissarro, Apr. 25, 1891, in Mathews 1984, p. 220.
For Durand-Ruel's shipment of Cassatt's color prints to New York, see Boston 1989, p. 72.
For the 1879 and 1892 Society of American Artists exhibitions, see Lifetime Exhibition History (New York 1879, New York 1892); and for Cassatt's early support of this organization, see Cassatt to J. Alden Weir, Mar. 10, 1878, in Mathews 1984, p. 137.

12. *New York Times* 1892.
On Cassatt's disappointment with the American response to her work, see Cassatt to Joseph Durand-Ruel, Feb. 18, [1892], in Mathews 1984, p. 228. In another letter, she wrote: "I am greatly disappointed that there have been no amateurs in New York"; see Cassatt to Paul Durand-Ruel, [Feb. 17, 1892], in Mathews 1984, pp. 227–28.

13. Rambaud 1890. *The Lesson* is Breeskin 1948, 127. For a detailed discussion of "The Lesson," commonly known as "The Map," see Eric Rosenberg, "Mary Cassatt's 'The Map': Gendering Location and Dislocation in 1890," in *All Within Reach of Human Sense: Episodes in the History of Art in America, 1492–1942* (at press). *L'Art dans les deux mondes* was a short-lived weekly (the last issue appeared on July 11, 1891) published by the Durand-Ruel firm in Paris to promote the artists it represented. As the inaugural issue noted, the "two worlds" in its title referred to Old Masters and modern art, "not only in Europe, but also in America." The issue with Cassatt's *The Lesson* on the cover

includes an article by L. de Fourcard, "L'Art en Amérique" (pp. 3–4), as well as the essay on Cassatt by Rambaud.
Lecomte 1892, pp. 129 (Breeskin 1970, 189), 169 (Breeskin 1970, 151). For an analysis of Durand-Ruel's private collection, see Robert Jensen, *Marketing Modernism in Fin-de-Siècle Europe* (Princeton, 1994), pp. 59–60.

14. For Cassatt's entries in Durand-Ruel's 1886 New York exhibition, see Lifetime Exhibition History (New York 1886). Cassatt may not have released any works for Durand-Ruel to take to New York in 1886. The New York show coincided with the eighth Impressionist exhibition in Paris, and the artist tended to hoard her own paintings and pastels in anticipation of Impressionist projects. She refused to send a selection of works to the Les Vingt exhibition in Brussels that same year, not wishing to reduce her ensemble for the Impressionist show. See Cassatt to Octave Maus, Dec. 13, 1885, in Brussels 1993, p. 29.

15. For Durand-Ruel's North American clients, see Venturi 1939, vol. 2, pp. 216–17. For the New York gallery's more conservative early inventory and more specifically H. O. Havemeyer's rather traditional taste in the early 1890s, see Weitzenhoffer 1986, p. 92. For a concise tally of the Havemeyers' purchases between 1889 and 1891, see New York 1993, pp. 207–13.
The North American passion for Monet started as early as 1886. Cassatt herself noted in a letter to Alexander's wife, Lois, that she wished they had bought more works by this artist "when they were at our price"; see Cassatt to Lois Cassatt, June 30, [1886], in Mathews 1984, p. 200. But after 1890 there was a decided boom in the market for Monet in America. Such collectors associated with Cassatt as Harris Whittemore, A. A. Pope, and Potter and Bertha Palmer contributed significantly to this boom (see Hirshler). For Whittemore and Pope, see Weitzenhoffer 1986, pp. 93–94; for the Palmers, see ibid., p. 87. Weitzenhoffer posited that, in 1891 alone, the Palmers purchased eleven paintings by Monet from Durand-Ruel, but Charles F. Stuckey counted only seven in that year; see The Art Institute of Chicago, *Claude Monet, 1840–1926*, exh. cat. by Charles F. Stuckey (1995), p. 221. Durand-Ruel's more aggressive promotion of Impressionism in the United States may have begun with the New York chapter of the Union League Club's Monet exhibition in February 1891,

to which Durand-Ruel and several of his early clients were lenders; see Weitzenhoffer 1986, p. 83. For Cassatt's plan to exhibit in New York in the fall of 1892, see Cassatt to Sara Hallowell, [July 23, 1892], in Mathews 1984, pp. 231–32.

16. For the mural commission, see Cassatt to Pissarro, June 17, [1892], in Mathews 1984, p. 229. By this time, Cassatt was already at work on the project, suggesting that she accepted the commission earlier in the spring. For Durand-Ruel's visit to see the mural, see Cassatt to Rose Lamb, Nov. 30, [1892], in Mathews 1984, p. 240; and Cassatt to Bertha Palmer, Dec. 1, [1892], in ibid., p. 241.

17. For Cassatt's dissatisfaction with the fair, see Cassatt to Paul Durand-Ruel, Jan. 6, 1893, in Mathews 1984, pp. 244–45: "Up to now I'm the one who has given everything, because the office of construction has fulfilled none of the conditions of the contract. I don't even have the least guarantee that they will accept and pay for the work."
"After all . . .": Sara Hallowell to Bertha Palmer, Feb. 6, [1894], in Mathews 1984, p. 254.

18. For facsimile copies of the Durand-Ruel catalogues of Monet's May 1891 exhibition, Pissarro's Feb. 1892 exhibition, Renoir's May 1892 exhibition, as well as Morisot's 1892 exhibition at Boussod, Valadon, & Co. in Paris, see *Modern Art in Paris: Exhibitions of Impressionist Art*, vol. 1, selected by Theodore Reff (New York/London, 1981). For Degas's 1892 Paris exhibition at Durand-Ruel's, see Richard Kendall, *Degas Landscapes* (London/New Haven, 1993), pp. 183–229. For evidence that the painting *At the Français, a Sketch* belonged to Martin, Camentron, and Co. by Nov. 1893, see Lifetime Exhibition History (Paris 1893 [no. 13, *La Loge*]) in this volume.
"I painted . . .": Cassatt to Harris Whittemore, Nov. 14, [1893], Hill-Stead. I am grateful to Sharon Stoltz and Polly Pasternak at the Hill-Stead Museum for sharing information from the collection's archives.

19. On the stagnant American economy of the 1890s, see Weitzenhoffer 1986, pp. 91–92. For the list of Durand-Ruel's American clients, see Venturi 1939, vol. 2, pp. 216–20.

20. For the death of Charles Durand-Ruel, see Mathews 1994, p. 210.
"And we admit . . .": *Paris and the Arts, 1851–1896: From the Goncourt* Journal, ed. and trans. George J. Becker and Edith Philips (Ithaca/London, 1971), p. 300.

21. For the Havemeyers' Jan. 16, 1894, purchases, see New York 1993, pp. 215–16. For Durand-Ruel's relocation of the New York gallery to 389 Fifth Avenue, see Weitzenhoffer 1986, pp. 94–95.

22. See for example the review by Alfred de Lostalot (Lostalot 1893). Pissarro wrote to his son: "Miss Cassatt has at this moment a truly beautiful exhibition of paintings at Durand's. She is certainly very strong!": Pissarro to Lucien Pissarro, Dec. 5, 1893, in Bailly-Herzberg 1988, vol. 3, p. 403. The *Mother and Child* the Luxembourg coveted is Breeskin 1970, 151.
"I am almost . . .": Cassatt to Harris Whittemore, Dec. 22, [1893], in Mathews 1984, p. 250.

23. Cassatt to Paul Durand-Ruel, Feb. 2, [1894], in Mathews 1984, p. 252.

24. For one of many documents expressing Cassatt's intense dislike of juries and awards, see Cassatt to Harrison S. Morris, [c. Mar. 1904], in Mathews 1984, p. 291, where the letter is dated Mar. 15. Given that a transcript of Morris's response in PAFA is dated Mar. 15, 1904, Cassatt must have written her letter earlier in the month.
There is some question as to the year in which Renoir and Monet refused to be made *chevaliers*. A letter from Monet to Gustave Caillebotte, dated May 12, 1890, suggests that Renoir at least was offered the decoration in 1890. A July 21, 1892, entry in the diary of the American artist Theodore Robinson implies that the honor was rejected by both artists during the winter of 1891–92. See The Art Institute of Chicago (note 15), p. 219.
"I agree . . .": Cassatt to Paul Durand-Ruel, [Feb. 10, 1894], in Mathews 1984, pp. 254–55.
"Which ends . . .": Cassatt to Harris Whittemore, Feb. 15, [1894], in Mathews 1984, p. 259.

25. "Worked amid . . .": Cassatt to Rose Lamb, Apr. 26, 1895, in Mathews 1984, p. 262.
On Havemeyer's purchases from Cassatt's 1895 New York exhibition, see New York 1993, nos. 52–53, pp. 298–99. On Whittemore's purchase, see Mathews 1994, p. 231. It seems unlikely that Whittemore purchased a painting or a pastel from the exhibition, but he could well have acquired prints. On that of the Popes, see cat. 26; on that of the Lawrences, see Breeskin 1970, 232.

26. Jensen (note 13), p. 60: "That it [Durand-Ruel's private collection] was not a permanent museum is testified to by the fact that although a number of the works illustrated in Lecomte's book [Lecomte 1892] remained with the dealer all his life,

just counting the Manets and Monets in the collection, a notable number very soon passed from his hands." The *Mother and Child* Durand-Ruel sold to the Havemeyers was only one of a handful of Cassatt's paintings that moved from Durand-Ruel's personal collection to the inventory of the gallery. *The Family* (cat. 71) was originally purchased for the collection of Joseph Durand-Ruel in 1893, but was sold to A. A. Pope less than three months later. Another painting, *Tea* (cat. 33), was acquired by Durand-Ruel possibly as early as 1883, and remained in his private collection until he sold it, probably in 1909, to James Stillman. For *The Family*, see Cassatt to Harris Whittemore, Nov. 14, [1893], Hill-Stead; see also New York 1993, no. 50, p. 298.

27. "Who had guaged [*sic*] . . .": Marks 1895a.
"Without doubt . . .": *New York Times* 1895a.
"Awakens the liveliest regret . . .": *New York Tribune* 1895.
"Right to regard . . .": *New York Times* 1895b.

28. *New York Times* 1895b.

29. During this period, the artist became increasingly interested in portraiture. When Louisine Havemeyer and her daughters, Electra and Adaline, visited in the summer of 1895, Cassatt produced at least two pastel portraits of them (fig. 10 and Breeskin 1970, 256); see New York 1993, pp. 84–87. In 1896 she depicted her young niece and namesake, Ellen Mary (cat. 81), the daughter of her brother Gardner, who probably took his family to France to console the artist after the death of Katherine Cassatt. Although Cassatt took comfort in her work and enjoyed many visitors, she would later describe this time in almost desperate terms. "I lost my Mother two years ago, in October, & was so bereft and so tired of life that I thought I could not live. . .": Cassatt to Rose Lamb, Jan. 14, 1898, in Weitzenhoffer 1986, p. 127.

30. Louise Chandler Moulton, *Lazy Tours of Spain and Elsewhere* (London, 1896), p. 171; quoted in Pollock 1980, p. 5.

31. Edgar Degas is also absent from these albums, probably because he was notoriously fussy about where his work appeared; see Degas to Aglaüs Bouvenne [late Apr./early May 1891], in Guérin 1945, pp. 185-86. For the print revival of the 1890s in France, see Ottawa, National Gallery of Art, *La Pierre parle: Lithography in France 1848–1900*, exh. cat. org. by Douglas Druick and Peter Zegers (1981). For Marty's portfolio series, see Donna M. Stein and Donald H. Karshan, *L'Estampe originale: A Catalogue*

Raisonné (New York, 1970).

32. For Vollard as a print publisher, see New York, The Museum of Modern Art, *Ambroise Vollard Editeur: Prints, Books, Bronzes*, exh. cat. by Una E. Johnson (1977). Vollard, a Créole born on Réunion, a French colony in the Indian Ocean, was hardly a nationalist or conservative. But in 1896 and 1897, when patriotism in France was particularly strong, the dealer might have felt compelled, for business reasons, not to invite international contributors. He also favored lithography over etching, which may also have contributed to the exclusion of Cassatt from his print-publishing projects. For a varying analysis of Cassatt's lack of participation in Vollard and Marty's albums, see Boston 1989, p. 85.

For Cassatt's still life by Cézanne, see Philadelphia Museum of Art, *Paul Cézanne*, exh. cat. (1996), p. 553.

33. "She wants . . .": Vernon Lee to Kit Anstruthur-Thomson, July 28, 1895, in Sweet 1966, p. 144. Although Cassatt later contributed a color print (*Woman and Child in the Grass* [Breeskin 1948, 162]) to *L'Estampe nouvelle* (Oct. 1897), n.p., by then the fashion for color prints had waned considerably, as had Cassatt's interest. Nonetheless she developed close ties with this publication's founders, Roger Marx and Eugène Rodrigués. Cassatt particularly valued the opinions of Marx. The critic's name appears often in the artist's letters to Louisine Havemeyer; she apparently consulted with him regularly before giving advice to her New York friend. Marx assembled an outstanding collection of Cassatt's works, particularly her prints; see Paris, Hôtel Drouot, *Catalogue des estampes modernes composant la collection Roger Marx*, sale cat. (Apr. 27–May 2, 1914), nos. 248–312. The copy in The Art Institute of Chicago's Ryerson and Burnham Libraries is annotated with prices. Cassatt's relationship with Rodrigués is not well-documented, but she executed two double portraits of his daughters; see Breeskin 1970, 830 and New York, Sotheby's, *Impressionist and Modern Art, Part II*, sale cat. (Nov. 9, 1995), no. 175.

34. On the Caillebotte donation, see Anne Distel, "Chronology," and "Gustave Caillebotte's Estate Inventory," in The Art Institute of Chicago et al., *Gustave Caillebotte: Urban Impressionist*, exh. cat. (1995), pp. 318–20. Cassatt apparently had been approached by the Luxembourg to donate one of her works as early as 1892, but had refused. As one American writer reported (Marks 1892, p. 5):

The proposed honor [of entering the Luxembourg's collection] to the Impressionists is intended to include our talented countrywoman, Miss Mary Cassatt. It was shrewdly suggested that as the lady is known to be very rich, she should be asked to give one of her pictures to the Luxembourg. Miss Cassatt declined to do this, however, thinking that the proposed honor to her would be discounted, so to speak, by making it so cheap that the Government would have to pay nothing to confer it upon her.

35. *Philadelphia Inquirer* 1898. For the works by Cassatt in the Pennsylvania Academy exhibition, see Lifetime Exhibition History (Philadelphia 1898).

36. See Lifetime Exhibition History (New York 1898, Boston 1898).

37. Cassatt to Louisine Havemeyer, Dec. 25, [1902], in Mathews 1984, p. 277.

38. Cassatt to Harris Whittemore, [late Feb.–early Mar. 1898], Hill-Stead. Since the portraits of the Hammond children were included in the St. Botolph Club exhibition, they must have been completed by Mar. 21, 1898. The letter therefore must date sometime before Mar. 21 as well. See Lifetime Exhibition History (Boston 1898).

39. Cassatt's portrait of Mrs. Newbold is Breeskin 1970, 289. For the rejection by Mrs. Riddle and her daughter of the 1883 portrait, see Mathews 1994, pp. 165–67.

Even though Cassatt clearly had Beaux's example in mind when she executed her Newbold portrait, she does not seem to have held Cecilia Beaux's aesthetic opinions in very high regard. She conceded that the Philadelphia portraitist was "not without ability, but you must not talk Art to her"; see Cassatt to Louisine Havemeyer, Dec. 25, [1902], in Mathews 1984, p. 277.

40. The pastel portraits of Cassatt's niece are Breeskin 1970, 286–87. For Cassatt's portraits of the Hammonds, Lawrences, and Whittemores, see Breeskin 1970, 291–99. For the portrait of Mrs. Thayer, see Mathews 1994, p. 247.

The Whittemore family's support of Cassatt's art continued for many years; see Cassatt to Harris Whittemore, Jr., July 8, [1915], in Mathews 1984, p. 325. In this letter, Cassatt revealed that, unsolicited, she had sent a work (Breeskin 1970, 472) to Whittemore bearing a price her art had heretofore never attained in the open market. Whittemore apparently not only paid it, but was grateful to do so. See Michael A. Findlay and Missy McHugh, "Introduction," in New York, Christie's, *Important Impressionist Paintings from the Collection of Harris Whittemore*, sale cat. (Nov. 12, 1985), p. 16. The Cassatts owned by the Whittemores are Breeskin 1970, 111, 228, 297–99, 332, 380, 408, 472.

41. Among the Havemeyers' acquisitions at this time was Manet's *A Matador* (Walker, fig. 20). Remembering Cassatt's visit, Louisine Havemeyer overestimated the number of works she and her husband had acquired by including some that were actually purchased later; see Havemeyer 1993, pp. 222–24 and p. 333, n. 323. Still, the spirit of the anecdote is no doubt reliable.

42. There is no record of financial transactions for the portraits Cassatt executed of Havemeyer family members; see New York 1993, pp. 84–87 and nos. 54–56, pp. 299–300.

"I bought . . .": H. O. Havemeyer to Paul Durand-Ruel, Feb. 20, 1899, in Weitzenhoffer 1986, p. 136. For the purchase of the *Mother and Child* that Degas admired, see Paul Durand-Ruel to H. O. Havemeyer, July 7, 1899, in ibid., p. 136. Cassatt's portrait of Durand-Ruel's daughter and her children is Breeskin 1970, 307.

43. For an interesting discussion of the emergence of annual exhibitions in the United States, see Kenneth Neal, *A Wise Extravagance: The Founding of the Carnegie International Exhibitions, 1895–1901* (Pittsburgh, 1996). For Cassatt's participation in American art annuals, see Lifetime Exhibition History (passim). An inventory of the works now in American public collections that passed through Durand-Ruel's hands is beyond the scope of this essay, but the figure is no doubt substantial; see Hirshler.

44. "We are most happy . . .": Harrison S. Morris to Cassatt, Feb. 15, [1904], in Sweet 1966, p. 164.

"I, however . . .": Cassatt to Harrison S. Morris, [c. Mar. 1904], in Mathews 1984, p. 291. On the date of this letter, see note 24.

45. When The Art Institute of Chicago awarded *The Caress* its Norman Wait Harris Prize later that year, Cassatt naturally refused, saying in a letter to the museum's director, William R. French:

I was one of the original "Independents" who founded a society where there was to be no jury, no medals, no awards. This was in protest against the government salon, and amongst the artists were Monet, Degas, Pissarro, Mme. Morisot, Sisley, and I. This was in 1879, and since then we none of us have sent to any official exhibitions and have stuck to the original tenets. . . . Of course unless you have lived in Paris and seen the ill effects of official exhibitions you can hardly understand how strongly we felt about being "Independents."

Mary Cassatt to William R. French, Dec. 4, [1904], in Sweet 1966, p. 168. For this incident, see Mathews 1994, pp. 267–68.

Contrary to Cassatt's assertion that "none of us have sent to any official exhibitions," Monet for one exhibited at the 1880 Paris Salon; see The Art Institute of Chicago (note 15), p. 205.

46. Wynford Dewhurst, *Impressionist*

Painting: Its Genesis and Development (London, 1904). Dewhurst's book grew out of a pair of articles of the same title he published in *The Studio* 28, 191 (Apr. 1903), pp. 159–68; and ibid. 29, 124 (July 1903), pp. 94–112. Pissarro wrote to the editor of the journal *Gil Blas* shortly after *The Studio* article appeared, suggesting that "now was a good time to refute errors and badly supported judgments"; see Pissarro to *Gil Blas*, May 6, 1903, in Bailly-Herzberg 1986, vol. 5, pp. 334–35. The critic Camille Mauclair, curiously enough a German national, was among the most strident advocates of French entitlement to Impressionism. His books were quickly translated into English; see for example Camille Mauclair, *The French Impressionists* (London, 1903). Even Cassatt's friend Théodore Duret did not include her in his *Histoire des peintres impressionnistes* (Paris, 1906). For the emergence of German and Russian collectors of Impressionist paintings after 1900, see Jensen (note 13), p. 67.

47. "There is to be . . .": Cassatt to Ada Pope, c. late Mar. 1903, in Sweet 1966, p. 159. Cassatt's *The Caress* is Breeskin 1970, 393; *Girl in a Large Hat* is Breeskin 1970, 345; *After the Bath* is Breeskin 1970, 384. The show, which did not attract as much attention as Cassatt had hoped, included, in addition to works by artists Cassatt mentioned, examples by Cézanne, Guillaumin, Pissarro, and Renoir. For Cassatt's loans, see Lifetime Exhibition History (Paris 1903), nos. 34, 43. For Cassatt's Morisot, see Hirshler, n. 9.

48. "If those painter-journalists . . .": Cassatt to Paul Durand-Ruel, [Nov. 1903], in Mathews 1984, p. 288.

49. For Cassatt's introduction of the Havemeyers to Vollard and their support of him, see Weitzenhoffer 1986, p. 142.

50. For Cassatt's story about *Portrait of a Little Girl*, see Cassatt to Ambroise Vollard, [1903], in Mathews 1984, pp. 281–83. Vollard's stockbooks can be consulted on microfilm at the Musée d'Orsay, Paris. The dealer was, at least then, a poor accountant; while it is difficult to identify many of the works by Cassatt he acquired, his entries indicate that he was buying them cheaply. I am grateful to Miriam Lowenstamm and Marina Ferretti for researching the Vollard material in Paris.

51. For the award, see Mathews 1994, pp. 271–72. Cassatt wrote to Carroll Tyson in Philadelphia on Jan. 22, 1905: "It was very gratifying to get the ribbon for there had been difficulties and my friends had some trouble, especially it is hard to get the honor awarded to a woman. Perhaps it will help me to a little influence with Museum directors at home"; see Sweet 1966, pp. 170–71.

52. For the Grafton Galleries exhibition, see London, Grafton Galleries, *Pictures by Boudin, Cézanne, Degas, Manet, Monet, Morisot, Pissarro, Renoir, Sisley Exhibited by Messrs. Durand-Ruel & Sons*, exh. cat. (1905).

53. For Cassatt's representation in the New Gallery show, see Lifetime Exhibition History (London 1905).

54. For Cassatt's trip to England, see Cassatt to Minnie Cassatt, Mar. 16, 1905, AAA.

55. "I believe . . .": Cassatt to Paul Durand-Ruel, Nov. 30, 1905, in Venturi 1939, vol. 2, p. 124 (misdated 1906).

56. "I have just received . . .": Cassatt to Paul Durand-Ruel, Jan. 22, [1906], in Mathews 1984, pp. 266–67 (misdated to 1898). In Mathews's translation of the letter, she referred to the "Ladies Art League," but Cassatt was actually referring to the Woman's Art Club in New York.

57. In the letter she wrote to Harrison Morris ([c. Mar.] 1904, in Mathews 1984, p. 291), refusing the Lippincott Prize, Cassatt noted, "I have no hopes of converting anyone, I even failed in getting the women students club here to try the effect of freedom for one year, I mean of course the American Students Club." This letter suggests a greater involvement by Cassatt with female art students and aspiring artists than has previously been understood. For a discussion of Cassatt's support of American art students in France, see Nancy Mathews, "Mary Cassatt and the Changing Face of the 'Modern Woman' in the Impressionist Era," in William U. Eiland, *Crosscurrents in American Impressionism at the Turn of the Century* (Athens, Ga., 1996), p. 35. For Cassatt's participation in the Women's Art Club show, see Lifetime Exhibition History (New York 1906a).

58. Durand-Ruel, sensing perhaps that their relationship had changed, behaved unusually with the artist: "He actually clings to me, which I am astonished at"; Cassatt to Louisine Havemeyer, Dec. 21, [1906], in Mathews 1994, p. 282.

59. Kelekian and Cassatt remained close friends for the rest of her life. In 1908 he asked her to execute portraits of his children, Adine and Charles (Breeskin 1970, 511, 512). He clearly respected her work, valued their friendship, and encouraged her patronage. He added at least four other significant examples by the artist to his collection (including the paintings *Woman Reading* [cat. 14] and *Tea* [cat. 27], as well as the pastel *Contemplation* [cat. 66]) and commissioned a second portrait of his own son

in 1910 (Breeskin 1970, 570). That year the dealer helped arrange a trip to Egypt for Cassatt and the family of her brother Gardner: "I hope my brother will be satisfied for it is all left to me, & I left it all to Kelekian who has been kindness himself"; Cassatt to Louisine Havemeyer, Nov. 13, [1910], NGA.

60. Many of the works Cassatt pursued were for the Havemeyers. For the Havemeyers' relationship with Kelekian, see New York 1993, pp. 105–10. See also Cassatt to H. O. Havemeyer, July 19, 1906, NGA.

61. For the "Courbet head" (*Portrait of a Man*; New York, The Metropolitan Museum of Art), see Havemeyer 1993, p. 294; and New York 1993, no. 143, p. 317. For Vollard's purchase of works from Cassatt's studio, see Cassatt to Louisine Havemeyer, July 27, [1906], NGA; and Mathews 1994, p. 282.

62. See Cassatt to Havemeyer, July 27, [1906], NGA. For a portion of this letter, see Weitzenhoffer 1986, p. 167.

63. On her destruction of works of art, see Cassatt to Louisine Havemeyer, July 27, [1906], NGA. If Cassatt burned her personal papers, along with the works of art she mentioned, she may also have been motivated by her strong view that her art should stand on its own merits, viewed without the influence of her personality, social standing, or gender. In 1908 she refused to send a photograph of herself for inclusion in the annual exhibition of the Carnegie Institute, Pittsburgh, explaining to Director John W. Beatty: "It is always unpleasant to me to see the photographs of the artists accompany their work, what has the public to do with the personal appearance of the author of picture or statue? Why should such curiosity if it exists be gratified?": Cassatt to John W. Beatty, Oct. 6, [1908], in Mathews 1984, p. 299.

64. Cassatt first mentioned Stillman in a letter to H. O. Havemeyer dated July 19, [1906], NGA, interestingly in regard to an inferior Watteau painting the banker wanted to buy. Their friendship developed rapidly, and by 1907 Cassatt referred to him frequently in her letters to Louisine Havemeyer and others. Similarly, beginning Feb. 17, 1907, Stillman noted in his diary regular visits to Beaufresne and Cassatt's Paris apartment. For Stillman's diaries—little more than appointment books—see Harvard.

65. For information on Stillman, see Burr 1927. Both Stillman's inspired purchases and his ill-advised choices are discussed by Cassatt in a letter to Louisine Havemeyer, July 19, 1906, NGA.

66. Stillman's first purchase of works by Cassatt seem to date no later than 1908, when he lent two paintings (Breeskin 1970, 524, 393) to her solo exhibition at Durand-Ruel's in Paris; see entries in Lifetime Exhibition History (Paris 1908b) with the notation "appartient à M. J. S." The earliest work by Cassatt in Stillman's collection was *Tea* (cat. 33). For the works by Cassatt that Stillman owned, see cats. 33, 70 and Breeskin 1970, 271, 282, 309, 393, 432, 433, 452, 455, 475, 486, 487, 524, 538, 549, 557, 562, 563, 571, 572, 574, 575, 580, 593, 594.

For other portraits of the period, see Breeskin 1970, 552–54, for example. The portrait of de Sailley is Breeskin 1970, 555. For a discussion of a possible portrait by Cassatt of Stillman, see Cassatt to Louisine Havemeyer, Mar. 8, [1911], NGA.

67. "I don't suppose . . .": Cassatt to James Stillman, Dec. 25, [1910], in Burr 1927, p. 303.
"I won't allow . . .": Cassatt to Louisine Havemeyer, Dec. 29, [1911], in Mathews 1994, p. 295.
"I thought my things . . .": Cassatt to Louisine Havemeyer, Jan. 25, [1910], NGA. For a portion of this letter, see Mathews 1994, p. 286.

68. Jacques E[mile] Blanche, *Notes sur la peinture moderne. A Propos de la collection Rouart et de M. Edgar Degas* (Paris, 1913) (First published in *La Revue de Paris* [Jan. 1, 15, 1913]).

69. James Stillman to Clara Stillman, Feb. 18, 1913, in Burr 1927, pp. 307–308.

70. Ibid.

71. Segard 1913.
"Mr. Stillman . . .": Cassatt to Joseph Durand-Ruel, Feb. 12, [1914], in Venturi 1939, vol. 2, pp. 133–34.
"I have just received . . .": Cassatt to Joseph Durand-Ruel, Feb. 17, [1914], in ibid., vol. 2, pp. 135–36 (misdated 1915).

72. "I may astonish . . .": Cassatt to Louisine Havemeyer, May 21, [1913], in Mathews 1994, p. 299. I am grateful to Natalia J. Lonchyna, Patrice A. Murtha, and Amelia L. Ramirez in the Ryerson and Burnham Libraries, The Art Institute of Chicago, for their assistance. For at least one other anonymous gift by Stillman, see note 77.

73. The work acquired by The Metropolitan Museum in 1908 is Breeskin 1970, 342; that acquired by the Detroit museum is Breeskin 1970, 272. The work that entered the Worcester museum is Breeskin 1970, 406.

74. *Current Literature* 1909.
Merrick 1909.
The Craftsman 1911.

Teall 1910.
Stanton 1911.

75. See "James Stillman, Head of City Bank, Dies Suddenly," *New York Times*, Mar. 16, 1918, pp. 1, 11.

76. Cassatt to Louisine Havemeyer, Aug. 22, 1918, NGA. Apparently Havemeyer did not buy this particular work by Courbet.

77. On Stillman's bequest, see B.B. 1922 and *Bulletin of the Metropolitan Museum of Art* 1922. For the works that went to various museums, see Breeskin 1970, 452, 538, 549, 571, 574.

78. For the chronology of Havemeyer's purchases, see New York 1993, pp. 298–302. *Girl Reading* is Breeskin 1970, 535.

79. "They expect . . .": Cassatt to Louisine Havemeyer, Nov. 15, [1912], NGA.
"Kelekian bought . . .": Cassatt to Louisine Havemeyer, Dec. 18, [1912], NGA.
"It was a matter . . .": Cassatt to Paul Durand-Ruel, Dec. 26, [1912], in Venturi 1939, vol. 2, p. 127 (misdated 1911); trans. and quoted in Weitzenhoffer 1986, p. 209.
More than once, Cassatt had evoked Louisine Havemeyer's late husband to get her friend's attention. When the artist became interested in twelfth- and thirteenth-century French architectural ornament, she suggested that, before his death, H. O. Havemeyer "was already on the road to the French Gothic"; see Cassatt to Louisine Havemeyer, Nov. 13, [1910], in Mathews 1984, pp. 302. For Louisine Havemeyer's eventual interest in French Gothic sculpture, see her correspondence with Galerie Demotte, Paris, NGA.

80. Late in 1911, Cassatt wrote to her niece Minnie Cassatt, "I ought to be making my fortune, but that is the way things go, here where pictures are sought for I cannot work!": Cassatt to Minnie Cassatt, [c. Dec. 1911], AAA.
"Mr. S wants . . .": Cassatt to Louisine Havemeyer, Sept. 18, [1913], NGA.

81. Nancy Mathews estimated Cassatt's fortune in 1910 to be roughly $200,000; see Mathews (note 57), p. 42. For Cassatt's will, see AAA. For the sale of her works to Durand-Ruel, see Cassatt to Louisine Havemeyer, Dec. 4, [1913], in Mathews 1984, pp. 311–12. For the Degas portrait, see Cassatt to Paul Durand-Ruel, [c. 1913], in Ottawa 1988, p. 442. For the ownership history of the portrait after it left Cassatt's possession, see Checklist, cat. 91.

82. See Paris, Galerie Manzi-Joyant, *Catalogue des tableaux, pastels . . . de la collection*

Roger Marx, sale cat. (May 11–12, 1914). For the bid, see Weitzenhoffer 1986, pp. 217-18. For the two Mother-and-Child images, see New York 1993, nos. 63, 65, pp. 301–302.

83. On Louisine Havemeyer's support of woman suffrage, see Weitzenhoffer 1986, pp. 205–207, 212, 220–23, 227–29, 232–36, 238, 242. On the exhibition, see New York 1993, pp. 89–95; and Lifetime Exhibition History (New York 1915a). Apparently Havemeyer switched the show's location from Durand-Ruel to Knoedler's when she expanded it to include Old Master paintings. In April 1912, Knoedler's had sponsored another exhibition in support of woman suffrage, "Paintings by El Greco and Goya."

84. "Go home . . .": Cassatt, quoted by Louisine Havemeyer, "The Waking Up of Women," unpub. mss., c. 1923/24, in Weitzenhoffer 1986, pp. 220, 268, n. 10.
For Cassatt's reluctance to exhibit *Lady at the Tea Table* and Havemeyer's urging of her to do so, see Louisine Havemeyer, "Remarks on Edgar Degas and Mary Cassatt," unpub. mss., 1915, in ibid., pp. 220, 268, n. 9.

85. On Cassatt's belief that her work would hold its own when juxtaposed with Degas's, see Cassatt to Louisine Havemeyer, Mar. 12, [1915], in Mathews 1984, p. 322.
"It is 'piquant' . . .": Cassatt to Louisine Havemeyer, Feb. 15, 1914, NGA.

86. Havemeyer 1993, p. 278.

87. Cassatt to Louisine Havemeyer, Feb. 1, 1915, in Mathews 1984, pp. 319–20.

88. See *New York Sun* 1915; and *New York World* 1915.

89. "Its home ought . . .": Cassatt to Louisine Havemeyer, Feb. 14, 1915, NGA.

90. The work Stillman donated to the Petit Palais, Paris, is Breeskin 1970, 580.
"Did I write . . .": Cassatt to Louisine Havemeyer, Aug. 24, [1918], NGA.
Cassatt's opinion of Sargent's work was less than favorable. Speaking to George Biddle of the portrait Sargent made of her brother Alexander (Railroad Museum of Pennsylvania), Cassatt asked, "And did you know the price he charged? And did you notice the way he smudged in the background? . . . I call it dishonesty. I told Alec he ought not to allow that thing in his house"; Biddle 1926, p. 108.

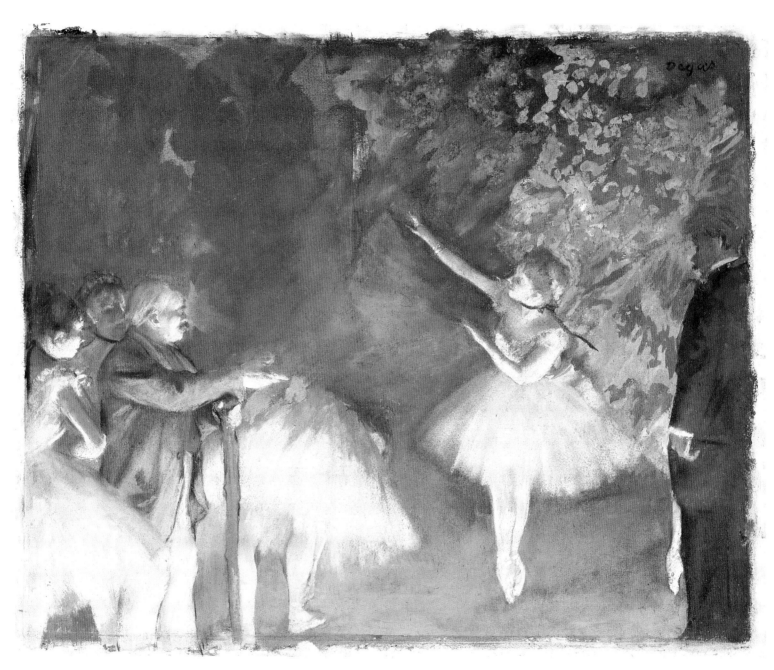

Fig. 1. Edgar Degas (French; 1834–1917). *Rehearsal of the Ballet*, c. 1876. Gouache and pastel over monotype on paper; 55.2 x 68 cm. Kansas City, Nelson-Atkins Museum of Art, purchased with the Kenneth A. and Helen F. Spencer Foundation Acquisition Fund.

Helping "Fine Things Across the Atlantic":
Mary Cassatt and Art Collecting in the United States

Erica E. Hirshler

In a letter to the Boston collector Frank Gair Mac-omber in 1909, Mary Cassatt revealed that "it has been one of the chief pleasures of my life to help fine things across the Atlantic." At Cassatt's suggestion, Macomber had just bought Edouard Manet's *Execution of Emperor Maximilian* (fig. 2); she had told him that it was "one of the most romantic pictures she had ever seen." Macomber was but one of the many North American art collectors to find in Cassatt an able advisor and an enthusiastic catalyst. Beginning in 1877, when she suggested that her friend Louisine Elder (later Havemeyer) purchase a work by Edgar Degas, Cassatt worked tirelessly to place the finest examples of European art, by masters both old and new, in American collections. She counseled family and friends, offered advice to dealers, and made new acquaintances through her passion for collecting. As the Parisian dealer Ambroise Vollard recalled of her work on behalf of the Impressionists, "It was with a sort of frenzy that generous Mary Cassatt laboured for the success of her comrades."[1]

While Cassatt's activity as an art advisor can be traced back to the second half of the 1870s, most of her efforts in this capacity took place between 1895 and 1914. These years coincided with the height of her artistic reputation in North America, as well as with the diminution of her own production after about 1905. Creating less and less of her own work, Cassatt made use of her position as "the most eminent of all living American women painters"[2] to shape another artistic legacy, one that was tied to a new development in American culture: collecting art had become an upper-class passion.

By the end of the nineteenth century, wealthy Americans had created their own patrician class. Its members believed that the acquisition and possession of fine manners and material goods made them almost equal to Europe's nobility. This accomplishment was often reinforced by the marriage of their wealthy daughters to impoverished aristocrats, a pro-

cess Edith Wharton described in her unfinished novel *The Buccaneers*. One aspect of this preoccupation with wealth and status was the transformation of fine-art collecting (once the domain of devoted connoisseurs) into a competitive pursuit. Since the foremost families of England and France had art collections, Americans would have them too, and they would buy what they could not inherit. This acquisitive goal was part of another aspect of life in the United States that developed in the 1890s, the culture of consumption, which demanded the continual accumulation of goods. Merchant John Wanamaker, whose Philadelphia department store included an art gallery, explained that the American dream was to "reach the Land of Desire."[3] With the fabulous amounts of capital amassed in their booming and largely unregulated enterprises, American businessmen and their wives began to buy art in unprecedented quantities, both for their palatial homes and for the new public museums that they were helping to create.

In 1889 the New Yorker Alfred Trumble, recognizing this new trend, began to publish a newsletter entitled *The Collector*, which provided current information on exhibitions and sales both in Europe and the United States. Two years later, he reported that "the promotion of the works of the modern French naturalists and impressionists is to go on more vigorously than ever."[4] Cassatt was to play a major role in this effort, encouraging such members of her native land's economic elite as her brother Alexander, president of the Pennsylvania Railroad; Louisine Elder and Henry O. Havemeyer, whose fortune came from sugar; Sarah Choate Sears and Bertha Honoré Palmer, whose husbands made vast profits in real estate; Harris Whittemore and Alfred Atmore Pope, who between them controlled a large portion of the malleable iron industry; and James Stillman, president of the National City Bank, New York.

Cassatt's determination to place fine paintings in North American collections was rooted in her expe-

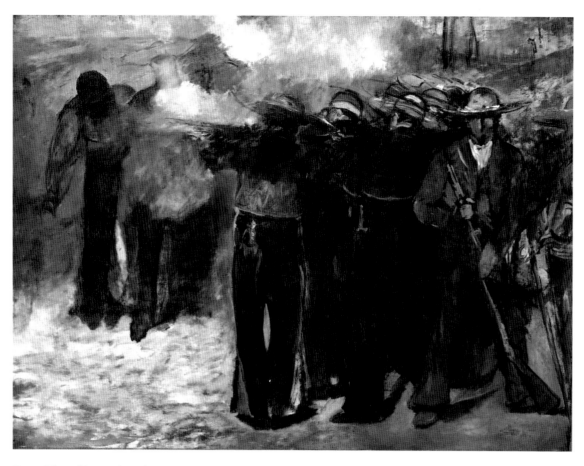

Fig. 2. Edouard Manet (French; 1832–1883). *Execution of Emperor Maximilian*, 1867. Oil on canvas; 196 x 259.8 cm. Boston, Museum of Fine Arts, gift of Mr. and Mrs. Frank Gair Macomber.

rience in the United States as a young art student, when she longed for such works to study. Like most aspiring artists, she considered the careful examination of Old Master paintings essential. By analyzing them completely, which most often involved copying, a young painter or sculptor could learn about technique, composition, and design. "I cannot tell you what I suffer for the want of seeing a good picture," Cassatt complained from Hollidaysburg, Pennsylvania, to her friend Emily Sartain in June 1871.[5] Cassatt clearly felt deprived and, by November of that year, she had fled to Italy. There she immediately began to copy the art of Correggio at the Church of S. Giovanni Evangelista in Parma (see Walker, pp. 24–30). She never forgot her frustration at the lack of appropriate models in the United States from which to study, a situation she sought to rectify through her later efforts as an art advisor.

Sending masterpieces from Europe to North America would benefit many more citizens than aspiring artists. The notion that art had the power to educate everyone was commonly held in late nineteenth-century America; it spurred the establishment of public museums and art societies ranging from The Metropolitan Museum of Art in New York to Boston's Saturday Evening Girls, each organization in its own way attempting to improve public intelligence and morals. As Joseph Choate, one of the founders of the Metropolitan Museum, declared in 1880, art "in its higher forms of beauty would tend directly to humanize, to educate, and refine a practical and laborious people." An expatriate in address only, Cassatt cared passionately about the arts in the United States. She believed in the power of art to inform, uplift, and inspire; she saw it as her duty to assist her country in obtaining the fine objects that could provide such opportunities. She explicated her agenda in 1905 in a letter to her friend and fellow American painter Carroll Tyson, shortly after the French government had named her *chevalier* of the Légion d'honneur. While she generally scorned awards and prizes, she confessed that, in this case, "it was very gratifying. . . . Perhaps it will help me to a little influence with Museum directors at home, to get them to acquire genuine old Masters and *educational* ones."[6]

Cassatt had a perspicacious eye, and her desire to enrich her native land's art collections was not limited to examples by Old Masters; she also wished to see them include the finest contemporary art. Louisine Havemeyer recalled Cassatt's fervor: "[She] suddenly looked up from her coffee, and holding the little spoon in her hand, she made a convincing gesture

and said emphatically: 'To make a great collection it is necessary to have the modern note in it, and to be a great painter, you must be classic as well as modern.'" Along with the adventurous French dealer Paul Durand-Ruel, Cassatt became one of the leading advocates for the exportation of Impressionism to the United States. Her unquestionable social stature enhanced her position, for, unlike Durand-Ruel, whose clearly commercial interests were sometimes noted in the North American press, Cassatt had no need to gain financially from championing her French colleagues. In fact she lent an air of respectability to a group of painters that at least one American art critic had described as "mad outlaws." In effect her recommendation made radical art respectable. The financiers, corporate and society leaders, and philanthropists who shared her passion for collecting also shared her cultural station; they too enhanced the reputations of the artists whose works they so avidly sought. "What we want," remarked critic and philosopher Herbert Croly, "is art with associations and a background."[7]

Cassatt's interest in the advancement of art in the United States also manifested itself in the care she

took to meet aspiring artists who arrived in Europe from North America. She lectured at the Art League in Paris, an association for American art students, and even agreed to be named the group's honorary president. She was friendly with several younger American women painters, among them May Alcott, Grace Gassette, Rose Lamb, and Anna Louise Thorne, as well as with a number of artists and art students from Philadelphia, including George Biddle and Tyson. Biddle later recalled many visits with Cassatt when he was studying in Paris, tea parties that turned into heated discussions about contemporary art, during which he found it "extraordinary that a woman of such social rigidity could have preserved such white-hot passion for her art."[8] Cassatt's passion was made manifest by the art she collected for herself, objects that provided a visual lesson for the painters and patrons who made their way to her Paris apartment or to her country estate.

Cassatt's personal collection was admired as early as 1876, when May Alcott (a painter and sister of the author Louisa May Alcott) described her apartment and mentioned the "fine pictures . . . [in] splendid frames," although she did not identify them. Cassatt bought more paintings in 1878, when the fabric merchant Ernest Hoschedé declared bankruptcy and was forced to sell his impressive Impressionist collection at auction. Cassatt purchased two canvases, one by Berthe Morisot entitled *Toilette*, for which she paid just ninety-five francs, and Claude Monet's *Beach at Trouville*, which sold for two hundred francs. She gave the Monet to her parents (at her recommendation, they later traded it for the artist's *Green Wave*), and kept the Morisot for herself.[9]

In the 1880s, Cassatt bought several other paintings by her Impressionist colleagues and by artists whom they especially admired. She owned works by Gustave Courbet and Manet, painters outside of the Impressionist circle but much revered within it. Cassatt considered Courbet to be "one of the greatest of the 19th century French artists," and she owned five of his paintings. Her first purchase, from the elegant Galerie Georges Petit in February 1878, was *Laundresses at Low Tide, Etretat* (fig. 3). A spare seascape enlivened by tiny figures of washerwomen on the beach, the painting was the sort of image the Impression-

Fig. 3. Gustave Courbet (French; 1819–1877). *Laundresses at Low Tide, Etretat*, 1866/69. Oil on canvas; 54.2 x 65.5 cm. Williamstown, Mass., Sterling and Francine Clark Art Institute.

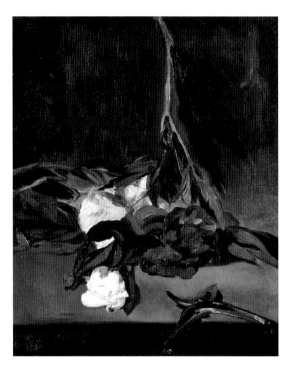

Fig. 4. Edouard Manet. *Peonies and Pruning Shears*, 1864. Oil on canvas; 56.8 x 46.2 cm. Paris, Musée d'Orsay. © Photo RMN—Hervé Lewandowski, R.F. 1996.

ists, particularly Monet, found inspiring; Cassatt may have enjoyed the resonance between this Courbet canvas and the Monet beach scene she bought a few months later at the Hoschedé sale. She acquired a second Courbet landscape, *The Black Rocks* (Buenos Aires, private collection), perhaps during the 1880s. In December 1881, Cassatt attended the exhibition preceding Courbet's estate sale at the Théâtre de la Gaîté in Paris, with her friend Louisine Elder. Elder, and her future husband, H. O. Havemeyer, would become among the most important American patrons of Courbet's work. As Louisine later recalled, "Mr. Havemeyer and I collected over thirty Courbets and our good fortune as usual was due to Miss Cassatt . . . who took me to see that exhibition in the foyer of the Gaîté in Paris, and said to me: 'Someday *you* must have a Courbet.'" During the 1890s, Cassatt's interest in Courbet's figure paintings increased. In addition to encouraging the Havemeyers to collect the artist's portraits, by 1903 she owned his coy, rococo figure study *Woman with a Cat* (Worcester Art Museum). In 1910 and 1911, Cassatt purchased two portraits for herself, *The Mayor of Ornans* (Urbain Cuénot)

and *Female Portrait* (*Madame Frond*) (both Philadelphia, Pennsylvania Academy of the Fine Arts).[10]

Cassatt regarded Manet's work especially highly and began recommending it to collectors as early as 1881. After Manet's memorial exhibition at the Ecole des beaux-arts, Paris, in 1884, Cassatt bought one of the artist's most beautiful still-life arrangements, *Peonies and Pruning Shears* (fig. 4), a painting she kept until 1903. She consistently sought out Manets for the Americans she advised; many of them, including Alexander Cassatt, the Havemeyers, Frank Macomber, the Palmers, the Popes, Sarah Sears, and the Whittemores, had at least one work by him in their collections. She made her dedication to bringing Manet's art to the United States abundantly clear in 1889, when, almost alone among her colleagues, she did not contribute to Monet's subscription campaign to purchase Manet's famous *Olympia* (Paris, Musée d'Orsay) for France. "As for Miss Cassatt," Monet reported to the poet Stéphane Mallarmé, "she has refused. I do not know what influenced her." Cassatt revealed her reasons to Camille Pissarro: "I declined to contribute. M. Eugène Manet told me that an American had wished to buy the picture & it was to prevent its leaving France that the subscription was opened. I wish it had gone to America. . . ."[11]

Cassatt also collected paintings by the other members of the Impressionist group. She did not have a particularly close friendship with Monet, but she bought his work at her earliest opportunity and advised her friends to do likewise. According to Monet's account books and Gustave Caillebotte's correspondence, Cassatt purchased a painting entitled *Springtime* in May 1879 for 300 francs. This may be the same picture she lent to the Monet-Rodin exhibition at Galerie Georges Petit in 1889 with the title *La Liseuse* (fig. 5). Like the canvas by Morisot she had purchased earlier, this depiction by Monet of his wife reading out-of-doors is an image of domesticity and femininity, a subject that clearly had special resonance for Cassatt. Her interest in this composition likely was more than thematic, however, for she must also have admired the picture for its artistic style, its new way of representing reality. She must have felt that it could provide a new visual standard for art in the United States, for in 1903 she was persuaded to sell

Fig. 6. Camille Pissarro (French; 1830–1903). *Cabbage Gatherers*, 1878/79. Gouache on silk; 16.5 x 52.1 cm. Private collection. Photo: courtesy Sotheby's, London.

it to the Baltimore collector Henry Walters, who visited her in Paris with his agent George Lucas. As Cassatt expected, Walters's collection would come to benefit the American public in the form of the Walters Art Gallery in Baltimore, founded in 1931. "All the pictures privately bought by rich Americans will eventually find their way into public collections and [will] enrich the nation and the national taste," Cassatt confidently predicted in a 1911 interview.[12]

Cassatt was not averse to profiting from her good judgment. The art of Monet was a sound investment, as Cassatt reported to her brother Alexander in 1883.

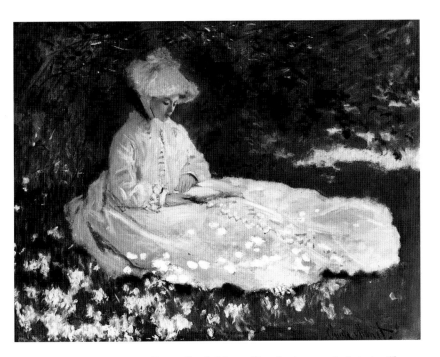

Fig. 5. Claude Monet (French; 1840–1926). *Springtime* (formerly *La Liseuse*), c. 1872. Oil on canvas; 50 x 65 cm. Baltimore, Walters Art Gallery.

She advised him to "hold on to your Monets," adding, "I am only sorry I did not urge you to buy more." Three years later, Cassatt once again expressed regret for not "lay[ing] in more [Monets] when they were at our price." By this time, many of Monet's paintings were being purchased for exceptionally high amounts by Cassatt's American compatriots. None of the Impressionists felt this more keenly than Pissarro, whose financial situation was always precarious. In an 1891 letter to his son Lucien, he complained that "people want nothing but Monets, apparently he can't paint enough pictures to meet the demand. Worst of all they all want *Sheaves [Grainstacks] in the Setting Sun!* always the same story, everything he does goes to America." Cassatt did her best to alleviate her friend's situation. "Before leaving Paris I went to see Miss Cassatt," Pissarro reported. "We had a long talk about the problem of selling pictures. . . . She will use all the influence she has to push our paintings and prints in New York . . . I hope [she] will get something of mine sold."[13]

Cassatt had been recommending Pissarro's work to North American collectors since about 1877, and she took her own advice. She possessed a number of his paintings, among them *Gardens at the Hermitage, Pontoise*; *Peasant Woman and Her Goat, Route d'Ennery*; and *Woman with a Green Scarf*. She also owned the gouaches *Mayenne Village*, *Potato Gatherers*, and *Working in the Fields*; two fans, *Cabbage Gatherers* (fig. 6) and *Harvesting Peas*; and three small, decorative tiles, including *Outskirts of Pontoise* and *Peasants Resting, Montfoucault*. Cassatt sold *Cabbage Gatherers* to Louisine Elder in about 1879 and bought an oil for her brother in 1881; he eventually owned four works by the artist. However, despite her per-

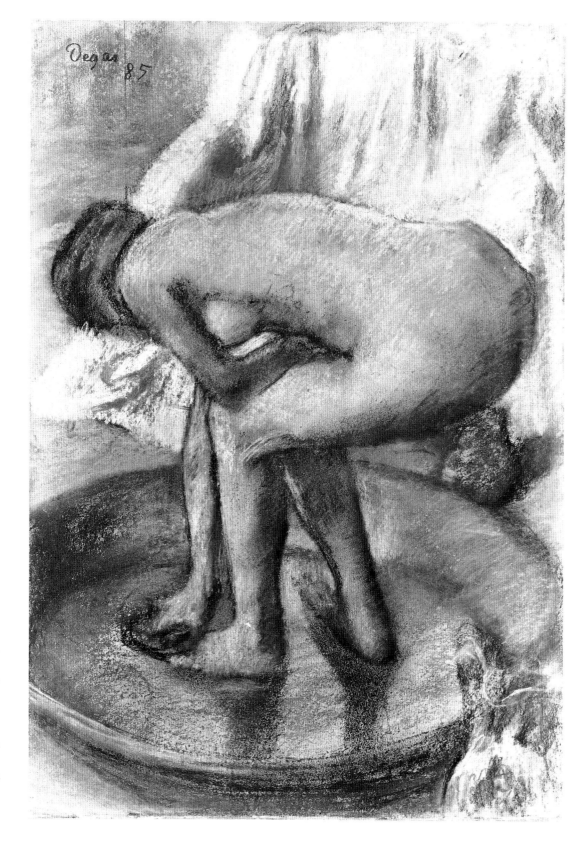

Fig. 7. Edgar Degas. *Woman Bathing in a Shallow Tub*, 1885. Charcoal and pastel on light-green wove paper, now discolored to warm gray, adhered to silk bolting; 81.3 x 56.2 cm. New York, The Metropolitan Museum of Art, H. O. Havemeyer Collection, bequest of Mrs. H. O. Havemeyer, 1929, 29.100.41.

sonal convictions and her friendship with Pissarro, Cassatt was not very successful in convincing her American friends to buy his paintings. After Louisine's early purchase, the Havemeyers acquired just five Pissarros (only one of these before the artist's death in 1903); this contrasts dramatically with their forty-one works by Courbet and thirty by Monet.[14]

Cassatt had much better luck promoting the work of another close friend, Edgar Degas. Cassatt remembered the moment that she saw her first Degas as the occasion when she realized paintings could be made in a fashion that coincided with her own artistic desires, and she remained a staunch supporter of the artist throughout her life. She advised all of her

collector friends to purchase Degas's work, and every one of them (save for Stillman) followed her recommendations. "I was about sixteen years old when I first heard of Degas, of course through Miss Cassatt," recalled Louisine Havemeyer. With the 500 francs she assembled from her own allowance and those of her sisters, she bought a Degas (fig. 1) in 1877, the same year that Cassatt met the French painter and even before Cassatt had been able to acquire a work for herself. Eventually the Havemeyers would top the list of Cassatt's Degas collectors, with sixty-five paintings and pastels to their credit.[15] Not long after her friend's first purchase, Cassatt began to assemble her own small collection of Degas's paintings and pastels.

It is difficult to reconstruct the exact order of Cassatt's Degas acquisitions, but her earliest seems to have been an ethereal fan with an image of ballet dancers (Barter, fig. 22). Degas's fan had been included in the fourth Impressionist exhibition, in 1879, the first show in which Cassatt participated, most likely displaying her pastel *At the Theater* (see Shackelford fig. 3). Featuring a fully open, flat, and frontal fan decorated with strokes of gold paint, this composition seems to share Degas's fascination with fans, to acknowledge his technique (he also used metallic paints), and to address his proposal to dedicate a room to fans in the fourth exhibition. Degas acquired Cassatt's *At the Theater*, and she secured his fan; it seems probable that the two painters made an exchange. Cassatt later described her fan as "the most beautiful one that Degas painted," and she included it in the background of her 1879/80 *Portrait of Madame J.* (cat. 16).[16] She kept it until January 1913, when—no doubt inspired by the record figure paid for a painting by Degas the month before at the Rouart auction—she consigned it to the Durand-Ruels for sale at a very high price. The dealers were unable to find a purchaser willing to pay the 25,000 francs she demanded. In June they returned the fan to Cassatt, who realized that her estimate had been overly optimistic. She kept it until December 1917 when, depressed over Degas's recent death, the state of her own health, and the progress of World War I, she offered it to Louisine Havemeyer, along with two other works by Degas. As Cassatt wrote, "I told Sat [Gardner Cassatt, her nephew] to offer you my Degas

if I die before I can see you. . . . No one in the family can understand them or would care in the least for them." Havemeyer bought the group for $20,000 and received them in 1919, after the end of the war.[17]

One canvas by Degas that Cassatt sold before 1919 was a painting she had for many years, the portrait Degas had made of her in the early 1880s (cat. 91), one of a number of depictions he made of friends in their own rooms. Cassatt had posed for Degas several times (see Shackelford, figs. 1, 11, 22, 23), but this is among the few images in which her features are clearly recognizable. It may have been a private joke between the two artists that Degas did not show Cassatt as a painter. Instead she sits forward in her chair and displays three *carte-de-visite* photographs (perhaps hers); she poses holding likenesses while Degas captured her own. Late in life, Cassatt expressed displeasure with this portrait. In 1912, when she was sixty-eight years old, she wrote, "I do not want to leave it with my family as being a picture of me. It has some qualities of art, but it is so painful and represents me as such a repugnant person, that I would not want it known that I posed for it." She may have been responding to her frustration in relating to the increasingly irascible Degas, to the social impropriety of her pose, or worse, to the possibility of being mistaken for a common fortune-teller with a handful of cards. Or she may simply have been expressing the embarrassment of an older woman for her younger self. In any case, she consigned it to Durand-Ruel and hoped that it would be sold, without her name attached to it, preferably to a non-American collector. Ambroise Vollard bought it in 1913 and sold it in 1918 as "Etude de femme" to a collector in Denmark. Before Cassatt's death, it entered the renowned collection of the Japanese connoisseur Kojiro Matsukata, where it remained until 1951.[18]

Of the other two works by Degas that Havemeyer bought from Cassatt's collection, Cassatt had been especially fond of her pastel *Woman Bathing in a Shallow Tub* (fig. 7). "Degas's art is for the very few," she wrote to Havemeyer. "I cannot believe that many would care for the nude I have. Those things are for painters and connoisseurs." Cassatt, who was both, had received the pastel from Degas in 1886 in exchange for her own oil on canvas *Study* (cat. 48). The

two pictures had been included in the eighth Impressionist exhibition, in 1886, where Degas's nudes provoked considerable criticism. It is unknown whether or not Cassatt selected *Woman Bathing in a Shallow Tub* from the group of about eight pastel nudes that Degas had displayed or whether Degas chose it for her, but the composition incorporates one of the most ungainly poses in the series. "[Degas] wanted to paint a woman as one would see her, hidden by a curtain, or through a keyhole," wrote the critic Gustave Geffroy in *La Justice*. "Thus he succeeds in seeing her . . . standing, head lowered, and her rump sticking out . . . and he has hidden none of her frog-like aspects." Cassatt may have admired this pastel for its very awkwardness. Academic artists of the day most often depicted the female nude in a sweetened context of mythology or romance, of smooth brush strokes and sensual curves, while Degas's subject is clearly contemporary, realistic, and devoid of sentimentality, the surface roughly worked and sketchlike.[19]

All of the American women Cassatt advised had

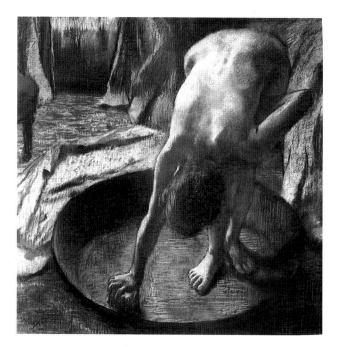

Fig. 9. Edgar Degas. *The Tub*, 1885–86. Pastel on paper; 69.9 x 69.9 cm. Farmington, Conn., Hill-Stead Museum.

doubtless seen Cassatt's bather in her Paris apartment and all of them owned Degas nudes. *Woman Bathing in a Shallow Tub* was one of several in Louisine Havemeyer's collection. Only *The Bath* (New York, The Metropolitan Museum of Art) was purchased before 1900; the Havemeyers bought this small pastel, dating from the years 1890/94, from Durand-Ruel in 1895, just as they began to acquire modern French art in quantity. But with Cassatt's encouragement, their collection of nudes would grow to seven. Boston's Sarah Sears acquired three nudes, *The Washbasin, After the Bath* (fig. 8), and an unidentified pastel of a nude woman reading on a couch. Connecticut architect Theodate Pope owned *The Tub* (fig. 9); it was one of the last objects Alfred Atmore Pope had purchased and one his daughter chose to keep when she refined his collection upon inheriting it. And Bertha Palmer purchased the large pastel *The Morning Bath* (fig. 10), which she bought in Paris for 5,000 francs in June 1896, just six months after Durand-Ruel had purchased it from the artist. These expand historian Richard Kendall's list of women who owned nudes by Degas, and strengthen his assertion that the artist's handling of this subject was less offensive to them than has previously been supposed.[20] In the United

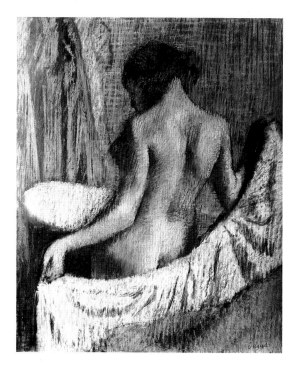

Fig. 8. Edgar Degas. *After the Bath*, c. 1893/97. Pastel on brown cardboard; 70 x 57.2 cm. Cambridge, Fogg Art Museum, gift of Mrs. J. Montgomery Sears, 1927.23.

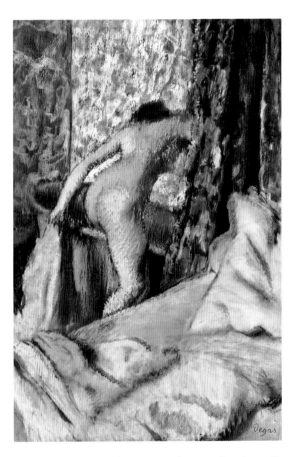

Fig. 10. Edgar Degas. *The Morning Bath*, c. 1895. Pastel on off-white laid paper mounted on board; 66.8 x 45 cm. The Art Institute of Chicago, Potter Palmer Collection, 1922.422.

States at least, the fact that Cassatt owned one endorsed them; if they were appropriate for a woman highly regarded in Philadelphia's social circles, they certainly were acceptable elsewhere. It is doubtful that any of these women, Cassatt included, viewed these pictures with the prurient eye of a Parisian critic, a number of whom saw in them only prostitutes and hard-worked flesh. It is far more likely that these female collectors identified with the intimate moments common to every woman and admired Degas's artistry in capturing them.

Degas's *Woman Bathing in a Shallow Tub* stands in marked contrast to another nude bather in Cassatt's collection, Simon Vouet's *Toilet of Venus* (see Barter, fig. 68). Cassatt bought the Vouet in Paris around 1905; it is one of the few Old Master pictures she owned. She installed it at Beaufresne, her country home, thus echoing the painting's original purpose as part of a suite of decorations for the marquis d'Ef-

fiat's gallery at the Château de Chilly. Yet while Cassatt may have appreciated the aristocratic pedigree of the Vouet (its former owners included Madame du Barry), it is unlikely that this alone would have inspired her purchase.[21] It was the painting's formal qualities—the Mannerist flattening of space and the expansion of the subject by the reflection in the mirror—that no doubt intrigued her; both were devices Cassatt explored in her own work (see cats. 65, 89–90 and Barter, pp. 97–99).

These characteristics were also evident in the Japanese prints Cassatt bought, which included several images of women with mirrors (see Barter, fig. 45). Cassatt especially admired the prints of Kitagawa Utamaro, particularly images of women engaged in domestic pursuits, often with children. She owned over twenty Japanese prints and seems to have favored, as did many of her colleagues, the faded, softened color schemes of woodcuts that had been exposed to light. These prints were held to be the most authentic: the bright colors of well-preserved examples were often, perhaps naively, mistaken for modern forgeries. Cassatt mounted her Japanese prints on gilt mats and kept many of them at Beaufresne, where she displayed them in closely hung groups in the glass gallery that overlooked her garden (see fig. 11). In addition to fashionable woodcuts by Ikeda Eisen, Torii Kiyonaga, and Utamaro, Cassatt owned several landscapes by Utagawa Hiroshige and Katsushika Hokusai; genre scenes by Yashima Gakutei, Iwakubo Hokkei, and Katsukawa Shunjo; a still life by Sakai Hoitsu; and prints by several other artists. Many of these were multisheet images. Cassatt had probably bought her first Japanese print well before Siegfried Bing's famous 1890 exhibition (see Barter, p. 82), as had most of her Impressionist colleagues. She had ample opportunity in Paris to collect the prints. She was still acquiring them after the turn of the century, when she purchased at least one print, an elegant outdoor image of women by Kiyonaga, at the important sale of the dealer Tadamasa Hayashi's collection in 1902 (see fig. 12).[22]

As she did with all of the objects she most admired, Cassatt encouraged her friends to collect Japanese prints, mostly during the 1890s. There were as many North Americans buying Japanese prints in

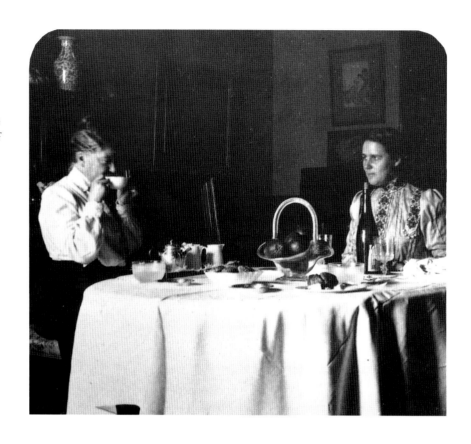

Fig. 11. Photograph of Mary Cassatt at her home in Beaufresne, with one of her Japanese woodblock prints seen on the wall behind her. Photo: courtesy Hill-Stead Museum, Farmington, Conn.

Fig. 12. Torii Kiyonaga (Japanese; 1752–1815). *A View of Cherry Blossoms on the Bank of the Sumida: A Pentaptych* (detail), 1792. Woodblock on paper; 38.1 x 24.4 cm. Boston, Museum of Fine Arts, Nellie P. Carter Collection. Cassatt owned a variant of this print.

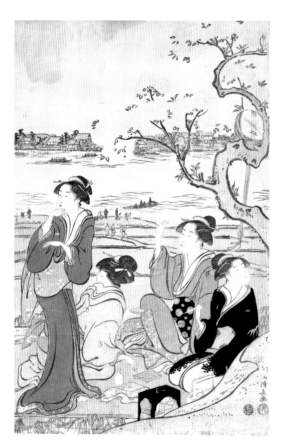

Paris as Impressionist paintings, as Edmond de Goncourt noted sourly in his journal:

> Dinner of Japanese enthusiasts at Véfour's. [The dealer Siegfried] Bing talks today of the craze for Japanese prints among various American amateurs. He tells of selling a little packet of such prints for 30,000 francs to the wife of one of the richest Yankees, who in her small drawing room has an Utamaro facing the most beautiful Gainsborough in existence. And we admit to each other that the Americans, who are in the process of acquiring taste, will, when they have acquired it, leave no art object for sale in Europe but will buy up everything.[23]

Bing's collector remains unidentified and may be apocryphal, but the Havemeyers did acquire Japanese prints (over eight hundred of them), as did many of the collectors with whom Cassatt was associated.

Cassatt's personal collection not only reflected her own preferences, but also served as a model for the American collectors she cultivated. Each of the categories of objects she admired and assembled—French Impressionists, Old Master paintings, Japanese prints—found its way into the homes of her North American associates, alongside paintings by

Cassatt herself. The main distinction between Cassatt's collection and the ones she helped to form is not one of artistic taste, but of financial resources. While Alexander Cassatt amassed a fortune estimated by some accounts to have been fifty million dollars, twice as much as even the Havemeyers accumulated, there is no evidence that he subsidized his sister, who was irritated when people assumed that he did. She was very proud of her independence and profession. To Havemeyer she wrote, "Oh the dignity of work, give me the chance of earning my own living, five francs a day and self respect."[24] She may not have felt the need to acquire for herself the expensive paintings she encouraged others to buy—she believed they would do far more good in the United States.

Among Cassatt's earliest recommendations were those she made to her family. In 1879 she wrote to Berthe Morisot that her father, Robert S. Cassatt, was planning to buy a Monet, and the first collector she advised repeatedly was her brother Alexander, whose holdings soon included paintings by his sister's favorite artists, Degas, Manet, Monet, and Pissarro. By 1880, when he began to purchase art on a regular basis, Alexander Cassatt (see cats. 32, 46) had established himself as a leading manager of the Pennsylvania Railroad, a corporation he had first joined as a civil engineer during the Civil War. That year Cassatt was promoted from third vice-president in charge of transportation and traffic to first vice-president; in 1882 he retired at age forty-two, but he retained a directorship and returned to the company in 1899 to serve as its president. His earliest art purchases reflect his recreational interests.[25]

By April 1881, Cassatt had bought for her brother a work by Pissarro (unidentified) and Monet's 1872 *Banks of the Zaan* (Switzerland, private collection), the latter described by their father as "a beauty." This harbor scene was the first of nine Monets Alexander Cassatt would own, six of them with boating themes, one of his chief pleasures. His business concerns were later represented by another canvas, the 1875 *Train in the Snow at Argenteuil* (New York, Richard Feigen Gallery), one of several paintings that Monet had given to Mary Cassatt to sell. Monet, whose substantial sales in the North American market had

allowed him to enjoy a prosperous life, stopped expressing concern that so many of his paintings went to the "land of the Yankees."[26] Collectors such as Alexander Cassatt encouraged further sales to Americans, for his Philadelphia colleagues trusted his aesthetic judgment and business acumen; he was not likely to pay too much for a painting that might plummet in value. Several of Alexander Cassatt's peers acquired canvases by Monet, among them Frank Thomson, who worked with Cassatt at the Pennsylvania Railroad. Mary Cassatt purchased Monet's 1871 *Argenteuil, The Bridge Under Repair* (private collection), a railway image, for Thomson in July 1884 from Durand-Ruel, and she was still advising him in 1886, encouraging him to look at paintings held by the dealer Alphonse Portier. "I telegraphed to Portier to call on [Mr. Thomson]," she reported to her brother, "as Mr. T. wanted to buy one or two Monets." When Thompson made his purchases at Durand-Ruel instead, Cassatt remarked, "I feel rather snubbed [since] I advised him to buy cheap, but I suppose he is the kind to prefer buying dear. I have very little doubt Portiers [*sic*] were the best pictures."[27]

Alexander Cassatt's interest in horse racing and breeding was a perfect pretext for his sister to introduce him to the work of the modern artist she most admired, Degas. She first wrote to him about Degas's work in 1880, recommending that he familiarize himself with the French painter's style through photographs and noting that she did not feel comfortable buying him art (perhaps especially by Degas) until he had "some idea of what it would be like." Such purchases were not a Cassatt family custom, as the artist confessed: "Mother does not give me much encouragement as 'au fond' I think she believes picture buying to be great extravagance." It may well be that this maternal disapproval was not only related to buying art in general, but also to the particular painting Mary Cassatt had in mind. She wanted to obtain for her brother Degas's large composition *The Steeplechase* (Upperville, Va., Mr. and Mrs. Paul Mellon), which the artist had first exhibited at the 1866 Salon. Although he had displayed the painting in that very public forum, Degas later became dissatisfied with his composition and began to rework it in 1880 and in 1881, probably because Cassatt had expressed

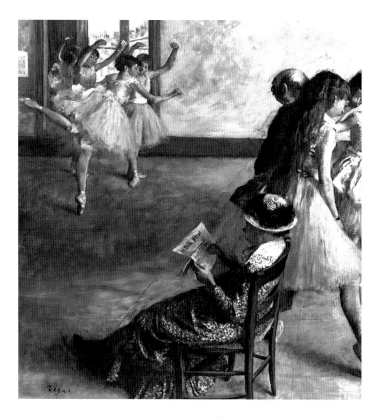

Fig. 13. Edgar Degas. *The Ballet Class*, c. 1880. Oil on canvas; 81.6 x 76.5 cm. Philadelphia Museum of Art, W. P. Wilstach Collection.

an interest in acquiring it. As the Cassatts feared, Degas could not leave it alone; he never finished his modifications, and the painting languished in the artist's studio until his death. Another equestrian subject, of women and children on horseback, was snapped up by a dealer before Cassatt could buy it. Despite these disappointments, the artist persisted. Early in 1881, Robert Cassatt reported to Alexander Cassatt that his sister was still "in hopes of getting a Degas for you one of these days." The first Degas the railroad executive received, in September 1881, was not a horse picture but another composition with which Degas had been struggling, *The Ballet Class* (fig. 13). Only in December 1889 would he acquire a Degas racehorse composition, *The Jockey* (Philadelphia Museum of Art), a pastel of 1888 his sister bought for him through Durand-Ruel for 300 francs.[28]

The Ballet Class had caused the family equal frustration. Cassatt, through her father, sent her brother photographs of three Degas compositions, "two of horses and one of dancers rehearsing on the stage."

Robert Cassatt noted, "I do not know what he will think of the horses but the dancers are wonderful." Alexander Cassatt must have responded favorably to the dancers, for Mary was set to buy this work for him in December 1880. However, as Katherine Cassatt reported to her son, "[Degas] says he must repaint it all." The following April, Degas was still promising to finish it; the work was not complete until June, when the artist, refusing to sell to Cassatt directly, delivered *The Ballet Class* to Durand-Ruel in exchange for 5,000 francs. Cassatt immediately bought it for 6,000 francs from the dealer, "who," Robert Cassatt noted, "lets her have it as a favor and at a less price than he would let it go for to anyone but an artist." Cassatt was not seduced by such reasoning and was, according to her mother, "furious at Degas and not a little provoked at Durand-Ruel." The painting was substantially different than it had been when Mary Cassatt had first admired it; Degas altered the position of the background dancers and changed the foreground figure from a ballerina adjusting her shoe to a woman reading a newspaper. There is no record of Alexander Cassatt's reaction to the changed composition, but his sister always considered it to be "one of Degas's best."[29]

Alexander Cassatt also owned several compositions by Manet. *L'Italienne* (current location unknown), indebted to the art of Camille Corot, and *Portrait of Marguerite de Conflans with Headdress* (Shackelford, fig. 10) may have been the paintings that Mary Cassatt arranged for her brother to buy from the 1884 Manet studio sale, pictures she described as "bargains and . . . very decorative." By 1886 he also owned Manet's *Marine in Holland* (fig. 14), a painting that complemented his *Banks of the Zaan* by Monet. These purchases were intended primarily for Alexander Cassatt's country home, Cheswold, in Haverford, Pennsylvania (fig. 15). The house was built in 1872/73 by the Philadelphia firm of Furness and Evans in its characteristic Victorian Gothic style; the Cassatts remodeled it several times, including an extensive campaign in 1880, while the family was touring Europe. Alexander's wife, Lois, made many purchases for the house during that trip, noting that her "room and the anti-chamber look like a large shop with all the boxes from the Louvre and other shops standing about."

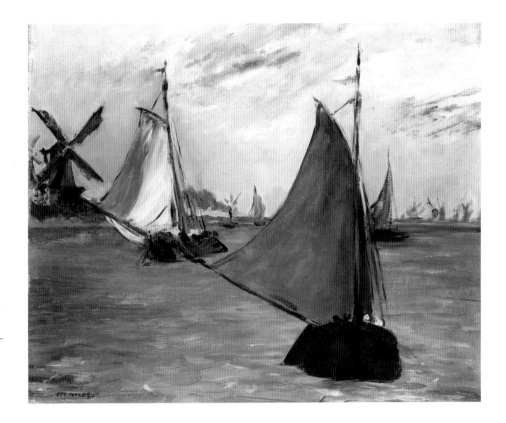

Fig. 14. Edouard Manet. *Marine in Holland*, 1872. Oil on canvas; 50.2 x 60.3 cm. Philadelphia Museum of Art, purchased with the W. P. Wilstach Fund.

Alexander Cassatt's collection—which eventually included several other works by Degas, as well as examples by Morisot, Pissarro, Raffaelli, Renoir, and Whistler—was largely complete by about 1892. While his purchases were meant essentially for his own (and his sister's) pleasure, he did lend them to at least two important American exhibitions, the 1886 Impressionist exhibition organized by the American Art Association in New York, and the international art display at the 1893 World's Columbian Exposition in Chicago.[30]

Robert Cassatt had warned his son in 1881 that "when you get these pictures you will probably be the only person in Philada. who owns specimens of either of the masters. Mame's [Mary's] friends the Elders," he continued, "have a Degas and a Pissarro & Mame thinks that there are no others in America." The Elders were Mathilde Elder, widow of George Elder, a New York businessman whose brother Lawrence was a partner in Frederick Havemeyer's sugar-refining company, and her three daughters, Annie, Louisine, and Adaline. George Elder died in 1873; his widow sought consolation with her children in Paris.

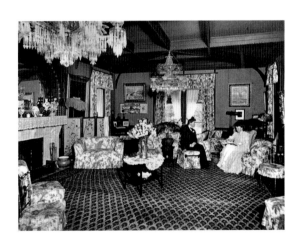

Fig. 15. Photograph of parlor of Alexander Cassatt's house, "Cheswold," Haverford, Penn., c. 1900. Photo: courtesy estate of Mrs. John B. Thayer.

Through their mutual friend Emily Sartain, the Elders were introduced to Cassatt in 1874, and Louisine (fig. 16) later recalled that the thirty-year-old painter "opened her heart to me about art while she showed me the great city of Paris."[31] They renewed their acquaintance during the summer of 1875, and despite an eleven-year age difference, the two women

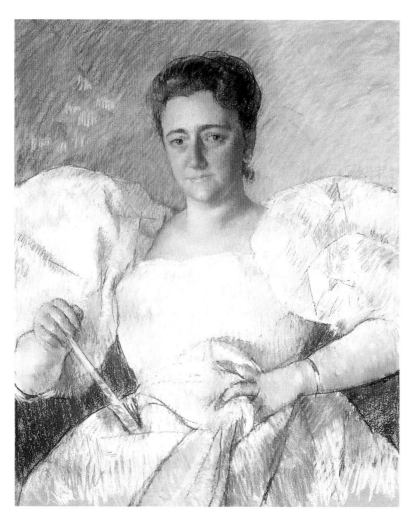

Fig. 16. Mary Cassatt. *Louisine Elder Havemeyer*, c. 1896. Pastel on woven paper; 73.7 x 61 cm. Shelburne, Vermont, Shelburne Museum, gift of J. Watson Webb, Jr., 1973, 27.3.1–1. Photograph by Ken Burris.

would remain devoted friends for almost fifty years.

As noted above, Louisine Elder bought her first work of art with Cassatt's advice in 1877, paying 500 francs for a Degas pastel, *Rehearsal of the Ballet* (fig. 1). This purchase was quickly followed by her acquisition of Monet's *Drawbridge, Amsterdam* (Shelburne, Vt., Shelburne Museum) and Pissarro's *Cabbage Gatherers* (fig. 6), the painted fan that Elder bought from Cassatt herself.[32] The two women went on to create, along with Louisine's husband, H. O. Havemeyer (they married in 1883), one of the late nineteenth century's most magnificent art collections. The Havemeyers owned over five hundred paintings, drawings, and watercolors; while Cassatt was not responsible for all of them, Louisine Havemeyer dubbed her the "godmother" of the collection.[33] Cassatt not only helped to shape the Havemeyers' artistic taste in general, but was also directly involved in the acquisition

of fully one-third of their holdings in all media. She offered her opinions on objects that ultimately did not enter the collection, as well as those that did; and she expanded her advice beyond Western paintings to include Persian pottery, ancient and contemporary glass, medieval sculpture, and Japanese prints.

The Havemeyers' holdings exemplified the kind of art that Mary Cassatt most admired and clearly reflected her tireless enthusiasm for collecting. It was not that the Havemeyers had no will of their own; on the contrary, both Louisine and H. O. Havemeyer had strong opinions about art and made many purchases both without and despite Cassatt's recommendations. These independent acquisitions were hardly undisciplined selections, for they included such masterpieces as their three finest portraits by Rembrandt van Rijn. But a surprising number of the Old Master paintings the Havemeyers bought came with Cassatt's imprimatur, including Paolo Veronese's *Boy with a Greyhound* and El Greco's *Portrait of a Cardinal* (both now in New York, The Metropolitan Museum of Art), among many others. Their modern French collection, without peer in the United States or Europe, benefited greatly from Cassatt's enthusiasm and intimate knowledge of the work. The Havemeyers trusted Cassatt's judgment enough to leave her with funds from which to make purchases for them. Of the artists Cassatt especially admired, the Havemeyers bought extensively, eventually accumulating, as mentioned previously, forty-one works by Courbet, sixty-five by Degas, thirty by Monet, and six by Pissarro, as well as thirteen by Paul Cézanne, twenty-five by Corot, twenty-five by Manet, and seventeen by Cassatt herself. To Cassatt's surprise, Louisine Havemeyer set the world's record price for a painting by a living artist when she bought

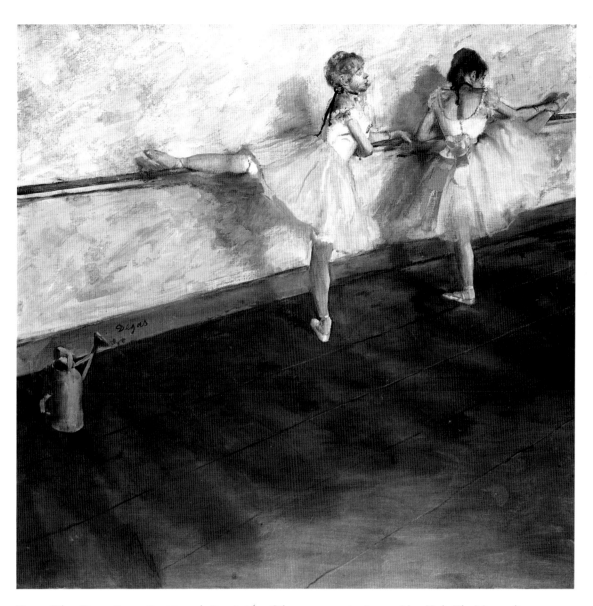

Fig. 17. Edgar Degas. *Dancers Practicing at the Bar*, 1876/77. Oil on canvas; 75.6 x 81.3 cm. New York, The Metropolitan Museum of Art, H. O. Havemeyer Collection, bequest of Mrs. H. O. Havemeyer, 1929, 29.100.38.

Degas's *Dancers Practicing at the Bar* (fig. 17) from the Henri Rouart sale in 1912.[34]

Cassatt's part in the formation of the Havemeyers' collection was not simply a matter of friendship, although the role of affection between these partners should not be understated. But Cassatt shared more than camaraderie with the Havemeyers; she also shared their social class and moral standards. Despite her adventurous artistic associations, Cassatt lived an upper-class life well within the boundaries of social convention. She was described by George Biddle as a "prim Philadelphia spinster . . . [who] would have lived much the same life had she never painted or left Philadelphia." Her ancestors had arrived in North America appropriately early, her family's professions had included business and law, and her father had

invested wisely enough to be able to retire in his early forties and list his occupation as "gentleman." It would seem no accident that Cassatt's closest associate among the Impressionists was Degas, himself the son of a banker with aristocratic pretensions. While Cassatt had traveled alone in Europe as an art student, by 1877 she was properly accompanied by her family and housed in a respectable Parisian neighborhood. She accepted the traditional role of an unmarried woman and cared for her sister and parents when they were ill, "[holding] her duty high before her as a pilgrim would his cross," recalled Louisine Havemeyer. "No sacrifice was too great for her to make for her family."[35] Thus, in every way, she was an appropriate companion and advisor for leading members of society.

Cassatt was also ideally situated, for Paris was the center of the market for all types of art. By necessity collectors who were not fortunate enough to live there had to have a local representative. The ever-increasing numbers of art dealers were only too happy to take on that role, but many collectors preferred the advice of individuals who might have a less direct financial interest in the selection of one object over another. Some American collectors entrusted themselves to agents; Sara Tyson Hallowell for example acted on behalf of the Potter Palmers.[36] Other collectors looked to artists for advice, believing that they could ascertain a painter's aesthetic taste through his or her work and that an artist's connections would put them in a good position to hear about available pictures. William Merritt Chase, William Morris Hunt, John Singer Sargent, and many others served American collectors who were anxious to have their potential purchases evaluated by someone whose artistic judgment they trusted. With the serious scholarly study of art history at its very beginning and the professionalization of the museum curator still many years away, it was the painters who were the experts. With these prerequisites, Cassatt was an ideal artistic consultant.

Cassatt worked with most of the major Paris dealers, mentioning them all frequently in her correspondence. Many of the paintings she encouraged her compatriots to buy, however, came from the gallery of Paul Durand-Ruel. While Durand-Ruel represented several Impressionist artists (including Cassatt herself) and hence necessarily would have had an important role in their sales, it is also clear that he and Cassatt worked closely together to place both modern and Old Master paintings in American collections. In 1891, when both he and Cassatt were disillusioned with Durand-Ruel, Pissarro described to his son the American artist's power over the Parisian dealer: "She has a lot of influence and Durand, who suspects that she is irritated with him, is trying to calm her down with promises and offers which he does not make good." In effect Cassatt's relationship with Durand-Ruel was symbiotic: she needed the gallery to handle logistics—negotiations with sellers, packing and transportation, import licenses, etc.—while the gallery was beholden to her for her impor-

tant connections to potential American customers (see Sharp). It would have been foolish for the gallery not to cultivate the advisor to the Havemeyers, who bought over forty percent of their paintings—from Bronzino to Cézanne—through Durand-Ruel alone. The major market for modern French art was not in France, but in the United States, and Cassatt's connections there were invaluable to the gallery. Any financial benefits Cassatt may have received for her efforts have yet to be determined. As the daughter of a businessman, Cassatt enjoyed playing the market and freely discussed prices for paintings in her correspondence, but she was extremely discreet in mentioning her own finances. In one letter to Louisine Havemeyer, dated 1910, she confided "strictly in confidence" that she had "doubled, more than doubled" her income over the last year, specifying the source as the Durand-Ruels.[37] It remains as yet unknown whether or not the gallery gave her a commission for the sales she encouraged or perhaps arranged more favorable conditions for the sale of her own work.

Despite any problems Cassatt may have had regarding Durand-Ruel's handling of her own sales, the artist and the dealer were particularly well-suited to work together to shape American art collections. While the art market was transformed in the late nineteenth century by dealers who applied a new entrepreneurial, big-business spirit to their undertakings, Paul Durand-Ruel cultivated an anti-commercial image, emphasizing his aesthetic convictions and his desire to serve the greater cause of art. As historian Robert Jensen noted, Durand-Ruel worked to fabricate an identity as "a Medici of contemporary art—for whom commerce was an unfortunate sideline," a characterization the gallery owners fostered in both the European and American press.[38] Alfred Trumble described the gallery's style in *The Collector*:

Mr. Durand-Ruel . . . is ably represented by his sons, to whom has been communicated much of those qualities which in their father make him a conspicuous figure in the world of art. They, like him, regard art with a personal as well as a commercial eye. It is not enough to sell a picture with them, but also to know and love the picture that they sell. . . . Their Gallic education . . . renders it possible for men to be the shrewdest of businessmen without ceasing to be gentlemen.[39]

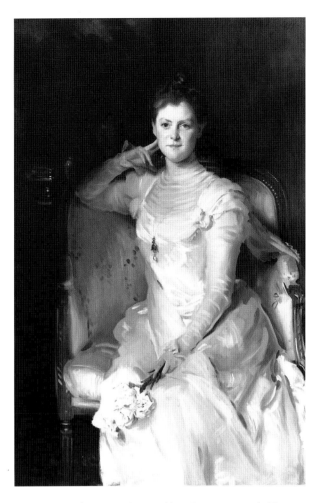

Fig. 18. John Singer Sargent (American; 1856–1925). *Mrs. Joshua Montgomery Sears*, 1899. Oil on canvas; 147.6 x 96.8 cm. Houston, Museum of Fine Arts, purchased with funds provided by George R. Brown in honor of his wife, Alice Pratt Brown.

The Durand-Ruels' carefully promoted gentility coincided neatly with Cassatt's own doctrine, that the purpose of all of these commercial transactions was, at least eventually, civic-minded. Ambroise Vollard noted that Cassatt "had persuaded [Havemeyer] that he could make no better use of his money, since his pictures were to enrich the artistic heritage of the United States."[40] Cassatt's insistence upon this altruistic agenda allowed her to pursue business and commercial activities that may otherwise have been perceived as inappropriate for a woman of her class; with the Durand-Ruels casting themselves in an analogous role, Cassatt's needs were perfectly met.

Because she is the best-known and most-documented collector, who had besides such a large and important group of paintings, Louisine Elder Havemeyer has come to dominate our understanding of Cassatt as an art advisor to North Americans. But she was not the only American woman to become a close friend of Cassatt's, an important collector of art, and a client of Durand-Ruel. Another art-lover, Sarah Choate Sears of Boston (fig. 18), described Cassatt as "one of my greatest friends for years."[41] Sears and her collection are little known today, likely because her holdings were dispersed among many institutions or remained with the family. She neither sought to establish a legacy by founding her own museum, as did her fellow Bostonian Isabella Stewart Gardner, nor, like the Havemeyers, did she donate the bulk of her holdings to a single organization. Nevertheless Sears's accomplishments should not be overlooked.

Sarah Choate Sears was the wife of Joshua Montgomery Sears, Boston's most successful real-estate investor. The couple owned a number of homes, in Boston at 12 Arlington Street, in Southborough, Massachusetts, and in Maine; these she furnished with one of the most adventurous art collections ever formed in Boston. Sears was an artist in her own right, winning awards for her paintings and simultaneously exploring a new artistic medium, photography, during the 1890s. She probably met Cassatt in Paris in 1892 and renewed their acquaintance on subsequent trips abroad and during Cassatt's visit to Boston in 1898. In 1905, following the death of her husband, Sears moved to Paris with her daughter, Helen. They stayed for two years, living in a home Sears purchased at 1 *bis* place de l'Alma and socializing frequently with Cassatt, whose rue Marignan apartment was only a few, short blocks away. In the fall of 1907, Sears and her daughter returned to Boston, but they fled to Paris once again in the fall of 1908, following the death of Sarah Sears's twenty-five-year-old son, Joshua Montgomery Sears, Jr., in an automobile accident. They stayed several months, and then returned to Paris regularly for the next twenty years. In addition to the friends they had in common and their mutual interest in art, Cassatt and Sears also had a more personal tie, for both lost close family members in the early years of the century. Hopeful for knowledge about the afterlife, the two women explored Spiritualism together. Sears hosted biweekly séances at her apartment, led by the well-known medium Madame de Thèbes, which Cassatt often attended. Cassatt's letters frequently mention her interest in the supernatural, a concern she also shared with her friend Theodate Pope.[42]

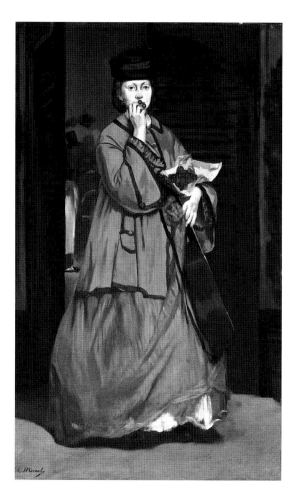

Fig. 19. Edouard Manet. *Street Singer*, 1862. Oil on canvas; 171.3 x 105.8 cm. Boston, Museum of Fine Arts, bequest of Sarah Choate Sears in memory of her husband, Joshua Montgomery Sears.

During her 1908 visit to Paris, Sears attempted to introduce Cassatt to some of the more modern painters she had begun to admire and to collect. They went together to an exhibition of Henri Matisse's work and also to Gertrude Stein's apartment, home to some of the most avant-garde art in the city. Sears later would acquire a still life and three pen drawings by Matisse, would support the 1913 Armory Show in New York by lending a work by Cézanne, and would purchase watercolors by such American modernists as Charles Demuth and John Marin. But she could not convince her friend Cassatt to accept either twentieth-century modernism or the people associated with it. Cassatt's meeting with Stein could best be described as a collision: "I have never in my life seen so many dreadful paintings in

one place; I have never seen so many dreadful people gathered together and I want to be taken home at once," Cassatt complained.[43] Sears, apparently expecting her friend's reaction, had asked her driver to stay at the door.

There were, however, many other painters about whom Cassatt and Sears agreed. Manet was one. In February 1899, Paul Durand-Ruel had offered to the Havemeyers two paintings that Cassatt especially admired: Degas's 1874 *Dancers at Rest* (private collection) and Manet's *Street Singer* (fig. 19). H. O. Havemeyer bought the Degas but refused the Manet, commenting that he found the latter a "superb" painting except for "the great drawback of having the visage obscured by her hand." That "drawback" would not have bothered Cassatt, who had used a similar device in her own composition *Tea* (cat. 27). It likely did not trouble Sears either; she had a modern eye and, as a photographer, a sensitivity to the idea of lending permanence to a fleeting pose. Sears soon bought *Street Singer* from Durand-Ruel for 70,000 francs.[44]

Cassatt was involved with another Sears purchase, one of the two Cézanne still lifes the collector owned. After meeting Cézanne in Giverny in 1894, Cassatt had acquired his *Still Life with Rum Bottle* (c. 1890; Japan, private collection) from Vollard (possibly from his 1895 exhibition of the artist's work). Louisine Havemeyer remembered the painting in Cassatt's drawing room, where it hung with rich Italian and Spanish brocades, a number of works by Degas, and a sculpture then thought to be by Donatello. "How many pictures of ours at one time or another were placed in that salon or in the hall, waiting to be sent to America, or to be seen and passed upon by friends and critics," she recalled.[45] Havemeyer did not describe Cassatt's Cézanne, a medium-sized still life of pears and a bottle resting on a table covered by a white cloth, although she and her husband began to collect Cézanne's paintings around 1901. But someone must have "passed upon" Cassatt's Cézanne for, in November 1904, she wrote to the journalist and collector Théodore Duret, "In response to your letter, I have no intention of selling my Cézanne still life." By 1910, when the market for Cézanne was very high, Cassatt changed her mind and sold the painting for 8,000 francs, noting to a friend that she had

been "one of the first to see merit in his pictures." When *Still Life with Rum Bottle* was included in the January 1910 Cézanne exhibition at Galerie Bernheim-Jeune in Paris, it was lent by Sarah Sears.[46]

Sears eventually owned almost two hundred paintings and works on paper, most of which she doubtless selected herself. She was an active participant in Boston's art community, where she supported such local artists as Dennis Bunker, Maurice Prendergast, and Edmund Tarbell. Her friendship with John Singer Sargent also informed her collection. Like many Bostonians, Sears owned paintings by Monet and Persian pottery, some of which she bought in Paris from the dealer Dikran Kelekian, who often worked with Cassatt. But several more pictures in Sears's collection seem to bear Mary Cassatt's unmistakable stamp. These include a Courbet figure study, *The Promenade* (fig. 20), which Sears bought from Durand-Ruel in 1907, and five works by Degas. Three—*The Washbasin*, *The Mante Family*, and *After the Bath* (fig. 8)—were apparently purchased in Paris between 1907 and 1909; the remaining two were small pastels—one of a nude woman reading on a couch

Fig. 20. Gustave Courbet. *The Promenade*, 1866. Oil on linen; 85.5 x 72.5 cm. Washington, D.C., National Gallery of Art, Chester Dale Collection, 193.10.113. © 1998 Board of Trustees.

and the other of a pink-skirted dancer resting (both unidentified).[47]

While only *The Mante Family* hung in a public space in her house on Arlington Street in Boston, Sears shared her more intimate, pastel nudes by Degas with the public in 1915, when she lent them to the exhibition Louisine Havemeyer organized for the benefit of women's suffrage, held in New York at M. Knoedler and Co. in April 1915 (see Shackelford, fig. 34). The project was one that Cassatt supported wholeheartedly, not only for its politics, but also for the benefit to young artists such a display would provide. She worked actively on the show's behalf, writing to potential lenders, many of whom she had advised. She found a sympathetic friend in Sears: With the three Degas pastels and three Cassatts she sent to New York, Sears was the second most prominent lender to the exhibition, after Havemeyer herself. Far from being antagonized by Cassatt's intelligence and political agenda, Sears pointed out that the painter's "mentality was so far above the average that I look back on the many years of our friendship as one remembers a luminous star—for I know nothing like it will ever come into my life again."[48]

Cassatt also became friendly with architect Theodate Pope, another American woman whose family collected paintings. Cassatt is often said to have first met the Popes (fig. 21) during her trip in 1898 to the United States, but it now has been established that she had known the family some years before. Theodate's father, Cleveland iron magnate Alfred Atmore Pope, had close personal and professional connections to John Horace Whittemore and his son Harris, whose business was also iron; both Pope and the Whittemores likely knew Alexander Cassatt through his railway interests. The Whittemores became acquainted with Cassatt in Paris at least by 1893, and this family's correspondence indicates that the Popes met her there as well.[49]

Alfred Pope and his wife, Ada Brooks Pope (whose father was a lawyer for the Pennsylvania Railroad), were among the early American collectors of Impressionist paintings. Most of their purchases were made between 1889 and 1896; Léonce Bénédite, writing about collections in the United States for *La Revue de l'art* in 1908, credited Cassatt with being their valu-

the dealers were exhausted from continual searching in every corner for the pearl. Finally this nabob purchased the *Woman with Guitar* from Durand-Ruel for 75,000 francs. Amazement far and wide![51]

Cassatt stayed in touch with the Popes by mail and through both the Whittemores and Louisine Havemeyer, who often included news of the family in their letters to the artist. A few years after moving into his new home in Farmington, Connecticut, Alfred Pope refined his collection, reframing several of his paintings and making two last acquisitions, likely with Cassatt's encouragement: Degas's large pastel *The Tub* (fig. 9) and his *Interior* (fig. 23). Pope bought *The Tub* from Durand-Ruel in 1907. The story of *Interior* is more complex. In August 1907, Pope bought the Degas pastel bather and was tempted also to purchase the interior, but he changed his mind, perhaps because Mrs. Pope disliked the painting. He continued to admire it, however, and in October 1909, his friend Harris Whittemore bought it from Durand-Ruel and gave it to Pope as a Christmas gift. Whittemore would later inherit it from Pope. *Interior* remains one of Degas's most mysterious and masterful compositions; given its unmistakable sexual tension, it was an adventurous purchase for an American collector.[52]

Despite her father's bold taste in paintings, Theodate Pope rebelled against the preferences of her parents. She had begun to work as a designer and architect, and planned the new house for her family in Farmington, which was completed in 1901. By 1903, when she visited Cassatt in Paris, Theodate was espousing a spare aesthetic; as Cassatt unhappily reported to Ada Pope, "she is still in favor of *bare walls.*" Theodate Pope's opposition to domestic interiors filled with paintings and to private ownership of works of art gave Cassatt an excuse to describe to her the benefits she saw in art. "You must remember," Cassatt wrote, "that art is a great intellectual stimulus, & not reduce everything to a decorative plane—What you say about pictures being things alone, & standing for so much, & therefore the wickedness of private individuals owning them, is I assure you a very false way of seeing things." Cassatt went on to argue that, during the time paintings

Fig. 21. Gertrude Käsebier (American; 1852–1934). Photograph of Alfred, Theodate, and Ada Pope, 1902. Photo: courtesy Hill-Stead Museum, Farmington, Conn.

able advisor.[50] The Popes acquired their first paintings during the winter of 1888–89, while on an extended European tour following Theodate's graduation from finishing school. During much of their stay, they shared the company of Harris Whittemore, who would propose marriage (unsuccessfully) to Theodate. In Paris the Popes, like many Americans, began their collection with Monet, buying his newly painted *View of Cap d'Antibes* and *Grainstacks, White Frost Effect* from Boussod, Valadon & Co. in 1889. Two years later, Pope bought another Monet, the 1890 *Grainstacks in Bright Sunlight,* one of the large series of paintings the artist promoted directly to several dealers. Over the next three years, Durand-Ruel sold the Popes an Alfred Sisley and two more Monets, including *Boats Leaving the Harbor at Le Havre* (fig. 22), an early seascape of the type Cassatt particularly admired. In 1892 they bought Degas's 1886 pastel *Jockeys,* a picture Cassatt may once have considered for her brother Alexander; and his striking, strawberry-toned *Dancers in Pink,* dating to 1880/85. In Paris in 1894 Pope paid a record price of $12,000 for Manet's *Guitar Player.* A jealous Pissarro described the purchase:

I met Vollard in Paris, he told me the story of this American who came to Paris to find a beautiful Manet and was willing to pay any price if the painting met his expectations. All

Fig. 22. Claude Monet. *Boats Leaving the Harbor at Le Havre*, 1865. Oil on canvas; 96 x 130 cm. Farmington, Conn., Hill-Stead Museum.

Fig. 23. Edgar Degas. *Interior*, 1868/69. Oil on canvas; 81 x 116 cm. Philadelphia Museum of Art, Henry P. McIlhenny Collection in memory of Frances P. McIlhenny.

were privately owned, judgments of quality could be made about an artist's work; she explained that Theodate should not want to have "museums crowded with *undigested* efforts of everyone." Cassatt praised the acquisition policy at the Musée du Louvre, where

paintings were not procured until after an artist's death. "I wish to goodness," she wrote, "we had some sensible rule of that kind at home, instead of that everything can be crowded into public Museums." Cassatt declared that "no standard is possible in such a mess" and added, "all the great public collections were formed by private individuals." She expressed her disgust with Theodate Pope's point of view more frankly in a letter to her friend Louisine Havemeyer:

I wish you could have heard Miss P—'s conversation here. Her fad now is that pictures are a bore. Rooms must be pictures, and bare walls are the things. She is made ill by the glitter of the gold frames, on the walls in her father's house and she complacently told me that the poor man was much discouraged and would probably never buy another picture! The monstrous selfishness of her attitude, depriving her father of one of his greatest pleasures never seemed to strike her! I hinted to her very plainly that ignorance was the trouble with her.[53]

Despite Theodate Pope's opinions, which Cassatt characterized as socialist, she kept her father's art collection largely intact when she inherited it. Her friendship with Cassatt survived as well. The collection, including the works by Degas, Manet, and Monet mentioned above, today forms the core of the museum Pope inaugurated at Hill-Stead.[54]

Like her relationship with the Popes, Cassatt's connection with the Whittemores spanned the generations. She had met them in Paris by 1893, although the exact circumstances are as yet unknown.[55] Harris Whittemore followed his father into the metal industry; both served as president of the Naugatuck Malleable Iron Company and become great benefactors of their Connecticut hometown. Cassatt corresponded regularly with the Whittemores from 1893 until her death in 1926; she recommended paintings to them both, although Harris Whittemore (fig. 24) was the primary collector.

"Take a cup of tea with [me] and discuss the art question," Cassatt wrote to Harris Whittemore and his bride, Justine, in the spring of 1893. By the time the artist had penned those words, the Whittemore family already owned five works by Monet, all purchased in Paris between 1890 and 1892 from Durand-Ruel and Boussod, Valadon & Co. Cassatt evidently planned to expand the Whittemores' taste and com-

mented that she had seen the dealer Alphonse Portier: "If you can go to his place . . . he will show you some drawings of Degas and other things that may interest you. He spoke of a large Manet . . . [and] some fine Renoirs, best period. Tell him what you want and give him time." Harris Whittemore took Cassatt's advice, and from Portier in April 1893 he acquired Sisley's 1885 *Dam of the Loing at St.-Mammès*, Morisot's *Landscape with Boats at the Bois de Boulogne* of about 1889 (both private collections), and, in a gesture of esteem for his advisor, a drawing by Degas of Cassatt at the Louvre (New York, private collection).[56]

Whittemore made many other acquisitions during his stay in Paris in 1893. In May he bought from Durand-Ruel Manet's equestrian scene *The Races in the Bois de Boulogne* (Mrs. John Hay Whitney) for $3,000. Cassatt was no doubt familiar with this 1872 composition. Shown in the artist's 1884 memorial exhibition, it includes a top-hatted spectator who is often said to represent Degas—a reflection of the two painters' shared interest in racing subjects around 1870. Whittemore soon returned to the dealer and bought two works by Degas, probably *Four Dancers in the Rehearsal Room* of about 1890 and *On the Stage* of about 1881; Manet's 1871 *Port of Calais*, and a Monet (perhaps the 1887 *Rocks at Belle-Ile*). From Boussod, Valadon & Co., he bought a Degas ballet scene of 1880/85, *Three Dancers in the Wings*, and three more Monets from the 1870s: *Snowy Street at Argenteuil*, *Boats at Argenteuil*, and *Apple Trees near Vétheuil*. In December he went back to Durand-Ruel for a Pissarro and a Monet. Cassatt was pleased and addressed a "family letter" to the Whittemores on December 22, just before leaving Paris for Cannes: "I am glad you saw the Degas & admired it, I also think your Manets better than my brother's as I remember his." She seems not to have favored one of Whittemore's early Degas purchases as much, for she confessed that "Camentron [a Parisian dealer] was here the other day & I told him what I had written to you about the Degas, he says I am wrong, & that he would buy back the Degas you bought in the Spring at an advance—he seemed sincere—I don't think my friend in N.Y. [Havemeyer] would sell her pastel if it would bring 20,000 fr. in Paris!" "Not a bad investment," Cassatt added, for she

often found financial allusions helpful for her recommendations to American collectors.[57]

In 1894 Cassatt began anew to encourage the Whittemores to buy French paintings. She wrote:

I have an interesting piece of artistic news for you. There was in Paris an amateur by name de Bellio, who had a large collection of Monets, Renoirs, one or two Manets, Degas, one, I believe, the Renoirs & the Monets very fine. This man has died lately & it is most probable that his collection will be sold at the Hotel Druot[*sic*]. I remember you wanting to buy some good Renoirs, this will be a chance; in the collection was a picture by Monet which he called "An Impression". It was taken up by the papers & was the origin of the name "Impressionist." My brother offered M. de Bellio 5000 frs for it eleven years ago, that was a high price then, but he was refused. As soon as I hear anymore particulars I will send them to you.[58]

A Romanian collector living in Paris, Georges de Bellio had plucked Monet's 1872 *Impression: Sunrise* (Paris, Musée Marmottan) for 210 francs from the same Hoschedé auction at which Cassatt had spent 200 francs for her own Monet. De Bellio was one of the earliest and most faithful collectors of Impressionist art and owned more than one hundred fifty paintings, including thirty by Monet, about ten by Pissarro, and ten by Renoir.[59] His heirs were aware of the cultural importance of the collection; instead of holding the auction Cassatt eagerly anticipated, they sold only a small number of works and eventually left the rest to the Musée Marmottan. Although de Bellio's best paintings were never sold, Cassatt's correspondence with the Whittemores clearly reveals her unfailing ambition to place important pictures in the hands of her compatriots.

The Whittemores' fondness for Cassatt was evident both in their enthusiasm for her work and for that of Degas. They favored his early paintings: In addition to those already mentioned, Harris Whittemore bought the luminous composition *The Rehearsal* (fig. 25) from Eugène Glaenzer and Co. in Paris in March 1907. He lent it to the Fogg Art Museum, Cambridge, Mass., in 1911, for one of the earliest exhibitions dedicated to the French painter. His friend Alfred Pope lent three pictures, including *Interior* (fig. 23), which Whittemore had given him. In 1921 Harris Whittemore purchased another early oil,

Fig. 24. Pirie MacDonald. Photograph of Harris Whittemore, c. 1910. Photo: New York, Christie's, *Important Impressionist Paintings From the Collection of Harris Whittemore*, sale cat. (Nov. 12, 1985), n.p.

Violinist and Young Woman Holding Sheet Music (The Detroit Institute of Arts), for $7,000. In addition to these important paintings, his collection eventually included a number of works on paper, among them two horseracing pastels and seven ballet scenes. Whittemore had acquired several of these by 1915, when he lent three of his works by Degas to the exhibition Louisine Havemeyer organized in support of women's suffrage. A few years later, just after Degas's death, he bought a preparatory sketch for Louisine Havemeyer's *Dancers Practicing at the Bar*, a vivid study on bright green paper (London, British Museum). The two collectors overlapped once again late in their lives when, in 1925, Joseph Durand-Ruel notified Louisine Havemeyer that he had just bought back Whittemore's Degas pastel of a bather; he offered it to her for $5,600. Whittemore's *Woman Bathing in a Shallow Tub* (Hiroshima Museum of Art) was similar in composition to the one Pope had purchased and also to Cassatt's own Degas bather. Havemeyer, who had bought that work from Cassatt in 1919, perhaps found Whittemore's too similar. More concerned now with the disposition of her collection than with new purchases, Havemeyer declined Durand-Ruel's offer.[60]

One of the Whittemore Manets, *The Port of Calais*, ended up in the Havemeyers' collection; the Whittemores sold it back to Durand-Ruel in 1896, and the Havemeyers bought it in 1898. This sort of exchange was common and was a distinct benefit for the gallery, which usually handled both parts of the sale. Many of these transactions involved another important pair of American collectors, Bertha Honoré (fig. 26) and Potter Palmer of Chicago, who, after the spectacular debut of their quickly assembled, private art gallery in 1893, began carefully to refine their collection. Two of the Whittemores' earliest Monet purchases, both dramatic Creuse valley scenes, had first been owned by the Palmers. The Palmers also once owned Monet's

1891 *Grainstacks, Snow Effect* (Shelburne, Vermont, Shelburne Museum), which was subsequently purchased by Alfred Pope and later by the Havemeyers, as well as another of the same date, *Grainstacks, Winter Effect* (New York, The Metropolitan Museum of Art), which the Havemeyers bought in 1894. The Palmers' collection was praised in *The Collector* as early as 1890, when Alfred Trumble described their holdings as possessing "truly regal character."[61] They too were connected to Mary Cassatt.

Cassatt shared one memorable experience with the Palmers even before they met, for both she and they were driven from their quarters by the Great Chicago Fire of October 1871. In the conflagration, Cassatt, who had traveled to the Midwest to sell her work, lost several of her paintings and the Palmers lost their newly constructed hotel, which burned along with

Fig. 25. Edgar Degas. *The Rehearsal*, c. 1873. Oil on canvas; 47 x 61.7 cm. Cambridge, Mass., Fogg Art Museum, Harvard University Art Museums, bequest from the Collection of Maurice Wertheim, Class of 1906.

the one in which Cassatt had been staying. Bertha Palmer and her husband rebuilt the Palmer House and were leading members of Chicago society by the time they were introduced to Cassatt. The Palmers traveled to Paris in May 1889, most likely for the opening of the great Exposition universelle—more than 150,000 Americans flocked to the French capital to see the fair, which boasted a significant juried

Fig. 26. Anders Zorn (Swedish; 1860–1920). *Portrait of Mrs. Bertha Honoré Palmer*, 1893. Oil on canvas; 258 x 141.2 cm. The Art Institute of Chicago, gift of Honoré and Potter Palmer, Potter Palmer Collection, 1922.450.

organizing international exhibitions and acting as an agent for American collectors.

The Palmers made their first purchase from Durand-Ruel, an unidentified set of aquatints, in Paris at the end of May 1889. In September, perhaps with Cassatt's encouragement, they inaugurated their collection of Impressionist paintings with a Degas pastel, *On the Stage* (fig. 27), for which they paid 600 francs. The Palmers acquired nothing else from the gallery until the summer of 1891, when they began to buy in quantity—that year, from Durand-Ruel, they acquired eight works by Monet and three by Eugène Boudin. From Goupil and Co., they bought Degas's *Dancers Preparing for the Ballet* (The Art Institute of Chicago). The following year, 1892, by which time they certainly knew Cassatt, they became some of Durand-Ruel's most important customers. The firm supplied them with twenty-four Monets, thirteen Renoirs, twelve Pissarros, and a Delacroix, as well as numerous works by such artists as Cazin, Corot, and Troyon. They did not only buy from Durand-Ruel; for example they also purchased Monets from Théodore Duret; Boussod, Valadon & Co.; Bernheim-Jeune; Knoedler; Montaignac; and the American Art Association.[62] Mrs. Palmer, an impressive exemplar of the culture of consumption, would be able to show the world her treasures during the festivities surrounding the 1893 Chicago World's Columbian Exposition.

It is difficult to ascertain the scope of Cassatt's involvement in the Palmer collection, for there is little extant correspondence between Cassatt, Bertha Palmer, and Hallowell. Almost all of the surviving letters concern Cassatt's mural for the Chicago fair (see Barter, pp. 87–96). Hallowell's communications with Potter Palmer mention many of their art purchases, but never Cassatt. It is important to note, however, that the bulk of the Palmer collection was complete by the time of the Columbian Exposition; it was during these years that the Palmers had the most contact with Cassatt, both by mail and in person. Certain works in the Palmer collection, including the six by Degas—particularly *The Morning Bath* (fig. 10)—Manet's *Races at Longchamp* (The Art Institute of Chicago), and *Departure from Boulogne Harbor* (fig. 28),[63] and their many Pissarros are typical of the

exhibition of American and international art, as well as the famous Eiffel Tower, newly constructed for the event. Cassatt, who had participated in a similar international show in 1878, was not represented in 1889; since she had joined the Impressionists in 1879, she had rejected the concept of a jury as a matter of principle. She may have met the Palmers at this time through Sara Tyson Hallowell. Originally from Philadelphia, Hallowell had moved to Chicago in 1873 to organize the art display for the Interstate Industrial Exposition, a project for which Potter Palmer served as president. Hallowell then began to divide her time between Paris and the United States,

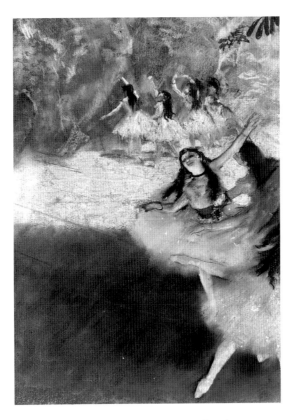

finally, in a letter from Hallowell to Bertha Palmer, there is a hint of Cassatt's admiration for the leading role Palmer assumed in organizing the Women's Building at the fair, a sign that the two women shared certain feminist principles:

Miss Cassatt . . . sends you her "kindest regards and compliments," saying previously—in reference to the Luxembourg [Museum in Paris] being in treaty for one of her pictures— "After all give me France—women do not have to fight for recognition here, if they do serious work. I suppose it is Mrs. Palmer's French blood which gives her her organizing powers and her determination that women should be *someone* and not *something*." I wish I could send you [Cassatt's] letter.[64]

Despite these sentiments, the Palmer name does not appear as a lender or even a potential lender to the exhibition benefiting women's suffrage that Havemeyer staged in New York in 1915.

There is no such uncertainty connected to the last major collector Cassatt advised, James Stillman (fig. 29). Six years younger than Cassatt, Stillman became her close friend in the later years of her life. His family boasted a long New England history, but Stillman spent his youth in Texas, where his father was a cotton merchant; he was sent East for his education. His early interest in finance brought him into the circle of Moses Taylor, president of the National City Bank, New York. By 1890 Stillman was a director of that organization and became its president the following year. Under his management, the bank became the nation's leading investment firm, and Stillman himself formed close ties to many of North Amer-

Fig. 27. Edgar Degas. *On the Stage*, 1876–77. Pastel over monotype on cream laid paper, laid down; 59.2 x 42.5 cm. The Art Institute of Chicago, Potter Palmer Collection, 1922.423.

Fig. 28. Edouard Manet. *Departure from Boulogne Harbor*, 1864–65. Oil on canvas; 71.1 x 90.2 cm. The Art Institute of Chicago, Potter Palmer Collection, 1922.425.

sort of painting Cassatt most frequently advocated. It is clear that by 1891 Hallowell had been engaged by the Palmers to purchase art on their behalf; Pissarro noted in 1894 that Cassatt recommended his work to Hallowell, presumably for the Palmers. There are other connections, too: Alexander Cassatt agreed to lend four of his Impressionist paintings to the display of "foreign masterpieces" the Palmers and Hallowell were organizing for the Palace of Fine Arts at the Chicago fair. One of the Palmers' Monets, *Poplars, White and Yellow Effect* (Philadelphia Museum of Art), was later sold to Frank Thomson, Alexander Cassatt's business associate, who had also lent to the Columbian Exposition. And

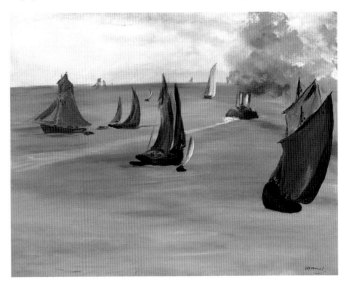

ica's most important industrialists, including the Rockefellers, E. H. Harriman, and Alexander Cassatt. Stillman was admired for his intellect and feared for his personal and professional coldness. In 1894, after twenty-three years of marriage, Stillman rejected his wife and allowed rumors to spread concerning her sanity. After 1906 he began to spend increasing amounts of time in Europe. Stillman retired from the presidency of the National City Bank in 1909 (maintaining a top position on its board), and spent most of the rest of his life in Paris.[65]

Stillman rented and later bought a large *hôtel particulier* on the rue Rembrandt overlooking the Parc Monceau, not too far from Cassatt's residence. A faithful diarist, the banker mentioned Cassatt on a regular basis, beginning February 17, 1907, when he paid her a call after lunching with the novelist Edith Wharton and her husband. During the following weeks, he saw her frequently and often dined with her and the Havemeyers, who arrived in Paris at the end of March. On April 7, he entertained Cassatt, Durand-Ruel, and the Havemeyers at his rue Rembrandt home; the date marks the beginning of a schedule of frequent social contact among this group (occasionally including Sarah Sears) punctuated by visits to museums, galleries, and antiquarians. As Stillman later described it, he engaged in the "usual Paris spectrum, calling, seeing works of art, entertaining, being entertained."[66]

Stillman's collection of Old Master paintings was shaped by Cassatt. His biographer Anna Robeson Burr noted that Cassatt's friendship, "of some years standing," became "an important one in James Stillman's later life, during the period when he was most active in forming a collection of paintings." He had begun to purchase art in the early 1890s and, Burr continued, "[although] he always protested that he wasn't a real collector, . . . there is no doubt . . . that Mary Cassatt's enthusiasm for the pictures she understood as well as created was a great stimulus and laid the foundation of friendship between them. . . . She threw herself with great zeal into his collecting

Fig. 29. Photograph of James Stillman, after 1906. Photo: Burr 1927, opp. p. 248.

plans, and . . . pursued his artistic education."[67] Stillman's diary records visits with Cassatt to art dealers, including Durand-Ruel, where he purchased Old Master paintings, and Dikran Kelekian, where he (like the Havemeyers and Sarah Sears) bought Persian pottery. Cassatt's correspondence with Louisine Havemeyer also includes many references to Stillman's purchases.

Cassatt encouraged Stillman to pursue a number of objects, including a Chardin portrait, a Corot that she had "a sort of longing for [him] to own," and Persian ceramics. She also wrote to him about paintings she disliked, notably works by Jean Baptiste Greuze and Elisabeth Vigée-Le Brun. Another biographer, John Winkler, noted that Stillman

practiced the art [of collecting] with that thoroughness with which he went into every speculation. Thoroughly shocked at [fellow collector and financier J. Pierpont] Morgan's manner of buying anything and everything that pleased him regardless of price, and fearful of the fate that other Americans of means had met in spending huge sums for practically valueless works, he calculated to a penny the worth of each picture in which he invested. A canvas would hang on his wall for days before he would decide to purchase it.

This deliberation annoyed Cassatt, although, as she wrote to Louisine Havemeyer, "I like the way he is learning and is subordinating his taste for the agreeable to the quality of art—he learnt that in your house."[68]

Stillman was most at home among the Old Masters and particularly favored sixteenth-century paintings; his taste might appropriately be compared with his New York colleagues Morgan and Henry Frick. Cassatt skillfully balanced her recommendations to Stillman with the Old Masters she encouraged the Havemeyers to buy. In 1901 for example she urged the Havemeyers to travel with her to Milan specifically to "see the Luinis, the Veroneses, and the Moronis." There they admired a Moroni portrait of a man offered by an Italian dealer, but Cassatt convinced H. O. Havemeyer that the painting was "not up to his standard." Five years later, however, when Cassatt was asked by the Parisian dealer René Avogli-Trotti to "come quietly" to examine some paintings he had recently acquired—a portrait by Titian of Cristoforo Madruzzo, Cardinal and Bishop of Trent (São Paolo

Museum of Art), and depictions of the cardinal's two nephews, *Gian Federico Madruzzo* (Washington, D.C., National Gallery of Art) and *Gian Ludovico Madruzzo* (fig. 30), both by Giovanni Battista Moroni—the intended client was Stillman. "What he showed me took my breath away," Cassatt confessed to Louisine Havemeyer, whom, she seemed sure, was not interested in buying them. "A full length portrait of a man by Titian . . . there are only 4 full lengths by Titian in the world . . . Opposite hung two most superb portraits *full* length by Moroni . . . now in my opinion, but I saw the pictures only by electric light, these two are more interesting than the Titian." She went on to explain that the "Moronis cost also a lot of money" but that she "would rather have the Moronis, either one, than the Titian." Cassatt recommended the paintings to Stillman, although she told Havemeyer that, if they stayed in France rather than going to North America, "then I don't see why I am bothering—[it would be] better [to] leave the Titian to Mr. Frick [who would bring it to New York]." She thought Stillman would purchase only the Titian; two weeks later, after receiving a letter and a cable requesting them, Cassatt sent the Havemeyers photographs of the Moronis. Stillman ended up buying them all, leaving Cassatt to confess to the Havemeyers that "Mr. S. means to have these pictures in Paris. I am sorry, I thought they would go to New York." In the end, however, Cassatt's work was justified, for all three paintings eventually entered American collections.[69]

Stillman's house and collection were described at length by his daughter-in-law Mildred Whitney Stillman, who recalled her first visit to Paris in 1911:

The cream of the old world seemed caught in that perfect house at 19 Rue Rembrandt. . . . I remember especially the lovely Gainsborough lady in the picture gallery. I can hear Mrs. Havemeyer saying to Mr. Stillman "I am so glad you have an Ingres," but what the Ingres was, I cannot remember. I do remember the Rembrandts, and the striking, almost sinister, Titians against the crimson velvet walls of the dining-room. One of these Titians and one of the two Moronis as well as the Murillo are now hanging in the Metropolitan Museum. But my favorite was the early Italian holy family which hung in its round frame over the library table.[70]

Stillman owned elegant portraits by J. A. D. Ingres

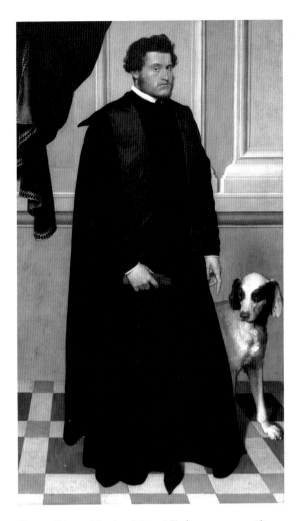

Fig. 30. Giovanni Battista Moroni (Italian; c. 1524–1578). *Gian Ludovico Madruzzo*, 1551/52. Oil on canvas; 202. 6 x 116.9 cm. The Art Institute of Chicago, Charles H. and Mary F. S. Worchester Collection, 1929.912.

(for example *Madame Cavé*; New York, The Metropolitan Museum of Art) and Jean Marc Nattier, among others, although Cassatt did not appreciate the latter completely. "I was rather cut-up when Mr. S. told me he had bought one of the Nattiers because I admired it," she mockingly wrote to Louisine. "So I did—for a Nattier."[71] In addition to these secular works, Stillman acquired Madonnas attributed to such masters as Bellini, Boccaccino, Gianpietrino, Murillo, and Tiepolo, perhaps finding in them precursors for the compositions of his friend Cassatt.

With the exception of the many works by Cassatt he purchased (see Sharp, p. 164 and n. 66), Stillman owned relatively few examples of modern art. Cassatt was unable to persuade him to buy Degas's *Orchestra Musicians* (Frankfurt, Städtische Galerie),[72] but she did encourage him to buy several paintings by

Courbet. Stillman noted in his diary that, on June 10, 1913, he acquired a Courbet landscape for 5,720 francs and that, on June 19, he purchased a "small" Courbet. These could be among three similar Courbets from the 1860s documented in Stillman's collection: *A Brook in a Clearing*, *The Hidden Brook*, and *The Brook of the Black Well*; he also owned Courbet's *Calm Sea*, a spare seascape of the type that appealed especially to Cassatt, who owned similar compositions (all four works are now in New York, The Metropolitan Museum of Art). Stillman later sold *Calm Sea* to Théodore Duret; it was purchased by Louisine Havemeyer in the fall of 1911, probably with Cassatt's encouragement. Early the following year, Duret wrote to Havemeyer, offering her Courbet's *Russet Wood* (San Francisco, Richard Shelton), a painting that Cassatt had admired. Stillman had already turned it down because, as Cassatt explained, he found it "too like an American landscape." Havemeyer, unperturbed, paid 18,000 francs for it. Among the other modern works in his collection, Stillman owned Berthe Morisot's *Le Repos* (now entitled *Behind the Blinds*; Mr. and Mrs. Moreton Binn), a painting akin to Cassatt's compositions, as well as to the Morisot she owned. Stillman also acquired two pictures by the fashionable French Pointillist Henri Le Sidaner, but the banker's interest in modern painting ended there. "Mr. Stillman has the greatest contempt for modern art," Cassatt complained to Louisine Havemeyer, "but he does not understand or do them justice. How can he when all of the finest pictures are in America."[73] With Stillman, Cassatt was a victim of her own success.

While Cassatt worked primarily with individual collectors, she also occasionally recommended paintings directly to institutions; this aspect of her activity can best be illustrated by her discovery in 1901 of El Greco's monumental *Assumption of the Virgin* (fig. 31). Cassatt traveled with the Havemeyers to Spain that spring, introducing them to the magnificent collections of the Museo del Prado, Madrid. There H. O. Havemeyer fell in love with the work of El Greco, a painter as yet little known in the United States.[74] While the Havemeyers went on to tour southern Spain, Cassatt remained in Madrid, studying paintings and acquainting herself with Joseph Wicht, an English-speaking dealer who was familiar with the

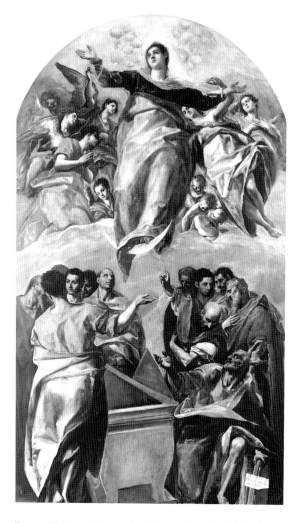

Fig. 31. El Greco (Domenikos Theotokopoulos) (Greek [worked in Spain]; 1541–1614). *Assumption of the Virgin*, 1577. Oil on canvas; 401.4 x 228.7 cm. The Art Institute of Chicago, gift of Nancy Atwood Sprague in memory of Albert Arnold Sprague, 1906.99.

private collections of Spain's noble families. Several of the works Wicht showed Cassatt eventually would enter the Havemeyers' collection. The *Assumption*, however, was clearly a museum picture. Originally executed for the church of S. Domingo el Antiguo in Toledo, the painting is enormous, over thirteen feet tall and seven feet wide, even unframed. Only a public institution could display it.

Over the next several years, Cassatt tried to get American museums to purchase this and other works by El Greco. In November 1903, she informed Paul Durand-Ruel, "I want to write Mr. [John G.] Johnson to ask him to get the Academy in Philadelphia to buy a Greco. . . . He told me that they have $40,000 per year to spend." The *Assumption* became available in November 1904, when Durand-Ruel at

last was able to purchase it after several years of wrangling with multiple heirs. H. O. Havemeyer had lent the dealer 100,000 francs toward the purchase "as an act of friendship," and in consequence New York's Metropolitan Museum seemed an appropriate destination for the painting. Louisine Havemeyer attempted unsuccessfully to convince the museum's trustees to acquire the *Assumption*; meanwhile Cassatt, who had been kept informed by Durand-Ruel throughout the dealer's protracted bargaining for the painting, asked him to appeal directly to J. Pierpont Morgan, who became president of the Metropolitan's board on November 21, 1904. The museum demurred and then purchased instead El Greco's *Adoration of the Shepherds*, a painting Cassatt found inferior to the *Assumption*. As Durand-Ruel reported to Cassatt, Morgan was so absorbed in his own business that "he doesn't have time to think of anything else and he is circumvented by the Duveens [Henry and Joseph Duveen, dealers and Morgan's chief advisors], who, it is said, do as they please with him."[75]

Cassatt had asked Durand-Ruel why Boston's Museum of Fine Arts had not bought the El Greco, noting that Washington B. Thomas, an important Boston businessman and a close associate of H. O. Havemeyer, should have influence there. But the museum, acting on the advice of its own favorite painter-connoisseur, John Singer Sargent, had just purchased another El Greco, *Fray Hortensio Félix Paravicino*, and apparently ignored the *Assumption*.[76] In January Cassatt and Durand-Ruel turned their attention to The Art Institute of Chicago. Cassatt corresponded with Charles L. Hutchinson, the museum's president:

I note what you say of your being here in February. I think you cannot fail to be struck with the Greco. It is a *great* museum picture, I doubt if such another is for sale in Europe—It is in perfect condition and untouched. Mr. Havemeyer has lately bought a superb portrait by Greco, he would have bought the Assumption if it had not been too large for his gallery. I don't know if you have seen Mr. Havemeyer's collection? I have just written to Mrs. Havemeyer that you would probably pass through New York, I know she will be delighted to show you.

Hutchinson was taken with the painting, although it would be more than a year before the arrangements were finalized, the painting shipped to Chicago for approval, the funds solicited, and the painting officially acquired.[77]

This activity on behalf of an American museum was motivated by Cassatt's desire to improve the situation of the arts in North America in any way she could. It was not the only time she worked directly with a museum. Characteristically she seems to have been especially anxious to cooperate with institutions associated with art schools, including The Art Institute of Chicago and the Pennsylvania Academy of the Fine Arts in Philadelphia. She noted that her relationship with the Carnegie Institute in Pittsburgh had started with the hope that they would "form the beginning of a Museum, and thereby give to American artists some of the advantages of the artists on this side [of the Atlantic]." Against her principles, Cassatt agreed to be listed as a juror at the Carnegie, explaining that "it was well understood I was never to serve, and I hoped I might be useful in urging the Institute to buy some really fine old Masters to create a standard." In 1912 she donated her own two Courbet portraits to the Pennsylvania Academy, describing them as "excellent examples for students to study" and noting that she hoped someday to contribute other paintings to the institution's collection for the same reason. That same year, she asked Louisine Havemeyer to lend her Courbets to the Metropolitan Museum, explaining that she was sure "it would help the young painters—it might make an artist." At the end of her life, she worked with Havemeyer for months to help her decide which of the paintings from the Havemeyer collection should be given to the Metropolitan.[78]

For Cassatt museums represented the future of art in North America. Her work with private collectors was intended for public benefit, to enrich the cultural heritage of the United States and to provide inspiration for her fellow artists. Without her many fine things might never have crossed the Atlantic.

Notes

I would like to thank Theodore E. Stebbins, Jr. and George T. M. Shackelford for their careful reading of the manuscript and their valuable suggestions. I am indebted to Carol Tonieri at the Getty Provenance Index and especially to three Barbara Fish Lee Fellows at the Museum of Fine Arts, Boston, for their tireless and cheerful research assistance: Karen Pfefferle, Amanda Prugh, and especially Ellen Roberts.

1. "It has been . . .": Cassatt, in Boston 1978, pp. 9–10; transcription of original letter, curatorial files, Department of Paintings, Museum of Fine Arts, Boston.

"One of the most . . .": Frank Gair Macomber to Arthur Fairbanks, July 28, 1909, Archives, Museum of Fine Arts, Boston. Macomber also owned Edouard Manet's *Children in the Tuileries Gardens* (now in Providence, Rhode Island School of Design Museum of Art; the painting is not included in Rouart/Wildenstein), which he lent to the Museum of Fine Arts, Boston, in 1905 (the circumstances of that purchase are unknown); Gustave Courbet's *Landscape* (now in the San Diego Museum of Art); and Edgar Degas's unlocated monotype and pastel *Landscape (Les Collines)* (Lemoisne 1047); most of his other paintings were by Old Masters. I am grateful to Maureen Melton, Archivist at the Museum of Fine Arts, Boston, for her generous help.

"It was with . . .": Vollard 1978, p. 181.

2. "The Most Eminent of All Living American Women Painters," *Current Literature* 1909.

3. Quoted in William Leach, *Land of Desire: Merchants, Power, and the Rise of a New American Culture* (New York, 1993), p. 3. See also Richard Wightman Fox and T. J. Jackson Lears, eds., *The Culture of Consumption: Critical Essays in American History, 1880–1980* (New York, 1983); and Lawrence W. Levine, *Highbrow/Lowbrow: The Emergence of Cultural Hierarchy in America* (Cambridge, Mass., 1988).

4. Alfred Trumble, "The Rise of the Curtain," *The Collector* 2 (Oct. 1, 1891), p. 225. Trumble himself expressed "contempt" for such artists as Claude Monet.

5. Cassatt to Emily Sartain, June 7, 1871, in Mathews 1984, p. 74.

6. Joseph Choate, *New York Herald*, Mar. 31, 1880, in Levine (note 3), p. 201.

Cassatt to Carroll Tyson, Jan. 22, 1905, in Sweet 1966, pp. 170–71.

7. "[She] suddenly . . .": Havemeyer 1993, p. 278.

"Mad outlaws": William Howe Downes, "Boston Painters and Paintings: Private Collections," *Atlantic Monthly* 62 (Dec. 1888), p. 782. Downes was among those who noted the profit motive involved in the introduction of Impressionism to the United States. In 1892 he wrote, "Almost all the Impressionist paintings brought to the United States thus far have been imported by a certain dealer whose principal shops are in Paris and New York. The other picture dealers here have received them from him, and have made such a market for them as was possible. Very soon a considerable number of American artists began to manifest marked symptoms of sympathy for the purple mania and a tendency to the noisy effects which the Impressionists produce in their mistaken attempts at brilliancy. . . . Impressionism is . . . a fad"; William Howe Downes, "Impressionism in Painting," *The New England Magazine* 6 (July 1892), pp. 602–603.

"What we want . . .": Herbert Croly, "American Artists and their Public," *The Architectural Record* 10, 3 (Jan. 1901), p. 257.

8. On Cassatt's involvement with young American artists and the Art League, see Mathews 1994, pp. 269–70; and Sweet 1966, pp. 160–61.

Biddle 1926, p. 108.

9. "Fine pictures . . .": Ticknor 1927–28, p. 151.

The exact identification of Cassatt's Morisot is difficult; it has variously been referred to as *Toilette* and *Woman in White*. Recent scholars have called into question its identification as Bataille/Wildenstein 63 (*La Toilette*, 1877; current location unknown), since that picture was never in Hoschedé's collection. Charles F. Stuckey and William P. Scott suggested instead *Woman at Her Toilette* (c. 1875; Bataille/Wildenstein 73), a seated figure in white, as the correct painting; see idem, in South Hadley, Mass., Mount Holyoke College Art Museum et al., *Berthe Morisot: Impressionist*, exh. cat. (1987), pp. 70, 76, 182. The Cassatts traded Monet's 1870 *Beach at Trouville* (private collection; Wildenstein 157) to Paul Durand-Ruel in 1883 for *The Green Wave* of 1865 (New York, The Metropolitan Museum of Art; Wildenstein 73), which they kept until 1898, when the Havemeyers acquired it. For the Hoschedé sale, see Merete Bodelsen, "Early Impressionist Sales 1874–94 in the light of some unpublished 'procès-verbaux,'" *The Burlington Magazine* 110, 783 (June 1968), pp. 339–41.

10. "One of the greatest . . .": Cassatt to John F. Lewis, Mar. 22, 1912, PAFA.

"Mr. Havemeyer and I . . .": Havemeyer 1993, p. 203. I am grateful to Sue Canterbury of the Robert and Sterling Clark Art Institute, Williamstown, Mass., for her help with the provenance of the Clark's *Laundresses at Low Tide, Etretat* by Courbet. For Cassatt's Courbets, see Fernier 521, 878, 431, 85, 543. George Lucas saw Courbet's *Woman with a Cat* in Cassatt's apartment in May 1903; see Randall 1979, vol. 2, p. 915. Louisine Havemeyer later bought it from Cassatt.

11. For the still life by Manet that Cassatt owned, see Rouart/Wildenstein 91.

Claude Monet to Stéphane Mallarmé, Oct. 12, 1889, in Mondor 1969, vol. 3, p. 364.

For Monet's efforts on behalf of Manet's *Olympia*, see New York, The Metropolitan Museum of Art et al., *Manet*, exh. cat. (1983), p. 183.

Cassatt to Camille Pissarro, Nov. 27, [1889], in Mathews 1984, p. 213. Cassatt was also instrumental in the disposition of both of Manet's portraits of Georges Clémenceau, which the artist's widow had given to the statesman after her husband's death in 1883. Clémenceau sought to sell them in 1896; Cassatt advised Louisine Havemeyer to buy one of them (Havemeyer later presented it to the Musée du Louvre, Paris; it is now at the Musée d'Orsay, Paris), and she told Ambroise Vollard that the second version was also available (Vollard sold it to a Hungarian collector; it now belongs to the Kimbell Art Museum, Fort Worth). I am grateful to Nancy Edwards at the Kimbell for her assistance. In 1910 Paul Durand-Ruel told Cassatt in confidence that Manet's *Luncheon in the Studio* was about to come on the market. Hoping to capture it for an American collection, Cassatt wrote immediately to Louisine Havemeyer, suggesting it to her or to their mutual friend Colonel Oliver Payne. The picture was purchased by a German collector for the Bayerische Staatsgemäldesammlungen in Munich, where it is today. "It ought to have gone to an American," Cassatt declared (see Cassatt to Louisine

Havemeyer, Jan. 28 and Mar. 15, [1910], NGA).

12. For Cassatt's purchase of *Le Printemps* from Monet, see San Francisco 1986, p. 265; and Gustave Caillebotte to Claude Monet, May 1, 1879, in Berhaut 1978, p. 245. It is difficult to ascertain whether Cassatt owned one or two works by Monet. George Lucas did not mention the title of the Monet in his diary when he outlined the transaction with Walters; see Randall 1979, pp. 913–14. The painting in the Walters Art Gallery is now entitled *Springtime*. The museum acknowledges the problem and offers two separate provenances for the picture; see William R. Johnston, *The Nineteenth Century Paintings in the Walters Art Gallery* (Baltimore, 1982), pp. 138, 142. In his catalogue raisonné, Daniel Wildenstein recorded Cassatt's purchase of *Le Printemps* from Monet but did not link the transaction to a specific painting (vol. 1, pp. 142–43). Wildenstein assumed that Cassatt acquired the Walters painting after the 1878 Hoschedé sale from the unidentified purchaser "Lussac" (see ibid. 205). Bodelsen (note 9) identified "Mad Lussac [?]" as the successful bidder at the Hoschedé sale for Monet's "young woman seated in a park," paying 165 francs (p. 340); the dimensions listed for this painting are almost identical to those of the Walters's composition. It is tempting to consider re-examining the handwriting of the *procès-verbaux* at the Archives de la Seine, Paris. By "Mad Lussac [?]," could Bodelsen have meant Mademoiselle Cassatt? The artist bought two other paintings at the sale. Along with the Monet, Cassatt sold Walters her Degas portrait of Estelle Musson Balfour (Lemoisne 40).

Cassatt interview: Philadelphia *Public Ledger*, May 7, 1911, in Philadelphia 1985, p. 12.

13. Cassatt to Alexander Cassatt, Oct. 14, [1883], and Cassatt to Lois Cassatt, June 30, [1886], in Mathews 1984, pp. 173, 200.

Camille Pissarro to Lucien Pissarro, Apr. 3 and 25, 1891, in Rewald 1972, pp. 159, 164–65.

14. Cassatt's holdings of works by Pissarro are known from the exhibitions to which she lent several examples she owned; these include the fourth (1879) and sixth (1881) Impressionist exhibitions, the 1893 Pissarro exhibition at Durand-Ruel, and the memorial exhibition held at Durand-Ruel in Apr. 1904. The tiles and one fan (*Harvesting Peas*) remain with the artist's descendants; two tiles, *Outskirts of Pontoise* and *Peasants Resting, Montfoucault*, were included in the 1980–81 Pissarro retrospective (Boston, Museum of Fine Arts et al., *Camille Pissarro*, exh. cat. by Richard R. Brettell and Christopher Lloyd [1980], no. 214); the fan appeared in Boston 1978, no. 66. The location of the other works is unknown, and many do not appear in the catalogue raisonné; for the rest, see Pissarro/Venturi 854 (*Woman with a Green Scarf*), 1338 (*Potato Gatherers*), and 1624 (*Cabbage Gatherers*).

Joachim Pissarro suggested that *Gardens at the Hermitage, Pontoise* could be Pissarro/Venturi 335 and that *Peasant Woman and her Goat, Route d'Ennery* is ibid. 546; I am very grateful for his assistance.

For the Pissarros in the Havemeyer collection, see New York 1993, pp. 368–70.

Bertha and Potter Palmer of Chicago owned many works by Pissarro, but Cassatt's role in their acquisition has not been established.

15. Havemeyer 1993, p. 249. For Louisine Havemeyer's first purchase, see Weitzenhoffer 1986, p. 21; and New York 1993, pp. 203, 329. For the couple's holdings of this artist's work, see New York 1993, pp. 325–38.

16. "Most beautiful . . .": in Venturi 1939, vol. 2, p. 129. See also Ottawa 1988, pp. 324–25. For the fan, see Lemoisne 566.

17. Cassatt to Louisine Havemeyer, Dec. 28, [1917], in Mathews 1984, p. 330. By 1917 most of Cassatt's immediate family members had died, leaving grown-up nieces and nephews. This comment about her family's disinterest in Degas seems to reflect her understanding that often her relatives had seemed to be humoring her enthusiasm for modern art rather than sharing it (with the exception of her brother Alexander). Havemeyer left all three works by Degas—the fan, the pastel *Woman Bathing in a Shallow Tub* (fig. 7), and *Portrait of a Young Woman* (Lemoisne 861)—to The Metropolitan Museum of Art in 1929 (see New York 1993, pp. 330–31, 334–35). For the Degas market after the Rouart sale, see Cassatt to Louisine Havemeyer, Mar. 30, [1913], NGA.

18. "I do not want to leave it . . .": Venturi 1939, vol. 2, p. 129.

For Cassatt's feelings about the painting, see Ottawa 1988, pp. 442–43; Richard Thomson, "Notes on Degas's Sense of Humour," in Richard Kendall, ed., *Degas 1834–1917* (Manchester, 1985), pp. 11–12; and Higonnet 1992, pp. 134–37, 277.

Matsukata lent it to a Degas exhibition at Galerie Georges Petit in Paris in 1924, where the sitter was once again identified as Cassatt.

19. Cassatt to Louisine Havemeyer, Apr. 1913 (?), in Ottawa 1988, p. 443.

Geffroy 1886. See also the discussion in San Francisco 1986, pp. 430–34; and in Ottawa 1988, pp. 365–72, 443–55.

20. London, National Gallery et al. *Degas: Beyond Impressionism*, exh. cat. by Richard Kendall (1996), pp. 143, 155–156. Harris Whittemore, another collector Cassatt advised, also owned a Degas bather (Lemoisne 1097), which he bought in 1921. Havemeyer owned Lemoisne 794, 816 (from Cassatt), 847, 875, 1031 *bis*, 1148, and 1406; Sears owned Lemoisne 966, 1221, and, as stated, one unidentified pastel; Pope owned Lemoisne 876; and Palmer owned Lemoisne 1028.

21. See Barbara Scott, "Madame du Barry, A Royal Favourite with Taste," *Apollo* 97 (Jan. 1973), pp. 69, 71.

22. For Cassatt's collection, see New York, Kende Galleries, Inc., *Rare Japanese Prints*, sale cat. (Apr. 21–22, 1950), with thirty-four lots once belonging to Cassatt. See also New York 1993, pp. 134–39; Sweet 1966, p. 142; Boston 1989, pp. 36–39, 64–67; and New York, The Metropolitan Museum of Art, *The Great Wave: The Influence of Japanese Woodcuts on French Prints*, exh. cat. by Colta Ives (1974), pp. 45–54.

23. Edmond de Goncourt, July 1, 1892, in George J. Becker and Edith Philips, eds., *Paris and the Arts, 1851-1896: From the Goncourt Journal* (Ithaca/London, 1971), p. 300.

24. See the discussion in Mathews 1994, pp. 277–80; and Cassatt to Louisine Havemeyer, Apr. 4 and 9, 1920, NGA, in which she expressed her bitterness about the common assumption that she lived on her brother's income, as well as her feeling that, even if she had done so, the paintings she recommended to him had increased so much in value that she had more than paid her own way.

"Oh, the dignity . . .": Cassatt to Louisine Havemeyer, Jan. 28, [1911], NGA.

25. Cassatt to Berthe Morisot, [fall 1879], in Mathews 1984, p. 149.

Alexander Cassatt retained a directorship of the Pennsylvania Railroad throughout his retirement. In 1885 he became president of the New York, Philadelphia, and Norfolk Railroad, a position he occupied until he returned to the Pennsylvania Railroad in 1899 to serve as its president, until his death in 1906; see *Dictionary of American Biography* (New York, 1946), vol. 3, pp. 564–67. For Alexander Cassatt's art collection and information about several other Philadelphia collectors (including Frank Thomson and the Scott family) that he and/or his sister may have inspired, see Philadelphia 1985, pp. 12–18.

26. "A beauty": Robert Cassatt to Alexander Cassatt, Apr. 18, 1881, PMA. Alexander Cassatt owned two Pissarros now at the Philadelphia Museum, *The Field and the Great Walnut Tree in Winter, Eragny* (1885) and *Landscape (Orchard)* (1892), as well as an 1888 Pontoise landscape, but their dates of execution preclude an 1881 purchase. He also owned a painting entitled *Spring* (possibly one of the above), which he lent to the World's Columbian Exposition in Chicago in 1893. See Pissarro/Venturi 658, 790; and Philadelphia 1985, pp. 14–15, 30. For Alexander Cassatt's Monet holdings, see Wildenstein 77a, 165, 168, 174, 309, 328, 340, 360, 682. That Monet gave these works to Cassatt to sell is mentioned in the provenance of Wildenstein 360; no further details are known.

"Land of the Yankees": Monet in Boston, Museum of Fine Arts, *Monet in the '90s*, exh. cat. by Paul Hayes Tucker (1990), p. 55.

27. Cassatt to Alexander Cassatt, Sept. 2, [1886], in Mathews 1984, pp. 201–202. Thomson assembled a small but important selection of Impressionist paintings, a number of which he lent to New York's Century Association in May 1885 and to the World's Columbian Exposition in Chicago in 1893. Like many of the collectors Cassatt advised, he also owned seascapes by Manet and Monet (now in the Philadelphia Museum of Art). For Thomson's collection, see Philadelphia 1985, pp. 15–16, 30; his Monet, *Argenteuil, The Bridge Under Repair*, is Wildenstein 194.

28. "Some idea . . ." and "Mother does not give me . . .": Cassatt to Alexander Cassatt, Nov. 18, [1880], in Mathews 1984, p. 153.

For *The Steeplechase*, see Ottawa 1988, pp. 561–63. The painting is Lemoisne 140.

Robert S. Cassatt to Alexander Cassatt, Jan. 21 and Feb. 14, 1881, PMA. Alexander Cassatt may also have owned Degas's *Chanteuse de Café-Concert*, a pastel over mono-

type, which is listed as having belonged to his son, Robert Kelso Cassatt; see Brame/Reff 69, p. 74.

The Jockey is Lemoisne 1001; see Ottawa 1988, pp. 389–90, 459.

29. "Two of horses . . .": Robert S. Cassatt to Edward B. and Robert K. Cassatt, Nov. 3, 1881, PMA.

"[Degas] says . . .": Katherine Cassatt to Alexander Cassatt, Dec. 10, [1880], in Mathews 1984, p. 155.

"Who lets her . . .": Robert S. Cassatt to Alexander Cassatt, Apr. 18, 1881, in ibid., p. 161.

"Furious at Degas . . .": Katherine Cassatt to Alexander Cassatt, Sept. 19, [1881], in ibid., p. 162.

"One of Degas's best . . .": Cassatt to Louisine Havemeyer, Apr. 18, 1920, in Ottawa 1988, p. 337. For details of the purchase and a lengthy discussion of the changes Degas made to the composition, see ibid., pp. 335–37.

30. Alexander Cassatt's Manets are Rouart/Wildenstein 29, 185, 204. Of the figure paintings, Cassatt wrote to her brother, "I hope you will like what was bought for you. There are two life size heads one a half figure, studies and neither of them cost 500 frcs. & the frame of one would have cost 200 frcs. so they are bargains & are very decorative"; Cassatt to Alexander Cassatt, Mar. 14, [1884], in Mathews 1984, p. 180. See also Robert S. Cassatt to Alexander Cassatt, Aug. 5, 1885, PMA, and Philadelphia 1985, p. 14.

"Room and the anti-chamber": Lois Cassatt, in Davis 1978 p. 82.

For the disposition of Alexander Cassatt's collection, see Cassatt to Louisine Havemeyer, Mar. 22, Apr. 4, Apr. 9, Apr. 18, Apr. 28, and Nov. 18, 1920; Robert K. Cassatt to Cassatt, Apr. 1, 1920; and Robert K. Cassatt to Louisine Havemeyer, Apr. 26, 1920, NGA. Cassatt had hoped Louisine Havemeyer would be able to buy Degas's *Dance Class*, but it remained in the family.

31. Robert S. Cassatt to Alexander Cassatt, Apr. 18, 1881, in Mathews 1984, pp. 161–62.

Louisine Havemeyer, in Weitzenhoffer 1986, pp. 21–22. Weitzenhoffer's book fully documents the Cassatt/Havemeyer relationship. Further references and a complete list of the Havemeyer collection of paintings can be found in New York 1993.

32. The Monet is Wildenstein 306.

33. Havemeyer 1993, p. 286. In return Cassatt acknowledged, "[My] constant preoccupation about your collection developed my critical faculty"; Cassatt to Louisine Havemeyer, Apr. 14, [1915], NGA.

34. The three finest Rembrandts in the Havemeyer collection, according to New York 1993, are: *Portrait of a Man* (1632), *Portrait of a Woman* (1632), and *Herman Doomer* (1640) (all in New York, The Metropolitan Museum of Art). See ibid., pp. 62–65, 371–75.

Cassatt referred to money entrusted to her by the Havemeyers: "I have not sent you an account of the funds belonging to you in my hands but they are still there"; Cassatt to H. O. Havemeyer, Feb. 3, 1903, in Mathews 1984, p. 280. She corresponded with them by letter and cable, and seems to have consulted with them before making purchases. Mrs. Havemeyer paid 478,500 francs for the Degas.

35. Biddle 1926, p. 108.

"Gentleman": in Mathews 1994, p. 7.

"[Holding] her duty high . . .": Louisine Havemeyer, in Weitzenhoffer 1986, p. 28.

36. For Hallowell see John D. Kysela, "Sara Hallowell Brings 'Modern Art' to the Midwest," *Art Quarterly* 27, 2 (1964), pp. 150–67.

37. Camille Pissarro to Lucien Pissarro, Apr. 25, 1891, in Rewald 1972, pp. 164–65.

For the importance of the American market for French art, see Robert Jensen, *Marketing Modernism in Fin-de-Siècle Europe* (Princeton, 1994), esp. pp. 49–67. For the transformation of the art market, see Nicholas Green, "Dealing in Temperaments: Economic Transformation of the Artistic Field in France during the Second Half of the Nineteenth Century," *Art History* 10, 1 (Mar. 1987), pp. 59–78.

"Strictly in confidence . . .": Cassatt to Louisine Havemeyer, Feb. 4, [1910], NGA.

38. Jensen (note 37), p. 56.

39. Alfred Trumble, "Picture Sellers and Picture Buyers," *The Collector* 2, 4 (Dec. 15, 1890), p. 44.

40. Vollard 1978, p. 142.

41. Sarah Choate Sears to Royal Cortissoz, July 24, 1926, Beinecke Rare Book and Manuscript Library, Yale University, New Haven, Conn.

42. For Sears see Stephanie Mary Buck, "Sarah Choate Sears: Artist, Photographer, and Art Patron," M.F.A. thesis, Syracuse University, 1985; and Erica E. Hirshler, "The Great Collectors: Isabella Stewart Gardner and Her Sisters," in Alicia Faxon and Sylvia Moore, eds., *Pilgrims and Pioneers: New England Women in the Arts* (New York, 1987), pp. 26–27. Sears's art collection is

the subject of a forthcoming article by the present author.

For letters from Cassatt on the supernatural, see Sweet 1966, pp. 179–81.

43. Sweet 1966, p. 196.

44. H. O. Havemeyer to Paul Durand-Ruel, Feb. 20, 1899, in New York 1993, p. 225. *Dancers at Rest* is Lemoisne 343. In addition to *The Street Singer* (Rouart/Wildenstein 50), Sears eventually owned two Manet pastel portraits, *Madame Jules Guillemet Wearing a Hat* (St. Louis Art Museum), purchased in Paris in 1907; and *Woman in a Hat with a Gray Feather (L'Inconnue)* (Rouart/Wildenstein 85), which she owned by 1905. It has yet to be ascertained, however, to what extent Cassatt influenced Sears to make these later acquisitions.

45. Havemeyer 1993, pp. 281–82. See also Weitzenhoffer 1986, pp. 142–43; and Philadelphia Museum of Art et al., *Cézanne*, exh. cat. by Françoise Cachin et al. (1996), pp. 551, 553, 565, 574. Cassatt may also have owned Cézanne's *Apples and Cloth* (1879–80; Japan, private collection [Rewald 339]); she sold a painting of this description to Vollard about 1904. She had another painting, *Still Life with Compote, Apples, and Loaf of Bread* (1879–80; Winterthur, Oskar Reinhardt Collection), in 1905, when she entrusted it to Durand-Ruel. It is unclear whether she actually owned it or was acting on behalf of a collector; see Rewald 339, 420. *Still Life with Rum Bottle* is ibid. 681.

46. "In response to . . .": Cassatt to Théodore Duret, Nov. 30, [1904], in Mathews 1984, p. 295.
"One of the first . . .": Cassatt to Adolph Borie, July 27, 1910, in Weitzenhoffer 1986, p. 192. Cassatt bought a Courbet with the proceeds, perhaps one of the two Courbet portraits she owned. It must be noted that, by this time, Cassatt had become disillusioned with the art of Cézanne, particularly due to his effect upon the younger generation of painters whose increasing abstractions she disliked. See also Cassatt to Louisine Havemeyer, Sept. 6, [1912], NGA; and John Rewald, *Cézanne and America* (Princeton, 1989), p. 25. In 1912 Bernheim offered to buy the Cézanne back from Sears for 12,500 francs, but she declined; Cassatt to Louisine Havemeyer, Oct. 2, [1912], NGA.

47. *The Washbasin* is Lemoisne 966; *The Mante Family* is ibid. 971. The two small Degas pastels have not yet been identified but were described in a 1958 inventory, curatorial files, Department of Paintings, Museum of Fine Arts, Boston.

48. Information on what hung in the Arlington Street house has come from a conversation between the author and Sarah Sears's grandson, July 17, 1997. Although Louisine Havemeyer described *The Mante Family* as if it were her own (Havemeyer 1993, p. 257), it actually belonged to Sears. In addition the Boston press reported in 1912 that Sears had purchased Degas's *Dancers Practicing at the Bar* for a record price from the Rouart sale in Paris, a claim Sears appropriately denied, for Louisine Havemeyer had made that acquisition ("Mrs. Sears Buyer of Degas," *Boston Evening Transcript*, Dec. 18, 1912, curatorial files, Department of Paintings, Museum of Fine Arts, Boston).
On the 1915 exhibition at Knoedler's, see the account of the exhibition in Weitzenhoffer 1986, pp. 219–27; and New York 1993, pp. 89–95. The extent of the friendship between Sarah Sears and Louisine Havemeyer remains unknown; however, Sears's daughter Helen was "great friends" with Louisine Havemeyer's daughter Electra (conversation with Sarah Sears's grandson, July 17, 1997).
"Mentality . . . so far above the average": Sarah Choate Sears to Royal Cortissoz, Aug. 4, [1926], Beinecke Rare Book and Manuscript Library, Yale University, New Haven, Conn.

49. Cassatt mentioned the Popes in a letter dated Mar. 31, 1894, Harris Whittemore Correspondence, Harris Whittemore, Jr., Trust, Naugatuck, Conn. I am grateful to Polly Pasternak of the Hill-Stead Museum Archives, Farmington, Conn., for sharing this letter with me.

50. "There is also a charming little scene of happy motherhood by Miss Cassatt, a family friend, [and] valuable advisor . . . who has done much to forge a bond between America and French art"; Bénédite 1908, p. 173.

51. For the Pope collection, see Helen Hall, *Hill-Stead Museum House Guide* (Farmington, Conn., 1988); and E. Waldmann, "Modern French Pictures: Some American Collections," *The Burlington Magazine* 17, 85 (Apr. 1910), pp. 62–66.
The works by Monet owned by the Popes are Wildenstein 126, 1175, 1215, 1267; the works by Degas are Lemoisne 596 and 617; that of Manet is Rouart/Wildenstein 122. The collection at Hill-Stead includes Manet's *La Posada* (Rouart/Wildenstein 110), acquired in 1896; Puvis de Chavanne's *Peace*, purchased in New York in 1894; Whistler's *Portrait of Carmen Rossi*, *The Blue Wave*, and *Symphony in Violet and Blue*, the latter bought directly from the artist; as well as a significant collection of Western and Japanese prints and two examples by Cassatt (Breeskin 1970, 379 and a color print,

Gathering Fruit). While not now at Hill-Stead, Pope also owned Cassatt's *The Child's Bath* (cat. 28), *The Barefooted Child* (Breeskin 1970, 276) and *Antoinette Holding Her Child by Both Hands* (Breeskin 1970, 339).
"I met Vollard . . .": Camille Pissarro to Lucien Pissarro, Oct. 21, 1894, in Rewald 1972, p. 248.

52. For the continuing connections among Cassatt, the Havemeyers, and the Popes, see for example Cassatt to Ada Pope, Feb. 18, [1903], Hill-Stead, in which she wrote: "I used to hear of you through Mrs. Havemeyer, but Miss Pope tells me you have been quite settled in the country and are not often in New York."
I am grateful to Robert Whittemore for clarifying the provenance of Degas's *Interior*. Just one year after Whittemore's purchase of *Interior*, the first Degas scholar, Paul André Lemoisne, claimed that the original title of the painting was *The Rape* (see Ottawa 1988, pp. 143–46); see also Barter, p. 68 and n. 58.

53. "She is still in favor . . .": Cassatt to Ada Pope, June 30, [1903], in Mathews 1984, p. 284.
"You must remember . . .": Cassatt to Theodate Pope, [Sept. 1903], in ibid., pp. 285–86.
"I wish you could have heard . . .": Cassatt to Louisine Havemeyer, n.d., in Weitzenhoffer 1986, p. 146.

54. For the paintings sold or otherwise disposed by Theodate Pope or by her father—including three by Cassatt, two by Degas (including *The Interior*, which was left to Harris Whittemore in Pope's will), five by Monet, one by Pissarro, one by Renoir (also inherited by Whittemore), and two by Whistler—see Hall (note 51), p. 50.

55. Harris Whittemore, Jr. surmised that his father and grandfather had been introduced to Cassatt by Clinton Peters, an American portraitist in Paris whose wife, Adele, was J. H. Whittemore's niece. However, Peters's traditional training and frequent participation in Salon exhibitions removed him from Cassatt's artistic circle; and, although Cassatt mentioned the Peterses in her correspondence, she seems to have known them primarily through her friendship with the Whittemores, rather than the other way around. Alexander Cassatt could also have provided the Whittemores an initial link with his sister.

56. "Take a cup . . .": Cassatt to Harris Whittemore, 1893, Whittemore family collection, in New York, Christie's, *Important Impressionist Paintings from the Collection of Harris Whittemore*, sale cat. (Nov. 12, 1985), p. 15.

Whittemore married Justine Morgan Brockway in Sept. 1892.

"If you can go . . .": Cassatt to Harris Whittemore, 1893, Whittemore family collection, in ibid., p. 14. The work by Sisley is not listed in François Daulte, *Alfred Sisley* (Lausanne, 1959). The Morisot has not been identified in Bataille/Wildenstein; the Degas is Brame/Reff 105. I am indebted to Robert Whittemore for his generous assistance and interest.

57. On *The Races in the Bois de Boulogne*, see Rouart/Wildenstein 184; and New York (note 11), pp. 338–39.

On Whittemore's purchases in Dec., see Weitzenhoffer 1986, p. 93. The work by Monet Whittemore purchased from Durand-Ruel in Dec. 1893 may have been *The Creuse, Dark Weather* (c. 1889; Wuppertal, Germany, Von der Heydt Museum). The Pissarro has not yet been identiified. Over the next thirty years, Whittemore bought twenty more Monets for a total of twenty-five paintings; in order of purchase, they are Wildenstein 688, 842, 1286, 1268, 1222a, 1111 (*Rocks at Belle-Ile*), 352 (*Snowy Street at Argenteuil*), 372 (*Boats at Argenteuil*), 488 (*Apple Trees near Vétheuil*), 1224, 769, 1514, 1465, 1121, 724, 1716, 736, 782, 835, 906, 980, 1173, 1333, 1339, 1101. The other works by Degas in Whittemore's collection included Lemoisne 91 (*Three Dancers in the Wings*), 274, 348, 409, 650, 661, and 1097; as well as Brame/Reff 60, 91, 105, 148 (*Four Dancers in the Rehearsal Room*). The Manet seascape is Rouart/Wildenstein 174; Whittemore also owned Manet's *Portrait of Pabillos de Valladolid* (ibid. 103).

"I am glad . . .": Cassatt to J. H. Whittemore, Dec. 22, [1893], in Mathews 1984, p. 250.

58. Cassatt to [J. H.] Whittemore, Feb. 15, [1894], in Mathews 1984, p. 259. This letter seems to have been intended for Harris, not J. H. Whittemore.

59. For de Bellio, see Distel 1990, pp. 108–23.

60. I am grateful to Miriam Stewart at the Fogg Art Museum for her help with the Whittemore collection. *Violinist and Young Woman Holding Sheet Music* is Lemoisne 274; the drawing for *Dancers Practicing at the Bar* is ibid. 409.

On Whittemore's *Woman Bathing in a Shallow Tub*, see Lemoisne 1097; and New York 1993, p. 282.

61. Alfred Trumble, "Picture Sellers and Picture Buyers," *The Collector* 2 (Nov. 15, 1890), p. 23. The Monets mentioned here are Wildenstein 1222a, 1224, 1274, 1279.

62. For the Palmers' purchases at Durand-Ruel, see the curatorial files,

Department of European Painting, The Art Institute of Chicago; the Durand-Ruel stock books list their initial Degas purchase as "Two Dancers." The Palmers made their acquisitions both in Paris and New York. For the Palmers, see their correspondence in AIC and the Chicago Historical Society; Aline Saarinen, *The Proud Possessors* (New York, 1958), pp. 3–24; Ishbel Ross, *Silhouette in Diamonds: The Life of Mrs. Potter Palmer* (New York, 1960); the various collections catalogues of The Art Institute of Chicago, particularly Richard R. Brettell and Suzanne Folds McCullagh, *Degas in The Art Institute of Chicago* (Chicago, 1984). For the Palmer collection, see Weitzenhoffer 1986, pp. 86–91; and Margo M. Hobbs, "Bertha Palmer's Philanthropy in the Arts," M.A. thesis (The School of The Art Institute of Chicago, 1992). The Palmers' holdings of works by Monet included Wildenstein 110, 284, 521, 538, 550, 611, 651, 678, 742, 830, 839, 854, 865, 892, 986, 988, 989, 998, 1007, 1025, 1052, 1060, 1068, 1071, 1097, 1106, 1136, 1188, 1195, 1204, 1210a, 1211, 1222a, 1224, 1231, 1246, 1252, 1253, 1258, 1270, 1271, 1273, 1274, 1278, 1279, 1283, 1290, 1293, 1704, 1731, 1298, 1299, 1348, 1352, 1435, 1474, 1524. Their Renoirs included 111, 297, 305, 306, 381, 464, 490, 580, and 610 in François Daulte, *Auguste Renoir* (Lausanne, 1971).

63. In addition to Degas's *On the Stage* and *The Morning Bath*, and two unidentified works, the Palmers owned Lemoisne 512 and 972. Their Manets were Rouart/Wildenstein 98, 78.

64. On Sara Hallowell's relationship with the Palmers, see Hallowell to Potter Palmer, Aug. 15, 1891, Palmer Papers, Chicago Historical Society.

On Cassatt's recommendation of Camille Pissarro's work to Hallowell, see Camille Pissarro to Lucien Pissarro, Oct. 21, 1894, in Rewald 1972, p. 249.

"Miss Cassatt . . . sends you . . .": Sara Hallowell to Bertha Palmer, Feb. 6, [1894], in Mathews 1984, p. 254.

65. For Stillman see Burr 1927; and John K. Winkler, *The First Billion: The Stillmans and the National City Bank* (New York, 1934). Stillman's diaries are preserved at Houghton Library, Harvard University, Cambridge, Mass. For his collection, see New York, American Art Association, *Important Paintings by Old and Modern Masters from the Estate of the Late James Stillman* (1927). The copy of this catalogue in the library of the Museum of Fine Arts, Boston, includes an unidentified clipping, dated Feb. 12, 1927, giving further information about the sale. See also René Gimpel, *Diary of an Art Dealer* (New York, 1966), pp. 11, 143, 145, 318.

66. James Stillman diary entry for May 9, 1914, Harvard.

67. Burr 1927, pp. 295, 297.

68. "A sort of longing . . .": Cassatt to James Stillman, June 28, 1908, in ibid. pp. 298–99.

Winkler (note 65), pp. 193–94.

"I like the way . . .": Cassatt to Louisine Havemeyer, Nov. 29, [1906], NGA. See also the letters of Apr. 25 and Sept. 26, [1910], in ibid., in which Cassatt referred to the slowness with which Stillman made decisions about his purchases and her inability to persuade him to consider things to which he did not immediately respond.

69. "See the Luinis . . ." and "Not up to his standard": in Havemeyer 1993, p. 88.

"What he showed me . . .": Cassatt to Louisine Havemeyer, Oct. 29, Nov. 8, Nov. 29, and Nov. 30, [1906], NGA.

Titian's *Cardinal Cristoforo Madruzzo* passed from Stillman in Paris to his daughter in New York. It was sold to the Saõ Paolo Museum in 1950. For the disposition of the Stillman collection, see Cassatt to Louisine Havemeyer, Aug. 22, [1918], NGA.

70. Quoted in Burr 1927, pp. 284–85.

71. Cassatt to Louisine Havemeyer, May 13, [1910], NGA. The Nattier, *Portrait of a Lady Dressed as Flora, Said to be Mlle. Blondel de Gagny*, is now attributed to the artist's circle. Its current location is unknown since it was on the art market in 1990.

72. "I was in town Monday and Mr. Stillman went with me to Durand-Ruel's, there we saw the Degas with the men's heads in the orchestra and the ballet behind, he acknowledged it was a fine painting but could not *endure* the subject"; Cassatt to Louisine Havemeyer, Sept. 7, [1910], NGA.

73. The Courbets in Stillman's possession that can be identified in Fernier are 325, 460, and 712 (*Calm Sea*).

"Too like an American landscape": Cassatt to Louisine Havemeyer, Mar. 1912, NGA. See also New York 1993, p. 258.

"Mr. Stillman has the greatest contempt . . .": Cassatt to Louisine Havemeyer, Sept. 6, [1912], NGA.

74. The work of El Greco was unfamiliar outside Spain until the Parisian writer Théophile Gautier admired it following his 1840 trip to Spain. El Greco's reputation grew in France in the 1860s with the praise of critic Zacharie Astruc and such artists as Manet. The first modern retrospective

of his work was held at the Prado in 1902. See Jonathan Brown, "El Greco, the Man and the Myths," in The Toledo Museum of Art, *El Greco of Toledo*, exh. cat. (1982), pp. 15–32.

75. "I want to write . . .": Cassatt to Paul Durand-Ruel, Nov. [1903], in Mathews 1984, p. 288.

The story of the Havemeyers' involvement with the El Greco and the Metropolitan's response to it appears in Weitzenhoffer 1986, pp. 140–41, 152–57; and in New York 1993, p. 238.

"He doesn't have time . . .": Durand-Ruel to Cassatt, [Dec.], 1904, Weitzenhoffer 1986, p. 157.

76. For Cassatt on Washington B. Thomas, see Cassatt to Durand-Ruel, [Nov. 1905], in Venturi 1939, vol. 2, p. 120. After H. O. Havemeyer's death in 1907, Thomas served as president of the American Sugar Refining Company from 1908 to 1911, during the sugar-fraud scandal; see Thomas's obituary, *Boston Evening Transcript*, May 29, 1929, p. 1.

"The Boston Directors . . . bought a fine portrait of Greco in Madrid," Cassatt noted; Cassatt to Carl Snyder, Apr. 21, 1904, in Mathews 1984, p. 292. The Boston purchase was written up in the Paris *Herald* (Georges Bal, "Le Tableau du Greco au Musée de Boston," undated clipping [1904], curatorial files, Department of Paintings, Museum of Fine Arts, Boston) and is further documented in correspondence between Sargent and Edward Robinson, curatorial files, Department of Paintings, Museum of Fine Arts, Boston.

77. "I note what you say . . .": Cassatt to Charles Hutchinson, Jan. 9, 1905, AIC.

For Hutchinson see Aileen Hollis, "Charles L. Hutchinson and the Development of The Art Institute of Chicago," M.A. thesis (The School of The Art Institute of Chicago, 1989). Despite her success at providing an American museum with an El Greco, Cassatt hated how the painting was displayed: "I have yours from Chicago where you had seen the Art Institute and the Greco—they greatly pride themselves on their shed of glass which was made especially for them in Pittsburgh. What are you to do with them? You certainly cannot give them taste. Well they have the picture and some day some one will come along and put things right"; Cassatt to Louisine Havemeyer, Sept. 7, [1910], NGA.

78. "Form the beginning . . .": Cassatt to Clarence Gihon, Sept. 13, [1905], in Mathews 1984, p. 297.

"It was well understood . . .": Cassatt to Harrison S. Morris, Aug. 29, [1904], in Sweet 1966, p. 166.

"Excellent examples . . .": Cassatt to John F. Lewis, Mar. 22, 1912, PAFA. See also Philadelphia 1985, p. 12; and Cassatt to Louisine Havemeyer, Jan. 9, [1912], NGA.

"It would help . . .": Cassatt to Louisine Havemeyer, Nov. 30, [1912], NGA. For the disposition of the Havemeyer collection, see Weitzenhoffer 1986, pp. 244–45, 248, 251–53; and Mary Cassatt to Louisine Havemeyer, May 24, 1919, NGA. Cassatt also advised the Metropolitan directly at the time of the Degas estate sales in 1918–19. See Gimpel (note 65), p. 17; and New York 1997, pp. 276–81.

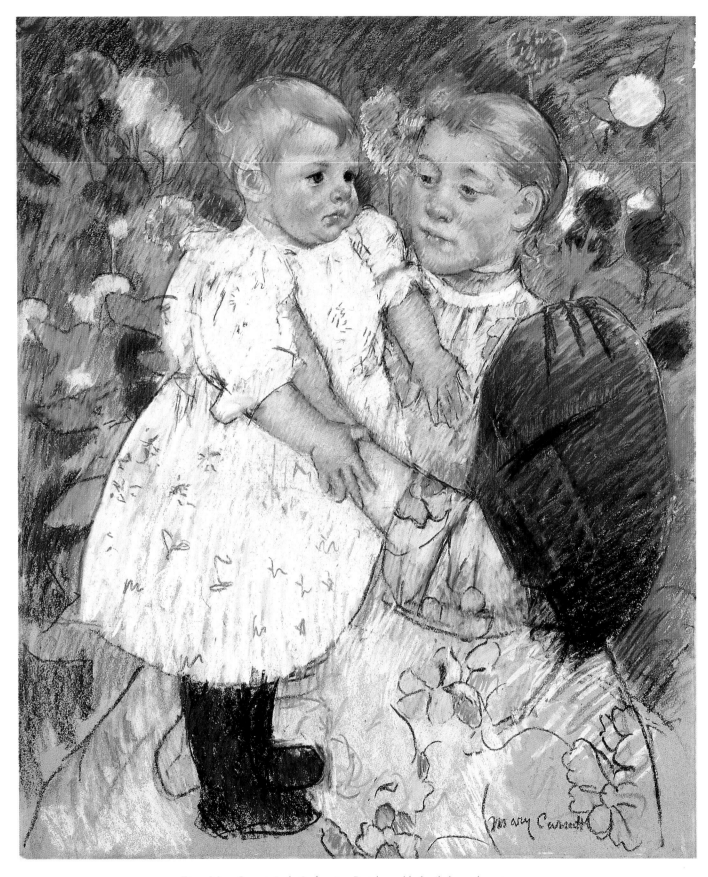

Fig. 1. Mary Cassatt. *In the Garden*, 1893. Pastel over black oiled pastel, on tan
wove paper (originally blue-gray); 73 x 60 cm. Baltimore Museum of Art, Cone
Collection, formed by Dr. Claribel Cone and Miss Etta Cone of Baltimore, Md.

Innovation and Tradition in Mary Cassatt's Pastels:
A Study of Her Methods and Materials

Harriet K. Stratis

Although it is unclear when Mary Cassatt first picked up a stick of pastel to draw, it is possible that she encountered the medium in the early 1860s, when she was studying at the Pennsylvania Academy of the Fine Arts.[1] Yet it is only after Cassatt settled in Paris, in the late 1870s, that her emergence as a pastelist can be securely documented. Her works at this time reveal her to have been an accomplished practitioner of the medium; they display a studied execution and a sophistication unusual in a beginner.[2] The colors are pure and unmuddied, the line is sure, and the subjects and compositions are complex. Cassatt was primarily a figure painter and portraitist, and as such she was allied with a growing number of female artists in France who produced pastel portraits as a respectable and at least marginally lucrative way to make a living. Although Cassatt never submitted a pastel to the annual Paris Salon, many of these women did so regularly. When drawings that appeared in these exhibitions are sorted by genre and medium, the numbers reveal that pastel was clearly the favored medium for portraiture. Moreover a high percentage of the pastel portraits were produced by women.[3] However, the vast majority of these artists received little attention within the traditional art circles of their day; fewer still found success and recognition outside these circles.

Cassatt departed from this largely anonymous community of women artists when in 1877 Edgar Degas invited her to exhibit with the independent artists who came to be known as the Impressionists. Unlike other women artists of the period, she and Berthe Morisot, a member of the Impressionist group from its inception in 1874, had a unique and unprecedented opportunity to achieve recognition. While Cassatt's contemporaries worked almost exclusively in pastel, she preferred a much broader array of materials, exploring distemper, metallic paint, pastel, gouache, watercolor, and etching— sometimes unconventionally combining several of these media into a single work. She was well aware of the methods and materials of Degas, who was an ever-present influence, as can be seen in many of the works she produced during these years. In the atmosphere of experimentation that was fostered by her colleagues in the Impressionist circle, Cassatt created many remarkable works. She used pastel, gouache, and metallic paint on paper mounted on canvas to create *At the Theater* of 1878/79 (cat. 19), perhaps one of her most ambitious and successful attempts to combine these materials. She applied the pastel in broad strokes over passages of gouache. Only in the woman's profile did Cassatt carefully blend and stump the pastel to achieve gradations of tone in the shadows, while using a precise line to record facial features. Looser strokes evoke, rather than delineate, the sitter's surroundings. It is primarily the fan, in the immediate foreground of this vertical composition, that draws the viewer's attention, and it is here that Cassatt displayed her virtuosity in combining matte media (gouache and pastel) with shimmering touches of metallic paint (see figs. 1, 2). Her use of materials, the presence of metallic paint in the fan—the inclusion of the fan itself—are all elements that link the artist and her work to Degas.

Degas created twenty-two fans between 1878 and 1885, most around 1879; he exchanged one of these (Barter, fig. 22) with Cassatt for a work of hers after he included it in the Impressionist exhibition of 1879.[4] The gestural spatterings of metallic paint in this and other fans surely inspired Cassatt's use of similar materials. Cassatt always acknowledged the crucial role Degas played in her career (see Shackelford); during the late 1870s and early 1880s, her art was most closely tied to his methods and materials. Works by Degas and Cassatt executed in varied media on both paper and fabric supports point to a time of intense collaboration, a constant dialogue between two artists experimenting with the same materials (and, to some degree, subjects) at the same

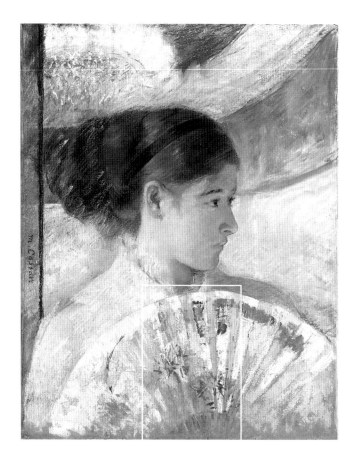

Fig. 2. Mary Cassatt. *At the Theater*, 1878/79 (cat. 19). The squared section indicated on this work is keyed to the detail seen in fig. 3.

Fig. 3. Detail of fig. 2. Cassatt applied touches of metallic paint over and adjacent to passages of gouache and pastel.

moment in their careers. There can be little doubt, however, that Degas initially introduced Cassatt to the matte media that appear in her works of this period. By this time, Degas had spent nearly twenty years in theaters, café-concerts, and dance halls, looking at entertainments set against scenic backdrops painted with these very same materials, and he had experimented through much of the 1870s with matte media such as tempera and distemper to depict these scenes.

By 1878 each artist's exploration of materials appears to have informed the other's. Degas's 1879 *Portrait After a Costume Ball (Portrait of Mme Dietz-Monnin)* (Shackelford, fig. 7) combines distemper with metallic paint and pastel on a fine-weave canvas prepared with a glue size. The artist selectively applied white, yellow, and touches of blue pastel over the distemper, and finished the work with strategically placed strokes of metallic paint. Dating from the same year, Cassatt's large, horizontal composition *At the Theater* (Shackelford, fig. 3) displays a remarkably similar use of materials; here pastel, applied in multiple layers on a primed canvas, appears nearly identical to distemper in handling and appearance.[5] Cassatt must surely have used moisture in conjunction with pastel to create the thick, horizontal bands that denote the tiered balconies. Over these painterly impastos, she applied pastel in a drier, more graphic manner. As in the vertically formatted *At the Theater* (cat. 19; see fig. 2), the artist enhanced the matte surface with touches of metallic paint, this time on the ribs of an open fan (fig. 3), a pivotal compositional element whose size and shape she altered during the working process. However, Cassatt's most ambitious undertaking at this time, in part by virtue of its size, was *Woman Standing, Holding a Fan*, of 1878/79 (cat. 15), an apparently unfinished work in distemper with touches of metallic paint added to the fan. The standing figure in the painting and the seated figure in Philadelphia's *At the Theater* appear to be wearing the same dress. The fans are identical as well, and both were reworked in a similar fashion to reduce their size. The images' painterly palettes are very closely related, and it is quite possible that there may indeed be a layer of distemper present beneath the layers of pastel in the loge subject.[6] Had Cassatt

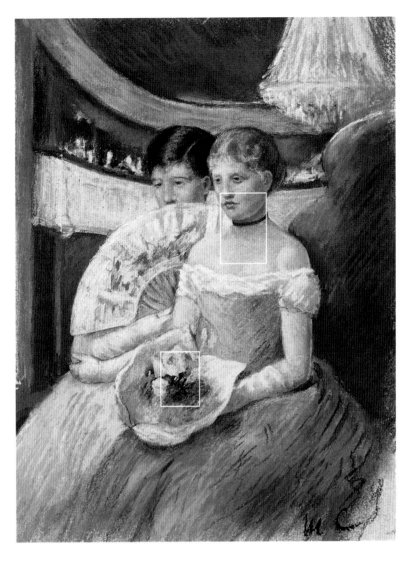

Fig. 4. Mary Cassatt. *Women in a Loge*, 1881/82 (cat. 21). The squared sections indicated on this work are keyed to the details seen in figs. 5 and 6.

Fig. 5. Detail of fig. 4. A band of heavily inked, fine-grain aquatint tone establishes the black choker worn by the figure on the right.

Fig. 6. Detail of fig. 4. In areas where pastel does not obscure the painted substrate, a pronounced aquatint grain is visible.

elaborated upon the painting further, she may well have chosen to add pastel to the distemper surface.

Yet nowhere is the similarity between Cassatt's and Degas's experimentation with materials more pronounced than in Cassatt's small pastel of 1881/82, *Women in a Loge* (cat. 21; see fig. 4). Here, as has recently been discovered, the artist combined pastel and gouache over a soft-ground etching and aquatint printed on textured wove paper (see figs. 5, 6).[7] This combination of materials is unprecedented in Cassatt's oeuvre, and she seemingly never repeated it. The use of pastel and gouache by her contemporaries to embellish printed works is well documented: Degas, Henri Fantin-Latour, Odilon Redon, and others all used similar colored media to almost completely obscure underlying substrates printed in black ink.[8] In Cassatt's work, the embossed plate marks are quite distinct, and the composition in pastel and gouache extends well beyond them to enlarge the background and the women's brightly colored skirts.[9] The artist first applied pale washes of color with a brush over the black printing ink. Over this wash

layer, she added pastel in several ways: she applied it thickly in the background, and perhaps used a fixative to secure underlayers of media where there appears to be more than one layer of pastel. She may have used a brush to apply pastel that she had crushed and mixed with water to form a paste. Where she worked the pastel more thinly, she stumped it lightly into the support, and then drew lines over tonal passages with the pointed tips of pastel crayons.

Cassatt had spent significant time studying the Old Masters in Italy and Spain and copying in the Musée du Louvre, Paris (see Walker). But the advent of new materials—for example brightly colored pastels made with synthetic pigments and dyes, colored papers with unusual surface textures and fibrous inclusions, and a variety of commercially available fixatives—intensified the urge to experiment and expanded opportunities to look forward and to create art in new ways.[10] Artists found that they could apply the chromatic theories published by Michel Eugène Chevreul in 1839 and Odgen Rood in 1879, alongside those of the Old Masters, to exploit more fully the aesthetic potential of new materials. As Cassatt herself stated, ". . . to be a great painter, you must be classic as well as modern." Thus her favored methods and chosen media were innovative at the same time that they remained rooted in tradition.[11]

The combination of old and new can be seen in a small pastel that Cassatt exhibited in 1880, *At the Theater* (Shackelford, fig. 6). She executed this drawing (and most of her works in the medium) on pale blue-gray paper, which, like so many of these papers, has altered to a more golden tone due to the fading of the fugitive aniline blue dye commonly used in their manufacture. The surface of the paper is rather rough and fibrous, made with a coating of finely ground pumice (often dyed blue) to which pastel readily adheres. Colored papers with rough, textured surfaces were extremely popular at this time, and Cassatt chose a variety that she used frequently. Although its color has changed, the paper was originally an integral tonal element in the drawing, and the artist deliberately allowed it to show in numerous passages. Her application of pastel in *At the Theater* resembles that used over the print for *Women in a Loge*

Fig. 7. Attributed to Ugolino di Nerio (Italian; act. 1317–27). *Virgin and Child Enthroned with Saints Peter, Paul, John the Baptist, Dominic, and a Donor*, 1325/35 (detail). Tempera on panel; 43.4 x 29.1 cm. The Art Institute of Chicago, Mr. and Mrs. Martin A. Ryerson Collection, 1937.1007.

(cat. 21), discussed above: the artist drew linear strokes over stumped and blended underlayers, which may have been fixed in earlier stages of the working process. Then she employed steam or moisture to further secure the powdery media, in part by softening the gum that adhered the pumice coating to the sheet. Using a brush, she applied crushed pastel, in the form of a paste, to the bright, white chandelier behind the seated figure.

A most unusual element of Cassatt's pastel technique was to become her standard practice by the later 1880s: her manner of establishing light and shadow in the flesh of her sitters by using shades of green (and sometimes blue) pastel over and under stumped passages of white, pink, and peach pastel (see cats. 53, 66, 86). Often criticized by reviewers for looking "dirty,"[12] the facial skin tones of Cassatt's theatergoers and women with children may have been

inspired by the pale-green features of the Madonnas of thirteenth-century Italian masters such as Giotto, Duccio, and their followers (see fig. 7). In their panel paintings, these artists delicately modeled flesh tones over green-earth underpaintings. In her pastels, Cassatt first applied and fixed or steamed an underlayer of green pastel (to secure it to the paper); over this she applied flesh-toned pastel, which she stumped and blended to create a velvety surface. Next she added lines of green or blue to establish shadows. In a final step, she again used steam to sink the darker pastel into the underlayers and establish shadows across the sitters' faces.[13]

Perhaps pastel—often thought of as painting in the dry manner—provided Cassatt with the opportunity to explore such chromatic relationships with more immediacy than painting, which does not allow for the spontaneous execution she found so desirable, since oil paint takes time to dry between applications. The wide range of newly available pastel colors and colored papers permitted Cassatt to bring the methods of the Old Masters up to date, while putting into practice the chromatic theories of her day. In invoking Degas's advice that "one must bow down before the Primitives," Cassatt indicated that she shared his reverence for the art of past.[14] She and the other Impressionists who concentrated on depictions of the human figure were deeply interested in the conventions of painting and looked to traditional techniques for ways to resolve some of their own artistic dilemmas.

In 1893, after completing *Modern Woman* (Barter, fig. 51) for the World's Columbian Exposition in Chicago, Cassatt returned to pastel with a newfound sensibility she had derived from her experience with mural painting. The women and children that she began to depict in 1882 now, for a brief time, inhabit more stylized, decorative worlds.[15] Accordingly Cassatt extended the range of her pastel palette and devised flattened compositions in which the figures appear close to the viewer. She delighted in setting brightly patterned dresses against contrasting, patterned backdrops, as in *In the Garden* (fig. 1), an 1893 pastel on fibrous paper that was once pale blue-gray in tone but today appears tan. In this work, most of the pastel was applied in only one or two layers over

an underdrawing that remains much in evidence. Rich, velvety, black lines of oiled pastel, only partially obscured by the layers of colored pastel over them, indicate that Cassatt shifted the position of the woman's arm and altered the size and shape of the child's legs.[16] Similar pentimenti that reveal the manner in which elements of the composition were changed remain visible in a number of pastels Cassatt made in the 1890s and later.

Cassatt very deliberately used oiled pastel (and, much less frequently, oiled charcoal) solely for the purpose of underdrawing. These media cling readily to paper fibers and, because of the oil that binds the black particles, they are extremely difficult to irradicate.[17] Unlike lines drawn with powdery media such as pastel or charcoal—which can easily be removed from the surface of the paper with the touch of a feather or with a smudge of a finger or rag—evidence of marks made with oiled media always remain visible. Their appearance in *In the Garden* and other works of this period is not surprising, given that Cassatt's pastels had begun to display new exuberance and to reveal more of her working process. While she continued to employ many of the pastel techniques she had used in works of the 1870s and 1880s—stumping and blending underlayers of tone, and contrasting tones to establish shadows in highly finished faces—now Cassatt more fully exploited the potential of pastel as a graphic medium with both hard and soft sticks, handled in a much more loose, free, and linear manner.[18]

Among the figures in *Modern Woman* was a seated banjo player, in the right-hand panel. After Cassatt completed her monumental painting, she treated this particular subject in a more intimate color print and in a series of pastels.[19] In this she displayed experimentation of a different sort than that which she had undertaken in the 1870s. She no longer combined varied media in a single image on a single support; instead she explored a theme in a number of different ways in independent but related works. In the print of the banjo player (fig. 8), she complemented delicate, drypoint lines with subdued, tonal passages of aquatint to establish a quiet, contemplative atmosphere. The 1893/94 pastels *The Two Sisters* and *The Banjo Lesson* (cats. 73, 75) feature a much

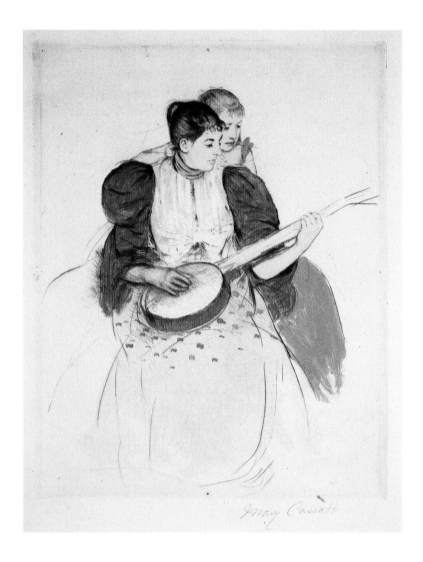

Fig. 8. Mary Cassatt. *The Banjo Lesson*, c. 1893. Drypoint and aquatint on cream wove paper; 29 x 25.6 cm. Collection of Kay and Michael A. Park, courtesy of R. S. Johnson Fine Art, Chicago.

brighter palette and more rigorous execution. Again Cassatt established her forms with black, oiled-pastel underdrawings that she subsequently modified with colored media, leaving pentimenti as she changed her compositions. She used no fewer than five different shades of blue pastel and four different shades of green in *The Banjo Lesson*. The bands of color in the background; the quick, frenzied lines in the foreground; and the way in which the banjo is tilted all reflect a more stylized approach to drawing with pastel. Still Cassatt preferred to render facial features and flesh tones by layering, careful blending, and cross-hatching with pink and peach pastel to produce smooth, velvety surfaces, and by using green pastel to establish shadows.

It is likely that *The Banjo Lesson* was the final version in the series of drawings. In their overall pro-

portion and pose, the sitters match those in *The Two Sisters*, and in fact corresponding areas of the two works share the same dimensions. Given its more sketchlike execution and a number of unresolved passages, *The Two Sisters* may have been one of two initial attempts to work out the composition that was finally realized in *The Banjo Lesson*.[20] Pentimenti in the work indicate that Cassatt grappled with the placement of the hands of the banjo player; she also struggled with the musician's hands and the neck of the instrument in *Girl with a Banjo* (cat. 74). In the end, she probably decided to cut down *The Two Sisters* and retain only the part of the composition that she had indeed resolved.[21]

Over the years that had intervened since Cassatt's early collaboration with Degas, two opposing tendencies emerged in her pastel technique. While she

would always retain a high degree of finish in her sitters' faces, she abandoned this treatment in their garments and surroundings. Certainly this attachment to physiognomic detail was driven in part by her desire as a portraitist to render an accurate likeness. In 1881 she had advised her nephew to "draw very carefully a portrait . . . beginning with the eyes,"[22] an approach she herself had often taken. Frequently Cassatt produced several versions of the same composition. Earlier versions are loose, sketchlike studies that anticipate the more finished, final rendering. She handled the pastel quite differently in each type of work, depending on the goal she wished to achieve.

By the mid-1890s, Cassatt had once again altered her materials and methods. She narrowed the range of colors in her pastel palette and worked almost exclusively on supports in which paper was adhered to canvas and wrapped around a wooden strainer. These were readily available in standard sizes from art suppliers, whose stamps or labels are often in evidence (see fig. 9).[23] Moreoever, because this type of support can be placed vertically upon an easel, one

Fig. 9. Verso of *Portrait of Mrs. Havemeyer and Her Daughter Electra* (fig. 10). The strainer and canvas display the stamps of F. Dupré, a Parisian merchant of fine-art supplies frequented by Cassatt.

can work with it much as one can work directly on canvas. These supports have the added advantage that the large amounts of pastel dust generated in the drawing process fall onto the base of the easel rather than remaining on the surface of the drawing itself.[24]

With the support now oriented vertically on an easel, Cassatt could further simplify her method of securing the media to the paper. While there is no evidence that she applied fixative to any of these works, she continued to employ steam and extended its use over broader expanses of paper: she no longer applied steam only locally as before, but seemingly used it over entire sheets, above and between layers of pastel.[25] Unfortunately this technique had serious drawbacks of which the artist was probably unaware. Certain pastel colors embrittle after exposure to moisture, often resulting in lifting and flaking of the pastel. Careful examination of the surfaces of many of these works reveals series of small, pinpoint losses where the unstable media has fallen away (see cat. 84). Most vulnerable are passages of white and yellow, colors Cassatt used extensively. These sticks may have been manufactured with a large amount of binder that readily reacted with the steam and then severely contracted upon drying. Consequently the majority of Cassatt's pastels, a century after their creation, are now among the most fragile ever produced.[26]

By the mid-1890s, Cassatt sought a more straightforward rendering of her subjects by restricting her materials and techniques. This can be seen in *Portrait of Mrs. Havemeyer and Her Daughter Electra* (fig. 10, and Sharp, fig. 10). Here Cassatt placed her sitters against a somber brown and black surround; moreover she cropped the composition, curtailing her earlier use of expansive, elaborate backgrounds. Thus she intensified the focus on the figures rather than on their surroundings. It is no coincidence that, during the mid-1890s, Cassatt became interested in the works of the great French eighteenth-century pastelists Jean Baptiste Siméon Chardin and especially Maurice Quentin de La Tour (see fig. 11), and appears to have made works in pastel in response to her contemplation of theirs. They too used papers mounted on canvas and applied fixatives sparingly, if at all. Their compositions emphasize only their sitters and the intensity of their gazes, with little background delin-

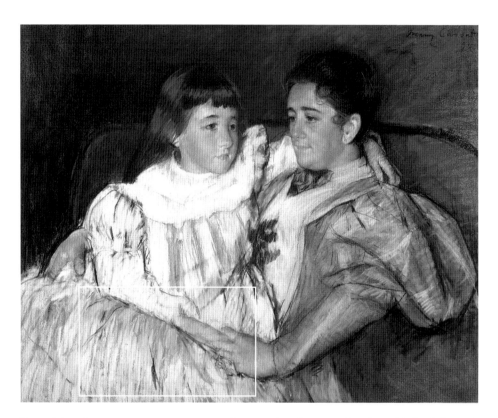

Fig. 10. Mary Cassatt. *Portrait of Mrs. Havemeyer and Her Daughter Electra*, 1895. Pastel over black oiled pastel, on tan wove paper (originally blue-gray), mounted on canvas, on a strainer; 61 x 77.5 cm. Shelburne, Vt., Shelburne Museum of Art. The squared section indicated on the pastel is keyed to the detail seen in fig. 12. For a color reproduction, see Sharp, fig. 10.

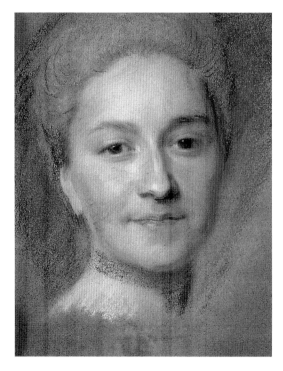

Fig. 11. Maurice Quentin de La Tour (French; 1704–1788). *Portrait of an Unidentified Woman*, n.d. Pastel on tan wove paper with fibrous inclusions; 32 x 24 cm. St.-Quentin, Musée La Tour. Photo: Christine Debrie, *Maurice Quentin de La Tour: "Peintre de portraits au pastel," 1704–1788, au Musée Antoine Lécuyer de Saint-Quentin* (St.-Quentin, 1991), p. 191.

eation. No doubt Cassatt would have studied pastels by both artists in the Louvre. During this period, she also made at least one visit to St.-Quentin, where she saw a collection of eighty of the most celebrated pastels by La Tour.[27] Cassatt's work of 1895 and beyond was informed by her re-evaluation of the traditional methods developed by pastelists more than a century earlier. She was not alone in this regard, for many of her contemporaries were fascinated by the art of the eighteenth century, as the more simple and direct execution in their work of the 1890s attests.

Unfortunately the 1895 pastel of the Havemeyers—exemplary in every way of Cassatt's newfound concerns—also demonstrates the instability of artists' materials manufactured at this time. The support, now tan, was once blue-gray, and the stripes of white and pink pastel in Electra's dress were originally two shades of pink, one more vibrant than the

Fig. 12. Mary Cassatt. *Portrait of Mrs. Havemeyer and Her Daughter Electra* (detail of fig. 10). Comparison of the area where the pastel was protected from light with those areas exposed to light reveals that a vibrant pink has faded to a very pale pink, which appears almost white.

other (see fig. 12). The brighter of the two has now faded drastically, so that the chromatic relationships originally established by the artist have shifted radically.[28] Examination of a number of pastels drawn after 1895 reveals that within Cassatt's large assortment of pastel sticks, it was primarily a group of deep reds and bright pinks that have faded or altered to such a degree.

For the next twenty years, Cassatt made pastels that deviate very little from the methods and materials found in *Portrait of Mrs. Havemeyer and Her Daughter Electra*. In her mature pastel style, she pared down her earlier explorations with materials and reduced her techniques to only a few. Writing to Harris Whittemore in 1898, the year she traveled to the United States and produced a number of pastel portraits on commission (see Sharp, pp. 156–58), she commented that pastel was "the most satisfactory medium for [portraying] children."[29] It may have been the velvety and tactile qualities of the medium that led her to associate its use with the depiction of youth. The spontaneity that pastel allowed was surely an advantage when drawing children who could not or would not sit still for long periods of time. Furthermore the subjects of many of these works are engaged in the act of touching (see Barter, p. 74–76); the gentleness of a caress was perhaps best conveyed with the softest of media.

An unusual body of work that bears mention is a series of counterproofs that were pulled from a number of Cassatt's pastels, most drawn after 1900. All of them—fourteen known pairs of pastels and counterproofs—were part of Ambroise Vollard's inventory until well after the artist's death.[30] It is not only likely that Cassatt was aware that her pastels were being used as the matrices for counterproofs but also that she had a hand in their production. Careful examination of one of these matrices, *The Banjo Lesson* discussed above (fig. 13 [cat. 75]), shows that portions of the media were lifted from passages throughout the drawing, most evidently in the blue and peach passages in the right sleeve of the seated musician. The degree to which the transfer process dislodged pastel seems to have been color dependent, as a reproduction of the now-unlocated counterproof made from the drawing (fig. 14) corroborates. The most vivid areas in the counterproof are precisely those from which the most media was lifted from the pastel matrix. Magnification revealed that pastel was selectively reapplied to some of the passages from which media had been transferred, and that this was achieved proficiently using an identical pastel palette. If Cassatt did not do this herself (and she probably did, given the assured hand in the drawing), she certainly would have had to provide an assortment of her pastel sticks to whomever did reinforce the drawing, since the reworked passages match so precisely those that had preceded them.[31]

Very likely Vollard himself conceived of the project to make the counterproofs, probably from those of Cassatt's pastels he acquired in 1906. He must have elicited the assistance of the printer Auguste Clot (whose firm had printed a number of the dealer's other projects), since a printing press certainly would have been required for this undertaking as well.[32] Drawings as large as Cassatt's must have been placed on the press, covered with sheets of dampened Japanese paper, and together run through the press. Under the weight of the rollers, a mirror image of the pastel would transfer onto the Japanese

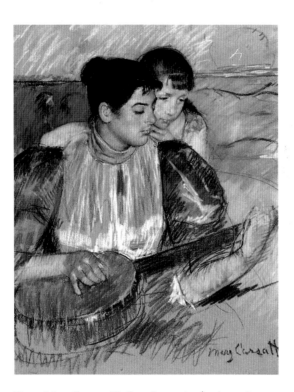

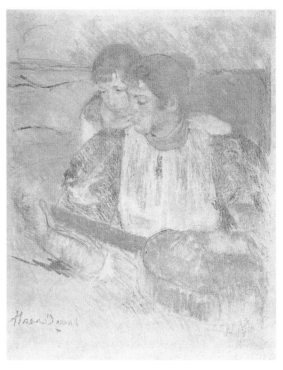

Fig. 13. Mary Cassatt. *The Banjo Lesson*, 1893/94 (cat. 75).

Fig. 14. Counterproof of *The Banjo Lesson* (fig. 13), c. 1906. Pastel offset printed on Japanese paper, mounted on cardboard; 70.5 x 57.3 cm. Location unknown. Photo: New York, Sotheby Parke Bernet, *Mary Cassatt Prints and Drawings*, sale cat. (Feb. 14, 1980), no. 738, p. 31.

paper, thus establishing the counterproof. With the expertise of someone like Clot, papers most conducive to accepting the transferred media would have been chosen. Regrettably the extent of Cassatt's involvement in the production of the counterproofs cannot be fully assessed until the majority of the counterproofs are located, examined, and compared to the matrices from which they derive.

It is, however, intriguing to speculate that Vollard may have had ambitions to see Cassatt's pastels translated into the medium of color lithography. During the mid-1890s, he published color lithographs from the pastels of other notable artists, among them Redon, Pierre Auguste Renoir, and Alfred Sisley. The counterproofs of Cassatt's pastels would surely have been required for Clot to correctly transfer, orient, and register the multicolored drawings onto stone. Clot had used related methods the previous decade, when he printed the works contained in two albums published by Vollard in 1896 and 1897 under the titles *L'Album des peintres-graveurs* and *L'Album*

d'estampes originales de la Galerie Vollard, both of which contained color lithographs derived from drawn works. Interestingly Vollard did not deem it necessary for the artists to actively participate in the making of the prints if they did not display the requisite skill or motivation. This was indeed the case when Clot translated Redon's pastel *Beatrice* (1885; private collection) into a color lithograph for the second album. Renoir too wanted little to do with Vollard's project, and participated by simply leaving his pastels in the dealer's hands to be transferred to stone by Clot.[33] Likewise Cassatt, an innovative printmaker in her own right who produced only one lithograph during her career (cat. 24), would surely not have engaged actively in the production of color lithographs at this stage in her life. While it may never be possible to ascertain Vollard's intentions for the counterproofs pulled from Cassatt's pastels, he may have considered using them in a publication that never materialized.

Failing eyesight and bouts of poor health deterred

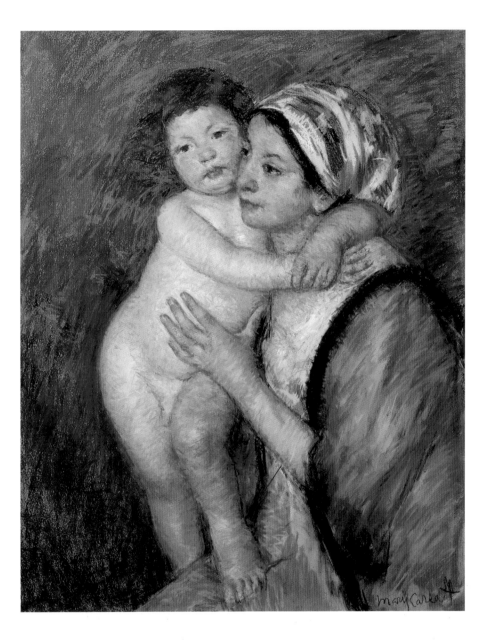

Fig. 15. Mary Cassatt. *Mother and Child*, 1914. Pastel on tan wove paper (originally blue-gray), mounted on canvas, on a strainer; 81.3 x 65.1 cm. New York, The Metropolitan Museum of Art, H. O. Havemeyer Collection, 1929, 29.100.49.

Cassatt from producing art for many of her last years. When she did find the strength and the motivation, she like Degas was inspired to work in pastel, in part because of her love of the medium, and in part because it did not require the efforts of painting. While there were times in 1913 when she could hold a stick of pastel for less than an hour at a time,[34] she persevered to produce at least eight pastels. Seven were delivered to Paul Durand-Ruel in October of that year, and in December she wrote to Louisine Havemeyer that "they were in many respects the best I have done, more freely handled & more brilliant in color."[35] When the opportunity arose in

1915 for Cassatt to present her work alongside that of her longtime friend and colleague Degas in an exhibition dedicated to woman suffrage organized by Havemeyer and held at M. Knoedler and Co. in New York, she felt satisfied that people would finally see "that I don't copy him in this age of copying."[36] And indeed one of her final works in pastel, *Mother and Child* (see fig. 15), made specifically for the exhibition, reflects, in its mastery of color, composition, and the contrapposto of the standing child, her lifelong efforts to integrate the artistic discoveries of the masters who preceded her with her own ambitions to produce an art of the modern age.

Notes

With thanks to Judith A. Barter, Douglas W. Druick, Erica Hirshler, Britt Salvesen, Kevin Sharp, and Peter Kort Zegers for their valuable comments and suggestions on this manuscript; and to numerous colleagues in conservation laboratories across the country who made these fragile works of art on paper available to me for in-depth study.

1. Among French artists, the popularity of pastel began to soar after mid-century; there is no doubt that these brightly colored pastel sticks made their way into the hands of American artists and art students soon thereafter. See Dianne H. Pilgrim, "The Revival of Pastels in Nineteenth-Century America: The Society of Painters in Pastel," *The American Art Journal* (Nov. 1978), pp. 43–62, esp. pp. 44–45.

2. This indeed suggests that Cassatt may not have been a beginner, although, if she produced substantial numbers of pastels prior to the late 1870s, they no longer survive. It is possible that her earliest pastels were lost after she left the United States for Europe in 1872, and that work she produced in France before the mid-1870s could have been destroyed in 1906. It was in this year, after the artist became angry with her dealer Paul Durand-Ruel, that she invited Ambroise Vollard to her studio and sold him a substantial number of works, most on paper; she then burned "all that was left to save my heirs the trouble." See Cassatt to Louisine Havemeyer, Dec. 21, 1906, in Mathews 1994, pp. 281–82, 352, n. 42.

3. These numbers are drawn from my database of the drawings executed in charcoal and pastel and exhibited in the Paris Salons between 1800 and 1890. Wherever possible I used the original Salon catalogue, *Explication des ouvrages de peinture, sculpture, architecture, gravure et lithographie des artistes vivants.* When these were unavailable, I referred to the facsimile edition by H. W. Janson, *Catalogues of the Paris Salon, 1673–1881* (New York, 1977). See also Harriet K. Stratis, "Beneath the Surface, Redon's Methods and Materials," in The Art Institute of Chicago et al., *Odilon Redon: Prince of Dreams*, exh. cat. by Douglas W. Druick et al. (1994), pp. 357–58.

4. Degas produced three additional fans between 1868 and 1869. He exhibited five fans (Lemoisne 457, 566, and possibly 567 among them) in the 1879 Impressionist exhibition. See Ottawa 1988, pp. 324–27.

5. I am grateful to Faith Zieske and Nancy Ash for allowing me to examine this work under magnification in the paper conservation laboratory of the Philadelphia Museum of Art. Ms. Zieske also graciously shared with me her technical findings on the piece. See also Philadelphia 1985, pp. 43–44.

6. It is hoped that the recent emergence of the previously unrecorded painting (cat. 15) that relates to the Philadelphia pastel *At the Theater* will prompt further inquiry into the similarity of materials Cassatt used to create both works.

When Cassatt exhibited with the Impressionists for the first time, she included *In the Garden*, a painting in distemper (unidentified; possibly lost or destroyed); see Lifetime Exhibition History (Paris 1879, no. 56).

7. I am grateful to Cecile Mear for allowing me to examine this work unframed and under magnification in the paper conservation laboratory of the Cincinnati Art Museum. Only in this way could the printed substrate be securely identified. I am also grateful to her and Anne F. Maheux for providing me with the photographic details used in this essay (figs. 4, 5).

8. See Anne F. Maheux, *Degas Pastels* (Ottawa, 1988), pp. 21–22; and Stratis (note 3), pp. 370–71.

9. Mysteriously an impression of the underlying print, unenhanced with color, has never been located among the artist's graphic works. The plate, perhaps like that used to print *Two Young Ladies in a Loge, Facing Right* (cat. 22), could have been destroyed, in this case after only one impression was pulled.

The plate marks measure approximately 22.5 x 18.2 cm. There must have been a distinct bevel along the lower edge of the plate, which resulted in a double plate mark along this edge. The bevel is approximately .5 cm wide and shortens the plate size in that direction to approximately 22 cm. The application of pastel and aqueous media over the print increased the image size approximately 3 cm along the top, 3 cm along the left edge, .8 cm along the right edge, and .35 cm along the bottom, resulting in an overall image that measures 29 x 22 cm.

10. For a thorough technical study on pastel, its development in Europe, and its use in the United States, see Marjorie Shelley, "American Pastels of the Late Nineteenth and Early Twentieth Centuries: Materials and Techniques," in Doreen Bolger et al., *American Pastels in The Metropolitan Museum of Art* (New York, 1989), pp. 33–45. For use of the medium by Degas, see Maheux (note 8); and Denis Rouart, *Degas in Search of His Technique*, trans. Pia C. DeSantis, Sarah L. Fisher, and Shelley Fletcher (New York, 1988).

11. Michel Eugène Chevreul, *De la Loi du contraste simultané des couleurs, et de l'assortiment des objets colorés, considéré d'après cette loi* (Paris, 1839).

Ogden Rood, *Modern Chromatics* (London, 1879).

"To be a great . . . ": Cassatt, in Havemeyer 1993, p. 278.

Many artists of Cassatt's generation who were interested in the techniques of the Italian masters turned to Cennino Cennini's *Libro dell'arte.* This late-medieval treatise was published in a modern Italian version in 1821 and translated into various languages. See Cennino d'Andrea Cennini, *The Book of the Art of Cenninno Cennini (Il Libro dell'arte)*, trans. Christiana J. Herringham (London, 1899).

12. See *New York Times* 1879, in which the writer referred to "a dirty-faced female, in variegated raiment, who, in real life, would never have been admitted in any decent society until she had washed her face and shoulders. . . ." See also Havard 1879.

13. My experiments with these techniques reveal that pastel which has been exposed to steam will sink into and visually blend with the underlying tones to a great degree, while unfixed media will remain on the surface and retain pure tone.

Cennini (note 11; ch. 147, p. 126) described the proper method for painting faces as follows:

Take a little verde-terra [green earth], and a little well-tempered biacca, and go twice over the face, hands, feet, and all the naked parts. . . . Then . . . you must prepare three gradations of flesh-colour, one lighter than the other, laying every tint in its right place in the face, taking care not to cover over the whole of the verdaccio, but shading partially on it with the darkest flesh-colour, making it very liquid, and softening off the colour in the tenderest manner. On a panel more coats of colour are required than on a wall, yet not so many that the green tint under the flesh-colour should be just visible through it.

Perhaps one of the best examples of

Cassatt's use of green can be found in *At the Window* (Breeskin 1970, 179), an 1889 pastel in the Musée d'Orsay, Paris. Curiously Cassatt was reluctant to employ these same tonal juxtapositions in her paintings.

Degas sometimes counseled younger colleagues and followers to use a technique he likened to that of the Venetians, of priming their canvases in green. When the primer dried, he instructed them to glaze over the green with red to obtain the desired tone. He advised that the green be an intense apple green. See Rouart (note 10), pp. 86–88; see also Barter, p. 52 and n. 12, and Shackelford, pp. 110–11.

14. See Cassatt to Carl Snyder, Apr. 21, [1904], in Mathews 1984, p. 292.

15. It is tempting to speculate that, in some way, this change could have represented a direct response to the lack of support given to her by Degas when she worked on the Chicago mural. While Cassatt described her fear of inviting him to see the work (see Shackelford, p. 134), the American painter Theodore Robinson stated that Cassatt "was *desolée* at Degas refusing to go and see [the mural]—he abhors decoration, says it is not of the century"; Theodore Robinson's diary, Oct. 3, 1892, Frick. Cassatt thus may have decided deliberately to contradict Degas by producing works in pastel (and in other media, for that matter) that were clearly more decorative in spirit than his.

16. I am grateful to Kimberly Schenck for allowing me to examine this pastel unframed and under magnification in the paper conservation laboratory of the Baltimore Museum of Art.

17. It is often possible, by using magnification, to discern a slight halo of oil around drawn lines of oiled media. The haloing may have a slightly golden-yellow appearance. It is difficult to identify in Cassatt's pastels, since she so frequently applied pastel over it. Rarely oiled media can be identified by a slight fluorescence under ultra-violet light.

18. Magnification reveals that the artist used harder sticks of pastel for the upper layers and softer sticks for the underlayers. The harder sticks actually incised the underlayers, leaving indented trails of media. This is quite common in Cassatt's pastels.

Smooth and compacted passages indicate that the artist probably used steam to settle the powdery media. This is certainly the case in the two sitters' profiles in *In the Garden*. Other than steam, there is no evidence of fixative on the surface of the drawing or between layers of media.

19. Even while painting *Modern Woman*, Cassatt expressed interest in translating her mural imagery to prints; see Cassatt to Paul Durand-Ruel, Jan. 6, 1893, in Mathews 1984, p. 244.

20. The other is *Sketch for "The Banjo Lesson"* (Breeskin 1970, 236). A pastel on paper, it is said to measure 45 x 48 cm; its present location is unknown.

21. I am grateful to Bruce Suffield for allowing me to examine *The Banjo Lesson* unframed and under magnification in the conservation laboratory of the Virginia Museum of Fine Arts, Richmond. He also provided helpful and insightful comments on the drawing.

22. Cassatt to Eddie Cassatt, Jan. 1881, in Mathews 1984, pp. 156–57; see also Sweet 1966, p. 60.

23. Invariably the paper was pale blue-gray with numerous colored-fiber inclusions, the majority of which are now altered to tan due to light exposure. The paper was adhered to the canvas overall, or alternatively only along the edges.

A Lefranc and Co. catalogue from around 1863 provides a chart of the dimensions of ready-stretched canvases. An 1888 Bourgeois *aîné* catalogue expands upon this, providing a chart of variously sized canvases appropriate for figure, landscape, and marine subjects. See London, National Gallery, *Art in the Making: Impressionism*, exh. cat. by David Bomford et al. (1990), pp. 45–46. There is every reason to believe that, by the 1890s, supports of paper and canvas would also have been similarly available in standard sizes, given the demand for materials used for pastel painting. Cassatt's supports of this type vary little in size, and it is likely that she chose a small number of standard-size supports upon which to work.

24. In fact examination of many of these supports reveals that there is often an accumulation of pastel along the bottom edge, where the strainer would rest on the base of the easel.

25. This method was quite unlike that of Degas, who often used so much fixative between layers of pastel and over them that they became virtually saturated with the material. For Degas fixative-laden drawings were the rule, rather than the exception; see Maheux (note 8), pp. 32–37; and Rouart (note 10), pp. 64–67.

26. Past conservation and restoration efforts have often resulted in the removal of Cassatt's pastels from original strainers and canvas backings, often followed by remounting onto solid supports. Treatments of this sort were sometimes necessary to prevent the paper from tearing or breaking at the corners as a result of so tautly stretching the paper and canvas around the strainer. Some of the remounted works I have studied indeed show that the paper had already been torn or completely broken away at one or more corner. Unfortunately examination also reveals a significant amount of media loss in many of these works, probably as a result of the removal and remounting processes used. Often modern fixatives were also applied to the drawings' surfaces during the course of treatment, altering the tone of the pastel colors. The removal of Cassatt's pastels from their mounts should be considered only as a last resort and only if the support is in extreme jeopardy of tearing or breaking. Certainly the application of a modern fixative that could easily change the colors in the pastel should be avoided at all cost. Conservation efforts would be better focused on the structural stabilization and proper framing of the support on its original strainer, rather than removal from it.

27. The museum in St.-Quentin had opened in 1886 under the name Musée Lécuyer (after the banker Antoine Lécuyer, who had donated works of art as well as the building in which they were to be housed). On Cassatt's visit to St.-Quentin, see Cassatt to Eugenie Heller, [c. Feb. 1, 1896], in Mathews 1984, p. 263. For the complete holdings of the artist in the La Tour Museum, see Christine Debrie, *Maurice Quentin de La Tour, "Peintre de portraits au pastel," 1704–1788, au Musée Antoine Lécuyer de Saint-Quentin* (St.-Quentin, 1991).

Degas also had at least two pastels by La Tour, inherited from his father, in his collection; see Colta Ives et al., comps., *The Private Collection of Edgar Degas: A Summary Catalogue* (New York, 1997), no. 753, p. 83.

28. I am grateful to Eloise Beil, Richard Kerschner, and Sloan Stevens for allowing me to unframe the work, carry out a thorough examination, and view it under the microscope. They also graciously provided me with photographs of areas of interest; two of these are reproduced in this essay (figs. 10, 12).

29. See Cassatt to Harris Whittemore, [late Feb.–early Mar. 1898], Hill-Stead.

30. Thirteen of the fourteen known counterproofs appear in Breeskin 1970; six are signed (270, 374, 382, 427, 439, 459), and seven are unsigned (313, 327, 365, 376, 429, 446, 449). The pastels from which they were made are Breeskin 1970, 269, 373, 381, 426, 438, 459, 312, 326, 364, 375, 428, 445, 448. The fourteenth counterproof (unsigned), fig. 14, was made from Breeskin 1970, 238. From those pastels whose early provenance history is known, it can be ascertained that twelve definitely belonged to Vollard, and it is likely the remaining two did as well.

31. This is not completely implausible, given that she had provided boxes of pastels to artist friends. See Cassatt to Carroll Tyson, Jan. 4, 1909, AAA, in which she stated that she had left him two boxes of pastels (brought from France to Philadelphia), as well as a case of pastel paper sketches. A box of Cassatt's pastels has been loaned by Edith Smith to the present exhibition *hors catalogue*.

32. Methods of counterproofing both printed and drawn works of art on paper interested a number of artists and printers working in Paris at this time. Paul Gauguin's counterproofs of prints and drawings had become familiar to many by the late 1890s. They were certainly well known to Vollard, who collected and sold them, and perhaps to Cassatt, who easily could have seen them at Vollard's. In 1897 Clot also printed a rather curious, little-known group of counterproofs from two of the lithographs of James McNeill Whistler; see The Art Institute of Chicago, *The Lithographs of James McNeill Whistler*, vol. 1, *A Catalogue Raisonné*, eds. Harriet K. Stratis and Martha Tedeschi (Chicago, 1998), pp. 487, 493, n. 176.2.

33. For *Beatrice*, see Alec Wildenstein, *Odilon Redon: Catalogue Raisonné de l'oeuvre peint et dessiné*, vol. 1 (Paris, 1992), no. 145.
Vollard's publication projects, color lithography, and the role of Auguste Clot are discussed in Douglas W. Druick, "Cézanne's Lithographs," in New York, The Museum of Modern Art, *Cézanne: The Late Work*, exh. cat. (1977), pp. 119–37.

34. See Cassatt to Louisine Havemeyer, Apr. 10, 1913, in Mathews 1994, pp. 298, 353, n. 14.

35. See Cassatt to Louisine Havemeyer, Dec. 4, [1913], in Mathews 1984, p. 311. The pastels were possibly Breeskin 1970, 593–600.

36. See Cassatt to Louisine Havemeyer, Mar. 12, [1915], in Mathews 1984, p. 322.

Plates

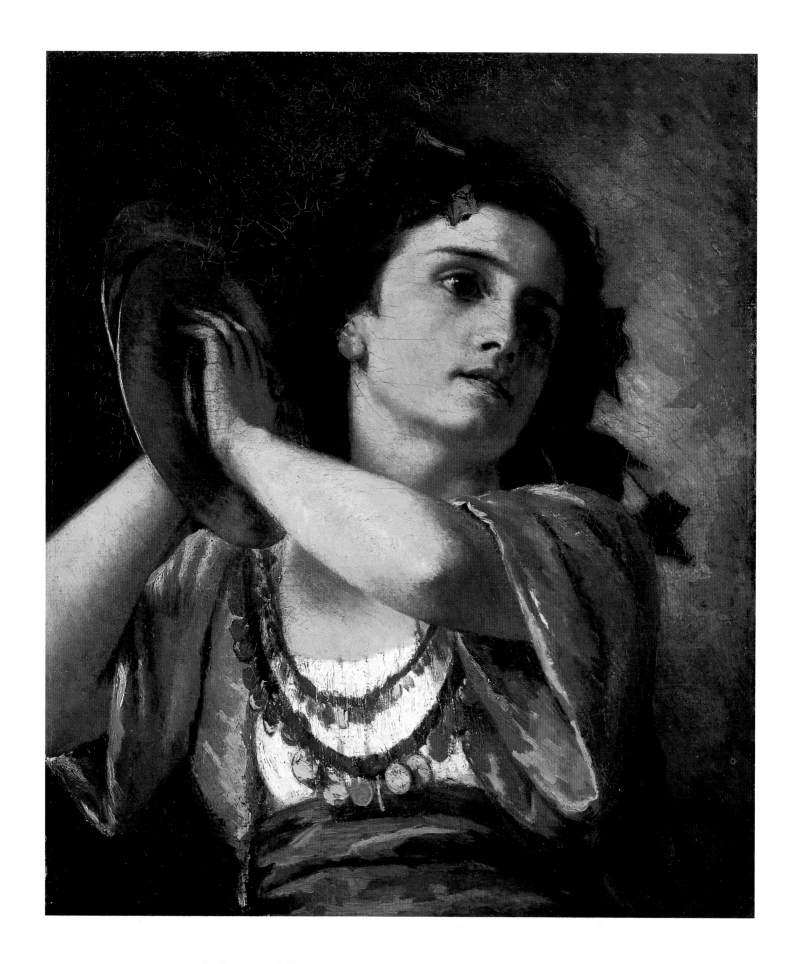

1. *Bacchante*, 1872. Oil on canvas; 62 x 50.7 cm. Philadelphia,
Museum of American Art of the Pennsylvania Academy
of the Fine Arts.

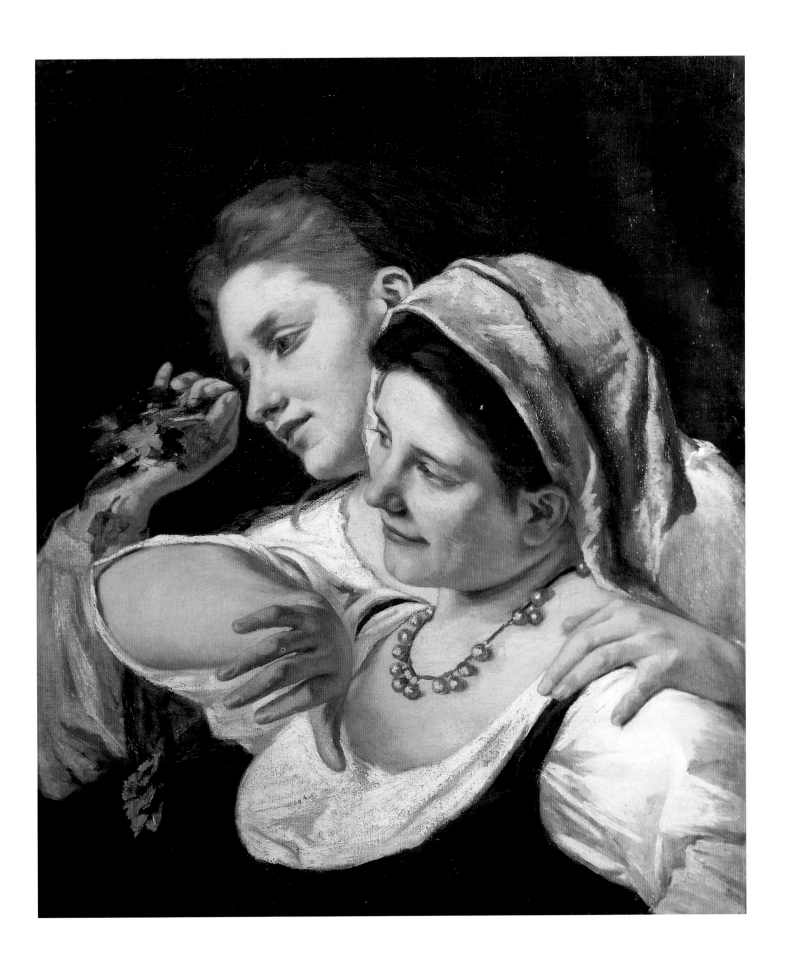

2. *During Carnival*, 1872. Oil on canvas; 63.5 x 54.6 cm.
Lent anonymously.

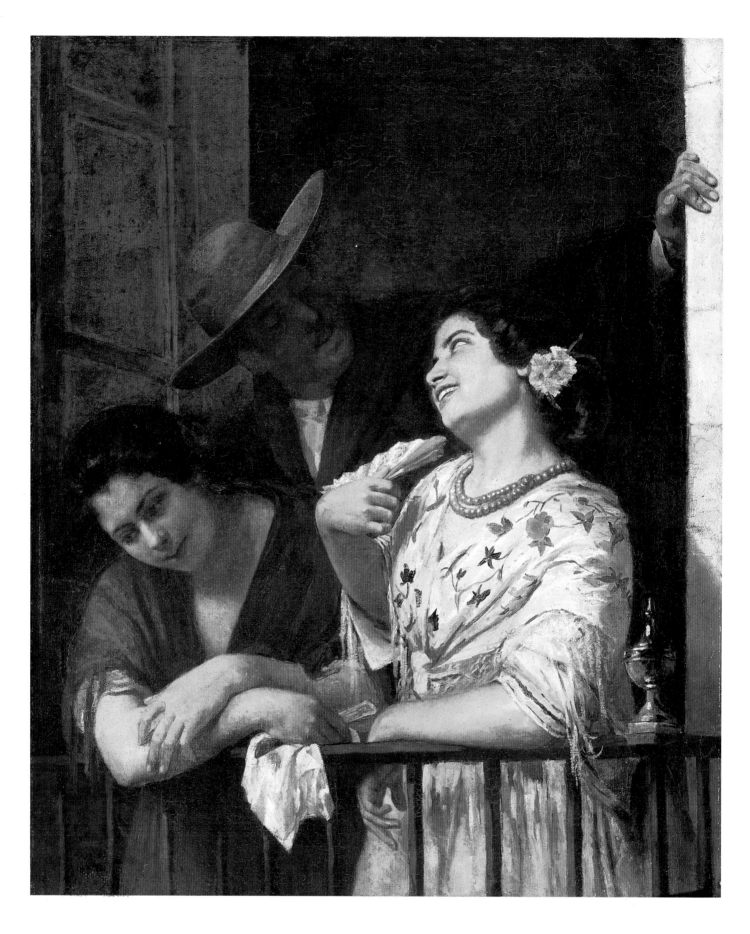

3. *The Flirtation: A Balcony in Seville*, 1872. Oil on canvas;
101 x 82.5 cm. Philadelphia Museum of Art.

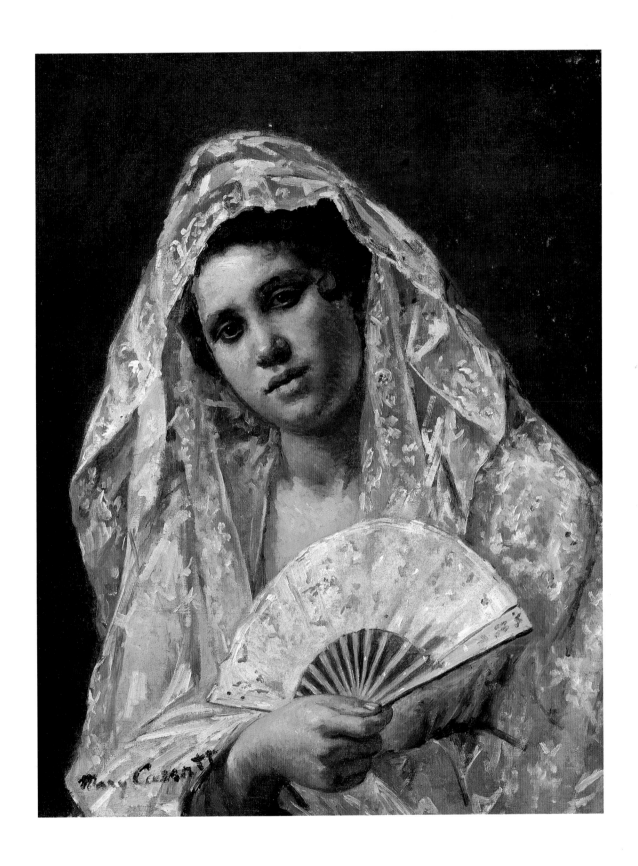

4. *A Seville Belle*, 1873. Oil on canvas; 65 x 49.5 cm.
Washington, D.C., National Museum of American
Art, Smithsonian Institution.

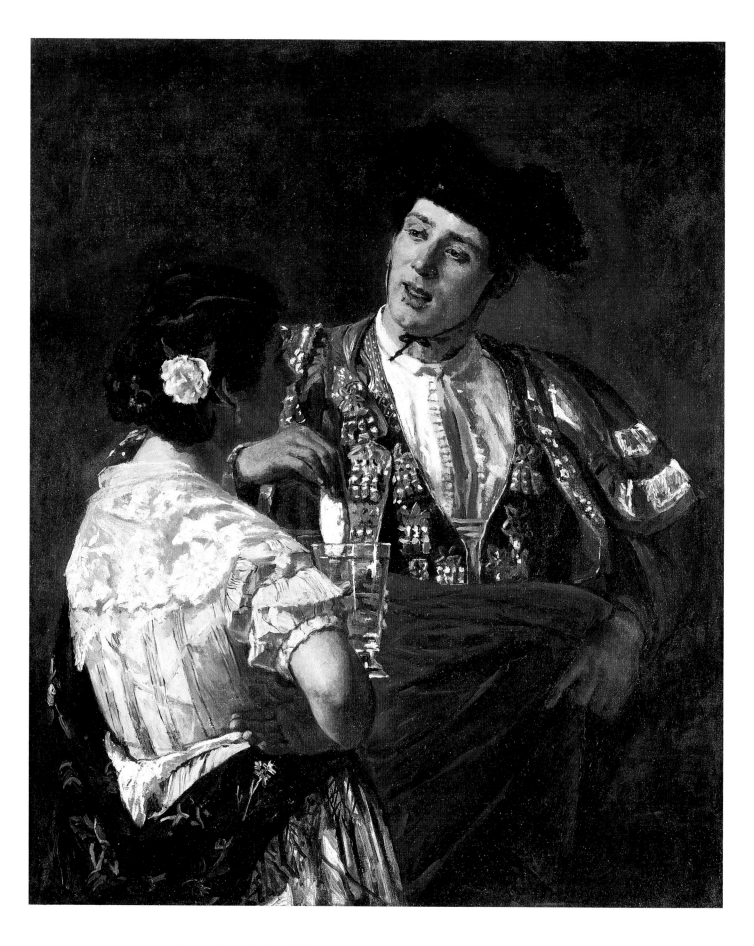

5. *Offering the Panal to the Bullfighter*, 1872–73. Oil on canvas;
100.6 x 85.1 cm. Williamstown, Mass., Sterling and Francine
Clark Art Institute.

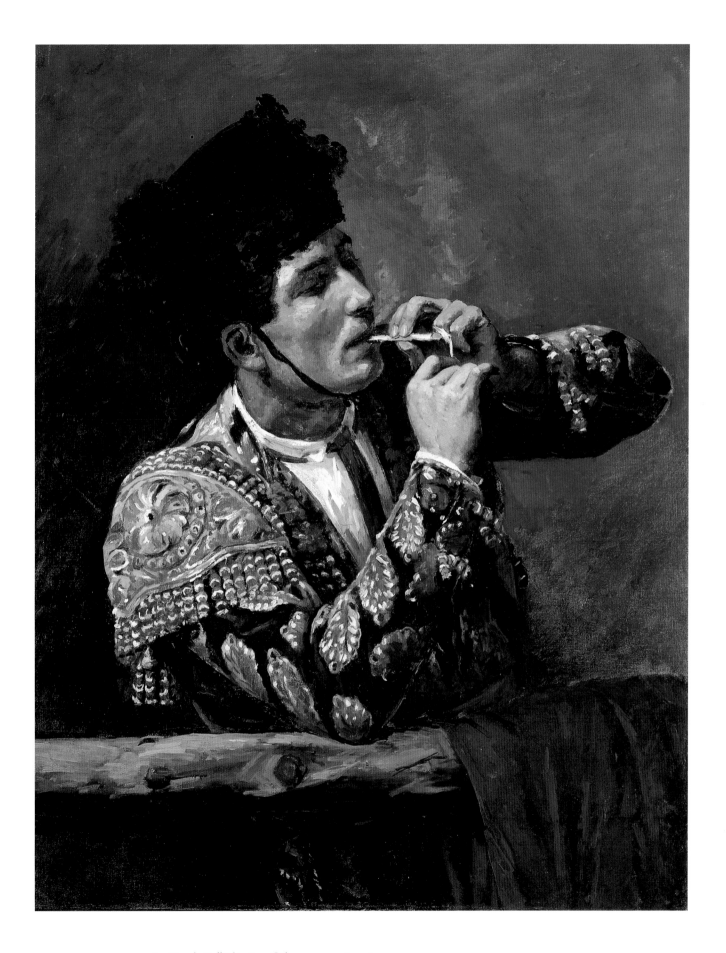

6. *After the Bullfight*, 1873. Oil on canvas; 82 x 64 cm.
The Art Institute of Chicago.

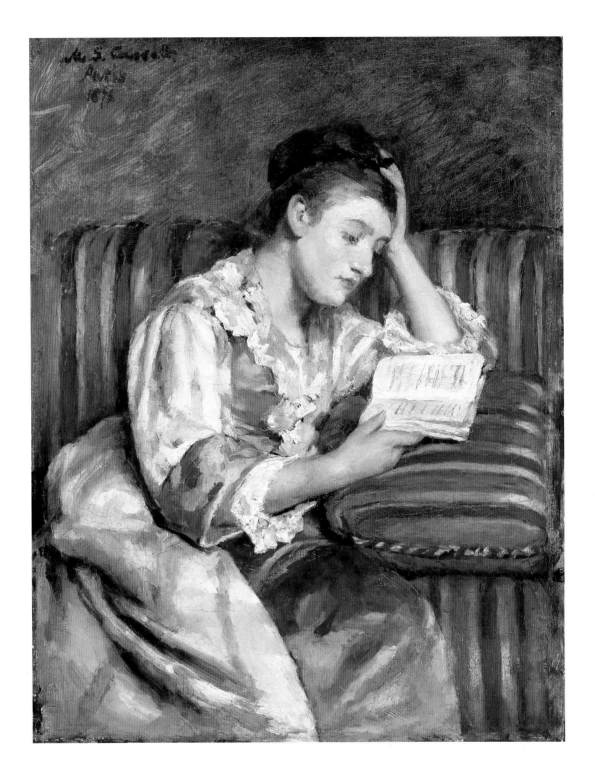

7. *Mrs. Duffee Seated on a Striped Sofa, Reading,* 1876. Oil on panel; 35 x 27 cm. Boston, Museum of Fine Arts.

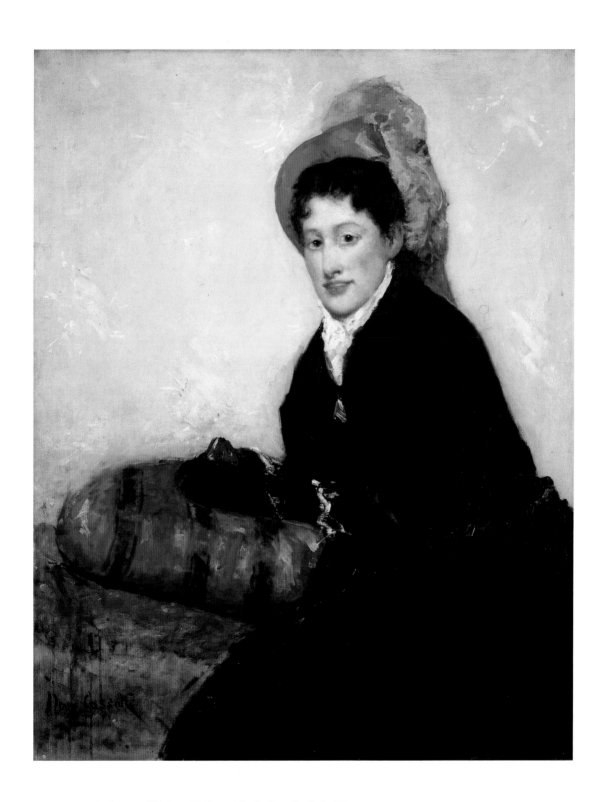

8. *Portrait of Madame X Dressed for the Matinée,* 1878. Oil on
canvas; 100 x 81 cm. Philip and Charlotte Hanes.

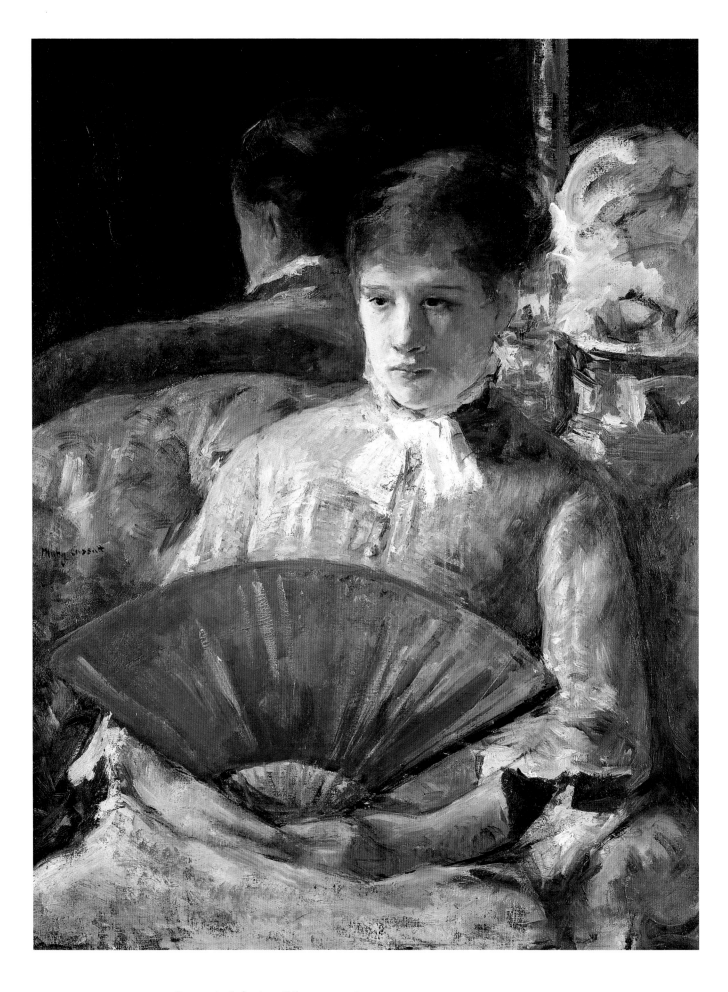

9. *Portrait of a Lady*, 1877. Oil on canvas; 85.7 x 65.2 cm.
Washington, D.C., National Gallery of Art.

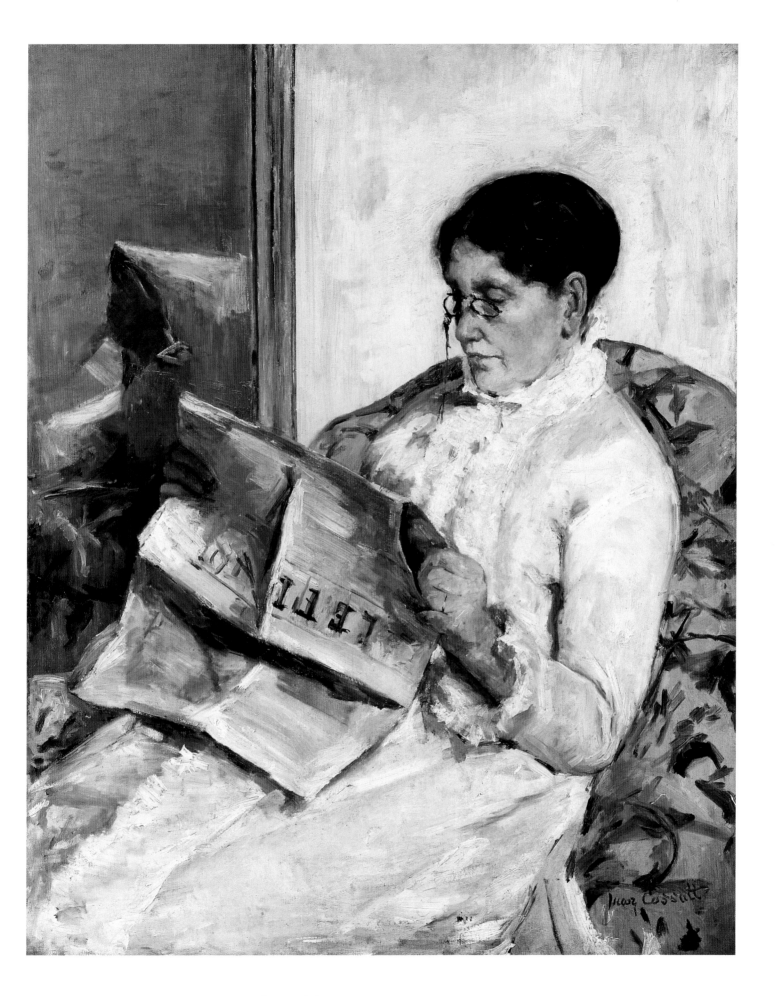

10. *Portrait of a Lady*, 1878. Oil on canvas; 104 x 83.7 cm.
Washington, D.C., private collection.

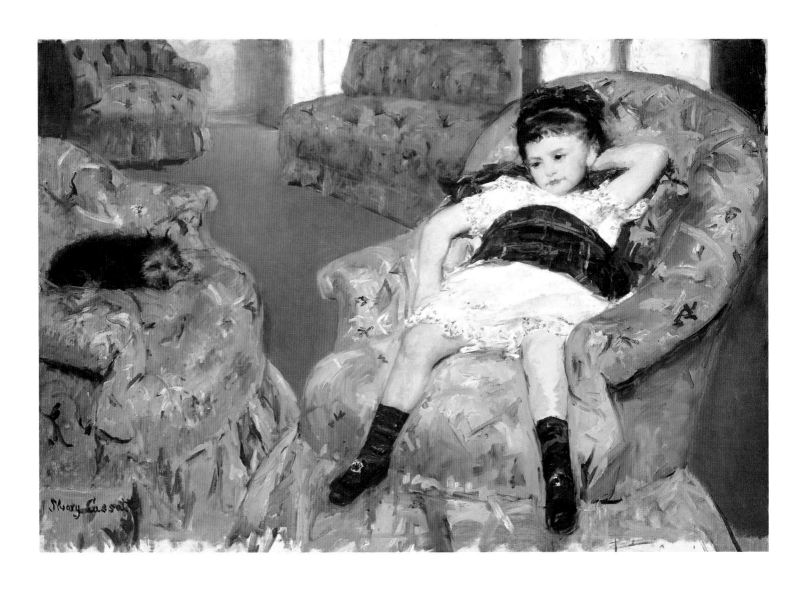

11. *Portrait of a Little Girl*, 1878. Oil on canvas; 89.5 x 129.8 cm.
Washington, D.C., National Gallery of Art.

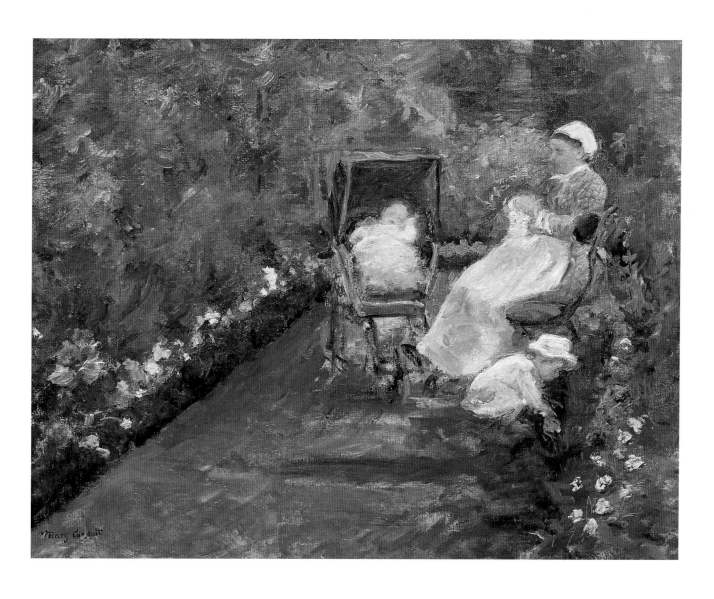

12. *Children in a Garden*, 1878. Oil on canvas; 73.6 x 92.6 cm.
Mr. and Mrs. Meredith J. Long.

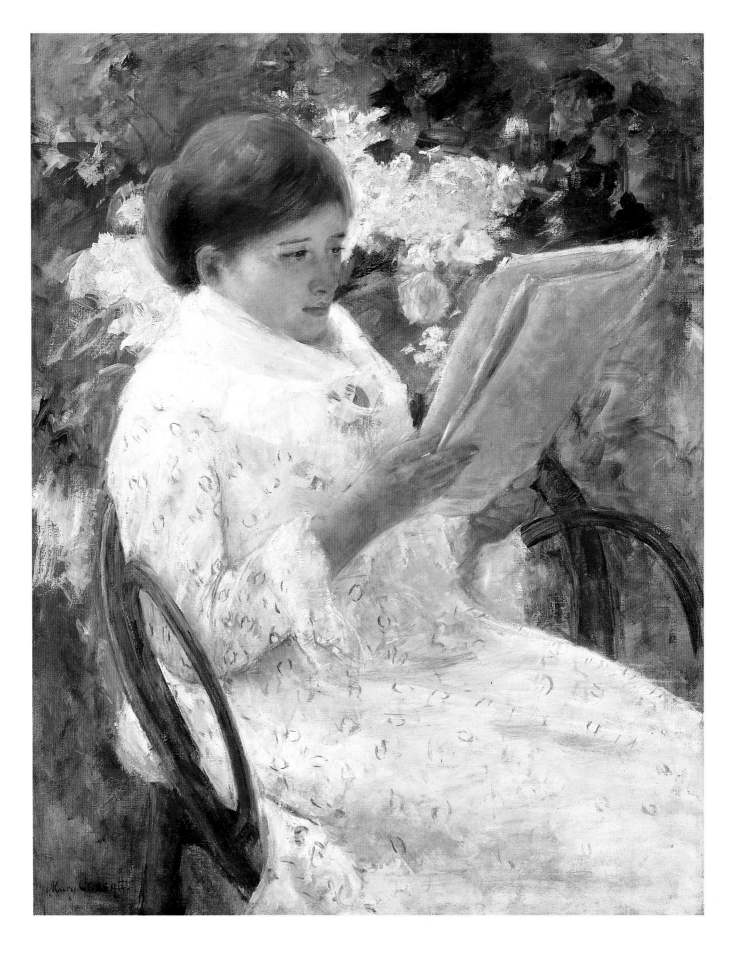

13. *On a Balcony*, 1878/79. Oil on canvas; 90 x 65 cm.
The Art Institute of Chicago.

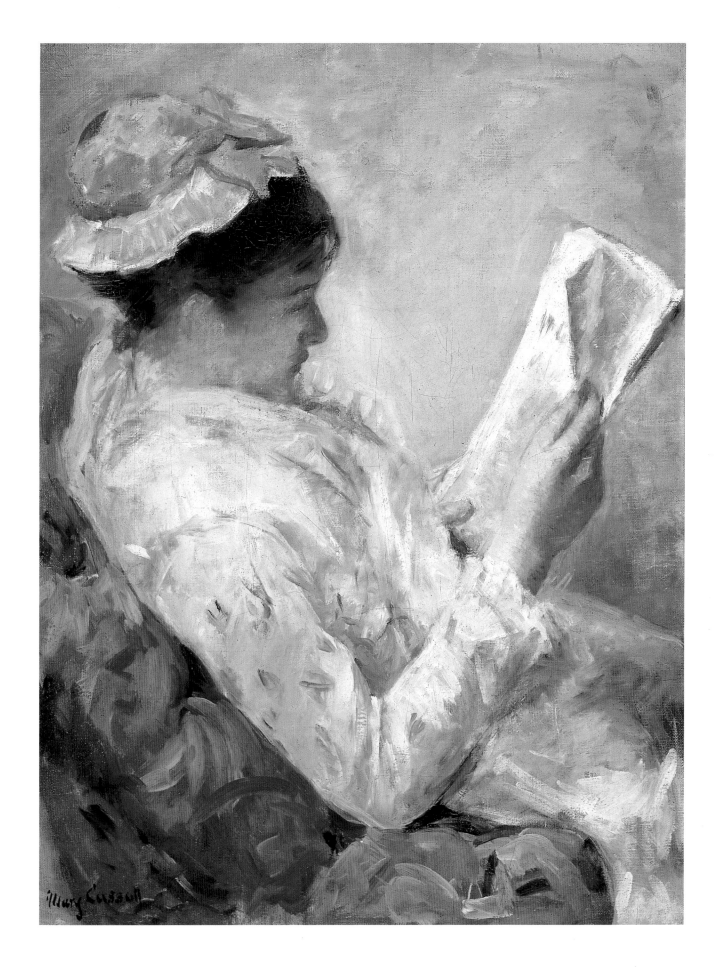

14. *Woman Reading*, 1878/79. Oil on canvas; 78.6 x 59 cm.
Omaha, Nebr., Joslyn Art Museum.

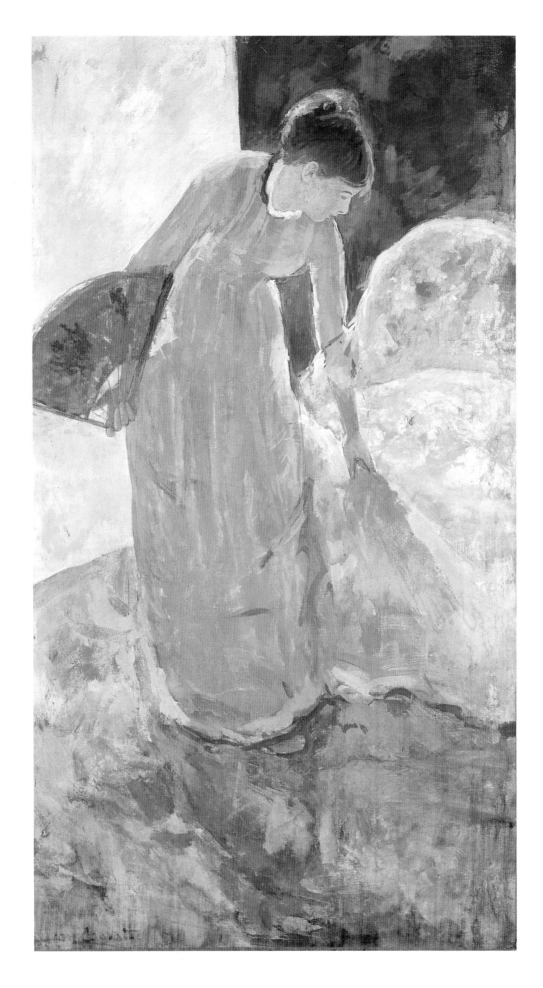

15. *Woman Standing, Holding a Fan*, 1878/79. Distemper with
metallic paint on canvas; 128.6 x 72 cm. Private collection.

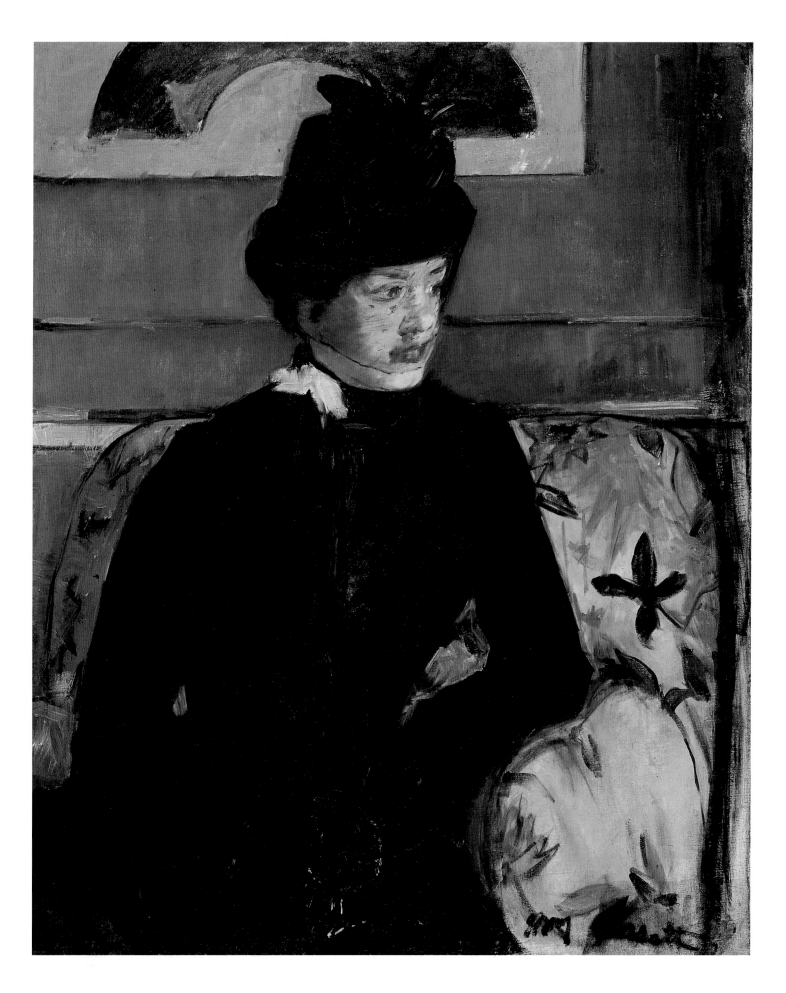

16. *Portrait of Madame J.*, 1879/80. Oil on canvas; 80.6 x 64.6 cm. Baltimore,
Peabody Art Collection, on loan to the Baltimore Museum of Art.

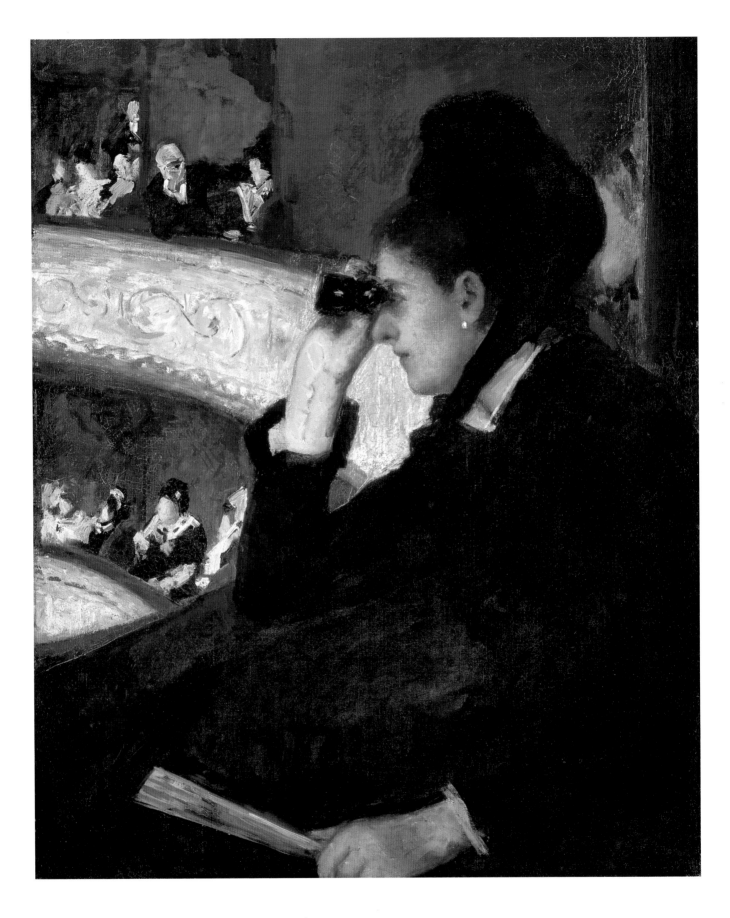

17. *At the Français, a Sketch*, 1877/78. Oil on canvas; 81 x 66 cm.
Boston, Museum of Fine Arts.

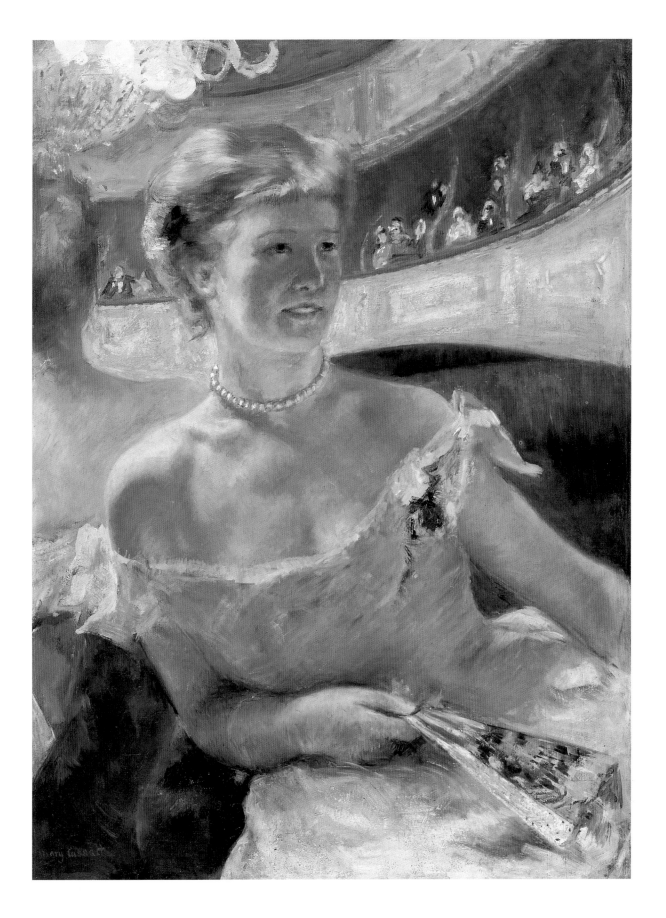

18. *Woman in a Loge*, 1878/79. Oil on canvas; 80.2 x 58.2 cm.
Philadelphia Museum of Art.

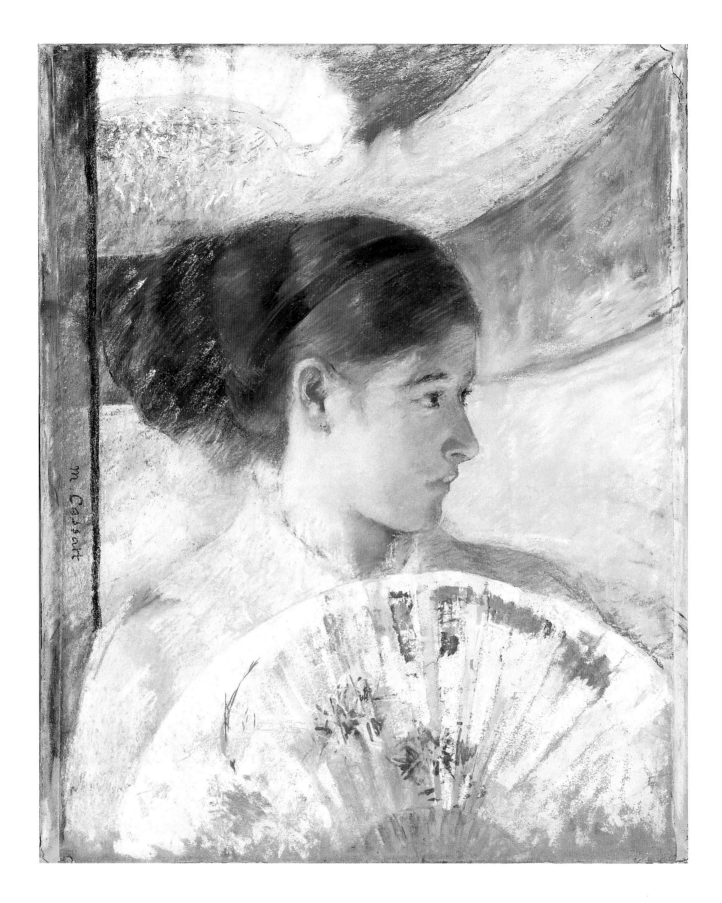

19. *At the Theater*, 1878/79. Pastel and gouache with metallic
paint on tan wove paper; 64.6 x 54.5 cm. Lent anonymously.

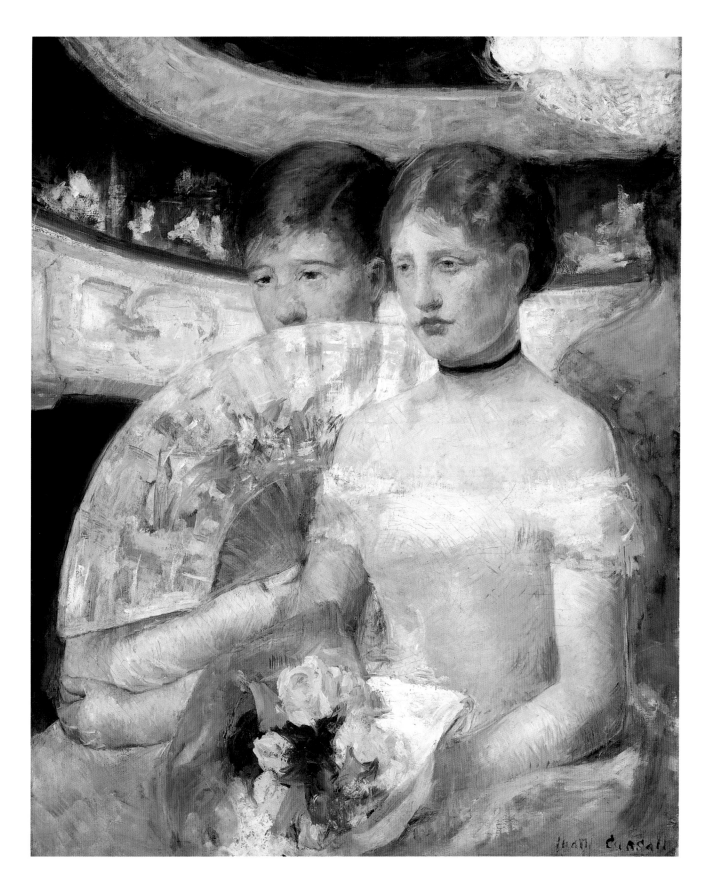

20. *Women in a Loge*, 1881/82. Oil on canvas; 80 x 64 cm.
Washington, D.C., National Gallery of Art.

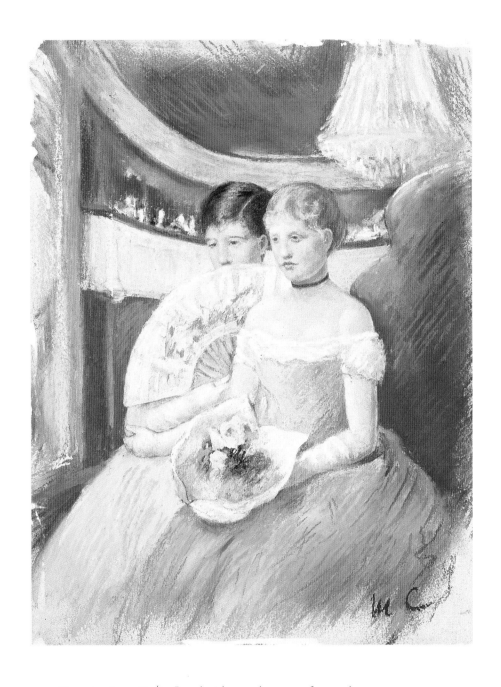

21. *Women in a Loge*, 1881/82. Pastel with gouache over softground etching and aquatint on off-white wove paper; 29 x 22 cm. Cincinnati Art Museum.

22. *Two Young Ladies in a Loge, Facing Right*, 1879/80. Softground etching, aquatint, and drypoint on paper; 27.6 x 21.8 cm. S. P. Avery Collection, Miriam and Ira D. Wallach Division of Art, Prints and Photographs, The New York Public Library, Astor, Lenox and Tilden Foundations.

23. *Woman at the Theater*, 1879/80. Softground etching and aquatint on cream Japanese paper; 20.5 x 18.7 cm. The Art Institute of Chicago.

24. *At the Theater*, 1879/80. Lithograph on paper; 29.1 x 22.2 cm.
S. P. Avery Collection, Miriam and Ira D. Wallach Division of
Art, Prints and Photographs, The New York Public Library,
Astor, Lenox and Tilden Foundations.

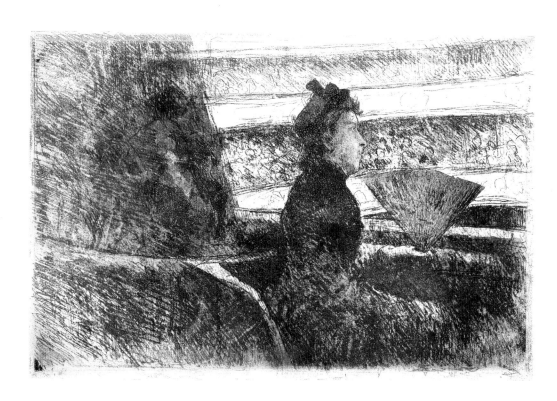

25. *At the Performance*, 1879/80. Softground etching and aquatint on
cream laid paper; 19.7 x 29.4 cm. The Art Institute of Chicago.

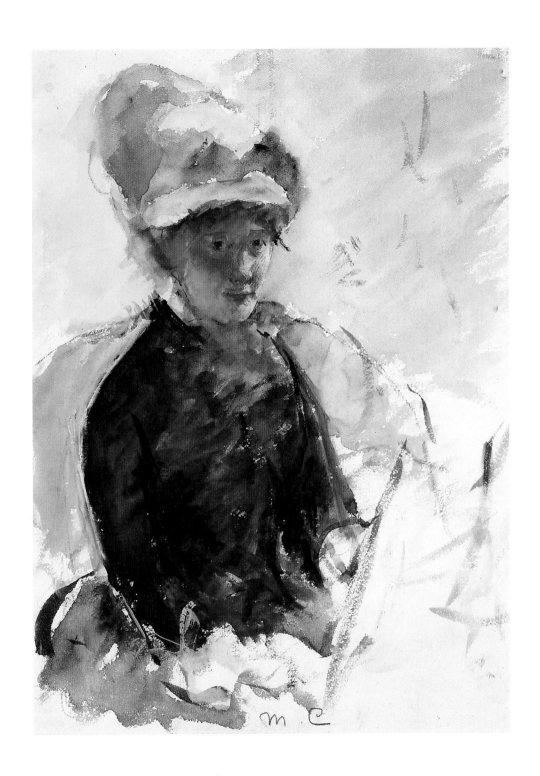

26. *Self-Portrait*, c. 1880. Watercolor on ivory wove paper;
33 x 24 cm. Washington, D.C., National Portrait Gallery.

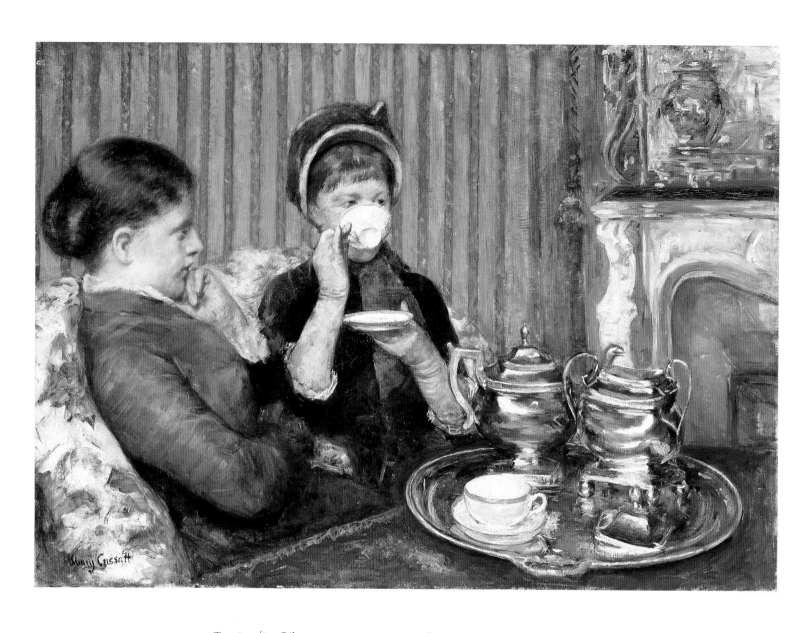

27. *Tea*, 1879/80. Oil on canvas; 64.7 x 92.7 cm. Boston,
Museum of Fine Arts.

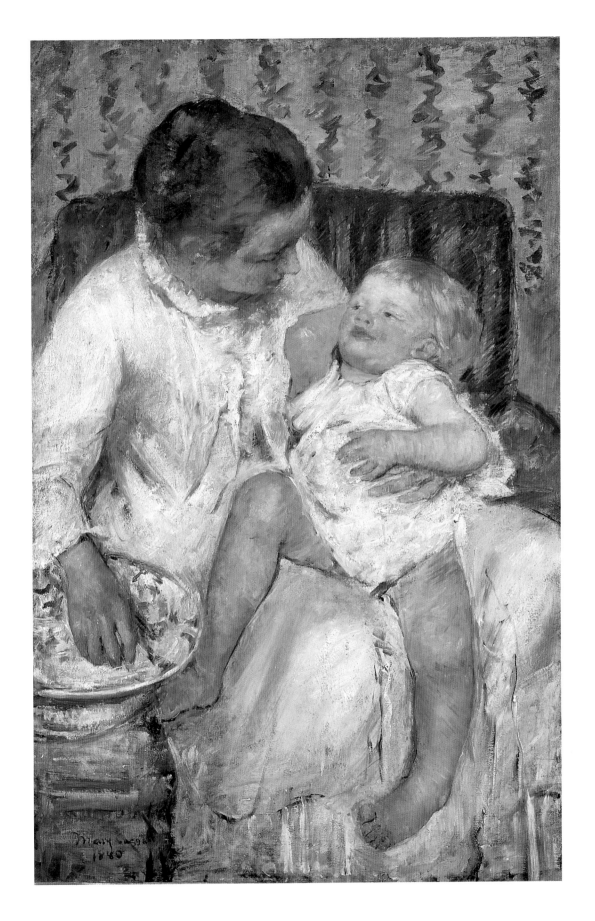

28. *The Child's Bath*, 1880. Oil on canvas; 100 x 65 cm.
Los Angeles County Museum of Art.

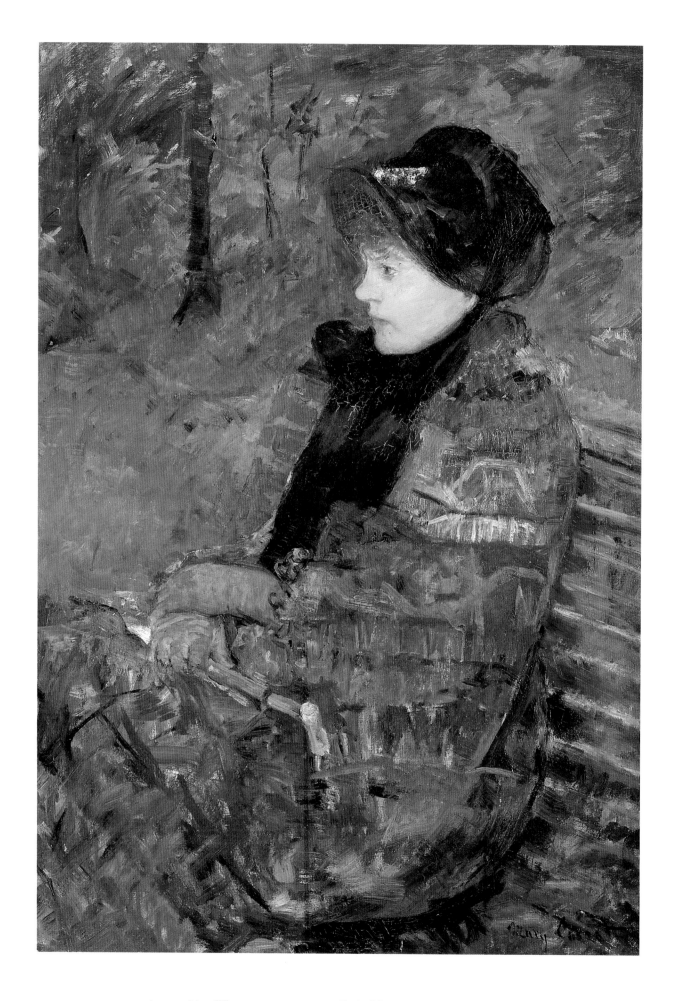

29. *Autumn*, 1880. Oil on canvas; 93 x 65 cm. Paris, Musée
du Petit Palais.

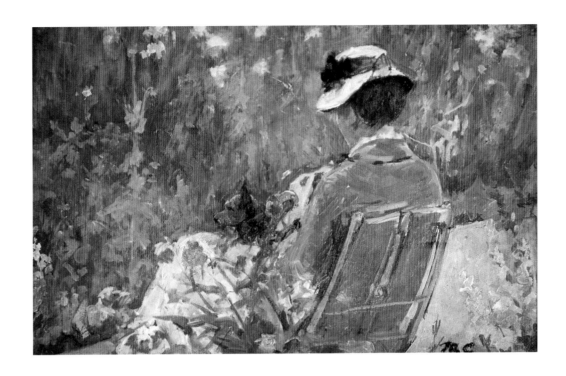

30. *Lydia Seated in the Garden with a Dog in Her Lap*, c. 1880.
Oil on canvas; 27.3 x 40.6 cm. Private collection.

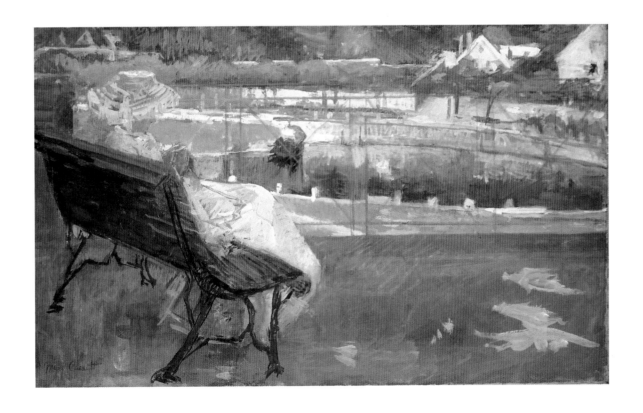

31. *Lydia Seated on a Terrace Crocheting*, 1881/82. Oil and tempera
on canvas; 38.1 x 61.5 cm. Collection of Mr. and Mrs. Charles
Hermanowski.

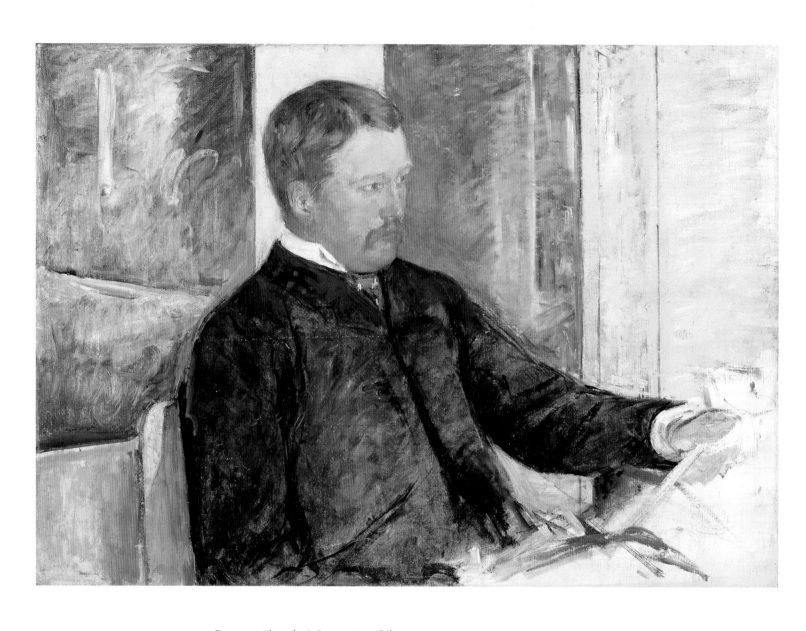

32. *Portrait of Alexander J. Cassatt*, 1880. Oil on canvas;
64.5 x 90.7 cm. Detroit Institute of Arts.

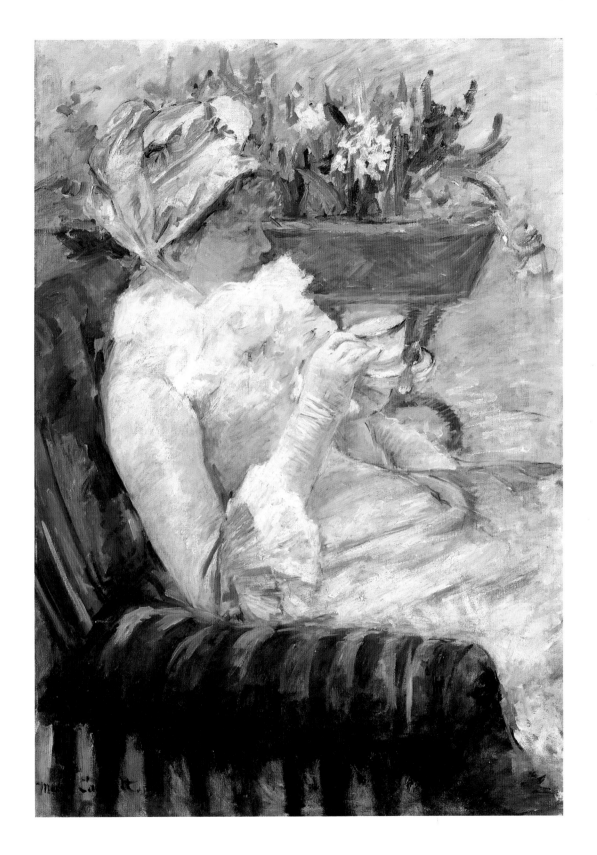

33. *Tea*, 1880/81. Oil on canvas; 92.4 x 65.4 cm. New York,
The Metropolitan Museum of Art.

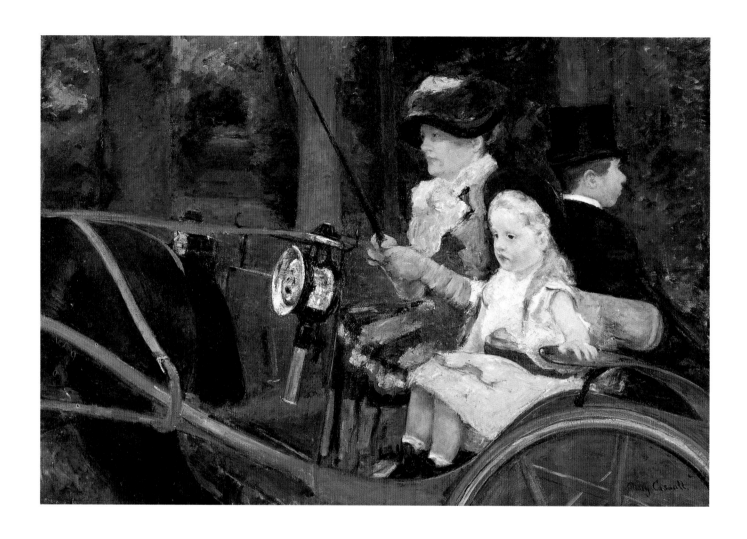

34. *Driving*, 1881. Oil on canvas; 89.3 x 130.8 cm. Philadelphia
Museum of Art.

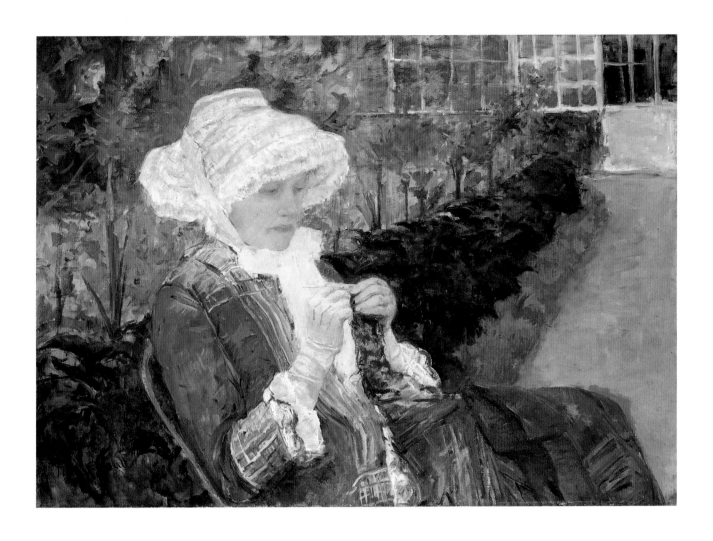

35. *The Garden*, 1880. Oil on canvas; 66 x 94 cm. New York,
The Metropolitan Museum of Art.

36. *Woman in a Chair*, 1879/80. Softground etching and
aquatint on cream wove paper; 21.6 x 14.6 cm. The Art
Institute of Chicago.

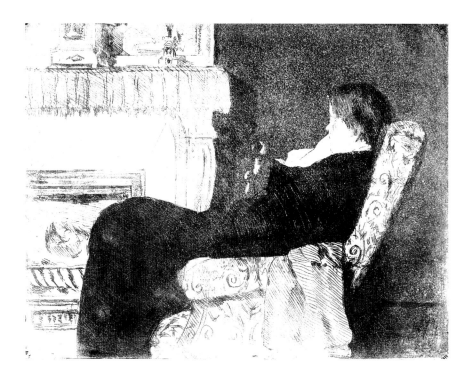

37. *By the Fireside*, 1879/80. Softground etching and aquatint on
paper; 16.4 x 20.5 cm. S. P. Avery Collection, Miriam and Ira D.
Wallach Division of Art, Prints and Photographs, The New
York Public Library, Astor, Lenox and Tilden Foundations.

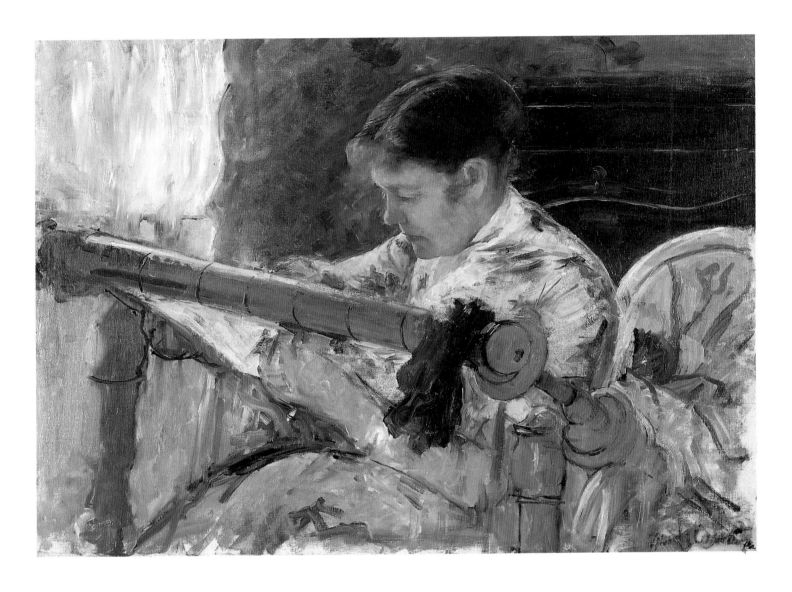

38. *Lydia Seated at an Embroidery Frame*, 1880/81. Oil on canvas;
65.5 x 92 cm. Flint, Mich., Flint Institute of Arts.

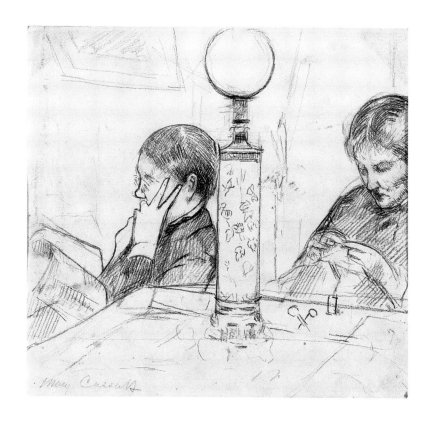

39. *Drawing for "Evening,"* 1879/80. Graphite on paper;
20.3 x 22.3 cm. Dr. and Mrs. Jeb Stewart.

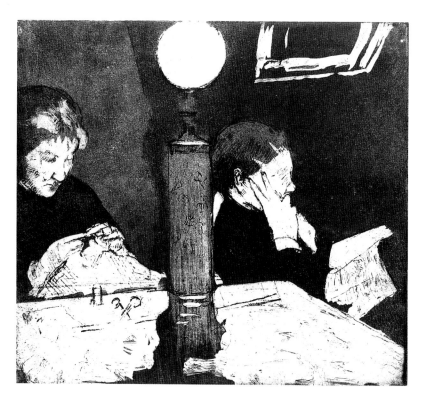

40. *Evening,* 1879/80. Softground etching and aquatint on
cream laid paper; 19.7 x 22.1 cm. The Art Institute of Chicago.

41. *Drawing for "Interior: On the Sofa,"* c. 1880. Graphite on paper;
14.5 x 22 cm. Chicago, Ursula and R. Stanley Johnson Family
Collection.

42. *Interior: On the Sofa,* c. 1880. Softground etching on
cream wove paper; 14.1 x 21.8 cm. Washington, D.C.,
National Gallery of Art.

43. *Drawing for "Interior Scene,"* 1879/80. Graphite on off-white wove paper; 40 x 30.9 cm. Cleveland Museum of Art.

44. *Interior Scene*, 1879/80. Softground etching, aquatint, and drypoint on cream laid paper; 39.7 x 31 cm. Washington, D.C., National Gallery of Art.

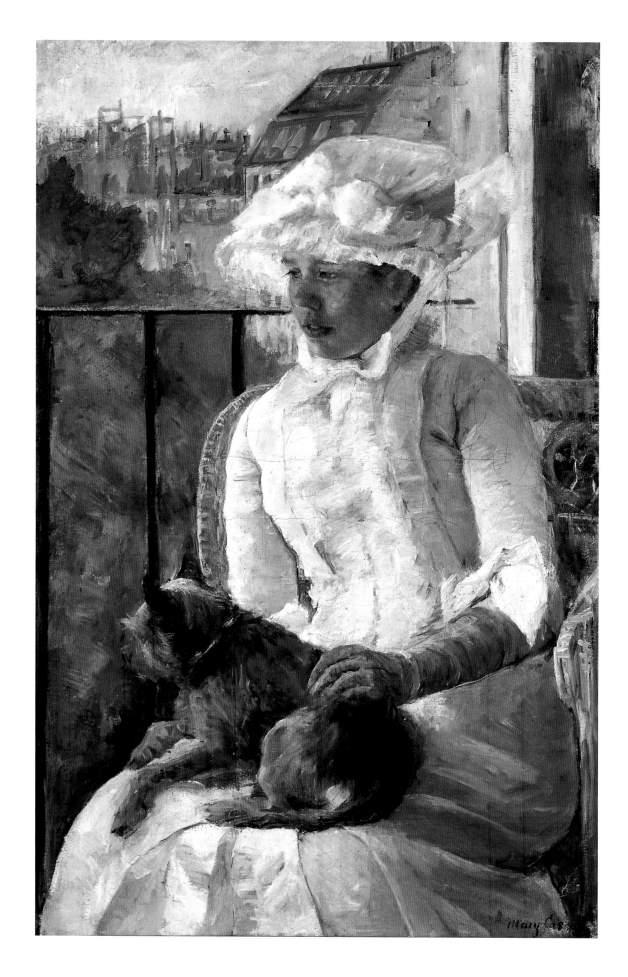

45. *Young Girl at a Window*, c. 1883. Oil on canvas; 100.3 x
64.7 cm. Washington, D.C., Corcoran Gallery of Art.

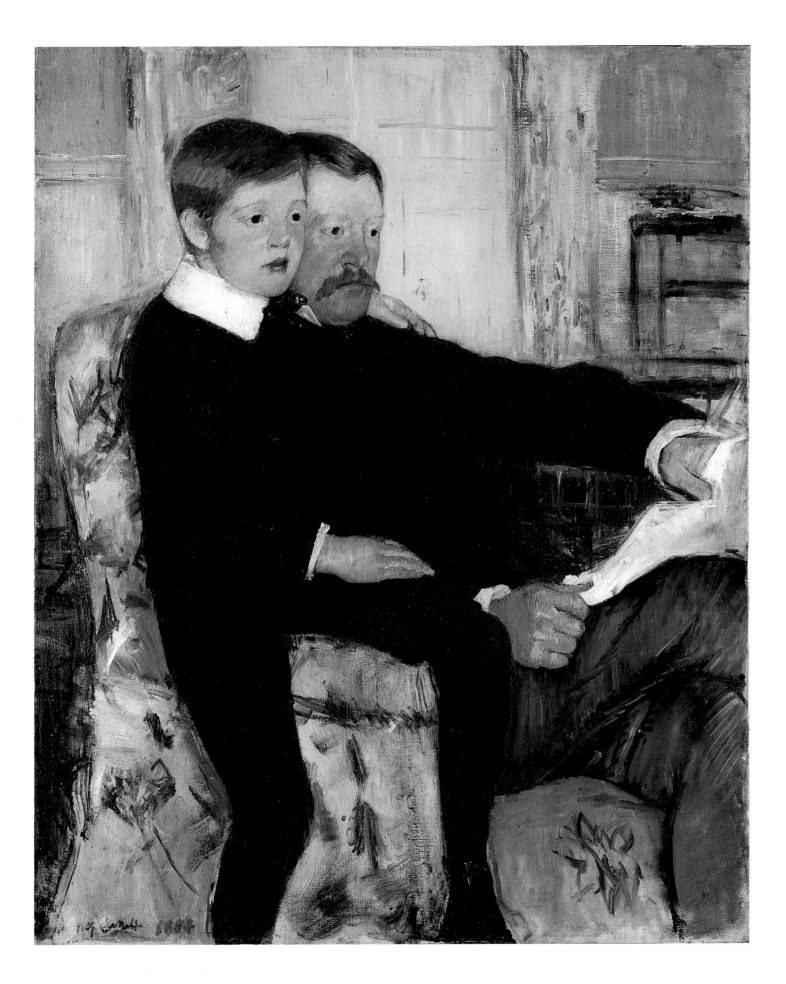

46. *Portrait of Alexander J. Cassatt and His Son Robert Kelso Cassatt*, 1884–85.
Oil on canvas; 100 x 81.2 cm. Philadelphia Museum of Art.

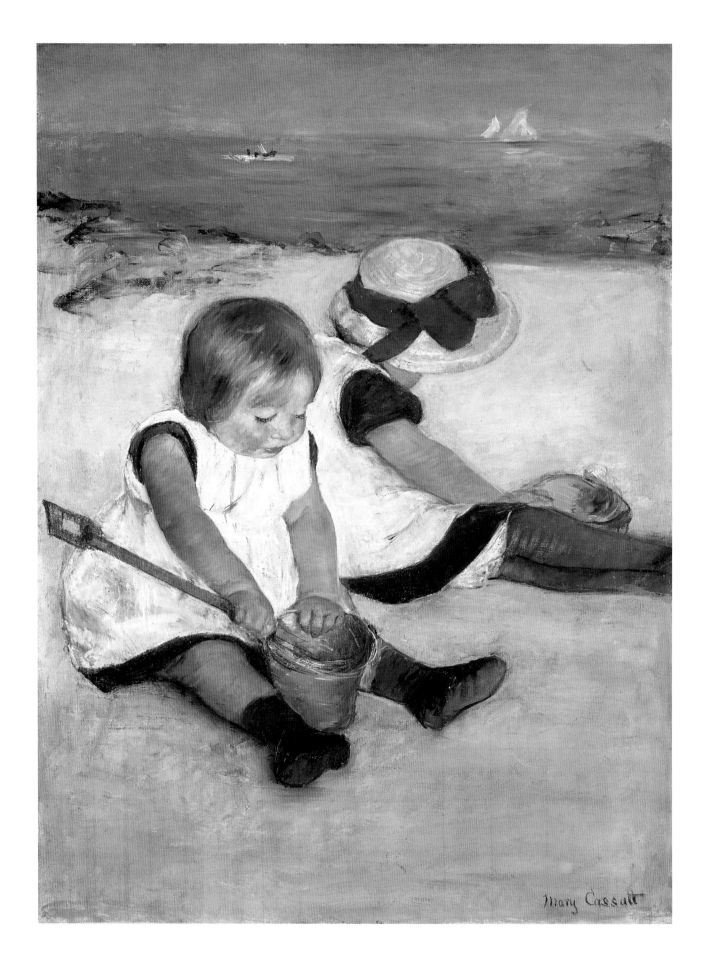

47. *Children on the Shore*, 1885. Oil on canvas; 97.6 x 74 cm.
Washington, D.C., National Gallery of Art.

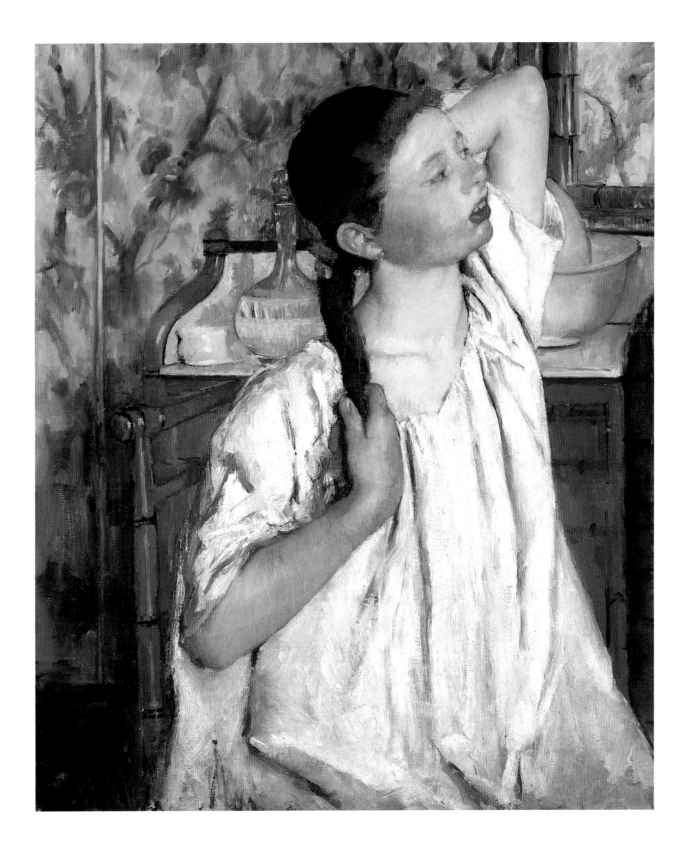

48. *Study*, 1885/86. Oil on canvas; 75 x 62.2 cm. Washington, D.C.,
National Gallery of Art.

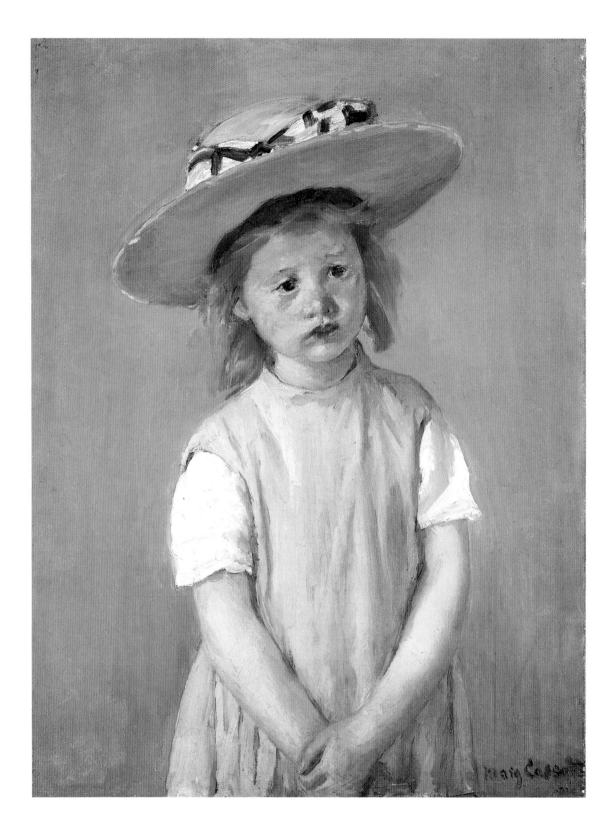

49. *Little Girl in a Big Straw Hat and a Pinafore*, c. 1886. Oil on canvas; 65.3 x 49 cm. Washington, D.C., National Gallery of Art.

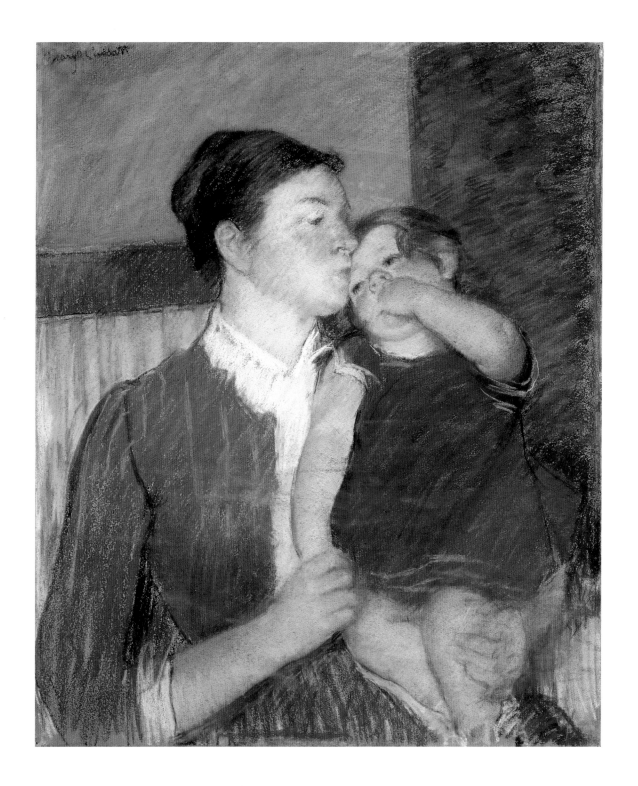

50. *Young Mother*, 1888. Pastel on tan wove paper; 84 x 73.8 cm.
The Art Institute of Chicago.

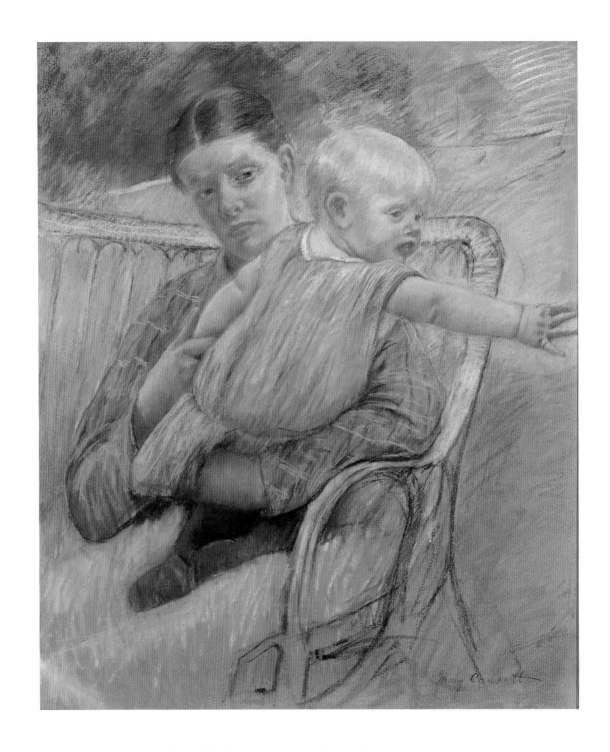

51. *Mathilde Holding a Baby Who Reaches out to the Right*, c. 1889.
Pastel on tan wove paper; 73 x 60 cm. Chicago, Ursula and
R. Stanley Johnson Family Collection.

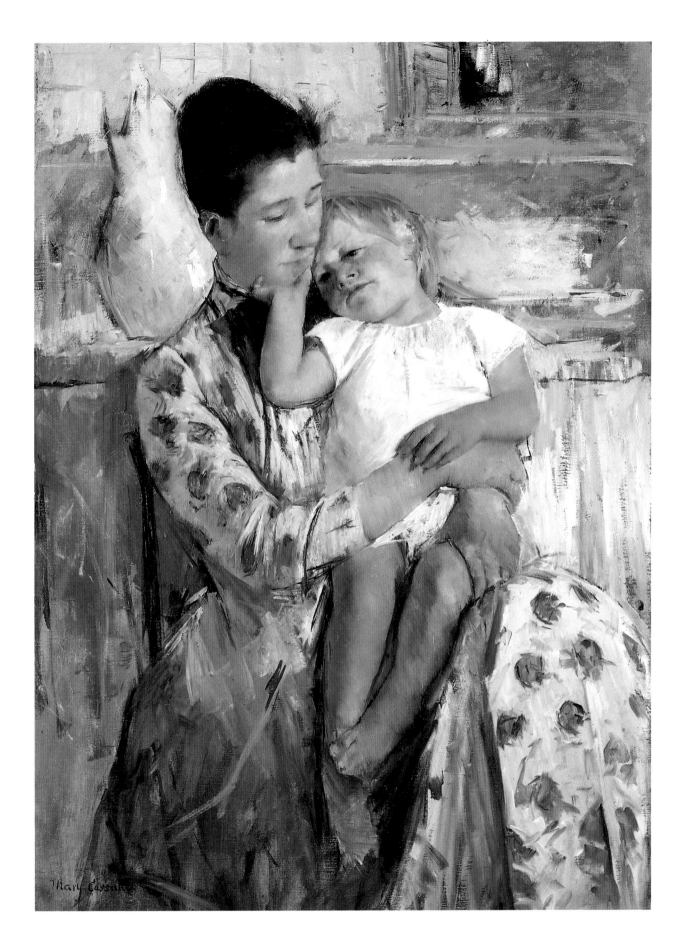

52. *Mother and Child*, 1889. Oil on canvas; 90 x 64.5 cm.
Wichita, Kans., Wichita Art Museum.

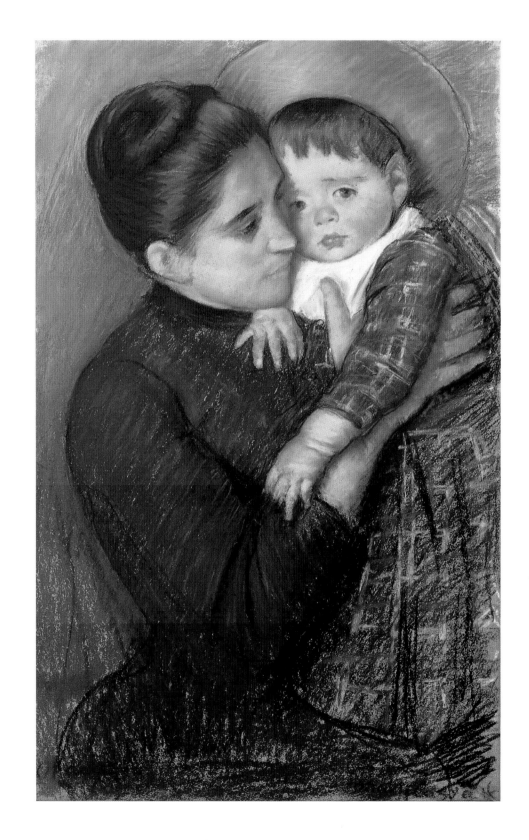

53. *Woman with Her Child*, 1889/90. Pastel on tan wove paper;
63.5 x 40.6 cm. Storrs, Conn., William Benton Museum of
Art, University of Connecticut.

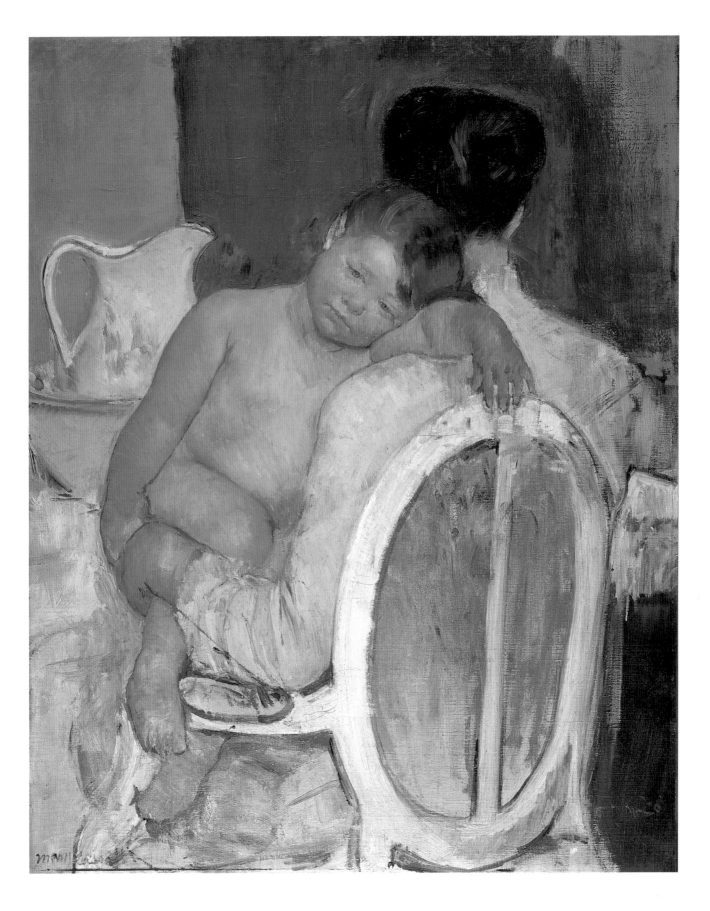

54. *Mother Holding a Child in Her Arms*, c. 1890. Oil on canvas;
81.5 x 65.5 cm. Bilbao, Spain, Museo de Bellas Artes de Bilbao.

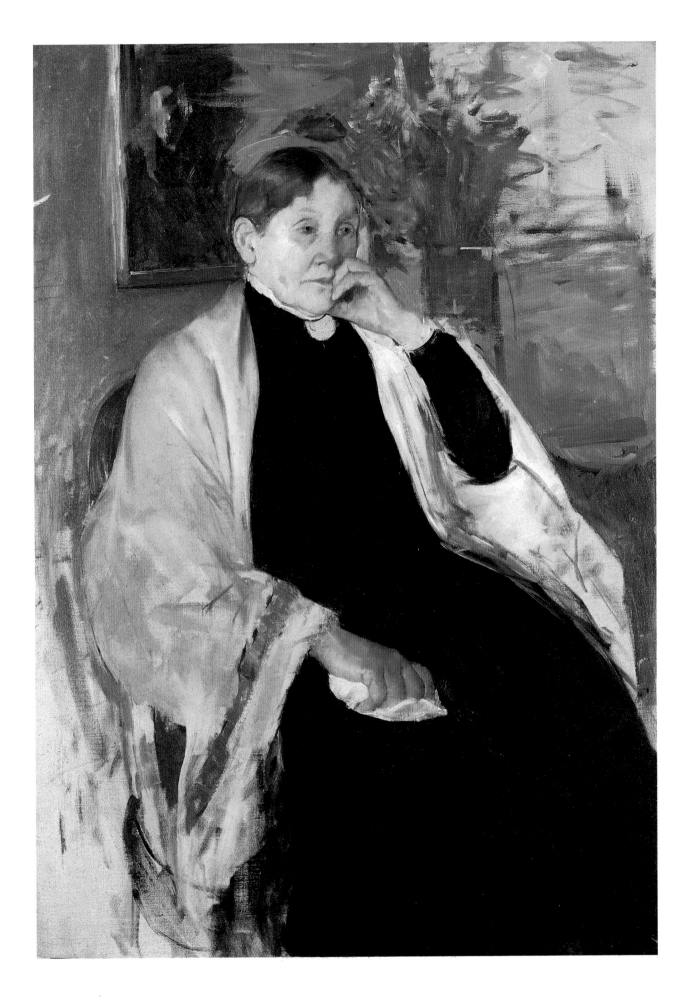

55. *Mrs. R. S. Cassatt*, c. 1889. Oil on canvas; 96.5 x 68.6 cm.
Fine Arts Museums of San Francisco.

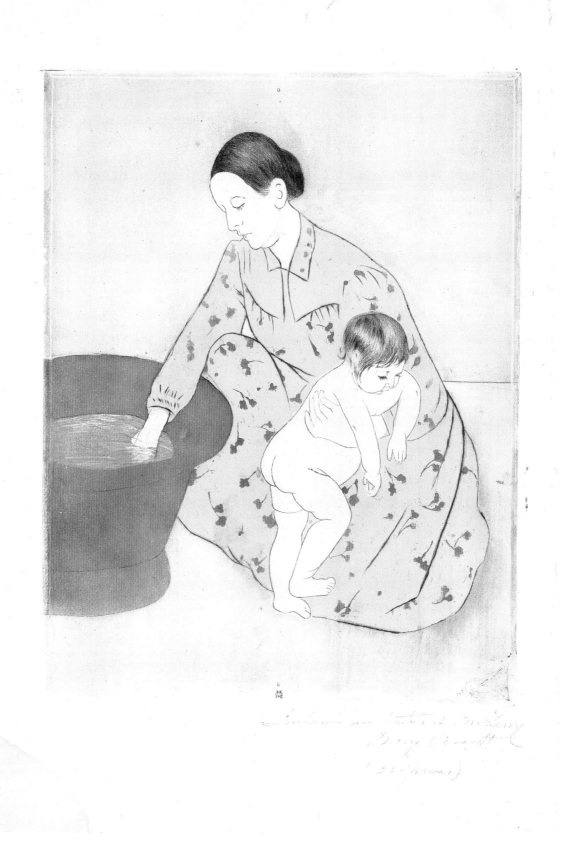

56. *The Child's Bath*, 1890–91. Drypoint and aquatint on cream
laid paper; 32.1 x 24.7 cm. The Art Institute of Chicago.

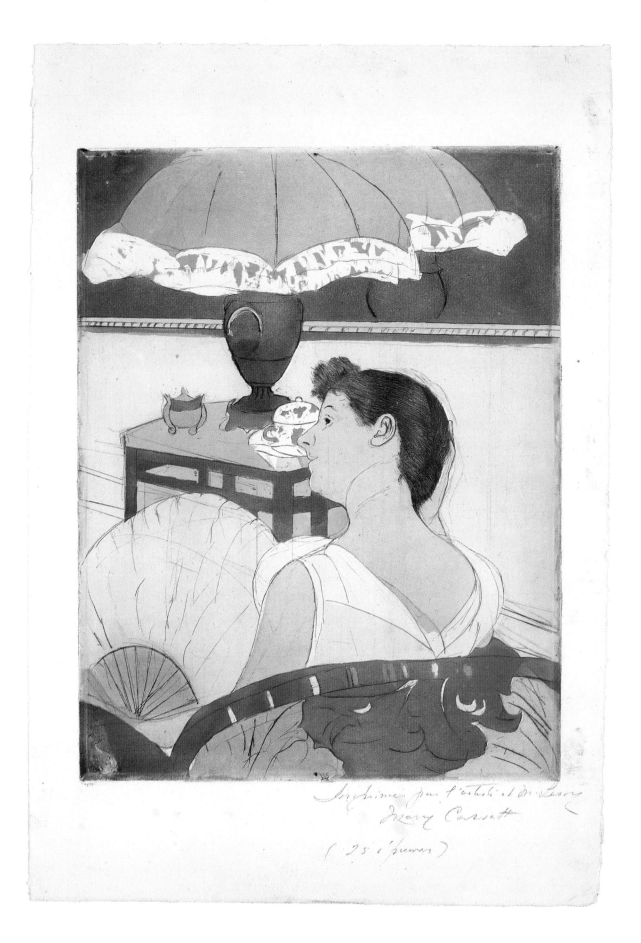

57. *The Lamp*, 1890–91. Drypoint and aquatint on cream
laid paper; 32.3 x 25.2 cm. The Art Institute of Chicago.

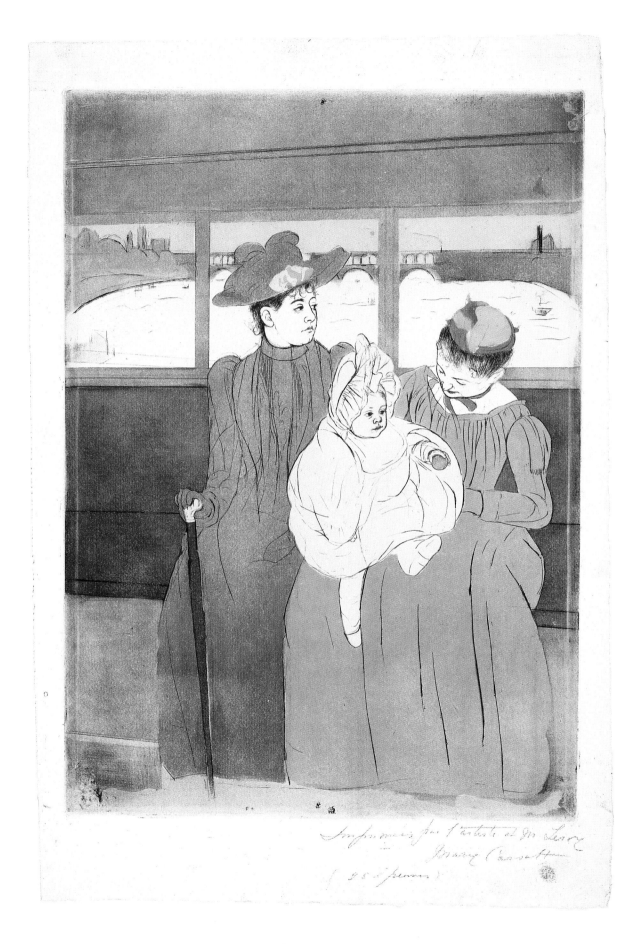

58. *Interior of a Tramway Passing a Bridge*, 1890–91. Drypoint
and aquatint on cream laid paper; 38.4 x 26.7 cm. The Art
Institute of Chicago.

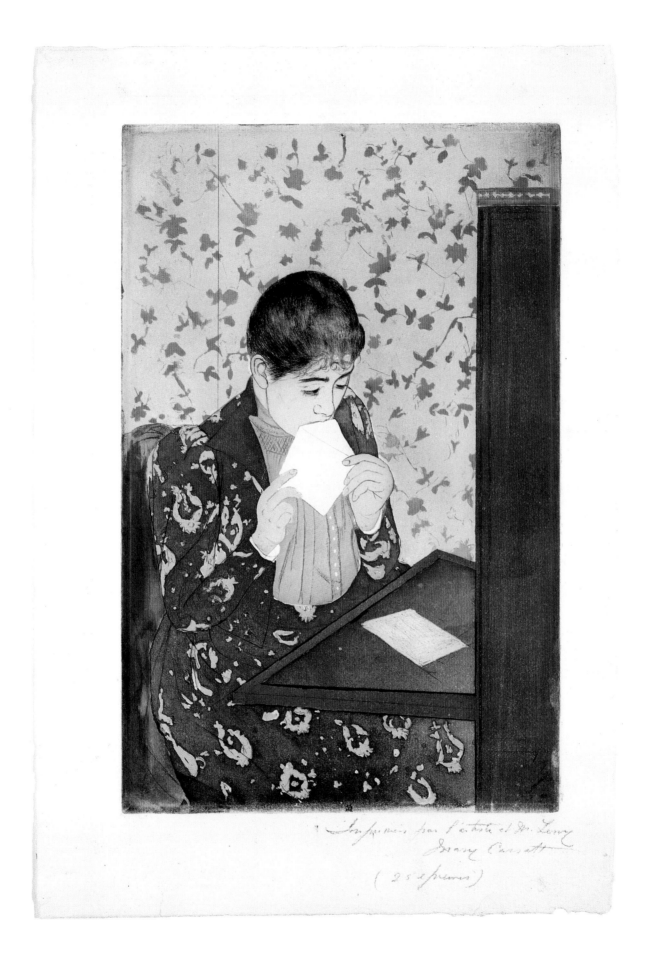

59. *The Letter*, 1890–91. Drypoint and aquatint on cream
laid paper; 34.5 x 21.1 cm. The Art Institute of Chicago.

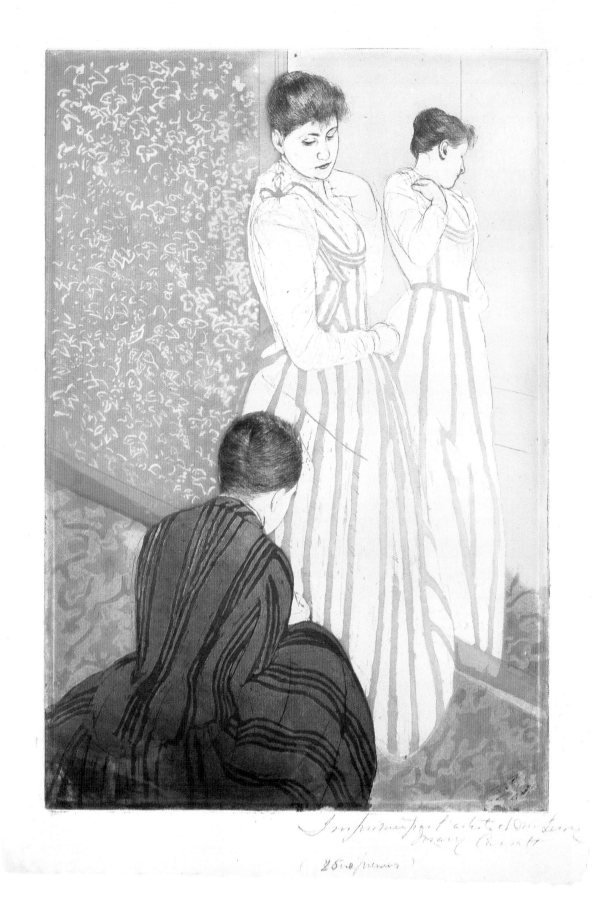

60. *Young Woman Trying on a Dress*, 1890–91. Drypoint and
aquatint on cream laid paper; 37.7 x 25.6 cm. The Art
Institute of Chicago.

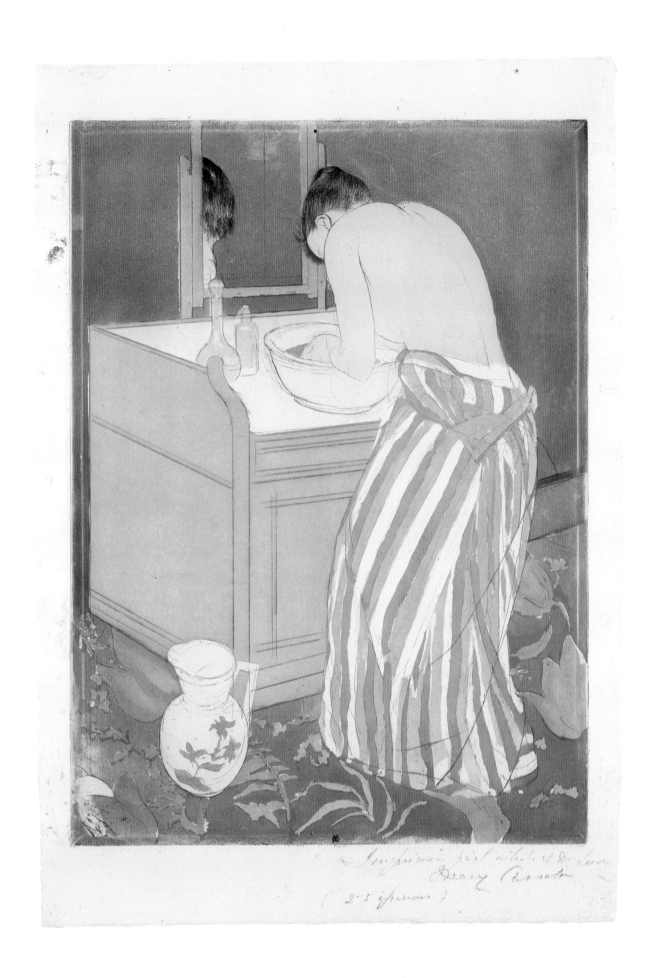

61. *The Bath*, 1890–91. Drypoint and aquatint on cream laid
paper; 36.8 x 26.3 cm. The Art Institute of Chicago.

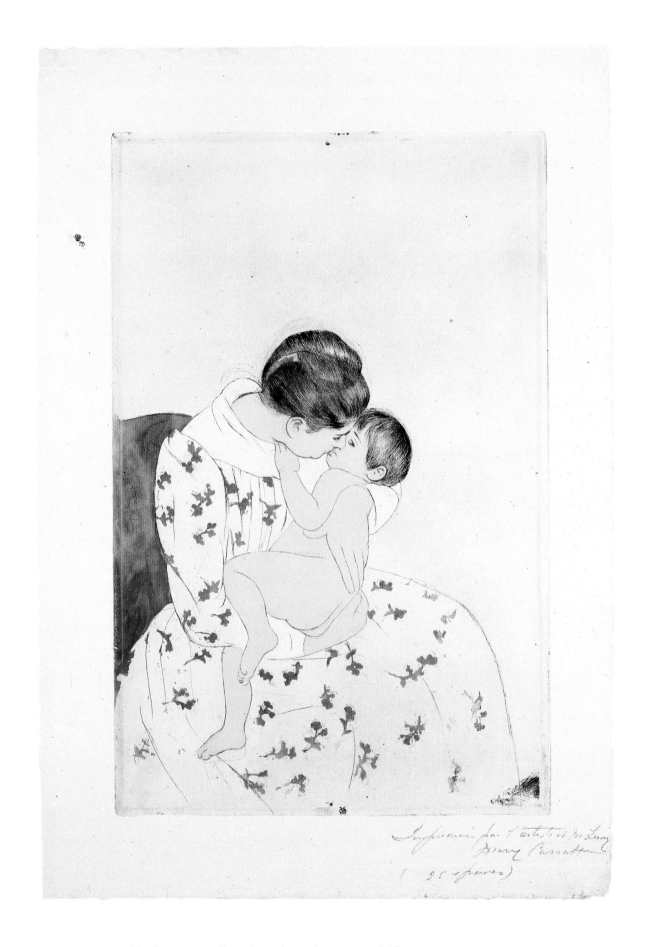

62. *The Kiss*, 1890–91. Drypoint and aquatint on cream laid
paper; 34.9 x 22.9 cm. The Art Institute of Chicago.

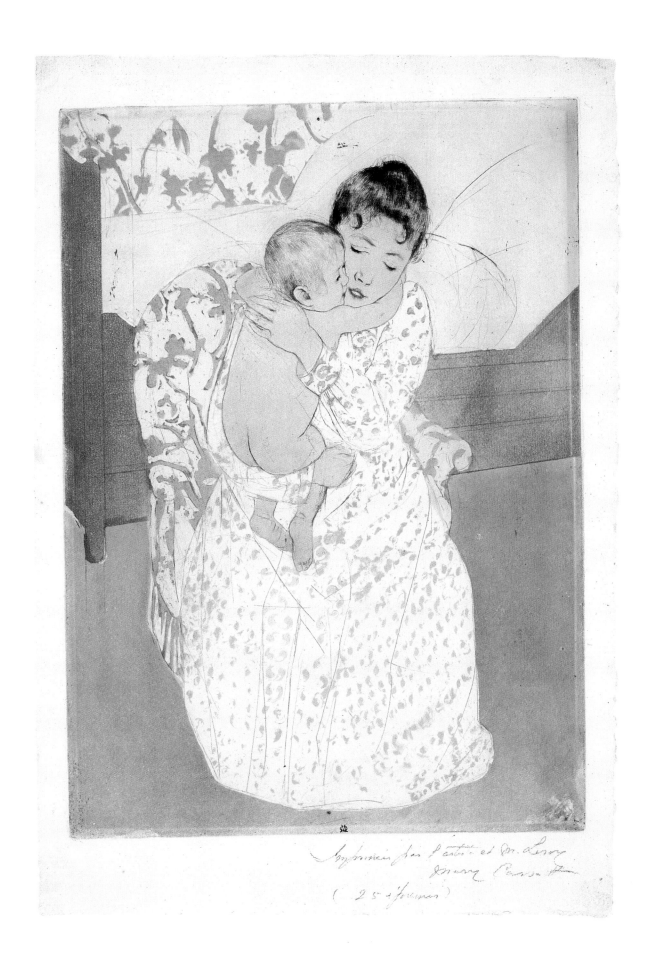

63. *Nude Child*, 1890–91. Drypoint and aquatint on cream
laid paper; 36.8 x 26.8 cm. The Art Institute of Chicago.

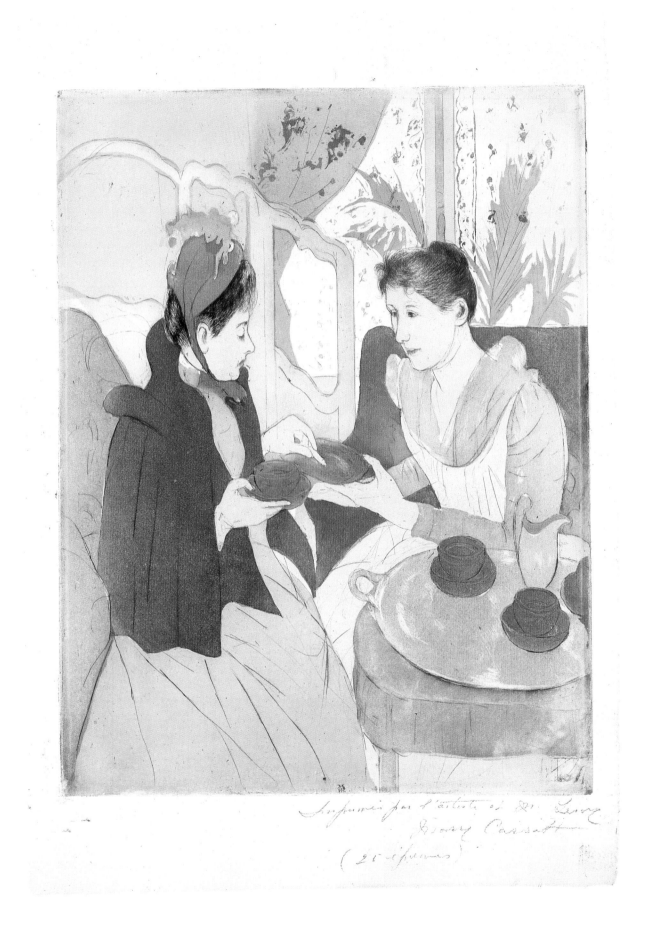

64. *The Visit*, 1890–91. Drypoint and aquatint on cream laid
paper; 34.8 x 26.3 cm. The Art Institute of Chicago.

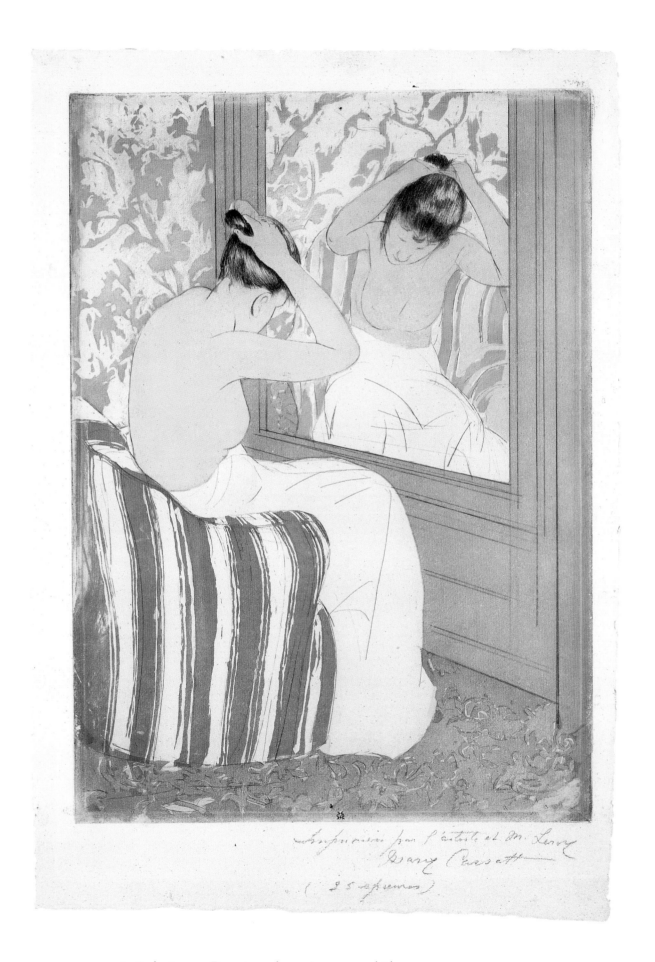

65. *Study*, 1890–91. Drypoint and aquatint on cream laid
paper; 36.5 x 26.7 cm. The Art Institute of Chicago.

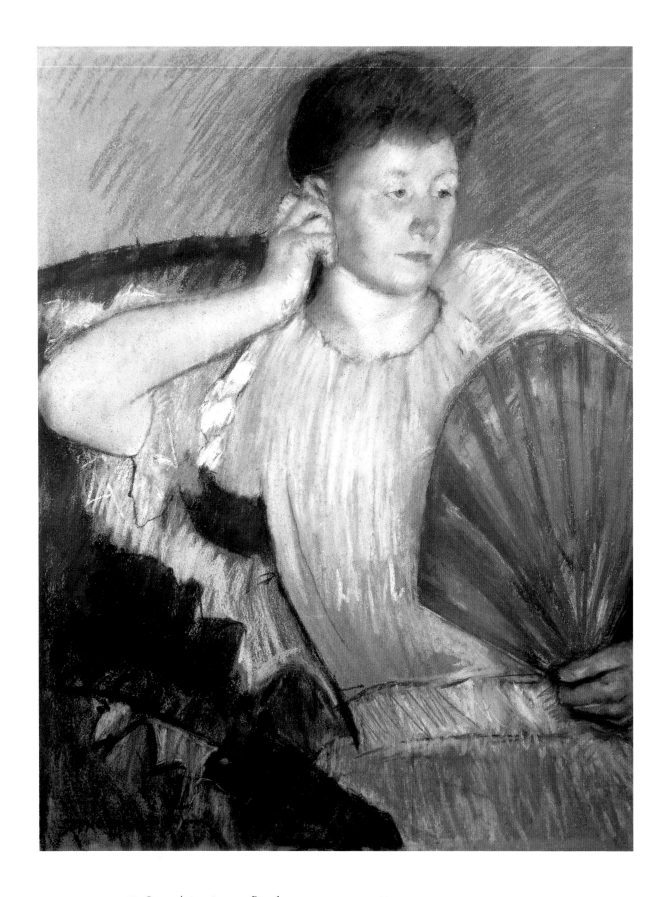

66. *Contemplation*, 1891–92. Pastel on tan wove paper; 66 x 51 cm.
Private collection.

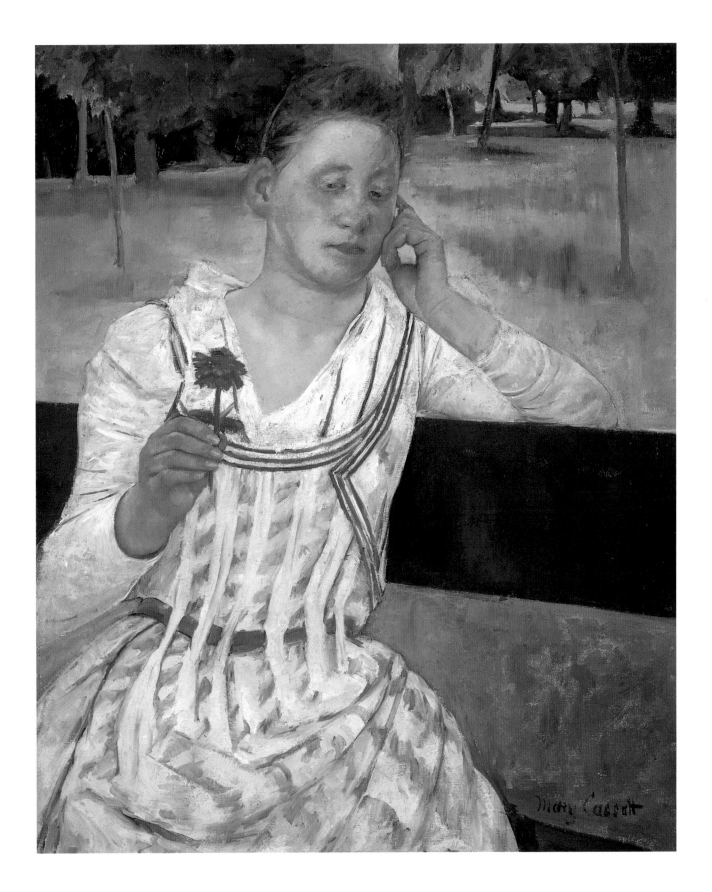

67. *Revery*, 1891–92. Oil on canvas; 73 x 60.5 cm.
Washington, D.C., National Gallery of Art.

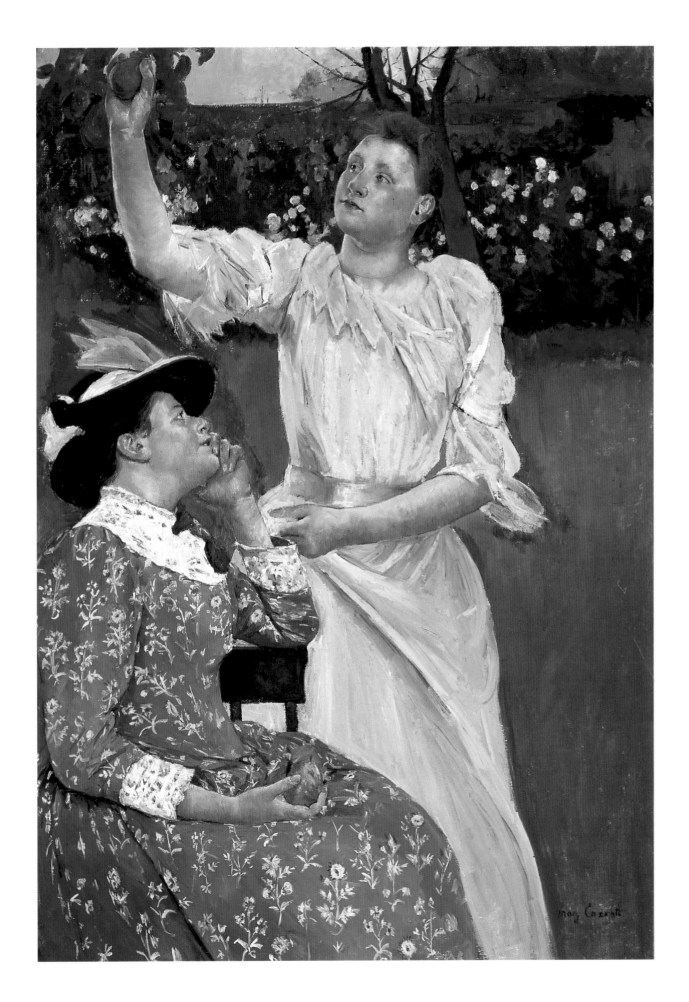

68. *Young Women Picking Fruit*, 1891/92. Oil on canvas; 132 x
91.5 cm. Pittsburgh, Carnegie Museum of Art.

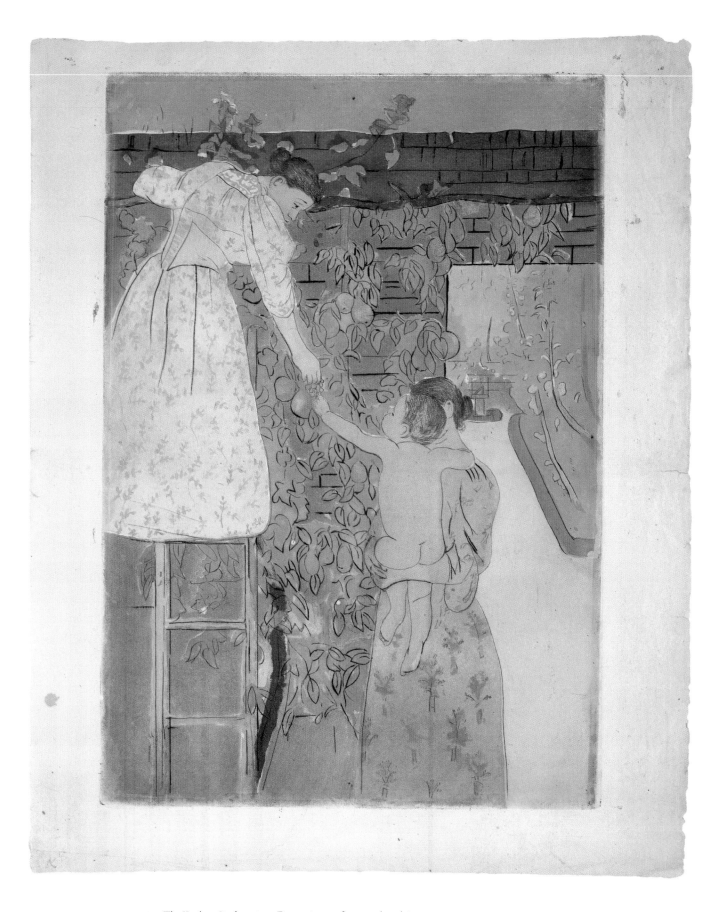

69. *The Kitchen Garden*, 1893. Drypoint, softground etching, and aquatint on paper; 42.2 x 29.8 cm. Washington, D.C., National Gallery of Art.

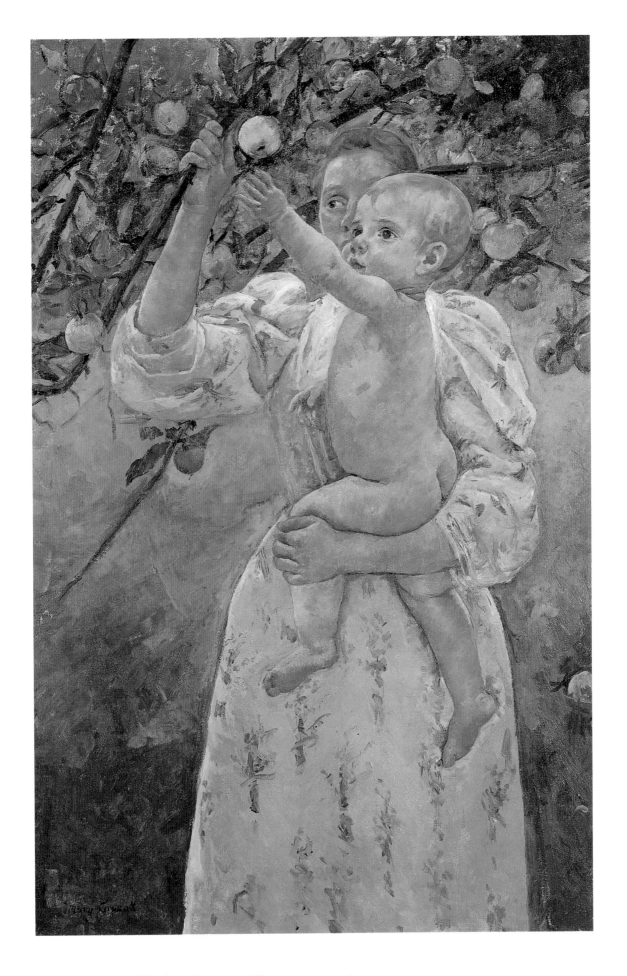

70. *Child Picking a Fruit*, 1893. Oil on canvas; 100 x 65 cm.
Richmond, Virginia Museum of Fine Arts.

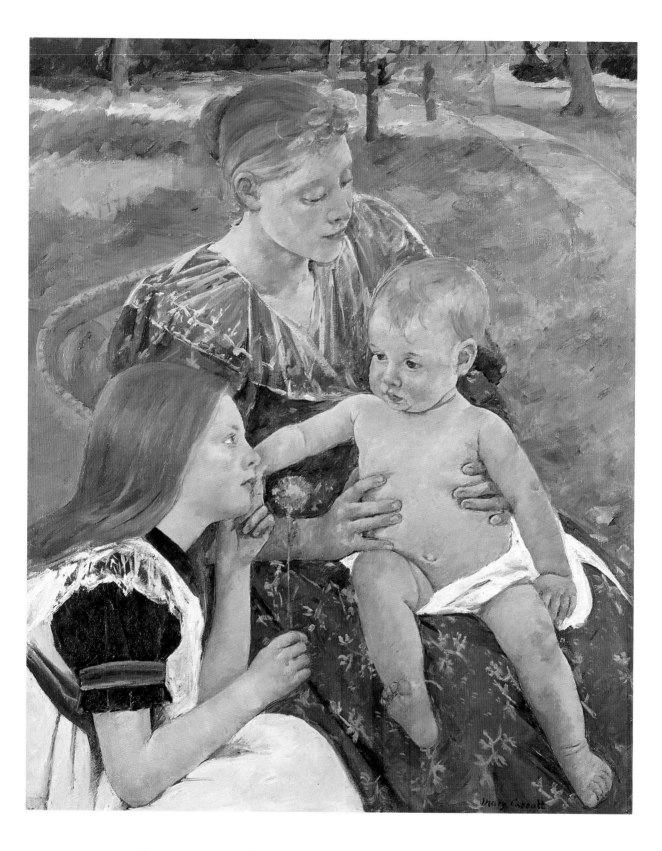

71. *The Family*, 1893. Oil on canvas; 81.2 x 66 cm. Norfolk, Va.,
Chrysler Museum.

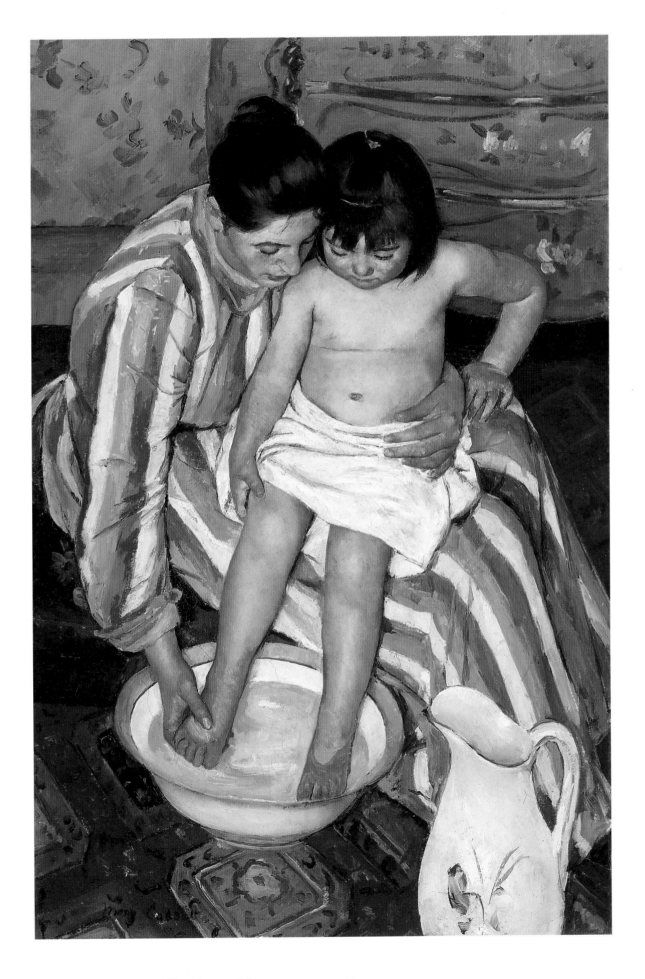

72. *The Child's Bath*, 1893. Oil on canvas; 100.3 x 66 cm.
The Art Institute of Chicago.

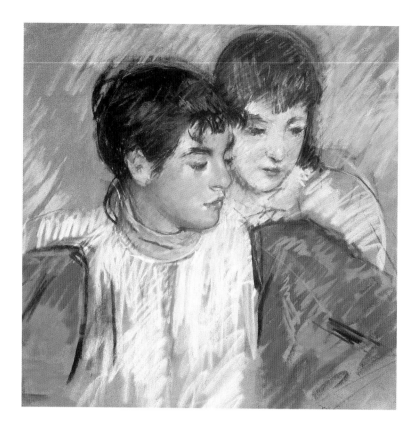

73. *The Two Sisters*, 1893/94. Pastel on tan wove pumice
paper; 44.5 x 44.5 cm. Boston, Museum of Fine Arts.

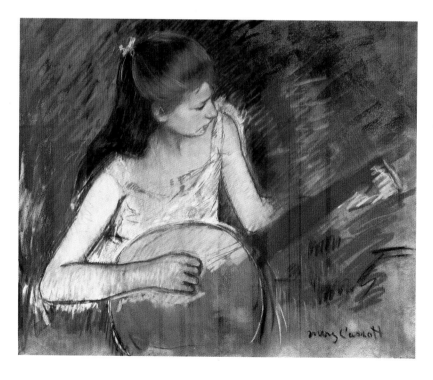

74. *Girl with a Banjo*, 1893/94. Pastel on tan wove paper; 60 x
73 cm. Los Angeles, private collection.

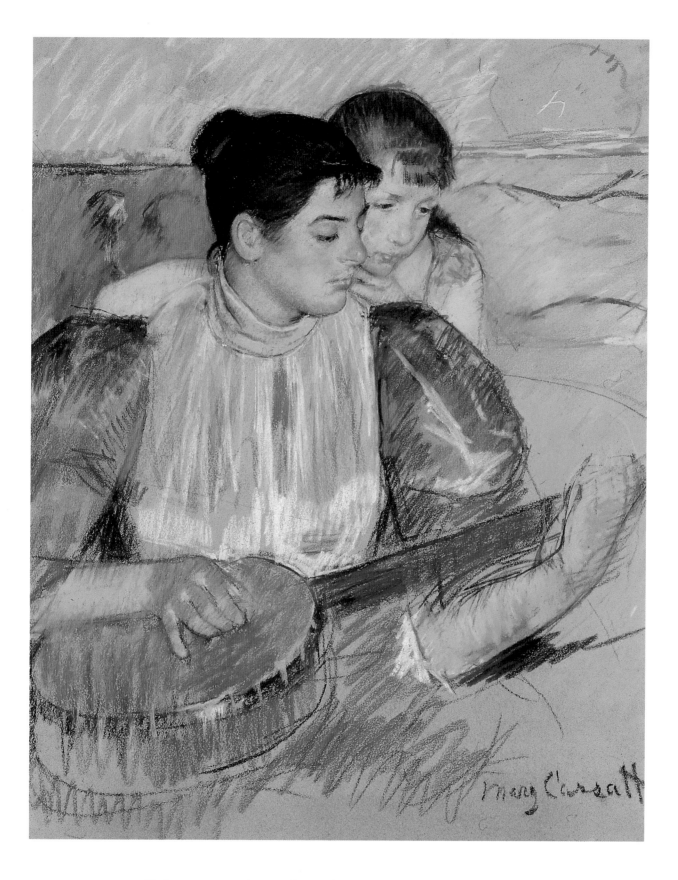

75. *The Banjo Lesson*, 1893/94. Pastel over oiled pastel on tan wove
paper; 72.2 x 58.6 cm. Richmond, Virginia Museum of Fine Arts.

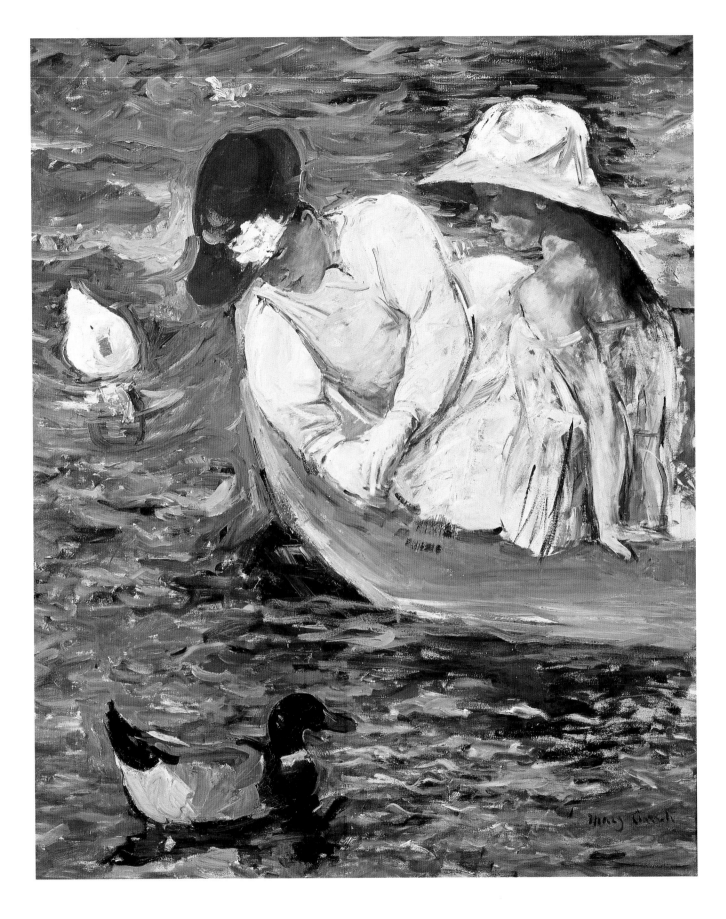

76. *Summertime*, c. 1894. Oil on canvas; 100.7 x 81.3 cm.
Terra Foundation for the Arts, Daniel J. Terra Collection.

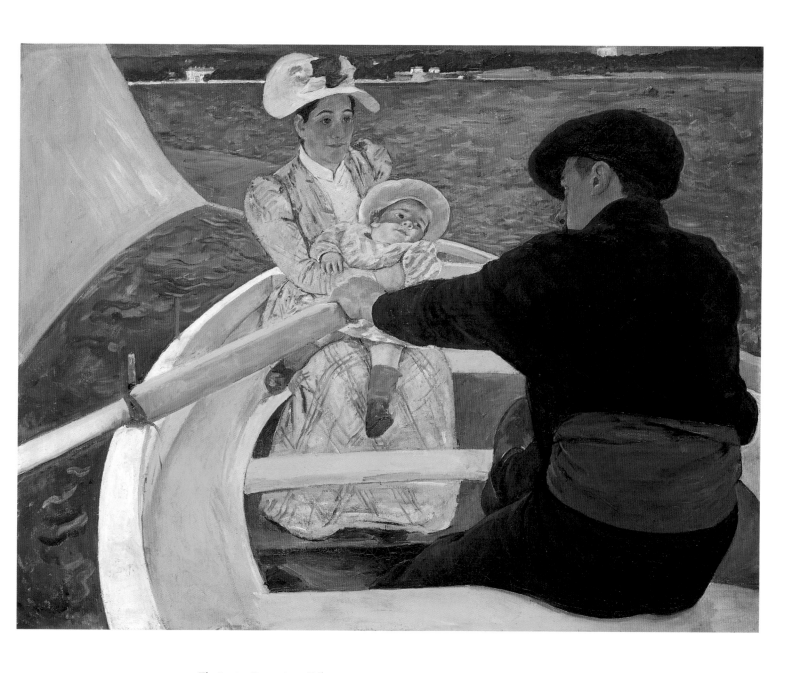

77. *The Boating Party,* 1894. Oil on canvas; 90 x 117 cm.
Washington, D.C., National Gallery of Art.

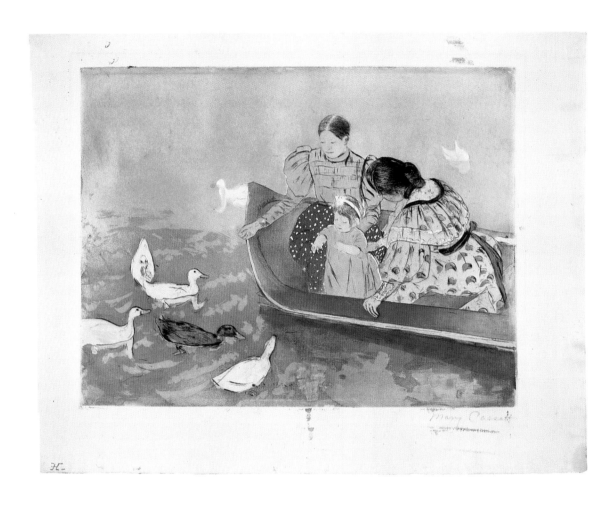

78. *Feeding the Ducks*, c. 1895. Drypoint and aquatint with
monotype additions on cream laid paper; 29.5 x 39.3 cm.
The Art Institute of Chicago.

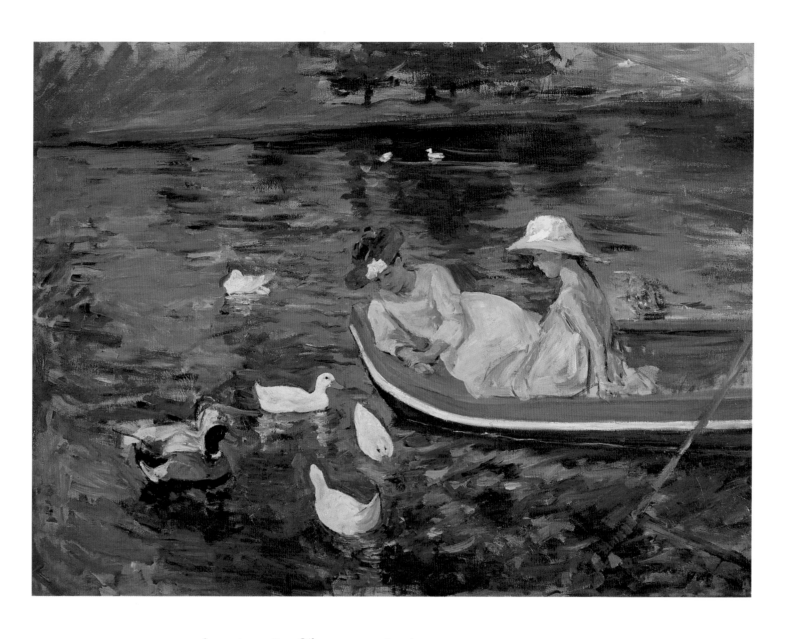

79. *Summertime*, c. 1894. Oil on canvas; 73.6 x 96.5 cm.
Los Angeles, Armand Hammer Collection, UCLA at the
Armand Hammer Museum of Art and Cultural Center.

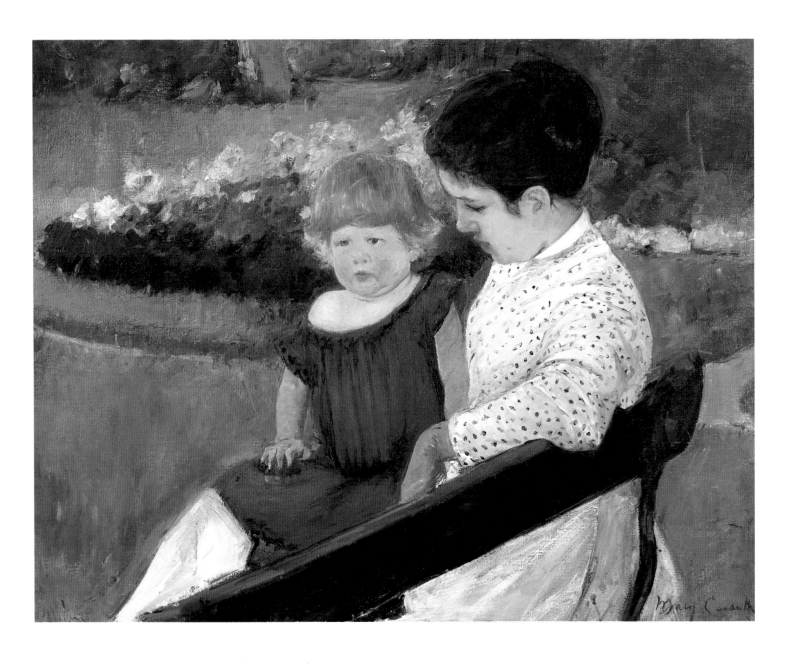

80. *In the Park*, c. 1894. Oil on canvas; 75 x 95.2 cm.
Collection of Mr. Fayez Sarofim.

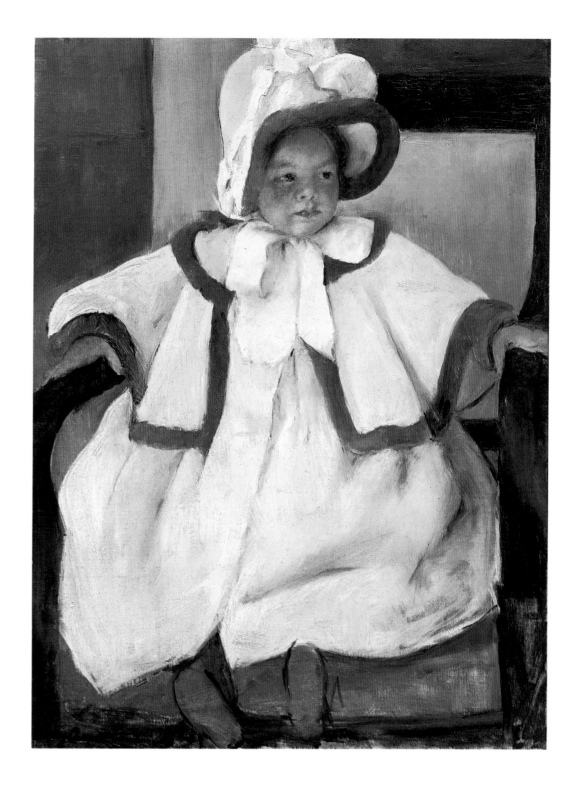

81. *Ellen Mary Cassatt in a White Coat*, c. 1896. Oil on canvas;
81.3 x 60.3 cm. Boston, Museum of Fine Arts.

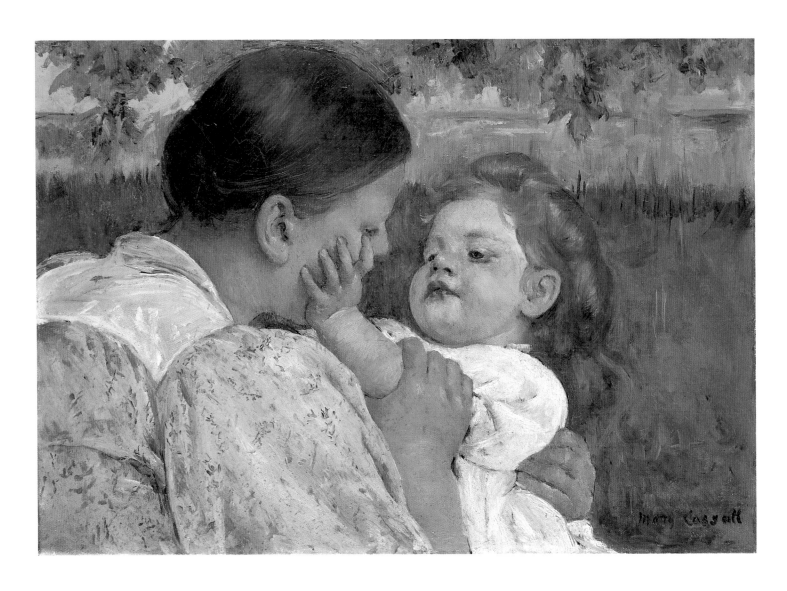

82. *Maternal Caress*, 1896. Oil on canvas; 38 x 54 cm.
Philadelphia Museum of Art.

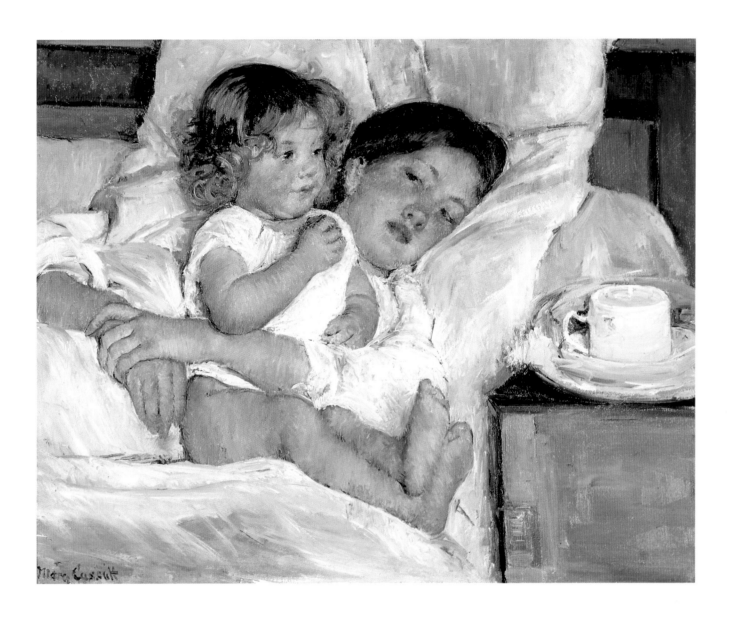

83. *Breakfast in Bed*, c. 1897. Oil on canvas; 65 x 73.6 cm.
San Marino, Calif., Virginia Steele Scott Collection,
Huntington Library and Art Gallery.

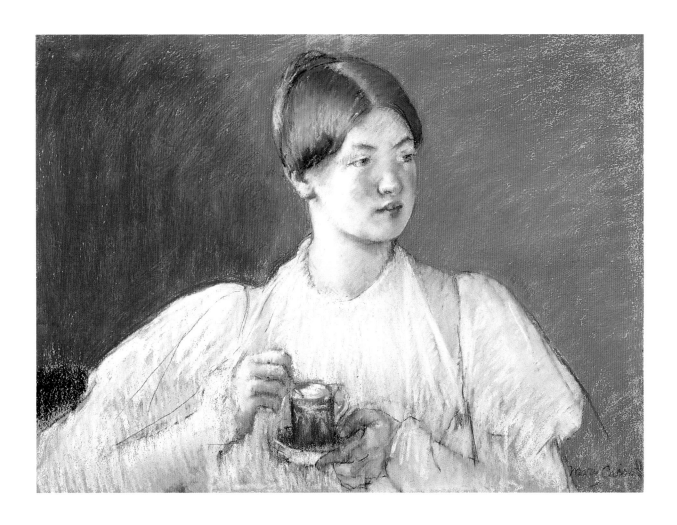

84. *The Cup of Tea*, 1897. Pastel on tan wove paper; 54.3 x
73 cm. Chicago, The Estate of Daniel J. Terra.

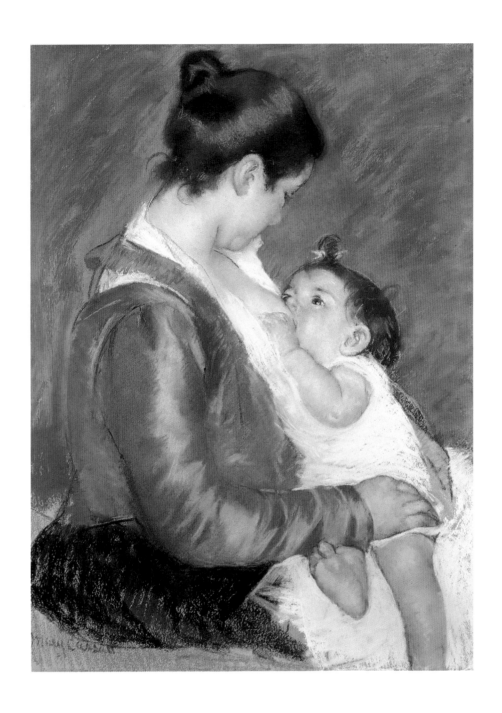

85. *Young Mother Nursing Her Child*, 1898. Pastel on tan wove
paper; 72.4 x 53.4 cm. Zurich, Collection Rau, Fondation Rau.

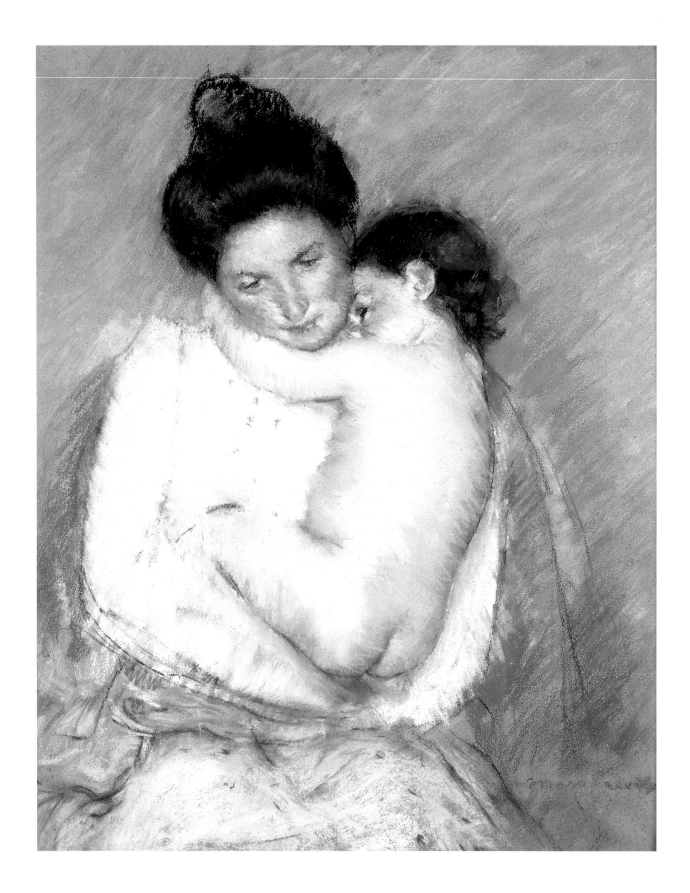

86. *Mother and Child*, c. 1900. Pastel on tan wove paper; 71 x 58.5 cm. The Art Institute of Chicago.

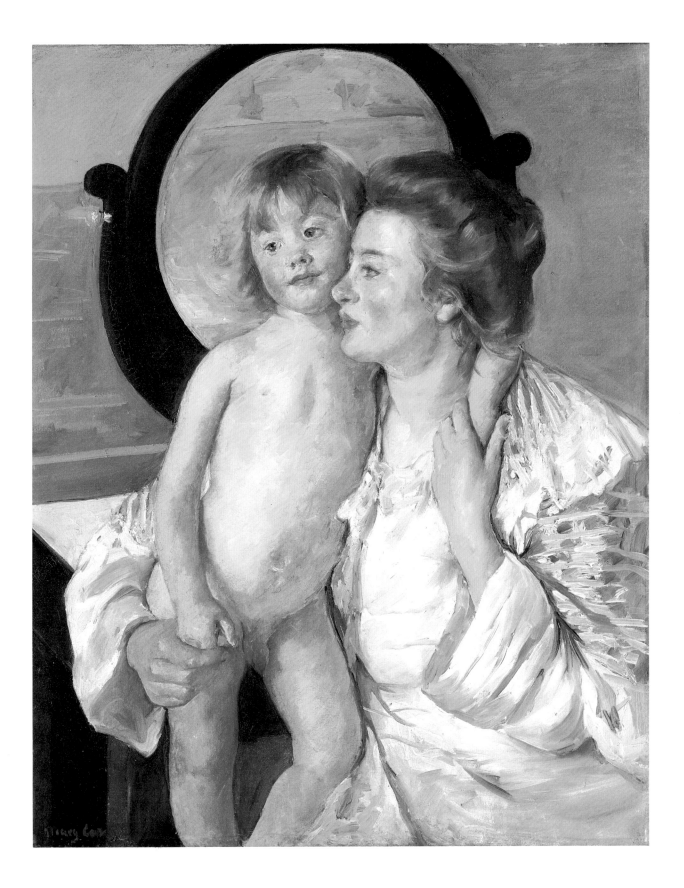

87. *Mother and Child*, 1898. Oil on canvas; 81.6 x 65.7 cm.
New York, The Metropolitan Museum of Art.

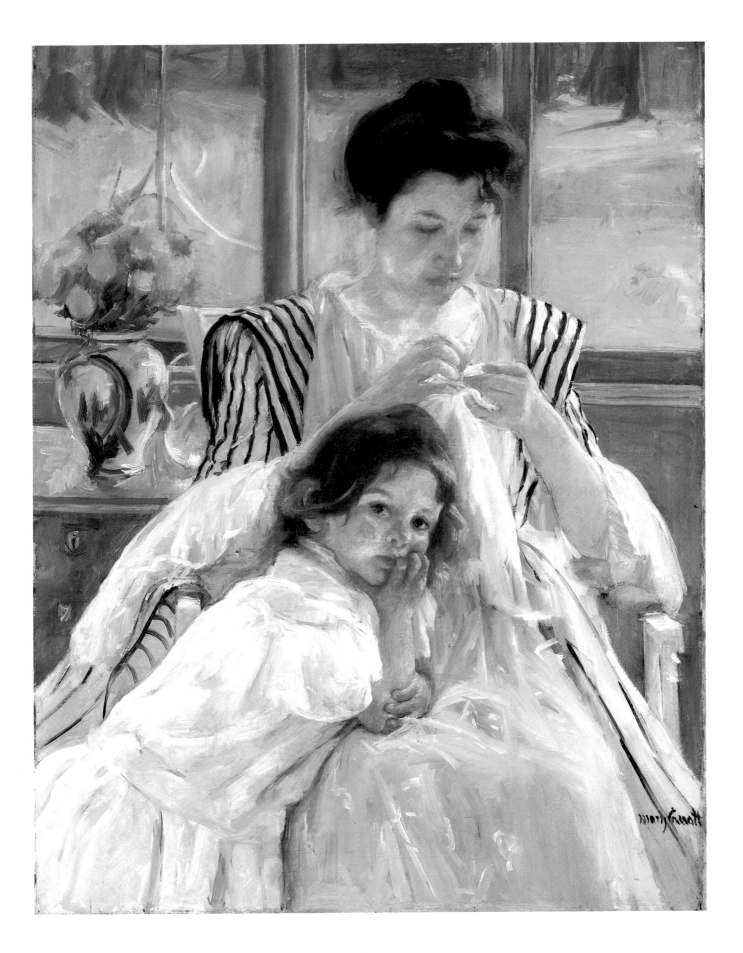

88. *Young Mother*, 1900. Oil on canvas; 92.4 x 73.7 cm.
New York, The Metropolitan Museum of Art.

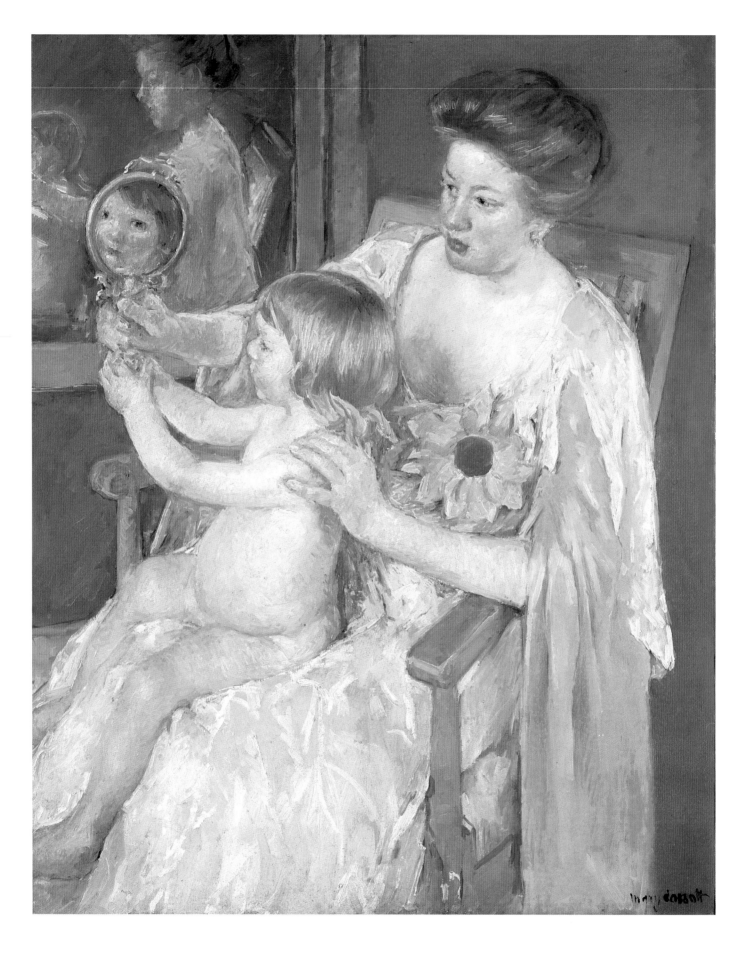

89. *The Mirror*, c. 1905. Oil on canvas; 91 x 72 cm.
Washington, D.C., National Gallery of Art.

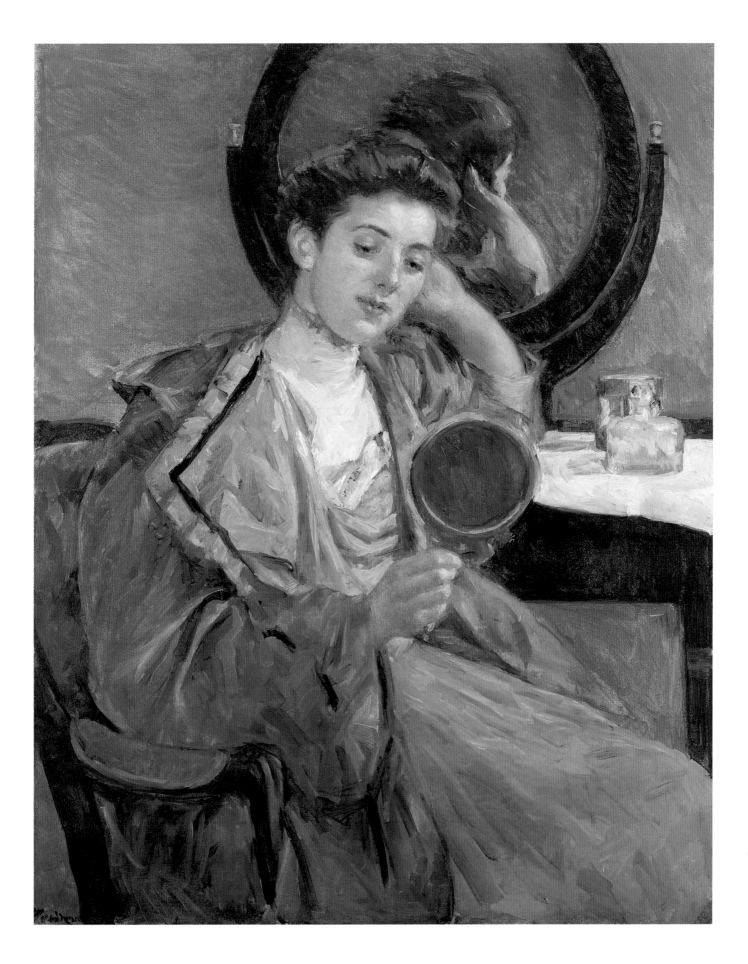

90. *Woman at Her Toilette*, 1909. Oil on canvas; 92.5 x 72.4 cm.
Collection of Mr. Fayez Sarofim.

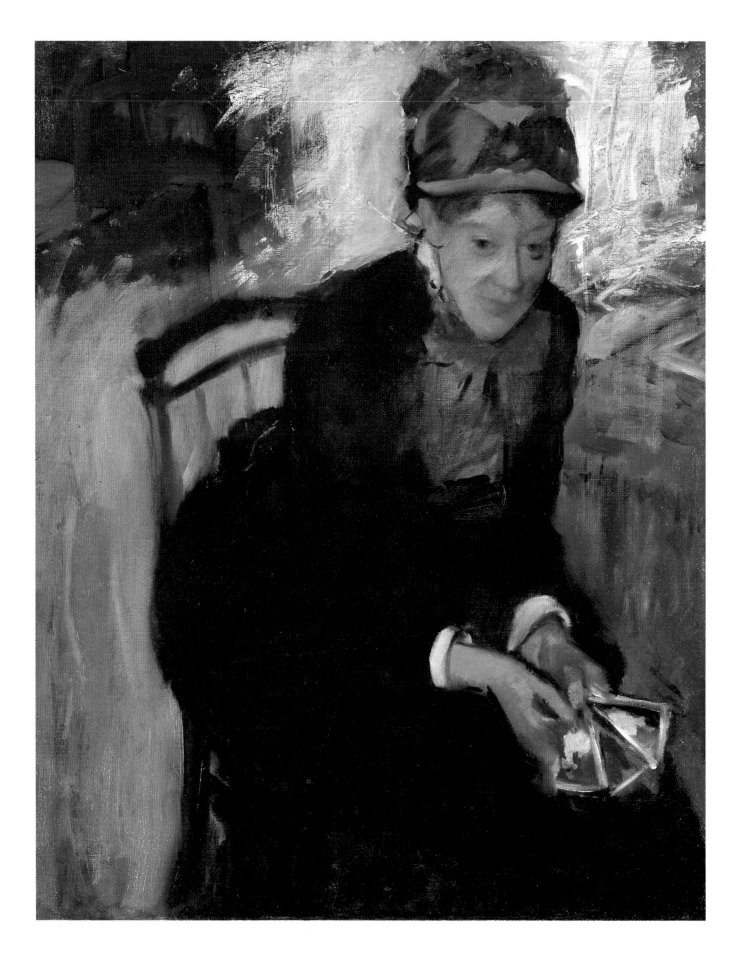

91. Edgar Degas (French; 1834–1917). *Mary Cassatt Seated, Holding Cards*, c. 1880–84. Oil on canvas; 74 x 60 cm. Washington, D.C., National Portrait Gallery.

Checklist

Notes to the Reader

Title: Titles are a particularly vexing problem in the study of Mary Cassatt's oeuvre. Adelyn Breeskin, in her 1948 and 1970 catalogues raisonné of Cassatt's prints and unique works, assigned largely descriptive titles that, for the most part, bear no relationship to those given by the artist herself. As often as possible, we have restored the titles used by Cassatt to the works included in this exhibition, in almost every case looking to the first public exhibition of a given work. Such a system is less than perfect. While the artist would have been directly responsible for titling most of the works she executed, showed, and sold before 1900, many of her late works were titled by Cassatt's dealers the Durand-Ruels and (less frequently) Ambroise Vollard. For works that seem never to have been exhibited during Cassatt's lifetime, Breeskin's titles have been preserved.

Date: Except for very early in her career, Cassatt never inscribed dates on her paintings, pastels, or prints. Some works can be dated securely on the basis of descriptions in the artist's or her family's correspondence; more often we have referred to the record of lifetime exhibitions in order to determine the latest possible date a work could have been produced. We have used the following conventions for dating:

1880	executed in 1880
c. 1880	executed sometime around 1880
1880–81	begun in 1880 and completed in 1881
1880/81	executed either in 1880 or 1881

Media description: Every work in this exhibition has been examined by a member of the Cassatt research team. The media descriptions are meant to be as detailed, consistent, and accurate as possible; but, in some cases, when a work could not be unframed or examined under magnification, these descriptions remain incomplete.

Dimensions: Dimensions are given in centimeters, height preceding width, followed by dimensions given in inches within parentheses.

Signature: All visible, relevant information inscribed or stamped upon a given work—including signatures, dates, inscriptions, annotations, and collector's marks—is noted.

Provenance: The provenance section is intended to provide information about Cassatt's relationship to and involvement with early collectors of her work. Due to lack of complete documentation, however, some gaps remain and a degree of speculation has been necessary, as indicated by the words "possibly" and "probably."

Exhibitions: Only exhibitions in which Cassatt participated during her lifetime are listed here, in abbreviated form. For complete citations, see the Lifetime Exhibition History.

Bibliography: Books and articles published during Cassatt's lifetime containing references to specific works, or to a work as a part of a group of objects, are listed here, in abbreviated form. For complete citations, see the Bibliography.

Letter references: Cassatt rarely discussed her own work in her correspondence, but, fortunately, her family, friends, colleagues, and dealers did. The sender and recipient of each letter in which a work by Cassatt is mentioned—whether individually or as part of a group of objects—are listed here; the following abbreviations are used for the most frequently cited names:

AC	Alexander Cassatt (brother)
KC	Katherine Cassatt (mother)
LC	Lois Cassatt (sister-in-law; wife of Alexander Cassatt)
MC	Mary Cassatt
RC	Robert (Robbie) Cassatt (nephew; son of Alexander and Lois Cassatt)
RSC	Robert S. Cassatt (father)
DR	Durand-Ruel Galleries, Paris and/or New York
GDR	George Durand-Ruel
JDR	Joseph Durand-Ruel
PDR	Paul Durand-Ruel
HOH	Henry O. Havemeyer
LH	Louisine Havemeyer
ES	Emily Sartain

The date of each letter is also provided, followed by a citation, in abbreviated form, to its published form or its location in an archive. For complete citations see the Bibliography.

Catalogue raisonné: For each work in the exhibition that was catalogued by Breeskin in her 1948 catalogue raisonné of Cassatt's prints or her 1970 catalogue raisonné of her paintings, pastels, watercolors, and drawings, Breeskin's title and date are given. Works not catalogued by Breeskin are identified as "uncatalogued."

1. *Bacchante*, 1872

Oil on canvas; 62 x 50.7 cm
(24⅛ x 20 in.)
Signed, inscribed, dated lower left: *Mary S. Cassatt/Parma/1872*
Philadelphia, courtesy Museum of American Art of the Pennsylvania Academy of the Fine Arts, gift of John Frederick Lewis, 1932.13.1

Chicago, Boston

PROVENANCE: From the artist to J. W. Lockwood, Philadelphia, by 1876
EXHIBITIONS: Philadelphia 1877, no. 343
LETTER REFERENCES: MC to ES, June 2, [1872], in Mathews 1984, pp. 101–102
CATALOGUE RAISONNÉ: Breeskin 1970, 15 (as *The Bacchante*, 1872)

2. *During Carnival (Pendant le carnaval)*, 1872

Oil on canvas; 63.5 x 54.6 cm
(25 x 21½ in.)
Signed lower left: *Mary Stevenson*
Lent anonymously

Chicago, Boston

PROVENANCE: From the artist to a collector in the United States, by Nov. 17, 1872
EXHIBITIONS: Paris 1872, no. 1433
BIBLIOGRAPHY: H. B. 1872 (as *Taming the Cannibal*)
LETTER REFERENCES: ES to John Sartain, Feb. 18, 1872, in Mathews 1984, pp. 92–93; ES to John Sartain, Mar. 7, 1872, in Mathews 1984, p. 95; MC to ES, May 25, [1872], in Mathews 1984, p. 99; AC to LC, [c. May–June 1872], in Pollock 1980, p. 65; MC to ES, June 2, [1872], in Mathews 1984, p. 100; ES to John Sartain, Oct. 9, 1872, in Mathews 1984, p. 104; ES to John Sartain, Nov. 17, 1872, in Mathews 1984, p. 111
CATALOGUE RAISONNÉ: uncatalogued

3. *The Flirtation: A Balcony in Seville*, 1872

Oil on canvas; 101 x 82.5 cm
(39¼ x 32½ in.)
Signed, dated, inscribed lower left: *M.S.C./1872/à Seville*

Philadelphia Museum of Art, Wilstach Collection, W'06.1.7.0

Chicago, Boston, Washington

PROVENANCE: Wilstach Collection, Philadelphia, by 1906

EXHIBITIONS: Cincinnati 1873, no. 184; New York 1874, no. 286 (as *A Balcony at Seville*); New York 1895b, no. 22 (as *Scène espagnole*)

BIBLIOGRAPHY: *The Nation* 1874; Marks 1895c; *New York Times* 1895e; *New York Tribune* 1895; Walton 1896; Cary 1908; Cary 1909

LETTER REFERENCES: MC to ES, Jan. 1, 1873, in Mathews 1984, p. 114; KC to ES, July 4, [1873], in Mathews 1984, pp. 122–23

CATALOGUE RAISONNÉ: Breeskin 1970, 18 (as *On the Balcony During the Carnival*, 1872)

4. *A Seville Belle*, 1873

Oil on canvas; 65 x 49.5 cm (25⅝ x 19½ in.)
Signed, dated, inscribed lower left: *Mary Cassatt/1873 à Seville*
Washington, D.C., National Museum of American Art, Smithsonian Institution, 1967.40

Chicago, Boston

PROVENANCE: From the artist to Mathilde Valet, Paris, 1927; Mathilde X Sale, Paris, 1927; Lévy, Paris; Hugo Perls, New York; Parke-Bernet, New York, Feb. 3, 1954, no. 76; Hirshl and Adler, New York; Mrs. Max Dreyfus

EXHIBITIONS: Cincinnati 1873, no. 160

BIBLIOGRAPHY: Benjamin 1879; Benjamin 1880b

LETTER REFERENCES: KC to ES, July 4, [1873], in Mathews 1984, pp. 122–23; KC to AC, Nov. 22, [1878], in Mathews 1984, p. 141

CATALOGUE RAISONNÉ: Breeskin 1970, 21 (as *Spanish Dancer Wearing a Lace Mantilla*, 1873)

5. *Offering the Panal to the Bullfighter (Offrant le "panal" au "torero")*, 1872–73

Oil on canvas; 100.6 x 85.1 cm (39⅝ x 33½ in.)
Signed, inscribed, dated lower right: *Mary S. Cassatt/Seville/1873*
Williamstown, Mass., Sterling and Francine Clark Art Institute

Chicago, Boston, Washington

PROVENANCE: Consigned by the artist to H. Teubner, Philadelphia, 1878;

returned to the artist possibly in Dec. 1878; possibly sold by the artist to M. Engrand, Paris, no earlier than Dec. 1878; M. Parisot; Durand-Ruel, New York, May 1947; Carroll Carstairs Gallery, New York, June 20, 1947; M. Knoedler and Co., New York, Sept. 29, 1947; Robert Sterling Clark, Oct. 2, 1947

EXHIBITIONS: Paris 1873, no. 1372; Cincinnati 1873, no. 250 (as *Il Torero*); New York 1874, no. 280; Philadelphia 1878, no. 192 (as *Spanish Matador*)

BIBLIOGRAPHY: G. G. 1873; *The Nation* 1874; *Philadelphia Daily Evening Telegraph* 1878; *Philadelphia Times* 1878

LETTER REFERENCES: ES to MC, [May 25, 1875], in Mathews 1984, pp. 127–28; KC to AC, Nov. 22, [1878], in Mathews 1984, p. 141

CATALOGUE RAISONNÉ: Breeskin 1970, 22 (as *Torero and Young Girl*, 1873)

6. *After the Bullfight*, 1873

Oil on canvas; 82 x 64 cm (32¼ x 25¼ in.)
Signed, inscribed, dated lower left: *M.S.C./Seville/1873*
The Art Institute of Chicago, gift of Mrs. Sterling Morton, 1969.332

Chicago, Boston

PROVENANCE: Consigned by the artist to Mrs. Mitchell, Philadelphia, June 1878; returned to the artist; sold by the artist to John Ruderman; Mr. and Mrs. Lewis Padawar; Mrs. Sterling Morton, Chicago, 1959

EXHIBITIONS: Boston 1878, no. 176

LETTER REFERENCES: RSC to AC, Oct. 4, 1878, in Mathews 1984, p. 138

CATALOGUE RAISONNÉ: Breeskin 1970, 23 (as *Toreador*, 1873)

7. *Mrs. Duffee Seated on a Striped Sofa, Reading*, 1876

Oil on panel; 35 x 27 cm (13¼ x 10⅛ in.)
Signed, inscribed, dated upper left: *M.S. Cassatt/Paris/1876*
Boston, Museum of Fine Arts, bequest of John T. Spaulding, 48.523

Chicago

PROVENANCE: From the artist to Mary E. G. Duffee; Francis Harold Duffee, 1894; American Art Galleries, New York, Mrs. I. N. Seligman Sale, 1928, no. 167; E. D. Levinson, Cedarhurst, New York; Wildenstein Galleries, New York; John T. Spaulding, 1934

CATALOGUE RAISONNÉ: Breeskin 1970,

47 (as *Mrs. Duffee Seated on a Striped Sofa, Reading*, 1876)

8. *Portrait of Madame X Dressed for the Matinée*, 1878

Oil on canvas; 100 x 81 cm (39⅜ x 31⅞ in.)
Signed lower left: *Mary Cassatt*
Philip and Charlotte Hanes

Chicago, Boston, Washington

PROVENANCE: From the artist to Ambroise Vollard, Paris; sold at Palais Galleria, Paris, Dec. 5, 1960; Mme R. G. Lanvin; E. V. Thaw and Co., New York

BIBLIOGRAPHY: Mauclair 1904, p. 208

CATALOGUE RAISONNÉ: Breeskin 1970, 54 (as *Portrait of Madame X Dressed for the Matinée*, 1878)

9. *Portrait of a Lady*, 1877

Oil on canvas; 85.7 x 65.2 cm (33¼ x 25⅝ in.)
Signed center left: *Mary Cassatt*
Washington, D.C., National Gallery of Art, 1963.10.95

Washington

PROVENANCE: Consigned by the artist to H. Teubner, Philadelphia, 1877; returned to the artist, Paris, by 1879; probably sold by the artist to Durand-Ruel, Paris, by 1893; to Durand-Ruel, New York, by 1895; Chester Dale, New York, Nov. 12, 1926

EXHIBITIONS: Possibly Philadelphia 1877–78; Philadelphia 1878, no. 175; Paris 1879, no. 48 (as *Etude de femme avec éventail*); Paris 1884 (as *Femme à l'éventail*); Paris 1893, no. 10 (as *Femme à l'éventail*); New York 1895b, no. 2 (as *Femme à l'éventail*); New York 1898; Boston 1898, no. 15 (as *Femme à l'éventail*); Cincinnati 1901, no. 1 (as *Femme à l'éventail: Woman with Fan*); New York 1903a, no. 2 (as *Femme à l'éventail*); Philadelphia 1907, no. 127 (as *Femme à l'éventail*); Boston 1909, no. 22 (as *Femme à l'éventail*); Cincinnati 1911, no. 90 (as *Woman with Fan*); Washington, D.C. 1911, no. 10 (as *Femme à l'éventail*); Pittsburgh 1912, no. 59 (as *Woman with Fan*); Chicago 1912, no. 43 (as *Woman with Fan*); Washington, D.C. 1914–15, no. 77 (as *Woman with Fan*); San Francisco 1915, no. 3010 (as *Woman with a Fan*); New York 1917, no. 2 (as *Femme à l'éventail*); New York 1923, no. 17 (as *Femme à l'éventail*); New York 1924, no. 2 (as *Femme à l'éventail*); Chicago 1925, no. 39 (as *Woman with a Fan*); Buffalo 1926, no. 21 (as *Woman with a Fan*)

BIBLIOGRAPHY: *Philadelphia Daily Evening*

Telegraph 1878; *Philadelphia Times* 1878; Besson 1879; Lostalot 1879; *New York Times* 1879b; *Le Soir* 1879; Marks 1895c; *New York Times* 1895c; Walton 1896; *New York Times Saturday Review of Books and Art* 1898; *Academy Notes* 1907; *New York Times Magazine* 1907; *Boston Daily Evening Transcript* 1909; Cary 1909; Hale 1909; Keeble 1912; *New York Times* 1917; *The Arts* 1923

CATALOGUE RAISONNÉ: Breeskin 1970, 80 (as *Miss Mary Ellison*, c. 1880)

10. *Portrait of a Lady*, 1878

Oil on canvas; 104 x 83.7 cm (41 x 33 in.)
Signed lower right: *Mary Cassatt*
Washington, D.C., private collection

Chicago, Washington

PROVENANCE: From the artist to her brother Alexander J. Cassatt, Philadelphia, by Dec. 13, 1878; to his widow, Lois Cassatt, Philadelphia, 1906–20; to her daughter Elsie Foster Cassatt (Mrs. W. Plunkett) Stewart, Philadelphia, 1920–31; to her daughter Katherine Stewart (Mrs. Eric) de Spoelberch, Philadelphia, after 1931; Christie's, New York, May 17, 1983; sold to Private Asset Management Group, Inc., New York

EXHIBITIONS: New York 1879, no. 99 (as *Portrait*); Philadelphia 1879, no. 158; New York 1886, no. 310; New York 1892, no. 40 (as *Portrait*); New York 1894b, no. 53 (as *Mrs. R. S. Cassatt*); New York 1895b, no. 34 (as *Portrait of Mrs. C.*); Philadelphia 1920, no. 13 (as *Portrait of Her Mother*)

BIBLIOGRAPHY: Carter 1879; *New York Times* 1879a; *New York Daily Tribune* 1879a; *New York Daily Tribune* 1879b; *New York World* 1879; *Philadelphia Daily Evening Telegraph* 1879; *New York Times* 1895c; Walton 1896

LETTER REFERENCES: KC to AC, [summer 1878], in Sweet 1966, p. 35; RSC to AC, Oct. 4, 1878, in Mathews 1984, p. 138; RSC to AC, Dec. 13, 1878, in Mathews 1984, p. 142; KC to AC, Dec. 23, 1881, PMA; AC to LC, Dec. 30, 1884, PMA; Bertha Palmer to MC, Dec. 15, 1892, in Mathews 1984, p. 242; MC to LH, Feb. 14, 1920, NGA; MC to LH, Mar. 22, 1920, NGA; RC to MC, Apr. 1, 1920, NGA; MC to LH, Apr. 10, 1920, NGA; MC to LH, May 18, 1920, NGA

CATALOGUE RAISONNÉ: Breeskin 1970, 128 (as *Reading "Le Figaro,"* 1883)

11. *Portrait of a Little Girl (Portrait de petite fille)*, 1878

Oil on canvas; 89.5 x 129.8 cm (35¼ x 51⅛ in.)
Signed lower left: *Mary Cassatt*
Washington, D.C., National Gallery of Art, collection of Mr. and Mrs. Paul Mellon, 1983.1.18

Chicago, Boston, Washington

PROVENANCE: From the artist to Ambroise Vollard, Paris, c. 1903 until at least 1929; Hector Brame, Paris; Mr. and Mrs. Paul Mellon, Upperville, Va., 1963

EXHIBITIONS: Paris 1879, no. 47

BIBLIOGRAPHY: Borgmeyer 1913

LETTER REFERENCES: MC to Ambroise Vollard, [1903], in Mathews 1984, pp. 281–82

CATALOGUE RAISONNÉ: Breeskin 1970, 56 (as *The Blue Room*, 1878)

12. *Children in a Garden (Enfants au jardin)*, 1878

Oil on canvas; 73.6 x 92.6 cm (29 x 36½ in.)
Signed lower left: *Mary Cassatt*
Mr. and Mrs. Meredith J. Long

Chicago, Boston, Washington

PROVENANCE: From the artist (possibly via Félix Bracquemond) to Charles Haviland, Paris, c. 1879; Hôtel Drouot, Paris, Charles Haviland Sale, Dec. 7, 1922, no. 41; M. Knoedler and Co., London, by 1923; E. G. Bing, London, 1925; Mr. and Mrs. A. Varick Stout, Greenwich, Conn.; Sotheby's, New York, May 2–4, 1973, no. 59

EXHIBITIONS: Paris 1886, no. 12; New York 1895b, no. 19 (as *Nourrice et enfant*); London 1923, no. 4 (as *The Nurse*)

BIBLIOGRAPHY: Christophe 1886; Geffroy 1886; *Moniteur des arts* 1886; Marks 1895c

LETTER REFERENCES: Edgar Degas to Félix Bracquemond, after May 11, 1879, in Guérin 1945, p. 47

CATALOGUE RAISONNÉ: Breeskin 1970, 57 (as *The Nurse*, 1878)

13. *On a Balcony (Sur un balcon)*, 1878/79

Oil on canvas; 90 x 65 cm (35⅛ x 25⅛ in.)
Signed lower left: *Mary Cassatt*
The Art Institute of Chicago, gift of Mrs. Albert J. Beveridge in memory of her aunt, Delia Spencer Field, 1938.18

Chicago, Boston, Washington

PROVENANCE: From the artist to Durand-Ruel, Paris and New York, by 1901–22; Mrs. Albert J. Beveridge, Chicago, 1922–38

EXHIBITIONS: Paris 1880, no. 20; Philadelphia 1902, no. 529 (as *Woman Reading in a Garden*); New York 1903a, no. 10 (as *Femme lisant dans un jardin*); Buffalo 1907, no. 18 (as *Woman Reading in a Garden*); New York 1909c; Philadelphia 1911, no. 328 (as *Woman Reading in a Garden*); Washington, D.C. 1914–15, no. 73 (as *Woman Reading in the Garden*); San Francisco 1915, no. 3006 (as *Woman Reading in a Garden*); Worcester 1917, no. 1; New York 1917, no. 5 (as *Femme lisant dans un jardin*); New York 1920b, no. 8 (as *Femme lisant dans un jardin*)

BIBLIOGRAPHY: *Philadelphia Inquirer* 1902; Hale 1909; *Current Opinion* 1917; *New York Times* 1917

CATALOGUE RAISONNÉ: Breeskin 1970, 94 (as *Lydia Reading in a Garden*, 1880)

14. *Woman Reading (Femme lisant)*, 1878/79

Oil on canvas; 78.6 x 59 cm (31 x 23¼ in.)
Signed lower left: *Mary Cassatt*
Omaha, Nebr., Joslyn Art Museum, museum purchase, 1943

Chicago, Boston, Washington

PROVENANCE: From the artist to Antonin Proust, Paris, c. 1879; Dikran G. Kelekian, Paris and New York, c. 1900–43

EXHIBITIONS: Paris 1879, no. 52

BIBLIOGRAPHY: Lostalot 1879; Martelli 1879; Silvestre 1879b; Syène 1879

CATALOGUE RAISONNÉ: Breeskin 1970, 51 (as *Lydia Reading the Morning Paper [No. 1]*, 1878)

15. *Woman Standing, Holding a Fan (Femme debout, tenant un éventail)*, 1878/79

Distemper with metallic paint on canvas; 128.6 x 72 cm (50⅝ x 27⅛ in.)
Signed lower left: *Mary Cassatt*
Private collection

Chicago, Boston

PROVENANCE: From the artist to Ambroise Vollard, Paris; Madame Beck; private collection

CATALOGUE RAISONNÉ: uncatalogued

16. *Portrait of Madame J. (Portrait de Madame J.)*, 1879/80

Oil on canvas; 80.6 x 64.6 cm (31¼ x 25⅛ in.)
Signed lower right: *Mary Cassatt*
Baltimore, Peabody Art Collection, courtesy the Maryland Commission on Artistic Property of the Maryland State Archives, on loan to the Baltimore Museum of Art, MSA SC 4680-1-5-P.I.10.10

Chicago, Boston, Washington

PROVENANCE: From the artist to Durand-Ruel, Paris and New York, by 1924–42; Peabody Institute, Baltimore

EXHIBITIONS: Paris 1880, no. 17; New York 1924a, no. 1 (as *Jeune femme en noir*)

BIBLIOGRAPHY: Burty 1880; Dalligny 1880; Ephrussi 1880; Mont 1880; Silvestre 1880a; Geffroy 1904

CATALOGUE RAISONNÉ: Breeskin 1970, 129 (as *Young Woman in Black*, 1883)

17. *At the Français, a Sketch*, 1877/78

Oil on canvas; 81 x 66 cm (31⅞ x 26 in.)
Signed lower left: *Mary Cassatt*
Boston, Museum of Fine Arts, Hayden Collection, 10.35

Chicago, Boston, Washington

PROVENANCE: From the artist to MM. Martin, Camentron, and Co., Paris, c. 1893; to Durand-Ruel, Paris and New York, c. 1894–1910; F. W. Bayley, Boston

EXHIBITIONS: Boston 1878, no. 234; Paris 1893, no. 13 (as *La Loge*); New York 1895a, no. 17 (as *Dans la loge*); New York 1895b, no. 5 (as *Dans la loge*); New York 1896b; Boston 1898, no. 14 (as *Dans la loge*); Cincinnati 1900, no. 12 (as *Dans la loge*); New York 1903a, no. 1 (as *Dans la Loge*); New York 1906b; Philadelphia 1907a, no. 124 (as *Dans la Lodge [sic]*; Boston 1909, no. 24 (as *Dans la loge*); New York 1909a

BIBLIOGRAPHY: Brownell 1881; Marks 1895b; Marks 1895c; *New York Times* 1895a; *New York Tribune* 1895; Trumble 1896; Walton 1896; Hoeber 1899; *New York Daily Tribune* 1903; *New York Times* 1903b; *American Art News* 1906c; *Boston Daily Evening Transcript* 1909; Cary 1909; Hartmann 1909; *New York Times* 1909b; Borgmeyer 1913; Hoeber 1914

CATALOGUE RAISONNÉ: Breeskin 1970, 73 (as *A Woman in Black at the Opera*, 1880)

18. *Woman in a Loge (Femme dans une loge)*, 1878/79

Oil on canvas; 80.2 x 58.2 cm (31⅝ x 22⅞ in.)
Signed lower left: *Mary Cassatt*
Philadelphia Museum of Art, bequest of Charlotte Dorrance Wright, 1978.1.5

Chicago, Boston, Washington

PROVENANCE: From the artist to Alexis Rouart, Paris, c. 1879–1911; to his son Henri Rouart, Paris, 1911–c. 1943; Marcel Midy, Paris, by 1954–Mar. 1967; Mr. and Mrs. William Coxe Wright, St. David's, Penn.

EXHIBITIONS: Paris 1879, no. 49; Paris 1893, no. 4 (as *Au théâtre*); New York 1895b, no. 32 (as *Au théâtre*); Paris 1908b, no. 8 (as *Au théâtre*)

BIBLIOGRAPHY: Besson 1879; Hervilly 1879; Lostalot 1879; Martelli 1879; *New York Times* 1879b; *Petite République française* 1879; Renoir 1879; Silvestre 1879c; *Le Soir* 1879; Syène 1879; *Art français* 1893; Marks 1895c; *New York Times* 1895c; *New York Evening Post* 1903; Bouyer 1908b; Cary 1909; Mellerio 1910; Segard 1913, pp. 11, 168, ill. opp. p. 5

LETTER REFERENCES: RSC to AC, Sept. 1, 1879, in Mathews 1984, p. 147

CATALOGUE RAISONNÉ: Breeskin 1970, 64 (as *Lydia in a Loge, Wearing a Pearl Necklace*, 1879)

19. *At the Theater (Au théâtre)*, 1878/79

Pastel and gouache with metallic paint on tan wove paper, formerly on a strainer; 64.6 x 54.5 cm (25⅛ x 21½ in.)
Signed center left, vertically: *Mary Cassatt*
Lent anonymously

Chicago, Boston

PROVENANCE: From the artist to Paul Gauguin, Paris, c. 1879; to his wife, Mette Gauguin, Copenhagen, c. 1885; Edward Brandes, Copenhagen; Dr. Alfred Gold, Berlin; sold to a private collector, Fairhaven, Mass., 1935; by descent to a New England estate; Sotheby's, New York, Nov. 10, 1992, no. 7

EXHIBITIONS: Paris 1879, no. 54

BIBLIOGRAPHY: Silvestre 1879b

LETTER REFERENCES: Paul Gauguin to Mette Gauguin, late Nov. 1885, in Malingue 1946, p. 75

CATALOGUE RAISONNÉ: Breeskin 1970, 72 (as *Young Lady in a Loge Gazing to Right*, c. 1880)

20. *Women in a Loge*, 1881/82

Oil on canvas; 80 x 64 cm (31½ x 25¼ in.)
Signed lower right: *Mary Cassatt*
Washington, D.C., National Gallery of Art, Chester Dale Collection, 1963.10.96

Washington

PROVENANCE: From the artist to Durand-Ruel, Paris, April 1896; Baron Herzog, Budapest, Aug. 1911; Marczell von Nemes, Budapest, by 1912; Galerie Manzi Joyant, Paris, von Nemes sale, June 18, 1913, no. 84; Wildenstein Galleries, New York; sold to Mr. and Mrs. Chester Dale, New York, Dec. 17, 1929

EXHIBITIONS: London 1882; Düsseldorf 1912, no. 103

BIBLIOGRAPHY: *The Standard* 1882; Geffroy 1904; Mellerio 1910

LETTER REFERENCES: RSC to AC, July 3, 1882, in Mathews 1984, pp. 164–65; RSC to AC, Aug. 2, 1882, PMA

CATALOGUE RAISONNÉ: Breeskin 1970, 121 (as *Two Young Ladies in a Loge*, 1882)

21. *Women in a Loge*, 1881/82

Pastel with gouache, over soft-ground etching and aquatint on off-white wove paper; 29 x 22 cm (11⁷⁄₁₆ x 8⅝ in.)
Signed lower right: *M.C.*
Cincinnati Art Museum, bequest of Mary Hanna, 1956.94

Chicago, Boston

PROVENANCE: Mary Hanna, Cincinnati, by 1933

CATALOGUE RAISONNÉ: Breeskin 1970, 120 (as *Sketch for "Two Young Ladies in a Loge,"* 1882)

22. *Two Young Ladies in a Loge, Facing Right*, 1879/80

Softground etching, aquatint, and drypoint on paper; 27.6 x 21.8 cm (10⅞ x 8⁹⁄₁₆ in.)
Signed, inscribed lower left in margin: *Mary Cassatt/plate Destroyed*
S. P. Avery Collection, Print Collection, Miriam and Ira D. Wallach Division of Art, Prints and Photographs, The New York Public Library, Astor, Lenox and Tilden Foundations

Chicago, Boston

PROVENANCE: Possibly sold by the artist to Auguste Delâtre, Paris; sold to George A. Lucas, Paris, for

Samuel P. Avery, New York, by Nov. 1, 1884

CATALOGUE RAISONNÉ: Breeskin 1948, 18 (as *Two Young Ladies Seated in a Loge, Facing Right*, c. 1880)

23. *Woman at the Theater (Femme au théâtre)*, 1879/80

Softground etching and aquatint on cream Japanese paper; 20.5 x 18.7 cm (8⅛ x 7⅜ in.)
Signed lower left: *Mary Cassatt*
The Art Institute of Chicago, restricted gift of Gaylord Donnelly and the Print and Drawing Club Fund, 1970.424

Chicago, Boston

PROVENANCE: R. S. Johnson Fine Art, Chicago

EXHIBITIONS: Paris 1880, no. 25 (2 states); Paris 1893, no. 52 (as *Au théâtre*)

CATALOGUE RAISONNÉ: Breeskin 1948, 22 (as *In the Opera Box [No. 3]*, c. 1880)

24. *At the Theater (Au théâtre)*, 1879/80

Lithograph on paper; 29.1 x 22.2 cm (11⁷⁄₁₆ x 8¾ in.)
Signed, inscribed lower right in margin: *To Mr. Avery with my best compliments/this early & only attempt at lithography/Mary Cassatt/Paris May 1891/5 proofs stone effaced*
S. P. Avery Collection, Print Collection, Miriam and Ira D. Wallach Division of Art, Prints and Photographs, The New York Public Library, Astor, Lenox and Tilden Foundations

Chicago, Boston

PROVENANCE: From the artist to George A. Lucas, Paris, after May 7, 1891, for Samuel P. Avery, New York

EXHIBITIONS: Paris 1891b; Paris 1893, no. 98; New York 1896a (no. 179, as *Lady in Opera-Box*)

LETTER REFERENCES: diary of George A. Lucas, May 7, 1891, in Randall 1979, vol. 2, pp. 728–29

BIBLIOGRAPHY: Béraldi 1891

CATALOGUE RAISONNÉ: Breeskin 1948, 23 (as *Woman Seated in a Loge*, c. 1881)

25. *At the Performance (Au Spectacle)*, 1879/80

Softground etching and aquatint, printed in brown ink on cream laid paper; 19.7 x 29.4 cm (7¾ x 11⁹⁄₁₆ in.)

Unsigned; stamped lower right: A. Beurdeley collection mark (Lugt 421)
The Art Institute of Chicago, Mary S. Adams and Mrs. Cyrus Adams Memorial Fund, 1967.43

Chicago, Boston

PROVENANCE: A. Beurdeley, Paris; Peter Deutch, New York

EXHIBITIONS: Paris 1893, no. 58

CATALOGUE RAISONNÉ: Breeskin 1948, 24 (as *Lady in Black, in a Loge, Facing Right*, c. 1881)

26. *Self-Portrait*, c. 1880

Watercolor on ivory wove paper; 33 x 24 cm (13 x 9⁷⁄₁₆ in.)
Signed lower center: *M.C.*
Washington, D.C., National Portrait Gallery, Smithsonian Institution, NPG.76.33

Chicago

PROVENANCE: Lucie Manguin, Paris; Galerie de Paris sale, 1963; A. P. Bersohn, New York

CATALOGUE RAISONNÉ: Breeskin 1970, 618 (as *Self-Portrait*, c. 1880)

27. *Tea (Le Thé)*, 1879/80

Oil on canvas; 64.7 x 92.7 cm (25½ x 36½ in.)
Signed lower left: *Mary Cassatt*
Boston, Museum of Fine Arts, M. Theresa B. Hopkins Fund, 1942.178

Chicago, Boston, Washington

PROVENANCE: Henri Rouart, Paris, c. 1880–1912; Galerie Manzi-Joyant, Paris, Henri Rouart sale, Dec. 9, 1912, no. 91; sold to Dikran G. Kelekian, Paris and New York, 1912–22; American Art Association, New York, Dikran Kelekian sale, Jan. 30–31, 1922

EXHIBITIONS: Paris 1880, no. 21; Paris 1893, no. 5 (as *Five o'clock*); New York 1895b, no. 8 (as *La Tasse de thé*); Paris 1908b, no. 7

BIBLIOGRAPHY: Baignères 1880; Burty 1880; Ephrussi 1880; Havard 1880; Huysmans 1880; Mantz 1880; Trianon 1880; Eugène Véron 1880; Mantz 1881; *New York Times* 1895c; Bouyer 1908b; Segard 1913, p. 124, ill. opp. p. 13; Wood 1914

LETTER REFERENCES: MC to LH, Nov. 15, 1912, NGA; MC to LH, Dec. 18, 1912, NGA

CATALOGUE RAISONNÉ: Breeskin 1970, 78 (as *Five O'Clock Tea*, 1880)

28. *The Child's Bath (La Toilette de l'enfant)*, 1880

Oil on canvas; 100 x 65 cm (39⅛ x 25⅝ in.)
Signed, dated lower left: *Mary Cassatt/1880*
Los Angeles County Museum of Art, gift of Mrs. Fred Hathaway Bixby Bequest, M.62.8.14

Chicago, Boston, Washington

PROVENANCE: Possibly Charles Ephrussi, Paris; Mr. and Mrs. A. A. Pope, Greenwich, Conn.; Mrs. John Riddle, 1940; M. Knoedler and Co., New York; Mrs. Fred Hathaway Bixby, 1946

EXHIBITIONS: New York 1895b, no. 9; Boston 1909, no. 20

BIBLIOGRAPHY: Geffroy 1904; Bénédite 1908; Segard 1913, p. 79, ill. opp. p. 12

LETTER REFERENCES: MC to Mrs. Ada Pope, [Mar. 1903], AAA

CATALOGUE RAISONNÉ: Breeskin 1970, 90 (as *Mother About to Wash Her Sleepy Child*, 1880)

29. *Autumn (L'Automne)*, 1880

Oil on canvas; 93 x 65 cm (36⅝ x 25⅝ in.)
Signed lower right: *Mary Cassatt*
Paris, Musée du Petit Palais, PPP 706

Chicago, Boston, Washington

PROVENANCE: Collection of the artist, Paris, 1880–1923

EXHIBITIONS: Paris 1881, no. 3

BIBLIOGRAPHY: Charry 1881; Ephrussi 1881b; Geffroy 1881b; Hoschedé 1881; Michel 1881; Mont 1881; Our Lady Correspondent 1881; Trianon 1881

LETTER REFERENCES: MC to LH, Oct. 2, 1923, NGA

CATALOGUE RAISONNÉ: Breeskin 1970, 96 (as *Profile Portrait of Lydia Cassatt*, 1880)

30. *Lydia Seated in the Garden with a Dog in Her Lap*, c. 1880

Oil on canvas; 27.3 x 40.6 cm (10¾ x 16 in.)
Signed lower right: *M.C.*
Private collection

Chicago, Boston, Washington

PROVENANCE: Estate of Ellen Mary Cassatt (Mrs. Horace Binney Hare), Radnor, Penn.; Adelson Galleries, New York

CATALOGUE RAISONNÉ: Breeskin 1970, 95 (as *Lydia Seated in the Garden with a Dog in Her Lap*, c. 1880)

31. *Lydia Seated on a Terrace Crocheting*, 1881/82

Oil and tempera on canvas; 38.1 x 61.5 cm (15 x 24¼ in.) Signed lower left: *Mary Cassatt* Collection of Mr. and Mrs. Charles Hermanowski

Chicago, Boston, Washington

PROVENANCE: From the artist to Durand-Ruel, Paris; Sarah Choate (Mrs. Montgomery) Sears, Boston; Mrs. Cornelius J. Sullivan, New York; Sotheby's, New York, Dec. 6, 1939, no. 169; Durand-Ruel, New York; Mrs. E. N. Graham (Elizabeth Arden), New York; M. Knoedler and Co., New York; Mr. and Mrs. Lansing W. Thoms, St. Louis; Christie's, London, Apr. 6, 1976, no. 17; Christie's, New York, May 23, 1996, no. 75

EXHIBITIONS: Paris 1924, no. 31

CATALOGUE RAISONNÉ: Breeskin 1970, 102 (as *Lydia Seated on a Porch, Crocheting*, 1881)

32. *Portrait of Alexander J. Cassatt*, 1880

Oil on canvas; 64.5 x 90.7 cm (25⅛ x 35¼ in.) Unsigned Detroit Institute of Arts, Founders Society Purchase, Robert H. Tannahill Foundation Fund, 1986.60

Chicago, Boston, Washington

PROVENANCE: Mr. and Mrs. Alexander J. Cassatt; R. S. Johnson Fine Art, Chicago

LETTER REFERENCES: LC to Eliza Buchanan, July 10, 1880, in Sweet 1966, pp. 54–55; KC to AC, Apr. 28, 1882, PMA; MC to AC, June 22, [1883], in Mathews 1984, pp. 169–70; MC to AC, Oct. 14, [1883], in Mathews 1984, pp. 172–73

CATALOGUE RAISONNÉ: Breeskin 1970, 126 (as *Portrait of Alexander J. Cassatt*, 1883)

33. *Tea (Le Thé)*, 1880/81

Oil on canvas; 92.4 x 65.4 cm (36⅜ x 25¾ in.) Signed lower left: *Mary Cassatt* New York, The Metropolitan Museum of Art, from the Collection of James Stillman, gift of Dr. Ernest G. Stillman, 1922.16.17

Chicago, Boston, Washington

PROVENANCE: From the artist to Durand-Ruel, Paris, c. 1881; sold to Léon Clapisson, Neuilly-sur-Seine, Apr. 3, 1882; sold back to Durand-Ruel, Paris, by 1893; James Stillman, Paris, after 1908

EXHIBITIONS: Paris 1881, no. 4; Paris 1893, no. 8 (as *La Tasse de thé*); Paris 1908b, no. 12 (as *La Tasse de thé*); New York 1922a

BIBLIOGRAPHY: *L'Art* 1881; Dalligny 1881; Geffroy 1881b; Huysmans 1881; Palette 1881; Silvestre 1881a; Trianon 1881; Vernay 1881; Villars 1881; L[ichtwark] 1884; Lecomte 1892; Geffroy 1904; B. B. 1922; Ely 1925

CATALOGUE RAISONNÉ: Breeskin 1970, 65 (as *The Cup of Tea*, 1879)

34. *Driving (En Voiture)*, 1881

Oil on canvas; 89.3 x 130.8 cm (35⅛ x 51½ in.) Signed lower right: *Mary Cassatt* Philadelphia Museum of Art, Wilstach Collection, W'1921.1.1

Chicago, Boston, Washington

PROVENANCE: Cassatt family, Paris, to Alexander J. Cassatt, Philadelphia, until 1906; to his widow, Lois Cassatt, Philadelphia, 1906–20; to her son Edward Cassatt, Philadelphia

EXHIBITIONS: New York 1895b, no. 28

BIBLIOGRAPHY: *New York Tribune* 1895

LETTER REFERENCES: KC to RC, Dec. 16, 1881, in Sweet 1966, p. 64; MC to LH, Mar. 31, 1920, NGA; RC to MC, Apr. 1, 1920, NGA; MC to LH, Apr. 4, 1920, NGA; MC to LH, Nov. 18, 1920, NGA

CATALOGUE RAISONNÉ: Breeskin 1970, 69 (as *Woman and Child Driving*, 1879)

35. *The Garden (Le Jardin)*, 1880

Oil on canvas; 66 x 94 cm (26 x 37 in.) Signed lower left: *Mary Cassatt* New York, The Metropolitan Museum of Art, gift of Mrs. Gardner Cassatt, 1965.184

Chicago, Boston, Washington

PROVENANCE: From the artist to her brother Alexander J. Cassatt, Philadelphia, c. 1895–1906; to his widow, Lois Cassatt, Philadelphia, 1906–20; to her son Robert Kelso Cassatt, New York, 1920–44; to his cousin J. Gardner Cassatt 1944–55; to his widow, Mrs. Gardner Cassatt, Villanova, Penn.

EXHIBITIONS: Paris 1881, no. 2; Paris 1893, no. 7 (as *En brodant*); New York 1895b, no. 18 (as *Dame tricotant*); Philadelphia 1916, no. 134 (as *Woman Sitting in a Garden*)

36. *Woman in a Chair (Femme dans un fauteuil)*, 1879/80

Softground etching and aquatint on cream wove paper; 21.6 x 14.6 cm (8½ x 5¾ in.) Unsigned; stamped verso, lower right: "Atelier Ed. Degas" (Lugt 657) The Art Institute of Chicago, Potter Palmer Collection, 1967.256

Chicago, Boston

PROVENANCE: From the artist to Edgar Degas, Paris, c. 1880–1917; Hôtel Drouot, Paris, Edgar Degas sale, Nov. 6–7, 1918; Durand-Ruel, Paris; R. S. Johnson Fine Art, Chicago

EXHIBITIONS: Paris 1893, no. 49

CATALOGUE RAISONNÉ: Breeskin 1948, 11 (as *Waiting*, c. 1880)

37. *By the Fireside (Au coin du feu)*, 1879/80

Softground etching and aquatint on paper; 16.4 x 20.5 cm (6⁷⁄₁₀ x 8ⁱ⁄₁₀ in.) Signed lower left in margin: *Mary Cassatt*; inscribed lower right in margin: *portrait/of my sister* S. P. Avery Collection, Print Collection, Miriam and Ira D. Wallach Division of Art, Prints and Photographs, The New York Public Library, Astor, Lenox and Tilden Foundations

Chicago, Boston

PROVENANCE: Probably from the artist to George A. Lucas, Paris, for Samuel P. Avery, New York

EXHIBITIONS: Paris 1880, no. 29; Paris 1893, no. 71 (as *Femme assise au coin du feu*)

BIBLIOGRAPHY: Champier 1881; Charry 1881; Comtesse Louise 1881; Dalligny 1881; Enjoiras 1881; Ephrussi 1881b; Geffroy 1881b; Hoschedé 1881; Huysmans 1881; Mantz 1881; Michel 1881; Mont 1881; Our Lady Correspondent 1881; Palette 1881; Silvestre 1881a; Trianon 1881; Valabrègue 1881; Mellerio 1893; *New York Times* 1895c; *New York Tribune* 1895; Geffroy 1904; Mellerio 1910; Brinton 1913; Segard 1913, p. 65, ill. opp. p. 16; *New York Times Magazine* 1916

LETTER REFERENCES: RC to MC, Apr. 1, 1920, NGA

CATALOGUE RAISONNÉ: Breeskin 1970, 98 (as *Lydia Crocheting in the Garden at Marly*, 1880)

CATALOGUE RAISONNÉ: Breeskin 1948, 64 (as *Before the Fireplace [No. 1]*, c. 1883)

38. *Lydia Seated at an Embroidery Frame*, 1880/81

Oil on canvas; 65.5 x 92 cm (25¾ x 36¼ in.)
Signed lower right: *Mary Cassatt*
Flint, Mich., Flint Institute of Arts, gift of the Whiting Foundation, 1967.32

Chicago, Boston, Washington

PROVENANCE: From the artist to Durand-Ruel, Paris, 1893; Ambroise Vollard, Paris; Mr. Barnsdale, New York; to Harry Brahms, New York; M. Knoedler and Co., New York, by 1966

CATALOGUE RAISONNÉ: Breeskin 1970, 115 (as *Lydia Working at a Tapestry Frame*, c. 1881)

39. *Drawing for "Evening,"* 1879/80

Graphite on paper; 20.3 x 22.3 cm (8 x 8¾ in.)
Signed lower left: *Mary Cassatt*
Dr. and Mrs. Jeb Stewart

Chicago, Boston

PROVENANCE: Mrs. Samuel H. Nowak, Philadelphia

CATALOGUE RAISONNÉ: Breeskin 1970, 748 (as *Drawing for "Under the Lamp,"* c. 1881)

40. *Evening (Le Soir)*, 1879/80

Softground etching and aquatint on cream laid paper; 19.7 x 22.1 cm (7¾ x 8¹¹⁄₁₆ in.)
Unsigned; stamped lower left: Alexis Rouart collection mark (Lugt Suppl. 2187 a)
The Art Institute of Chicago, Albert H. Wolf Memorial Collection, 1938.33

Chicago, Boston

PROVENANCE: From the artist to Alexis Rouart, Paris c. 1880–1911; Hôtel Drouot, Paris, Alexis Rouart Collection sale, Dec., 1911

EXHIBITIONS: Paris 1880, no. 31; Paris 1893, no. 55 (as *Scène d'intérieur*)

CATALOGUE RAISONNÉ: Breeskin 1948, 71 (as *Under the Lamp*, c. 1883)

41. *Drawing for "Interior: On the Sofa,"* c. 1880

Graphite on paper; 14.5 x 22 cm (5¹¹⁄₁₆ x 8⅝ in.)
Signed upper right: *MC*
Chicago, Ursula and R. Stanley Johnson Family Collection

Chicago, Boston

PROVENANCE: M. Suzor, Paris; O. Wertheimer, Paris; R. S. Johnson Fine Art, Chicago

CATALOGUE RAISONNÉ: Breeskin 1970, 769 (as *Drawing for "Interior: On the Sofa,"* c. 1883)

42. *Interior: On the Sofa*, c. 1880

Softground etching on cream wove paper; 14.1 x 21.8 cm (5⁹⁄₁₆ x 8⁹⁄₁₆ in.)
Unsigned
Washington, D.C., National Gallery of Art, Rosenwald Collection, 1949.5.469

Chicago, Boston

CATALOGUE RAISONNÉ: Breeskin 1948, 76 (as *Interior: On the Sofa*, c. 1883)

43. *Drawing for "Interior Scene,"* 1879/80

Recto: graphite; verso: softground offset on off-white wove paper; 40 x 30.9 cm (15¾ x 12¹⁄₁₆ in.)
Cleveland Museum of Art, gift of Fifty Members of the Print Club of Cleveland on the Occasion of the Fiftieth Anniversary, 1966.176

Chicago, Boston

PROVENANCE: From the artist to Edgar Degas, Paris c. 1880–1917; Hôtel Drouot, Paris, Edgar Degas sale, Nov. 15–16, 1918, no. 82; René de Gas, Paris

CATALOGUE RAISONNÉ: uncatalogued

44. *Interior Scene (Scène d'intérieur)*, 1879/80

Softground etching, aquatint, and drypoint on cream laid paper; 39.7 x 31 cm (15⅝ x 12¼ in.)
Unsigned
Washington, D.C., National Gallery of Art, Rosenwald Collection, 1946.21.94

Chicago, Boston

EXHIBITIONS: Paris 1893, no. 72

CATALOGUE RAISONNÉ: Breeskin 1948, 34 (as *The Visitor*, c. 1881)

45. *Young Girl at a Window (Jeune Fille à la fenêtre)*, c. 1883

Oil on canvas; 100.3 x 64.7 cm (39½ x 25½ in.)
Signed lower right: *Mary Cassatt*
Washington, D.C., Corcoran Gallery of Art, museum purchase, gallery fund, 09.8

Chicago, Boston, Washington

PROVENANCE: M. Berend, Paris, by 1886; Durand-Ruel, Paris and New York, by 1902

EXHIBITIONS: Paris 1886, no. 7; Philadelphia 1903, no. 37 (as *La femme au chien*); New York 1903a, no. 9 (as *La femme au chien*); Pittsburgh 1908b, no. 49 (as *Woman with Dog*); Washington, D.C. 1908–1909, no. 252 (as *La Femme au chien*)

BIBLIOGRAPHY: Geffroy 1886; Hermel 1886; Maus 1886; Marks 1895c; *New York Daily Tribune* 1903; *New York Times* 1903a; *New York Times* 1903b

CATALOGUE RAISONNÉ: Breeskin 1970, 125 (as *Susan on a Balcony Holding a Dog*, 1883)

46. *Portrait of Alexander J. Cassatt and His Son Robert Kelso Cassatt*, 1884–85

Oil on canvas; 100 x 81.2 cm (39⅛ x 32 in.)
Signed, dated lower left: *Mary Cassatt, 1884*
Philadelphia Museum of Art, purchased with the W. P. Wilstach Fund and funds contributed by Mrs. William Coxe Wright, W'1959.1.1

Chicago, Boston, Washington

PROVENANCE: From the artist to her brother Alexander J. Cassatt, Philadelphia, c. 1885–1906; to his widow, Lois Cassatt, 1906–1920; to her son Robert Kelso Cassatt, New York, 1920–44; to his son Alexander J. Cassatt, 1944–59; Parke-Bernet, New York, Apr. 15, 1959, no. 68; Mr. and Mrs. William Coxe Wright

LETTER REFERENCES: AC to LC, Dec. 30, 1884, PMA; RC to LC, [c. Jan. 1885], in Sweet 1966, p. 94; RC to LC, [c. Jan. 1885], in Sweet 1966, p. 94; KC to Katharine Cassatt, Jan. 21, 1885, in Mathews 1984, p. 187; AC to LC, Jan. 22, 1885 (letter misdated by AC to 1884), in Sweet 1966, p. 93; MC to AC, May 17, [1885], in Mathews 1984, p. 194

CATALOGUE RAISONNÉ: Breeskin 1970, 136 (as *Portrait of Mr. Alexander J. Cassatt and His Son Robert Kelso Cassatt*, 1884)

47. *Children on the Shore
(Enfants sur la plage)*, 1885
Oil on canvas; 97.6 x 74 cm
(38⅜ x 29⅛ in.)
Signed lower right: *Mary Cassatt*
Washington, D.C., National
Gallery of Art, Alisa Mellon
Bruce Collection, 1970.17.19

Chicago, Boston, Washington

PROVENANCE: Probably from the artist
to Alphonse Portier, Paris; sold to
Durand-Ruel, Paris, April 4, 1886;
M. Lanquety, Mar. 12, 1910; by
inheritance to his godson, Pierre
Marbeau; Mrs. Alisa Mellon Bruce,
Mar. 5, 1965

EXHIBITIONS: Paris 1886, no. 11; New
York 1895b, no. 7 (as *Marine*);
Manchester 1907–1908, no. 71 (as
Children Playing on the Shore); Paris
1908b, no. 13 (as *Enfants jouant sur une
plage*)

BIBLIOGRAPHY: Adam 1886; Ajalbert
1886; Christophe 1886; Darzens 1886;
Geffroy 1886; Hermel 1886;
Labruyère 1886; Mirbeau 1886;
Moniteur des arts 1886; Geffroy 1904;
Harper's Weekly 1911

CATALOGUE RAISONNÉ: Breeskin 1970,
131 (as *Two Children at the Seashore*,
1884)

48. *Study (Etude)*, 1885/86
Oil on canvas; 75 x 62.2 cm
(29½ x 24½ in.)
Signed lower left: *Mary Cassatt*
Washington, D.C., National
Gallery of Art, Chester Dale
Collection, 1963.10.97

Washington

PROVENANCE: From the artist to Edgar
Degas, Paris, 1886 (in exchange for
his pastel *Woman Bathing in a Shallow
Tub* [Lemoisne 816]); deposited with
Durand-Ruel, Paris, Oct. 3–Dec. 2,
1908 (on loan to Paris 1908b); Gal-
erie Georges Petit, Paris, Edgar Degas
sale, Mar. 26–27, 1918, no. 8; bought
by Durand-Ruel for Mrs. H. O.
Havemeyer, New York; Mrs. H. O.
Havemeyer, New York, until 1929;
American Art Association, New
York, Havemeyer Estate sale, Apr.
10, 1930, no. 75; Chester Dale, New
York, until 1962

EXHIBITIONS: Paris 1886, no. 9; Paris
1893, no. 17 (as *Jeune Fille se coiffant*);
Paris 1908b, no. 1 (as *La Toilette*);
Philadelphia 1920, no. 7 (as *Filet
[sic] de [sic] coiffant*)

BIBLIOGRAPHY: Geffroy 1886; Maus
1886; Segard 1913, ill. opp. p. 20

LETTER REFERENCES: RSC to AC, Apr. 14,
1886, in Sweet 1966, pp. 102–103; MC
to LH, Aug. 16, 1918, NGA

CATALOGUE RAISONNÉ: Breeskin 1970,
146 (as *Girl Arranging Her Hair*, 1886)

49. *Little Girl in a Big Straw Hat
and a Pinafore*, c. 1886
Oil on canvas; 65.3 x 49 cm
(25½ x 19¼ in.)
Signed lower right: *Mary Cassatt*
Washington, D.C., National
Gallery of Art, Collection of Mr.
and Mrs. Paul Mellon, 1983.1.17

Chicago, Boston, Washington

PROVENANCE: Ambroise Vollard, Paris;
Chrétien de Gallea, Paris; Edward
Speelman, Zurich; Mr. and Mrs.
Paul Mellon, Upperville, Va., Jan.
1965

CATALOGUE RAISONNÉ: Breeskin 1970,
143 (as *Little Girl in a Big Straw Hat
and Pinafore*, c. 1886)

50. *Young Mother (Jeune Mère)*,
1888
Pastel on tan wove paper (origi-
nally blue-gray), mounted on can-
vas, on a strainer; 84 x 73.8 cm
(33⅛ x 29 in.)
Signed upper left: *Mary Cassatt*
The Art Institute of Chicago,
Potter Palmer Collection, 1922.421

Chicago

PROVENANCE: From the artist to
Durand-Ruel, Paris; sold to Mrs.
Potter Palmer, Chicago, Apr. 29,
1892

LETTER REFERENCES: MC to Harris
Whittemore, Nov. 14, 1893, Hill-
Stead

CATALOGUE RAISONNÉ: Breeskin 1970,
152 (as *Mother's Goodnight Kiss*, 1888)

51. *Mathilde Holding a Baby Who
Reaches out to the Right*, c. 1889
Pastel on tan wove paper (origi-
nally blue-gray), mounted on
board; 73 x 60 cm (28¾ x 23⅝ in.)
Signed lower right: *Mary Cassatt*
Chicago, Ursula and R. Stanley
Johnson Family Collection

Chicago, Boston

PROVENANCE: Dr. Paul Paulin, Paris,
1890; Galerie Georges Petit, Paris,
Paulin-Nijhoff sale, May 22, 1919,
no. 38; Galerie Durand-Ruel, Paris;
Durand-Ruel Gallery, New York,
Apr. 20, 1920; private collection,
Switzerland, 1948; R. S. Johnson
Fine Art, Chicago, 1964

CATALOGUE RAISONNÉ: Breeskin 1970,
187 (as *Mathilde Holding a Baby Who
Reaches out to the Right*, 1890)

52. *Mother and Child (Mère et
enfant)*, 1889
Oil on canvas; 90 x 64.5 cm
(35⅛ x 25⅛ in.)
Signed lower left: *Mary Cassatt*
Wichita, Kans., Wichita Art
Museum, Roland P. Murdock
Collection, M.109.53

Chicago, Boston, Washington

PROVENANCE: From the artist to
Durand-Ruel, Paris, c. 1899; Georges
Viau, Paris, by 1903–1907; Galerie
Durand-Ruel, Paris, Georges Viau
sale, Mar. 4, 1907, no. 9; acquired by
Durand-Ruel for Sarah Choate
(Mrs. Montgomery) Sears, Boston,
1907–35; Helen Sears (Mrs. J. Cam-
eron) Bradley, Boston; M. Knoedler
and Co., New York, 1953; Roland P.
Murdock

EXHIBITIONS: Paris 1903, no. 1

BIBLIOGRAPHY: *American Art News* 1907c;
Pica 1907

CATALOGUE RAISONNÉ: Breeskin 1970,
156 (as *Emmie and Her Child*, 1889)

53. *Woman with Her Child (Femme
avec son enfant)*, 1889/90
Pastel on tan wove paper (origi-
nally blue-gray); 63.5 x 40.6 cm
(25 x 16 in.)
Signed lower right: *Mary Cassatt*
Storrs, Conn., William Benton
Museum of Art, University of
Connecticut, Louise Crombie
Beach Memorial Collection,
1948.1

Chicago, Boston

PROVENANCE: From the artist to
Durand-Ruel, Paris; Paul Gallimard,
Paris, by 1891; Galerie Bernheim-
Jeune, Paris, by 1903; Demotte
Gallery, New York; Victor Spark,
New York, 1930–48

EXHIBITIONS: Paris 1891a, no. 3; Paris
1893, no. 22 (as *Après la promenade*);
possibly Paris 1903, no. 8 (as *Femme
embrassant un enfant*)

CATALOGUE RAISONNÉ: Breeskin 1970,
185 (as *Hélène of Septeuil*, c. 1890)

54. *Mother Holding a Child in
Her Arms*, c. 1890
Oil on canvas; 81.5 x 65.5 cm
(31¼ x 25½ in.)

Signed lower left: *Mary Cassatt*
Bilbao, Spain, Museo de Bellas
Artes de Bilbao, 82/25

Chicago, Boston, Washington

PROVENANCE: Durand-Ruel, Paris
EXHIBITIONS: Bilbao 1919, no. 79 (as
Mujer sentada con un niño en sus brazos)
CATALOGUE RAISONNÉ: Breeskin 1970,
178 (as *Baby with His Hands on the Back
of a Chair*, c. 1890)

55. *Mrs. R. S. Cassatt*, c. 1889
Oil on canvas; 96.5 x 68.6 cm
(38 x 27 in.)
Unsigned
Fine Arts Museums of San Fran-
cisco, museum purchase, William
H. Noble Bequest Fund, 1979.35

Chicago, Boston, Washington

PROVENANCE: From the artist to her
brother Alexander J. Cassatt,
Philadelphia, by 1895–1906; to his
daughter Elsie Foster Cassatt (Mrs.
W. Plunkett) Stewart, Philadelphia,
1906–1909; to her uncle J. Gardner
Cassatt by 1909–11; to his widow,
Mrs. J. Gardner Cassatt, 1911–29; to
her son Gardner Cassatt 1929–55; to
his widow, Mrs. Gardner Cassatt,
1955 to at least 1966
EXHIBITIONS: Boston 1895, no. 59;
Paris 1908b, no. 4 (as *Portrait de Mme
C.*); Boston 1909, no. 10 (as *Portrait de
Mme C.*); Philadelphia 1920, no. 45
(as *Portrait of Her Mother*)
BIBLIOGRAPHY: *Boston Daily Evening
Transcript* 1909
CATALOGUE RAISONNÉ: Breeskin 1970,
162 (as *Portrait of Mrs. Robert S. Cassatt*,
c. 1889)

56.–65. Cassatt's series of ten dry-
points and aquatints will be rep-
resented at each exhibition venue
by a different set.

Chicago: The Art Institute of
Chicago, Mr. and Mrs. Martin A.
Ryerson Collection, 1932.1281–90.
PROVENANCE: From the artist to
Durand-Ruel; Albert Roullier
Gallery, Chicago; Martin A.
Ryerson, Chicago

Boston: Ottawa, National Gallery
of Canada, bequest of Guy M.
Drummond, Montreal, 1922 1987,
29873–82
PROVENANCE: From the artist to
Durand-Ruel; purchased by Lady
Julia Drummond, Montreal, after
1910; Guy M. Drummond, Montreal

Washington: Washington, D.C.,
National Gallery of Art, Chester
Dale Collection, 1963.10 248–57
PROVENANCE: Chester Dale, New York
Each print is drypoint and aquatint
on cream laid paper

Each print is inscribed, signed
lower right: *Imprimée par l'artiste et
M. Leroy/Mary Cassatt/(25 épreuves)*
The lifetime exhibition history
and bibliography of the series is
as follows:
EXHIBITIONS: Paris 1891a, nos. 1–10;
Brussels 1893, nos. 32–41; New York
1898; Boston 1898; New York 1921
BIBLIOGRAPHY: Dalligny 1891; Fénéon
1891; Geffroy 1891; Lecomte 1891a;
Lecomte 1891b; *New York Times* 1891b
CATALOGUE RAISONNÉ: Breeskin 1970,
162 (as *Portrait of Mrs. Robert S. Cassatt*,
c. 1889)

56. *The Child's Bath* (*Bain
d'enfant*), 1890–91
32.1 x 24.7 cm (12⅝ x 9¼ in.)

Chicago: 1932.1287; Ottawa: 1987,
29873; Washington: 1963.10.248

CATALOGUE RAISONNÉ: Breeskin 1948,
143 (as *The Bath*, 1891)

57. *The Lamp* (*La Lampe*), 1890–91
32.3 x 25.2 cm (12¾ x 9¹¹⁄₁₆ in.)

Chicago: 1932.1290; Ottawa: 1987,
29874; Washington: 1963.10.249

CATALOGUE RAISONNÉ: Breeskin 1948,
144 (as *The Lamp*, 1891)

58. *Interior of a Tramway Passing
a Bridge* (*Intérieur d'un
tramway passant un pont*),
1890–91
38.4 x 26.7 cm (15⅛ x 10½ in.)

Chicago: 1932.1289; Ottawa: 1987,
29875; Washington: 1963.10.250

CATALOGUE RAISONNÉ: Breeskin 1948,
145 (as *In the Omnibus*, 1891)

59. *The Letter* (*La Lettre*), 1890–91
34.5 x 21.1 cm (13⅝ x 8⁵⁄₁₆ in.)

Chicago: 1932.1282; Ottawa: 1987,

29876; Washington: 1963.10.251

CATALOGUE RAISONNÉ: Breeskin 1948,
146 (as *The Letter*, 1891)

60. *Young Woman Trying on a
Dress* (*Jeune femme essayant
une robe*), 1890–91
37.7 x 25.6 cm (34⅞ x 10¹⁄₁₆ in.)

Chicago: 1932.1283; Ottawa: 1987,
29877; Washington: 1963.10.252

CATALOGUE RAISONNÉ: Breeskin 1948,
147 (as *The Fitting*, 1891)

61. *The Bath* (*La Toilette*), 1890–91
36.8 x 26.3 cm (14¼ x 10⅜ in.)

Chicago: 1932.1281; Ottawa: 1987,
29878; Washington: 1963.10.253

CATALOGUE RAISONNÉ: Breeskin 1948,
148 (as *Woman Bathing*, 1891)

62. *The Kiss* (*Le Baiser*), 1890–91
34.9 x 22.9 cm (13¼ x 9 in.)

Chicago: 1932.1286; Ottawa: 1987,
29879; Washington: 1963.10.254

CATALOGUE RAISONNÉ: Breeskin 1948,
149 (as *Mother's Kiss*, 1891)

63. *Nude Child* (*Enfant nu*),
1890–91
36.8 x 26.8 cm (14¼ x 10⁹⁄₁₆ in.)

Chicago: 1932.1288; Ottawa: 1987,
29880; Washington: 1963.10.255

CATALOGUE RAISONNÉ: Breeskin 1948, 150
(as *Maternal Caress*, 1891)

64. *The Visit* (*La Visite*), 1890–91
34.8 x 26.3 cm (13¼ x 10⅜ in.)

Chicago: 1932.1285; Ottawa: 1987,
29881; Washington: 1963.10.256

CATALOGUE RAISONNÉ: Breeskin 1948,
151 (as *Afternoon Tea Party*, 1891)

65. *Study (Etude)*, 1890–91

36.5 x 26.7 cm (14⅛ x 10½ in.)

Chicago: 1932.1284; Ottawa: 1987, 29882; Washington: 1963.10.257

CATALOGUE RAISONNÉ: Breeskin 1948, 152 (as *The Coiffure*, 1891)

66. *Contemplation (Contemplation)* 1891–92

Pastel on tan wove paper (originally blue-gray); 66 x 51 cm (26 x 20 in.)
Signed lower left: *Mary Cassatt*
Private collection, courtesy Margo Pollins Schab, Inc., New York, and Parrish and Reinish, Inc., New York

Chicago

PROVENANCE: M. G. Murat, Paris, by 1893; Hôtel Drouot, Paris, Murat sale, Apr. 28, 1899; M. Moline, 1899; possibly Roger Marx, Paris; Dikran G. Kelekian, Paris; Kelekian sale, Paris, Nov. 4, 1913, no. 120; Mrs. Mark C. Steinberg, St. Louis; Mrs. Ellen M. Schuppli, Avon, Conn.; Christie's, New York, May 19, 1981, no. 334
EXHIBITIONS: Paris 1893, no 31; New York 1924a, no. 6 (as *Portrait de femme tenant un éventail*)
CATALOGUE RAISONNÉ: Breeskin 1970, 250 (as *Clarissa, Turned Right, with Her Hand to Her Ear*, 1895)

67. *Revery (Rêverie)*, 1891–92

Oil on canvas; 73 x 60.5 cm (28¾ x 23⅞ in.)
Signed lower right: *Mary Cassatt*
Washington, D.C., National Gallery of Art, Chester Dale Collection, 1963.10.99

Washington

PROVENANCE: From the artist to Durand-Ruel, Paris and New York; Chester Dale, Washington, D.C.
EXHIBITIONS: Paris 1893, no. 15; New York 1895b, no. 12 (as *Femme assise*); Philadelphia 1898, no. 61 (as *Woman Seated*); Boston 1898, no. 17 (as *Femme assise*); New York 1903a, no. 5 (as *Femme assise*); Boston 1909, no. 14 (as *Femme assise*); Cincinnati 1915, no. 121 (as *Woman Seated in a Garden*); New York 1920b, no. 15 (as *Femme assise*); New York 1924a, no. 17 (as *Femme assise*)
BIBLIOGRAPHY: Walton 1896; *New York Times* 1903b

CATALOGUE RAISONNÉ: Breeskin 1970, 198 (as *Woman Holding a Zinnia*, 1891)

68. *Young Women Picking Fruit (Jeunes Femmes cueillant des fruits)*, 1891/92

Oil on canvas; 132 x 91.5 cm (52 x 36 in.)
Signed lower right: *Mary Cassatt*
Pittsburgh, Carnegie Museum of Art, Patrons Art Fund, 1922.8

Chicago, Boston, Washington

PROVENANCE: From the artist to Durand-Ruel, Paris, Aug. 1892; Durand-Ruel, New York, 1895–1922
EXHIBITIONS: Paris 1893, no. 9; New York 1895b, no. 3 (as *Jeune Femme cueillant un fruit*); Boston 1898, no. 16 (as *Jeune Femme cueillant un fruit*); Cincinnati 1898, no. 188 (as *Young Woman Gathering Apples*); Pittsburgh 1899–1900, no. 33 (as *Young Woman Plucking Fruit*); Philadelphia 1900, no. 217 (as *Young Woman Gathering Fruit*); New York 1903a, no. 3 (as *Jeune Femme cueillant un fruit*); Boston 1909, no. 12 (as *Jeune Femme cueillant un fruit*); Chicago 1916, no. 51 (as *Picking Fruit*) New York 1917, no. 17 (as *Jeune Femme cueillant un fruit*); Dallas 1919, no. 7 (as *Young Women Gathering Fruit*); New York 1920b, no. 18 (as *Jeune Femme cueillant un fruit*); Pittsburgh 1922b, no. 26 (as *Two Women in the Garden*)
BIBLIOGRAPHY: Mellerio 1893; Marks 1895c; *New York Times* 1895c; *New York Tribune* 1895; Sheafer 1899; *New York Daily Evening Post* 1903; *New York Times* 1903b; Geffroy 1904; *Boston Daily Evening Transcript* 1909; McCauley 1916
LETTER REFERENCES: MC to Homer Saint-Gaudens, Dec. 28, 1922, in Mathews 1984, p. 335
CATALOGUE RAISONNÉ: Breeskin 1970, 197 (as *Young Women Picking Fruit*, 1891)

69. *The Kitchen Garden (Le Potager)*, 1893

Drypoint, softground etching, and aquatint on paper; 42.2 x 29.8 cm (16⅝ x 11¾ in.)
Unsigned
Washington, D.C., National Gallery of Art, Rosenwald Collection, 1943.3.2757

Chicago, Boston

EXHIBITIONS: Paris 1893, nos. 42–43 (2 states); New York 1895b, no. 47; New York 1915b, no. 34
CATALOGUE RAISONNÉ: Breeskin 1948, 157 (as *Gathering Fruit*, c. 1895)

70. *Child Picking a Fruit (Enfant cueillant un fruit)*, 1893

Oil on canvas; 100 x 65 cm (39⅜ x 25⅝ in.)
Signed lower left: *Mary Cassatt*
Richmond, Virginia Museum of Fine Arts, gift of Ivor and Anne Massey, 75.18

Chicago, Boston, Washington

PROVENANCE: From the artist to Durand-Ruel, Paris and New York, 1893; James Stillman, Paris, 1910; Dr. E. G. Stillman, New York; Mrs. Blaine Durham, Hume, Va.
EXHIBITIONS: Paris 1893, no. 2; New York 1895b, no. 4; Paris 1908b, no. 14
BIBLIOGRAPHY: *New York Times* 1895c; Walton 1896; Segard 1913, p. 113, ill. opp. p. 36
LETTER REFERENCES: MC to Harris Whittemore, Nov. 14, 1893, Hill-Stead
CATALOGUE RAISONNÉ: Breeskin 1970, 216 (as *Nude Baby Reaching for an Apple*, 1893)

71. *The Family (La Famille)*, 1893

Oil on canvas; 81.2 x 66 cm (32 x 26 in.)
Signed lower right: *Mary Cassatt*
Norfolk, Va., Chrysler Museum, gift of Walter P. Chrysler, Jr., 71.498

Chicago, Boston, Washington

PROVENANCE: From the artist to Durand-Ruel, Paris, Nov. 24, 1893; Durand-Ruel, New York, Feb. 7, 1894; Alfred A. Pope, Cleveland, Feb. 28, 1894; Durand-Ruel, New York, May 24, 1894; Mr. and Mrs. H. O. Havemeyer, New York, June 1894; American Art Association, New York, Havemeyer Estate sale, Apr. 10, 1930, no. 78; R. D. Smith; Durand-Ruel, New York, c. 1939– at least 1947; F. Dupré, Paris; Marlborough Fine Art, London, until 1954; Trafo, Zurich, sold Mar. 23, 1954; Walter P. Chrysler, Jr., New York, by 1960
EXHIBITIONS: Paris 1893, no. 3; New York 1895b, no. 36; New York 1911a
BIBLIOGRAPHY: Walton 1896; Pica 1907; *The Craftsman* 1911
LETTER REFERENCES: MC to Harris Whittemore, Nov. 14, 1893, Hill-Stead; MC to Harris Whittemore, Feb. 15, 1894, in Mathews 1984, p. 259; MC to Harris Whittemore, Mar. 31, 1894, Hill-Stead
CATALOGUE RAISONNÉ: Breeskin 1970, 145 (as *The Family*, c. 1886)

72. The Child's Bath (La Toilette de l'enfant), 1893

Oil on canvas; 100.3 x 66 cm (39½ x 26 in.)
Signed lower left: *Mary Cassatt*
The Art Institute of Chicago, Robert A. Waller Fund, 1910.2

Chicago, Boston, Washington

PROVENANCE: From the artist to Durand-Ruel, Paris, Nov.–Dec. 1893; Durand-Ruel, New York, Dec. 1893–1910

EXHIBITIONS: Paris 1893, no. 1; New York 1895b, no. 21 (as *La Toilette*); Pittsburgh 1897–98, no. 41 (as *La Toilette*); Philadelphia 1898, no. 62 (as *The Toilet*); New York 1898; Boston 1898, no. 13 (as *La Toilette*); Omaha 1898, no. 132 (as *La Toilette*); Cincinnati 1900, no. 13 (as *La Toilette*); Worcester 1901, no. 32 (as *La Toilette*); New York 1903a, no. 6 (as *La Toilette*); Worcester 1905, no. 37 (as *The Toilet*); Boston 1909, no. 5 (as *La Toilette*); Minneapolis 1915, no. 151 (as *The Toilet*)

BIBLIOGRAPHY: Marks 1895c; Marks 1898; *New York Times Saturday Review of Books and Art* 1898; *Philadelphia Inquirer* 1898; *Brush and Pencil* 1900; Mauclair 1902; *New York Times* 1903b; Cary 1905; Henderson 1905; *Boston Daily Evening Transcript* 1909; Hartmann 1909; *New York Times Magazine* 1910c; Segard 1913, ill. opp. p. 53; Hoeber 1914

LETTER REFERENCES: MC to Harris Whittemore, Nov. 14, 1893, Hill-Stead

CATALOGUE RAISONNÉ: Breeskin 1970, 205 (as *The Bath*, 1892)

73. The Two Sisters (Les Deux Soeurs), 1893/94

Pastel on tan wove pumice paper, mounted on cardboard; 44.5 x 44.5 cm (17½ x 17½ in.)
Signed lower right: *M.C.*
Boston, Museum of Fine Arts, Charles Henry Hayden Fund, 32.98

Boston

PROVENANCE: From the artist to Payson T. Thompson; American Art Association, New York, Collection of Payson T. Thompson sale, Jan. 12, 1928, no. 80; to J. P. Henry

EXHIBITIONS: New York 1917, no. 6; New York 1923, no. 3

BIBLIOGRAPHY: Field 1920

CATALOGUE RAISONNÉ: Breeskin 1970, 237 (as *Study for "The Banjo Lesson,"* 1894)

74. Girl with a Banjo, 1893/94

Pastel on tan wove paper, mounted on linen, on a strainer; 60 x 73 cm (23⅝ x 28¼ in.)
Signed lower right: *Mary Cassatt*
Los Angeles, private collection

Chicago, Boston

PROVENANCE: Roger Marx, Paris; private collection, Tokyo; private collection, Texas

CATALOGUE RAISONNÉ: uncatalogued

75. The Banjo Lesson, 1893/94

Pastel over oiled pastel on tan wove paper (originally blue-gray), mounted on mat; 72.2 x 58.6 cm (28⅜ x 23⅛ in.)
Signed lower right: *Mary Cassatt*
Richmond, Virginia Museum of Fine Arts, Williams Fund, 58.43

Chicago

PROVENANCE: From the artist to Ambroise Vollard, Paris 1904 (as *Femme à la guitare avec enfant*); Durand-Ruel, Paris; Durand-Ruel, New York; Sarah Choate (Mrs. Montgomery) Sears; Helen Sears (Mrs. J. Cameron) Bradley, Boston

CATALOGUE RAISONNÉ: Breeskin 1970, 238 (as *The Banjo Lesson*, 1894)

76. Summertime, c. 1894

Oil on canvas; 100.7 x 81.3 cm (39⅝ x 32 in.)
Signed lower right: *Mary Cassatt*
Terra Foundation for the Arts, Daniel J. Terra Collection, 1988.25

Chicago, Boston, Washington

CATALOGUE RAISONNÉ: uncatalogued

77. The Boating Party (Les Canotiers), 1894

Oil on canvas; 90 x 117 cm (35⅛ x 46⅛ in.)
Unsigned
Washington, D.C., National Gallery of Art, Chester Dale Collection, 1963.10.94

Washington

PROVENANCE: In the possession of the artist until c. 1914; Durand-Ruel, Paris and New York; Chester Dale, New York, Oct. 1, 1929

EXHIBITIONS: New York 1895b, no. 1; St. Louis 1915, no. 31 (as *A Boating Party*); New York 1917, no. 12 (as *La Partie en bateau*); New York 1920b, no. 16 (as *La Partie en bateau*); New York 1923, no. 13 (as *La Partie en bateau*)

BIBLIOGRAPHY: Marks 1895c; Walton 1896; Mauclair 1902; Geffroy 1904; Segard 1913, ill. opp. p. 36; *New York Times* 1917

LETTER REFERENCES: MC to LH, Nov. 24, 1914, NGA

CATALOGUE RAISONNÉ: Breeskin 1970, 230 (as *The Boating Party [Near Antibes]*, 1893)

78. Feeding the Ducks, c. 1895

Drypoint and aquatint with monotype additions on cream laid paper; 29.5 x 39.3 cm (11⅝ x 15½ in.)
Signed lower right: *Mary Cassatt*
The Art Institute of Chicago, bequest of Laura May Ripley, 1992.159

Chicago, Boston

LETTER REFERENCES: LH to JDR, Apr. 17, 1914, in Weitzenhoffer 1986, p. 217; LH to JDR, Apr. 24, 1914, in Weitzenhoffer 1986, p. 217; JDR to LH, Apr. 30, 1914, in Weitzenhoffer 1986, p. 218

CATALOGUE RAISONNÉ: Breeskin 1948, 158 (as *Feeding the Ducks*, c. 1895)

79. Summertime, c. 1894

Oil on canvas; 73.6 x 96.5 cm (29 x 38 in.)
Signed lower right: *Mary Cassatt*
Los Angeles, Armand Hammer Collection, UCLA at the Armand Hammer Museum of Art and Cultural Center, AH.90.9

Chicago, Boston, Washington

PROVENANCE: Mrs. W. A. Carr, Philadelphia; M. Knoedler and Co., Inc., New York; Huntington Hartford Collection, New York; Sotheby's, New York, Mar. 10, 1971, no. 28

CATALOGUE RAISONNÉ: Breeskin 1970, 240 (as *Summertime*, 1894)

80. In the Park, c. 1894

Oil on canvas; 75 x 95.2 cm (29½ x 37½ in.)
Signed lower right: *Mary Cassatt*
Collection of Mr. Fayez Sarofim

Chicago, Boston, Washington

PROVENANCE: From the artist to

Ambroise Vollard, Paris; Chrétien de Gallia, until 1959; French and Co., New York, until 1963; Hirschl and Adler; private collection, New Caanan, Conn.

EXHIBITIONS: Paris 1924, no. 6

CATALOGUE RAISONNÉ: Breeskin 1970, 239 (as *In the Park*, c. 1894)

81. *Ellen Mary Cassatt in a White Coat*, c. 1896

Oil on canvas; 81.3 x 60.3 cm (32 x 24 in.)
Signed lower left: *Mary Cassatt*
Boston, Museum of Fine Arts, 1982.630

Chicago, Boston, Washington

PROVENANCE: Estate of Ellen Mary Cassatt (Mrs. Horace Binney Hare), Radnor, Penn.

CATALOGUE RAISONNÉ: Breeskin 1970, 258 (as *Ellen Mary Cassatt in a White Coat*, c. 1896)

82. *Maternal Caress*, 1896

Oil on canvas; 38 x 54 cm (15 x 21¼ in.)
Signed lower right: *Mary Cassatt*
Philadelphia Museum of Art, bequest of Aaron E. Carpenter, '70.75.2

Chicago, Boston, Washington

PROVENANCE: From the artist to Durand-Ruel, Paris, 1896; Durand-Ruel, New York, 1896; Cyrus J. Lawrence, New York, 1897; American Art Association, New York, Cyrus J. Lawrence sale, Jan. 21, 1910, no. 64; Durand-Ruel, New York; Aaron E. Carpenter, 1942

EXHIBITIONS: Los Angeles 1925–26, no. 12

BIBLIOGRAPHY: *The Craftsman* 1911; Segard 1913, ill. opp. p. 68; Ruskin 1920

CATALOGUE RAISONNÉ: Breeskin 1970, 262 (as *A Caress for Grandmother*, c. 1896)

83. *Breakfast in Bed* (*Le Déjeuner au lit*), c. 1897

Oil on canvas; 65 x 73.6 cm (25⅝ x 28⅞ in.)
Signed lower left: *Mary Cassatt*
San Marino, Calif., Virginia Steele Scott Collection, Huntington Library and Art Gallery, 83.8.6

Chicago, Boston, Washington

PROVENANCE: Mrs. Chauncey Blair; Mrs. William F. Borland, Chicago; M. Knoedler and Co., New York, 1967; Dr. John J. McDonough, Youngstown, Ohio

EXHIBITIONS: New York 1898 (as *Mother and Child in Bed*); Boston 1898, no. 12

BIBLIOGRAPHY: *New York Times Saturday Review of Books and Art* 1898; Riordan 1898; Allan 1903; Merrick 1909; *The Craftsman* 1911; Ruskin 1920

CATALOGUE RAISONNÉ: Breeskin 1970, 275 (as *Breakfast in Bed*, 1897)

84. *The Cup of Tea* (*La Tasse de thé*), 1897

Pastel on tan wove paper (originally blue-gray), mounted on canvas, on a strainer; 54.3 x 73 cm (21⅛ x 28¼ in.)
Signed lower left: *Mary Cassatt*
Chicago, The Estate of Daniel J. Terra, 30.1986

Chicago

PROVENANCE: From the artist to Durand-Ruel, Paris and New York, 1897–1942

EXHIBITIONS: Boston 1898, no. 9; New York 1903a, no. 21; New York 1906a; New York 1911c, no. 102; New York 1917, no. 4

BIBLIOGRAPHY: *New York Times* 1903b; *New York Times* 1906; *New York Herald* 1907; *Harper's Weekly* 1911; *New York Times* 1917

CATALOGUE RAISONNÉ: Breeskin 1970, 281 (as *The Cup of Chocolate*, 1898)

85. *Young Mother Nursing Her Child* (*Mère allaitant son bébé*), 1898

Pastel on tan wove paper; 72.4 x 53.4 cm (28½ x 21 in.)
Signed lower left: *Mary Cassatt*
Zurich, Collection Rau, Fondation Rau, GR.1949

Chicago, Boston

PROVENANCE: From the artist to Mme d'Alayer de Costemore, Apr. 1899; Collection d'Alayer, France; Collection Durand-Ruel, Paris, c. 1932; Sotheby's, London, Dec. 2, 1986, no. 11; Foundation Rau pour le Tiers-Monde

EXHIBITIONS: Manchester 1907–1908, no. 69; Paris 1908b, no. 44

BIBLIOGRAPHY: Mauclair 1902; Geffroy 1904; Mellerio 1910; Segard 1913, ill. opp. p. 88; Cary 1914

CATALOGUE RAISONNÉ: Breeskin 1970, 311 (as *Mother Louise, Nursing Her Baby*, 1898)

86. *Mother and Child* (*Mère et enfant*), c. 1900

Pastel on tan wove paper (originally blue-gray), mounted on board; 71 x 58.5 cm (28 x 23 in.)
Signed lower right: *Mary Cassatt*
The Art Institute of Chicago, bequest of Dr. John Jay Ireland, 1968.81

Chicago

PROVENANCE: From the artist to Ambroise Vollard, Paris, summer 1904; E. and A. Silberman Galleries, New York; Dr. John Jay Ireland, Chicago

CATALOGUE RAISONNÉ: Breeskin 1970, 318 (as *Sleepy Nicolle*, c. 1900)

87. *Mother and Child* (*Mère et enfant*), 1898

Oil on canvas; 81.6 x 65.7 cm (32⅛ x 25⅞ in.)
Signed lower left: *Mary Cassatt*
New York, The Metropolitan Museum of Art, H. O. Havemeyer Collection, bequest of Mrs. H. O. Havemeyer, 1929, 29.100.47

Boston

PROVENANCE: From the artist to Durand-Ruel, Paris, Apr. 21, 1899; Durand-Ruel, New York, July 4, 1899; Mr. and Mrs. H. O. Havemeyer, New York, July 25, 1899; Mrs. H. O. Havemeyer, New York, 1907–29 (on deposit with Durand-Ruel, New York, Jan. 25–Mar. 2, 1909, and again May 25–28, 1909)

EXHIBITIONS: Boston 1909, no. 3; New York 1915a, no. 46 (as *Mother and Son with Mirror*)

BIBLIOGRAPHY: Pica 1907; Hale 1909

LETTER REFERENCES: HOH to PDR, c. June 1899, in Weitzenhoffer 1986, p. 136; PDR to HOH, July 7, 1899, in Weitzenhoffer 1986, pp. 131, 136

CATALOGUE RAISONNÉ: Breeskin 1970, 338, as *The Oval Mirror*, 1901

88. *Young Mother* (*Jeune Mère*), 1900

Oil on canvas; 92.4 x 73.7 cm (36⅜ x 29 in.)
Signed lower right: *Mary Cassatt*
New York, The Metropolitan Museum of Art, H. O. Havemeyer Collection, bequest of Mrs. H. O. Havemeyer, 1929, 29.100.48

Chicago

PROVENANCE: From the artist to Durand-Ruel, Paris, Jan. 3, 1901; Mr. and Mrs. H. O. Havemeyer, New York, Apr. 23, 1901; Mrs. H. O. Havemeyer, New York, 1907–29 (on deposit with Durand-Ruel, New York, Jan. 25–Mar. 2, 1909)

EXHIBITIONS: Boston 1909, no. 13; New York 1915a, no. 47 (as *Little Girl Leaning upon Her Mother's Knee*); Philadelphia 1920, no. 9

BIBLIOGRAPHY: Geffroy 1904; *Boston Daily Evening Transcript* 1909

CATALOGUE RAISONNÉ: Breeskin 1970, 415 (as *Young Mother Sewing*, 1902)

89. *The Mirror (Le Miroir)*, c. 1905

Oil on canvas; 91 x 72 cm (35⅞ x 28⅜ in.)
Signed lower right: *Mary Cassatt*
Washington, D.C., National Gallery of Art, Chester Dale Collection, 1963.10.98

Washington

PROVENANCE: From the artist to Roger Marx, Paris, by 1908 (on deposit with Durand-Ruel, Paris, Oct. 30–Dec. 2, 1908); Galerie Manzi-Joyant, Paris, Roger Marx sale, May 11, 1914, no. 15; bought by Durand-Ruel for Mrs. H. O. Havemeyer, New York; Mrs. H. O. Havemeyer, New York; American Art Association, New York, Havemeyer Estate sale, Apr. 10, 1930, no. 82 (as *La Femme au tournesol*); Chester Dale, New York, until 1962

EXHIBITIONS: Paris 1908b, no. 6; New York 1915a, no. 50 (as *Mother and Baby Reflected in Mirror*)

BIBLIOGRAPHY: Pach 1909; *Art in Europe* 1914

LETTER REFERENCES: LH to JDR, Apr. 17, 1914, in Weitzenhoffer 1986, p. 217; LH to JDR, Apr. 24, 1914, in Weitzenhoffer 1986, p. 217

CATALOGUE RAISONNÉ: Breeskin 1970, 473 (as *Mother Wearing a Sunflower on Her Dress*, c. 1905)

90. *Woman at Her Toilette (Femme à sa toilette)*, 1909

Oil on canvas; 92.5 x 72.4 cm (36¼ x 28½ in.)
Signed lower right: *Mary Cassatt*
Collection of Mr. Fayez Sarofim

Chicago

PROVENANCE: From the artist to Durand-Ruel, Paris, 1910; Durand-Ruel, New York; Mrs. Nelson Robinson, New York, 1910; Durand-Ruel,

New York, 1912; private collection, Switzerland, 1948; Mrs. Samuel E. Johnson, Chicago; private collection, Ohio

EXHIBITIONS: Berlin 1910 (as *Bei der Toilette*); Boston 1913, no. 24; Pittsburgh 1913, no. 54; St. Louis 1913, no. 14; Chicago 1913, no. 63; Washington, D.C. 1916–17, no. 364; Philadelphia 1917a, no. 99; New York 1917, no. 9; New York 1920b, no. 22; New York 1923, no. 8; New York 1924a, no. 20; Cincinnati 1925, no. 4

BIBLIOGRAPHY: MacChesney 1913; Segard 1913, ill. opp. p. 168; *Art et les artistes* 1919

CATALOGUE RAISONNÉ: Breeskin 1970, 543 (as *Antoinette at Her Dressing Table*, 1909)

91. Edgar Degas (French; 1834–1917) *Mary Cassatt Seated, Holding Cards (Miss Cassatt assise, tenant des cartes)*, c. 1880–84

Oil on canvas; 74 x 60 cm (29⅛ x 23⅝ in.)
Signed upper left: *Degas*
Washington, D.C., National Portrait Gallery, Smithsonian Institution, NPG.84.34

Chicago, Boston, Washington

PROVENANCE: From the artist to Mary Cassatt, Paris, until Jan. 1913; deposited by Cassatt with Galerie Durand-Ruel, Paris, from c. Jan. 22, 1913, until Apr. 2, 1913; returned to Cassatt Apr. 2, 1913; sold by Cassatt to Ambroise Vollard, Paris, by Apr. 4, 1913, until at least 1917; Wilhelm Hansen, Ordrupgaard, Denmark; Kojiro Matsukata, Paris, by 1924; M. André Meyer, New York, by 1962

EXHIBITIONS: "Franzosische Kunst des XIX. u. XX Jahrhunderts," Zürcher Kunsthaus, Zurich, 1917, no. 90 (as *Portrait de femme*); "Exposition Degas," Galerie Georges Petit, Paris, 1924, no. 58

BIBLIOGRAPHY: Paul Lafond, *Degas* (Paris, 1919), vol. 2, p. 17; Ragnard Hoppe, *Degas: Och Hans Arbeten I, Nordisk ägo* (Stockholm, 1922), p. 30

LETTER REFERENCES: MC to PDR, Jan. 22, 1913, in Venturi 1939, vol. 2, pp. 129–30; MC to GDR, Apr. 9, 1913, in Venturi, 1939, vol. 2, pp. 130–31

CATALOGUE RAISONNÉ: Lemoisne 796 (as *Mary Cassatt assise, tenant des cartes*, c. 1884)

Chronology

Compiled by Wendy Bellion

Principal secondary sources for the following chronology of Mary Cassatt's life and career are: Havemeyer 1993, Mathews 1984, Mathews 1994, Sweet 1963, and Weizenhoffer 1986. The reader is encouraged to refer to these books for biographical facts. References are given below for all quoted material; for full citations, see Archival Sources and Frequently Cited Sources, in the Bibliography. "Cassatt" used without a first name refers to Mary Cassatt; "Durand-Ruel" to Paul Durand-Ruel; and "Havemeyer" to Louisine Havemeyer. Only selected exhibitions including Cassatt's works are listed here; for a complete record, see the Lifetime Exhibition History.

Fig. 1. Peter Baumgärtner (German; 1834–?). *Robert Cassatt and His Children*, 1854 (from left: Gardner, Robert, Mary, and Robert Stevenson Cassatt). Graphite on paper. Private collection.

1844

May 22. Mary Stevenson Cassatt is born in Pittsburgh, Pennsylvania, to Robert Cassatt (born 1807, near Wheeling, West Virginia), and Katherine Kelso (née Johnston) Cassatt (born 1816, in Pittsburgh). In 1829 Robert Cassatt founded Cook & Cassatt, a mercantile shipping company. He married Katherine in Pittsburgh's Trinity Church on Jan. 22, 1835. The couple lived at Burgess Row, Liberty Street, then moved in 1840 to Rebecca (now Reesdale) Street in Allegheny City, across the Ohio River from Pittsburgh.

Mary Cassatt is the couple's fourth child and second daughter. Her birth follows those of Katherine Kelso (born and died on Dec. 30, 1835), Lydia Simpson (July 23, 1837), Alexander Johnston (Dec. 17, 1839), and Robert Kelso (June 5, 1842). A sixth child, George Johnston, dies within a month of his birth on Jan. 22, 1846; the seventh child, Joseph Gardner (called Gardner or Gard) is born Jan. 13, 1849.

1847

Robert Cassatt is elected mayor of Allegheny City, Pennsylvania.

Apr. 2. Cassatt is baptized by the Reverend Dr. Upbold in Pittsburgh's Trinity Church.

1848

Robert Cassatt retires, and the family moves to the corner of Pennsylvania Avenue and Marbury Street, in Pittsburgh. Before the year's end, they relocate to Hardwicke, a country estate built in 1795, near Lancaster.

1849

Nov. The Cassatts move to 496 West Chestnut Street, in Philadelphia's old Southward district.

1851

June. The Cassatt family travels to Europe, seeking medical care for nine-year-old Robert, who suffers from a bone disease. By the fall, the Cassatts are living at the Hôtel Continental in Paris.

1852

The Cassatts rent a furnished apartment in Paris, and Alexander studies at M. Gachotte's school.

Dec. Founding of France's Second Empire, one year after Louis Napoleon's coup d'état.

1853

Spring. The Cassatts move to Heidelberg and then Darmstadt, Germany. Alexander studies engineering at the Technische Hochschule in Darmstadt.

1855

May 24. Thirteen-year-old Robert Kelso Cassatt dies in Darmstadt.

Nov. or Dec. The Cassatts return to the United States and rent a house at the southeastern corner of High and Minor Streets, West Chester, Pennsylvania. Alexander remains abroad in Darmstadt.

1857

The Cassatts move to a house on the north side of Chestnut Street, between Walnut and Matlack Streets, in West Chester.

Jan. Alexander enters Rensselaer Polytechnic Institute, in Troy, New York.

1858

Mar. 18. The Cassatts purchase a house in Philadelphia, at Olive and Fifteenth Streets (now 1436 South Penn Square), for $4,000, but often reside at their rented West Chester home.

1860

Mar. 30. Robert Cassatt acquires thirty-seven acres of land for $3,232.47 in Cheyney, Thornbury Township, Chester County, Pennsylvania.

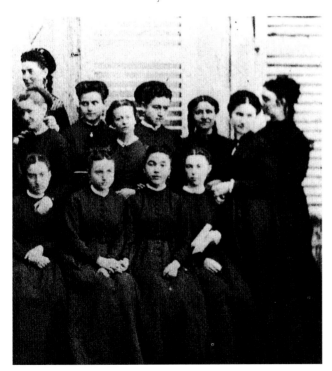

Fig. 2. Photograph of students of Charles Chaplin, Paris, 1866 (top left: Mary Cassatt; second from right, standing: Eliza Haldeman). Location of original unknown. Photo: Nancy Mowll Mathews, ed., *Mary Cassatt: A Retrospective* (New York, 1996), p. 59.

Apr. 25. Cassatt enrolls in the Antique Class at the Pennsylvania Academy of the Fine Arts (PAFA) in Philadelphia. Women are excluded from the life-drawing classes, but notably they are permitted to attend anatomy classes at the Pennsylvania Medical University for the first time this year.

Oct. Cassatt studies drawing with Christian Schussele and painting with Peter Rothermel at the PAFA. Alexander Cassatt anticipates that "in three years Mary will want to go to Rome" to study (Alexander Cassatt to Robert Cassatt, Nov. 17, in Sweet 1966, p. 14). The father of Cassatt's classmate, Eliza Haldeman, is less supportive of his daughter's ambitions: "You will get married and settle down into a good housekeeper like all married women & send off your paints into the garret! There is a prediction for you, and one founded upon almost universal experience" (Samuel Haldeman to Eliza Haldeman, Mar. 2, 1863, in Mathews 1994, p. 58).

1861

The Cassatts build a country house on their land in Cheyney, Pennsylvania.

Apr. 12. The Civil War begins when South Carolina militia fire on Fort Sumner.

1862

Mar. 4. Cassatt and Haldeman are granted permission to copy a portion of Johann Bernhard Wittkamp's *Deliverance of Leyden* (Walker, fig. 2) at the PAFA.

Apr. The family's move to its newly built country house may force Cassatt to discontinue her studies at the PAFA, but correspondence indi-

cates that she takes occasional trips to Philadelphia.

1863

Alexander Cassatt begins a highly successful career with the Pennsylvania Railroad, mentored by Col. Thomas Scott, husband of Katherine Cassatt's cousin Anna Riddle Scott. Alexander enjoys frequent promotions following his first job as an assistant engineer, eventually ascending to the presidency of the company in 1899.

Jan. 1. President Abraham Lincoln signs the Emancipation Proclamation.

July 1–3. Battle of Gettysburg takes place in southern Pennsylvania.

1865

Robert Cassatt opens the brokerage office Cassatt and Co. in Philadelphia.

Apr. Civil War ends. Lincoln is assassinated.

Oct. 4. Cassatt applies for a passport.

Dec. Cassatt and Eliza Haldeman (figs. 3, 4), accompanied by Katherine Cassatt, settle in Paris.

1866

Early summer. Katherine Cassatt returns from Paris to the United States.

Apr. Robert Cassatt sells the family's Cheyney estate to Addinell Hewell of Philadelphia for $10,000. He and Katherine Cassatt move, with Lydia and Gardner, to Renovo, in central Pennsylvania, in order to be with recently promoted Alexander.

Fig. 3. Photograph of Mary Cassatt, Paris, c. 1867. Photo: courtesy Henry B. and Audrey S. Haldeman.

Fig. 4. Photograph of Eliza Haldeman, Paris, c. 1867. Photo: courtesy Henry B. and Audrey S. Haldeman.

Oct. In Paris Cassatt and Haldeman attend Charles Chaplin's art class for women (see fig. 2), in which they find themselves "about as 'forte' as any" and work from models every day (Eliza Haldeman to Samuel Haldeman, Dec. 4, in Mathews 1984, p. 39). They attend evening classes in the Latin Quarter three times a week and copy works in the Musée du Louvre.

Nov. The renowned academic painter Jean Léon Gérôme accepts Cassatt as a student, generating excitement among her peers from Philadelphia, including Thomas Eakins.

Dec. 18. Mrs. Haldeman writes to her daughter in Paris: "I fear that you with Miss Cassatt may venture too far, do not rely on her judgment as she has no religion to guide her and from the impulse of a moment you may rush with her into things that may injure you" (Mary Haldeman to Eliza Haldeman, Dec. 18, in Mathews 1994, p. 36).

1867

Robert, Lydia, and Gardner Cassatt move with Alexander to northwestern Pennsylvania when he is promoted to a position in the isolated town of Irvineton, in Warren County.

Feb. Cassatt and Haldeman travel to Courances, about thirty miles south of Paris, where they work on paintings for submission to the Salon.

Apr.–May. Cassatt and Haldeman relocate to Ecouen, north of Paris, in order to study with genre painters Pierre Edouard Frère and Paul Constant Soyer.

May. Cassatt's and Haldeman's paintings are refused by the Salon jury. Although Cassatt aspires to "paint *better* than the old masters," her mother, according to Haldeman, "wants her to become a portrait painter as she has a talent for likenesses and thinks she is very ambitious to want to paint pictures. . . . Mary expects to stay two years more abroad, she is getting on very well and studies hard. I think she has a great deal of talent and industry" (Eliza Haldeman to Mary Haldeman, May 15, in Mathews 1984, pp. 45–46).

Oct. Seeking relief from a stomach ailment, Cassatt travels with Haldeman through Picardy to a Normandy coast resort, "Bains de Mer," at St.-Valéry-sur-Somme. Haldeman has "never seen a place more rich in genre pictures i.e. if they were painted" (Eliza Haldeman

to Samuel Haldeman, Oct. 1, in Mathews 1984, p. 50).

Nov. The Cassatt family follows Alexander to Altoona, Pennsylvania.

1868

Late Apr. Cassatt and Haldeman return to Courances, following a short visit to Barbizon. Cassatt, "very anxious to learn the style" of Barbizon landscape painting, had become displeased with her instructor, identified only as "one of the Best of the school of Barbizon . . . engaged [in] painting a fat pig being led to slaughter" (Eliza Haldeman to Samuel Haldeman, Apr. 24, in Mathews 1984, p. 51).

May. Cassatt's *Mandolin Player* (Walker, fig. 3) is accepted by the Salon. She signs the painting "Mary Stevenson," using her middle name, which is a family surname. Late this month, Cassatt travels to the village of Villiers-le-Bel, near Ecouen, where she remains through April 1869 in order to study with the renowned artist Thomas Couture.

Mid-May. Haldeman and Cassatt, as part of their education, often make copies in the Louvre. Haldeman fears that "the Louvre will become a second Academy for talking and amusing ourselves. . . . As gentlemen cannot come to see us at the Hotel we are obliged to receive them at the Louvre" (Eliza Haldeman to Alice [?] Haldeman, May 13, in Mathews 1984, p. 56).

June 7. Mr. Ryan, whom Cassatt and Haldeman met in mid-May, reviews the Paris Salon in the *New York Times*, mentioning both artists.

Aug. Cassatt, an admirer of Alfred Tennyson, is at work on a painting

(now lost) based on Tennyson's poem "Mariana of the Moated Grange."

Nov. 25. Alexander Cassatt marries Lois Buchanan, a niece of former president James Buchanan.

Dec. Haldeman returns to the United States.

1869

Apr.–June. When the Salon rejects her entry, Cassatt complains to her former teacher and jury member Gérôme. He tells her that ". . . if [she] had come twenty four hours sooner he would have got [her] picture through!" (Cassatt to Eliza Haldeman, Aug. 17, in Mathews 1984, p. 62). Cézanne, Monet, and Sisley are also rejected; Bazille, Degas, Pissarro, and Renoir each have one work accepted.

July 10–Aug. Accompanied by Miss Gordon, a fellow Philadelphian and amateur painter—"and you must know we professionals despise amateurs"—Cassatt journeys through

Fig. 5. Photograph of the Sartain family, Philadelphia, c. 1865 (from left: John, Henry, William, and Emily Sartain). Photo: Nancy Mowll Mathews, ed., *Mary Cassatt: A Retrospective* (New York, 1996), p. 75.

the south of France to Beaufort-sur-Doron, in Savoy, near the Italian border: "As the costumes & surroundings are good for painters we have concluded to put up with all discomforts for a time" (Cassatt to Lois Cassatt, Aug. 1, in Mathews 1984, p. 61).

Aug. 23. Edward, first child of Alexander and Lois Cassatt, is born.

Fall. Cassatt probably returns to Ecouen.

Dec. Cassatt's mother, Katherine Cassatt, arrives in Paris.

1870

Early 1870. Cassatt and her mother reside in Rome, which like Paris attracts many American artists at this time. Cassatt prepares her Salon submission in the Rome studio of French artist Charles Bellay.

May. Cassatt's *Una Contadina di Fobello; val Sesia (Piémont)* (now lost) is accepted by the Paris Salon.

July. Cassatt and her mother return to Paris, but the outbreak of war between France and Prussia on July 19 likely prompts them to sail for the United States.

Late Aug. After three and one-half years in France, Cassatt joins her family in Altoona, Pennsylvania.

Sept. 2. Napoleon III is captured following the defeat of his armies at Sedan, the last major battle of the Franco-Prussian war. Paris is besieged by Prussian troops for the next four months.

Fall. Cassatt re-enters her old artistic circles when her family moves to 23 South Street, in Philadelphia. By

the following spring, she has set up a studio, places two paintings (now destroyed) with the New York branch of the Parisian gallery Goupil and Co., and becomes acquainted with artist Emily Sartain, the daughter of Philadelphia engraver John Sartain (see fig. 5).

1871

Jan. William, King of Prussia, crowns himself Emperor of Germany in the Hall of Mirrors at Versailles. France signs an armistice, surrendering to Prussia.

Mar. 18. The Paris Commune is established.

Spring. In a Philadelphia studio, Cassatt and Emily Sartain are working from the same male model and hope to find a woman to pose for them as well.

May 21–28. Violent fighting erupts in Paris when the Versailles government attempts to suppress the Commune. Over the summer months, about 50,000 people suspected of being Communards are arrested and killed. Cassatt is sympathetic to the Communards' plight; she sends Sartain "a Plea for the Commune which I wish you would read, I think it does more justice than most newspaper correspondents" (Cassatt to Emily Sartain, May 22, in Mathews 1984, p. 72).

Late May. The Cassatts move to the small town of Hollidaysburg, near Altoona. Mary locates a large studio with a "high ceiling & a studio window built for a portrait painter rent $4 (four dollars) a month!" (Cassatt to Emily Sartain, May 22, in Mathews 1984, p. 71). Nevertheless she is frustrated with her work and longs to return to Europe.

July 30. Katharine Kelso, second child of Alexander and Lois Cassatt, is born.

Sept. In Pittsburgh Bishop Michael Domenec offers Cassatt $300 to paint copies of Correggio's *Madonna of Saint Jerome* and *Coronation of the Virgin* for the city's cathedral (see Walker, figs. 6–9).

Oct. Cassatt retrieves her two paintings from Goupil and Co. and takes them to Chicago, but they are destroyed in the Great Chicago Fire while on display in a jewelry store.

Early Dec. Following a short trip to Washington, D.C., Cassatt departs for Europe with Sartain. They arrive in Liverpool and spend several days in London before traveling on to Paris, which has been devastated by the Franco-Prussian war and the Commune. They endure a twenty-eight-hour train ride to Turin before arriving in Parma, where they lodge at the home of Signora Bricoli, Borgo Riolo 21. In Philadelphia the Cassatt family moves to a house on Twenty-first Street, three blocks from Alexander's home on Delancey Place (now part of Rittenhouse Square).

1872

Robert Cassatt leaves retirement to establish a new brokerage firm, Lloyd, Cassatt & Company, with Altoona partner John Lloyd.

Jan. Cassatt and Sartain study with Carlo Raimondi, professor and head of engraving at Parma's Accademia. Raimondi, who had made engravings after Correggio with his own teacher Paolo Toschi, eagerly shows his print collection to the two American women. Cassatt works on her copies, as well as a

Fig. 6. Photograph of Mary Cassatt, Parma, Italy, 1872. Photo: courtesy Archives Pennsylvania Academy of the Fine Arts, Philadelphia.

painting for the 1872 Paris Salon. Sartain describes her friend's success: "The compliments she receives are over-whelming—At Prof. Caggiati's reception men of talent and distinction to say nothing of titled people, are brought up to be presented, having requested the honor of an introduction—I shine a little, by her reflection—One of the custode [guards] yesterday, looking around carefully first to be sure he was not overheard, assured her she was much more 'brava' than any of the professors—One of the professors has begged her to come to his studio and give him criticism and advice" (Emily Sartain to John Sartain, Mar. 7, in Mathews 1984, p. 95). Cassatt reproduces Correggio's *Coronation of the Virgin* for the Pittsburgh Cathedral, working in part from a copy by Annibale Carracci. She begins and, for unknown reasons, abandons her copy of *Madonna of Saint Jerome*. The copy of

the *Coronation* is sent to Pittsburgh in June.

May. Cassatt remains in Parma while Sartain travels to Paris to study with Evariste Luminais. Cassatt's *During Carnival* (cat. 2) is accepted by the Salon.

June. Cassatt scolds Sartain: "You don't tell me if you have the life model all day or if you have the nude or in fact any particulars of the Luminais school, remember I am interested." Cassatt begins painting *Bacchante* (cat. 1), using a lame girl who "has a splendid head like a Roman" as her model (Cassatt to Emily Sartain, June 2, in Mathews 1984, pp. 100–102).

Oct. 1. Cassatt travels for four days by train to Madrid and spends the next six months entirely on her own in Spain. She is awed by Spanish paintings in the Museo del Prado and urges Sartain to join her in Madrid.

Before Oct. 27. Cassatt travels to Seville. She establishes a studio in the historic Casa de Pilatos (see Walker, fig. 14), palace of the dukes of Medinaceli, and finds few social diversions from her industrious day, which begins at about 10:00 a.m. and concludes at 5:00 p.m.

Nov. 17. Cassatt sells *During Carnival* (cat. 2) to an American collector. Sartain reports to her father that Cassatt had once said that "no woman artist ever sold her pictures except by favor in America,—that people bought them, not because they wanted them but only to patronize a woman. Perhaps now . . . her opinion is modified" (Emily Sartain to John Sartain, Oct. 17, in Mathews 1984, p. 112).

1873

Alexander Cassatt begins to build a country house, "Cheswold," in Haverford, Pennsylvania, designed by Frank Furness, architect of the PAFA.

Jan. Cassatt confesses, "If I did not live to paint life would be dull here. . . ." She works on a composition with three figures, probably *The Flirtation: A Balcony in Seville* (cat. 3) (Cassatt to Emily Sartain, Jan. 1, in Mathews 1984, p. 114).

Late Apr.–May. Cassatt travels for three days by train from Seville to Paris, where she is reunited with her mother and Emily Sartain.

May 8. Cassatt, her mother, and Sartain tour the art collection of expatriate American William Hood Stewart, who holds a salon for artists every Thursday. Stewart collected paintings by contemporary Spanish artists including Mariano Fortuny, Eduardo Zamacois, and Raymundo de Madrazo.

May 15. The Salon des refusés (Salon of Rejected Works), organized to protest Salon conservatism, opens in Paris at the request of such artists as Cézanne, Fantin-Latour, Jongkind, Manet, and Pissarro. Cassatt also begins to voice criticisms of academic art, although she exhibits *Offering the Panal to the Bullfighter* (cat. 5) at the Salon under the name "Mary Stevenson-Cassatt." Sartain finds Cassatt "entirely too slashing,—snubs all modern Art," but concedes that her harsh assessment of modern painting derives from an earnest love of "nature and her profession" (Emily Sartain to John Sartain, May 8, in Mathews 1984, pp. 117–18).

Before June 25. Mary and Katherine

Cassatt travel to The Hague and then to Antwerp, where Cassatt meets Joseph Gabriel Tourny and his wife, acquaintances of her future friend Edgar Degas.

Sept. 28. Robert Kelso, third child of Alexander and Lois Cassatt, is born.

Fig. 7. STOP (L. P. G. B. Morel-Retz) (French; 1825–1899). *Caricature of "Ida,"* published in *Le Journal amusant* (June 27, 1874), p. 4. Photo: Paris, Bibliothèque nationale.

Oct. Cassatt returns to Paris to see her mother off to the United States.

Nov. Cassatt briefly visits former instructors Raimondi in Parma and Bellay in Rome. Writing from Rome, she laments, "All the good models are taken for the winter and of course would rather pose for men" (Cassatt to Emily Sartain, Nov. 26, in Mathews 1984, p. 123).

Dec. 27. In Paris a group of artists, later to become known as the Impressionists, found the Société anonyme cooperative des artistes peintres, sculpteurs, graveurs, etc.

1874

Apr. 15–May 15. Thirty artists stage

the inaugural Société anonyme exhibition—the first "Impressionist" show—in the former studio of the photographer Nadar at 35, boulevard des Capucines. Cassatt, still in Rome, misses the event. She is represented at the Salon by the painting *Ida* (Shackelford, fig. 2), which is caricatured in *Le Journal amusant* (fig. 7). According to Cassatt's first biographer, Achille Segard, Tourny shows *Ida* to a very enthusiastic Degas.

June. Cassatt settles in Paris. She exhibits *A Musical Party* (fig. 8) at a gallery on the boulevard Haussmann. At the exclusive boarding school of Mme Del Sartre, Sartain introduces Cassatt to Louisine Elder, who will become a close friend. Louisine later recollects, "I felt then that Miss Cassatt was the most intelligent woman I had ever met" (Havemeyer 1993, p. 269).

Summer. Cassatt resumes studies with Couture in Villiers-le-Bel after an absence of six years.

Fig. 8. Mary Cassatt. *A Musical Party*, c. 1874. Oil on canvas; 96.5 x 66 cm. Paris, Musée du Petit Palais. Photo: © Photothèque des Musées de la Ville de Paris.

1875

May. Cassatt submits a portrait of Lydia and one of a young girl to the Salon (both works now presumed lost or destroyed). Only the latter is accepted; it is caricatured in *Le Journal amusant*. Cassatt and Sartain, whose tastes in art and instructors have often differed, have a bitter falling out. Sartain returns to Philadelphia by the following fall.

May 31. Cassatt departs for Philadelphia aboard the S.S. *Illinois*. Her reasons for making the trip and activities during the visit are unknown.

Aug. 7. Cassatt returns to Paris.

Aug. 14. Elizabeth (Elsie) Foster, fourth child of Alexander and Lois Cassatt, is born.

Fall. Cassatt rents a studio at 19, rue Laval (after 1885, rue de Victor-Massé), near the place Pigalle (Paris *Cadastre*, 1875). Her sister, Lydia, joins her.

1876

Apr. 1–30. Nineteen artists exhibit 252 works in the second "Impressionist" exhibition, held in three rooms of Paul Durand-Ruel's gallery at 11, rue le Peletier. At about the same time, critic Edmond Duranty publishes "La Nouvelle Peinture" ("The New Painting"), an important analysis of avant-garde art in the 1870s.

May. Cassatt's 1875 portrait of Lydia, repainted with a darker background, is accepted for this year's Salon, along with another portrait of a female subject.

1877

The Society of American Artists is

Fig. 9. Photograph of the Exposition universelle of 1878, Paris: Palais du Trocadéro and Pavillon de Monaco. Photo: © ND–Viollet.

founded in New York. Artist J. Alden Weir, keeps Cassatt informed about the society's activities.

Apr. 1–30. The third Impressionist exhibition is held in the second floor of a building at 6, rue le Peletier, across the street from Durand-Ruel's. The eighteen exhibitors embrace the label "Impressionniste" for the first time, and the show enjoys successful attendance and positive critical reception.

May. Two events mark a turning point in Cassatt's career: Degas invites Cassatt, whose two Salon entries have been rejected, to exhibit with the Impressionists, possibly during a visit to her studio. Cassatt also guides Louisine Havemeyer's first purchase of modern art, Degas's *Rehearsal of the Ballet* (Hirshler, fig. 1), likely from the art-supply shop of Julien ("Père") Tanguy, 14, rue Clauzel.

Oct. The artist's parents and sister, Lydia, settle permanently with Cassatt in Paris. Lydia Cassatt has been diagnosed with Bright's disease, a fatal kidney ailment; her health, which has never been strong, slowly deteriorates during the next few years.

1878

The correspondence of Camille Pissarro indicates the beginning of a long friendship and professional collaboration with Cassatt.

Mar. 10. In a letter to J. Alden Weir, Cassatt identifies herself as part of the Impressionist group, although she has yet to exhibit with them (Cassatt to J. Alden Weir, in Mathews 1984, p. 137).

Late Mar. Degas drafts a list of thirteen artists—including Cassatt—whom he hopes will participate in the proposed Impressionist exhibition of 1878.

Spring. The Cassatts move to 13, avenue Trudaine, between the place Pigalle and Montmartre (see fig. 10).

May 1. The Exposition universelle opens in Paris (see fig. 9). Cassatt's *Tête de femme* (unidentified) is exhibited in the American Pavilion, but the jury refuses her *Portrait of a Little Girl* (cat. 11). Théodore Duret publishes his brochure *Les Peintres impressionnistes*; Cassatt is not mentioned.

June. The fourth Impressionist exhibition, toward which Cassatt has worked all year, is postponed until 1879. Cassatt sends four pictures to a Philadelphia dealer, H. Teubner: *A Seville Belle* (cat. 4), *Offering the Panal to the Bullfighter* (cat. 5), *A Musical Party* (fig. 8) and *At the Français, a Sketch* (cat. 17).

Summer. Cassatt and Pissarro visit each other frequently. Cassatt admires Pissarro's work and considers purchasing several of his paintings.

Fig. 10. Postcard showing place Pigalle and the boulevard de Clichy, Paris, 1904. Photograph. Paris, Bibliothèque nationale. Cassatt rented a studio on the nearby rue Duperré in 1882 Photo: Courtesy Judith A. Barter.

Oct. The Massachusetts Charitable Mechanic Association in Boston awards Cassatt a silver medal for her contribution to their thirteenth annual exhibition. At least two of the four works Cassatt had sent to Teubner in June are included in the show. Cassatt ships her recent portrait of her mother (cat. 10) to Alexander.

Nov.–Dec. Cassatt decides to reclaim her paintings from an increasingly uncooperative Teubner and to market them in New York. Robert Cassatt insists that his daughter's studio be self-supporting. "This makes Mame, very uneasy, as she must either make sale of the pictures she has on hand or else take to painting *pot boilers* as the artists say—a thing that she never yet has done & cannot bear the idea of being obliged to do" (Robert Cassatt to Alexander Cassatt, Dec. 13, in Mathews 1984, p. 143).

1879

Mar. 16. Cassatt calls on Berthe Morisot to learn if she intends to contribute to the approaching fourth Impressionist exhibition. Although they may have met earlier, the origins of their long friendship can be dated securely to this visit.

Apr. 10–May 11. Cassatt debuts with the Impressionists, contributing twelve works (one *hors catalogue*) to the group's fourth exhibition, held at 28, avenue de l'Opéra. Cassatt assists Degas with preparations for this profitable and well-attended exhibition, which features 246 works by sixteen artists. Several of the artists associated with the first three shows—among them Cézanne, Renoir, and Sisley— decline to participate when Degas and his supporters request that the Impressionists abstain from submitting work to the Salon.

A number of critics admire Cassatt's work, including Burty, Duranty, Houssaye, Huysmans, and Silvestre, although some are critical. Antonin Proust purchases *Woman Reading* (cat. 14), and Alexis Rouart buys *Woman in a Loge* (cat. 18). "In short everybody says now that in future it dont [*sic*] matter what the papers say about her—She is now known to the Art world as well as to the general public in such a way as not to be forgotten again so long as she continues to paint!! Every one of the leading daily French papers mentioned the Exposition & nearly all named Mame—most of them in terms of praise, only one of the American papers noticed it and *it* named her rather disparagingly!!" (Robert Cassatt to Alexander Cassatt, May 21, in Mathews 1984, p. 144).

Degas recruits Cassatt (as well as Pissarro and Félix Braquemond) to contribute to *La Jour et la nuit*, a journal of original prints that he intends to establish. The artists work on etchings through the fall, but the publication is never realized. Cassatt also begins to purchase the work of her peers at about this time.

Aug. 9. Cassatt's painting *Corner of a Loge* (Barter, fig. 1) is reproduced in the Parisian periodical *La Vie moderne*.

Sept. Following a brief trip to the Isle of Wight and England, Cassatt travels with her father through the Swiss and Italian Alps. She meets her mother in Lausanne in early Sept., and together they voyage to Divonne-les-Bains, on the Lac de Genéves. Cassatt finds "many things to admire, beautiful frescoes," which lead her to judge, "I don't see that the moderns have discovered anything about color. It seems to me that we haven't learned anything more about color or drawing" (Cassatt to Berthe Morisot, [fall], in Mathews 1984, p. 149).

1880

Winter–spring. Degas and Caillebotte feud during preparations for the upcoming Impressionist exhibition.

Apr. 1. The fifth Impressionist exhibition opens at 10, rue des Pyramides. The show is not as financially or critically successful as the previous one; Cézanne, Monet, Renoir, and Sisley do not participate.

Early July. The Cassatts rent a house in Marly-le-Roi, where they are joined for the summer by Alexander and Lois's four children. Cassatt capitalizes on the large

Fig. 11. Photograph of parlor of Alexander Cassatt's house, "Cheswold," Haverford, Penn., c. 1900. Photo: courtesy estate of Mrs. John B. Thayer.

gathering by producing a number of family portraits (see cats. 29–31).

Sept. Alexander Cassatt's family returns to the United States and moves into its new home, Cheswold, in Haverford, Pennsylvania (fig. 11 and Hirshler, fig. 15).

Mid-Oct. The Cassatts return to Paris from Louveciennes. Degas finds that the work Cassatt has produced over the summer "looks very well in the studio light. It is much stronger and nobler than what she had last year" (Degas to Henri Rouart, in Guérin 1945, p. 61).

Nov. 18. Cassatt begins to advise her brother Alexander in his acquisition of paintings by Degas.

1881

Paul Durand-Ruel (fig. 12), a prominent dealer in Impressionist art, begins to buy work by Cassatt, albeit tentatively.

Jan. 24. Caillebotte, unhappy that Degas has introduced new artists such as François Rafaëlli and Fed-

erico Zandomeneghi into the Impressionist circle, suggests that only those who already have made significant contributions to the group be permitted to show works in the upcoming exhibition. Pissarro, supported by Cassatt, rejects Caillebotte's proposal; Pissarro wants Degas to participate in the show and reminds Caillebotte that Degas was responsible for involving

Fig. 12. Marcellin Desboutin (French; 1823–1904). *Paul Durand-Ruel*, 1882. Drypoint on paper; 19.5 x 15 cm. Paris, Bibliothèque nationale.

Cassatt, Forain, and Caillebotte himself in the group.

Spring. After considering spending the summer in Auvers, Cassatt instead arranges to rent a property adjacent to the villa Coeur Volant in Louveciennes.

Apr. Cassatt plans to purchase works by Degas and Pissarro, and a "Marine" by Monet, for her brother Alexander. "It [the Monet] is a beauty, and you will see the day when you will have an offer of 8000 [francs] for it" (Robert Cassatt to Alexander Cassatt, Apr. 18, in Mathews 1984, p. 161).

Apr. 2–May 1. Eleven works by Cassatt appear in the sixth Impressionist exhibition, held in five small rooms at 35, boulevard des Capucines. Her father reports: "Mame's success is certainly more marked this year than at any time previous," but, because she keeps the American "colony" at bay, she receives scant attention from American reviewers. "The thing that pleases her most in this success is not the newspaper publicity . . . but the fact that artists of talent & reputation & other persons prominent in art matters ask to be introduced to her. . . . The things she painted last summer in the open air are those that have been the most praised" (Robert Cassatt to Alexander Cassatt, Apr. 18, in Mathews 1984, pp. 160–61).

Apr. 15. Moïse Dreyfus (fig. 13) expresses interest in Cassatt's *Reading* (Barter, fig. 32), a portrait of Katherine Cassatt reading to her grandchildren. Katherine Cassatt writes to her granddaughter: "I don't think your Aunt Mary will sell it—she could hardly sell her mother and nieces and nephew I think." But Cassatt does sell the painting to Dreyfus, causing some

Fig. 13. Mary Cassatt. *Moïse Dreyfus*, c. 1877. Pastel on paper mounted on canvas; 81.3 x 65 cm. Paris, Musée du Petit Palais, gift of Justin Mayer in the name of Mme Moïse Dreyfus, in memory of Moïse Dreyfus. Photo: © Photothèque des Musées de la Ville de Paris.

discord within the family (Katherine Cassatt to Katharine Kelso Cassatt, Apr. 15, in Mathews 1984, p. 159). Dreyfus later returns it to Alexander Cassatt (see June 1883).

June. Cassatt and Louisine Elder visit a small Courbet exhibition, held in the foyer of the Théâtre de la Gaîté, Paris. Both women admire a painting of a nude, *Torso of a Woman* (1863; New York, The Metropolitan Museum of Art); in 1892, Havemeyer acquires it.

Summer. Gardner Cassatt visits his family at Coeur Volant, a rented house in Louveciennes (adjacent to Marly-le-Roi); Lydia Cassatt's health declines.

1882

The Cassatts hire Mathilde Valet, an Alsatian servant, who remains with the household until Cassatt's death in 1926. Sometime after 1878,

Cassatt rents a studio at 2, rue Duperré, off the place Pigalle (Paris *Cadastre*, 1882).

Mid-Jan. Katherine and Lydia Cassatt, suffering, respectively, from heart problems and Bright's disease, travel to Pau, in the south of France, in hopes that a warmer climate will improve their health.

Spring. Cassatt does not participate in the seventh Impressionist exhibition, held at 251, rue St.-Honoré. Her absence demonstrates support for Degas, who has withdrawn in protest of the reluctance of Caillebotte, Renoir, and others to welcome newcomers into the Impressionist group.

Summer. The Cassatts rent a house in Louveciennes, next to the one they had occupied the previous summer. Cassatt pushes work aside as Lydia's illness worsens.

Oct. The Cassatts return to Paris; in the United States, Gardner Cassatt marries Eugenia (Jennie) Carter.

Nov. 7. Lydia Cassatt dies. Louisine Elder arrives in Paris shortly after Lydia's death. Alexander Cassatt, who had recently resigned from his job as first vice-president of the Pennsylvania Railroad, sails with his wife and children to join his mourning family.

1883

Apr. 3. In London Alexander and Lois Cassatt commission American expatriate artist James McNeill Whistler to paint a portrait of Lois (*Arrangement in Black, No. 8: Mrs. A. J. Cassatt*, 1883–85; private collection). Lois Cassatt writes, "We found the distinguished artist most polite and most curious looking." The next day, Whistler "spent more than one

hour in deciding which dress I should wear in the portrait & finally after trying on five he decided in favor of the riding habit, much to my disappointment" (Travel Diary). Four years later, the portrait has still not been delivered.

Late Apr. Alexander Cassatt's family returns to the United States. Edward remains in school in Paris, under the care of his grandparents.

May. Whistler visits the Cassatts in Paris.

Robert Cassatt mails a copy of J. K. Huysmans's book *L'Art moderne*, an anthology of the writer's art criticism, to Alexander Cassatt; Mary Cassatt is mentioned frequently in these previously published reviews.

Cassatt resumes work, but is "not in good spirits at all—One of her gloomy spells—all artists I believe are subject to them" (Robert Cassatt to Alexander Cassatt, May 25, in Mathews 1984, p. 166).

June. At Alexander Cassatt's request, Moïse Dreyfus promises to return Cassatt's *Reading*. The artist writes to her brother: "Dreyfus told me finally that I might have the group of Mother & the children for you. I would rather keep it myself but I know he would not be pleased if I made him give it up to anyone but you. He won't take back the money for the picture, I am either to paint a portrait of his wife or if she won't consent to that I am to give them another picture. . . ." (Cassatt to Alexander Cassatt, June 22, in Mathews 1984, pp. 169–70).

July 25. Gardner and Jennie Cassatt arrive in Paris.

Aug. 22. Louisine Elder marries Henry Osborne (better known as Harry or H. O.) Havemeyer, the

"Sugar King of New York."

Aug.–Sept. Cassatt acquires several paintings by Manet for Alexander Cassatt. The family travels to the Isle of Wight, and is hosted by Mary Dickinson Riddle in London. Cassatt visits Whistler's studio to inspect his portrait of Lois and finds it "a fine picture, the figure especially beautifully drawn, I don't think it by any means a striking likeness, the head inferior to the rest—The face has no animation but that I believe he does on purpose, he does not talk to his sitters, but sacrifices the head to the ensemble. He told Mother . . . that he would have liked a few more sittings, that he felt as if he was working against time. . . . After all I don't think you could have done better, it is a work of Art, & as young Sargent said to Mother this afternoon, it is a good thing to have a portrait by Whistler in the family" (Cassatt to Alexander Cassatt, Oct. 14, in Mathews 1984, p. 172). Cassatt maintains her opinion despite Lois's displeasure: "I am sorry you don't like it, you remember I recommended Renoir but neither you nor Alexander liked what you saw of his, I think Whistler's picture very fine" (Cassatt to Lois Cassatt, Dec. 29, 1884, in Mathews 1984, p. 186).

Oct. Cassatt paints *Lady at the Tea Table* (Shackelford, fig. 24), a portrait of Mary Dickinson Riddle that prominently features a Japanese tea service given by Riddle to Cassatt. "Mary asked Mrs. Riddle to sit for her portrait, thinking it was the only way she could return their kindness & she consented at once & [daughter] Annie [Scott] seemed very much pleased. . . . As they are not very artistic in their likes & dislikes of pictures & as a likeness is a hard thing to make to please the

nearest friends I don't know what the result will be . . ." (Katherine Cassatt to Alexander Cassatt, Nov. 30, in Mathews 1984, p. 174). In fact, finding the completed painting unflattering, Mrs. Riddle refuses to accept it.

Dec. Cassatt, her mother, and Mathilde Valet travel to Spain in hopes that a warmer climate will improve Katherine Cassatt's health.

1884

Jan. Katherine Cassatt's deteriorating condition requires a halt in the Cassatts' trip and prevents Cassatt from doing much painting.

Feb. 4. A posthumous sale of works by Manet (who had died on Apr. 30, 1883), organized by Durand-Ruel and Théodore Duret, begins at the Hôtel Drouot, Paris. From Spain Cassatt arranges for the purchase of several paintings for Alexander.

Mid-Feb. After visiting the Mediterranean city Alicante, followed by Madrid, the Cassatts return to France and stay at the Hôtel d'Angleterre, in Biarritz.

Mar. 10. In deference to her mother's failing health, Cassatt decides to search for a new apartment in a building with an elevator. She departs for Paris, leaving Katherine Cassatt with Valet in Biarritz.

Mar. 28. Cassatt rents quarters for the family at 14, rue Pierre Charron (now called avenue Pierre Iᵉʳ de Serbie, near the place d'Iéna), in part because the apartment on the avenue Trudaine was too sad for them after Lydia's death.

Mid-Apr. Cassatt finds her mother critically ill upon her return to Biarritz.

Apr. 19. Cassatt's name is cited for the first time in the diary of George Lucas, an American who works in Paris as an agent for American collectors between 1857 and 1909 (Randall 1979, vol. 2, p. 585). Lucas maintains frequent contact with Cassatt throughout the next few years and facilitates the sale of her prints to dealer and art patron Samuel P. Avery in New York.

Apr. 27. Between finding a new apartment, travel, and caring for her mother, Cassatt is left with little time to paint. "I have not touched a brush since we went home, have not been out of Mother's room except for a walk. . . . It will do me good to get to work again" (Cassatt to Alexander Cassatt, Apr. 27, in Mathews 1984, p. 184). At some point in 1884, Cassatt gives up her Paris studio at 2, rue Duperré (Paris *Cadastre*, 1884).

May 12. The Cassatts retreat to a summer house in Viarmes, about twenty miles north of Paris.

Dec. 3. Robert Cassatt describes his daughter's activities to Alexander: "She is engaged in etchings. She was invited to meet Clemenceau (the great radical leader) at breakfast the other day and went" (Robert Cassatt to Alexander Cassatt, Dec. 3, in Sweet 1966, p. 96).

Dec. 25. Alexander Cassatt and his son Robert surprise Katherine Cassatt with a month-long visit to Paris. Cassatt paints a double portrait of her brother and nephew (cat. 46).

1885

Summer. The Cassatts rent a house in Presles, north of Paris, where they remain through late September. Cassatt visits the seashore to

recover from severe bronchitis.
Late Nov. Paul Gauguin suggests
to his estranged wife, Mette, who
is in need of money, that she sell a
drawing by Degas, but not their
two Cézannes, their Manet, or their
pastel by Cassatt (cat. 19) (Paul
Gauguin to Mette Gauguin, late
Nov., in Malingue 1946, p. 75).

Dec. 7. Cassatt discusses plans for
an Impressionist exhibition with
Pissarro, who suggests to Monet,
"All of us, Degas, Caillebotte,
Guillaumin, Berthe Morisot, Miss
Cassatt and two or three others
would make an excellent nucleus for
a show. The difficulty is coming to
an agreement" (Pissarro to Monet,
in Sweet 1966, p. 100).

Dec. 13. Cassatt declines Octave
Maus's invitation to participate in
the 1886 exhibition of the avant-
garde group Les Vingt, in Brussels,
anticipating that lending work to
this exhibition would make it diffi-
cult for her to exhibit elsewhere at
the same time (Brussels 1993).

1886

Mar. 5. Pissarro envies the financial
security of Cassatt and Degas and
hopes for their cooperation in the
upcoming Impressionist show:
"The exhibition is completely
blocked. . . . Degas doesn't care, he
doesn't have to sell, he will always
have Miss Cassatt and not a few
exhibitors outside our group. . . .
But what we need is money, other-
wise we could organize an exhibi-
tion ourselves. . . . To spend money
exhibiting at the same time as the
official Salon is to run the risk of
selling nothing. Miss Cassatt and
Degas say that this is no objection,
but it's easy to talk that way when
you don't have to wonder where
your next meal will come from!"

Fig. 14. Postcard of nursemaids and children on the Champs-Elysées, Paris, c. 1900.
The Cassatts moved to an apartment at 10, rue de Marignan, very near this site, in 1887.
Photo: Paris, Bibliothèque national.

(Pissarro to Monet, in Sweet 1966,
pp. 100–101).

Apr. 10–28. Alexander Cassatt loans
two of his sister's paintings, *Reading*
(Barter, fig. 32; shown as *Family
Group*) and *Portrait of a Lady* (cat. 10),
to the first exhibition of Impres-
sionist art in New York, "Works in
Oil and Pastel by the Impressionists
in Paris," staged by Durand-Ruel at
the National Academy of Design.

May 15–June 15. Cassatt contributes
six paintings and one pastel to the
eighth and final Impressionist exhi-
bition, held at 1, rue Laffitte. She
not only shows with the group, but
she also (along with Degas and
Morisot) helps to finance the exhi-
bition.

Summer. The Cassatts rent a sum-
mer house at Arques-la-Bataille,
near Dieppe.

Sept. 1. Joseph Gardner Cassatt III,
first child of Gardner and Jennie
Cassatt, is born.

Dec. Cassatt again declines to par-
ticipate in an exhibition of Les
Vingt, organized by Octave Maus.

She explains that she owns little of
her work on view in Paris, and sus-
pects that Durand-Ruel has taken
all the paintings he owns by her to
New York (Brussels 1993, pp. 29,
175.2, n. 42).

Dec. 10. Cassatt begins to search for
another apartment for her family.

1887

Mid-Mar. The Cassatts move into
an elevator building at 10, rue de
Marignan, "a quiet, fashionable
street of nearly all private hôtels
and good houses without shops in
front" (see fig. 14) (Robert Cassatt
to Alexander Cassatt, Feb. 18, in
Sweet 1966, pp. 109–10).

Summer. The Cassatts return to
their rented house at Arques-la-
Bataille. They are joined by Alexan-
der and his family, who remain in
France for a year.

Winter. Cassatt spends increasing
amounts of time caring for her
elderly parents. George Lucas's
diary indicates frequent contact
with Cassatt regarding her prints
(Randall 1979, vol. 2, pp. 660–61).

1888

Feb. Paul Durand-Ruel establishes a New York branch of his gallery at 297 Fifth Avenue (Sharp, fig. 6).

Summer. Alexander Cassatt's family leaves Europe, and Cassatt vacations with her parents in Fontainebleau.

1889

Paris hosts the Exposition universelle, one of the largest world's fairs of the nineteenth century.

Jan. 22. Cassatt invites Stéphane Mallarmé to dinner at her home, along with Degas. At around this time, Degas writes eight sonnets, including one dedicated to Cassatt (see Shackelford, p. 131).

Jan. 23–Feb. 14. Two prints and one pastel by Cassatt are included in the Exposition des peintres-graveurs (Exhibition of Painter-Printmakers), the first in a series of print exhibitions at Durand-Ruel's Paris gallery.

Apr. A trial proof of the title page of Mallarmé's *Pages* promises an etching by Cassatt as an illustration, even though she does not participate in the project (Mondor 1984, vol. 11, p. 46).

Summer. Cassatt is immobilized for the summer at Les Tournelles, a mansion in the town of Septeuil, west of Paris, after she breaks her leg and injures her shoulder in a riding accident. In Aug. she meets

Fig. 15. Leonetto Cappiello (French; 1875–1942). *Siegfried Bing*, from *70 Dessins de Cappiello* (Paris, 1905). Photo: Paris, Musée d'Orsay.

Louisine Havemeyer's husband, H. O. Havemeyer, and their three children for the first time, when they come to France for the Exposition universelle; by now, Cassatt is actively working as an art advisor to the family.

Nov. Cassatt begins a series of drypoints using a newly acquired printing press.

Dec. 18. Cassatt purchases Degas's pastel *The Jockey* (1888; Philadelphia Museum of Art) from Durand-Ruel for Alexander.

1890

Mar. 6–26. Cassatt exhibits a recently completed series of twelve drypoints in Durand-Ruel's second Exposition des peintres-graveurs. She also shows a series of aquatints and a pastel. Philippe Burty's encouragement leads Gustave Larroument, director of the Ecole des beaux-arts, Paris, to acquire fifty prints by Cassatt and her colleagues in 1891 (Boston 1989, p. 74).

Mar.–Apr. George Lucas purchases one set of Cassatt's drypoints for himself and another set for Samuel P. Avery, now the foremost American collector of Cassatt's work (Randall 1979, vol. 2, pp. 704–11).

Apr. 15. Cassatt and her colleagues are deeply impressed by an exhibition organized by the dealer Siegfried Bing (fig. 15) of over 700 Japanese prints, scrolls, and other work, held at the Ecole des beaux-arts.

Summer. Cassatt is slightly injured when she is tossed from her carriage in Paris. She takes her printing press from Paris to Septeuil in order to begin the complex production of her series of ten color dry-

points and aquatints (cats. 56–65). She maintains frequent contact with Morisot, who resides ten miles away at Mézy-sur-Seine. Morisot also plans (but then abandons) a series of color lithographs.

Late summer. Alexander and two of his children, Katharine and Robert, visit the Cassatts in Septeuil and Paris.

Nov. 22. As Cassatt continues work on her color prints, her drypoint *The Lesson* is reproduced on the cover of the first volume of the new journal *L'Art dans les deux mondes* (Sharp, fig. 1), published by Durand-Ruel to promote the artists he represents.

1891

Apr. Cassatt likely visits Degas's studio with Louisine and H. O. Havemeyer, who purchase Degas's painting *Collector of Prints* (1866; New York, The Metropolitan Museum of Art). It nonetheless remains with the artist for over three years.

Cassatt and Pissarro (fig. 16), both born outside of France, are excluded from participating in the third Exposition des peintres-graveurs, when the group reforms under the title Société des peintres-graveurs français. The two friends stage simultaneous exhibitions of their own alongside the Société's at Durand-Ruel's. "We open Saturday," writes Pissarro, "the same day as the patriots, who, between the two of us, are going to be furious when they discover right next to their exhibition a show of rare and exquisite works. . . . I am certain that Miss Cassatt's efforts will be taken up by all the tricksters who will make empty and pretty things. We have to act before the idea is seized by people without aesthetic principle" (Camille Pissarro to

Lucien Pissarro, Apr. 3, in Mathews 1984, p. 219).

Apr. 8. Pissarro is dismayed when Cassatt's prints meet "great indifference on the part of the visitors and even much opposition. Zandomeneghi was severe, Degas, on the other hand, was flattering. . . . The general response is mostly hostile . . ." (Camille Pissarro to Lucien Pissarro, Apr. 8, in Rewald 1972, p. 160–61).

Apr. 25. Pissarro visits Cassatt. He observes her at work, printing her color aquatints: "Her method is the same as ours *except* that she does not use pure colors, she mixes her tones and thus is able to get along with only two plates. The drawback is that she cannot obtain pure and

luminous tones, however her tones are attractive enough." Both Pissarro and Cassatt are disappointed in Durand-Ruel's representation, and they consider other marketing and exhibition strategies. Pissarro is pleased when Cassatt expresses admiration for his recent "Neo-Impressionist" paintings: "I believe Miss Cassatt is beginning to understand my recent work, she never before was as enthusiastic as this last time" (Camille Pissarro to Lucien Pissarro, Apr. 25, in Mathews 1984, p. 220).

June. Cassatt tries to bolster Pissarro's income by recommending he teach American women art students.

June 9. Cassatt describes her printing methods to Avery: "The printing is a great work; sometimes we worked all day (eight hours) both, as hard as we could work & only printed eight or ten proofs in the day. My method is very simple. I drew an outline in dry point and transferred this to two other plates, making in all, three plates, never more, for each proof—Then I put an aquatint wherever the color was to be printed; the color was painted on the plate as it was to appear in the proof. . . . If any of the etchers

in New York care to try the method you can tell them how it is done" (Cassatt to Samuel P. Avery, June 9, in Mathews 1984, p. 221).

Early July. Cassatt and her parents rent a summer house, the Château de Bachivillers (fig. 17), about forty miles northwest of Paris. Katherine describes Cassatt's activity: "happily for her she is immensely interested in her painting & bent on doing something on a larger canvas as good as her pictures of last summer which were considered very fine by critics & amateurs" (Katherine Cassatt to Alexander Cassatt, July 23, in Mathews 1984, p. 222).

Aug. 17. H. O. Havemeyer purchases a set of Cassatt's color prints from the Durand-Ruel gallery in New York.

Fall. Jennie Cassatt arrives in Paris with her son Gardner Cassatt III.

Oct.–Nov. Cassatt's series of ten color prints is exhibited at Frederick Keppel and Co., a prominent New York gallery. Sales are generally slow.

Dec. 9. Cassatt's father, Robert Cassatt, dies.

Fig. 17. Photograph of the Château de Bachivillers, Seine et Oise, 1993. Photo: Judith A. Barter.

Fig. 18. Mary Fairchild Mac-Monnies (American; 1858–1946). *Portrait of Mlle S. H. (Sara Tyson Hallowell)*, 1886. Oil on canvas; 97.2 x 111.8 cm. Cambridge, England, Cambridge University, Robinson College, gift of Marion Hardy. Photo: Mary Smart, *A Flight with Fame: The Life and Art of Frederick Mac-Monnies (1863–1937)* (Madison, Conn., 1996), p. 72.

1892

Art agent and representative of The Art Institute of Chicago Sara Tyson Hallowell (fig. 18) corresponds with Chicago collector Bertha Honoré Palmer (Hirshler, fig. 26) about plans for the art exhibition at Chicago's 1893 World's Columbian Exposition.

Feb. Cassatt travels through the south of France and Italy with her mother and sister-in-law Jennie.

Feb. Cassatt exhibits her suite of color prints with the Belgian group Les Vingt in Brussels.

Apr. Cassatt returns to Paris. When Elizabeth Gardner, a fellow American expatriate artist, declines to paint a mural for the Woman's Building (fig. 19) of the World's Columbian Exposition, Hallowell, now Bertha Palmer's representative, offers Cassatt the commission. Cassatt agrees sometimes before June to paint *Modern Woman* to complement Mary MacMonnies's *Primitive Woman* (both lost).

May 25–June 18. Berthe Morisot holds her first solo exhibition at Boussod, Valadon, & Co., Paris.

She expects no accolades from Cassatt: "Miss Cassatt is not one to write me about an exhibition of mine" (Morisot to Louise Riesener, [June], in Mathews 1994, p. 216). Cassatt does express her admiration to Pissarro.

Summer. Cassatt and her mother again set up residence at Bachivillers. In late July, Palmer relieves Cassatt's concern about the terms of her commission by explaining that the $3,000 payment is comparable to what the esteemed male artists Frank D. Millet and Walter McEwen will receive. By the end of August, both Cassatt and Mac-Monnies resolve their disputes over the Chicago contracts. Alexander Cassatt's family arrives in Aug. for a two-month visit; Cassatt renovates the greenhouse at Bachivillers to accommodate the painting of her mural, which she works on through Dec.

Late Sept. Cassatt approaches the dealer Alphonse Portier regarding the potential purchase of a picture of a flowering apple tree by Pissarro. She attends the funeral of Paul Durand-Ruel's son Charles with her sister-in-law Lois Cassatt.

Oct. 3. Cassatt's visit to Giverny, the home of Monet and the site of a substantial colony of American artists, is noted by the American painter Theodore Robinson in his diary (Frick).

Dec. Bertha Palmer attempts to enlist Cassatt as a juror for the art exhibition at the Columbian Exposition, insisting that it is "a great point gained by women to have their names prominently mentioned on art juries, and this effort has been successful only after a long struggle. If it stands, therefore, even though you perform no service at

all, it will help your sex who are generally entirely unrecognized in art matters" (Palmer to Cassatt, Dec. 15, in Mathews 1984, p. 242). Cassatt refuses, not only because of her aversion to juries but also because, as she confides to Durand-Ruel: "It seems to me that I have enough of Chicago for the moment and I will not be sorry to regain my freedom" (Cassatt to Paul Durand-Ruel, Dec. 19, in Mathews 1984, p. 243).

1893

Feb. Cassatt ships her completed mural (Barter, fig. 51) to Chicago and takes a month's trip through Italy with her mother. Palmer urges her to come to the Exposition: "We cannot consent to allow you to go to the ancients this summer,—you must come here instead and see if you receive no inspiration from the Moderns" (Palmer to Cassatt, Mar. 3, in Mathews 1984, p. 247). The artist declines Palmer's invitation. "Chicago is rather a hard task mistress the time given to me was so short that every minute of the long summer days was devoted to my work," Cassatt writes to Avery from Sienna. "I enjoyed the new experience in painting very much but the result of course is very imperfect, & you cannot excuse a work of art by explaining that the artist was obliged to do in six months what it required two years to do. I hope to do some dry points during my journey & certainly shall do something on my return to Paris, you may be sure I shall put by everything for you" (Cassatt to Avery, Feb. 2, in Mathews 1984, p. 246).

May. World's Columbian Exposition opens in Chicago; Cassatt's mural is not well received.

Nov. 27–Dec. 16. Galerie Durand-

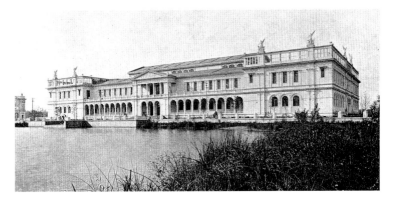

Fig. 19. Sophia G. Hayden (American; c. 1868–1953). View of the Woman's Building, World's Columbian Exposition, Chicago, 1893. Photo: Maud Elliott, ed., *Art and Handicraft in the Woman's Building* (New York, 1893), frontis.

Ruel, in Paris features ninety-eight works in the large retrospective "Exposition de tableaux, pastels et gravures de Mary Cassatt." Pissarro exclaims, "At this moment Miss Cassatt has a very impressive show at Durand-Ruel's. She is really very able!" (Camille Pissarro to Lucien Pissarro, Dec. 5, in Rewald 1972, pp. 222–23).,

Probably through Whittemore, Cassatt meets the Alfred A. Pope family. She will form a close friendship with the Popes' spirited daughter Theodate, an architect.

1894

Jan. 8. Ellen Mary Cassatt, second child of Gardner and Jennie Cassatt, is born.

Jan.–Feb. Cassatt and her mother spend the winter months at the villa La Cigaronne in Cap d'Antibes. Cassatt admires the efforts of several (unnamed) American landscape painters working nearby and feels that the landscape "is rather too panoramic for my taste, but doubtless could be interpreted by a great man, in an artistic way; I have never yet seen it done to my satisfaction. I content myself with a little bit as background to my figures" (Cassatt to Joseph Durand-Ruel, Feb. 2, in Mathews 1984, p. 252).

Feb. 15. Cassatt encourages collector Harris Whittemore (Hirshler, fig. 24) to visit Durand-Ruel's New York gallery "to see a picture of three figures [*The Family* (cat. 71)],

which has just been sent there" (Cassatt to Harris Whittemore, Feb. 15, in Mathews 1984, p. 259). Whittemore may have gone to see Cassatt's painting with his friend the iron magnate and collector Alfred A. Pope, who buys the work on Feb. 28.

Mar. Cassatt and her mother return to Paris.

Spring. Cassatt acquires Beaufresne (fig. 20), a château in Mesnil-Théribus, fifty miles northwest of Paris. She has little time for painting during the summer, which she spends making renovations to the building.

May 24. Alfred Pope returns Cas-

satt's painting *The Family* to the Durand-Ruel Gallery in New York. The Havemeyers promptly purchase the work in June.

Oct. Pissarro hopes that Cassatt will facilitate the sale of his paintings to Hallowell, "whom I know and who I know loves my work," even though Cassatt "has not yet gotten anything of mine sold" (Camille Pissarro to Lucien Pissarro, Oct. 21, in Rewald 1972, pp. 248–50).

Dec. Captain Alfred Dreyfus is tried and convicted on charges of espionage. The "Dreyfus Affair," as it became known, will polarize public opinion for the next twelve years. Defenders of Dreyfus included Zola, Monet, and Cassatt; Degas was among his anti-Semitic detractors.

1895

Apr. 8. The Havemeyers buy Cassatt's painting *Mother and Child* (Sharp, fig. 4) and a pastel, *Baby's First Caress* (c. 1890; New Britain Museum of American Art).

Fig. 20. Photograph of Mary Cassatt and Mme Joseph Durand-Ruel at Beaufresne, July 1909. Photo: courtesy Archives Durand-Ruel, Paris.

Apr. 16–30. Cassatt's first large one-person exhibition in the United States is held at Durand-Ruel's New York gallery. The show is critically and commercially successful.

Summer. At Beaufresne Cassatt and her mother entertain Violet Paget, a writer and friend of John Singer Sargent, who publishes under the pseudonym Vernon Lee. "Miss Cassatt is very nice, simple, an odd mixture of a self-recognizing artist, with passionate appreciation in literature, and the most childish garrulous American provincial" (Vernon Lee to Kit Anstruther-Thompson, July 28, in Sweet 1966, p. 144).

Aug. The Havemeyers visit Cassatt at Beaufresne. Cassatt produces two pastel portraits, one of Louisine with her daughter Electra (Sharp, fig. 10), and another of daughter Adaline (private collection).

Oct. 21. Cassatt's mother, Katherine Cassatt, dies at Beaufresne.

1896

Feb. Cassatt plans a day trip to St.-Quentin with her sister-in-law Jennie Cassatt and Sara Hallowell to view pastels by Maurice Quentin de La Tour at the Musée Lécuyer. She writes to a friend: "There are Latour's [sic] in the Louvre, but the St. Quentin ones are celebrated . . ." (Cassatt to Eugenie Heller, [Feb. 1], in Mathews 1984, p. 263).

Spring. Although she visits the annual exhibition of the Société nationale des beaux-arts at the Champ de Mars, Cassatt claims that she no longer takes much interest in this sort of exhibition: "There is so much that one does not care to see amongst a few good things" (Cassatt to Eugenie Heller,

Sept. 22, in Mathews 1984, p. 266).

Summer. Cassatt is at Beaufresne by mid-May, where she is later joined by Gardner Cassatt and his family. She busies herself with the production of pastels and oil paintings, finding inspiration in the countryside: "If I were a landscape painter, I would [have] no trouble in seeking beautiful subjects—The country looks lovely not withstanding the drought" (Cassatt to Paul Durand-Ruel, May 19, in Mathews 1984, p. 65).

1897

Feb. 9. The collection of Gustave Caillebotte, bequeathed to the Musée du Luxembourg in Paris after the artist's death on Feb. 21, 1894, opens to the public in the museum's new wing. No works by Cassatt are included.

Summer–fall. Cassatt returns to Beaufresne. Eugenia, third child of Gardner and Jennie Cassatt, is born in Aug.

Winter. In Paris Cassatt initiates a busy year of work, likely in anticipation of an 1898 exhibition scheduled for New York. Before the year is out, she presents Durand-Ruel with twelve new paintings and pastels.

1898

Jan. 4. Accompanied by Valet and by her Belgian griffon, Cassatt arrives in New York for her first visit to her homeland in more than two decades. In Philadelphia she lodges with Gardner's family at 1418 Spruce Street and reflects upon her life: "I lost my Mother two years ago, in October, & was so bereft and so tired of life that I thought I could not live, now I know I must & I am here to see quite a new

world & renew old ties, & to work. There is a question of my going to Boston to do a pastel portrait of a child. . . . This is a curious experience to me, after twenty-two years absence everything is so different that I wonder if I really remember anything" (Cassatt to Rose Lamb, Jan. 14, in Weitzenhoffer 1986, p. 127).

Winter. After a visit with the Havemeyers, Cassatt travels to Boston and to Naugatuck, Connecticut. She fulfills commissions for about twenty portraits (see for example Sharp, fig. 9) and visits with friends, including Rose Lamb, collector Sarah Choate Sears (Hirshler, fig. 18), the Whittemores, and the Popes.

Feb.–Apr. Cassatt's work is featured in exhibitions at Durand-Ruel's, New York, in Feb. and Mar., and at Boston's St. Botolph Club between Mar. 21 and Apr. 8.

April or May. Cassatt returns to France.

1899

Alexander Cassatt re-enters the business world as president of the Pennsylvania Railroad.

Late Feb. H. O. Havemeyer purchases Cassatt's *Garden Lecture* (Sharp, fig. 11).

Mar. 14. Pissarro defends Cassatt's work from criticism by Zandomeneghi: "I find her full of talent; and I see only an artist in her" (Camille Pissarro to Georges Pissarro, May 14, in Bailly-Herzberg 1991, vol. 5, p. 16).

July 25. The Havemeyers acquire Cassatt's painting *Mother and Child* (cat. 87).

1900

The Exposition universelle is held in Paris for six months.

Winter–summer. Cassatt gardens and continues renovations at Beaufresne: "I have over a thousand [flowers] planted & already fancy myself sniffing the perfume & revelling in the color—. . . . There is nothing like making pictures with real things" (Cassatt to Ada Pope, Apr. 7, in Mathews 1984, p. 274). Her solitude is broken only by occasional visits to Paris and by successive visits from her brothers and their families.

Apr. 7. Cassatt asks Ada Pope what her husband, Alfred, a collector of Cassatt's work, thinks "of the 'boom' in our set, 43,000 frcs for a picture of Sisley, the original price 80 frcs & Renoir, poor man, crippled with rheumatism just as his turn has come" (Cassatt to Ada Pope, Apr. 7, in Mathews 1984, p. 275).

1901

The census report of the Département de Mesnil-Théribus lists Cassatt as an "artiste peintre" and incorrectly cites her age as 50 years old (she turns 57 this year). Her household, according to the census, includes Valet (recorded as "Wallet"), described as a "demoiselle de compagnie"; three gardeners; and eight farmworkers (Rencensement de 1901, Département de Mesnil-Théribus).

Jan.–Apr. Cassatt joins the Havemeyers on a hunt for Old Master paintings in Italy and Spain. In Florence they recruit Cassatt's acquaintance Arthur Harnisch to work as an agent, and through him they buy many paintings then believed to be authentic works by artists such as Mino da Fiesole, Fra Filippo Lippi,

and Raphael, among others. Cassatt negotiates potential purchases in Madrid with dealer Joseph Wicht and El Greco scholar Manuel Cossío, while the Havemeyers visit Toledo, Seville, Cordoba, and Granada.

Spring. Cassatt advises dealer Ambroise Vollard that H. O. Havemeyer is actively collecting European art. "I've been talking to Mr. Havemeyer about you. So do put all your best things aside for him. You know who I mean by Havemeyer?" (Cassatt to Ambroise Vollard, [spring], in Weitzenhoffer 1986, p. 142).

June. Cassatt makes a quick trip to Madrid and Italy to examine works of art for the Havemeyers.

Aug. Cassatt receives her Connecticut friends, Alfred and Ada Pope, at Beaufresne and urges them to visit Louisine Havemeyer when they return to the United States.

1902

Aug. Camille Mauclair publishes "Un Peintre de l'enfance: Miss Mary Cassatt," in L'Art décoratif (Mauclair 1902).

1903

Mauclair publishes The French Impressionists: 1860–1900 (London) and cites Cassatt as a "minor Impressionist."

Sometime in this year, Cassatt sells Portrait of a Little Girl (cat. 11) to Vollard.

Jan. Cassatt rejects an aristocrat's offer to sell his collection of paintings to the Havemeyers. "I am always so sorry for these people, it is so evident that the money is almost a necessity to them, & they have no way of making money . . . Never having been brought up to

do anything. . . . [It] is impossible for me to advise your taking any interest in these pictures. . . . To give you a perfect insight of my mind, when I got back here I sat down before the last little picture I painted & *admired* it! I felt that it would be a better investment than those! *You* will appreciate what that means. These poor people are suffering from want of knowledge and taste in their ancestors" (Cassatt to Louisine Havemeyer, Jan. 26, NGA).

Late Feb. Cassatt enjoys a visit from Theodate Pope and her friend the educator Mary Hilliard. Writing frequently to Louisine Havemeyer on the subject of collecting, Cassatt favorably compares Havemeyer's taste to that of rival collectors in Boston, Sarah Choate Sears and Isabella Stewart Gardner: "No my dear, you & I are about the only two . . . we two must just do the best we can, helped by men. . . . Of course Mrs. Jack Gardner did not like to see the riches in your house, & her pictures must have increased in number if she has the 'best' collection of Old Masters, in America . . ." (Cassatt to Louisine Havemeyer, Feb. 2, in Weitzenhoffer 1986, p. 145). The artist praises El Greco for having been "two centuries ahead of his time, that is why painters, Manet amongst others thought so much of him" (quoted in Mathews 1994, p. 263).

Apr. Cassatt and Louisine Havemeyer visit Degas's studio, where Havemeyer becomes captivated with the original wax model, then in pieces, of Degas's sculpture The Little Fourteen-Year-Old Dancer (1879–81; collection of Mr. and Mrs. Paul Mellon, Upperville, Va.).

Apr. 2–25. Cassatt exhibits eight of her own works and lends one painting by Manet and one by Morisot

to the "Exposition d'oeuvres de l'é-cole impressionniste" held at the Galerie Bernheim-Jeune, Paris.

Apr. 21. Cassatt agrees to sit for a photographic portrait by Theodate Pope (see Introduction, fig.1).

Apr. 26. Cassatt recommends to Theodate Pope a spiritualist and medium named Mme Fontvielle (see Breeskin 1970, 855–57) and suggests she attend a séance.

June–July. Cassatt visits Holland to view works by Rembrandt van Rijn, and is at Beaufresne by late July.

Nov. 5–21. Durand-Ruel holds an exhibition of Cassatt's paintings and pastels in New York.

1904

Jan. 25–Mar. 5. During its Seventy-third Annual Exhibition, the PAFA awards its Walter Lippincott Prize to Cassatt's 1902 painting *The Caress* (Sharp, fig. 12). Cassatt rejects this honor, as well as director Harrison S. Morris's Aug. 29 request that she serve on the PAFA's jury.

Apr. 28. Cassatt arranges for Car-roll Tyson, a young American artist, to view the collection of Roger Marx. "Please believe that I will do all in my power to help you. I have lived so long in the intimacy of artists now so celebrated, but when I first knew them so neglected, and as far as Degas is concerned I know so well the sort of advice he gave. I feel it my duty to pass it on" (Cas-satt to Carroll Tyson, Apr. 28, in Sweet 1966, p. 161).

Oct. 20–Nov. 27. Cassatt is awarded the Norman Wait Harris Prize by The Art Institute of Chicago for *The Caress*, shown in its Seventeenth Annual Exhibition. Cassatt donates her $500 prize to Alan Philbrick, a School of the Art Institute gradu-ate living in Paris, following the rec-ommendation of the museum's director, William M. French.

Dec. 31. Cassatt is named a *chevalier* of the Légion d'honneur.

1905

Alexander and Lois Cassatt's eldest daughter, Katharine Kelso, dies.

Jan. 9. Cassatt encourages the presi-dent of The Art Institute of Chi-cago, Charles Hutchinson, to acquire El Greco's *Assumption of the Virgin* (Hirshler, fig. 31) from Durand-Ruel. The acquisition is made the follow-ing year.

Feb. Cassatt is upset when Durand-Ruel excludes her from an Impres-sionist exhibition he holds in London.

Sept. 5. Cassatt refuses another request that she serve on an exhibi-tion jury, this one from the director of Pittsburgh's Carnegie Institute, John W. Beatty.

1906

Captain Alfred Dreyfus is vindi-cated; Cassatt—one of his sup-porters—is extremely pleased, and is touched when she happens to see Mme Dreyfus being treated with respect at a train station.

Cassatt, an automobile enthusiast, purchases a Renault. Alexander and Lois Cassatt visit her early in the year. This year's census records for the Département de Mesnil-Théribus describe Cassatt as "Chef artiste peintre, patronne." The occupation of Mathilde Valet ("Wallet") is no longer cited, but the census lists three domestic workers, four gar-deners, and ten farmworkers as resi-dents of Beaufresne. As in 1901, seven years are shaved off Cassatt's age, so that her date of birth is listed as 1851 (Rencensement de 1906, Département de Mesnil-Théribus).

Late Apr.–early May. The Have-meyers purchase Courbet's *Woman in a Riding Habit* (1856; New York, The Metropolitan Museum of Art) from Théodore Duret after Cassatt arranges a showing of the painting at her apartment. Cassatt requests to keep the portrait in order to study it; it is not shipped to New York for nearly a decade.

Spring. Cassatt meets the American banker James Stillman, who will form a strong friendship with the artist and become one of the most important collectors of her work.

Summer. Cassatt invites Durand-Ruel's rival Ambroise Vollard to select items of his choice from her studio at Beaufresne. He purchases many works, especially on paper.

Dec. 28. Alexander Cassatt dies at age 67, following a lengthy investi-gation into the Pennsylvania Rail-road's investments in the coal industry.

1907

Feb. The Havemeyers, facing the onset of what will become a federal investigation of the Sugar Trust, postpone plans for a voyage in Spain with Cassatt.

Apr. The Havemeyers travel to France and Italy with Cassatt. Late in the month, they make a quick trip, accompanied by Cassatt and Théodore Duret, to Brussels, where they purchase Courbet's *Mme de Brayer* (1858; New York, The Met-ropolitan Museum of Art).

Fig. 21. Pierre Auguste Renoir (French; 1841–1919). *Joseph Durand-Ruel*, 1882. Oil on canvas; 81 x 65 cm. Private collection. Photo: courtesy Archives Durand-Ruel, Paris.

Apr. 7. In Paris Cassatt views paintings by Rembrandt with the Havemeyers, Paul Durand-Ruel, and Stillman.

Apr. 9. Stillman purchases two works by Cassatt—*The Caress* (Sharp, fig. 12) and *Young Girl Sitting in a Chair* (1902; New York, The Metropolitan Museum of Art) from Durand-Ruel.

Dec. 4. H. O. Havemeyer succumbs to kidney failure. "I lost in Mr. Havemeyer a friend and am sincerely grieved . . . this has been a disastrous year for me, it closes in sadness" (Cassatt to Minnie Cassatt, Dec. 14, AAA).

1908

Mar. 24–Apr. 15. Vollard holds a large exhibition of Cassatt's work—mainly pastels—in Paris.

Late Apr. Cassatt joins Stillman, Louisine Havemeyer, and Louisine's daughter Electra on several outings, including visits to see Moorish marbles, a painting by Elizabeth Vigée-LeBrun, and the Collection St. Etienne in Beauvais.

Spring. Cassatt and her brother Gardner travel to Darmstadt to arrange for the transfer of the remains of their long-deceased brother Robert to Beaufresne.

Aug. Cassatt's nephew Robert visits with his wife, Minnie, and their two sons, Alexander and Anthony.

Nov. 3–28. Durand-Ruel exhibits "Tableaux et pastels par Mary Cassatt" in Paris.

Nov. Cassatt makes her final visit to the United States, in order to comfort Louisine Havemeyer on the first anniversary of her husband's death. She also visits the Popes in Connecticut and her family in Philadelphia.

1909

Stillman settles in Paris, where he resides until 1916.

Jan. 4. Cassatt sails for France, arriving in Paris on Jan. 14.

Feb. 20. Charles Loeser, an American collector of Cézanne's paintings and a resident of Florence,

describes in his diary an evening he spent in Paris: "Dinner at Vollards with de Stuers, Mme D'Annunzio + Mary Cassatt + one Bernard d'Heudecourt. The Cassatt a tiresome cackling old maid with loud opinions very Bostonese—most boresome" (quoted in John Rewald, *Cézanne and America: Dealers, Collectors, Artists and Critics, 1891–1921* [Princeton, N.J., 1989], p. 109).

Mar. Cassatt rejects the Musée du Luxembourg's request for a portrait bust of herself to exhibit "with all the other painters of our set. . . . What one would like to leave behind one is superior art, & a hidden personality" (Cassatt to Louisine Havemeyer, Mar. 10, NGA).

Dec. 8. Cassatt encourages Havemeyer to "go in for the Suffrage, that means great things for the future" (Cassatt to Louisine Havemeyer, Dec. 8, in Weitzenhoffer 1986, pp. 195–96).

1910

Early fall. With Stillman and his sisters, Cassatt travels to Brussels. There they view a an exhibition of

Fig. 22. Joseph Durand-Ruel (French; 1862–1928). Photograph of Beaufresne, September 1910 (left to right: Mme Joseph Durand-Ruel, Mary Cassatt, unidentified woman, Marie Louise Durand-Ruel). Photo: courtesy Archives Durand-Ruel, Paris.

Fig. 23. Photograph of Mary Cassatt at the cloisters of St.-Trophîme, Arles, 1912. Photo: courtesy Archives Durand-Ruel, Paris.

the work of Peter Paul Rubens. "The exhibition as a whole is disappointing. I mean of course the pictures . . . we see things differently now—& after all one must be of one's time" (Cassatt to Louisine Havemeyer, Oct. 11, NGA).

Nov. Cassatt accompanies Stillman to the studio of sculptor Auguste Rodin, whom she deems a poor artist but good collector.

Dec. 10. Cassatt travels to Munich to join Gardner Cassatt and his family. They travel through eastern Europe, visiting Vienna, Budapest, Sophia, and Constantinople, before arriving in Egypt.

Dec. 23. Cassatt writes to Theodate Pope from Constantinople: "Just think how much better if women know all about the men's work— At present men lead double lives—

What we ought to fight for is equality it would lead to more happiness for both" (Cassatt to Theodate Pope, in Mathews 1984, p. 304).

1911

The Département de Mesnil-Théribus census report no longer cites Cassatt's birth or profession. Valet's ("Wallet") occupation likewise remains unlisted; but two domestic servants, one chauffeur, four gardeners, and eight farmworkers are included (Rencensement de 1911, Département de Mesnil-Théribus).

Jan. The Cassatts begin a two-month voyage down the Nile aboard a dahabeah. "We got here from Constantinople on the New Year . . . [and we were] whisked . . . out to the Pyramids & then to see the tree the Virgin Mary rested under when she fled to Egypt! & we drank from the well she drank from!" (Cassatt to Louisine Havemeyer, Jan. 4, NGA).

Feb. Cassatt has a complicated response to ancient Egyptian art. Early on she is "thoroughly disappointed. The tombs don't seem so interesting to me. I am looking for Art not Archeology" (Cassatt to Louisine Havemeyer, Feb. 11, NGA). But by March, she is awestruck: "Fancy going back to babies & women, to paint. . . . I am crushed by the strength of this Art. I wonder though if ever I can paint again" (Cassatt to Louisine Havemeyer, Mar. 8, NGA). The trip is disrupted when Gardner falls ill.

Late Mar. Cassatt returns to Paris via Italy.

Apr. 8. Gardner Cassatt dies in Paris. Cassatt falls into a severe state of depression that leaves her unable to work for two years. She is diagnosed

as suffering from diabetes, rheumatism, and neuralgia. Treatments include "cure" baths and applications of electricity. Havemeyer offers to rush to her side, but Cassatt suggests a delay, noting that her doctors have ordered her to "rest and to be alone . . . " (Cassatt to Louisine Havemeyer, in Weitzenhoffer 1986, p. 204).

July 18. Cassatt rewrites her will, leaving Beaufresne and the contents of the apartment at 10, rue de Marignan, in Paris, to the children of her brother Gardner Cassatt.

Dec. Cassatt rents the Villa Angeletto in the southern town of Grasse, a major center of perfume production about fifteen miles north of Cannes.

1912

Cassatt and the much younger Philadelphia painter George Biddle meet and form a lasting friendship.

Jan. 8. Cassatt visits Renoir, who lives thirty miles away from Grasse in a villa at Cagnes.

Jan.–Feb. Stillman tends to the ailing Cassatt by taking her on car drives, and makes notes about her condition almost daily in his diary (Harvard).

Feb. 27. Havemeyer buys Cassatt's *Girl Reading* (1908; private collection) from Durand-Ruel.

Mar. 6. Cassatt leaves Grasse for Paris and Beaufresne. At an auction, she sees Degas "looking very old but well, he surely must miss his old friends most of them are gone, all of those I used to know this is a stifling scene" (Cassatt to Louisine Havemeyer, [Mar.], NGA).

June 6. Achille Segard, preparing Cassatt's first biography, visits the artist at Beaufresne. Cassatt finds that "silence and solitude are best for my state," even though "all my doctors want me to work! How is it possible, they don't know what it is to paint, they say only ten *minutes* a day" (quoted in Mathews 1994, p. 291).

Sept. Cassatt advises Havemeyer to sell several of her Cézanne paintings, which are quickly escalating in value, and to use the profits to purchase art at the upcoming estate sale of Henri Rouart (Cassatt to Louisine Havemeyer, Sept. 6, NGA).

Late Oct. Segard visits Beaufresne a second time.

Mid-Nov. Cassatt returns to the Villa Angeletto. She urges Louisine Havemeyer to lend her substantial collection of Courbet paintings to

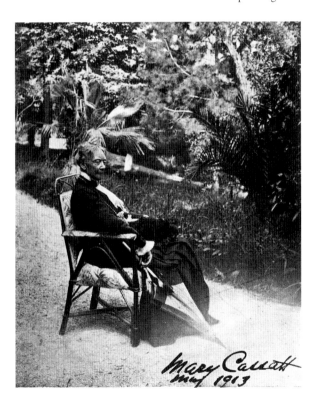

Fig. 24. Photograph of Mary Cassatt, Grasse, May 1913. Photo: courtesy Archives Durand-Ruel, Paris.

The Metropolitan Museum of Art: "Only you can show what Courbet is, what influence he had—I am sure it would help the young painters it might make an artist?" (Cassatt to Louisine Havemeyer, Nov. 30, NGA).

Dec. 9. The first of several auctions of the collection of Henri Rouart begin at Galerie Manzi-Joyant, in Paris. Degas's *Dancers Practicing at the Bar* (Hirshler, fig. 17) sells to an anonymous buyer for 478,500 francs (almost $100,000), setting a record for the highest amount ever paid for a work by a living artist. Cassatt learns two weeks later that the anonymous buyer was Louisine Havemeyer.

1913

Jan. Cassatt supports Louisine Havemeyer's activism for women's suffrage: "I don't see why women should pay taxes, except on their earnings, mostly they are living on their incomes made by the husbands therefore they are represented. I believe that the vote will be given freely, when women want it, the trouble is that so many don't want it for themselves and never think of others. American women have been spoiled, treated and indulged like children they must wake up to their duties. It seems that Mr S[tillman] says, so Joseph D[urand-]. R[uel]. tells me as he told him, that women and men have different spheres and each must stay in their own. I would like him to define these spheres. Nothing he enjoys more than ordering clothes for his daughter, I should say that was their sphere" (Cassatt to Havemeyer, Jan. 11, in Mathews 1984, p. 309).

Feb. The International Exhibition of Modern Art, better known as the Armory Show, opens in New

York; it constitutes North America's first exposure to modern European movements. Although two of her own works are included, Cassatt expresses disdain for avant-garde French art, especially Fauvism and Cubism, and its patrons, particularly the Steins. She disparages Matisse as a *farceur*: "If you could see his early work! Such a commonplace vision such weak execution. . . . My dear Louie it is not alone in politics that anarchy reigns, it saddens me, of course it is a certain measure of our set which has made this possible. People have been persuaded that composition, picture, were not necessary that sketches were enough—Certain things should not have left the artists [*sic*] studio nor his portfolios" (Cassatt to Louisine Havemeyer, [c. March], NGA).

Late May. Cassatt returns to Paris from Grasse.

Summer. Cassatt resumes work after two years of inactivity. "I may have still something to do in this World—I never thought I would have. I felt as if I were half way over the border—I am so much better I think I may be still stronger, strong enough to paint once more. Perhaps I may astonish Segard yet, who rather finishes me in his book on my Art" (Cassatt to Louisine Havemeyer, May 21, [1913], NGA).

Oct. Cassatt presents Durand-Ruel with seven pastels that she thinks "in many respects the best I have done, more freely handled & more brilliant in color. I kept one only. It is one of the best & very important I felt I ought to keep something of mine for my family" (Cassatt to Louisine Havemeyer, Dec. 4, [1913], in Mathews 1984, p. 311).

Nov. Cassatt receives treatment in Paris for worsening eye problems.

Dec. Cassatt arrives in Grasse after stops in Lyon, Dijon, and Vézélay. She visits with Renoir and Degas's nieces, works half-days, and assures Louisine Havemeyer of her renewed vitality: "If you should see the photo taken here last spring & see me now you would see the difference, I can bear a good deal of fatigue, of course few women work. I mean at a profession, so that they don't know that fatigue. . . . Nothing takes it out of one like painting. I have only to look around me to see that, to see Degas a mere wreck, and Renoir and Monet too" (Cassatt to Louisine Havemeyer, Dec. 4, in Mathews 1984, p. 313).

1914

Late Mar. Havemeyer visits Grasse for two months. The PAFA awards Cassatt its "Gold Medal for Eminent Service in the Cause of Art."

May. Cassatt returns to Paris. Havemeyer convinces Cassatt to join Degas in a suffrage exhibition proposed for New York.

June 8–27. Cassatt's *Lady at the Tea Table* (Shackleford, fig. 24), which had never been exhibited publicly, generates considerable excitement when it is included in Durand-Ruel's Paris exhibition "Tableaux, pastels, dessins et pointes-sèches par Mary Cassatt." under the title "Portrait."

Summer. Cassatt's widowed sister-in-law Jennie visits Beaufresne with her daughters, Ellen Mary and Eugenia.

Aug. 4. World War I begins, with Germany's declaration of war on France. Cassatt optimistically pre-

dicts the conflict will end after a short battle in Belgium.

Oct. The German invasion of northern France prompts Cassatt to evacuate to Dinard, near St.-Mâlo, where she helps care for Belgian refugees (Weitzenhoffer 1986, p. 220). Valet's Alsatian roots force her to flee the country.

Late Nov. Cassatt relocates to Grasse, where she remains for much of the war, despite Havemeyer's pleas that she return to the United States.

1915

Mar. Cassatt is critical of "the stingy French" for not giving money to the war effort. She mentions a woman who failed to support her gardener's family while he was at the front, adding, "I tell you dear I am becoming absolutely socialist in my sympathies" (Cassatt to Louisine Havemeyer, Mar. 12, in Mathews 1984, p. 322).

Apr. 6–24. An exhibition in support of woman suffrage, organized by Havemeyer, is held at M. Knoedler and Co., New York; it includes substantial installations of works by Cassatt and by Degas. Havemeyer presents "Remarks on Edgar Degas and Mary Cassatt" to an enthusiastic audience of eighty on the opening day. Included in the exhibition are eighteen works by Cassatt, most completed after 1900. Cassatt applauds her friend's efforts: "Now you are destined to accomplish something & I have probably been a help, just as you and Mr. Havemeyer have been to me. The constant preoccupation with your collection developed my critical faculty. . . . You will be a[n] anchor till the last, perhaps I may be too" (Cassatt to Louisine Havemeyer,

Apr. 15, in Weitzenhoffer 1986, p. 226).

July. Cassatt returns to Paris and makes a trip to a "very neglected" Beaufresne, which is in the "zone des armées" (Cassatt to Louisine Havemeyer, July 13, NGA).

Sept.–Oct. Cassatt seeks treatment in Paris for her cataracts, hoping to avoid surgery, but an operation proves necessary.

Nov. Cassatt returns to Grasse.

1916

At Cassatt's urging, Degas's niece Jeanne Fèvre moves to Paris to care for her elderly uncle.

June–Aug. Cassatt spends much of the summer at Beaufresne. From her country estate, she describes the war: "The cannon is not so loud, so the heavy artillery is not in action" (Cassatt to Louisine Havemeyer, Aug. 3, in Mathews 1994, p. 311).

Aug. Looking forward to her return to Grasse, Cassatt wonders "why more painters don't go there, last January one could have worked out of doors all the month—Renoir had himself carried out to his garden nearly every day" (Cassatt to George Biddle, Aug. 1, in Mathews 1984, p. 327).

1917

Apr. The United States enters World War I.

Summer–fall. Cassatt lives in Paris; although she would prefer to return to Grasse, the war delays her trip south.

Aug. Stillman is forced by the war to return to New York.

Sept. 27. Degas dies in Paris.

Oct.–Nov. Cassatt has a second operation for cataracts.

Late Dec. Cassatt travels to Grasse and remains here through the summer of 1918, while the Germans occupy Paris. "In looking back over my life, how elated I would have been if in my youth I had been told I would have the place in the world of Art I have acquired and now at the end of life how little it seems, what difference does it all make" (Cassatt to Louisine Havemeyer, Dec. 28, in Mathews 1984, p. 330).

1918

Feb. At Cassatt's request, Vollard removes paintings from her apartment and stores them with the Durand-Ruels for the duration of the war.

Mar. 15. Stillman dies in New York.

Mar. 20. Dealer René Gimpel visits Cassatt and finds "the great devotee of light" to be "almost blind. She who so loved the sun and drew from it so much beauty is scarcely touched by its rays. . . . She lives in this enchanting villa perched on the mountains like a nest among branches. . . . She takes my children's heads between her hands and, her face close to theirs, looks at them intently, saying: 'How I should have loved to paint them!' My paternal heart is flattered, for Mary Cassatt was always independent enough to refuse to do a portrait of any child who wasn't pretty" (René Gimpel, *Diary of an Art Dealer*, trans. John Rosenberg [New York, 1966], p. 9).

May 6–8. Cassatt takes great interest in the first round of auctions of Degas's work, held at Galerie

Georges Petit, Paris.

May 5. When the Louvre buys Degas's portrait of the Bellelli family (1858–67; Paris, Musée d'Orsay), Cassatt complains to Paul Durand-Ruel that the money would have been better spent on the war effort (Ottawa 1988, p. 318).

Sept. Cassatt has a third operation for cataracts.

Nov. 11. Armistice is signed, ending World War I.

Sept. 11–13. Second auction of Degas's estate is held at Galerie Georges Petit.

1919

Feb. Louisine Havemeyer is arrested and jailed during a mass suffrage protest in Washington, D.C.

Apr. New York's Grolier Club requests Cassatt's assistance in preparing an exhibition and catalogue of her prints, to be held in 1921.

Apr. 7–9. Third auction of Degas's estate is held at Galerie Georges Petit.

May. Cassatt returns to Paris for a fourth operation for cataracts.

June 2–4. Fourth and final auction of Degas's estate is held at Galerie Georges Petit.

Fall. Cassatt accepts 5,000 francs from the Durand-Ruels for 100 drypoints, pastels, and drawings. She had hoped for 10,000 francs, but the dealers assure her that the market for her work is not strong enough.

1920

Jan. Cassatt's sister-in-law Lois Cassatt dies. Cassatt advises Jeanne

Fèvre not to have Degas's wax sculpture *The Little Fourteen-Year-Old Dancer* cast in bronze: "I have told her that her uncle is known only to a *very* few people as a sculptor. Let the other statues be cast, there are 60 in all . . . then when Degas['s] reputation as a sculptor is established they can sell the danseuse as a unique piece" (Cassatt to Louisine Havemeyer, Jan. 16, NGA). Fèvre proceeds with the casting; in January 1922, Louisine Havemeyer will acquire the first number in the edition (New York, The Metropolitan Museum of Art).

Mar. 22. Cassatt sells her painting *The Boating Party* (cat. 77) to Durand-Ruel. She had first offered it to her niece Ellen Mary, but received no response.

Apr. Alexander and Lois Cassatt's collection is auctioned. All works by Cassatt, except family portraits, are sold: "It is a relief & I must sell my only remaining picture, then there will be nothing left" (Cassatt to Louisine Havemeyer, Apr. 9, in Weitzenhoffer 1986, p. 238).

Apr. 17–May 9. The PAFA devotes a room to Cassatt's work in its "Exhibition of Paintings and Drawings by Representative Modern Masters." Louisine Havemeyer anonymously lends two paintings to the show.

Apr. 20. Havemeyer delivers a lecture on Cassatt to the National Association of Women Painters and Sculptors in New York.

Late Apr. Cassatt returns to Paris from Grasse.

Summer. Jennie Cassatt and her daughters visit Beaufresne. Valet returns from wartime exile in Italy.

Aug. 20. American women gain the right to vote, when the United States Congress passes the Nineteenth Amendment.

Dec. Cassatt returns to Grasse.

1921

Census records from the Département de Mesnil-Théribus list Cassatt's date and place of birth as 1847, Transylvania—no doubt a mistaken attempt to write Pennsylvania. Valet's ("Wallet") date and place of birth are listed as 1858, Ulm, Württemburg. Her profession, like Cassatt's, is once again omitted. Also noted as residents of Beaufresne are one cook, one chauffeur, six gardeners, and six farmworkers (Rencensement de 1921, Département de Mesnil-Théribus).

Jan. 28–Feb. 26. An exhibition of etchings by Cassatt is held at the Grolier Club, New York. Hundreds attend Louisine Havemeyer's Feb. 12 lecture, "Recollections of Miss Cassatt and Her Work." The exhibition is shown at The Art Institute of Chicago in Sept. 1922.

Summer. Cassatt goes to Paris in May for more cataract surgery. She spends the summer at Beaufresne with Havemeyer.

Dec. Cassatt returns to Grasse.

1923

Apr. The Musée du Petit Palais, Paris, accepts Cassatt's donation of *Autumn* (cat. 29), a portrait of her sister, Lydia.

1923–24

Cassatt has nine sets of twenty-five drypoints printed from copper plates discovered by Valet at Beaufresne. She refuses to believe Louisine Havemeyer and William Ivins, print curator at The Metropolitan Museum of Art, when they tell her that the plates had been printed before, and they encourage her to recall or date the prints. Cassatt becomes estranged from Havemeyer, who "assures me that what they all want is to protect my reputation! to prove that I am not a fraud! I will never forgive that. I told her that I could take care of my own reputation and that she should take care of hers. Poor woman, there wasn't a word, a gesture, nothing that one might have expected. But since she has become a politician, journalist, orator, she is nothing anymore" (Cassatt to Joseph Durand-Ruel, Jan. 19, [1924], in Mathews 1984, p. 339). Despite her anger at her dearest friend, Cassatt professes that the addition of this work to her oeuvre creates "a sense of joy from which no one can rob me—I have touched with a sense of art some people once more . . ." (Cassatt to Ivins, Jan. 17, 1924, in Mathews 1984, p. 338).

1924

Feb. 5. Paul Durand-Ruel dies.

Spring. Cassatt gives up the Villa Angeletto, in Grasse.

1925

Jan. 7. Cassatt writes to Jennie Cassatt about the condition of her eyes: she can see only light with her left eye, but can make out the clock with her right one.

Mar. Cassatt reflects on her career and life in France: "Ever since my mother's death thirty years ago I have lived alone. Carrying on this place & working here on my art. Of course I have been better known as an artist in France than in the U.S." (Cassatt to Mary Gardner Smith, [c. Mar. 8], in Sweet 1966, p. 207).

Oct. 14. Valet writes to Gardner Cassatt, the artist's nephew, about his aunt's health: "Dr. Moinsôn never comes to see her, but the good Dr. Auneuil comes from time to time. . . . [Cassatt] goes out in the car daily. . . . Her leg is less swollen, although she is still not meant to walk on it" (Mathilde Valet to Gardner Cassatt, Oct. 14, AAA).

1926

Cassatt's date and place of birth are cited as 1846, Pittsburgh, in this year's census record of the Département de Mesnil-Théribus. Valet is described as the "gouvernante." Two domestic servants and five farmworkers are also recorded as Beaufresne residents (Rencensement de 1926, Département de Mesnil-Théribus).

Apr. 30. In a letter to Havemeyer, Valet quotes her longtime employer: "Yes, you are right, Mrs. Havemeyer is my best friend." Cassatt had attempted to add a note of her own, but the message is illegible (Weitzenhoffer 1986, p. 250).

June 14. Mary Cassatt dies at age eighty-three. Havemeyer writes, "While I am glad that Miss Cassatt is at last at rest, her death is a very, very sad loss to me. It is the breaking of a lifelong friendship" (Louisine Havemeyer to Joseph Durand-Ruel, June 16, in Mathews 1984, p. 342).

June 28. Valet writes to Havemeyer: "I am sure, in spite of the fact that she had many friends, nobody in the world loved her as Madame [Louisine] and I have loved her, and she knew it well" (Weitzenhoffer 1986, p. 250).

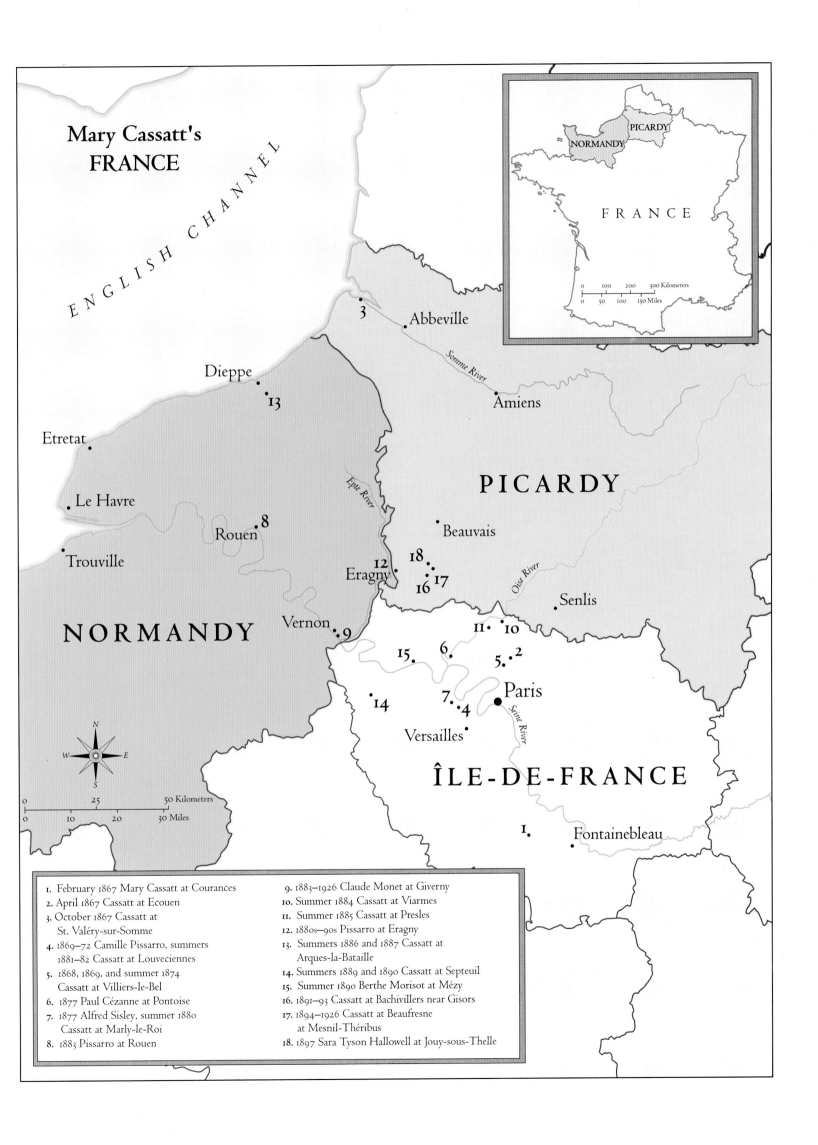

Mary Cassatt's
FRANCE

ENGLISH CHANNEL

PICARDY

NORMANDY

FRANCE

3 Abbeville

Somme River

Dieppe
• 13

Etretat

Amiens

Le Havre

Rouen • 8

PICARDY

• Beauvais

12 18
Eragny 16 17

Oise River

• Senlis

Trouville

Epte River

NORMANDY

Vernon • 9

11 10

15 6 5 2

7 4 • Paris

• 14

Versailles

Seine River

ÎLE-DE-FRANCE

N
W E
S

0 — 25 — 50 Kilometers
0 — 10 — 20 — 30 Miles

1 • Fontainebleau

1. February 1867 Mary Cassatt at Courances
2. April 1867 Cassatt at Ecouen
3. October 1867 Cassatt at
 St. Valéry-sur-Somme
4. 1869–72 Camille Pissarro, summers
 1881–82 Cassatt at Louveciennes
5. 1868, 1869, and summer 1874
 Cassatt at Villiers-le-Bel
6. 1877 Paul Cézanne at Pontoise
7. 1877 Alfred Sisley, summer 1880
 Cassatt at Marly-le-Roi
8. 1883 Pissarro at Rouen

9. 1883–1926 Claude Monet at Giverny
10. Summer 1884 Cassatt at Viarmes
11. Summer 1885 Cassatt at Presles
12. 1880s–90s Pissarro at Eragny
13. Summers 1886 and 1887 Cassatt at
 Arques-la-Bataille
14. Summers 1889 and 1890 Cassatt at Septeuil
15. Summer 1890 Berthe Morisot at Mézy
16. 1891–93 Cassatt at Bachivillers near Gisors
17. 1894–1926 Cassatt at Beaufresne
 at Mesnil-Théribus
18. 1897 Sara Tyson Hallowell at Jouy-sous-Thelle

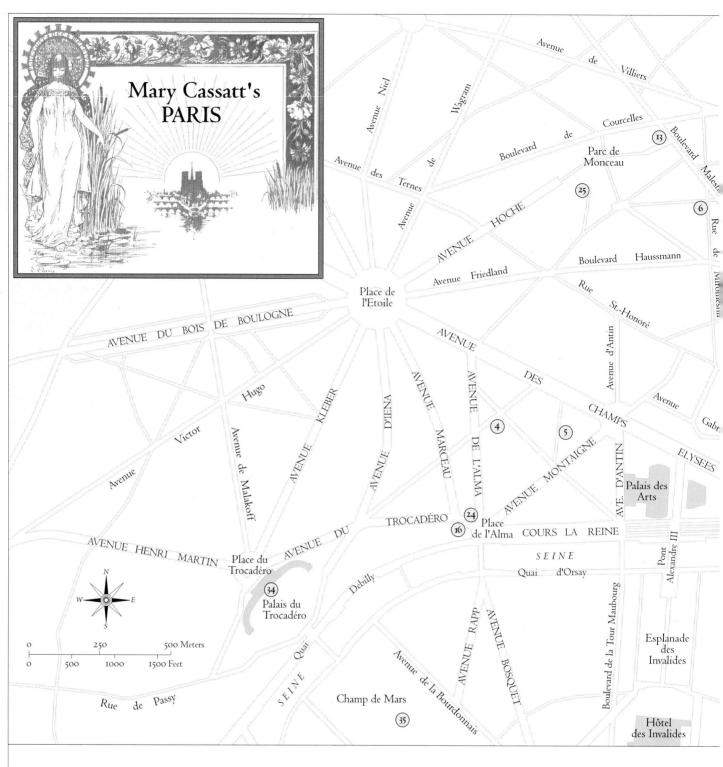

Mary Cassatt's PARIS

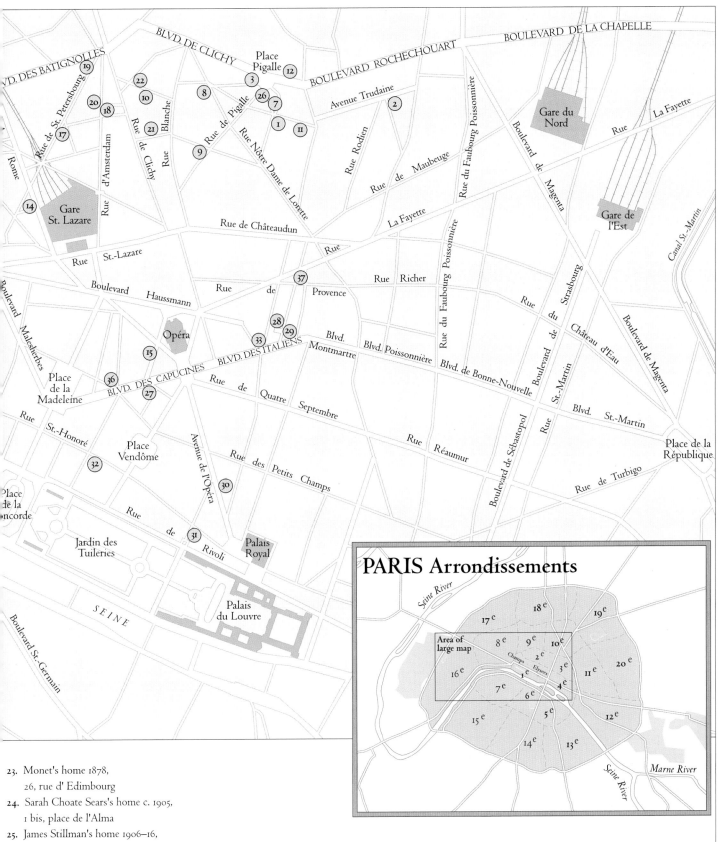

BLVD. DE CLICHY

Place Pigalle

BLVD. DES BATIGNOLLES

BOULEVARD ROCHECHOUART

BOULEVARD DE LA CHAPELLE

Avenue Trudaine

Rue de St.-Petersbourg

Rue d'Amsterdam

Rue de Clichy

Blanche

Rue de Pigalle

Rue Nôtre Dame de Lorette

Rue Rodien

Rue de Maubeuge

Rue du Faubourg Poissonnière

Boulevard de Magenta

Gare du Nord

La Fayette

Rue

Rome

Gare St. Lazare

Rue St.-Lazare

Rue de Châteaudun

La Fayette

Rue du Faubourg Poissonnière

Gare de l'Est

Canal St.-Martin

Boulevard Haussmann

Rue de Provence

Rue Richer

Rue du Château d'Eau

Boulevard de Strasbourg

Boulevard de Magenta

Opéra

Boulevard Malesherbes

Place de la Madeleine

BLVD. DES CAPUCINES

BLVD. DES ITALIENS

Blvd. Montmartre

Blvd. Poissonnière

Blvd. de Bonne-Nouvelle

Boulevard de Sébastopol

Rue du Château d'Eau

Boulevard St.-Martin

Blvd. St.-Martin

Place de la République

Rue St.-Honoré

Rue de Quatre Septembre

Rue Réaumur

Place Vendôme

Avenue de l'Opéra

Rue des Petits Champs

Rue de Turbigo

Place de la Concorde

Rue de Rivoli

Jardin des Tuileries

Palais Royal

Palais du Louvre

SEINE

Boulevard St.-Germain

PARIS Arrondissements

Seine River

Area of large map

17ᵉ 18ᵉ 19ᵉ

8ᵉ 9ᵉ 10ᵉ

Champs 2ᵉ

16ᵉ Elysees 3ᵉ 11ᵉ 20ᵉ

1ᵉ 4ᵉ

7ᵉ 6ᵉ 5ᵉ 12ᵉ

15ᵉ 13ᵉ

14ᵉ

Marne River

Seine River

23. Monet's home 1878,
 26, rue d'Edimbourg

24. Sarah Choate Sears's home c. 1905,
 1 bis, place de l'Alma

25. James Stillman's home 1906–16,
 19, rue de Rembrandt, on the Parc de Monceau

26. Café de la Nouvelle Athènes, place Pigalle,
 meetingplace of the Impressionists

27. Site of the first Impressionist Exhibition 1874 and
 the sixth Impressionist Exhibition 1881,
 35, boulevard des Capucines

28. Site of second Impressionist Exhibition 1876,
 Galerie Durand-Ruel, 11, rue le Peletier

29. Site of the third Impressionist Exhibition 1877,
 6, rue le Peletier

30. Site of the fourth Impressionist Exhibition 1879,
 28, avenue de l'Opéra

31. Site of the fifth Impressionist Exhibition 1880,
 10, rue des Pyramides

32. Site of the seventh Impressionist Exhibition 1882,
 251, rue St.-Honoré

33. Site of the eighth Impressionist Exhibition 1886,
 1, rue Laffitte

34. Exposition universelle 1878, Trocadéro

35. Exposition universelle 1889,
 Champ de Mars

36. Galerie Georges Petit,
 8, rue de Sèze

37. Siegfried Bing's shop "L'Art nouveau"
 1895, corner of the rue de Provence
 and the rue Chauchat

Lifetime Exhibition History

The following list includes all solo and group exhibitions in which Mary Cassatt is known to have participated during her lifetime. Most exhibition titles have been adopted from catalogues; in a few cases, more common designations (i.e. "Salon of 1870" or "fourth Impressionist exhibition") are provided in brackets. The names of the organizing institution(s) and venue(s) are also transcribed as they are listed in the catalogues. Titles of individual works are given as they appear in the catalogues, followed by any other accompanying information. For reasons of space, we have listed prints by catalogue numbers only. If a work can be securely identified, we have given its number in Adelyn Breeskin's catalogues raisonné of 1948 (for Cassatt's prints) and 1970 (for her paintings, drawings, pastels, and watercolors)—abbreviated here as "BR PRINTS" and "BR" respectively, unless uncatalogued by Breeskin. When appropriate, a number from the present exhibition catalogue also appears. Alternate sources of documentation are noted for exhibitions for which no catalogue has been located. Inclusive dates, an opening date, or a general estimate of the month or season during which each exhibition took place are provided according to the amount of information available.

1868

Paris. Explication des ouvrages de peinture, sculpture, architecture, gravure et lithographie des artistes vivants [Salon of 1868], May 1, Palais des Champs-Elysées. 2335. *La mandoline* [BR 17]

1870

Paris. Explication des ouvrages de peinture, sculpture, architecture, gravure et lithographie des artistes vivants [Salon of 1870], May 1, Palais des Champs-Elysées. 2675. *Una Contadina di Fobello; val Sesia (Piémont)*

1871

New York. Goupil Gallery[1]

1. "In Pittsburgh, I joined two of my cousins and went with them to Chicago and took with me, my two pictures (the ones that were at Goupil's). In Chicago . . . I had every hope, both for orders and selling my pictures, when the fire broke out, and the pictures (which were at the largest jewelry store in the city) were burned": Cassatt to Emily Sartain, Oct. 21, [1871], in Mathews 1984, p. 76.

1872

Paris. Explication des ouvrages de peinture, sculpture, architecture, gravure et lithographie des artistes vivants [Salon of 1872], May 1, Palais des Champs-Elysées. 1433. *Pendant le carnaval* [cat. 2]

Milan. Esposizione di belle arti di Milano, Aug. 26. 368. *Baccante* [BR 15; cat. 1]

1873

Paris. Explication des ouvrages de peinture, sculpture, architecture, gravure et lithographie des artistes vivants [Salon of 1873], May 1, Palais des Champs-Elysées. 1372. *Offrant le panal au torero* [BR 22; cat. 5]

Vienna. Weltausstellung. American Department, Gallery of Fine Arts. 620. *Oil-Painting. Tableau à l'huile*

Philadelphia. June–July, Bailey and Co.[1] *Balcony* [BR 18]; *Girl with White Veil* [BR 21]

1. See Katherine Cassatt to Emily Sartain, July 4, [1873], in Mathews 1984, pp. 122–23.

Cincinnati. Exhibition of Paintings, Engravings, Drawings, and Works of Household Art in the Cincinnati Industrial Exposition, Sept. 3–Oct. 4. 160. *A Seville Belle* [BR 21; cat. 4]; 184. *The Flirtation: A Balcony in Seville* [BR 18; cat. 3]; 250. *Il Torero* [BR 22; cat. 5]

1874

Paris. Explication des ouvrages de peinture, sculpture, architecture, gravure et lithographie des artistes vivants [Salon of 1874], May 1, Palais des Champs-Elysées. 326. *Ida* (Mathews 1994, p. 91)

New York. Forty-ninth Annual Exhibition of the National Academy of Design, May, National Academy of Design. 280. *Offering the Panale* [sic] *to the Bull Fighter*, For Sale [BR 22; cat. 5]; 286. *A Balcony at Seville*, For Sale [BR 18]

1875

Paris. Explication des ouvrages de peinture, sculpture, architecture, gravure et lithographie des artistes vivants [Salon of 1875], May 1, Palais des Champs-Elysées. 367. *Portrait de Mlle E. C.*

1876

Philadelphia. Forty-seventh Annual Exhibition, Apr. 24–end of May 1876, Pennsylvania Academy of the Fine Arts. 121. *Portrait of a Gentleman*, owned by the artist [BR 49]; 136. *Portrait of a Child*, owned by the artist [BR 12]; 151. *A Musical Party*, owned by the artist [BR 29]

Paris. Explication des ouvrages de peinture, sculpture, architecture, gravure et lithographie des artistes vivants [Salon of 1876], May 1, Palais des Champs-Elysées. 352. *Portrait de Mme W.*; 353. *Portrait de Mlle C.*

1877

Philadelphia. Exhibition of Choice Paintings Loaned from Private Galleries of Philadelphia and Hans Makart's Great Picture of "Venice Paying Homage to Caterina Cornaro," Jan., Pennsylvania Academy of the Fine Arts. 343. *Bacchante*, J. W. Lockwood [BR 15; cat. 1]

1877/78

Philadelphia. Earles's Gallery, late 1877 or early 1878.[1] *Portrait of a Lady* [BR 80; cat. 9]

1. This exhibition is mentioned in a review of the forty-ninth Annual exhibition of the Pennsylvania Academy of the Fine Arts (Philadelphia 1878). "The three-quarter length seated portrait of a lady No. 180 [sic], was noticed in these columns, some months ago, when it was on view at Earles": *Philadelphia Daily Evening Telegraph* 1878.

1878

New York. Fifty-third Annual Exhibition of the National Academy of Design, Mar., National Academy of Design. 348. *Mrs. W. D. Birney*

Philadelphia. Forty-ninth Annual Exhibition, Apr. 22–June 2, Pennsylvania Academy of the Fine Arts. 175. *Portrait of a Lady*, H. Teubner [BR 80; cat. 9] 192. *Spanish Matador*, H. Teubner [BR 22; cat. 5]

Paris. Exposition universelle de 1878, May 1–mid-Nov., Palais du Champ de Mars, Galerie des beaux-arts. 17. *Tête de femme*

Boston. Thirteenth Exhibition. M.F.A. Massachusetts Charitable Mechanics Association. 176. *After the Bull-Fight* [BR 23; cat. 6]; 209. *The Music Lesson* [BR 29]; 234. *At the Français, a Sketch* [BR 73; cat. 17]

1879

New York. Society of American Artists, Second Exhibition, Mar. 10–29, Kurtz Gallery. 99. *Portrait, Mrs. Cassatt* [BR 128; cat. 10]; 136. *The Mandolin Player*, for sale. [BR 17]

Paris. Quatrième Exposition de peinture [fourth Impressionist exhibition], Apr. 10–May 11, 28, avenue de l'Opéra. 46. *Portrait de M. C.* [BR 49]; 47. *Portrait de petite fille* [BR 56; cat. 11]; 48. *Etude de femme avec éventail* [BR 80; cat. 9]; 49. *Femme dans une loge* [BR 64; cat. 18]; 50. *Tête de jeune fille*, appartient à M. R. [possibly BR 40]; 51. *Portrait de Mlle P*; 52. *Femme lisant* [BR 51; cat. 14]; 53. *Portrait de M. D*, pastel [BR 66]; 54. *Au théâtre*, pastel [BR 72; cat. 19]; 55. *Au théâtre*, pastel [BR 61]; 56. *Dans un jardin*, couleur à la détrempe [possibly BR 92]; hors catalogue [BR 62]

Philadelphia. Fiftieth Annual Exhibition, Apr. 28–end of May, Pennsylvania Academy of the Fine Arts. 158. *Portrait of a Lady* [BR 128; cat. 10]; 190. *Mandolin Player*, price $125 [BR 17]

1880

New York. Thirteenth Annual Exhibition of the American Water Color Society, Feb.–Mar. 1, National Academy of Design. 628. *A Study for a Portrait of a Lady*, Mrs. A. S. W. Elder [BR 55]

Paris. Cinquième Exposition de peinture [fifth Impressionist exhibition], Apr. 1–30, 10, rue des Pyramides. 17. *Portrait de Mme J.* [BR 129; cat. 16]; 18. *Portrait de Mlle G.*; 19. *Portrait de Mlle H.* 20. *Sur un balcon* [BR 94; cat. 13]; 21. *Le Thé* [BR 78; cat. 27]; 22. *Au théâtre* [BR 63]; 23. *Portrait de Mme C* [BR 128]; 24. *Jeune Femme*; 25. [BR PRINTS 22 (2 states); cat. 23]; 26. [BR PRINTS 63]; 27. [BR PRINTS 49 (2 states)]; 28. [BR PRINTS 48]; 29. [BR PRINTS 64; cat. 37]; 30. [BR PRINTS 74]; 31. [BR PRINTS 71; cat. 40]; 32. [BR PRINTS 5]

1881

Paris. Sixième Exposition de peinture [sixth Impressionist exhibition], Apr. 2–May 1, 35, boulevard des Capucines. 1. *La Lecture* [BR 77]; 2. *Le Jardin* [BR 98; cat. 35]; 3. *L'Automne* [BR 96; cat. 29]; 4. *Le Thé* [BR 65; cat. 33]; 5. *Tête de jeune fille*, pastel [possibly BR 86, 106, or 132]; 6. *Tête de jeune fille*, pastel [possibly BR 86, 106, or 132]; 7. *Tête d'enfant*, pastel; 8. *Mère et enfant*, pastel [BR 88]; 9. *Portrait d'enfant*, pastel [possibly BR 86, 106, or 132]; 10. *Portrait d'une jeune violoniste*, pastel; 11. *Tête d'enfant*, pastel

1882

London. *The Impressionists* (organized by Durand-Ruel), summer, White Gallery. [BR 121; cat. 20][1]

1. See *Standard* 1882.

1883

London. Paintings, Drawings, and Pastels by Members of "La Société des Impressionnistes," May–Aug. 1883, Dowdeswell and Dowdeswell. 37. *In the Box* [BR 62]; 68. *Portrait of Elsie Cassatt* [BR 81]

Berlin. Kunstausstellung: Die Pariser Impressionisten, c. Nov., Galerie Fritz Gurlitt. [BR 65][1]

1. See Lichtwark 1884.

1884

Paris. Exposition du Cercle artistique de la Seine, Jan., 3 bis, rue de la Chaussée d'Antin. *Femme à l'eventail* [BR 80; cat. 9][1]

1. See Fénéon 1884.

1885

Philadelphia. Fifty-sixth Annual Exhibition, Oct. 29–Dec. 10, Pennsylvania Academy of the Fine Arts. 62. *Family Group* (portraits),

loaned by A. J. Cassatt [BR 77]; 398. *Portrait of a Child* in pastel, loaned by A. J. Cassatt [BR 81]

1886

New York. Works in Oil and Pastel by the Impressionists in Paris, Apr. 10–28, National Academy of Design. 309. *Family Group*, loaned by A. J. Cassatt, Esq. [BR 77]; 310. *Portrait of a Lady*, loaned by A. J. Cassatt, Esq. [BR 128; cat. 10]

Paris. Huitième Exposition de peinture [eighth Impressionist exhibition], May 15–June 15, 1, rue Laffitte. 7. *Jeune Fille à la fenêtre*, appartient à M. Berend [BR 125; cat. 45]; 8. *Jeune Fille au jardin*, appartient à M. Personnaz [BR 144]; 9. *Etude* [BR 146; cat. 48]; 10. *Portrait*; 11. *Enfants sur la plage* [BR 131; cat. 47]; 12. *Enfants au jardin*, appartient à M. H. [BR 57; cat. 12]; 13. *Mère et enfant* (Pastel), appartient à M. Nunès

1887

Boston. The Work of the Women Etchers of America, late 1887. Traveled to New York, Apr. 1888, Union League. "Twenty-four unfinished studies"[1]

1. Boston 1989, p. 33.

1889

Paris. Exposition de peintres-graveurs, Jan. 23–Feb. 14, Galerie Durand-Ruel. 94. *Mère et enfant*, pastel; 95–96. Gravures

Copenhagen. Impressionnistes scandinaves et français, Oct. 30–Nov. 11, Société artistique. [BR 72][1]

1. See Merete Bodelson, "Gauguin Studies," *Burlington Magazine* 109 (Apr. 1967), p. 226 and n. 33.

1890

Paris. Deuxième Exposition de peintres-graveurs, Mar. 6–26, Galerie Durand-Ruel. 53. Epreuves de pointe-sèche faisant partie d'une série de douze [BR PRINTS 127–38]; 54. Epreuves d'aqua-tinte faisant partie d'une série; hors catalogue [BR 186]

1891

New York (a). Second Exhibition of the Woman's Art Club, Feb., Woman's Art Club.[1]

1. ". . . a group of etchings by Mary Cassatt . . .": *Art Collector* 1891.

Paris (a). Exposition de tableaux et gravures par Mlle Mary Cassatt, Apr., Galerie Durand-Ruel. PEINTURES ET PASTELS: 1. *Mère et enfant*, appartient à Monsieur Durand-Ruel [BR 151]; 2. *Une Caresse* [BR 189]; 3. *Femme avec son enfant*, appartient à Monsieur Paul Gallimard [BR 185; cat. 53]; 4. *Mère et enfant* [BR 195 or 199]; POINTE-

SECHE ET AQUATINTE: 1–10. [BR PRINTS 143–52; cats. 56–65]

Paris (b). Exposition générale de la lithographie, Apr. 26–May 24, Ecole des beaux-arts. "Une élégante *Spectatrice qui lorgne*" [BR PRINTS 23; cat. 24][1]

1. Béraldi 1891, p. 486.

New York (b). Oct.–Nov., Frederick Keppel and Co. [BR PRINTS 143–52; cats. 56–65][1]

1. See *New York Times* 1891b.

1892

Brussels. Les XX, Bruxelles neuvième exposition annuelle, Feb. 1–10. Série de dix planches, pointe-sèche et aquatinte [BR PRINTS 143–52; cats. 56–65]

New York. Retrospective Exhibition of the Society of American Artists, Dec. 5–25, Galleries of the American Fine Arts Society. 39. *N. Portrait.* Owner, H. O. Havemeyer, Esq. [BR 55]; 40. *N. Portrait.* Owner, A. J. Cassatt, Esq. [BR 128; cat. 10]; 41. *N. Portrait.* Owner, A. J. Cassatt, Esq.

1893

Chicago. World's Columbian Exposition, May–Nov., Woman's Building. *The Young Mother* [possibly BR 152, cat. 50]; four drypoints; *Modern Woman* (mural)

Paris. Exposition de tableaux, pastels et gravures de Mary Cassatt, Nov. 27–Dec. 16, Galerie Durand-Ruel. TABLEAUX: 1. *La Toilette de l'enfant* [BR 205; cat. 72]; 2. *Enfant cueillant un fruit* [BR 216; cat. 70]; 3. *La Famille* [BR 145; cat. 70]; 4. *Au théâtre*, appartient à M. A. Rouart [BR 64; cat. 18] 5. *Five o'clock*, appartient à M. Henri Rouart [BR 78; cat. 27]; 6. *Femme mettant ses gants*, appartient à M. A. Rouart [BR 74; cat. 35]; 7. *En brodant* [BR 98; cat. 35]; 8. *La Tasse de thé* [BR 65; cat. 33]; 9. *Jeunes Femmes cueillant des fruits* [BR 197; cat. 68]; 10. *Femme à l'éventail* [BR 80; cat. 9]; 11. *Mère et enfant*, appartient à M. Durand-Ruel [BR 151]; 12. *Dans la prairie*, appartient à MM. Martin et Camentron [BR 93]; 13. *La Loge*, appartient à MM. Martin et Camentron [BR 73; cat. 17]; 14. *Jeune Fille travaillant*, appartient à M. Personnaz [BR 144]; 15. *Rêverie*, appartient à M. Durand-Ruel [BR 198; cat. 67]; 16. *Jeunes Filles travaillant*, appartient à M. Viau [BR 110]; 17. *Jeune Fille se coiffant*, appartient à M. E. Degas [BR 146; cat. 48]; PASTELS: 18. *L'Enfant à l'orange* [BR 220]; 19. *Dans le jardin* [BR 221]; 20. *Enfant dans un fauteuil* [BR 86]; 21. *L'Enfant en bleu*, appartient à M. Viau [BR 132]; 22. *Après la promenade*, appartient à M. Gallimard [BR 185; cat. 53]; 23. *Avant la toilette*, appartient à M. H. Rouart [BR 154]; 24. *Tête de femme*, appartient à M. E. Degas [BR 168]; 25. *La Caresse*, appartient à M. Durand-Ruel [BR 189]; 26. *Tête de*

femme, appartient à M. E. Degas [possibly BR 591]; 27. *Femme et enfant*, appartient à M. Durand-Ruel [BR 199]; 28. *Mère et enfant*, appartient à M. le docteur Peyrot [BR 223]; 29. *Le Lever de l'enfant*, appartient à M. Manzi [BR 190]; 30. *Femme dans une loge*, appartient à M. E. Degas [BR 61]; 31. *Contemplation*, appartient à M. G. Murat [BR 250; cat. 66]; POINTE-SECHE ET AQUATINTE: 32–47. Impressions en couleurs; série de dix planches [BR PRINTS 143–52, 156 (4 states) 157 (2 states); cats. 56–65, 69]; EAX-FORTES, POINTES-SECHES: 48–97. [BR PRINTS 11 (cat. 36), 22, 24 (cat. 25), 34 (cat. 44), 48, 49, 56, 63, 64 (cat. 37) 71 (cat. 40), 74, 95, 99, 100, 102 (2 states), 106, 108, 120, 126, 127, 128 (3 states), 129 (3 states), 130 (5 states), 131, 132 (3 states), 133 (2 states), 134, 135, 136 (2 states), 137–40, 142, 143]; LITHO-GRAPHIE: 98. [BR PRINTS 23; cat. 24]

1894

New York (a). Fifth Annual Exhibition, Feb. 13, Woman's Art Club of New York, Klackner's Gallery. 19. *Modern Women* [possibly BR PRINTS 157]; 20. *The Banjo*, courtesy of Mr. Durand-Ruel [BR PRINTS 156]

New York (b). Portraits of Women. Loan Exhibition for the Benefit of St. John's Guild and the Orthopaedic Hospital, Nov. 1–Dec. 1, National Academy of Design. 53. *Mrs. R. S. Cassatt*, lent by A. J. Cassatt, Esq., Haverford, Pennsylvania [BR 128; cat. 10]; 54. *Miss Katharine Cassatt*, lent by A. J. Cassatt, Esq., Haverford, Pennsylvania [BR 469]

1895

New York (a). Woman's Art Club Show, Feb. 17, Klackner's Gallery. 17. *Dans la loge* [BR 73; cat. 17]

Boston. Loan Collection of Portraits of Women for the Benefit of the Boston Children's Aid Society and the Sunnyside Day Nursery, Mar., Copley Hall. 59. *Mrs. R. S. Cassatt*, Mr. A. J. Cassatt, Philadelphia [BR 162; cat. 55]

New York (b). Exposition of Paintings, Pastels, and Etchings by Miss Mary Cassatt, Apr. 16–30, Durand-Ruel Gallery. PAINTINGS AND PASTELS: 1. *Les Canotiers* [BR 230; cat. 77]; 2. *Femme à l'éventail* [BR 80; cat. 9]; 3. *Jeune Femme cueillant un fruit* [BR 197; cat. 68]; 4. *Enfant cueillant un fruit* [BR 216; cat. 70]; 5. *Dans la loge* [BR 73; cat. 17]; 6. *Enfant à l'orange*, pastel [BR 220]; 7. *Marine* [BR 131; cat. 47]; 8. *La Tasse de thé* [BR 78; cat. 27]; 9. *La Toilette de l'enfant* [BR 90; cat. 28]; 10. *Dans la prairie* [BR 93]; 11. *La Jeune Mère*, pastel [possibly BR 154]; 12. *Femme assise* [BR 198; cat. 67]; 13. *Dans le jardin*, pastel [BR 221]; 14. *Mère et enfant*, pastel [possibly BR 232]; 15. *Jeune Mère*, pastel; 16. *Mère et enfant*, pastel [possibly BR 232]; 17. *Sollicitude maternelle*; LOAN COLLECTION: 18. *Dame tricotant* [BR 98; cat. 35]; 19.

Nourrice et enfant [BR 57; cat. 12]; 20. *Portrait* [BR 48]; 21. *La Toilette* [BR 205; cat. 72]; 22. *Scène espagnole* [BR 18; cat. 3]; 23. *Mère et enfant*, pastel [BR 226]; 24. *Portrait d'enfant*, pastel [possibly BR 87]; 25. *Mère et enfant* [BR 175]; 26. *La Caresse*, pastel [BR 189]; 27. *Portrait of Mr. C* [BR 49]; 28. *En Voiture* [BR 69; cat. 34]; 29. *Enfant au chien*; 30. *Portrait d'enfant*; 31. *Portraits* [BR 77]; 32. *Au théâtre* [BR 64; cat. 18]; 33. *Portrait de Miss S.* [BR 244]; 34. *Portrait of Mrs. C.* [BR 128; cat. 10]; 35. *Jeune Femme assise*, gouache [BR 55]; 36. *La Famille* [BR 145; cat. 71]; DRYPOINTS: 37–46. Series of 10 drypoints printed in colors [BR PRINTS 143–52; cats. 56–65]; 47–52. [BR PRINTS 156, 157 (cat. 69), 159]; 53–64. Series of 12 dry-points [BR PRINTS 127–38]

New York (c). Loan Exhibition of Portraits for the Benefit of St. John's Guild and the Orthopaedic Hospital, Oct. 30–Dec. 7, National Academy of Design. 53. *Child*, lent by Prof. Wm. M. Sloane [BR 219]

Montreal. Eighteenth Loan Exhibition of Paintings, Nov. 18, Art Association of Montreal, New Gallery. 7. *Mother and Child*, lent by Sir Wiliam C. Van Horne, K.C.M.G. [BR 195]

1896

New York (a). Exhibition Illustrative of a Centenary of Artistic Lithography, 1796–1896, Mar., Grolier Club. 179. *Lady in Opera-Box* (1891) [BR PRINTS 23; cat. 24]

New York (b). Dec., Durand-Ruel Gallery. [BR 73; cat. 73][1]

1. ". . . the half-length figure of a lady in an opera box, surveying the house through her lorgnette . . .": Trumble 1896.

1897–98

Pittsburgh. Second Annual Exhibition at the Carnegie Institute, Nov. 4, 1897–Jan. 1, 1898, Carnegie Institute. 41. *La Toilette* [BR 205; cat. 72]

1898

Philadelphia. Sixty-seventh Annual Exhibition, Jan. 10–Feb. 22, Pennsylvania Academy of the Fine Arts. 61. *Woman Seated*, lent by Messrs. Durand-Ruel and Sons [BR 198; cat. 67]; 62. *The Toilet*, lent by Messrs. Durand-Ruel and Sons [BR 205; cat. 72]

New York. Exhibition of Paintings, Pastels, and Drypoints by Mary Cassatt, Feb.–Mar., Durand-Ruel Gallery. *The Child's Bath* [BR 205; cat. 72]; *Mother and Child in Bed* [BR 275; cat. 83]; "mother and sisters admiring a prize infant" [BR 272]; "little Miss Sloane" [BR 220]; "portrait of a girl with a fan" [BR 80; cat. 9]; "Miss Havemeyer" [BR 256]; [BR PRINTS 143–52; cats. 56–65]; [BR 151]; [BR 189][2]

1. See *New York Times Saturday Review of Books and Art* 1898.
2. See New York 1993, p. 298–99.

Boston. An Exhibition of Paintings, Pastels, and Etchings by Miss Mary Cassatt, Mar. 21–Apr. 8, St. Botolph Club. 1. *Portrait sketch*, pastel, lent by Mrs. Bayard Thayer; 3. *Portrait d'enfant*, pastel; 4. *L'Enfant à l'orange*, pastel [BR 220]; 5. *Mère et enfant*, pastel; 6. *La Conversation*, pastel [BR 260]; 7. *Mère et enfant*, pastel, lent by Mrs. J. Montgomery Sears; 8. *Femme et enfant*, pastel; 9. *La Tasse de thé*, pastel [BR 281; cat. 84]; 10. *Mère et enfant*, pastel; 11. *Dans le jardin*, pastel [BR 221]; 12. *Le Déjeuner au lit* [BR 275; cat. 83]; 13. *La Toilette* [BR 205; cat. 72]; 14. *Dans la loge* [BR 73; cat. 17]; 15. *Femme à l'éventail* [BR 80; cat. 9]; 16. *Jeune Femme cueillant un fruit* [BR 197; cat. 68]; 17. *Femme assise* [BR 198; cat. 67]; 18. *La Lecture*; 19–22. Etchings; 23–36. Colored drypoints [BR PRINTS 143–52; cats. 56–65]; 37–46. Etchings; 47. *Portraits of G. F. and G. G. Hammond III*, pastel, lent by Mrs. G. G. Hammond, Jr. [BR 294]; 48. *Portrait of Frances L. Hammond*, pastel, lent by Mrs. G. G. Hammond, Jr. [BR 295]; 49. *Portrait of G. G. Hammond III*, pastel, lent by Mrs. G. G. Hammond, Jr. [BR 293]

Cincinnati. Fifth Annual Exhibition of Works by American Artists, May 21–July 5, Cincinnati Museum Association, Art Museum. 188. *Young Woman Gathering Apples* [BR 197; cat. 68]; 189. *In the Garden* [BR 221]

Omaha. Trans-Mississippi and International Exposition, June 1–Nov. 1, Fine Arts Building. 132. *La Toilette* [BR 205; cat. 72]

1898–99

Pittsburgh. Third Annual Exhibition at the Carnegie Institute, Nov. 3, 1898–Jan. 1, 1899, Carnegie Institute. 170. *Mother and Child*

1899

Philadelphia. Sixty-eighth Annual Exhibition, Jan. 16–Feb. 25, Pennsylvania Academy of the Fine Arts. 708. *Mother and Child*

Paris. Jan., Galerie Durand-Ruel. "Cinq ou six pastels seulement et deux peintures"[1]

1. Leclercq 1899.

1899–1900

Pittsburgh. Fourth Annual Exhibition at the Carnegie Institute, Nov. 2, 1899–Jan. 1, 1900, Carnegie Institute. 33. *Young Woman Plucking Fruit* [BR 197; cat. 68]

1900

Philadelphia. Sixty-ninth Annual Exhibition, Jan. 15–Feb. 24, Pennsylvania Academy of the Fine Arts. 217. *Young Woman Gathering Fruit* [BR 197; cat. 68]

Cincinnati. Seventh Annual Exhibition of American Art in the Museum, May 19–July 9, Cincinnati Museum Association, Art Museum. 12. *Dans la loge*, lent by M. Durand-Ruel and Son, New York [BR 73; cat. 17]; 13. *La Toilette*, lent by M. Durand-Ruel and Son, New York [BR 205; cat. 72]

1900–1901

Pittsburgh. Fifth Annual Exhibition at the Carnegie Institute, Nov. 1, 1900–Jan. 1, 1901, Carnegie Institute. 33. *Baby Arises* [BR 342]

1901

Philadelphia. Seventieth Annual Exhibition, Jan. 14–Feb. 23, 1901, Pennsylvania Academy of the Fine Arts. 124. *Baby Arises*, lent by Messrs. Durand-Ruel [BR 342]

Buffalo. Pan-American Exposition, Exhibition of Fine Arts, Art Building. 105. *The Morning Bath*, lent by Messrs. Durand-Ruel [BR 342]

Cincinnati. Eighth Annual Exhibition of American Art, May 18–July 8, Cincinnati Museum. 1. *Femme à l'éventail: Woman with Fan* [BR 80; cat. 9]

Worcester. Third Annual Exhibition of Oil Paintings (Summer Exhibition), June 3–Oct. 14, Worcester Art Museum. 32. *La Toilette* [BR 205; cat. 72]

1901–1902

Pittsburgh. Sixth Annual International Exhibition, Nov. 7, 1901–Jan. 1, 1902, Carnegie Institute. 48. *In the Meadow* [BR 93]

1902

Philadelphia. Seventy-first Annual Exhibition, Jan. 20–Mar. 1, Pennsylvania Academy of the Fine Arts. 529. *Woman Reading in a Garden* [BR 94; cat. 13]

Worcester. Fourth Annual Exhibition of Oil Paintings (Summer Exhibition), May 29–Sept. 15, Worcester Art Museum. 4. *Mère et enfant*; 8. *Après le bain*

1903

Philadelphia. Seventy-second Annual Exhibition, Jan. 19–Feb. 28, Pennsylvania Academy of the Fine Arts. 37. *La Femme au chien* [BR 125; cat. 45]

Paris. Exposition d'oeuvres de l'Ecole Impressionniste, Apr. 2–25, Galerie Bernheim-Jeune et fils.[1] 1. *Mère et enfant*, appartient à M. Georges Viau [BR 156; cat. 52]; 2. *Caresses enfantines* [BR 393]; 3. *Mère et enfant*; 4. *La Fillette au grand chapeau* [BR 345]; 5. *La Sortie du bain* [BR 384]; 6. *Mère et enfant*; 7. *Enfant tenant une pomme*, appartient à M. D. R. [BR 305]; 8. *Femme embrassant un enfant*, appartient à MM. Bernheim-Jeune [possibly BR 185; cat. 53]

1. Cassatt was also a lender to this exhibition: Manet, 34. *Fleurs (Pivoines)*, Appartient à Miss Cassatt; . . . Morizot [*sic*], 43. *Femme en blanc*, appartient à Miss Cassatt.

New York (a). Exhibition of Paintings and Pastels by Mary Cassatt, Nov. 5–21, Durand-Ruel Gallery. PAINTINGS: 1. *Dans la loge* [BR 73; cat. 17]; 2. *Femme à l'éventail* [BR 80; cat. 9]; 3. *Jeune Femme cueillant un fruit* [BR 197; cat. 68]; 4. *Dans la prairie* [BR 93]; 5. *Femme assise* [BR 198; cat. 67]; 6. *La Toilette* [BR 205; cat. 72]; 7. *Le Lever de bébé* [BR 342]; 8. *Après le bain* [BR 336]; 9. *La Femme au chien* [BR 125; cat. 45]; 10. *Femme lisant dans un jardin* [BR 94; cat. 13]; 11. *La Sortie du bain* [BR 332]; 12. *Fillette au grand chapeau* [BR 345]; 13. *Caresse enfantine* [BR 393]; 14. *Mère et deux enfants* [BR 379]; 15. *Mère et enfant*; PASTELS: 16. *Dans le jardin* [BR 221]; 17. *L'Enfant à l'orange* [BR 220]; 18. *Femme et enfant* [BR 272]; 19. *Mère et enfant* [BR 281; cat. 84]; 22. *La Tasse de thé* [BR 344]; 23. *Enfants jouant avec leur mère* [BR 386]; 24. *Buste d'enfant* [BR 303]; 25. *Enfant tenant une pomme* [BR 305]

New York (b). Thirteenth Annual Exhibition of the Woman's Art Club, Dec. 1–14, National Arts Club. 6. *Fillette au grand chapeau*, loaned by Durand-Ruel Gallery [BR 345]; 7. *Woman and Child*, loaned by Durand-Ruel Gallery

1904

Philadelphia. Seventy-third Annual Exhibition, Jan. 25–Mar. 5, Pennsylvania Academy of the Fine Arts. 6. *Caress* [BR 393]

Brussels. Exposition des peintres impressionnistes, Mar., La Libre Esthétique[1]

1. See Madeline Octave Maus, *Trente Années de lutte pour l'art* (Brussels, 1926), p. 307.

Cincinnati. Eleventh Annual Exhibition of American Art, May 21–July 11, Cincinnati Museum. 55. *In the Park*, lent by Messrs. Durand-Ruel, New York [BR 93]; 56. *Caress*, lent by Messrs. Durand-Ruel, New York [BR 393]; 57. *Woman and Child*, lent by Messrs. Durand-Ruel, New York

Worcester. Seventh Annual Exhibition of Oil Paintings (Summer Exhibition), May 29–Sept. 26, Worcester Art Musuem. 119. *The Baby's Toilet*

Chicago. Seventeenth Annual Exhibition of Oil Paintings and Sculpture by American Artists, Oct. 20–Nov. 27, The Art Institute of Chicago. 50. *Caress* [BR 393]; 51. *In the Park* [possibly BR 93]; 52. *Mother and Child*; 53. *Reading Lesson* [BR 380]

Providence. Autumn Exhibition, Oct. 26–Nov. 16, Rhode Island School of Design. 4. *La Sortie du bain* [possibly BR 384]

1905

London. Pictures, Drawings, Prints, and Sculpture at the Fifth Exhibition of the International Society of Sculptors, Painters, and Gravers, Jan.–Feb., New Gallery. 63–71. [BR PRINTS 143, 145, 146, 148, 152]

Philadelphia (a). One-hundredth Anniversary Exhibition, Jan. 23–Mar. 4, Pennsylvania Academy of the Fine Arts. 403. *Portrait of M. D. S.*, lent by Mrs. Clement B. Newbold [BR 289]; 407. *The Toilet; Mother and Two Children*, lent by Alfred Atmore Pope, Esq. [BR 379]

Philadelphia (b). Fourteenth Annual Exhibition of Water Colors and Pastels, Mar. 20–Apr. 16, Art Club of Philadelphia. 179. *The Caress* [BR 268]; 187. *In the Garden* [BR 221]

Philadelphia (c). Second Annual Philadelphia Water Color Exhibition, Apr. 3–29, Pennsylvania Academy of the Fine Arts and the Philadelphia Water Color Club. 7. *Mother and Child*, lent by Clement B. Newbold, Esq. [BR 227]; 8. Colored etching, lent by J. Gardner Cassatt, Esq.; 9. Group of colored etchings, lent by J. Gardner Cassatt, Esq.; 10. Pastel portrait, lent by J. Gardner Cassatt, Esq. [possibly BR 208 or BR 287]; 466. Group of eleven drypoints, lent by J. Gardner Cassatt, Esq.; 495. Drypoint, lent by J. Gardner Cassatt, Esq.

Chicago. Seventeenth Annual Exhibition of Water Colors, Pastels, and Miniatures by American Artists, May 11–June 11, The Art Institute of Chicago. 66. *Mother and Child*, pastel

Worcester. Eighth Annual Exhibition of Oil Paintings (Summer Exhibition), June 2–Sept. 24, Worcester Art Museum. 37. *The Toilet* [BR 205; cat. 72]

Philadelphia (d). Seventeenth Annual Exhibition of Oil Paintings and Sculpture, Nov. 20–Dec. 17, Art Club of Philadelphia. 176. *Mother and Child* [BR 342]; 195. *In the Park* [possibly BR 93]

1906

Philadelphia (a). One-hundred-first Annual Exhibition, Jan. 22–Mar. 3, Pennsylvania Academy of the Fine Arts. 19. *In the Woods* [BR 93]; 336. *Mother and Child* [BR 406]

Philadelphia (b). Fifteenth Annual Exhibition of Water Colors and Pastels, Mar. 19–Apr. 15, Art Club of Philadelphia. 157. *Enfants jouant avec leur mère* [BR 386]; 158. *Girl with an Orange* [BR 220]

New York (a). Woman's Art Club Annual Exhibition, Apr. 17, National Arts Club. "The Cup of Tea" [BR 281; cat. 84][1]

1. *New York Times* 1906.

Cincinnati. Thirteenth Annual Exhibition of American Art, May 19–July 16, Cincinnati Art Museum. 90. *In the Woods*, lent by Messrs. Durand-Ruel and Co., New York [BR 93]; 91. *Le Lever de bébé*, lent by Messrs. Durand-Ruel and Co., New York [BR 342]

Buffalo. First Annual Exhibition of Selected Paintings by American Artists, May 31–Sept. 2, Buffalo Fine Arts Academy, Albright Art Gallery. 20. *Mother and Child* (pastel), lent by M. Durand-Ruel, New York

Richmond (Indiana). Tenth Annual Exhibition of the Art Association of Richmond, Indiana, June 12–26, Garfield School Building. 21. *La Leçon de lecture*, exhibited by Durand-Ruel, New York [BR 380]; 22. *Mère et enfant*, exhibited by Durand-Ruel, New York

Philadelphia (c). Eighteenth Annual Exhibition of Oil Paintings and Sculpture, Nov. 19–Dec. 16, Art Club of Philadelphia. 156. *Après le bain* [BR 336]

New York (b). Paintings, Pastels and Etchings by Mary Cassatt, Dec. 12–31, Durand-Ruel Gallery. "At the Opera" [BR 73; cat. 17]; "Mother and Child"; "Child's Bath"[1]

1. *American Art News* 1906c.

1907

Philadelphia (a). One-hundred-second Annual Exhibition, Jan. 21–Feb. 24, Pennsylvania Academy of the Fine Arts. 124. *Dans le Lodge* [sic] [BR 73; cat. 17]; 127. *Femme à l'éventail* [BR 80; cat. 9]

New York. Woman's Art Club Exhibition, Feb. 4–16, Clausen Galleries[1]

1. *New York Times* 1907a.

Washington, D.C. First Annual Exhibition: Oil Paintings by Contemporary American Artists, Feb. 7–Mar. 9, Corcoran Gallery of Art. 219. *Woman and Child*, lent by Messrs. Durand-Ruel [BR 406]

Philadelphia (b). Sixteenth Annual Exhibition of Water Colors and Pastels, Mar. 4–31, Art Club of Philadelphia. 135. *Femmes et enfant*, pastel [BR 272]

Philadelphia (c). Fourth Annual Philadelphia Water Color Exhibition, Apr. 1–27, Pennsylvania Academy of the Fine Arts and the Philadelphia Water Color Club. 1. *A Cup of Tea* [BR 281]; 4. *Mother and Child*; 221. *Baby's Toilet*

Pittsburgh. Eleventh Annual Exhibition at the Carnegie Institute, Apr. 11–June 13, Carnegie Institute. 83. *Mother and Child*; 84. *Reading Lesson* [BR 380]

Buffalo. Exhibition of Paintings by the French Impressionists, Oct. 31–Dec. 8, Buffalo Fine Arts Academy, Albright Art

Gallery. 16. *Woman and Child* (pastel); 17. *After Baby's Bath*; 18. *Woman Reading in a Garden* [BR 94; cat. 13]; 19. *After Baby's Bath*; 20. *The Caress* [BR 393]

Barcelona. Exposición de bellas artes, fall/winter. "Niña en el jardín" [BR 424][1]

1. Utrillo 1907, pp. 325, 339, 358.

1907–1908

Manchester (England). Exhibition of Modern French Paintings, Dec. 1907–Jan. 1908, City of Manchester Art Gallery. 68. *Motherly Caresses* [BR 418]; 69. *Young Mother Nursing Her Child*, pastel [BR 311; cat. 85]; 70. *Child in Blue Dress*, pastel [BR 434]; 71. *Children Playing on the Shore* [BR 131; cat. 47]; 72. *Young Mother*, pastel [BR 226]; 73. *Mother Playing with Her Child*, pastel [BR 271]

1908

Pittsburgh (a). Paintings by the French Impressionists, Feb. 10–Mar. 11, Carnegie Institute.[1] *Morning Caress* [BR 342][2]

1. *Pittsburgh Post* 1908.
2. Illustrated in *Pittsburgh Gazette-Times* 1908a.

Paris (a). Mar. 24–Apr. 15, 1908, Galerie Ambroise Vollard. "L'Intérieur"; "Femme accoudée"; "Une quarantaine de pastels"[1]

1. Vaudoyer 1908.

Pittsburgh (b). Twelfth Annual Exhibition at the Carnegie Institute, Apr. 13–June 30, Carnegie Institute. 49. *Woman with Dog*, lent by Messrs. Durand-Ruel, New York [BR 125; cat. 45]

Paris (b). Tableaux et pastels par Mary Cassatt, Nov. 3–28, Galerie Durand-Ruel. TABLEAUX: 1. *La Toilette*, Appartient à M. E. D. [BR 146; cat. 48]; 2. *Dans la barque*, Appartient à M. J. S. [BR 524]; 3. *Caresse maternelle*, Appartient à M. J. S. [BR 393]; 4. *Portrait de Mme C.*, Appartient à Mlle M. C. [BR 162; cat. 55]; 5. *Fillette au chien griffon*, Appartient à Mme. C. P. H. [BR 378]; 6. *Le Miroir*, Appartient à M. R. M. [BR 473; cat. 89]; 7. *Le Thé*, Appartient à M. H. R. [BR 78; cat. 27]; 8. *Au théâtre*, Appartient à M. A. R. [BR 64; cat. 18]; 9. *Les Dentellières*, Appartient à M. G. V. [BR 110]; 10. *Petite Fille assise*, Appartient à M. G. [BR 385]; 11. *Mère et enfant*, Appartient à M. X; 12. *La Tasse de thé* [BR 65; cat. 33]; 13. *Enfants jouant sur une plage* [BR 131; cat. 47]; 14. *Enfant cueillant* [BR 216; cat. 70]; 15. *La Loge*; 16. *Portrait de jeune fille*; 17. *Caresse maternelle* [BR 418]; 18. *Mère et enfant* [BR 408]; 19. *Fillette dans un jardin* [BR 424]; 20. *Jeune Mère et ses deux enfants* [BR 501]; 21. *Enfants jouant avec un chat* [BR 505]; 22. *Jeune Femme allaitant son enfant* [BR 504]; 23. *Jeune Mère et son enfant*; PASTELS: 24. *Portrait de Mme O. de S . . . et de ses enfants*, Appartient à M. le baron de S. [BR 554]; 25. *Portrait de Mlle de S.*, Appartient à M. le baron de S. [BR 553]; 26. *Portrait de Mme A. M. A.*, Appartient à Mme

A. M. A. [BR 479]; 27. *Fillette assise dans un fauteuil*, Appartient à M. J. S. [BR 433]; 28. *Portrait de fillette*, Appartient à M. X; 29. *Portrait de fillette*, Appartient à M. X; 30. *Jeune Mère*, Appartient à M. H. R. [BR 154]; 31. *Fillette au chapeau blanc*, Appartient à M. A. R. [BR 432]; 32. *Caresse maternelle*, Appartient à M. H. M.; 33. *La Lecture*, Appartient à M. R. M. [BR 341]; 34. *Maternité*, Appartient à M. O. S. [BR 186]; 35. *Portrait de Mlle A. K.*, Appartient à M. K. [BR 511]; 36. *Portrait de Mr. D. K.*, Appartient à M. K. [BR 512]; 37. *La Lecture*, Appartient à Mme S. M.; 38. *Jeune Mère coiffant son enfant*, Appartient à Mme S. M. [BR 353]; 39. *Jeune Mère avec ses enfants*, Appartient à M. A. V. [BR 381]; 40. *Petite Fille au chien*, Appartient à M. A. V. [BR 372]; 41. *Jeune Mère coiffant son enfant*, Appartient à M. A. V. [BR 348]; 42. *Portrait de Mlle A. M. D. R.*, appartient à M. J. D. R. [BR 513]; 43. *Mère jouant avec son enfant* [BR 271]; 44. *Mère allaitant son bébé* [BR 311; cat. 85]; 45. *Fillette à la robe bleue* [BR 434]

Philadelphia. Nineteenth Annual Exhibition of Oil Paintings and Sculpture, Nov. 16–Dec. 20, Art Club of Philadelphia. 48. *Fillette au grand chapeau* [BR 345]

1908–1909

Indianapolis. Twenty-fourth Annual Exhibition of Paintings, Dec. 6, 1908–Jan. 4, 1909, John Herron Art Institute. 10. *Head of a Young Girl* (watercolor), lent by Mr. George E. Hume [BR 423]

Washington, D.C. Second Exhibition: Oil Paintings by Contemporary American Artists, Dec. 8, 1908–Jan. 17, 1909, Corcoran Gallery of Art. 96. *Caresse enfantine* [BR 393]; 252. *La Femme au chien* [BR 125; cat. 45]

1909

Boston. Pictures by Mary Cassatt, Feb. 8–20, St. Botolph Club. 1. *La Leçon de lecture*, loaned by Durand-Ruel and Sons [BR 380]; 2. *Enfants jouant avec un chat*, loaned by Durand-Ruel and Sons [BR 505]; 3. *Mère et enfant*, loaned by Mrs. H. O. Havemeyer, New York [BR 338; cat. 87]; 4. *Fillette au grand chapeau*, loaned by Durand-Ruel and Sons [BR 345]; 5. *La Toilette*, loaned by Durand-Ruel and Sons [BR 205; cat. 72]; 6. *Lever du bébé*, loaned by Alfred Atmore Pope, Esq. [BR 379]; 7. *Femme avec deux enfants*, loaned by J. G. Cassatt, Esq. [BR 502]; 8. *Jeune Mère allaitant son enfant*, loaned by Mrs. H. O. Havemeyer, New York [BR 504]; 9. *Au jardin*, loaned by Mrs. H. O. Havemeyer, New York [BR 452]; 10. *Portrait de Mme C*, loaned by J. G. Cassatt, Esq. [BR 162; cat. 55]; 11. *Jeune mère et ses deux enfants*, loaned by Durand-Ruel and Sons [BR 501]; 12. *Jeune Femme cueillant un fruit*, loaned by Durand-Ruel and Sons [BR 197; cat. 68]; 13. *Jeune Mère*, loaned by Mrs. H. O. Havemeyer [BR 415; cat. 88]; 14. *Femme assise*, loaned by

Durand-Ruel and Sons [BR 198; cat. 67]; 15. *Après le bain*, loaned by Durand-Ruel and Sons [BR 334]; 16. *Femme au corsage rouge et enfant*, loaned by Mrs. C. J. Lawrence [BR 325]; 17. *Mère et enfant*, loaned by Mrs. H. O. Havemeyer [BR 189]; 18. *La Sortie du bain*, loaned by Durand-Ruel and Sons [BR 332]; 19. *Mère et enfant*, loaned by J. G. Cassatt, Esq.; 20. *La Toilette de l'enfant*, loaned by Alfred Atmore Pope, Esq. [BR 90; cat. 28]; 21. *Dans la prairie*, loaned by Durand-Ruel and Sons [BR 93]; 22. *Femme à l'éventail*, loaned by Durand-Ruel and Sons [BR 80; cat. 9]; 23. *La Lecture*, loaned by Durand-Ruel and Sons; 24. *Dans la loge*, loaned by Durand-Ruel and Sons [BR 73; cat. 17]; 25. *Caresse maternelle*, loaned by Mrs. C. J. Lawrence [BR 88]

New York (a). Mar.–Apr., Durand-Ruel Gallery. "Dans la loge" [BR 73; cat. 17][1]

1. *New York Times* 1909b.

New York (b). Eighty-fourth Annual Exhibition, Mar. 13–Apr. 17, National Academy of Design. 192. *Children Playing with a Cat* [BR 505]

Pittsburgh. Thirteenth Annual Exhibition at the Carnegie Institute, Apr. 29–June 30, Carnegie Institute. 43. *Young Mother and Her Two Children*

Buffalo. Fourth Annual Exhibition of Selected Paintings by American Artists, May 10–Aug. 30, Buffalo Fine Arts Academy, Albright Art Gallery. 30. *Children Playing with a Cat*, lent by Messrs. Durand-Ruel, New York [BR 505]

Worcester. Twelfth Annual Exhibition of Oil Paintings (Summer Exhibition), May 28–Sept. 19, Worcester Art Museum. 61. *Mother and Child* [BR 406]

St. Louis. Fifth Annual Exhibition of Selected Paintings by American Artists, Sept. 12, City Art Museum of St. Louis. 30. *Children Playing with a Cat*, loaned by Messrs. Durand-Ruel, New York [BR 505]

New York (c). Impressionist Pictures, Oct., Durand-Ruel Gallery. ". . . a woman reading in a garden, her blonde head relieved against a riot of full-hued flowers, her sprigged muslim dress and white kerchief as eloquent of the pleasant season as the blossoming garden beds, the concentration of the eyes and the firm curve of the lips . . ." [BR 94; cat. 13]; ". . . this pastel . . . is a mother and child . . ."[1]

1. *New York Times Magazine* 1909b.

Chicago. Twenty-second Annual Exhibition of Paintings and Sculpture by American Artists, Oct. 19–Nov. 28, The Art Institute of Chicago. 48. *Mother and Child* [BR 408]

Philadelphia. Seventh Annual Philadelphia Water Color Exhibition, Nov. 8–Dec. 19, Pennsylvania Academy of the Fine Arts and

the Philadelphia Water Color Club. 114. *Fete [sic] d'enfant*, lent by Mrs. George E. Hume [BR 423]; 217. *Children Playing with Their Mother* [possibly BR 386]

1909–10

Seattle. Alaska-Yukon-Pacific Exposition, June 1, 1909–Jan. 1910, Department of Fine Arts. 220. *Après le bain*, loaned by Durand-Ruel and Sons, New York

1910

Philadelphia (a). One-hundred-fifth Annual Exhibition, Jan. 23–Mar. 20, Pennsylvania Academy of the Fine Arts. 682. *Children Playing with a Cat* [BR 505]

Paris. Exposition de peintures de Mary Cassatt, Mar., Galerie Durand-Ruel. "A striking collection of twenty paintings . . ."¹
1. *New York Times* 1910a.

Berlin. Ausstellung Amerikanischer Kunst, Mar.–Apr., Königliche Akademie der Künste zu Berlin. Traveled to Munich, May. *Bei der Toilette*, im Besitz der Herren Durand-Ruel, Paris [BR 543; cat. 90]; *Mutter und Kind*, im Besitz der Herren Durand-Ruel, Paris [BR 418]

Pittsburgh. Fourteenth Annual Exhibition at the Carnegie Institute, May 2–June 30, Carnegie Institute. 41. *Children Playing with a Cat* [BR 505]; 42. *Reading* [BR 346]

Buffalo. Fifth Annual Exhibition of Selected Paintings by American Artists, May 11–Sept. 1, Buffalo Fine Arts Academy, Albright Art Gallery. 28. *Mother and Child*, lent by Messrs. Durand-Ruel

St. Louis. Fifth Annual Exhibition of Selected Paintings by American Artists, Sept. 15–Nov. 15, City Art Museum of St. Louis. 29. *Mother and Child*, lent by Messrs. Durand-Ruel

Chicago. Twenty-third Annual Exhibition of Oil Paintings and Sculpture by American Artists, Oct. 18–Nov. 27, The Art Institute of Chicago. 41. *Children Playing with a Cat* [BR 505]

Philadelphia (b). Eighth Annual Philadelphia Water Color Exhibition, Nov. 17–Dec. 18, Pennsylvania Academy of the Fine Arts and the Philadelphia Water Color Club. 339. *Girl with an Orange* [BR 220]

New York. Dec., Durand-Ruel Gallery. *Le Bain* [BR 580]; "A Mother and Child"¹
1. *American Art News* 1910d.

1910–11

Washington, D.C. Third Exhibition: Oil Paintings by Contemporary American Artists, Dec. 13, 1910–Jan. 22, 1911, Corcoran Gallery of Art. 51. *Mother and Child*, lent by

Messrs. Durand-Ruel; 63. *Reading*, lent by Messrs. Durand-Ruel [BR 346]

1911

New York (a). Jan. 3–21, Durand-Ruel Gallery. "Nine characteristic paintings of mothers and children . . ."; "*Femme et enfant* of 1910"; "*Caresse maternelle* of 1903" [possibly BR 393]; "*Fille lisant*, 1901" [BR 535]; "*Enfants jouant avec un chat*, also 1901" [BR 505]; "*Sortie du bain*, 1901" [possibly BR 332]; "*Après le bain*, 1901" [possibly BR 334 or 346]; "*La Leçon de lecture*, 1902" [BR 380]; [also see BR 145; cat. 71]¹
1. *American Art News* 1911b.

New York (b). The Pastellists, Jan. 10–25, Folsom Galleries. "Mother and Child"¹
1. *American Art News* 1911c.

Philadelphia. One-hundred-sixth Annual Exhibition, Feb. 5–Mar. 26, Pennsylvania Academy of the Fine Arts. 328. *Woman Reading in a Garden* [BR 94; cat. 13]; 471. *Woman and Child* [BR 509]

Washington, D.C. Special Exhibition of Paintings by the Masters of the Modern French School, Feb. 11–Mar. 5, Corcoran Gallery of Art. 9. *Dans la prairie* [BR 93]; 10. *Femme à l'éventail* [BR 80; cat. 9]

New York (c). Forty-fourth Annual Exhibition of the American Watercolor Society, Apr. 27–May 21, American Watercolor Society, American Fine Arts Galleries. 102. *A Cup of Tea*, pastel, $1,600 [BR 281; cat. 84]

Pittsburgh. Fifteenth Annual Exhibition at the Carnegie Institute, Apr. 27–June 30, Carnegie Institute. 38. *Little Girl Reading* [BR 535]

Buffalo. Sixth Annual Exhibition of Selected Paintings by American Artists, May 12–Aug. 28, Buffalo Fine Arts Academy, Albright Art Gallery. 17. *Dans la prairie* [BR 93]

Cincinnati. Eighteenth Annual Exhibition of American Art, May 20–July 22, Cincinnati Art Museum. 89. *The Reading Lesson* [BR 380]; 90. *Woman with Fan* [BR 80]

Worcester. Fourteenth Annual Exhibition of Oil Paintings by American Painters (Summer Exhibition), May 28–Sept. 18, Worcester Art Museum. 8. *Caresse maternelle* [BR 418]

St. Louis. Sixth Annual Exhibition of Selected Paintings by American Artists, Sept. 17–Nov. 17, City Art Museum of St. Louis. 14. *Dans la prairie* [BR 93]

Chicago. Twenty-fourth Annual Exhibition of American Oil Paintings and Sculpture, Nov. 14–Dec. 27, The Art Institute of Chicago. 59. *Little Girl Reading* [BR 535]

1912

Toledo. Inaugural Exhibition, Jan. 17–Feb. 12, Toledo Museum of Art. 17. *Woman and Child*, lent by Messrs. Durand-Ruel, New York

Philadelphia. One-hundred-seventh Annual Exhibition, Feb. 4–Mar. 24, Pennsylvania Academy of the Fine Arts. 472. *Mother and Children*, lent by Mrs. J. G. Cassatt [BR 502]

Pittsburgh. Sixteenth Annual Exhibition at the Carnegie Institute, Apr. 25–June 30, Carnegie Institute. 59. *Woman with Fan* [BR 80; cat. 9]

Buffalo. Seventh Annual Exhibition of Selected Paintings by American Artists, May 21–Sept. 2, Buffalo Fine Arts Academy. 14. *Femme et enfant*, lent by Messrs. Durand-Ruel and Son, New York [BR 509]

Cincinnati. Nineteenth Annual Exhibition of American Art, May 25–July 27, Cincinnati Art Museum. 4. *La Lecture*, lent by Messrs. Durand-Ruel and Son [BR 346]; 5. *Fillette tenant un petit chien*, lent by Messrs. Durand-Ruel and Son [BR 528]

Worcester. Fifteenth Annual Exhibition of Oil Paintings (Summer Exhibition), June 7–Sept. 15, Worcester Art Museum. 7. *After the Bath* [BR 406]

St. Louis. Seventh Annual Exhibition of Selected Paintings by American Artists, Sept. 15, City Art Museum of St. Louis. 16. *Femme et enfant* [BR 509]

Chicago. Twenty-fifth Annual Exhibition of American Oil Paintings and Sculpture, Nov. 5–Dec. 8, The Art Institute of Chicago. 43. *Woman with Fan* [BR 80; cat. 9]; 44. *Mother and Child*

Paris. Exposition d'art moderne, June 1, Hôtel des Modes, 15, rue de la Ville-Lévêque.¹ *Child in Blue* [BR 370]; *Child in Yellow* [BR 450]; *Child and Dog* [BR 375]
1. F. M. 1912; see also Borgmeyer 1913.

Düsseldorf. Gemälde aus der Sammlung von Nemes, Städliches Kunsthalle. 103. *Damen in der Loge* [BR 121; cat. 20]

1912–13

Washington, D.C. Fourth Exhibition: Oil Paintings by Contemporary American Artists, Dec. 17, 1912–Jan. 26, 1913, Corcoran Gallery of Art. 103. *Children Playing with a Cat*, lent by Messrs. Durand-Ruel and Sons [BR 505]

1913

Boston. Impressionist Paintings Lent by Messrs. Durand-Ruel and Sons, Jan. 20–31, Saint Botolph Club. 24. *Femme à sa toilette*, lent by Messrs. Durand-Ruel and Sons [BR 543; cat. 90]

New York. International Exhibition of Modern Art [Armory Show], Feb. 15–Mar. 15, 69th Street Armory. Traveled to Chicago, Mar. 24–Apr. 16, The Art Institute of Chicago; and to Boston, Apr. 28–May 18, Copley Hall. 493. *Mère et enfant*, lent by MM. Durand-Ruel and Sons [BR 408]; 584. *Mère et enfant*, lent by John Quinn, Esq. [BR 623]

Pittsburgh. Seventeenth Annual Exhibition at the Carnegie Institute, Apr. 24–June 30, Carnegie Institute. 54. *Woman at Her Toilet* [BR 543; cat. 90]

Cincinnati. Twentieth Annual Exhibition of American Art, May 24–July 26, Cincinnati Art Museum. 4. *Mother and Child*, lent by Messrs. Durand-Ruel and Sons [BR 408]

St. Louis. Eighth Annual Exhibition of Selected Paintings by American Artists, Sept. 14, City Art Museum of St. Louis. 14. *Woman at Her Toilet*, lent by Messrs. Durand-Ruel and Sons, New York City [BR 543; cat. 90]

Chicago. Twenty-sixth Annual Exhibition of American Oil Paintings and Sculpture, Nov. 14–Dec. 25, The Art Institute of Chicago. 63. *Woman at Her Toilet* [BR 543; cat. 90]

New York. George A. Hearn Gift to The Metropolitan Museum of Art in the City of New York and Arthur Hoppock Hearn Memorial Fund, The Metropolitan Museum of Art. 79. *Mother and Child* [BR 342]

1914

Pittsburgh. Eighteenth Annual Exhibition at the Carnegie Institute, Apr. 30–June 13, Carnegie Institute. 48. *Woman and Child with Pink Scarf* [BR 509]; 49. *Child Holding a Little Dog* [BR 528]

Cincinnati. Twenty-first Annual Exhibition of American Art, May 23–July 31, Cincinnati Art Museum. 51. *Fillette au grand chapeau*, 1900 [BR 345]

Paris. Tableaux, pastels, dessins et pointes-sèches par Mary Cassatt, June 8–27, Galerie Durand-Ruel. TABLEAUX: 1. *Femme et enfant*; 2. *Femme tenant un enfant sur ses genoux*; 3. *Buste de jeune fille*; 4. *Jeune Fille cousant* [BR 558]; 5. *Femme et enfant*; 6. *Femme en robe jaune et deux enfants* [BR 472]; 7. *Femme en robe rose et enfant dans un jardin* [BR 561]; 8. *Portrait* [BR 139]; 9. *Buste de fillette*; 10. *Caresse maternelle* [BR 418]; 11. *Femme appuyée sur sa main droite* [BR 545]; 12. *Femme lisant*; PASTELS: 13. *Jeune Fille au chapeau de paille* [BR 548]; 14. *Fillette*; 15. *Mère et enfant*; 16. *Femme et enfant*; 17. *Jeune Mère, fillette et bébé* [BR 597]; 18. *Mère et enfant*; 19. *Femme nue, buste* [BR 598]; 20. *Mère et enfant*; 21. *Après le bain de bébé* [BR 384]; 22. *Bébé souriant à sa mère* [BR 594]; 23. *Mère jouant avec son bébé* [BR 604]; 24. *Fillette au chapeau bleu*; 25. *Jeune Femme en corsage bleu et fillette en robe rouge* [BR 595]; 26. *Mère et enfant*; 27. *Fillette et chien* [BR 530]; 28. *Fillette assise, en robe rouge* [BR 596]; 29. *La Toilette*; AQUARELLES: 30. *Fillette*; 31. *Tête de femme*; 32.

Tête de femme; 33. *Femme et enfant*; 34. *Tête de fillette*; 35. *Femme et enfant*; 36. *Femme et deux enfants*; 37. *Femme et enfant dans un paysage* [BR 636]; 38. *Jeune Femme et enfant*; 39. *Femme et enfant*; DESSINS: 40. *Portrait de femme*; 41. *Deux jeunes femmes*; 42. *Femme et enfant*; 43. *Le Bain de l'enfant*; 44. *La Cueillette*; 45. *Femme à l'éventail*; 46. *Femme et enfant*; 47. *La Lettre* [BR 805]; 48. *Le Bain* [BR 801 or 802]; 49. *La Lampe* [BR 803]; 50. *Le Thé* [BR 812]; 51. *Le Tramway* [BR 804]; 52. *Mère et enfant*; 53. *La Toilette*; POINTES-SÈCHES EN COULEURS: 54–57. [BR PRINTS 156, 159–61]; EAUX-FORTES, POINTES-SECHES, VERNIS MOU, LITHO-GRAPHIE: 58–109.

St. Louis. Ninth Annual Exhibition of Selected Paintings by American Artists, Sept. 6, City Art Museum of St. Louis. 14. *Child Holding a Little Dog*, lent by Durand-Ruel and Sons [BR 528]

1914–15

Washington, D.C. Fifth Exhibition: Oil Paintings by Contemporary American Artists, Dec. 15, 1914–Jan. 24, 1915, Corcoran Gallery of Art. 73. *Woman Reading in the Garden* [BR 94; cat. 13]; 77. *Woman with a Fan* [BR 80]

1915

Minneapolis. Inaugural Exhibition, Jan. 7–Feb. 7, Minneapolis Institute of Arts. 151. *The Toilet*, lent by The Art Institute of Chicago [BR 205; cat. 72]

Philadelphia. One-hundred-tenth Annual Exhibition, Feb. 7–Mar. 28, Pennsylvania Academy of the Fine Arts. 354. *After the Bath* [possibly BR 384]; 419. *Mother and Child* [BR 408]

New York (a). Loan Exhibition of Masterpieces by Old and Modern Painters for the Benefit of Woman Suffrage, Apr. 6–24, M. Knoedler and Co. OILS: 42. *Femme en robe jaune et deux enfants* [BR 472]; 43. *Femme et enfant vu de dos* [BR 550]; 44. *Lady at the Tea Table* [BR 139]; 45. *Après le bain* [BR 336]; 46. *Mother and Son with Mirror* [BR 338; cat. 87]; 47. *Little Girl Leaning upon Her Mother's Knee* [BR 415; cat. 88]; 48. *Mother and Child* [BR 151]; 49. *Mother and Baby in Pink and Lilac* [BR 504]; 50. *Mother and Baby Reflected in Mirror* [BR 473; cat. 89]; PASTELS: 51. *Mother and Child* [BR 224]; 52. *Sleeping Child* [BR 577]; 53. *Portrait* [BR 489]; 54. *Mère et enfant* [BR 600]; 55. *Mother Playing with Her Baby* [BR 604]; 56. *Family Group* [BR 597]; 57. *Child Asleep on Mother's Shoulder* [BR 599]; 58. *Maternal Love* [BR 189]; 59. *Mother and Child* [BR 195]; hors catalogue [BR 281]

New York (b). Exhibition of Water Colors and Dry Points by Mary Cassatt, Apr. 5–20, Durand-Ruel Gallery. AQUARELLES: 1. *Tête d'enfant*; 2. *Tête d'enfant*; 3. *Tête d'enfant*; 4. *Femme et enfant*; 5. *Femme et enfant*; 6. *Tête de femme*; 7.

Femme et enfant; 8. *Tête d'enfant*; 9. *Femme et enfant*; 10. *Femme et enfant*; 11. *Tête de femme*; 12. *Femme dans un jardin*; 13. *Deux esquisses* (recto et verso); 14. *Femme et enfant*; 15. *Femme et enfant*; 16. *Tête de femme*; 17. *Femme et enfant*; 18. *Femme et enfant*; 19. *Femme et enfant*; 20. *Femme et enfant*; 21. *Femme et enfant*; 22–35. POINTES-SÈCHES: Pointes-sèches en couleurs [BR PRINTS 143–52 (cats. 56–65), 157 (cat. 69), 159, 160, 162]; 36–81. Pointes-sèches

Cincinnati. Twenty-second Annual Exhibition of American Art, May 22–July 31, Cincinnati Art Museum. 121. *Woman Seated in a Garden* [BR 198; cat. 67]; 122. *Children Playing with a Cat* [BR 505]

Buffalo. Tenth Annual Exhibition of Selected Paintings by American Artists, May 22–Aug. 30, Buffalo Fine Arts Academy, Albright Art Gallery. 36. *Little Girl Holding a Dog* [BR 528]

St. Louis. Tenth Annual Exhibition of Selected Paintings by American Artists, Sept. 12, City Art Museum of St. Louis. 31. *A Boating Party*, lent by Messrs. Durand-Ruel [BR 230; cat. 77]

Philadelphia. Thirteenth Annual Philadelphia Water Color Exhibition, and the Fourteenth Annual Exhibition of Miniatures, Nov. 7–Dec. 12, Pennsylvania Academy of the Fine Arts, Philadelphia Water Color Club and the Pennsylvania Society of Miniature Painters. WATERCOLORS: 691. *Head of a Child* [BR 662]; 692. *Mother and Child*; 829. *Mother and Child*; 830. *Mother and Child*; 848. *Head of a Child*; 849. *Mother and Child*

San Francisco. Panama-Pacific International Exposition, Palace of Fine Arts. 3006. *Woman Reading in a Garden* [BR 94; cat. 13]; 3008. *Woman and Child: Rose Scarf* [BR 509]; 3010. *Woman with a Fan* [BR 80; cat. 9]

1915–16

Chicago. Twenty-eighth Annual Exhibition of American Oil Paintings and Sculpture, Nov. 16, 1915–Jan. 2, 1916, The Art Institute of Chicago. 69. *After the Bath* [BR 336]

1916

Philadelphia. One-hundred-eleventh Annual Exhibition, Feb. 6–Mar. 26, Pennsylvania Academy of the Fine Arts. 134. *Woman Sitting in a Garden* [BR 98; cat. 35]

Cincinnati. Twenty-third Annual Exhibition of American Art, May 27–July 31, Cincinnati Art Museum. 4. *Woman and Child with Rose Scarf*, Messrs. Durand-Ruel, New York [BR 509]

St. Louis. Eleventh Annual Exhibition of Selected Paintings by American Artists, Sept. 3, St. Louis Art Museum. 29. *La Leçon de lecture*, lent by Messrs. Durand-Ruel, New York [BR 380]

Chicago. Twenty-ninth Annual Exhibition of American Oil Paintings and Sculpture, Nov. 2–Dec. 7, The Art Institute of Chicago. 51. *Picking Fruit* [BR 197; cat. 68]

Brooklyn. First Annual Exhibition, Nov. 28–Dec. 31, Brooklyn Society of Etchers

1916–17

Washington, D.C. Sixth Exhibition: Oil Paintings by Contemporary American Artists, Dec. 17, 1916–Jan. 21, 1917, Corcoran Gallery of Art. 236. *After the Bath* [BR 334]; 364. *Femme à sa toilette* [BR 543; cat. 90]

1917

Philadelphia (a). One-hundred-twelfth Annual Exhibition, Feb. 4–Mar. 25, Pennsylvania Academy of the Fine Arts. 99. *Woman at Her Toilet* [BR 543; cat. 90]

Worcester. Exhibition of Paintings by Modern French Masters, Worcester Art Museum. 1. [BR 94; cat. 13]

New York. Exhibition of Paintings by Mary Cassatt, Apr. 21–May 5, Durand-Ruel Gallery. 1. *Fillette tenant un petit chien* [BR 528]; 2. *Femme à l'éventail* [BR 80; cat. 9]; 3. *La Lecture* [BR 346]; 4. *La Tasse de thé* [BR 281; cat. 84]; 5. *Femme lisant dans un jardin* [BR 94; cat. 13]; 6. *Les deux soeurs* [BR 237; cat. 73]; 7. *Femme et enfant avec écharpe rose* [BR 509]; 8. *La Leçon de lecture* [BR 380]; 9. *Femme à sa toilette* [BR 543; cat. 90]; 10. *Dans la prairie* [BR 93]; 11. *Enfants jouant avec leur mère* [BR 386]; 12. *La Partie en bateau* [BR 230; cat. 77]; 13. *Mère et enfant*; 14. *L'enfant à l'orange* [BR 220]; 15. *Après le bain* [BR 332]; 16. *Femme et enfant vu de dos*; 17. *Jeune femme cueillant un fruit* [BR 197; cat. 68]; 18. *Fillette au grand chapeau* [BR 345]; 19. *Enfants jouant avec un chat* [BR 505]; 20. *Dans le jardin* [BR 221]

Buffalo. Eleventh Annual Exhibition of Selected Paintings by American Artists, May 12–Sept. 17, Buffalo Fine Arts Academy, Albright Art Gallery. 26. *After the Bath* [BR 332]

Philadelphia (b). Fifteenth Annual Philadelphia Water Color Exhibition, and the Sixteenth Annual Exhibition of Miniatures, Nov. 4–Dec. 9, Pennsylvania Academy of the Fine Arts, Philadelphia Water Color Club and the Pennsylvania Society of Miniature Painters. WATERCOLORS: 575. *Child's Head, No. 1*; 581. *Woman and Child*, [BR 674]; 587. *Child's Head, No. 2*

1919

Detroit. Fifth Annual Exhibition of Paintings by American Artists, Apr. 16–May 31, Detroit Museum of Art. *Woman and Child* [BR 509]

Buffalo. Thirteenth Annual Exhibition of

Selected Paintings by American Artists and a Group of Small Selected Bronzes by American Sculptors, May 24–Sept. 8, Buffalo Fine Arts Academy, Albright Art Gallery. 17. *Mother and Child*, lent by the Worcester Art Museum [BR 406]

Dallas. First Annual Exhibition of Contemporary International Art, Nov. 18–27, Adolphus Hotel, Dallas Art Association. 7. *Young Women Gathering Fruit* [BR 197; cat. 68]

Paris. Exposition d'artistes de l'école américaine, Oct. 6–Nov., Musée national du Luxembourg. "Mère et enfant"[1]

1. *Art et les artistes* 1919.

Philadelphia. Seventeenth Annual Philadelphia Water Color Exhibition, and the Eighteenth Annual Exhibition of Miniatures, Nov. 9–Dec. 14, Pennsylvania Academy of the Fine Arts, Philadelphia Water Color Club and the Pennsylvania Society of Miniature Painters. PASTELS: 439. *Mother and Child*; 440. *The Sisters* [BR 260]; 441. *Mother and Child*

Bilbao. Primera Exposición internacional de pintura y escultura. 79. *Mujer sentada con un niño en sus brazos* [BR 178; cat. 54]

1919–20

Washington, D.C. Seventh Exhibition: Oil Paintings by Contemporary American Artists, Dec. 21, 1919–Jan. 25, 1920, Corcoran Gallery of Art. 65. *Coming from the Bath* [BR 332]; 109. *Girl with a Large Hat* [BR 564]

1920

New York (a). Etchings and Drawings, Feb., Durand-Ruel Gallery. [BR PRINTS 138, 143–52; cats. 56–65]

Philadelphia. Exhibition of Paintings and Drawings by Representative Modern Masters, Apr. 17–May 9, Pennsylvania Academy of the Fine Arts. 7. *Filet* [sic] *de* [sic] *Coiffant*, loaned anonymously [BR 146; cat. 48]; 8. *Young Mother and Her Children*, loaned by Mrs. Anne Thompson [possibly BR 386]; 9. *Young Mother*, loaned anonymously [BR 415; cat. 88]; 10. *In the Theater*, loaned by Mrs. Edgar Scott [BR 62]; 11. *Portrait of a Young Girl*, loaned by Mrs. W. Plunkett Stewart [BR 469]; 12. *Portrait of a Child*, loaned by Mrs. W. Plunkett Stewart [possibly BR 86]; 13. *Portrait of Her Mother*, loaned by Mrs. W. Plunkett Stewart [BR 128]; 14. *Child with a Dog*, loaned by Mrs. W. Plunkett Stewart [BR 81]; 15. *Portrait*, loaned by Mrs. Clement B. Newbold [BR 289]; 16. *Portrait of a Child*, loaned by Mrs. J. Gardner Cassatt [BR 287]; 17. *Woman with Two Children*, loaned by Mrs. J. Gardner Cassatt [possibly BR 502]; 18. *Mother and Child*, loaned by Mrs. J. Gardner Cassatt [BR 471]; 19–40. Etchings and etchings in color, loaned by Mrs. J. Gardner Cassatt; 41. *Portrait of a Child*, loaned

by Mr. Robert Kelso Cassatt [possibly BR 119]; 42. *Portrait of a Child*, loaned by Mr. Robert Kelso Cassatt [possibly BR 568]; 43. *Portrait: Alexander J. Cassatt*, loaned by Mr. Robert Kelso Cassatt [BR 79, 126, or 150]; 44. *Portrait of Two Children*, loaned by Mrs. J. Gardner Cassatt [BR 302]; 45. *Portrait of Her Mother*, loaned by Mrs. J. Gardner Cassatt [BR 162; cat. 55]; 46. *Family Group*, loaned by Mr. Robert Kelso Cassatt [BR 77]; 47. *Child's Head*, loaned by Mrs. J. Gardner Cassatt [possibly BR 286]

1. For a photograph of the installation, see Philadelphia, Museum of American Art of the Pennsylvania Academy of the Fine Arts, *To Be Modern: American Encounters with Cézanne and Company*, exh. cat. by Sylvia Yount and Elizabeth Johns (1996), p. 17.

Pittsburgh. Nineteenth Annual International Exhibition of Paintings, Apr. 29–June 30, Carnegie Institute. 64. *Coming from the Bath*

Cincinnati. Twenty-seventh Annual Exhibition of American Art, May 29–July 31, Cincinnati Art Museum. 8. *Mother and Child*, pastel [BR 274]

New York (b). Exhibition of Paintings and Pastels by Mary Cassatt, Nov. 15–Dec. 4, Durand-Ruel Gallery. 1. *Fillette au chien* [BR 530]; 2. *Fillette tenant un petit chien* [BR 528]; 3. *Caresse maternelle* [BR 418]; 4. *Dans la prairie* [BR 93]; 5. *Portrait de femme*; 6. *Buste de fillette*; 7. *Femme lisant* [BR 485]; 8. *Femme lisant dans un jardin* [BR 94; cat. 13]; 9. *Maternité*; 10. *Après le bain* [BR 334]; 11. *Mère et enfant* [BR 226]; 12. *La Sortie du bain* [BR 332]; 13. *Jeune Femme et fillette*; 14. *Femme et enfant avec écharpe rose* [BR 509]; 15. *Femme assise* [BR 198; cat. 67]; 16. *La Partie en bateau* [BR 230; cat. 77]; 17. *Dans le jardin* [BR 221]; 18. *Jeune Femme cueillant un fruit* [BR 197; cat. 68]; 19. *Femme vue de face tenant un enfant dans les bras* [BR 601]; 20. *Fillette au grand chapeau* [BR 345]; 21. *Enfants jouant avec leur mère* [BR 386]; 22. *Femme à sa toilette* [BR 543; cat. 90]; 23. *Les deux soeurs* [BR 595]; 24. *L'Enfant à l'orange* [BR 220]; 25. *Femme vue de dos tenant un enfant dans les bras*

1921

New York. Etchings by Mary Cassatt, Jan. 28–Feb. 26, Grolier Club.¹ Traveled to Chicago, Sept. 1922, The Art Institute of Chicago.² [BR PRINTS 143–52; cats. 56–65]

1. See *New York Times Book Review and Magazine* 1921b.
2. See *Arts and Decoration* 1922.

Pittsburgh. Twentieth Annual International Exhibition of Paintings, Apr. 28–June 30, Carnegie Institute. 49. *Woman Reading*

Dallas. Second Annual Exhibition of American and European Art, Apr. 7–21, Adolphus Hotel, Dallas Art Association. 24. *Mother and Child*, lent anonymously; 25. *Mother and Baby*, lent anonymously; 26. *After the Bath*, courtesy of Durand-Ruel Gallery

[BR 336]; 26 (a, b). Color etchings, lent by Miss Mary Livingston Willard

1921–22

Washington, D.C. Eighth Exhibition of Oil Paintings by Contemporary American Artists, Dec. 18, 1921–Jan. 22, 1922, Corcoran Gallery of Art. 224. *Young Mother with Two Children* [BR 501]

1922

New York (a). Five Paintings, Four Pastels, and Etchings by Mary Cassatt, Jan.–Feb., The Metropolitan Museum of Art. "A ∏Cup of Tea" [BR 65; cat. 33]¹

1. *New York Times* 1922.

New York (b). Modern Prints by Daumier, Delacroix, Degas, Forain, Manet, Corot, Millet, Pissarro, Cézanne, Steinlen, John, Cassatt, Davies, Feb. 3–Mar. 4, Frederick Keppel and Co. 109–21. Drypoints, soft-grounds, aquatints, and etchings (some in color)

Pittsburgh (a). Twenty-first Annual International Exhibition of Paintings, Apr. 27–June 15, Carnegie Institute. 25. *Portrait of a Little Girl*

Buffalo. Sixteenth Annual Exhibition of Selected Paintings by American Artists and a Group of Small Selected Bronzes by American Sculptors, Apr. 9–June 12, Buffalo Academy of Fine Arts, Albright Art Gallery. 46. *Young Mother with Two Children* [BR 501]

Paris. Exposition d'oeuvres de grands maîtres du dix-neuvième siècle, May 3–June 3, Galerie Paul Rosenberg. 4. *Fillette assise dans un fauteuil*, pastel appartient à MM. Durand-Ruel

Concord. Sixth Annual Exhibition, May 14–29, Concord Art Association, Town Hall. 15. *Mother and Child*

Pittsburgh (b). Exhibition of Art and Science in Gardens, June 18–July 31, Carnegie Institute. 26. *Two Women in the Garden* [BR 197; cat. 68]

1923

New York. Exhibition of Paintings, Pastels, Drypoints and Watercolors by Mary Cassatt, Apr. 28, Durand-Ruel Gallery. PAINTINGS AND PASTELS: 1. *Enfants jouant avec leur mère* [BR 386]; 2. *Femme vue de face tenant un enfant dans les bras*; 3. *Les deux soeurs* [BR 237; cat. 73]; 4. *Jeune Mère et ses deux enfants* [BR 501]; 5. *Mère et enfant*; 6. *Femme vue de dos tenant un enfant dans ses bras*; 7. *Enfants jouant avec un chat* [BR 505]; 8. *Femme à sa toilette* [BR 543; cat. 90]; 9. *Femme lisant*; 10. *Fillette au chien* [BR 530]; 11. *Caresse maternelle* [BR 418]; 12. *Dans la prairie* [BR 93]; 13. *La Partie en*

bateau [BR 230; cat. 77]; 14. *La Lecture* [BR 346]; 15. *Buste de fillette*; 16. *Fillette au grand chapeau* [BR 345]; 17. *Femme à l'éventail* [BR 80; cat. 9]; ETCHINGS AND DRYPOINTS: 18–56; WATERCOLORS: 57. *Tête de fillette*; 58. *Bébé*; 59. *Femme dans un jardin*; 60. *Femme et enfant*; 61. *Tête de femme*; 62. *Tête d'enfant*; 63. *Tête d'enfant*; 64. *Femme et enfant*; 65. *Femme et enfant*; 66. *Femme et enfant*; 67. *Tête d'enfant*; 68. *Tête d'enfant*; 69. *Tête de femme*; 70. *Tête d'enfant*; 71. *Femme et enfant*; 72. *Femme et enfant*

Concord. [Seventh] Annual Exhibition of Paintings and Sculpture, May 6–June 3, Concord Art Association, Concord Art Centre. 9. *After the Bath*, lent by Messrs. Durand-Ruel [BR 333]

London. Nineteenth-Century French Painters, June 26–July 21, M. Knoedler and Co. 4. *The Nurse* [BR 57; cat. 12]

Cleveland. Etchings, Drypoints, and Drawings by Mary Cassatt, Oct. 31–Dec. 9, Cleveland Museum of Art. Hartshorne Collection of prints and drawings; "several prints and drawings lent by Charles T. Brooks"; "Femme appuyée sur la main droite" [BR 571]; "La Sortie du bain" [BR 384]¹

1. *Bulletin of the Cleveland Museum of Art* 1923.

1923–24

Washington, D.C. Ninth Exhibition of Contemporary American Oil Paintings, Dec. 16, 1923–Jan. 20, 1924, Corcoran Gallery of Art. 113. *Portrait of a Lady* [BR 542]

1924

Paris. Exposition de tableaux et pastels par Mary Cassatt, Mar., Galerie Durand-Ruel. 4. [BR 531]; 6. [BR 239; cat. 80]; 8. [BR 598]; 9. *En bateau* [BR 524]; 19. *Fillette assise sur un banc* [BR 573]; 23. [BR 247]; 25. [BR 549]; 26. [BR 586]; 28. [BR 596]; 30. [BR 189]; 31. [BR 102; cat. 31]; 35. [BR 513]

New York (a). Exhibition of Paintings and Pastels by Mary Cassatt, May 1, Durand-Ruel Gallery. 1. *Jeune Femme en noir* [BR 129; cat. 16]; 2. *Femme à l'éventail* [BR 80; cat. 9]; 3. *Au jardin* [BR 452]; 4. *Femme et fillette*; 5. *Fillette au grand chapeau* [BR 345]; 6. *Portrait de femme tenant un éventail* [BR 250; cat. 66]; 7. *Après le bain* [BR 332]; 8. *Têtes de femme et de bébé*; 9. *Enfant dans un jardin* [BR 424]; 10. *Jeune Mère et ses deux enfants* [BR 501]; 11. *Tête de jeune femme*; 12. *Jeune Femme et enfant* [BR 319]; 13. *Fillette assise sur un banc* [BR 573]; 14. *Enfants jouant avec un chat* [BR 505]; 15. *Fillette au chapeau bleu* [BR 437]; 16. *En bateau* [BR 524]; 17. *Femme assise* [BR 198; cat. 67]; 18. *Enfants jouant avec leur mère* [BR 386]; 19. *Fillette en robe groseille* [BR 587]; 20. *Femme à sa toilette* [BR 543; cat. 90]; 21. *Jeune Fille au corsage rose* [BR 596]; 22. *Les deux soeurs*; 23. *Mère et enfants*; 24. *Tête de fillette*

Concord. [Eighth] Annual Exhibition of Paintings and Sculpture, May 4–July 1, Concord Art Association, Concord Art Centre. 8. *Femme lisant*, lent by Messrs. Durand-Ruel [BR 485]

New York (b). An Important Collection of Paintings, Dec., C. W. Kraushaar Art Galleries. *Head of a Young Girl* [BR 482]

1925

Cincinnati. Thirty-second Annual Exhibition of American Art, May 23–July 31, Cincinnati Art Museum. 4. *Femme à sa toilette* [possbily BR 543; cat. 90]; 5. *Mother and Two Children* [BR 501]; 214–19. Etchings

Chicago. Thirty-eighth Annual Exhibition of American Paintings and Sculpture, Oct. 29–Dec. 13, The Art Institute of Chicago. 39. *Woman with a Fan* [BR 80; cat. 9]

1925–26

Los Angeles. First Pan-American Exhibition of Oil Paintings, Nov. 27, 1925–Jan. 31, 1926, Los Angeles Museum. 12. *Maternal Caress*, lent by Durand-Ruel [BR 262; cat. 82]

1926

Washington, D.C. Tenth Exhibition of Contemporary American Oil Paintings, Apr. 4–May 16, Corcoran Gallery of Art. 113. *Fillette au grand chapeau* [BR 345]; 125. *Enfants jouant avec un chat* [BR 505]

Buffalo. Twentieth Exhibition of Selected Paintings by American Artists, Apr. 25–June 21, Buffalo Fine Arts Academy, Albright Art Gallery. 21. *Woman with a Fan* [BR 80; cat. 9]

Bibliography

1. Archival Sources

AAA. Mary Cassatt and Cassatt family correspondence in the Frederick Sweet Papers, available on microfilm at the Archives of American Art, Washington, D.C.

AIC. Letters from Mary Cassatt to Bertha Honoré Palmer, Charles Hutchinson, and William French in the Archives of The Art Institute of Chicago.

Frick. Theodore Robinson's unpublished diaries; vol. 1 (Mar. 29, 1892–Feb. 4, 1893) and vol. 2 (Feb. 5, 1893–June 9, 1894). Collection of the Frick Art Reference Library, New York.

Harvard. James Stillman's unpublished diaries; Feb. 17, 1907–Feb. 1916. Houghton Library, Harvard University, Cambridge, Mass.

Hill-Stead. Letters from Mary Cassatt to Ada and Theodate Pope, and to Harris Whittemore (property of the Harris Whittemore, Jr. Trust, Naugatuck, Conn.) in the Hill-Stead Museum Archives, Farmington, Conn.

NGA. Letters from Mary Cassatt to Louisine Havemeyer, available on microfilm in the Library of the National Gallery of Art, Washington, D.C. The original letters are in the Archives of The Metropolitan Museum of Art, New York, and are quoted by courtesy of the Estate of Mrs. John B. Thayer.

PAFA. Letters from Mary Cassatt to Harrison S. Morris in the Archives of the Pennsylvania Academy of the Fine Arts, Philadelphia.

PMA. Cassatt family correspondence and transcriptions of correspondence in the Archives of the Philadelphia Museum of Art.

Travel Diary. Lois Cassatt's unpublished diary; Nov. 18, 1882–Apr. 23, 1883, compiled when Lois and Alexander Cassatt and their four children traveled to London, Paris, and Italy after the death of Lydia Cassatt. Private collection.

2. Frequently Cited Sources

Adler/Garb 1987. Adler, Kathleen, and Tamar Garb, eds. *Berthe Morisot.* Oxford.

Bailly-Herzberg 1980–91. Bailly-Herzberg, Janine, ed. *Correspondance de Camille Pissarro.* 5 vols. Paris.

Bataille/Wildenstein. Bataille, M. L., and Georges Wildenstein. *Berthe Morisot: Catalogue des peintures, pastels et aquarelles.* Paris, 1961.

Berhaut. Berhaut, Marie. *Gustave Caillebotte: Catalogue raisonné des peintures et pastels.* Paris, 1994.

Berhaut 1978. Berhaut, Marie. *Gustave Caillebotte: Sa Vie et son oeuvre.* Paris.

Berson 1996. Berson, Ruth, ed. *The New Painting: Impressionism, 1874–1886. Documentation.* 2 vols. San Francisco.

Biddle 1926. Biddle, George. "Some Memories of Mary Cassatt." *The Arts* 10, 2 (Aug.), pp. 107–11.

Boston 1978. Boston, Museum of Fine Arts. *Mary Cassatt at Home.* Exh. cat.

Boston 1984. Boston, Museum of Fine Arts. *Degas: The Painter as Printmaker.* Exh. cat. by Sue Welsh Reed et al. In addition to texts by these authors, see especially: Douglas Druick and Peter Zegers, "Degas and the Printed Image, 1856–1914," pp. xv–lxxii.

Boston 1989. Boston, Museum of Fine Arts. *Mary Cassatt: The Color Prints.* Exh. cat. by Nancy Mowll Mathews and Barbara Stern Shapiro.

Brame/Reff. Brame, Philippe, and Theodore Reff. *Degas et son oeuvre.* New York/London, 1984.

Breeskin 1948. Breeskin, Adelyn Dohme. *The Graphic Work of Mary Cassatt.* New York.

Breeskin 1970. Breeskin, Adelyn Dohme. *Mary Cassatt: A Catalogue Raisonné of the Oils, Pastels, Watercolors, and Drawings.* Washington, D.C.

Brussels 1993. Brussels, Musée royaux des beaux-arts de Belgique. *Les XX et La Libre Esthétique. Cent ans après/Honderd jaar later.* Exh. cat. by Gisèle Ollinger-Zinque et al.

Burr 1927. Burr, Anna Robeson. *Portrait of a Banker: James Stillman, 1850–1918.* New York.

Chicago 1954. Chicago, The Art Institute of Chicago. *Sargent, Whistler, and Mary Cassatt.* Exh. cat. by Frederick A. Sweet.

Chicago 1997. Chicago, R. S. Johnson Fine Art. *Mary Cassatt.* Sale cat.

Davis 1978. Davis, Patricia T. *End of the Line: Alexander J. Cassatt and the Pennsylvania Railroad.* New York.

Delteil 1906–30. Delteil, Loys. *Le Peintre-graveur illustré: xixe et xxe siècles.* 31 vols. Paris.

Distel 1990. Distel, Anne. *Impressionism: The First Collectors.* Trans. Barbara Perroud-Benson. New York.

Faxon 1982–83. Faxon, Alicia. "Painter and Patron: Collaboration of Mary Cassatt and Louisine Havemeyer." *Woman's Art Journal* 3, 2 (fall 1982–winter 1983), pp. 15–20.

Fernier. Fernier, Robert. *La Vie et l'oeuvre de Gustave Courbet: Catalogue raisonné.* Lausanne, 1978.

Guérin 1945. Guérin, Marcel, ed. *Lettres de Degas.* Paris.

Guérin 1947. Guérin, Marcel, ed. *E. G. H. Degas: Letters.* Trans. Marguerite Kay. Oxford.

Havemeyer 1993. Havemeyer, Louisine W. *Sixteen to Sixty: Memoirs of a Collector.* Ed. Susan Alyson Stein. New York.

Higonnet 1990. Higonnet, Anne. *Berthe Morisot.* New York.

Higonnet 1992. Higonnet, Anne. *Berthe Morisot's Images of Women.* Cambridge, Mass.

Lemoisne. Lemoisne, P. A., *Degas et son oeuvre.* 2 vols. Paris, 1946.

Malingue 1946. Malingue, Maurice, ed. *Lettres de Gauguin à sa femme et à ses amis.* Paris.

Mathews 1984. Mathews, Nancy Mowll, ed. *Cassatt and Her Circle: Selected Letters.* New York.

Mathews 1994. Mathews, Nancy Mowll. *Mary Cassatt: A Life.* New York.

Mondor 1969–85. Mondor, Henri, and Lloyd James Austin, eds. *Stéphane Mallarmé Correspondance.* Vols. 3–11. Paris. 1969–85.

New York 1993. New York, The Metropolitan Museum of Art. *Splendid Legacy: The Havemeyer Collection.* Exh. cat. by Alice Cooney et al. See especially: Gary Tinterow, "The Havemeyer Pictures," pp. 2–53; H. Barbara Weinberg, "Four Pastels of Havemeyer Women: Louisine, Electra, Adaline," pp. 84–87; Rebecca A. Rabinow, "The Suffrage Exhibition of 1915," pp. 88–95; Susan Alyson Stein, "Chronology," pp. 199–287; and Gretchen Wold, "Appendix," pp. 289–384.

New York 1997. New York, The Metropolitan Museum of Art. *The Private Collection of Edgar Degas.* Exh. cat. by Ann Dumas et al. See especially: Barbara Stern Shapiro, "A Printmaking Encounter," pp. 234–45; and Susan Alyson Stein, "The Metropolitan Museum's Purchases from the Degas Sales: New Acquisitions and Lost Opportunities," pp. 270–91.

Ottawa 1988. Ottawa, National Gallery of Canada. *Degas.* Exh. cat. by Jean Sutherland Boggs et al.

Philadelphia 1985. Philadelphia Museum of Art. *Mary Cassatt and Philadelphia.* Exh. cat. by Suzanne G. Lindsay.

Pissarro/Venturi. Pissarro, Ludovic Rodolpho, and Lionello Venturi. *Camille Pissarro: Son art, son oeuvre.* 2 vols. Paris, 1939.

Pollock 1980. Pollock, Griselda. *Mary Cassatt.* New York.

Randall 1979. Randall, Lillian M. C., ed. *The Diary of George A. Lucas: An American Art Agent in Paris, 1857–1909.* 2 vols. Princeton.

Rewald 1972. Rewald, John, ed. *Camille Pissarro: Letters to His Son Lucien.* Mamaroneck, New York.

Rewald. Rewald, John, in collaboration with Walter Feilchenfeldt and Jayne Warman. *The Paintings of Paul Cézanne: A Catalog Raisonné.* New York, 1996.

Rouart 1950. Rouart, Denis, ed. *Correspondance de Berthe Morisot.* Paris.

Rouart/Wildenstein. Rouart, Denis, and Daniel Wildenstein. *Edouard Manet: Catalogue Raisonné.* Lausanne, 1975.

San Francisco 1986. San Francisco, The Fine Arts Museums of San Francisco. *The New Painting: Impressionism, 1874–1886.* Exh. cat. by Charles S. Moffett et al. See especially: Ronald Pickvance, "Contemporary Popularity and Posthumous Neglect," pp. 243–65; and Joel Isaacson, "The Painters Called Impressionists," pp. 375–93.

Sweet 1966. Sweet, Frederick A. *Miss Mary Cassatt: Impressionist from Pennsylvania.* Norman, Okla.

Ticknor 1927–28. Ticknor, Caroline. *May Alcott: A Memoir.* Boston.

Venturi 1939. Venturi, Lionello. *Les Archives de l'impressionnisme.* 2 vols. Paris/New York.

Vollard 1978. Vollard, Ambroise. *Recollections of a Picture Dealer.* Trans. Violet M. MacDonald. London.

Weitzenhoffer 1986. Weitzenhoffer, Frances. *The Havemeyers: Impressionism Comes to America.* New York.

Wildenstein. Wildenstein, Daniel. *Monet: Catalogue raisonné.* 4 vols. Paris, 1996.

3. Lifetime Bibliography

1861

Hume. "Woman's Position in Art." *The Crayon* 8, 2 (Feb.), pp. 25–28.

1868

Ryan. "France: American Artists at the Salon." *New York Times*, June 7, p. 8.

1872

H. B. "Art in Paris." *New York Times*, June 30, p. 3.

H. C. S. "Sketches of Philadelphia." *Lippincott's Magazine* 9 (May), pp. 505–21.

[S]hinn, [E]arl (a). "The First American Art Academy, pt. 1." *Lippincott's Magazine* 9 (Feb.), pp. 143–53.

[S]hinn, [E]arl (b). "The First American Art Academy, pt. 2" *Lippincott's Magazine* 9 (Mar.), pp. 309–32.

[S]hinn, [E]arl (c). "Private Art Collections of Philadelphia I—Mr. James L. Claghorn Gallery." *Lippincott's Magazine* 9 (Apr.), pp. 443–53.

[S]hinn, [E]arl (d). "Private Art Collections of Philadelphia VIII—Mr. Henry C. Carey." *Lippincott's Magazine* 10 (Oct.), pp. 454–58.

1873

G. G. "Art in France." *New York Times*, June 16, p. 1.

1874

The Nation. "The National Academy Exhibition II." 18, 463 (May 14), pp. 320–21.

STOP (pseud. for L. P. G. B. Morel-Retz). "Ces rousses ont un éclat!" *Journal amusant*, June 27.

1875

Journal amusant. "Mlle Mary Cassatt. Ce qui me charme dans l'enfance, c'est la naïveté." June 26.

1876

Art Journal. "Academy of the Fine Arts, Philadelphia." 2, p. 202.

1877

Mauris, Maurice. "The Fan." *Scribner's Monthly Magazine* 14, 3 (Sept.), pp. 589–99.

1878

Boston Daily Evening Transcript. "The M. C. M. A. Exhibition: The Art Gallery—The Oil Paintings." Sept. 3, p. 4.

Lefort, Paul. "Exposition universelle: Les Ecoles étrangères de peinture." *Gazette des beaux-arts* 18, pp. 470–85.

New York Times (a). "Open on Sunday." Mar. 10, p. 7.

New York Times (b). "Old and Young Painters." Mar. 17, p. 5.

New York Times (c). "The World's Fair at Paris." May 16, p. 2.

Philadelphia Daily Evening Telegraph. "The Fine Arts: The Spring Exhibition of the Academy of the Fine Arts—Second Notice." Apr. 25, p. 4.

Philadelphia Times. "The Fine Arts: Forty-ninth Annual Exhibition of the Pennsylvania Academy." Apr. 24, p. 2.

1879

American Register. "The Exhibition of Independent Artists." May 17, p. 6 (Berson 1996, vol. 1, p. 209).

Bachaumont. "Notes parisiennes." *Le Sportsman*, Apr. 12, p. 2 (Berson 1996, vol. 1, pp. 210–11).

Benjamin, S. G. W. "Present Tendencies of American Art." *Harper's New Monthly Magazine* 58, 346 (Mar.), pp. 481–96.

Bertall. "Exposition des indépendants: Ex–Impressionnistes, demain intentionistes." *L'Artiste* 99 (June 1), pp. 396–98 (Berson 1996, vol. 1, pp. 212–13).

Besson, Louis. "MM. les Impressionnistes." *L'Evénement*, Apr. 11, p. 2 (Berson 1996, vol. 1, pp. 213–14).

Brownell, William. "The Art Schools of Philadelphia." *Scribner's Monthly Magazine* 18, 3 (Sept.), pp. 737–50.

B[urty], Ph[ilippe]. "L'Exposition des artistes indépendants." *République française*, Apr. 16, p. 3 (Berson 1996, vol. 1, pp. 209–10).

E. C. "Deux Expositions." *Le Soleil*, Apr. 11, p. 2 (Berson 1996, vol. 1, p. 214).

Carter, Susan N. "Exhibition of the Society of American Artists." *Art Journal* 5 (May), pp. 156–58.

Champier, Victor. "Chronique de l'année." In *L'Année artistique: 1879*. Paris, 1880 (Berson 1996, vol. 1, p. 215).

Le Charivari (a). "Chronique du jour." Apr. 8, p. 2 (Berson 1996, vol. 1, p. 215).

Le Charivari (b). "Chronique du jour." Apr. 11, p. 2 (Berson 1996, vol. 1, p. 215).

La Charivari (c). "Croquis par Cham." Apr. 20, p. 3 (Berson 1996, vol. 1, p. 215).

Le Charivari (d). "Croquis par Cham." Apr. 27, p. 3 (Berson 1996, vol. 1, p. 215).

Claretie, Jules. "Le Mouvement parisien: Les Impressionnistes et les aquarellistes." *Indépendance belge*, Apr. 20, p. 1 (Berson 1996, vol. 1, p. 215).

Duranty, Edmond. "La Quatrième Exposition faite par un groupe d'artistes indépendants." *Chronique des arts et de la curiosité*, no. 16 (Apr. 19), pp. 126–28 (Berson 1996, vol. 1, pp. 218–19).

La France. "Lettres, sciences et beaux-arts." Apr. 10, p. 3.

Le Gaulois (a). "Chroniques parisiennes: Les Indépendants." Apr. 11, p. 2.

Le Gaulois (b), Apr. 18, p. 2.

Havard, Henry. "L'Exposition des artistes indépendants." *Le Siècle*, Apr. 27, p. 3 (Berson 1996, vol. 1, pp. 222–24).

Hervilly, Ernest d'. "Exposition des impressionnistes." *Le Rappel*, Apr. 11, p. 2 (Berson 1996, vol. 1, p. 214).

Houssaye, Arsène. See Syène, F. C. de.

Lafenestre, George. "Les Expositions d'art: Les Indépendants et les aquarellistes." *Revue des deux mondes* 33 (May 15), pp. 478–85 (Berson 1996, vol. 1, pp. 225–27).

Lejeune, L. "The Impressionist School of Painting." *Lippincott's Magazine* 24 (Dec.), pp. 720–27.

Leroy, Louis. "Beaux-arts." *Le Charivari*, Apr. 17, p. 2 (Berson 1996, vol. 1, pp. 227–28).

Leude, Jean de la (a). "Les Ratés de la peinture (les indépendants)." *La Plume*, no. 9 (May 1), pp. 65–66 (Berson 1996, vol. 1, p. 228).

Leude, Jean de la (b). "Revue artistique." *La Plume*, no. 10 (May 15), p. 73.

Lostalot, Alfred de. "Exposition des artistes indépendants." *Beaux-arts illustrés* 10, pp. 82–84 (Berson 1996, vol. 1, pp. 228–30).

Martelli, Diego. "I pittori impressionisti francesi: Quarta esposizione." *Roma artistica* (July 5), pp. 178–79 (Berson 1996, vol. 1, pp. 230–31).

Montjoyeux. "Chroniques parisiennes: Les Indépendants." *Le Gaulois*, Apr. 18, p. 1 (Berson 1996, vol. 1, pp. 232–34).

New York Daily Tribune (a). "The Society of American Artists: Second Annual Exhibition—Varnishing Day," Mar. 8.

New York Daily Tribune (b). "The Society of American Artists: Second Annual Exhibition," Mar. 22, p. 5.

New York Times (a). "American Art Methods." Mar. 10, p. 5.

New York Times (b). "Art in Paris." Apr. 27, p. 2.

New York World. "The Society of American Artists." Mar. 27, p. 4.

Petite Presse. "Deux Expositions." Apr. 12, p. 2 (Berson 1996, vol. 1, p. 236).

Petite République française. "Exposition de peinture par un groupe d'artistes dissi-dents." Apr. 13, pp. 2–3 (Berson 1996, vol. 1, pp. 236–37).

Petit Moniteur universel. "L'Exposition des impressionnistes." Apr. 11, p. 2 (Berson 1996, vol. 1, p. 235).

Philadelphia Daily Evening Telegraph. "The Fine Arts: The Spring Exhibition of the Academy—Third Notice." May 6, p. 8.

Philadelphia Inquirer. "Pennsylvania Academy, 50th Annual Exhibition." Apr. 28, p. 4.

Renoir, Edmond. "Les Impressionnistes." *La Presse*, Apr. 11, p. 2 (Berson 1996, vol. 1, p. 237).

Sébillot, Paul. "Revue artistique." *La Plume*, no. 10 (May 15), p. 73 (Berson 1996, vol. 1, pp. 238–39).

Silvestre, Armand (a). "Les Expositions: Des Indépendants." *L'Estafette*, Apr. 16, p. 3 (Berson 1996, vol. 1, p. 239).

Silvestre, Armand (b). "Le Monde des arts: Les Indépendants—Les Aquarellistes." *Vie moderne* (Apr. 24), pp. 38–39 (Berson 1996, vol. 1, pp. 239–40).

Silvestre, Armand (c). "Le Monde des arts." *Vie moderne* (May 1), pp. 52–53 (Berson 1996, vol. 1, pp. 240–41).

Le Soir. "Exposition des impressionnistes." Apr. 12, p. 1 (Berson 1996, vol. 1, p. 241).

Syène, F. C. de (pseud. for Arsène Houssaye). "Salon de 1879." *L'Artiste* 99 (May 1), pp. 289–93 (Berson 1996, vol. 1, p. 242–44).

Le Temps. "Chronique." Apr. 11, p. 2 (Berson 1996, vol. 1, pp. 245–46).

Terade, J. de (a). "L'Exposition des peintres indépendants." *Europe artiste* (Apr. 27), pp. 1–2 (Berson 1996, vol. 1, pp. 244–45).

Terade, J. de (b). "Deuxième Visite aux peintres indépendants." *Europe artiste* (May 4), pp. 1–2 (Berson 1996, vol. 1, p. 245).

Valter, Jehan. "Echos de Paris." *Le Gaulois*, Apr. 10, p. 1.

Vie moderne. "Dans un loge." (Aug. 9), p. 283 (Berson 1996, vol. 1, p. 254).

Le Voltaire (a). "Echos de Paris." Apr. 16, p. 2.

Le Voltaire (b). "Echos de Paris." May 1, p. 1 (Berson 1996, vol. 1, pp. 250–51).

Wolff, Albert. "Les Indépendants." *Le Figaro*, Apr. 11, p. 1 (Berson 1996, vol. 1, p. 51).

X. "Expositions des artistes indépendants, avenue de l'Opera." *Journal des arts* (May 9), p. 2 (Berson 1996, vol. 1, pp. 251–52).

Zola, Emile. "Nouvelles artistiques et litterature (Salon 1879)." *Messager de l'Europe* (July) (Berson 1996, vol. 1, p. 253).

1880

L'Artiste. "Les Impressionnistes." 101 (Feb.), pp. 140–42 (Berson 1996, vol. 1, pp. 265–66).

Baignères, Arthur. "Exposition des oeuvres de M. J. de Nittis: 5ᵉ Exposition de peinture, par MM. Braquemond, Caillebotte, Degas, etc." *Chronique des arts et de la curiosité*, no. 15 (Apr. 10), pp. 117–18 (Berson 1996, vol. 1, pp. 266–67).

Benjamin, S. G. W. (a). "American Watercolor Society: Thirteenth Annual Exhibition." *Art Journal* 6 (Mar.), pp. 91–93.

Benjamin, S. G. W. (b). *Art in America: A Critical and Historical Sketch*. New York.

Bertall (a). "L'Antichambre du salon." *Paris-Journal*, Apr. 3, pp. 1–2 (Berson 1996, vol. 1, pp. 267–68).

Bertall (b). "Les Indépendants: Exposition des ex-impressionnistes, ex-naturalistes, ex-nihilistes, etc., etc.: rue des Pyramides." *Paris-Journal*, Apr. 7, p. 2 (Berson 1996, vol. 1, pp. 268–69).

Burty, Ph[ilippe]. "Exposition des oeuvres des artistes indépendants," *République française*, Apr. 10, p. 2 (Berson 1996, vol. 1, pp. 269–70).

Cardon, Emile. "Choses d'art: L'Exposition des impressionnistes." *Le Soleil*, Apr. 5, p. 3 (Berson 1996, vol. 1, pp. 270–71).

Champier, Victor. "La Société des artistes indépendants." In *L'Année artistique: 1880–1881*. Paris, 1881 (Berson 1996, vol. 1, p. 271).

Le Charivari. "Croquis par Pif." Apr. 11, p. 3 (Berson 1996, vol. 1, p. 304).

Charry, Paul de. "Le Salon de 1880: Préface: Les Impressionnistes." *Le Pays*, Apr. 10, p. 3 (Berson 1996, vol. 1, pp. 271–73).

Claretie/Havard. Claretie, Jules, and Victor Havard, eds. *La Vie à Paris 1880*. Paris.

Claretie, Jules. "La Vie à Paris: M. de Nittis et les impressionnistes." *Le Temps*, Apr. 6, p. 3 (Berson 1996, vol. 1, pp. 273–74).

Dalligny, Aug[uste]. "L'Exposition de la rue des Pyramides." *Journal des arts* (Apr. 16), p. 1 (Berson 1996, vol. 1, pp. 274–75).

Delaville, Camille. "Chronique parisienne: Débauche de peinture." *La Presse*, Apr. 2, pp. 1–2 (Berson 1996, vol. 1, pp. 275–76).

E[cherac], A[rthur d']. "L'Exposition des impressionnistes." *La Justice*, Apr. 5, p. 2 (Berson 1996, vol. 1, p. 276).

Enault, Louis. "Chronique: XVII." *Moniteur des arts*, no. 1319 (Apr. 23), p. 1 (Berson 1996, vol. 1, pp. 276–77).

Ephrussi, Charles. "Exposition des artistes indépendants." *Gazette des beaux-arts* 21, 373 (May 1), pp. 485–88 (Berson 1996, vol. 1, pp. 277–79).

Esmond, Henry. "Les Expositions: Les Artistes indépendants." *Europe artiste* (May 2), p. 1 (Berson 1996, vol. 1, pp. 279–80).

L'Evénement. "Echos de Paris." Apr. 5, p. 1 (Berson 1996, vol. 1, p. 308).

Flor, Charles. "Les Ateliers de Paris: Les Impressionnistes." *Le National*, Apr. 16, pp. 2–3 (Berson 1996, vol. 1, pp. 280–81).

Fouquier, Henry. "Chronique." *XIXème Siècle* (Apr. 10), p. 2 (Berson 1996, vol. 1, p. 281).

La France. "Lettres, sciences et beaux-arts." Apr. 2, p. 3 (Berson 1996, vol. 1, p. 282).

Gérôme. "Courrier de Paris." *Universel illustré*, Apr. 24, p. 258.

Goetschy, Gustave. "Indépendants et impressionnistes." *Le Voltaire*, Apr. 6, p. 2 (Berson 1996, vol. 1, pp. 282–83).

Havard, Henry. "L'Exposition des artistes indépendants." *Le Siècle*, Apr. 2, p. 2 (Berson 1996, vol. 1, pp. 284–85).

Hooper, Lucy. "Art Notes from Paris." *Art Journal* 6, pp. 188–90.

Huysmans, J. K. "L'Exposition des indépendants en 1880." In *L'Art moderne*. Paris, 1883 (Berson 1996, vol. 1, pp. 285–93).

Javel, Firmin. "L'Exposition des impressionnistes." *L'Evénement*, Apr. 3, pp. 1–2 (Berson 1996, vol. 1, pp. 294–95).

Journal des arts. "Informations." (Apr. 2) (Berson 1996, vol. 1, p. 295).

J. L. "L'Exposition des impressionnistes." *L'Ordre*, Apr. 6, p. 2 (Berson 1996, vol. 1, pp. 295–96).

Lancelot (a). "Echos de partout." *La Liberté*, Apr. 1 (Berson 1996, vol. 1, p. 296).

Lancelot (b). "Echos de partout." *La Liberté*, Apr. 3 (Berson 1996, vol. 1, p. 296).

M. "Art Abroad." *Artist* 1, 4 (Apr. 15), p. 117.

Mantz, Paul. "Exposition des oeuvres des artistes indépendants." *Le Temps*, Apr. 14, p. 3 (Berson 1996, vol. 1, pp. 296–99).

Moniteur universel (a). "Le Moniteur à Paris: Beaux-arts." Apr. 2, p. 3 (Berson 1996, vol. 1, pp. 300–301).

Moniteur universel (b). "Revue artistique: Les Artistes indépendants." Apr. 12, p. 407 (Berson 1996, vol. 1, pp. 300–301).

Mont, Elie de. "Cinquième Exposition des impressionnistes, 10, rue des Pyramides." *La Civilisation*, Apr. 20, p. 2 (Berson 1996, vol. 1, pp. 301–302).

Mornand, H. "Les Impressionnistes." *Revue littéraire et artistique* (May 1), pp. 67–68 (Berson 1996, vol. 1, p. 303).

New York Times (a). "The New Watercolors." Jan. 31, p. 5.

New York Times (b). "The Water-colors Again." Feb. 1, p. 2.

New York Times (c). "They Hired Their Own Hall." Apr. 26, p. 5.

Passant (a). "Les On-dit." *Le Rappel*, Apr. 2, p. 2 (Berson 1996, vol. 1, p. 304).

Passant (b). "Les On-dit." *Le Rappel*, Apr. 3, p. 2 (Berson 1996, vol. 1, p. 304).

Petit Journal. "Nouvelles artistiques." Apr. 10 (Berson 1996, vol. 1, p. 304).

Renoir, Edmond. "Exposition des impressionnistes." *La Presse*, Apr. 9 (Berson 1996, vol. 1, pp. 305–306).

Silvestre, Armand (a). "Le Monde des arts: Exposition de la rue des Pyramides (premier article)." *Vie moderne* (Apr. 24), pp. 262, 264 (Berson 1996, vol. 1, pp. 306–307).

Silvestre, Armand (b). "Le Monde des arts: Exposition de la rue des Pyramides (suite et fin)." *Vie moderne* (May 1), pp. 275–76 (Berson 1996, vol. 1, pp. 307–308).

Le Soleil. "Nouvelles diverses." Apr. 1 (Berson 1996, vol. 1, p. 308).

Tout-Paris (a). "La Journée parisienne: Impressions d'un impressionniste." *Le Gaulois*, Jan. 24, p. 2 (Berson 1996, vol. 1, pp. 311–12).

Tout-Paris (b). "La Journée parisienne: Les Impressionnistes." *Le Gaulois*, Apr. 2, p. 1 (Berson 1996, vol. 1, pp. 310–11).

Trianon, Henry. "Cinquième Exposition par un groupe d'artistes indépendants." *Le Constitutionnel*, Apr. 8, pp. 2–3 (Berson 1996, vol. 1, pp. 312–14).

Vachon, Marius. "Les Artistes indépendants." *La France*, Apr. 3, p. 2 (Berson 1996, vol. 1, pp. 314–15).

Véron, Eugène. "Cinquième Exposition des indépendants." *L'Art* 21, pp. 92–94 (Berson 1996, vol. 1, pp. 315–18).

Véron, Pierre. "Courrier de Paris." *Monde illustré*, Apr. 10, p. 219 (Berson 1996, vol. 1, p. 318).

Wolff, Albert. "Beaux-arts: Les Impressionnistes." *Le Figaro*, Apr. 9, pp. 1–2 (Berson 1996, vol. 1, p. 318).

Zadig. "Echos de Paris." *Le Voltaire*, Apr. 3, p. 2 (Berson 1996, vol. 1, p. 319).

1881

Alisy, René d'. "Exposition d'artistes indépendants." *Monde artiste* (Apr. 16), pp. 3–4 (Berson 1996, vol. 1, p. 329).

L'Art. "Expositions." 25, pp. 40–42 (Berson 1996, vol. 1, pp. 329–30).

Art moderne (Brussels). "Nouvelles artistiques parisiennes." 1, 8 (Apr. 24), pp. 62–63.

Bertall. "Exposition: Des Peintres intransigeants et nihilistes: 36, boulevard des Capucines." *Paris-Journal*, Apr. 21, pp. 1–2 (Berson 1996, vol. 1, pp. 330–31).

Brownell, William C. "The Younger Painters of America III." *Scribner's Monthly Magazine* 22, 3 (July), pp. 322–34.

Cardon, Emile. "Choses d'art: L'Exposition des artistes indépendants." *Le Soleil*, Apr. 7, pp. 3–4 (Berson 1996, vol. 1, pp. 331–32).

La Caricature. "Le Mois comique, par Trock." Apr. 23, p. 130 (Berson 1996, vol. 1, p. 369).

Champier, Victor. "La Société des artistes indépendants." In *L'Année artistique: 1881*. Paris, 1882 (Berson 1996, vol. 1, pp. 332–33).

Le Charivari (a). "Croquis par Pif." Apr. 10, p. 3 (Berson 1996, vol. 1, p. 364).

Le Charivari (b). "Croquis par Pif." Apr. 24, p. 3 (Berson 1996, vol. 1, p. 364).

Charry, Paul de. "Les Indépendants." *Le Pays*, Apr. 22, p. 3 (Berson 1996, vol. 1, pp. 333–34).

Chronique des arts et de la curiosité. "Exposition des artistes indépendants." No. 14 (Apr. 2), pp. 109–10.

Claretie, Jules. "La Vie à Paris: Les Artistes indépendants." *Le Temps*, Apr. 5, p. 3 (Berson 1996, vol. 1, pp. 334–35).

Comtesse Louise. "Lettres familières sur l'art: Salon de 1881." *France nouvelle* (May 1–2), pp. 2–3 (Berson 1996, vol. 1, pp. 355–56).

Dalligny, Auguste. "Les Indépendants: Sixième Exposition." *Journal des arts* (Apr. 8), p. 1 (Berson 1996, vol. 1, pp. 335–36).

Domino. "Echos de Paris." *Le Gaulois*, Apr. 3, p. 1 (Berson 1996, vol. 1, p. 336).

Enault, Louis. "Chronique." *Moniteur des arts* (Apr. 15), p. 1 (Berson 1996, vol. 1, p. 339).

Enjoiras. "Causerie artistique: Exposition des artistes indépendants." *L'Intransigeant*, Apr. 12, p. 3 (Berson 1996, vol. 1, pp. 339–41).

E[phrussi], C[harles] (a). "Exposition des artistes indépendants." *Chronique des arts et de le curiosité*, no. 16 (Apr. 16), pp. 126–27 (Berson 1996, vol. 1, pp. 336–37).

E[phrussi], C[harles] (b). "Exposition des peintres indépendants." *Chronique des arts et de la curiosité*, no. 17 (Apr. 23), pp. 134–35 (Berson 1996, vol. 1, pp. 337–39).

G[effroy], G[ustave] (a). "L'Exposition des artistes indépendants." *La Justice*, Apr. 4, p. 3 (Berson 1996, vol. 1, pp. 341–42).

Geffroy, Gustave (b). "L'Exposition des artistes indépendants." *La Justice*, Apr. 19, p. 3 (Berson 1996, vol. 1, pp. 342–44).

Goetschy, Gustave. "Exposition des artistes indépendants." *Le Voltaire*, Apr. 5, pp. 1–2 (Berson 1996, vol. 1, pp. 344–45).

Gonzague-Privat. "L'Exposition des artistes indépendants." *L'Evénement*, Apr. 5, pp. 2–3 (Berson 1996, vol. 1, pp. 345–46).

Havard, Henry. "L'Exposition des artistes indépendants." *Le Siècle*, Apr. 3, p. 2 (Berson 1996, vol. 1, pp. 346–47).

Hoschedé, E. "Les Femmes artistes." *Art de la mode* (Apr. 2), pp. 54–59 (Berson 1996, vol. 1, pp. 347–48).

Huysmans, J. K. "L'Exposition des indépendants en 1881." In *L'Art moderne*. Paris, 1883 (Berson 1996, vol. 1, pp. 348–55).

Journal amusant. "Au long cours, de Paris à St.-Germain." Apr. 30, p. 5 (Berson 1996, vol. 1, p. 373).

Mantz, Paul. "Exposition des oeuvres des artistes indépendants." *Le Temps*, Apr. 23, p. 3 (Berson 1996, vol. 1, pp. 356–59).

Michel, André. "Exposition des artistes indépendants." *Le Parlement*, Apr. 5, p. 3 (Berson 1996, vol. 1, pp. 359–60).

Moniteur universel. "Chronique des arts: Les Ateliers des jeunes." Apr. 2, p. 3 (Berson 1996, vol. 1, p. 360).

Mont, Elie de. "L'Exposition du boulevard des Capucines." *La Civilisation*, Apr. 21, p. 2 (Berson 1996, vol. 1, pp. 360–62).

New York Times (a). "The Academy Exhibition." Mar. 20, p. 2.

New York Times (b). "The American Artists." Mar. 27, p. 2.

L'Opinion. "Echos de Paris" (Apr. 5), p. 1 (Berson 1996, vol. 1, p. 362).

Our Lady Correspondent. *Artist* 2, 17 (May 1), p. 153.

Palette. "Les Expositions particulières." *Paris-Moderne* 1, 4 (Apr. 15), pp. 71–72 (Berson 1996, vol. 1, pp. 362–63).

Petit Journal (a). "Nouvelles artistiques." Apr. 2 (Berson 1996, vol. 1, p. 363).

Petit Journal (b). "Nouvelles artistiques: Les Impressionnistes." Apr. 4, p. 2 (Berson 1996, vol. 1, p. 363).

Petit Parisien. "Beaux-arts: Sixième Exposition des artistes 'indépendants.'" Apr. 8, p. 3 (Berson 1996, vol. 1, pp. 363–64).

Petite Presse. "Exposition des impressionnistes." Apr. 3.

Petite République française. "Petite Chronique." Apr. 14 (Berson 1996, vol. 1, p. 364).

Philadelphia Record. "Academy of the Fine Arts." Apr. 4, p. 4.

La Presse. "Echos du jour." Apr. 4, p. 1 (Berson 1996, vol. 1, p. 364).

Silvestre, Armand (a). "Sixième Exposition des artistes indépendants." *L'Estafette*, Apr. 11, p. 3 (Berson 1996, vol. 1, pp. 364–65).

Silvestre, Armand (b). "Le Monde des arts: Sixième Exposition des artistes indépendants." *La Vie moderne* (Apr. 16), pp. 250–51 (Berson 1996, vol. 1, pp. 365–66).

Sphinx. *L'Evénement*, Apr. 3.

Strahan, Edward. "Works of American Artists Abroad: The Second Philadelphia Exhibition." *Art Amateur* 6, 1 (Dec.), pp. 4–6.

Trianon, Henry. "Sixième Exposition de peinture par un groupe d'artistes: 35, boulevard des Capucines." *Le Constitutionnel*, Apr. 24, pp. 2–3 (Berson 1996, vol. 1, pp. 366–69).

Valabrègue, Antony. "Beaux-arts: L'Exposition des impressionnistes." *Revue littéraire et artistique* (Apr. 15), pp. 180–81 (Berson 1996, vol. 1, pp. 369–70).

Vernay. "Les Impressionnistes." *Le Soir*, Apr. 4, p. 2 (Berson 1996, vol. 1, p. 370).

Villars, Nina de. "Exposition des artistes indépendants." *Courrier du soir*, Apr. 23 (Berson 1996, vol. 1, pp. 370–71).

Wolff, Albert. "Courrier de Paris." *Le Figaro*, Apr. 10, p. 1 (Berson 1996, vol. 1, pp. 371–72).

X. "Exposition des artistes indépendants." *Chronique des arts et de la curiosité*, 11 (Apr. 2), pp. 109–10 (Berson 1996, vol. 1, p. 372).

1882

Biez, Jacques de. "Les Petits Salons: Les 'Indépendants.'" *Paris*, Mar. 8, p. 2 (Berson 1996, vol. 1, pp. 380–81).

Bigot, Charles. "Beaux-arts: Les Petits Salons: L'Exposition des artistes indépendants." *Revue politique et littéraire* (Mar. 4), pp. 281–82 (Berson 1996, vol. 1, p. 381).

Claretie, Jules. "La Vie à Paris: Les Indépendants." *Le Temps*, Mar. 3, p. 3 (Berson 1996, vol. 1, p. 386).

Fare. "Chez les Impressionnistes." *Le Gaulois*, Feb. 23, pp. 1–2 (Berson 1996, vol. 1, pp. 399–400).

Gérôme. "Courrier de Paris: L'Exposition des peintres indépendants." *Univers illustré*, Mar. 18, p. 163 (Berson 1996, vol. 1, pp. 389–90).

Havard, Henry. "Exposition des artistes indépendants." *Le Siècle*, Mar. 2, p. 2 (Berson 1996, vol. 1, pp. 391–92).

Hustin, A. "L'Exposition des impressionnistes." *Moniteur des arts* (Mar. 10), p. 1 (Berson 1996, vol. 1, pp. 395–96).

New York Times. "Art Notes." Apr. 2, p. 6.

Rivière, Henri. "Aux Indépendants." *Chat noir* (Apr. 8), p. 4 (Berson 1996, vol. 1, p. 409).

Sallanches, Armand. "L'Exposition des artistes indépendants." *Journal des arts* (Mar. 3), p. 1 (Berson 1996, vol. 1, p. 412).

Silvestre, Armand. "Le Monde des arts: Expositions particulières: Septième Exposition des artistes indépendants." *Vie moderne* (Mar. 11), pp. 150–51 (Berson 1996, vol. 1, pp. 413–14).

The Standard. "The 'Impressionists.'" July 1, p. 3. Repr. in Flint, Kate, ed. *Impressionists in England: The Critical Reception*. London, 1984, pp. 44–46.

M. V. "Beaux-arts, lettres et sciences." *La France*, Mar. 3, p. 3 (Berson 1996, vol. 1, p. 415).

1883

Artist. 4, 41 (May 1), pp. 137–38.

Blackburn, Henry, ed. "Les Impressionnistes, 1883." In *Academy Sketches*, p. 155. London.

The Century. "Bacon's Parisian Art and Artists." 25, 4 (Feb.), p. 628.

Daily Telegraph. "Société des impressionnistes." Apr. 26, p. 4.

Forgue, Jules La. "Critique d'art." In *Mélanges posthumes*. Paris.

Huysmans, Joris Karl. *L'Art moderne*. Paris.

New York Times (a). "The Society of American Artists." Apr. 8, p. 4.

New York Times (b). "Art Notes." May 13, p. 12.

Pigeon, Amadée. *Le Figaro*, Oct. 31.

Wedmore, Frederick (a). "The Impressionists." *Fortnightly Review* 33 (Jan.), pp. 75–82. Repr. in Flint, Kate, ed. *Impressionists in England: The Critical Reception*. London, 1984, pp. 46–55.

Wedmore, Frederick (b). *The Standard*, Apr. 25, p. 2.

1884

Fénéon, Félix. "Exposition du cercle artistique de la Seine." *Libre Revue*, Jan. 16. Repr. in Fénéon, Félix. *Oeuvres plus complètes*, ed.

Jason U. Halperin, vol. 1, p. 72. Geneva, 1970.

L[ichtwark], A[lfred]. "Kunstausstellung: Die Parisen Impressionisten in Gurlitt's Salon." *Die Gegenwart* 24, 51, pp. 400–401.

Mirbeau, Octave. "Notes sur l'art." *La France*, Nov. 15.

1885

Conant, Cornelia W. "An Art Student in Ecouen." *Harper's New Monthly Magazine* 70, 417 (Feb.), pp. 388–99.

1886

Adam, Paul. "Peintres impressionnistes." *Revue contemporaine: Littéraire, politique et philosophique* 4 (Apr.), pp. 541–51 (Berson 1996, vol. 1, pp. 427–30).

Ajalbert, Jean. "Le Salon des impressionnistes." *Revue moderne* (June 20), pp. 385–93 (Berson 1996, vol. 1, pp. 430–34).

Auriol, George. "Huitième Exposition." *Chat noir* (May 22), p. 708 (Berson 1996, vol. 1, pp. 434–35).

The Bat. "Half-a-Dozen Enthusiasts." (May 25), pp. 185–86.

Christophe, Jules. "Chronique; rue Laffitte, No. 1." *Journal des artistes* (June 13), pp. 193–94 (Berson 1996, vol. 1, pp. 436–37).

Chronique des arts et de la curiosité. "Mouvement des arts." No. 20 (May 15), p. 156 (Berson 1996, vol. 1, p. 437).

Courrier de l'art. "Chronique des expositions: La Société libre des artistes français." 26, 21 (May 21), p. 244 (Berson 1996, vol. 1, p. 437).

Courrier du soir. "Au Jour le jour." May 15, p. 3 (Berson 1996, vol. 1, p. 437).

Dargenty, G. "Les Impressionnistes." *Courrier de l'art* 26, 21 (May 21), pp. 244–45 (Berson 1996, vol. 1, pp. 437–38).

Darzens, Rodolphe. "Chronique artistique: Exposition des impressionnistes." *La Pléiade*, no. 3 (May), pp. 88–91 (Berson 1996, vol. 1, pp. 438–39).

Desclozeaux, Jules. "Chronique: Les Impressionnistes." *L'Opinion*, no. 3182 (May 27), pp. 2–3 (Berson 1996, vol. 1, pp. 439–40).

Eyries, Patrice. "L'Exposition des impressionnistes." *La Nation*, May 21, p. 2 (Berson 1996, vol. 1, pp. 440–41).

F. "Exposition de peinture: 1, rue Laffitte." *Le Gaulois*, May 16, p. 2 (Berson 1996, vol. 1, p. 441).

Fénéon, Félix. "Les Impressionnistes." *La Vogue* (June 13–20), pp. 261–75 (Berson 1996, vol. 1, pp. 441–45).

Fèvre, Henry. "L'Exposition des impressionnistes." *Revue de demain* (May–June), pp. 148–56 (Berson 1996, vol. 1, pp. 445–47).

Fouquier, Marcel. "Les Impressionnistes." *XIXème Siècle* (May 16), p. 2 (Berson 1996, vol. 1, pp. 447–49).

Gazette de France. "Informations." May 15, p. 3 (Berson 1996, vol. 1, p. 449).

Geffroy, Gustave. "Salon de 1886: VIII. Hors du Salon: Les Impressionnistes." *La Justice*, May 26, pp. 1–2 (Berson 1996, vol. 1, pp. 449–52).

H. "Les Impressionnistes." *Journal des arts* (June 11), p. 2 (Berson 1996, vol. 1, p. 452).

Havard, Henry. "La Peinture indépendante: Huitième Exposition des impressionnistes." *Le Siècle*, May 17, pp. 2–3 (Berson 1996, vol. 1, pp. 452–53).

Hennequin, Emile. "Notes d'art: Les Impressionnistes." *Vie moderne* (June 19), pp. 389–90 (Berson 1996, vol. 1, pp. 453–54).

Hermel, Maurice. "L'Exposition de peinture de la rue Laffitte." *France libre*, May 27, pp. 1–2 (Berson 1996, vol. 1, pp. 455–56).

L'Intransigeant. "Beaux-arts." May 15, p. 3 (Berson 1996, vol. 1, pp. 458–59).

Javel, Firmin. "Les Impressionnistes." *L'Evénement*, May 16, p. 1 (Berson 1996, vol. 1, p. 459).

Labruyère. "Les Impressionnistes." *Cri du peuple*, May 28, pp. 1–2 (Berson 1996, vol. 1, pp. 460–61).

La Liberté. "Echos de partout." May 15, p. 3 (Berson 1996, vol. 1, p. 461).

Marx, Roger. "Les Impressionnistes." *Le Voltaire*, May 17, p. 2 (Berson 1996, vol. 1, pp. 461–62).

Maus, Octave. "Les Vingtistes parisiens." *Art moderne* (Brussels) 6, 26 (June 27), pp. 201–204 (Berson 1996, vol. 1, pp. 462–64).

Michel, J. M. "Exposition des impressionnistes." *Petite Gazette*, May 18, p. 2 (Berson 1996, vol. 1, pp. 464–65).

Mirbeau, Octave. "Exposition de peinture (1 rue Laffitte)." *La France*, May 21, pp. 1–2 (Berson 1996, vol. 1, pp. 465–66).

Moniteur des arts. "L'Exposition des indépendants." (May 21), p. 174 (Berson 1996, vol. 1, pp. 466–67).

New York Daily Tribune (a). "The Week in Art Circles." Apr. 5, p. 2.

New York Daily Tribune (b). "Art News and Comments." Apr. 26, p. 3.

Passant. "Les On-dit." *Le Rappel*, May 15, p. 2 (Berson 1996, vol. 1, p. 467).

Paulet, Alfred. "Les Impressionnistes."

Paris, June 5, pp. 1–2 (Berson 1996, vol. 1, pp. 467–70).

Petite République française. "Beaux-arts: Les Artistes indépendants." May 21, p. 2 (Berson 1996, vol. 1, pp. 470–71).

Ravier, A. "Bruits et nouvelles." *La France*, May 15, p. 2 (Berson 1996, vol. 1, p. 471).

République française. "L'Exposition des impressionnistes." May 17, p. 3 (Berson 1996, vol. 1, pp. 471–72).

Le Soir. "Informations: Les Impressionnistes." May 15, p. 2 (Berson 1996, vol. 1, p. 472).

Le Symboliste. "Peintures." (Oct. 22–29).

X. "Les Artistes indépendants." *La Liberté*, May 18, pp. 1–2 (Berson 1996, vol. 1, pp. 473–74).

1887

Child, Theodore. "A Note on Impressionist Painting." *Harper's New Monthly Magazine* 74, 440 (Jan.), pp. 313–15.

New York Times (a). "The Durand-Ruel Picture Sale." May 6, p. 8.

New York Times (b). "Good Prices Realized." May 7, p. 5.

1889

The Collector. "Impressionists and Imitators." 1, 1 (Nov.), p. 11.

Coudray, Jean. "Chronique." *Paris-Croquis*, Feb. 2, p. 2.

Courboin, Françoise. "Les Peintres-graveurs." *L'Artiste* 119 (Feb.), pp. 124–25.

Dalligny, Auguste. "L'Exposition de peintres-graveurs." *Journal des arts* (Jan. 29).

Fénéon, Félix. "Les Peintres-graveurs." *La Cravache*, Feb. 2.

Geffroy, Gustave. "Chronique: Peintres-graveurs." *La Justice*, Feb. 8.

Javel, Firmin. "Les Peintres-graveurs." *Art français* (Feb. 2).

Jourdain, Frantz. "Les Peintres-graveurs chez Durand-Ruel." *Revue indépendante* 10, 27 (Jan.–Feb.), pp. 339–46.

Lostalot, Alfred de (a). "Exposition des peintres-graveurs." *Chronique des arts et de la curiosité*, no. 4 (Jan. 26), p. 25.

Lostalot, Alfred de (b). "Expositions diverses." *Gazette des beaux-arts*, ser. 3, 1 (Mar.), pp. 234–40.

Madsen, Karl. *Politiken*, Nov. 9.

Marcello. "Expositions des peintres-graveurs." *Le Soir*, Jan. 24.

Marx, Roger. "Les Peintres-graveurs." *Le Voltaire*, Jan. 29.

Le Matin. "Exposition nouvelle rue Laffitte—Les peintres-graveurs—Les artistes et les oeuvres." Jan. 25, p. 3.

Le Temps. "Les Peintres-graveurs." Jan. 25. Repr. in *Vie artistique* (Feb. 3), pp. 38–39.

1890

Alexandre, Arsène. "Les Peintres-graveurs." *Paris*, Mar. 7.

Antoine, Jules. "Galerie Durand-Ruel—Deuxième exposition des peintres-graveurs." *Art et critique* (Mar. 15), pp. 171–73.

Bénédite, Léonce. "L'Exposition des peintres-graveurs." *L'Artiste* 121 (Mar.), pp. 161–69.

Cardon, Emile. "Exposition des peintres-graveurs." *Moniteur des arts* (Mar. 14), pp. 81–82.

L. D. "Beaux-arts: Exposition des peintres-graveurs." *Mercure de France* 1, 5 (May), p. 174.

Dalligny, Auguste. "La Deuxième Exposition de peintres-graveurs." *Journal des arts* (Mar. 14).

Dargenty, G. "Exposition de dessins et de gravures." *Courrier de l'art* 10, 13 (Mar. 28), pp. 98–99.

Geffroy, Gustave. "Chronique d'art I: Modes de Paris." *Revue d'aujourd'hui* 1, 3 (Mar. 15), pp. 174–78.

Javel, Firmin (a). "Les Peintres-graveurs." *Gil Blas*, Mar. 7, p. 3.

Javel, Firmin (b). "Les Peintres-graveurs." *Art française* (Mar. 15).

Lafage, Paul. "Galerie Durand-Ruel: Exposition des peintres-graveurs." *Le Soir*, Mar. 6.

Lostalot, Alfred de. "L'Exposition des peintres-graveurs." *Chronique des arts et de la curiosité*, no. 11 (Mar. 15), p. 82.

Miles, L. Roger. "Le Salon des peintres-graveurs." *L'Evénement*, Mar. 11.

New York Times, Oct. 12, p. 4.

Portalis, Baron Roger. "La Gravure en couleur." *Gazette des beaux-arts*, ser. 3, 3 (Feb.), pp. 118–28.

Rambaud, Yveling B. "Miss Cassatt." *Art dans les deux mondes* no. 1 (Nov. 22), pp. 1, 7.

Sertat, Raoul (a). "Les Peintres-graveurs—Exposition E. Petitjean." *Journal des artistes* (Mar. 10), pp. 73–74.

Sertat, Raoul (b). "Les Peintres-graveurs." *Le Voltaire*, Mar. 16.

Le Télégraphe. "Le Mouvement artistique." Mar. 8.

1891

A. G. A. "Choses d'art." *Mercure de France* 2, 15 (Mar.), p. 189.

Art Collector. "The Woman's Art Club." 2, 9 (Mar. 1), p. 107.

Art Interchange. "Art Gossip." 27 (Nov.), p. 142.

Béraldi, Henri. "Exposition de lithographie." *Gazette des beaux-arts*, ser. 3, 5, p. 486.

Dalligny, Auguste. "L'Exposition de peintres-graveurs français." *Journal des arts* (Apr. 10).

Fénéon, Félix. "Cassatt, Pissarro." *Chat noir* (Apr. 11), p. 1728.

Greta. "Art in Boston: The Wave of Impressionism." *Art Amateur* 24, 6 (May), p. 141.

Geffroy, Gustave. "Pastellistes et peintres-graveurs." *La Justice*, Apr. 28.

P. H. "L'Exposition de Monet à l'Union League Club, New York." *Art dans les deux mondes*, no. 15 (Feb. 28), p. 175.

Lecomte, Georges (a). "A Côté des peintres-graveurs." *Art dans les deux mondes*, no. 22 (Apr. 18), pp. 261–62.

Lecomte, Georges (b). "Expositions à Paris, pastellistes français, peintres-graveurs: Camille Pissarro, Mary Cassatt." *Art moderne* (Brussels) 11, 17 (Apr. 26), pp. 136–37.

Moore, Charles H. "The Modern Art of Painting in France." *Atlantic Monthly* 68, 410 (Dec.), pp. 805–16.

Montezuma. "My Note Book." *Art Amateur* 25, 6 (Nov.), p. 130.

Le Matin. "Les Peintres-graveurs: La troisième exposition de la Société—Les principaux envois." Apr. 5.

New York Times (a). "Art Notes." Feb. 22, p. 13.

New York Times (b). "Colored Prints by Miss Cassatt." Oct. 3, p. 4.

1892

Amateur. "L'Album du salon des XX." *Art moderne* (Brussels) 12, 7 (Feb. 14), p. 51.

Art Interchange. "The Impressionists." 29 (July), pp. 1–7.

Bradford-Whiting, Mary. "Where We Two Parted." *Frank Leslie's Popular Monthly* (June), pp. 535–37. Illustrations by Cassatt.

Brownell, William C. "French Art III—The Realistic Painting." *Scribner's Monthly Magazine* 12, 5 (Nov.), pp. 604–27.

Demolder, Eugène. "Les XX, à Bruxelles." *L'Artiste* 125 (Mar.), pp. 225–29.

Downes, William Howe. "Impressionism in Painting." *New England in Painting*, no. 6 (July), pp. 600–603.

Lecomte, Georges. *L'Art impressionniste d'après la collection privée de M. Durand-Ruel*. Paris.

Marks, Montague. "My Note Book." *Art Amateur* 27, 3 (Aug.), p. 51.

New York Times. "The Society's Retrospect." Dec. 3, p. 4.

Olin, Pierre M. "Les XX." *Mercure de France* 4, 28 (Apr.), pp. 341–45.

Philadelphia Inquirer. "The Stranger at the Art Shows." Feb. 7, p. 16.

R. R. "From Another Point of View." *Art Amateur* 27, 7 (Dec.), p. 5.

Van Rennsalear, Marianna. "Current Questions of Art." *The World*, Dec. 18, p. 24.

W. H. W. (a). "What is Impressionism?" *Art Amateur* 27, 6 (Nov.), pp. 140–41.

W. H. W. (b). "What is Impressionism? II." *Art Amateur* 27, 7 (Dec.), p. 5.

Waern, Cecilia. "Some Notes on French Impressionism." *Atlantic Monthly* 61, 414 (Apr.), pp. 535–41.

1893

Art Amateur (a). "French and American Impressionists." 29, 1 (June), p. 4.

Art Amateur (b). "Women's Work in the Fine Arts." 29, 1 (June), p. 10.

Art français. "Les Expositions: Peintures et gravures de Miss Mary Cassatt." 9, 346 (Dec. 9).

Chronique des arts et de la curiosité. "Councours et expositions." No. 37 (Dec. 2), p. 289.

The Collector. "De Omnibus Rebus." 5, 4 (Dec. 15), p. 55.

Cortissoz, Royal. "Loan Exhibition of Portraits." *Harper's Weekly* 30, 2030 (Nov.), pp. 1089–91.

Ermite, Kalophile. "Chronique des arts: Galerie Durand-Ruel—peintures, pastels, dessins et gravures de Miss Mary Cassatt." *L'Ermitage* 4, 12 (Dec.), p. 373.

Greatorex, Eleanor E. "Mary Fairchild MacMonnies." *Godey's Magazine* 126, 755 (May), pp. 624–32.

Henrotin, Ellen. "Outsider's View of the Women's Exhibit." *Cosmopolitan* 15, 5 (Sept.), pp. 560–66.

Lostalot, Alfred de. "Exposition des oeuvres de Miss Mary Cassatt." *Chronique des arts et de la curiosité*, no. 38 (Dec. 9), p. 299.

Marks, Montague. "My Note Book." *Art Amateur* 28, 2 (Jan.), p. 42.

Mellerio, André. "Exposition Mary Cassatt—Gallery Durand-Ruel, Paris; Nov.–Dec., 1893." Trans. Eleanor B. Caldwell. *Modern Art* 3, 1 (winter), pp. 4–5.

Miller, Florence F. "Art in the Women's Section of the Chicago Exhibition." *Art Journal* 45, suppl., pp. 13–16.

Monroe, Lucy. "Chicago Letter." *The Critic* 22, 582 (Apr. 15), pp. 240–41.

Review of Reviews. "Dress Reform at the Fair." 7 (Apr.), pp. 312–16.

Trumble, Alfred. "Impressionism and Impressions." *The Collector* 4, 14 (May), pp. 213–14.

Wheeler, Candace. "A Dream City." *Harper's New Monthly Magazine* 86, 516 (May), pp. 830–46.

White, Frank L. "Young American Women in Art." *Frank Leslie's Popular Monthly* 36 (Nov.), pp. 538–44.

1894

Art Amateur. "The Impressionists." 30, 4 (Mar.), p. 99.

Hamerton, Philip. "Edouard Manet." *Scribner's Monthly Magazine* 15, 1 (Jan.), pp. 48–51.

Morice, Charles. "Salons et salonettes." *Mercure de France* 10, 49 (Jan.), pp. 62–70.

New York Times (a), Feb. 12, p. 3.

New York Times (b). "Woman's Art Club." Feb. 14, p. 8.

Scudder, Horace E. *Childhood in Literature and Art*. Boston.

1895

Art Amateur. "Minor Exhibitions." 32, 3 (Feb.). p. 128.

The Collector. "Theodore Robinson at the MacBeth Galleries." 6, 8 (Feb.), p. 122.

L. K. "Two Weeks of Paris Gossip." *New York Times*, June 3, p. 28.

Marks, Montague (a). "My Note Book." *Art Amateur* 32, 3 (Feb.), p. 76.

Marks, Montague (b). "My Note Book: Exhibition of the Women's Art Club." *Art Amateur* 32, 4 (Mar.), p. 106.

Marks, Montague (c). "My Note Book: Exhibitions." *Art Amateur* 32, 6 (May), p. 158.

New York Times (a). "Art Notes." Feb. 14, p. 4.

New York Times (b). "Art Notes." Feb. 27, p. 4.

New York Times (c). "Pictures by Mary Cassatt." Apr. 18, p. 4.

New York Times (d). "In the World of Art, Exhibitions of the Week." Apr. 21, p. 13.

New York Times (e). "An Artistic Retrospect." May 11, p. 4.

New York Tribune. "The Chronicle of Arts: Miss Cassatt's Pictures." Apr. 21, p. 25.

Trumble, Alfred. "May-Day Facts and Fancies." *The Collector* 6, 13 (May 1), p. 208.

1896

Hoeber, Arthur. "Plain Talks on Art—Impressionism." *Art Interchange* 37 (July), pp. 5–7.

New York Times Saturday Review of Books and Art. "Magazine Art and Some Others." Dec. 12, p. 8.

Thurber, Martha C. "Impressionism in Art—Its Origins and Influence." *Arts for America* 5, 5 (June), pp. 181–84.

Trumble, Alfred. "News and Views." *The Collector* 8, 4 (Dec.), p. 49.

Walton, William. "Miss Mary Cassatt." *Scribner's Monthly Magazine* 19, 3 (Mar.), pp. 353–61.

1897

Chamberlain, Arthur. "Impressionism and Its Obstacles." *Art Interchange* 38 (Nov.), p. 101.

Nowles, W. L. Everett. "Art and Its Mission." *Arts for America* 7, 2 (Oct.), pp. 70–73.

Scribner's Monthly Magazine. "Impressionism and After." 21, 3 (Mar.), pp. 391–92.

1898

Art Amateur (a). "The National Academy of Design." 38, 6 (May), p. 131.

Art Amateur (b). "Ten American Painters." 38, 6 (May), pp. 133–34.

Marks, Montague. "My Note Book: Exhibitions." *Art Amateur* 38, 5 (Apr.), p. 107.

New York Daily Tribune. "Art Exhibitions: Miss Cassatt." Mar. 15, p. 7.

New York Times Saturday Review of Books and Art. "The Week in the Art World." Mar. 5, p. 158.

Philadelphia Inquirer. "Annual Academy Exhibition Open to the Public Tomorrow." Jan. 9, p. 9.

Riordan, Roger. "Miss Mary Cassatt." *Art Amateur* 38, 6 (May), p. 130.

1899

Fontainas, André. "Revue du mois: Art moderne." *Mercure de France* 29, 109 (Jan.), p. 241.

Hoeber, Arthur. "*The Century's* American Artist Series: Mary Cassatt." *The Century* 57, 5 (Mar.), pp. 740–41.

Johnson, Virginia C. "The School of Modern Impressionism." *Art Interchange* 42 (Apr.), p. 88.

Leclercq, Julien. "Petites Expositions—Miss Mary Cassatt." *Chronique des arts et de la curiosité*, no. 2 (Jan. 14), p. 10.

New York Times Saturday Review of Books and Art. "The Week in Art." Oct. 14, p. 704.

Sheafer, Frances B. "The Pittsburgh Exhibition." *Brush and Pencil* 5, 3 (Dec.), pp. 125–37.

Strong, Rowland. "Art in Three Cities, II: Impressionists in Paris." *New York Times Saturday Review of Books and Art*, May 20, pp. 322–23.

1900

Brush and Pencil. "The Cincinnati Exhibition." 6, 4 (July), pp. 180–90.

Fontainas, André. "Revue de mois: Art moderne." *Mercure de France* 33, 122 (Feb.), pp. 522–27.

New York Times. "Pennsylvania Academy Pictures." Jan. 14, p. 6.

New York Times Saturday Review of Books and Art (a). "Honors from the Pennsylvania Academy." Feb. 3, p. 79.

New York Times Saturday Review of Books and Art (b). "The Week in Art." June 2, p. 359.

1901

Fowler, Frank. "The New Heritage of Painting of the Nineteenth Century." *Scribner's Monthly Magazine* 30, 2 (Aug.), pp. 253–56.

Morris, Harris S. "American Portraiture of Children." *Scribner's Monthly Magazine* 30, 6 (Dec.), pp. 641–56.

Proust, Antonin. "The Art of Edouard Manet." *International Studio* 12, 48 (Feb.), pp. 227–36.

1902

King, Pauline. *American Mural Painting*. Boston.

Lockington, Walter. "The Limited Range of the Luminist." *Art Interchange* 48 (May), pp. 120–21.

Mauclair, Camille. "Un Peintre de l'enfance: Miss Mary Cassatt." *Art décoratif* 8, 47 (Aug.), pp. 177–85.

Philadelphia Inquirer. "Annual Exhibition at the Academy." Jan. 19, p. 12.

1903

Allan, Sidney. "The Value of the Apparently Meaningless and Inaccurate." *Camera Work*, no. 3 (July), pp. 17–21.

Dewhurst, Wynford. "Impressionist Painting: Its Genesis and Development." *International Studio* 20, 78 (Aug.), pp. 94–112.

Holland, Clive. "Lady Art Students' Life in Paris." *The Studio* 30, 129 (Dec.), pp. 225–30.

Kay, Charles de. "Exhibition of the Women's Art Club." *New York Times*, Dec. 6, p. 7.

Marx, Roger. "Petites Expositions: Exposition d'impressionnistes." *Chronique des arts et de la curiosité*, no. 14 (Apr. 4), pp. 110–11.

Mauclair, Camille. *The French Impressionists (1860–1900)*. Trans. P. F. Konody. London/New York.

Morice, Charles. "Revue du mois: Art moderne." *Mercure de France* 46, 161 (May), pp. 544–46.

New York Daily Tribune. "Opening of the Season—Paintings by Mary Cassatt and Louis Loeb." Nov. 11, p. 8.

New York Evening Post. "Some Picture Shows: An Exhibition of the Works of Mary Cassatt." Nov. 5, p. 7.

New York Times (a). "The Pennsylvania Academy." Jan. 18, p. 14.

New York Times (b). "The Cassatt Oils and Pastels." Nov. 6, p. 7.

Smith, F. Hopkinson. "Impressionism and Realism in Art." *Art Interchange* 50 (Mar.), p. 58.

Stephens, Henry G. "Impressionism: The Nineteenth Century's Distinctive Contribution to Art." *Brush and Pencil* 11, 4 (Jan.), pp. 279–97.

1904
Chicago American, Oct. 22.

Chicago Chronicle (a). "Prize Paintings Chosen." Nov. 20.

Chicago Chronicle (b). "Miss Cassatt's Successful Painting, *A Caress*." Nov. 21.

Chicago Inter-Ocean (a). "The American Exhibit at the Chicago Art Institute." Nov. 13, p. 5.

Chicago Inter-Ocean (b). "This Painting Won Woman First Prize at Chicago Art Institute Exhibition." Nov. 20, p. 3.

Chicago Record-Herald (a). "Current News of Art: Seventeenth Annual Exhibition of Works by American Artists Opens." Oct. 23.

Chicago Record-Herald (b). "Name Winners in Art: Institute Critics Give Cash Prizes to Mary Cassatt and William Wendt." Nov. 20.

Chicago Tribune. "Exhibitions Next Week." Oct. 22.

Dewhurst, Wynford. *Impressionist Painting: Its Genesis and Development*. London.

Geffroy, Gustave. "Femmes artistes: Un Peintre de l'enfance—Miss Mary Cassatt." *Les Modes* 4, 38 (Aug.), pp. 4–11.

Kay, Charles de. "French and American Impressionists." *New York Times*, Jan. 31, p. 23.

Mauclair, Camille. *L'Impressionnisme*. Paris.

New York Times. "Art Notes." Aug. 14, p. 12.

Philadelphia Sunday Press. "Notable Paintings at the Annual Exhibition at the Academy." Jan. 24, p. 6.

1905
American Art News (a). "Among the Artists." 3, 61 (Jan. 7), p. 3.

American Art News (b). 3, 62 (Jan. 14), p. 2.

American Art News (c). "The Portland Exposition." 3, 8 (Sept. 15), p. 3.

Brinton, Christian. "Concerning Miss Cassatt and Certain Etchings." *International Studio* 27, 105 (Nov.), pp. 1–7.

Cary, Elisabeth L. "The Art of Mary Cassatt." *The Scrip* 1 (Oct.), pp. 1–5.

Chicago American (a), May 13.

Chicago American (b), May 20.

Chicago Post. "Art." May 13, p. 12.

Henderson, Helen W. "Centenary Exhibition of the Pennsylvania Academy of the Fine Arts." *Brush and Pencil* 15, 3 (Mar.), pp. 145–55.

New York Evening Post (a), Jan. 28.

New York Evening Post (b), Apr. 29.

New York Times (a). "Cassatt Etchings in Free: Appraisers Decide That Railroad Man's Sister Is a Real Artist." Apr. 13, p. 1.

New York Times (b). "Miss Sara Hallowell Unique in the Art World." Dec. 31, p. 6.

Oliver, Jean N. "Monet and His Art." *New England Magazine* 32 (Mar.), pp. 66–73.

Philadelphia Inquirer. "One Hundredth Anniversary Exhibition of the Academy of the Fine Arts Opens its Doors." Jan. 22, p. 13.

Scribner's Monthly Magazine. "French Painting at the Beginning of the Twentieth Century." 38, 3 (Sept.), pp. 381–84.

Sparrow, Walter S. *Women Painters of the World*. London.

1906
American Art News (a). "American Art News: The Woman's Art Club." 4, 28 (Apr. 21), p. 4.

American Art News (b). "Exhibitions Now On." 5, 9 (Dec. 15), p. 6.

American Art News (c). "Exhibitions Now On." 5, 10 (Dec. 22), p. 6.

Kay, Charles de. "Girl Art Students." *New York Times*, May 20, p. 4.

New York Evening Post. "Art News." Dec. 15, p. 6.

New York Times. "Woman's Art Club." Apr. 19, p. 13.

Philadelphia Inquirer. "Academy of the Fine Arts Exhibition Begins Tomorrow." Jan. 21, p. 2.

Philadelphia Press. "Annual Exhibiton of the Academy of the Fine Arts Nearing a Close After a Successful Season." Feb. 25, p. 1.

Ruge, Clara. "The Tonal School of America." *International Studio* 27, 107 (Jan.), pp. 57–68.

1907
Academy Notes. "Two Exhibitions: At the Pennsylvania Academy and the Corcoran Gallery." 2, 11 (Apr.), pp. 167–73.

American Art News (a). "Exhibitions Now On: The New York Women's Art Club." 5, 16 (Feb. 2), p. 6.

American Art News (b). "Exhibitions Now On." 5, 21 (Mar. 9), p. 6.

American Art News (c). "Paris Letter." 5, 23 (Mar. 23), p. 5.

American Art News (d). "Exhibitions Now On." 6, 6 (Nov. 23), p. 6.

McBride, Henry. *The Sun*, Apr. 29.

New York Herald. "An Uplift for American Art." Feb. 24, p. 3.

New York Times (a). "Woman's Art Club Exhibition." Feb. 10, p. 5.

New York Times (b). "Two Pleinairist Sales." Feb. 24, p. 5.

New York Times Magazine. "Miss Cassatt's 'Triumphs of Uncomeliness.'" Aug. 25, p. 8.

Pica, Victorio. "Artisti contemporanei: Berthe Morisot—Mary Cassatt." *Emporium* 26, 151 (July), pp. 3–16.

Utrillo, M. V. "Exposición internacional de arte de Barcelona." *Forma* 2, 20, pp. 325, 339, 358.

1908
Bénédite, Léonce. "Les Collections d'art aux Etats-unis." *Revue de l'art ancien et moderne* 23 (Jan.–June), pp. 160–76.

Bouyer, Raymond (a). "Expositions et concours." *Bulletin de l'art ancien et moderne* no. 378 (Apr. 4), pp. 109–10.

Bouyer, Raymond (b). "Expositions et concours." *Bulletin de l'art ancien et moderne* no. 399 (Nov. 14), pp. 278–79.

Cary, Elisabeth L. "Recent Acquisitions of Modern Art in the Wilstach Collection." *International Studio* 35, 137 (July), pp. 31–36.

Hepp, Pierre. "Petites Expositions: Exposition Mary Cassatt (Galerie Vollard)." *Chronique des arts et de la curiosité*, no. 16 (Apr. 18), pp. 146–47.

The Index. "Art." Feb. 15, p. 17.

F. M. "Le Mois artistique." *Art et les artistes* 8 (Oct. 1908– Mar. 1909), pp. 176–78.

Morice, Charles. "Revue de la quinzaine: Art moderne." *Mercure de France* 72, 260 (Apr. 16), p. 736.

New York Times (a). "The Painting of Miss Mary Cassatt, a Great American Artist Who's Better Known in France than at Home." Nov. 22, p. 6.

New York Times (b). "Two Canvases Shown at the Philadelphia Art Club's Exhibition." Dec. 6, p. 4.

Pach, Walter. "At the Studio of Claude Monet." *Scribner's Monthly Magazine* 43, 6 (June), pp. 765–68.

Philadelphia Inquirer. "News of Art and Artists." Feb. 23.

Pilgrim, A. "Fine Examples of Impressionist School, Including Originals by Monet and Miss Cassatt." *Pittsburgh Dispatch*, Feb. 12, p. 6.

Pittsburgh Dispatch. "New Loan Collection at Carnegie Galleries." Feb. 11, p. 5.

Pittsburgh Gazette-Times (a). "Mode of Paintings by Impressionists." Feb. 16, p. 10.

Pittsburgh Gazette-Times (b). "Artists Seek the Truth." Mar. 1, p. 6.

Pittsburgh Gazette-Times (c). "Fine Pictures Now Ready for the People." Apr. 30, p. 5.

Pittsburgh Post. "French Impressionist Exhibits Paintings." Feb. 11, p. 2.

Townsend, James B. "Annual Carnegie Exhibit (Second Notice)." *American Art News* 6, 30 (May 9), pp. 3–4.

Vaudoyer, Jean Louis. "Petites Expositions." *Chronique des arts et de la curiosité*, no. 36 (Nov. 21), pp. 370–71.

1909
American Art News (a). "With the Dealers." 3, 13 (Jan. 9), p. 6.

American Art News (b). "Exhibitions Now On: Yukon-Alaska Art Exhibit." 7, 24 (Mar. 27), p. 6.

Boston Daily Evening Transcript. "Miss Mary Cassatt's Exhibition." Feb. 9.

Bulletin of the Detroit Museum of Art. "Two Notable Gifts." 3, 1 (Jan.), pp. 1–2.

R. C. "Art Exhibitions." *New York Daily Tribune*, Mar. 18, p. 7.

Cary, Elisabeth L. *Artists Past and Present: Random Studies*. New York.

Chicago Tribune. "Many Fine Canvases in Art Institute Annual Exhibit." Oct. 24, p. 4.

Current Literature. "Most Eminent of Living American Women Painters." 46 (Feb.), pp. 167–70.

Clarke, Sir Caspar P. "Little Talks on Pictures: Boy with a Sword." *Everybody's* 21 (Sept.–Oct.), pp. 432, 532–33.

Hale, Philip L. "St. Botolph Club Exhibition." *Boston Herald*, Feb. 8, p. 3.

Hartmann, Sadakichi. *History of American Art.* Boston.

McCauley, Lena M. "Art and Artists." *Chicago Post*, Oct. 23, p. 4.

Mechlin, L. "Contemporary American Landscape Painting." *International Studio* 39, 153 (Nov.), pp. 3–14.

Merrick, Lula. "The Art of Mary Cassatt: Talent, Intelligence, Industry and Poetic Feeling Have Placed an American Girl in the Front Rank of Contemporary Painters." *Delineator* 74, 2 (Aug.), pp. 121, 132.

New York Evening Post. "Pictures at the Academy." Mar. 16, p. 7.

New York Sun. "The Spring Academy." Mar. 16, p. 6.

New York Times (a). "The Pennsylvania Art Exhibition." Feb. 7, p. 6.

New York Times (b). "Art Notes Here and There." Apr. 11, p. 6.

New York Times Magazine (a), Jan. 17, p. 5.

New York Times Magazine (b). "A Notable Group of Pictures Revealing the Intellectual Vigor of the French Impressionistic School." Oct. 24, p. 12.

Pach, Walter. "Quelques Notes sur les peintres américains." *Gazette des beaux-arts*, ser. 4, 2 (Oct.), pp. 324–35.

Pittsburgh Gazette-Times. "Thirteenth Annual Art Exhibit Opens Today." Apr. 29, p. 12.

Weitenkampf, Frank. "Some Women Etchers." *Scribner's Monthly Magazine* 46, 6 (Dec.), pp. 731–39.

1910

American Art News (a). "With the Dealers." 8, 20 (Feb. 26), p. 7.

American Art News (b). "As to Women Artists." 8, 21 (Mar. 5).

American Art News (c). "Paris Letter." 8, 22 (Mar. 12), p. 5.

American Art News (d). "Exhibitions Now On: Pictures at Durand-Ruel's." 9, 9 (Dec. 10), pp. 1–2.

American Art News (e). "Third Annual Corcoran Exhibition." 9, 12 (Dec. 31), p. 2.

American Art News (f). "Around the Galleries." 9, 12 (Dec. 31), p. 7.

Bulletin of the Worcester Art Museum. "Acquisitions." 1, 1 (Mar.), p. 4.

Elliot, Huger. "The Rhode Island School of Design and Its Museum." *Art and Progress* 1, 10 (Aug.), pp. 295–301.

Isham, Samuel. *The History of American Painting.* New York/London.

McCauley, Lena M. (a). "Art and Artists." *Chicago Post*, Oct. 15, p. 17.

McCauley, Lena M. (b). "Chicago Art Institute Exhibition." *Art and Progress* 2, 2 (Dec.), pp. 46–51.

Mellerio, André. "Mary Cassatt." *Art et les artistes* 12 (Nov.), pp. 69–75.

New York Times (a). "Paintings by Miss Cassatt." Mar. 6, p. 2.

New York Times (b). "Two Notable Paintings by Mary Cassatt." Nov. 13, p. 5.

New York Times Magazine (a). "Much Good Painting in the Pennsylvania Academy Exhibition—Older Men Send Fine Work." Jan. 23, p. 14.

New York Times Magazine (b). "Subject Pictures an Important Feature of the Philadelphia Exhibition—Many Good Ones Shown." Jan. 30, p. 14

New York Times Magazine (c). "Work of Miss Cassatt, the American Painter Living in France, Who Is a Chevalier of the Legion of Honor." Nov. 27, p. 15.

Pach, Walter. "Manet and Modern American Art." *The Craftsman* 17, 5 (Feb.), pp. 483–92.

Teall, Gardner. "Mother and Child: The Theme as Developed in the Art of Mary Cassatt." *Good Housekeeping* 50, 2 (Feb.), pp. 141–46.

1911

American Art News (a). "Cassatt at Durand-Ruel's." 9, 13 (Jan. 7), p. 6.

American Art News (b). "Around the Galleries." 9, 13 (Jan. 7), p. 7.

American Art News (c). "Pastellists at Folsom's." 9, 14 (Jan. 14), p. 6.

Bulletin of the Worcester Art Museum. "Fourteenth Annual Exhibition of Oil Paintings by American Painters." 2, 2 (July), pp. 4–7.

Carrell, Maud. "In the Local World of Art." *Pittsburgh Dispatch*, May 28, p. 1.

Chicago Tribune. "Notable Works of Art Entered for Annual American Exhibition." Nov. 11, p. 2.

The Craftsman. "Mary Cassatt's Achievement: Its Value to the World of Art." 19, 6 (Mar.), pp. 540–46.

Dundas, Jane. "Chatter of the Studios." *Pittsburgh Gazette-Times*, May 14, p. 8.

Harper's Weekly. "Some Canvases At the American Water-color Show." 55, 20 (May), p. 24.

Monroe, Harriet. "Autumn Exhibition's Fine Work; Bennett to Be Guest at Opening." *Chicago Tribune*, Nov. 12, p. 3.

New York Times. "Awards at Carnegie Exhibit." Apr. 28, p. 11.

New York Times Magazine (a). "First Exhibition of 'The Pastellists' Suggests the Revival of a Charming Form of Eighteenth-Century Art." Jan. 15, p. 15.

New York Times Magazine (b). "News and Notes of the Art World." Jan. 15, p. 15.

New York Tribune. "Miss Cassatt." Jan. 8.

Pittsburgh Post. "Exhibits of Local Artists: Mary Cassatt and H. O. Tanner Contribute Notable Paintings." June 5, p. 5.

Stanton, Howard W. "Mother and Child, by Mary Cassatt." *Harper's Monthly Magazine* 123, 736 (Sept.), pp. 596–97.

Webster, H. Effa. "Certainty in Brush Work Feature of Art Exhibit." *Chicago Examiner*, Nov. 12.

1912

Kahn, Gustave. "Revue de la quinzaine: Art." *Mercure de France* 98, 361 (July 1), pp. 167–70.

Keeble, Glendinning. "International Prize Pictures." *Pittsburgh Gazette-Times*, Apr. 29, p. 8.

F. M. "Le Mois artistique." *Art et les artistes* 15 (Apr.–Sept.), pp. 234–35.

McCauley, Lena M. (a). "An Exhibition of Art at The Art Institute of Chicago." *Art and Progress* 3, 3 (Jan.), pp. 454–57.

McCauley, Lena M. (b). "Color and Sunlight." *Chicago Evening Post*, Nov. 9, p. 6.

Phillips, Duncan C., Jr. (a). "The Impressionist Point of View." *Art and Progress* 3, 5 (Mar.), pp. 505–11.

Phillips, Duncan C., Jr. (b). "What is Impressionism?" *Art and Progress* 3, 11 (Sept.), pp. 702–707.

World Today 2 (Jan.), p. 1660.

1913

Bodnar, John. "International Art Exhibition is Wonderful." *Pittsburgh Post*, Apr. 24, p. 4.

Borgmeyer, Charles R. *Master Impressionists.* Chicago.

Brinton, Christian. "La Peinture américaine." *Art et les artistes* 17 (May), pp. 49–81.

Brown, Bolton. "Art in the Armory (Letter to the Editor)." *New York Times*, Mar. 1, p. 14.

Bulletin of the Detroit Museum of Art. "A Gallery Set Aside." 7, 2 (Apr.), p. 23.

Carrell, Maud. "Extremist Art Has No Place at Exhibition." *Pittsburgh Dispatch*, Apr. 24, p. 4.

Kahn, Gustave. "Revue de la quinzaine: Art." *Mercure de France* 104, 386 (July 16), pp. 416–18.

Keeble, Glendinning (a). "Advance Glimpse of Art Exhibits Reveals Merit." *Pittsburgh Gazette-Times*, Apr. 24, p. 7.

Keeble, Glendinning (b). "Beauty of Truth in Art Real Test." *Pittsburgh Gazette-Times*, Apr. 28, p. 7.

MacChesney, Clara. "Mary Cassatt and Her Work." *Arts and Decoration* 3, 8 (June), pp. 265–67.

McCauley, Lena M. "Art and Artists." *Chicago Post*, Nov. 13, p. 10.

New York Times (a). "Modern Art Exhibition." Jan. 12, p. 18.

New York Times (b). "Art Notes." Feb. 17, p. 10.

New York Times (c). "50,000 Visit Art Show." Mar. 9, p. 12.

New York Times (d). "Art Show Here Attacked." Mar. 23, p. 1.

New York Times Magazine (a). "History of Modern Art at the International Exhibition Illustrated by Paintings and Sculpture." Feb. 23, p. 15.

New York Times Magazine (b). "American Pictures at the International Exhibition Show Influence of Modern Foreign Schools." Mar. 2, p. 15.

Nichols, Eleanor. "Seventeenth Annual Art Exhibition." *The Index*, Apr. 26, p. 10.

Seaton-Schmidt, Anna. "The Carnegie Institute's Annual Exhibition." *Art and Progress* 4, 8 (June), pp. 988–92.

Segard, Achille. *Mary Cassatt: Un Peintre des enfants et des mères.* Paris.

1914

Art in Europe. "Modern Art: The Roger Marx Sale." 1, 3 (June 1), p. 92.

Cary, Elisabeth L. "Painting Health and Sanity." *Good Housekeeping* 58, 2 (Feb.), pp. 152–58.

Hautecoeur, Louis. "Petites Expositions: Exposition de Miss Mary Cassatt (Galerie

Durand-Ruel)." *Chronique des arts et de la curiosité*, no. 25 (June 27), p. 197.

Hoeber, Arthur. "Famous American Women Painters." *The Mentor* 2 (Mar. 16), pp. 1–11.

New York Times (a). "List 344 Paintings at Pittsburgh Show." Apr. 20, p. 11.

New York Times (b). "Art Notes: 344 Paintings in Exhibition at Carnegie Institute, Pittsburgh." Apr. 21, p. 10.

New York Times Magazine. "The Collection of Roger Marx." May 10, p. 11.

Pène du Bois, Guy. "The French Impressionists and Their Place in Art." *Arts and Decoration* 4, 3 (Jan.), pp. 101–105.

Wood, Martin T. "The Grosvenor House Exhibition of French Art." *International Studio* 54, 213 (Nov.), pp. 2–11.

1915

Art and Progress. "Tenth Annual Exhibition, Albright Gallery, Buffalo." 6, 11 (Sept.), pp. 410–15.

Boston Press. "Some Etchings by Mary Cassatt." Sept. 20.

Cortissoz, Royal. "M. Degas and Miss Cassatt, Types Once Revolutionary Which Now Seem Almost Classical." *New York Tribune*, Apr. 4, p. 3.

Ellis, Anne. "Art by Anne Ellis." *Chicago Tribune*, Nov. 28, p. 8.

Evening Post Saturday Magazine. "At the Loan Exhibition for Woman Suffrage." Apr. 3, p. 6.

Havemeyer, Louisine. "Remarks on Edgar Degas and Mary Cassatt." Address read at M. Knoedler and Co., New York, Apr. 6.

McCauley, Lena M. "Art and Artists." *Chicago Post*, Nov. 18, p. 10.

Montgelas, Dr. Albrecht. "Gallery 47 Best Room at Exhibit." *Chicago Tribune*, Nov. 27.

New York Sun. "Loan Exhibition in Aid of Suffrage, Behind the Scenes Types Shown To-day with Miss Cassatt's Work, Impressionist Works." Apr. 6, p. 7.

New York Times (a). "Art Show for Suffrage." Mar. 15, p. 10.

New York Times (b). "Art Exhibit for Suffrage." Apr. 6, p. 10.

New York Times (c). "'Art and Artists' by Mrs. Havemeyer." Apr. 7, p. 7.

New York Times Magazine (a). "Pennsylvania Academy's Annual Exhibition." Feb. 14, pp. 22–23.

New York Times Magazine (b). "Art at Home and Abroad: Exhibition for Suffrage

Cause: Pictures Representing Many Phases of the Art of Edgar Degas and Mary Cassatt in Exhibition for the Suffrage Cause." Apr. 4, pp. 14–15.

New York Times Magazine (c). "Miss Cassatt at the Durand-Ruel Galleries." Apr. 11, p. 23.

New York Times Magazine (d). "Ten American Artists Honored." Aug. 8, pp. 8–9.

New York World (a). "News of the Art World." Apr. 4, p. 2.

New York World (b). "Suffrage Art Show Nets $1,100 in a Day, Mrs. H. O. Havemeyer Opens Display with Talk on Miss Cassatt and Degas." Apr. 7, p. 7.

1916

McCauley, Lena M. "Exhibitions Invite Art Lovers Today." *Chicago Post*, Nov. 2, p. 10.

New York Times Magazine "Art at Home and Abroad: The Exhibition at the Pennsylvania Academy." Feb. 13, pp. 21–22.

Weitenkampf, Frank. "The Dry Points of Mary Cassatt." *Print Collector's Quarterly* 6, 2 (Dec.), pp. 397–409.

1917

Current Opinion. "American Woman's Unique Achievement in Modern Art." 62 (June), pp. 426–27.

New York Times. "Two Examples of Pictures Displaying Wonderful Effects—At the Durand-Ruel Galleries." Apr. 26, p. 12.

M. S. "Painting by Mary Cassatt." *Bulletin of the Rhode Island School of Design* 5, 4 (Oct.), pp. 29–30.

1919

Art et les artistes. "Une Exposition d'artistes américains au Luxembourg." 1 (Apr.–Sept.), pp. 134–36.

C. H. B. "Fifth Annual Exhibition." *Bulletin of The Detroit Museum of Art* 13, 6 (Apr.), pp. 49–53.

Brinton, Christian. "The Conquest of Color." *Scribner's Monthly Magazine* 62 (Oct.), pp. 513–16.

Bulletin of the Cleveland Museum of Art. "Jan. Exhibitions." 5, 1 (Jan.), p. 4.

Bulletin of The Detroit Museum of Art. "Fifth Annual Exhibition." 13, 6 (Apr.), pp. 49–53.

New York Times (a). "Artists Exhibit in Paris." Jan. 17, p. 12.

New York Times (b). "A Responsibility." Jan. 21, p. 8.

New York Times (c). "American Artists to Exhibit in Paris." Mar. 21, p. 12.

New York Times (d). "French Art Exhibition." Mar. 22, p. 14.

New York Times (e). "American Art in France." Mar. 24, p. 12.

New York Times (f). "Paris Sees American Art." Oct. 7, p. 18.

1920

Field, Hamilton E. "Current Art Exhibitions." *The Arts* 1, 1 (Dec.), p. 33.

M. W. M. "*La Sortie du Bain* by Mary Cassatt." *Bulletin of the Cleveland Museum of Art* 7, 10 (Dec.), pp. 146–49.

New York Times (a). "French Impressionists." Jan. 10, p. 10.

New York Times (b). "From Pissarro to Matisse." Feb. 1, p. 2.

New York Times (c). "Notes on Current Art." Feb. 29, p. 10.

New York Times (d). "Notes on Current Art: Prints by Mary Cassatt." Mar. 21, p. 6.

New York Times (e). "Art: Exhibitions of Paintings." Nov. 21, p. 6.

New York Times Book Review and Magazine. "The World of Art: New Pictures in Various Galleries." Sept. 26, p. 20.

Ruskin, John. "A Talk About Children." *The Touchstone* 6, 4 (July), pp. 262–67.

1921

New York Times Book Review and Magazine (a). "The World of Art: Degas, Mary Cassatt and Others." Jan. 23, p. 20.

New York Times Book Review and Magazine (b). "The World of Art: Exhibitions and Openings." Feb. 6, p. 20.

New York Times Book Review and Magazine (c). "The World of Art: A Retrospective Exhibition." May 15, p. 20.

1922

Arts and Decoration. "The Work of Mary Cassatt." 17, 5 (Sept.), p. 377.

B. B. "An Anonymous Gift." *Bulletin of The Metropolitan Museum of Art* 17, 3 (Mar.), pp. 55–58.

Bulletin of The Metropolitan Museum of Art. "A Notable Gift." 17, 2 (Feb.), p. 26.

C. H. B. "Painting by Mary Cassatt Presented." *Bulletin of The Detroit Institute of Arts* 3, 7 (Apr.), pp. 66–67.

M. W. M. (a). "Rearrangement of Gallery VII." *Bulletin of the Cleveland Museum of Art* 9, 6 (June), pp. 103–104.

M. W. M. (b). "An Oil Painting by Mary Cassatt." *Bulletin of the Cleveland Museum of Art* 9, 7 (July), pp. 119–20.

New York Times. "New Treasures in Museum of Art: Nine Paintings by Mary

Cassatt and a Rare Van Dyck on View." Feb. 16, p. 14.

1923

The Arts 3, 6 (June), p. 432.

Bulletin of the Cleveland Museum of Art. "Current Exhibitions, Gallery IX." 10, 9 (Nov.), pp. 163–65.

New York Times. "Art Exhibitions of the Week: Mary Cassatt." May 6, p. 8.

1924

Alexandre, Arsène. "Miss Mary Cassatt, aquafortiste." *Renaissance de l'art français et des industries de luxe* 7, 3 (Mar.), pp. 127–33.

Art News (a). "Mary Cassatt Has Her Final Exhibit." 22, 22 (Mar. 8), p. 5.

Art News (b). "Miss Cassatt Gives Etchings to France." 22, 27 (Apr. 12), p. 4.

Ciolkowska, Muriel. "Painters' Ideals of Childhood." *International Studio* 78, 322 (Mar.), pp. 481–85.

Kahn, Gustave. "Revue de la quinzaine: Art." *Mercure de France* 171, 619 (Apr. 1), pp. 223–24.

New York Evening Post. "Mary Cassatt Exhibition at Durand-Ruel Gallery." May 8.

New York Times Magazine. "The World of Art." Dec. 21, pp. 12–13.

1925

Art News. "Los Angeles: The Pan-American Exhibition." 24, 9 (Dec. 5), p. 10.

Bulletin of the Minneapolis Institute of Arts. "Best in the World." 14, 13 (Nov. 14), p. 83.

H. C. "International Show of Etchings Held." *Art News* 23, 28 (Apr. 18), p. 6.

Ciolkowska, Muriel. "Letter from the U.S." *Artwork* 1, 4 (May–Aug.), pp. 237–38.

Ely, Catherine B. *The Modern Tendency in American Painting*. New York.

1926

Art News (a). "Exhibitions in New York." 24, 18 (Feb. 6), p. 7.

Art News (b). "Impressionist Exhibition at Durand-Ruel." 25, 11 (Dec. 18), pp. 1–2.

Art News (c). "Childhood in Art at Knoedler's." 25, 9 (Dec. 4), pp. 1, 9.

Art News (d). "Cassatt Show for Chicago." 25, 11 (Dec. 18), p. 2.

Art News (e). "Prints at the Public Library." 25, 11 (Dec. 18), p. 9.

Art News (f). "Impressionists at Durand-Ruel is Magnificent." 25, 12 (Dec. 25), pp. 1–2.

Cary, Elisabeth L. "Fifty Years of French Impressionism." *New York Times*, Dec. 19, p. 13.

Goodrich, Lloyd. "New York Exhibitions." *The Arts* 10, 6 (Dec.), pp. 348–49.
New York Times. "Old and Young Art in the New York Galleries." Oct. 31, p. 11.

New York Times Magazine. "Mary Cassatt—An Individual Artist." June 27, pp. 14–15.

New York World. "Mary Cassatt and Duveneck Recall Viewpoints of Other Days." Oct. 31.

Watson, Forbes. "Mary Cassatt." *The Arts* 10, 1 (July), pp. 2–3.

4. Selected Bibliography after 1926

Alexandre, Arsène. "La Collection Havemeyer et Miss Cassatt." *La Renaissance de l'art français* 13 (Feb. 1930), pp. 51–56.

Baltimore Museum of Art. *Mary Cassatt: The Catalog of a Comprehensive Exhibition of Her Work.* Exh. cat. by Adelyn Dohme Breeskin. 1941.

Bass, Ruth. "NY Reviews: Mary Cassatt, Coe Kerr." *Artnews* 84, 1 (Jan. 1985), p. 147.

Berman, Avis. "Adelyn Breeskin: Fifty Years of Excellence, Pt. I." *The Feminist Art Journal* 6, 2 (summer 1977), pp. 9–14.

Bodelson, Merete. "Gauguin's Cassatt." *Burlington Magazine* 109, 769 (Apr. 1967), pp. 226–27.

Boone, M. Elizabeth. "Bullfights and Balconies: Flirtation and Majismo in Mary Cassatt's Spanish Paintings of 1872–73." *American Art* 9, 1 (spring 1995), pp. 55–71.

Bouillon, Jean Paul. "Degas, Bracquemond, Cassatt: Actualité de l'Ingrisme autour de 1880." *Gazette des beaux-arts*, ser. 6, 3 (Jan.–Feb. 1988), pp. 125–27.

Breeskin, Adelyn Dohme. "The Graphic Works of Mary Cassatt." *Prints* 7, 2 (Dec. 1936), pp. 63–71.

Breeskin, Adelyn Dohme. "The Line of Mary Cassatt." *Magazine of Art* 35, 1 (Jan. 1942), pp. 29–31.

Breeskin, Adelyn Dohme. "Books in Review." *Art Journal* 33, 3 (spring 1974), pp. 280–81.

Breeskin, Adelyn Dohme. "Mary Cassatt: Her Life and Her Art." *Arts in Virginia* 21, 3 (spring 1981), pp. 2–15.

Breeskin, Adelyn Dohme. "Little Girl in a Blue Armchair–1878." In *Essays in Honor of Paul Mellon, Collector and Benefactor.* Ed. John Wilmerding. Washington, D.C., 1986.

Breuning, Margaret. "Cassatt and Morisot." *Magazine of Art* 32, 12 (Dec. 1939), pp. 732–33.

Breuning, Margaret. *Mary Cassatt.* New York, 1944.

Broude, Norma, and Mary D. Garrard, eds. *The Expanding Discourse: Feminism and Art History.* New York, 1992.

Bullard, E. John. "An American in Paris: Mary Cassatt." *American Artist* 37, 368 (Mar. 1973), pp. 40–47, 75–76.

Bullard, E. John. *Mary Cassatt Oils and Pastels.* New York, 1972.

Cain, Michael. *American Women of Achievement: Mary Cassatt.* New York, 1989.

Carr, Carolyn Kinder, and Sally Webster. "Mary Cassatt and Mary Fairchild MacMonnies: The Search for Their 1893 Murals." *American Art* 8, 1 (winter 1994), pp. 53–69.

Carson, Julia M. H. *Mary Cassatt.* New York, 1966.

Chicago, The Art Institute of Chicago. *Mary Cassatt, 1844–1926: Retrospective Exhibition.* Exh. cat. by Frederick A. Sweet and S. E. Johnson. 1965.

Costantino, Maria. *Mary Cassatt.* New York, 1995.

Dillon, Millicent. *After Egypt: Isadora Duncan and Mary Cassatt.* New York, 1990.

Effeny, Alison. *Cassatt.* London, 1991.

Elliot, Bridget, and Jo-Ann Wallace. *Women Artists and Writers: Modernist (Im)positionings.* New York, 1994.

Faxon, Alicia. "New Light on Cassatt: Reviews." *Woman's Art Journal* (fall 1985–winter 1986), pp. 50–53.

Fink, Lois. "Children as Innocence from Cole to Cassatt." *Nineteenth Century* 3, 4 (winter 1977), pp. 71–75.

Flint, Kate, ed. *Impressionists in England: The Critical Reception.* London, 1984.

Frelinghuysen, Alice C. "Les Havemeyer, Collectionneurs modèles." *Connaissance des arts*, no. 494 (Apr. 1993), pp. 26–32.

Fuller, Sue. "Mary Cassatt's Use of Soft-Ground Etching." *Magazine of Art* 43, 2 (Feb. 1950), pp. 54–57.

Gaitskell, C. D. "Imaginary and Probably Inaccurate Musings of a Drawing Master, 1853." *School Arts* 61 (Feb. 1962), p. 14.

Garb, Tamar. *Women Impressionists.* Oxford, 1986.

Garb, Tamar. "Gender and Representation." In *Modernity and Modernism: French Painting in the Nineteenth Century.* Eds. Francis Frascina et al. New Haven/London, 1993.

Getlein, Frank. *Mary Cassatt: Paintings and Prints.* New York, 1980.

Gordon, Mary. "Mary Cassatt." *Art and Antiques* (Dec. 1985), pp. 46–53.

Grafly, Dorothy. "In Retrospect: Mary Cassatt." *American Magazine of Art* 18, 6 (June 1927), pp. 305–12.

T. B. H. "The Degas-Cassatt Story." *Art News Annual* 46, 9 (Nov. 1947), pp. 18–20, 52–53.

Hale, Nancy. *Mary Cassatt.* New York, 1975.

Hale, Nancy. "Book Review." *Archives of American Art Journal* 24, 3 (1984), pp. 24–25.

Halévy, Ludovic. "Les Carnets de Ludovic Halévy." Ed. Daniel Halévy. *Revue des deux mondes* 37 (Feb. 15, 1937), pp. 823, 826.

Havemeyer, Ann. "Cassatt: The Shy American." *Horizon* 24, 3 (Mar. 1981), pp. 56–63.

Havemeyer, Louisine W. "The Cassatt Exhibition." *Pennsylvania Museum Bulletin* 22, 113 (May 1927), pp. 373–82.

Huth, Hans. "Impressionism Comes to America." *Gazette des beaux-arts* 29 (Apr. 1946), pp. 225–52.

Hyslop, Francis E., Jr. "Berthe Morisot and Mary Cassatt." *College Art Journal* 13, 3 (spring 1954), pp. 179–84.

Iskin, Ruth. "Mary Cassatt's Mural of *Modern Woman*." Paper presented at the College Art Association conference, Washington, D.C., Jan. 1975.

Ivins, William M., Jr. "New Exhibition in the Print Galleries: Prints by Mary Cassatt." *Bulletin of The Metropolitan Museum of Art* 22, 1 (Jan. 1927), pp. 8–10.

Johnson, Deborah. "Williamstown, Mary Cassatt: The Color Prints." *Burlington Magazine* 132, 1042 (Jan. 1990), pp. 72–73.

Johnson, Deborah. "Cassatt's Color Prints of 1891: The Unique Evolution of a Palette." *Source* 9, 3 (spring 1990), pp. 31–39.

Johnson, Una E. "The Graphic Art of Mary Cassatt." *American Artist* 9, 9 (Nov. 1945), pp. 18–21.

Johnston, P. "Impressionist Mary Cassatt." *American History Illustrated* 18 (Dec. 1983), pp. 24–29.

Kysela, John D. S. J. "Mary Cassatt's Mystery Mural and the World's Fair of 1893." *Art Quarterly* 29, 2 (1966), pp. 129–45.

Leeper, John Palmer. "Mary Cassatt and Her Parisian Friends." *Bulletin of the Pasadena Art Institute* 2 (Oct. 1951), pp. 1–9.

Lloyd, Christopher. "Mary Cassatt." *Print Quarterly* 7, 2 (June 1990), pp. 196–97.

Love, Richard H. *Cassatt: The Independent.* Chicago, 1980.

Lowe, David. "Mary Cassatt." *American Heritage* 25 (Dec. 1973), pp. 10–21, 96–100.

Lowe, Jeannette. "The Women Impressionist Masters: Important Unfamiliar Works by Morisot and Cassatt." *Art News* 38, 5 (Nov. 4, 1939), pp. 9, 17.

Lucas, E. V. "Mary Cassatt." *Ladies Home Journal* 44, 27 (Nov. 1927), pp. 24, 161.

Mathews, Nancy Mowll. "Mary Cassatt and the 'Modern Madonna' of the Nineteenth Century." Dissertation abstract in *Marsyas* 20 (1979–80), pp. 89–90.

Mathews, Nancy Mowll. "Mary Cassatt and the 'Modern Madonna' of the Nineteenth Century." Ph.D. diss., New York University, 1980.

Mathews, Nancy Mowll. "Reviews and Re-Views." *Woman's Art Journal* 2, 1 (spring–summer 1981), p. 57.

Mathews, Nancy Mowll. "Mary Cassatt's *The Bath*: The Happy Mother Revised." *Southeast College Art Conference* 10, 3 (1983) p. 154.

Mathews, Nancy Mowll. "Beauty, Truth and the Artist's Mirror: A Drypoint by Mary Cassatt." *Source* 4, 2–3 (winter–spring 1985), pp. 75–79.

Mathews, Nancy Mowll. *Mary Cassatt.* New York, 1987.

Mathews, Nancy Mowll. "Mary Cassatt in the 1890s: The Color Prints in Context." *Antiques* 136, 4 (Oct. 1989), pp. 860–71.

Mathews, Nancy Mowll. "Mary Cassatt and the Changing Face of the 'Modern Woman' in the Impressionist Era." In *Crosscurrents in American Impressionism at the Turn of the Century.* Ed. William U. Eiland, pp. 25–42. Athens, Ga., 1996.

Mathews, Nancy Mowll, ed. *Mary Cassatt: A Retrospective.* New York, 1996.

Mazur, Michael. "The Case for Cassatt." *The Print Collector's Newsletter* 20, 6 (Jan.–Feb. 1990), pp. 197–201.

McCarthy, Kathleen D. *Women's Culture: American Philanthropy and Art, 1830–1930.* Chicago, 1991.

Memphis, Tenn., Dixon Gallery and Gardens. *Mary Cassatt and the American Impressionists.* Exh. cat. by Michael Milkovich. 1976.

Mühlberger, Richard. *What Makes a Cassatt a Cassatt?* New York, 1994.

Neve, Christopher. "Sit Still for Miss Cassatt: Mary Cassatt Among the Impressionists." *Country Life* 153, 3941 (Jan. 4, 1973), pp. 10–11.

Newman, Gemma. "The Greatness of Mary Cassatt." *American Artist* 30, 2 (Feb. 1966), pp. 42–49.

New York, Coe Kerr Gallery. *Mary Cassatt: An American Observer. A Loan Exhibition for the Benefit of the American Wing of The Metropolitan Museum of Art.* Exh. cat. by Warren Adelson and Donna Seldin. 1984.

New York, Museum of Graphic Art. *The Graphic Art of Mary Cassatt.* Exh. cat., intro. by Adelyn Dohme Breeskin. 1967.

New York, Wildenstein and Co., Inc. *A Loan Exhibition of Mary Cassatt for the Benefit of the Goddard Neighborhood Center.* Exh. cat. by Adelyn Dohme Breeskin. 1947.

Omaha, Neb., Joslyn Art Museum. *Mary Cassatt Among the Impressionists.* Exh. cat. by Adelyn Dohme Breeskin and William A. McGonagle. 1969.

Paris, Musée d'Orsay. *Mary Cassatt.* Exh. cat. by Martine Mauvieux. 1988.

Paris, Musée Marmottan. *Les Femmes Impressionnistes: Mary Cassatt, Eva Gonzalès, Berthe Morisot.* Exh. cat. 1993.

Parker, Rozsika, and Griselda Pollock. *Old Mistresses: Women, Art and Ideology.* New York, 1981.

Peet, Phyllis. "The Art Education of Emily Sartain." *Woman's Art Journal* 11, 1 (spring/summer 1990), pp. 9–15.

Plain, Nancy. *Mary Cassatt: An Artist's Life.* New York, 1994.

Pohl, Frances K. "Historical Reality or Utopian Ideal? The Woman's Building at the World's Columbian Exposition, Chicago, 1893." *International Journal of Women's Studies* 5 (Sept.–Oct. 1982), pp. 289–311.

Richards, Louise S. "Cassatt's Drawing of The Visitor." *Bulletin of the Cleveland Museum of Art* 65, 8 (Oct. 1978), pp. 268–77.

Roger-Marx, Claude. "Mary Cassatt et les femmes peintres." *Revue de Paris* 67 (Jan. 1960), pp. 45–49.

Roudebush, Jay. *Mary Cassatt.* New York, 1979.

Russell, John. "Mary Cassatt: Decor and Decorum." *Art in America* 66, 6 (Nov./Dec. 1978), pp. 96–99.

San José Museum of Art. *Mary Cassatt and Edgar Degas.* Exh. cat. by Nancy Mowll Mathews. 1981.

Seldis, Henry J. "Mary Cassatt . . . The Rebel Retrieved at Newport Beach." *American Art Review* 1 (Mar.–Apr. 1974), pp. 58–64.

Shapiro, Barbara Stern. *Mary Cassatt at Home.* Boston, 1978.

Shapiro, Barbara Stern. "Book Review." *Print Collector's Newsletter* 16, 1 (Mar.–Apr. 1985), pp. 27–29.

Sorel, Nancy Caldwell. "Edgar Degas and Mary Cassatt." *Atlantic Monthly* (Nov. 1993), p. 137.

Sweet, Frederick A. "A Chateau in the Country." *Art Quarterly* 21, 2 (summer 1958), pp. 202–15.

Sweet, Frederick A. "Paintings and Pastels by Mary Cassatt in the Collection of the Art Institute and in Chicago Collections." *Museum Studies* 2 (1967), pp. 32–49.

Thorne, Anna. "My Afternoon with Mary Cassatt." *School Arts* 59 (May 1960), pp. 10–12.

Turner, Robyn. *Mary Cassatt.* Boston, 1992.

Valerio, Edith. *Mary Cassatt.* Paris, 1930.

Valerio, Edith. "A Shelf of New Books: Mary Cassatt (review)." *International Studio* 98, 405 (Feb. 1931), p. 66.

Washington, D.C., National Gallery of Art. *Mary Cassatt, 1844–1926.* Exh. cat. by Adelyn Dohme Breeskin. 1970.

Washington, D.C., Smithsonian Institution. *The Paintings of Mary Cassatt.* Exh. cat. by Adelyn Dohme Breeskin. 1966.

Watson, Forbes. "Philadelphia Pays Tribute to Mary Cassatt." *The Arts* 11, 6 (June 1927), pp. 288–97.

Watson, Forbes. *Mary Cassatt.* New York, 1932.

Webster, Sally. "Mary Cassatt's Allegory of Modern Women." *Helicon Nine* 1 (fall/winter 1979), pp. 38–47.

Webster, Sally. "The 'Ultra' Feminism of Mary Cassatt: Murals for the 1893 Woman's Building." Paper presented at the College Art Association conference, Chicago, Feb. 1992.

Weitzenhoffer, Frances. "Lousine Havemeyer and Electra Havemeyer Webb." *Antiques* 133, 2 (Feb. 1988), pp. 430–37.

Welch, M. L. "Mary Cassatt." *American Society of the Legion of Honor Magazine* 25 (summer 1954), pp. 155–65.

Wells, William. "Who was Degas' Lyda?" *Apollo* 95, 120 (Feb. 1972), pp. 129–34.

Wilson, Doris Jean. "Mary Cassatt and Charles Griffes: American Impressionists in an Era of Change." M.A. thesis, Northeast Missouri State University, 1980.

Wilson, Ellen. *American Painter in Paris: A Life of Mary Cassatt.* New York, 1971.

Yeh, Susan Fillin. "Mary Cassatt's Images of Women." *Art Journal* 35, 4 (summer 1976), pp. 359–63.

Yeldham, Charlotte. *Women Artists in Nineteenth-Century France and England.* 2 vols. New York/London, 1984.

Index

This index of selected names, places, and works of art by Mary Cassatt includes all six essays, plates, and the Chronology. Page numbers in **boldface** type refer to illustrations. Most exhibitions are found under the venue; larger exhibitions are found under the name of the exhibition (i.e., Exposition universelle; Salon).